Photoshop CS5

Lesa Snider

POGUE PRESS™
O'REILLY®

Beijing · Cambridge · Farnham · Köln · Sebastopol · Taipei · Tokyo

Photoshop CS5: The Missing Manual
by Lesa Snider

Copyright © 2010 Lesa Snider. All rights reserved.

Printed in Canada.

Published by O'Reilly Media, Inc., 1005 Gravenstein Highway North, Sebastopol, CA 95472.

O'Reilly Media books may be purchased for educational, business, or sales promotional use. Online editions are also available for most titles: safari.oreilly.com. For more information, contact our corporate/institutional sales department: 800-998-9938 or *corporate@oreilly.com*.

May 2010: First Edition.

This book uses a durable and flexible lay-flat binding.

ISBN: 9781449381684

[TI]

Table of Contents

Part One: The Basics

Part Two: Editing Images

TABLE OF CONTENTS

Part Three: The Artistic Side of Photoshop

Chapter 12: Painting in Photoshop 485

Note: Head to www.missingmanuals.com and click the Missing CD link to download five appendixes.

Part Six: Appendixes

The Missing Credits

About the Author

 Lesa Snider is on a mission to teach the world to create—and use!—better graphics. She's a stock photographer and chief evangelist for iStockphoto.com, and founder of the creative tutorial site GraphicReporter.com. Lesa is the author of many video training titles including "From Photo to Graphic Art," "Practical Photoshop Elements," and "Photoshop Elements 8 for Photographers" (all by KelbyTraining.com), as well as "Graphic Secrets for Business Professionals" (Lynda.com). She writes a regular column for *Photoshop User*, *Elements Techniques*, and *Macworld* magazines, and contributes frequently to CreativePro.com and Layers magazine. Lesa is also a long-time member of the Photoshop World Dream Team of instructors and can be spotted teaching at other conferences such as Macworld Expo, UCDA Design Conference, Geek Girl Boot Camp, Graphics of the Americas, the Santa Fe Workshops, and many more.

During free time, you'll find her carving the twisties on her sportbike or hanging with fellow Apple Mac enthusiasts. Lesa is a proud member of the BMWMOA, F800 Riders Club, and the Colorado Mac User Group (CoMUG.com) a.k.a the Boulder Mac Maniacs. Email: *lesa@graphicreporter.com*.

About the Creative Team

Dawn Mann (editor) is assistant editor for the Missing Manual series. When not working, she likes rock climbing, playing soccer, and causing trouble. Email: *dawn@oreilly.com*.

Nellie McKesson (production editor) lives in Brockton, Mass., and spends her spare time studying graphic design, making t-shirts (*www.endplasticdesigns.com*), and fighting the endless battle of DIY home renovations. Email: *nellie@oreilly.com*.

Nancy Reinhardt (copy editor) Nancy Reinhardt is a freelance copy editor living in the Midwest, who enjoys swimming, biking, and history. She is surrounded by electrical engineers and yet she is "...still fairly certain that given a cape, a wand, and nice tiara, she could save the world," (to quote Leigh Standley). Email: *reinhardt8@comcast.net*.

Ron Strauss (indexer) is a full-time freelance indexer specializing in IT. When not working, he moonlights as a concert violist and alternative medicine health consultant. Email: *rstrauss@mchsi.com*.

Robert Barnes (technical reviewer) is an award-winning digital artist and photographer. He lives in Santa Fe, NM and owns an online gallery (*www.barnesgallery.com*). Robert offers Media Arts Services including DVD production, scanning, photo-restoration, and individual instruction in Photoshop to an expanding client base. He works internationally as a contract photographer and was Chief Photographer at Turner Broadcasting and CNN for 14 years before spending 10 more years at Apple, Inc. Email: *robert@barnesgallery.com*.

Shangara Singh (technical reviewer) is a photographer and a heavy Photoshop and Lightroom user. He owns (*www.examaids.com*) and is the author of the popular Photoshop and Lightroom ACE Exam Aids—study guides for people who want to become Adobe Certified Experts. He also shoots stock and has his own stock-photo website: (*www.mpxstockimages.com*).

Acknowledgements

This book is dedicated to the Greek god of wine, Bacchus, and all the brave little grapes who so valiantly sacrificed their lives so this book could be written. In vino veritas!

I'd like to express galactic thanks to iStockphoto.com for providing most of the beautiful imagery you see throughout this book: An image really is worth a thousand words (if you ever need high-quality, affordable graphics, iStockphoto.com is the way to go!). A big hug and thanks to David Pogue who roped me into this project and so graciously wrote the foreword of this book (while we were in disturbingly rough seas teaching on a cruise ship, no less!). To Scott and Jeff Kelby for believing in me and nurturing my career in *immeasurable* ways throughout so many years. To John "Bynkii" Welch for convincing me that I should say yes to taking on this monstrous project, and to Derrick Story for his wisdom and guidance before I got started. Also, big jugs of Umbrian vino rosso go to Pete Meyers and Dawn Mann for editing this book and keeping me on track. Their input has made me a better writer and I will forever be grateful to them both.

You would not, however, be holding this book if it weren't for Jeff Gamet, managing editor of MacObserver.com, contributor to Design-Tools.com, and author of *Designers Guide to Mac OS X* (Peachpit), who cleared his schedule to help meet the world's ugliest deadline, and for staying up with me on iChat more nights than I can count (it's one big blur). Here's to the sugar-free Red Bull and the Mozart station we made on Pandora.com that got us through the last of it! And when I ended up working straight through my Italian vacation, I'm *really* glad you kept me from jumping overboard while in the middle of the Mediterranean. In hindsight, I shudder to think of all the shopping in Firenze I would have missed.

Special thanks to Richard Harrington (*www.photoshopforvideo.com*) for his help on the actions chapter, to Taz Tally (*www.taztallyphotography.com*) for helping with the print chapter, to Marcus Conge (*www.digitalmanipulation.com*) and Bert Monroy (*www.bertmonroy.com*) for their help with all things 3-D and vector-related, and to the wonderfully brilliant Veronica Hanley who sacrificed two days at sea in order to make the vector chapter make sense! To Melissa Findley (*www.wickedeye.com*) for her superb guidance on the painting chapter, and to photographer extraordinaire, Tony Corbell (*www.corbellproductions.com*), for his guidance on the plug-ins chapter.

To my esteemed colleagues—and good friends—Andy Ihnatko, Ben Willmore, Kevin Ames, Dave Cross, Larry Becker, Jack Davis, Terry White, Dave Moser, Matt Kloskowski, and Eddie Tapp who all expressed how very proud of me they are and who each, in their own special way, convinced me I could survive writing a book of this magnitude.

A big thank you to all of my friends who continually gave their support when I needed it the most: Leslie Raguso, Kathryn Kroll, Ruth Lind, Leslie Fishlock, Melissa Olilla, J. Charles Holt, Erica Gamet, Sarah Friedlander, Kirk Aplin, Loren Finkelstein, and Lorene Romero, as well as the best mama a girl could have, Fran Snider (wish Daddy could've held this book!). To my true love, Jay Nelson, whose respect, support, and caring nature makes me strive to be a better person every single day, and to our kitties, Samantha and Sylvester, who forced me to get out of my pretty purple Aeron chair and play The Laser Pointer Game with them.

May the creative force be with all y'all! Yee-haw ☺

—*Lesa Snider*

Foreword

In the short but crowded history of consumer technology, only two products ever became so common, influential, and powerful that their names become *verbs*.

Google is one.

Photoshop is the other.

("Did you Google that guy who asked you out?" "Yeah—he's crazy. He Photoshopped his last girlfriend out of all his pictures!")

It's safe to say that these days, not a single photograph gets published, in print or online, without having been processed in Photoshop first. It's usually perfectly innocent stuff: a little color adjustment, contrast boosting, or cropping.

But not always. Sometimes, the editing actually changes the photo so that it no longer represents the original, and all kinds of ethical questions arise. Remember when *TV Guide* Photoshopped Oprah's head onto Ann-Margaret's body? When *Time* magazine darkened O.J. Simpson's skin to make him look more menacing on the cover? Or when *National Geographic* moved two of the pyramids closer together to improve the composition?

Well, you get the point: Photoshop is magic. Thanks to Photoshop, photography is no longer a reliable record of reality.

And now, all that magic is in your hands. Use it wisely.

There's only one problem: Photoshop is a *monster*. It's *huge*. Just opening it is like watching a slumbering beast heave into consciousness. Dudes: Photoshop CS5 has over *500 menu commands*.

In short, installing Photoshop is like being told that you've just won a 747 jumbo jet. You sit down in the cockpit and survey the endless panels of controls and switches. *Now what?*

You don't even get a printed manual anymore.

If there were ever a piece of software that needed the Missing Manual treatment, it was Photoshop. And yet, despite having published over 100 books since I started this series in 1999, we had never tackled Photoshop. It was the elephant in the room for all those years, and it had been bugging me.

Frankly, we were terrified.

But no longer. In 2009, the beast was tamed at last by its new master, Lesa Snider: a natural-born Missing Manual author with Photoshop credentials as long as your arm.

She had worked on Missing Manuals, side by side with me in my office, for 4 years, in all kinds of editorial and production capacities. And when she wasn't at my place, she was out in the real world, teaching Photoshop seminars, writing Photoshop how-to articles for the Web, retouching hundreds of photos in Photoshop, and eventually becoming a Photoshop master (which I would define as, "anyone who knows what more than 50 percent of those 500 menu commands actually do").

The result of all that training was that the Missing Manual mantra ran through her blood: make it clear, make it entertaining, make it complete (hence the thickness of the book in your hands). And above all, don't just identify a feature: tell us *what it's for*. Tell us when to use it. (And if the answer is, "You'll *never* use it," tell us that, too.)

The resulting book, *Photoshop CS4: The Missing Manual*, was a critical and popular hit. And now Lesa is back, thank heaven, with a new edition to demystify Photoshop CS5.

Now, I'll be the first to admit that this book isn't for everybody. In fact, it's aimed primarily at two kinds of people: Photoshop beginners and Photoshop veterans.

But seriously, folks. If you're new to Photoshop, you'll find patient, friendly introductions to all those nutty Photoshoppy concepts like layers, color spaces, image resolution, and so on. And, mercifully, you'll find a lot of loving attention to a time-honored Missing Manual specialty—tips and shortcuts. As Photoshop pros can tell you, you pretty much *have* to learn some of Photoshop's shortcuts or it will crush you like a bug.

On the other hand, if you already have some Photoshop experience, you'll appreciate this book's coverage of CS5's new features. Some of them are pretty sweet indeed. (Content-Aware Fill, Puppet Warp, Merge to HDR Pro—mmm.)

In any case, get psyched. You now have both the most famous, powerful, magical piece of software on earth—and an 800-page treasure map to help you find your way.

The only missing ingredients are time, some photos to work on, and a little good taste. You'll have to supply those yourself.

Good luck!

—*David Pogue*

David Pogue is the weekly tech columnist for the New York Times, *an Emmy-winning TV correspondent (CBS News and CNBC), and the creator of the Missing Manual series.*

Introduction

Congratulations on buying one of the most complicated pieces of software ever created. Fortunately, it's also one of the most rewarding. No other program on the market lets you massage, beautify, and transform your images like Photoshop. It's so popular that people use its name as a verb: "Dude, you Photoshopped the *heck* out of her!" You'd be hard-pressed to find a published image that *hasn't* spent some quality time in this program, and those that didn't probably should have.

The bad news is that it's a tough program to learn; you won't become a Photoshop guru overnight. Luckily, you hold in your hot little hands a book that covers Photoshop from a *practical* standpoint, so you'll learn the kinds of techniques you can use every day. It's written in plain English for normal people, so you don't have to be any kind of expert to understand it. You'll also learn just enough theory (where appropriate) to help you understand *why* you're doing what you're doing.

Note: This book focuses primarily on the standard edition of Photoshop CS5, which runs about $700. Adobe also offers Photoshop CS5 Extended, which costs about $1,000 and offers more features primarily designed for folks who work in fields like architecture and medical science. Page 5 lists some of the new Extended-only goodies.

What's New in Photoshop CS5

Adobe has added some amazing new features to Photoshop and incorporated many items that have been on customers' wishlists for years (such as changing the Fill and Opacity settings of several layers at once!). Here's an overview:

- **Workspace updates.** If you're upgrading from CS4, the workspace doesn't look much different than it did, although the Tools icons got a facelift to look more modern. Also, the Application bar now includes a live workspace switcher (they're really workspace buttons) that you can drag leftward to hold as many saved workspaces as you want. In fact, the Hand and Rotate View tools were removed from the Application bar to make room for this new feature.

 If you're upgrading from CS3 or an older version, your whole Photoshop world now exists within a compact frame that you can move around and resize (this was new in CS4 for Mac users, anyway). Using the Arrange Documents menu (page 67), you can see and work with several documents at once, whether they're side by side or stacked on top of each other. And you can create even more room for your images by collapsing panels with a double-click (page 19). The Application bar (page 14) gives you quick access to zoom controls, extras such as guides and grids, as well as screen modes. The Rotate View tool (now *only* in the Tools panel, page 65) lets you spin your canvas around so you can work with it at an angle.

Note: In Photoshop CS4, you could expand or collapse panels with a single-click. However, since most folks are used to double-clicking to do things like that, so Adobe changed panel expand/collapse to a double-click in CS5.

- **Mini Bridge.** To give you easier access to files through Adobe Bridge (see Appendix C, online), Adobe gave Bridge its very own panel inside Photoshop. It's named Mini Bridge because of its size and the fact that it can't quite do everything Bridge can (although you can still use full-blown Bridge anytime you want). You can drag files from the Mini Bridge panel into a Photoshop or InDesign window, search for files, get a full-screen preview by pressing the space bar, and run commands on multiple files such as the new "Merge to HDR Pro" option you'll read about on page 414.

 Speaking of Bridge, the regular version sports an improved Batch Renaming dialog box (for renaming multiple files at once), its "Output to PDF" option now lets you add a watermark to your files (a slightly opaque symbol or text overlay to discourage image theft), plus you can save your custom PDF and web-gallery settings to use again later. Yippee!

- **Content-Aware Fill.** Arguably one of the most useful new features in CS5, this option makes zapping unwanted content from photos easier than ever. It compares your selection to nearby pixels and attempts to fill the selected area so it

blends seamlessly with the background. It works with the Spot Healing brush and the Edit→Fill command.

- **Puppet Warp.** If you ever need to move your subject's arms, legs, or tail into a better position, this new tool can get it done. You begin by dropping markers (called *pins*) onto the item you want to move, and then Photoshop automatically generates anchor points, handles, and a grid-like mesh that you use to move and distort the item. It works with pixel-based layers as well as Smart Objects.

- **New painting tools.** The painting engine (the brains behind Photoshop's painting features) got an overhaul in CS5 that improves the program's overall performance anytime you're using a brush cursor. The new Bristle Tips make existing brushes—and tools that use a brush cursor—behave like their real-world counterparts, letting you create more natural paint strokes. A new Brush Preset panel lets you see what the new bristles look like and the new Mixer Brush lets you mix colors right there on your Photoshop canvas. You can even determine how wet the canvas is, how much paint you're mixing from canvas to brush, and how many colors you want to load onto your brush tip. Heck, there's even a brush-cleaning option that doesn't involve turpentine! You can also change brush hardness with the same keyboard shortcut (Ctrl-Option-drag on a Mac, or right-click+Alt+drag on a PC). And if you've used the Rotate View tool to spin your canvas so it's at a more natural angle, your brushes *won't* rotate.

 Other painterly improvements include keyboard shortcut access to a "heads-up" version of the Color Picker (it appears on top of your document, making it easier to swap color while you're painting), improved support for graphic tablets (like the option to make tablet settings override brush settings), and a new sample ring for the Eyedropper, which shows the current and new colors, making it easier to grab the color you want.

- **Refine Edge enhancements.** One of the most exciting features of CS5 is the Refine Edge dialog box, which was redesigned so it's easier to use and now sports several options for making tough selections easier (like hair and fur). For example, a new Smart Radius option detects the difference between soft and hard edges, and the new Color Decontamination option all but eliminates any leftover pixels from the object's original background. You can also control exactly where the new selection goes—to the current layer, a new layer, a layer mask, a new layer with a mask, a new document, and so on—from within the Refine Edge dialog box!

- **HDR Pro.** If you're a fan of HDR photography—taking multiple exposures and merging them into a single image—you'll love CS5's improvements related to it. The "Merge to HDR Pro" dialog box (page 416) was redesigned so it's easier to use, and it includes several useful presets (built-in recipes for various HDR settings) for creating beautiful images right out of the box. The programming code was revamped so Photoshop merges your images faster, and a de-ghosting

option was added, which is helpful if something in your image moved or shifted between shots. You can also apply HDR settings to normal images by using the new HDR Toning option in the Image→Adjustments menu.

- **Lens Correction.** This filter got an upgrade *and* a new home: It leapt out of the Distort filter category right into the main level of the Filter menu. The Lens Correction dialog box now lets you import specific lens profiles so its distortion-removing voodoo works a lot better and, out of the box, the annoying grid option is off so you can actually *see* your image while you're tweaking it—a handy improvement over CS4. These lens profiles are also used by other tools such as Auto-Align Layers (page 305), "Merge to HDR Pro" (page 414), and Photomerge for panoramas (page 308).

- **64-bit support in Mac OS X.** The new buzzword in computing circles is "64-bit." All it really means is that Photoshop lets you open and edit huge files—ones that are over 4 gigabytes—as well as use more memory (RAM), which can make the program run faster. See the box on page 6 for more info.

- **Improved Camera Raw.** The newest version of the Camera Raw plug-in (page 58) now includes better noise reduction for zapping grain introduced by shooting in low light at a high-light sensitivity setting (ISO). Other enhancements include more options for adding post-crop vignettes (such as a soft, darkened edge) and improved sharpening that pays attention to an image's tone, contrast, and fine details. Camera Raw is discussed throughout this book, but the bulk of the coverage lives in Chapter 9.

- **Layer management.** Layers got a few upgrades, too. For example, you can now adjust the opacity and fill of multiple layers at once, nest layers into a deeper folder structure, save your favorite layer style settings as defaults from within the Layer Style dialog box, drag and drop files from your computer's desktop into another open Photoshop document, drag content from an open window onto another document tab, and so on. Other additions include a ghosted outline as you drag layer content using the Move tool (helpful when moving small items), visual feedback when you're dragging layer styles from one layer to another (you see a big, partially transparent *fx* as you drag), a new option that lets you control whether or not the word "copy" is added to layers' names when you duplicate them, the ability to create a layer mask from transparency, and a new Paste Special menu that lets you do all kinds of neat pasting tricks (page 278). Whew!

- **CS Review.** This new online subscription service lets folks share and post their projects on the Web so clients and/or colleagues can give them feedback. It works with several Adobe Creative Suite programs including Photoshop, InDesign, Illustrator, and Premiere.

There are also a few features that you'll only find in Photoshop CS5 Extended:

- **Repoussé.** This new option (pronounced "Rep-poose-ay") lets you easily create 3-D versions of a variety of 2-D items such as text, paths, layer masks, and selections. It creates a 3D layer that you can use with Photoshop's full arsenal of 3-D tools.

- **Enhanced 3-D editing.** Adobe has added even more features to its 3-D resume, such as the new Ground Plane Shadow Catcher, giving you an easy way to generate a realistic shadow cast on the ground (on, in this case, mesh) beneath a 3-D object. CS5 also sports faster 3-D Ray Tracer rendering (you can think of Ray-Tracing as tracing the path of light rays reflected off an object and back to the camera for a more photorealistic look), which lets you render a selection, pause and resume rendering, and change render quality. They also added a slew of new materials, light sources, and overlays, the ability to change 3-D depth of field, new 3-D preferences, and more.

There are also tons of little changes in Photoshop CS5, too, that are the direct result of Adobe's customer feedback initiative called Just Do It (JDI). For example, Photoshop now automatically saves 16-bit JPEGs as 8-bit (see page 45 for more about image bit depth); Adobe added a Straighten option to the Ruler tool (finally!); the Crop tool has a rule-of-thirds grid overlay; the Save dialog box includes an "apply to all" checkbox; there's a preference that lets you turn off gestures on laptop trackpads; the Shadows/Highlight adjustment is set to 35% from the factory instead of 50%—the list goes on and on. The activation process (Appendix A, online) also got simpler, as the program now automatically gets registered and activated when you install it.

With the good comes a little bad: To accommodate the new programming code that allows for 64-bit processing on the Mac, some plug-ins and filters now only work in 32-bit mode. Thankfully, it's easy to switch between the 32-bit and 64-bit versions of the program (page 6 tells you how), so your favorite add-ons will still work (and rest assured those companies are hard at work updating them for 64-bit mode!).

About This Book

Adobe has pulled together an amazing amount of information in its new online help system (Appendix B), but despite all these efforts, it's geared toward seasoned Photoshop jockeys and assumes a level of skill that you may not have. The explanations are very clipped and to the point, which makes it difficult to get a real feel for the tool or technique you're learning about.

That's where this book comes in. It's intended to make learning Photoshop CS5 tolerable—and even enjoyable—by avoiding technical jargon as much as possible and explaining *why* and *when* you'll want to use (or avoid) certain features of the program. It's a conversational and friendly approach intended to speak to beginners and seasoned pixel pushers alike.

Some of the tutorials in this book refer to files you can download from this book's Missing CD page on the Missing Manuals website (*www.missingmanuals.com/cds*) so you can practice the techniques you're reading about. And throughout the book, you'll find several kinds of sidebar articles. The ones labeled "Up to Speed" help newcomers to Photoshop CS5 do things or explain concepts that veterans are probably already familiar with. Those labeled "Power Users' Clinic" cover more advanced topics for the brave of heart.

Note: Photoshop CS5 functions almost identically on Mac and Windows computers, but the screenshots in this book were all taken on a Mac for the sake of consistency. However, the keyboard shortcuts for the two operating systems are different, so you'll find both included here—Mac shortcuts first, followed by Windows shortcuts in parentheses. In a few instances, the locations of certain folders differ and in those cases, you get the directions for both operating systems.

What Does "64-bit" Mean?

The cool phrase in computing circles these days is "64-bit." While that term may sound pretty geeky, it's actually not that intimidating. 64-bit programs (a.k.a. "applications" or "apps") simply know how to count higher than 32-bit programs.

So what does that mean in practice? 32-bit programs can open and work with files that are up to 4 gigabytes in size—which is already huge. 64-bit programs, on the other hand, can open files that are way bigger than that, as long as your operating system can handle 64-bit apps. (Mac OS X 10.5 [Leopard] and Microsoft Windows Vista [the 64-bit version, anyway] and later are up to the task.) 64-bit programs can also make use of more memory than their 32-bit counterparts, which is crucial when you're working with big honkin' files. For example, the 64-bit version of Photoshop lets you use more than 4 gigs of RAM, which makes it run faster. (You can change how your machine's memory is allotted by tweaking Photoshop's preferences as described on page 34.)

The bottom line is that, if you work with gigantic files, you'll want to use the 64-bit version of Photoshop. The downside is that some adjustments (like Variations—page 355), third-party plug-ins (Chapter 19), and filters (Lighting Effects [page 645], PatternMaker [page 655]) don't work with

the 64-bit version of the program. But never fear; you can launch the 32-bit version of Photoshop and they'll work just fine. When you install Photoshop on a PC, you get two full versions of the program in two separate folders: one for 32-bit mode and another for 64-bit mode (located in Program Files→Adobe→Photoshop C5 and Program Files (x86)→Adobe→Photoshop CS5, respectively). Simply quit one program and then launch the other.

On a Mac, open your Applications folder and then locate the Adobe Photoshop CS5 folder. Open the folder by double-clicking it, find the application icon (it looks like a tiny blue suitcase), click it once to select it and then choose File→Get Info. In the resulting dialog box, locate the General section (it's in the middle) and turn on the "Open in 32-bit mode" checkbox. Quit Photoshop, relaunch it, and you're all set.

You'll still be able to share Photoshop files with both Mac and PC folks just like you always have, and you shouldn't see any big difference in how Photoshop behaves no matter which version you use. Unless you plan on working with files that are bigger than 4 gigabytes, it doesn't really matter whether you use the 64-bit or 32-bit version of Photoshop CS5, though the 64-bit version might feel like it runs faster.

About the Outline

This hefty book is divided into six parts, each devoted to the type of things you'll do in Photoshop CS5:

- **Part One: The Basics.** Here's where you'll learn the essential skills you need to know before moving forward. Chapter 1 gives you the lay of the land and teaches you how to work with panels and make the Photoshop workspace your own. You'll also find out the many ways of undoing what you've done, which is crucial when you're still learning. Chapter 2 covers how to open and view your documents efficiently, and how to set up new documents so you have a solid foundation on which to build your masterpieces.

 Chapter 3 dives into the most powerful Photoshop feature of all: layers. You'll learn about the different kinds of layers and how to manage them, the power of layer masks, and how to use layer styles for special effects. Chapter 4 explains how to select part of an image so you can edit just that area. In Chapter 5, you'll dive headfirst into the science of color as you explore channels (Photoshop's way of storing the colors that make up your image) and learn how to use channels to create selections; you'll also pick up some channel-specific editing tips along the way.

- **Part Two: Editing Images.** Chapter 6 starts off by explaining a variety of ways you can crop images, both in Photoshop and in Camera Raw. The chapter then demystifies resolution once and for all so you'll understand how to resize images without reducing their quality. In Chapter 7, you'll learn how to combine images in a variety of ways, from simple techniques to more complex ones. Chapter 8 covers draining, changing, and adding color, arming you with several techniques for creating gorgeous black-and-white images, delicious duotones, partial-color effects, and more. You'll also learn how to change the color of almost anything.

 Chapter 9 focuses on color-correcting images, beginning with auto fixer-uppers, and then moving on to the wonderfully simple world of Camera Raw and the more complicated realm of Levels and Curves. Chapter 10 is all about retouching people and is packed with practical techniques for slimming, trimming, and beautifying the faces and bodies that grace your pictures. It also explains how to use the Dodge and Burn tools in ways that won't harm your images. Chapter 11 covers all kinds of ways to sharpen images to make them look especially crisp.

- **Part Three: The Artistic Side of Photoshop.** This part of the book is all about creativity. Chapter 12 explains the many ways of choosing colors for your documents, and teaches you how to create a painting from scratch. Chapter 13 focuses on using the mighty Pen tool to create complex illustrations and selections, along with how to use Photoshop's Shape tools. Chapter 14 teaches you the basics of typography and then moves on to how to create and format text in Photoshop.

You'll find out how to outline, texturize, and place text, among other fun stuff. Chapter 15 covers the wide world of filters; you'll come away with at least one practical use for one or more of the filters in each filter category.

- **Part Four: Printing and the Web.** In Chapter 16, you'll learn about printing your images, beginning with why it's so darn hard to make what comes out of your printer match what you see onscreen. You'll learn about the different color modes and how to prepare your images for printing, whether you're using an inkjet printer or sending your files to a commercial printing press. Chapter 17 focuses on preparing images for the Web, and walks you through the various file formats you can use, explains how to protect your images online, and shows you how to use Bridge to create Web galleries. Rounding out the chapter is info on using the Slice tool on a web page design, and step-by-step instructions for creating an animated GIF.

- **Part Five: Photoshop Power.** This part is all about working smarter and faster. It starts with an entire chapter devoted to using actions (Chapter 18), which help you automate tasks you perform regularly. Chapter 19 covers installing and using plug-ins (small programs you can add on to Photoshop) and recommends some of the best on the market today.

- **Part Six: Appendixes.** Appendix A covers installing and uninstalling Photoshop. Appendix B gives you some troubleshooting tips, explains Photoshop's help system, and points you to resources other than this book. Appendix C gets you up to speed on using Adobe Bridge to import, organize, and export your images. Appendix D gives you a tour of the mighty Tools panel. And finally, Appendix E walks you through Photoshop CS5's 258 menu items.

Tip: All the appendixes are available on this book's Missing CD page at *www.missingmanuals.com/cds*.

For Photographers

If you're relatively new to digital-image editing or you've always shot film and are taking your first brave steps into the world of digital cameras, you'll be amazed at what you can do in Photoshop, but there's a lot to learn. By breaking Photoshop down into digestible chunks that are most important to *you*, the learning process will feel less overwhelming. (There's no sense in tackling the whole program when you'll only use a quarter of it—if that much.)

The most important thing to remember is to be patient and try not to get frustrated. With patience and practice, you *can* master the bits of Photoshop that you need to do your job better. And with the help of this book you'll conquer everything faster than you might think. As you gain confidence, you can start branching out into other

parts of the program to broaden your skills. Here's a suggested roadmap for quickly learning the most useful aspects of the program:

1. **Read all of Chapters 1 and 2 (or at the very least skim them).**

 These two chapters show you where to find all of Photoshop's tools and features and explain how the program is organized. You'll learn how to open, view, and save your images, which is vital stuff to know.

2. **If your photos aren't on your computer already, read Appendix C (online) about Adobe Bridge.**

 Bridge is an amazingly powerful image organizer and browser that can help get your images onto your computer. It takes care of importing, renaming, and even backing up your precious photos.

3. **If you're shooting in Raw format (page 57) and need to color-correct your images in a hurry, skip ahead to the section on editing in Camera Raw in Chapter 9 (page 381).**

 This chapter includes an entire section on practical editing techniques you can use in Camera Raw, and a quick reference that points you to where you'll find other Camera-Raw techniques throughout this book.

4. **If you're *not* shooting in Raw and you need to resize your images before you edit them, read Chapter 6.**

 This chapter explains resolution and how to resize images without reducing their quality.

5. **Proceed with Chapters 8, 9, and 10 to learn about color effects, color-correcting, and retouching people, respectively.**

6. **When you're ready to sharpen your images, read Chapter 11.**

7. **Finally, when you want to print your photos, read the section on printing with an inkjet printer in Chapter 16 (page 676).**

 This chapter walks you through printing your photos, and includes advice on how to print borderless images.

That's all you need to get started. When you're ready to dive more fully into Photoshop, pick back up at Chapter 3, which covers layers, and then move on through the book as time permits.

The Very Basics

This book assumes that you know how to use a computer and that, to some extent, you're an expert double-clicker, drag and dropper, and menu opener. If not, here's a quick refresher:

To *click* means to move the point of your mouse or trackpad cursor over an object on your screen and press the left mouse or trackpad button once. To *right-click* means to press the right mouse button once, which produces a menu of special features called a *shortcut menu*. (If you're on a Mac and have a mouse with only one button, hold down the Option key while you click to simulate right-clicking.) To *double-click* means to press the left button twice, quickly, without moving the mouse between clicks. To *drag* means to click an object and use the mouse to move it while holding down the left mouse button. Most selection buttons onscreen are pretty obvious, but you may not be familiar with *radio buttons*: To choose an option, you click one of these little empty circles that are arranged in a list. If you're comfortable with basic concepts like these, you're ready to get started with this book.

You'll find tons of keyboard shortcuts along the way, and they're huge timesavers. If you see "Press ⌘-S (Ctrl+S on a PC) to save your file," that means to hold down the ⌘ (or Ctrl) key while pressing the S key. Press one and keep holding it as you press the other. (This book lists Mac keyboard shortcuts first, followed by Windows shortcuts in parentheses.) Other keyboard shortcuts are so complex that you'll need to use multiple fingers, both hands, and a well-placed elbow. Use them at your own risk!

About→These→Arrows

In *Photoshop CS5: The Missing Manual* (and in all Missing Manuals, for that matter), you'll see arrows sprinkled throughout each chapter in sentences like this: "Choose Filter→Blur→Gaussian Blur." This is a shorthand way of helping you find files, folders, and menu choices without having to read through painfully long and boring instructions. For example, the sentence quoted above is a short way of saying: "At the top of the Photoshop window, locate the Filter menu. Click it and, in the list that appears, look for the Blur category. Point to the word Blur without clicking and, in the resulting submenu, click Gaussian Blur" (see Figure I-1).

About MissingManuals.com

On the Missing Manuals website (*www.missingmanuals.com*), you'll find this book's Missing CD page, which includes links to downloadable images mentioned in this book's tutorials, in case you want to practice techniques without using your own photos.

A word about the image files for the tutorials: To make life easier for people with dial-up Internet connections, the file sizes have been kept pretty small. This means you probably won't want to print the results of what you create (you'll end up with a print about the size of a matchbook). But that doesn't really matter because the files are only meant for onscreen use. You'll see notes throughout the book about which practice images are available for any given chapter.

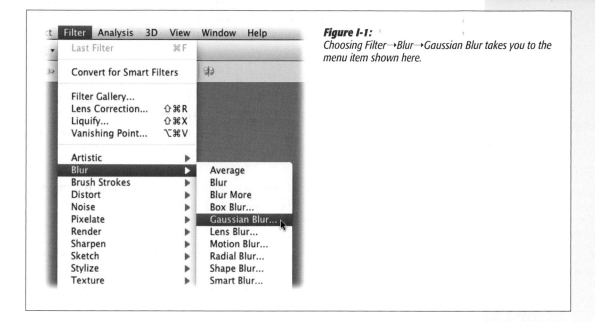

Figure I-1:
Choosing Filter→Blur→Gaussian Blur takes you to the menu item shown here.

On the website, you can also find articles, tips, and updates to this book. If you click the Errata link, you'll see any corrections we've made to the book, too; if you find something in these pages that you think is wrong, feel free to report it by clicking that link. Each time the book is printed, we'll update it with any confirmed corrections. If you want to be certain that your own copy is up to the minute, this is where to check for any changes. And thanks for reporting any errors or suggesting corrections.

We'd love to hear your suggestions for new books in the Missing Manual line. There's a place for that on *www.missingmanuals.com*, too. And while you're online, you can also register this book at *www.oreilly.com* (you can jump directly to the registration page by going here: *www.tinyurl.com/yo82k3*. Registering means we can send you updates about this book, and you'll be eligible for special offers like discounts on future editions.

Safari® Books Online

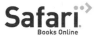 Safari® Books Online is an on-demand digital library that lets you easily search over 7,500 technology and creative reference books and videos to find the answers you need quickly.

With a subscription, you can read any page and watch any video from our library online. Read books on your cellphone and mobile devices. Access new titles before they're available for print, and get exclusive access to manuscripts in development

and post feedback for the authors. Copy and paste code samples, organize your favorites, download chapters, bookmark key sections, create notes, print out pages, and benefit from tons of other timesaving features.

O'Reilly Media has uploaded this book to the Safari Books Online service. To have full digital access to this book and others on similar topics from O'Reilly and other publishers, sign up for free at *http://my.safaribooksonline.com*.

Photoshop CS5 Guided Tour

Photoshop CS5 is bursting with amazing features that'll help you edit and create your very own digital masterpieces. If this is your first foray into the world of Photoshop, all these features will be new to you. If you're an experienced pixel pusher, there are some surprises waiting for you, too. If you skipped the previous version and are leapfrogging from Photoshop CS3 to CS5, Adobe introduced major changes to the work environment in CS4, and while these changes make Photoshop easier to use, they take some time to get used to.

Throughout the rest of this book, you'll dive much deeper into specific tools and techniques, but this chapter gives you a good, solid foundation on which to build your Photoshop skills. You'll learn how to work with the Application Frame and Application bar, plus how to wrangle document windows and panels. Once you've gotten them placed just right, you'll learn how to save your setup as a custom work-space. If you're a beginner, the section on using Undo commands and history states will show you how to fix mistakes and back out of almost anything you've done. Finally, you'll learn how to fine-tune Photoshop's behavior through preferences and built-in tools (called presets) that let you personalize your work environment even more.

Meet the Application Frame

When you launch Photoshop CS5 for the first time, you'll be greeted by the *Application Frame* shown in Figure 1-1 (although if you're restarting Photoshop after deleting your preferences as described in Appendix B, online, it'll be turned off). It's part of Adobe's effort to consolidate your work environment and lessen clutter; the frame confines all things Photoshop to a single resizable and movable window. You can

grab the whole mess—documents, panels, and all—and move it to one side of your screen (or better yet, to another monitor) so it's out of the way. If you open more than one document, they're displayed in handy tabs that you can rearrange by dragging.

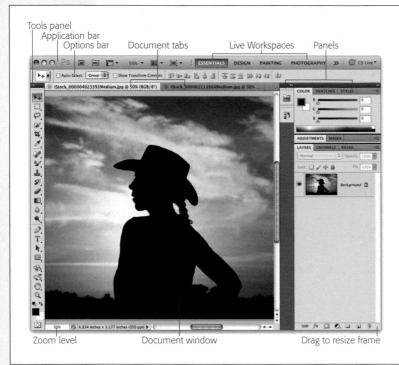

Tools panel
Application bar
Options bar
Document tabs
Live Workspaces
Panels

Zoom level
Document window
Drag to resize frame

Figure 1-1:
Click an image's document tab to summon it front and center. Photoshop stores the vast majority of its tools in the panels on the left and right sides of the Application Frame; a full introduction to panels starts on page 19.

The upside of using the Application Frame is that all of Photoshop's bits and pieces stay together as you move things around. Resizing the frame also automatically changes the size of your panels and windows to fit within it. Chances are, you'll either love it or hate it. If the latter is the case and you're on a Mac, you can turn if off by choosing Window→Application Frame to make Photoshop switch to the floating-window view you're used to.

Tip: If you need to do some work on your desktop or in another program, you can temporarily *hide* Photoshop. On a Mac, press ⌘-H or click the yellow dot at the top left of the Application Frame. Your workspace disappears, but Photoshop keeps running in the background. To bring it back to the forefront, click its shrunken icon in the Dock. In Photoshop CS5, the first time you press ⌘-H, a dialog box appears asking if you'd like to reassign that keyboard shortcut to hide Photoshop instead of hiding selections. (To change it back, you can edit your keyboard shortcuts, as explained in the box on page 36, or delete Photoshop's preferences as described in Appendix B, online at *www.missingmanuals.com/cds*.)

If you're on a PC, you can minimize the program by clicking the upper-right – sign button and Windows tucks the program down into your taskbar. To get it back, click its taskbar icon.

The Application Bar

At the very top of the Application Frame is a row of tools called the *Application bar* (Figure 1-2), which gives you one-click access to handy stuff like Adobe Bridge (covered in Appendix C, online), extras (guides, grids, and rulers), zoom controls, and

more. The real gems, though, are the Arrange Documents menu and the new Live Workspace buttons (shown in Figure 1-1 and discussed on page 18). The Arrange Documents menu lets you organize your open documents so you can see them all at one time, which is handy for evaluating before and after versions of images or just managing a bunch of open windows (more on that in Chapter 2!). A new option in CS5 is the CS Live button on the far right, which launches the new community-driven help system you'll learn about in Appendix B, online.

Figure 1-2:
The Application bar gives you quick access to both Bridge and Mini Bridge (see Appendix C, online), as well as the Arrange Documents (page 67), Zoom level (page 60), and Screen Mode (page 16) options.

In the Windows version of Photoshop CS5, the Application bar is also home to all the program's main menus (File, Edit, Image, Layer, and so on); in the Mac version, those menus appear at the top of your screen instead.

Note: In CS4, the Hand and Rotate Canvas tools also roosted in the Application bar. However, in CS5 Adobe took them out in order to make room for the new Live Workspace buttons shown in Figure 1-1. Flip to page 18 for to learn how to customize your workspace.

The Almighty Options Bar

Lording over your document window is the Options bar, which lets you customize the settings for nearly every tool in the Tools panel (see Figure 1-3, top). This bar automatically changes to show settings related to the tool you're currently using. Unfortunately, its labels are fairly cryptic, so it can be hard to figure out what the heck all that stuff does. Luckily, you can hover your cursor over any item to see a little yellow pop-up description called a *tooltip* (you don't need to click—just don't move your mouse for a couple seconds). When you move your cursor away from the item, the tooltip disappears.

Figure 1-3:
Top: The Options bar is customization central for whatever tool you're currently using. However, it doesn't have to live at the top of your screen; you can undock it by dragging the tiny dotted lines circled here.

Middle: Once you've freed the Options bar, you can drag it anywhere you want by grabbing the dark gray bar on its far left.

Bottom: To redock the Options bar, drag it to the top of your screen. Once you see a thin blue line—like the one shown here—release your mouse button.

When you first install Photoshop, the Options bar is perched near the top of the screen, beneath the Application bar. If you'd rather put it somewhere else, grab its left end and drag it wherever you want, as shown in Figure 1-3, middle. If you decide to put it back later (also called *docking*), drag it to the top of the screen (see Figure 1-3, bottom).

Tip: If a tool seems to be misbehaving, it's likely because you changed one of the Options bar's settings and forgot to change it back! These settings are "sticky": Once you change them, they stay that way until you change them back.

Swapping Screen Modes

Photoshop also includes three different *screen modes* for your document-viewing pleasure. Depending on what you're doing, one will suit you better than another. For example, you can make your image take up your whole screen (with or without the Application and Options bars), you can hide your panels, and so on (see Figure 1-4).

Figure 1-4:
The many faces of Photoshop: Standard with Application Frame on (top), Full Screen With Menu Bar (bottom left), and Full Screen (bottom right). You can edit images in any of these modes. Also, pressing the Tab key lets you hide or show menus and panels.

Flip ahead to page 51 to learn how to open an image. The short version: Choose File→Open, navigate to where the image lives, and then click Open.

It's a snap to jump between modes—just press the F key repeatedly (as long as you're not using the Type tool—if you are, you'll type a bunch of *f*s) or use the Screen Mode pop-up menu in the Application bar (see Figure 1-2). Your choices are:

- **Standard Screen Mode** is the view you see when you launch Photoshop for the first time. This mode shows menus, the Application Frame, the Application bar, panels, and document windows. Use this mode when the Application Frame is active and you need to scoot the whole Photoshop application—windows and all—around on your monitor.

- **Full Screen Mode With Menu Bar** completely takes over your screen, puts your currently open document in the center on a gray background, and attaches any open panels to the left and right edges of your monitor. This mode is great for day-to-day editing because you can see all your tools and menus without being distracted by the files and folders on your desktop. The gray background is also easy on your eyes and a great choice when color-correcting your images (a brightly colored desktop can affect your color perception).

- **Full Screen Mode** hides all of Photoshop's menus and panels, centers the document on your screen, and puts it on a black background. This mode is great for displaying and evaluating your work or for editing distraction-free. And the black background really makes images pop off the screen!

Tip: You can free up precious screen real estate by pressing the Tab key to hide menus and panels. This trick is a great way to get rid of distracting elements when you're editing, especially if you've got a small monitor. Pressing Shift-Tab hides everything except the Tools panel, Options bar, and Application bar. To show the panels again, press Tab or mouse over to the edge of your monitor where the panels should be; when you move your mouse away from the panels, they'll disappear again.

Customizing Your Workspace

The folks at Adobe understand that once you arrange your panels just so, you want to keep 'em that way. That's why Photoshop lets you save your setup as a *workspace* using the Workspace menu at the top right of the Application bar. Once you've created a workspace, it appears as a clickable button in the Application bar (see Figure 1-5). To swap workspaces, click one of the new Live Workspace presets (built-in settings) to make Photoshop rearrange your panels accordingly. Straight from the factory, you see four clickable preset buttons: Essentials, Design, Painting, and Photography; however, if you click the Workspace menu—or drag the little dividing line next to Essentials leftward—you'll see even more.

Figure 1-5:
Most of the preset workspaces are designed to help you perform specialized tasks. For example, the Painting workspace puts the Brushes and Navigation panels at the top right and groups the color-related panels you'll undoubtedly use when painting. Take the built-in workspaces for a test drive—they may give you customization ideas you hadn't thought of.

If you're familiar with Photoshop but new to CS5, try out the "New in CS5" workspace. It highlights all the menu items that are new in CS5, which is a great way to see additions at a glance.

To save your own custom workspace, first get things looking the way you want. (The next section has details on working with panels.) Next, click the Workspace menu and choose New Workspace (it's at the bottom of the menu). In the resulting dialog box, give your workspace a meaningful name and turn on the options for the features you want to include. You can pick from panel locations, keyboard shortcuts, and

menu settings; just be sure to turn on the options for *all* the features you changed or they won't be included in your custom workspace. After you click Save, your custom workspace shows up as the leftmost option in the Live Workspaces area, as well as in the Workspace menu.

If you've created some custom workspaces that you'll never use again, you can send 'em packin'. First, make sure the workspace you want to delete isn't active. Next, choose Delete Workspace from the Workspace menu and, in the resulting Delete Workspace dialog box, pick the offending workspace and then click Delete. Photoshop will ask if you're sure, so you have to click OK to finish it off.

Note: New in Photoshop CS5 is the ability to delete any workspace you want—including the presets!

Working with Panels

The far right side of the Application Frame is home to a slew of small windows called *panels* (years ago they were called palettes), which let you work with commonly used features like colors, adjustments, layers, and so on. Panels don't have to live alone; you can link them together in groups, which you can then move around. Feel free to organize the panels however you like and position them anywhere you want. Panels can be free floating or *docked* (attached) to the left, top, or right side of your screen.

Photoshop starts you off with three docked panel groups filled with the panels it thinks you'll most likely need first. The first group includes the Colors, Swatches, and Styles panels; the second group includes Adjustments and Masks; and the third includes Layers, Channels, and Paths (there's more on docked panels coming up shortly).

To work with a panel, select it by clicking its tab. Panels are like Silly Putty—they're incredibly flexible. You can collapse, expand, move, and resize them or swap 'em for other panels (the Windows menu lists all the panels in Photoshop). Here's how:

- **Collapse or expand panels.** If the panels are encroaching on your editing space, you can shrink them both horizontally and vertically so they look and behave like buttons (see Figure 1-6). To collapse a panel horizontally into a button nestled against the side of another panel (or the edge of your screen), click the tiny double arrow in its top-right corner (click this same button again to expand the panel). To collapse a panel vertically against the bottom of the panel above it, double-click a blank spot in the dark gray area near the panel's tab to make it roll up like a window shade (double-click it again to roll it back down). To adjust a panel's width, hover your cursor over its left edge and, when your cursor turns into a double-headed arrow, drag left or right to make the panel bigger or smaller. Collapsing and expanding panel groups works exactly the same way.

Double-click here to collapse
panels vertically

Click here to collapse
panels horitzontally

Figure 1-6:
Here you can see the difference between expanded (left) and collapsed (right) panels. Double-click the medium gray bar at the top of a panel to collapse it vertically (circled on the left), rolling it up like a window shade; double-click the bar again to expand it. You can also collapse a panel horizontally by clicking the double arrows at the top right of the panel (circled, right), at which point it turns into a small square button.

Note: In Photoshop CS4, you accomplished this panel collapsing and expanding business with a single-click; in CS5, it takes a *double*-click. Flip back to page 2 to learn why.

- **Modify panel groups.** As mentioned earlier, Photoshop clumps frequently used panels into *panel groups*. If you don't use a certain panel in a group, you can replace it with one you *do* use. To remove a panel, click its tab and drag it out of the panel group to a different area of your screen (see Figure 1-7, top); then click the tiny circle in the panel's top-left corner to close it. (On a PC, click the X button in the panel's top-right corner instead.) Don't worry—the panel isn't gone forever; if you want to reopen it, simply choose it from the Windows menu.

 To add a panel to a group, first make sure the panel is open (if not, select it from the Windows menu). Then grab the top of the panel near its tab and drag it into the group you want to add it to; when you see a blue outline appear around the panel group, release your mouse button (see Figure 1-7, middle).

Figure 1-7:
Top: You can remove panels you don't use to free up space. For example, if you never use the Styles panel (and you probably won't use it much), drag it out of the panel group and close it.

Middle: When you're dragging a panel into a panel group, wait until you see a blue line around the inside of the group before you release your mouse button. Here the Kuler panel is being added to a panel group.

Bottom: When you release your mouse button, the new panel becomes part of the group. To rearrange panels within a group, drag their tabs left or right.

- **Dock and undock panels.** The first time you open Photoshop, it docks three sets of panel groups to the right side of your screen (or Application Frame). But you're not stuck with your panels glued to this spot; you can set them free by turning them into *floating* panels. To liberate a panel, grab its tab, pull it out of the group it's in, and then move it anywhere you want. When you let go of your mouse button, the panel appears where you put it—all by itself.

To undock a whole panel group, click an empty spot in the group's tab area and drag it out of the dock (Figure 1-8, top). Once you release your mouse button, you can drag the panel group around by clicking the same empty spot in the tab area. Or, if the group is collapsed, click the tiny dotted lines at the top of the group, just below the dark gray bar (Figure 1-8, bottom). To dock the panel (or panel group) again, drag it back to the right side of your screen.

Drag this way to undock the panel

Figure 1-8:
Top: To undock a panel or panel group, grab a free area to the right of the tabs at the top of the panel and drag it somewhere else on your screen. To dock it again, drag it to the right side of your screen—on top of the other panels. When you see a thin blue line appear where you want the panel or group to land, release your mouse button.

Bottom: You can move vertically collapsed panels in the same way, but you grab them by the row of tiny dots that appears at the top (shown here).

Drag this way to dock the panel

Drag to move vertical panels

Getting the hang of undocking, redocking, and arranging panels takes a little practice because it's tough to control where the little buggers *land*. When the panel you're dragging is about to join the dock area at the right side of your screen (or a different panel group), a thin blue line appears showing you where the panel or group will go. Unfortunately, the line can be tough to spot because it's so thin and light colored.

Tip: If the thin blue highlight lines are hard to see when you're trying to group or dock panels, try dragging the panels more slowly. When you drag the panel into a group or dockable area, the blue highlight hangs around longer and the panel itself becomes momentarily transparent.

Using the Tools Panel

One of the panels you'll frequent the most is named Tools (Figure 1-9, left); it serves as home base for all of Photoshop's editing tools. When you first launch the program,

you'll see the Tools panel on the left side of your screen, but you can drag it anywhere you want by clicking the double row of dots near its top (Figure 1-9, right).

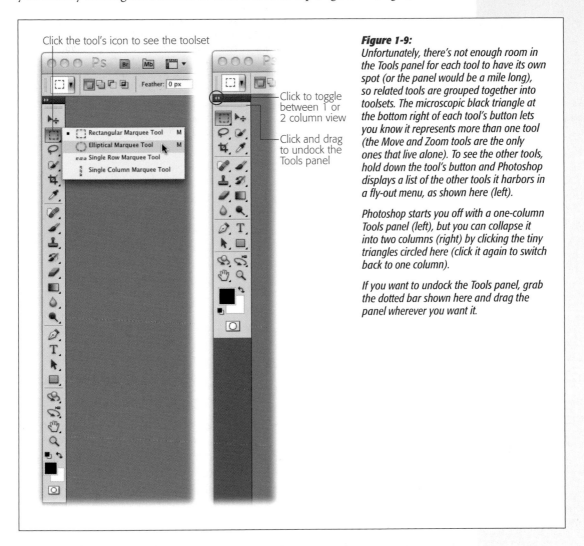

Click the tool's icon to see the toolset

Figure 1-9:
Unfortunately, there's not enough room in the Tools panel for each tool to have its own spot (or the panel would be a mile long), so related tools are grouped together into toolsets. The microscopic black triangle at the bottom right of each tool's button lets you know it represents more than one tool (the Move and Zoom tools are the only ones that live alone). To see the other tools, hold down the tool's button and Photoshop displays a list of the other tools it harbors in a fly-out menu, as shown here (left).

Photoshop starts you off with a one-column Tools panel (left), but you can collapse it into two columns (right) by clicking the tiny triangles circled here (click it again to switch back to one column).

If you want to undock the Tools panel, grab the dotted bar shown here and drag the panel wherever you want it.

Click to toggle between 1 or 2 column view

Click and drag to undock the Tools panel

Once you expand a toolset, you'll see the tool's keyboard shortcut listed to the right of its name. These shortcuts are great timesavers because they let you switch between tools without moving your hands off the keyboard. To access a tool that's hidden deep within a toolset, add the Shift key to the tool's shortcut and you'll cycle through all the tools in that toolset. For example, to select the Elliptical Marquee tool, press Shift-M repeatedly until that tool appears in the Tools panel.

Tip: If you need to switch tools *temporarily*—for a quick edit—you can use the spring-loaded tools feature. Just press and hold a tool's keyboard shortcut to switch to that tool and then perform your edit. As soon as you release the key, you'll jump back to the tool you were using before. For example, if you're painting with the Brush and suddenly make an error, press and hold E to switch to the Eraser and fix your mistake. Once you release the E key, you're back to using the Brush tool. Sweet!

For an overview of all the tools in this panel, check out Appendix D, online. For a quick reminder of what each tool does, hover your cursor over its icon for a couple of seconds and Photoshop displays a handy tooltip that includes the tool's name and keyboard shortcut (you have to keep your mouse perfectly still).

Foreground and background color chips

Photoshop can handle millions of colors, but its tools let you work with only two at a time: a foreground color and a background color. Each of these is visible as a square *color chip* near the bottom of the Tools panel (in Figure 1-9, they're black and white, respectively). Photoshop uses your foreground color when you paint or fill something with color. It uses your background color to do things like set the second color of a *gradient* (a smooth transition from one color to another, or to transparency) and erase parts of a locked Background layer (page 85); it's also helpful when you're running special effects like the Clouds filter (page 645). In other words, the foreground color is where most of the action is. If you want to change either color, click its color chip once to make Photoshop open the Color Picker (page 493), which lets you select another color for that particular color chip. To swap your foreground and background colors, click the double-headed arrow just above the two chips or press X. (Remember this shortcut; it's extremely handy when you work with layer masks, which are discussed in Chapter 3.)

Colors

In the upper-right part of your screen is the Color panel, which also displays your current foreground and background color chips. This panel lets you pick a new color for either chip *without* having to open the just-mentioned Color Picker (which means Photoshop won't pop open a big dialog box that hides part of your image). The Color panel is discussed in Chapter 12 on page 498.

Tip: If you're using the Brush tool, you can summon Photoshop CS5's new onscreen Color Picker (page 506). Instead of being inside a dialog box, it appears to sprout from within your image! To see it for yourself, press B to grab the Brush tool and then press and hold Ctrl-Option-⌘ (right-click+Alt+Ctrl on a PC).

Swatches

The Swatches panel holds miniature samples of colors, giving you easy access to them for use in painting or colorizing your images. This panel also stores a variety of

color libraries like the Pantone Matching System (special inks used in professional printing). You'll learn all about the Swatches panel in Chapter 12 on page 496.

Styles

Styles are special effects created with a variety of layer styles (page 128). For example, if you've created a glass-button look by using several layer styles, you can save the whole lot of 'em as a *single* style—which means you can apply it with a single click (instead of adding each layer style individually). You can also choose from tons of built-in styles; they're all discussed starting on page 132.

Adjustments

The Adjustments panel gives you one-stop access to all of Photoshop's Adjustment layers, as well as their various presets. Instead of making color and lighting changes to your original image, you can use Adjustment layers to make the change on a *separate* layer, giving you all kinds of editing flexibility and keeping your original image out of harm's way. They're explained in detail in Chapter 3 (page 77) though you'll see 'em used throughout this book.

Masks

This panel lets you create and fine-tune layer masks. You'll dive headfirst into masks in Chapter 3 (page 113), but, for now, you can think of them as digital masking tape that lets you hide the contents of a layer, whether it's an adjustment of some sort (a color or lighting change) or parts of an image. This panel also gives you access to several ways to fine-tune a mask once you've created it.

Layers

The Layers panel is the single most important panel in Photoshop. Layers let you work with your images as if they were a stack of transparencies, so you can create one image from many. By using layers, you can resize, adjust the opacity, and add layer styles to each item independently. Understanding layers is the *key* to Photoshop success, and you'll learn all about them in Chapter 3.

Channels

Channels are where Photoshop stores the color information your images are made from, whether that's RGB (red, green, blue), CMYK (cyan, magenta, yellow, black), grayscale, and so on. Channels are extremely powerful, and you can use them to edit the individual colors in your image, which is helpful in sharpening images, creating selections (telling Photoshop which part of an image you want to work with), and so on. Chapter 5 has the scoop on channels.

Paths

Paths are the outlines you make with the Pen and Shape tools. But these aren't your average, run-of-the-mill lines—they're made up of points and paths instead of pixels, so they'll always print perfectly crisp. You can also make them bigger or smaller without losing any quality. You'll learn all about paths in Chapter 13.

Navigator

Think of the Navigator panel as a map. It displays a mini version of your image with a frame around the area you're currently zoomed in on. You can use this panel to move around in your document and change your zoom level. The Navigator panel is especially useful when you're working with huge images and you're zoomed in to work on fine details. To see it in action, flip to Chapter 2, page 65.

Histogram

A histogram is a mountainous-looking graph that represents the color and brightness info contained in your image. The left side of the graph shows how much of the image falls into the darkest range of colors (shadows), the far right shows the lightest range (highlights), and the area in the middle represents colors in between (midtones). Histograms are crucial when you're color-correcting images, and they're discussed at length in Chapter 9, beginning on page 390.

Info

The Info panel is your command center for general info about the image you're working on. It shows you the color values of certain pixels, your cursor's location within the document, image size, and other useful bits of, well, image info. It changes on the fly to show info that relates to the currently selected tool and gives you a handy tip about using that tool (provided you have that option turned on). You can find out more on pages 401 and 404.

The Power of Undo

Thankfully, Photoshop is extremely forgiving: It'll let you back out of almost anything you do, which is *muy importante* when you're first learning.

You've got several ways to retrace your steps, including the lifesaving Undo command—just choose Edit→Undo or press ⌘-Z (Ctrl+Z on a PC). Unfortunately, the Undo command lets you undo only the last edit you made.

If you need to go back *more* than one step, use the Step Backward command—choose Edit→Step Backward or press ⌘-Option-Z (Ctrl+Alt+Z on a PC). Out of the box, this command lets you undo the last 20 things you did, one at a time. If you want

to go back even further, you can change that number by digging into Photoshop's preferences, as the next section explains. You can step forward through your edit history, too, by choosing Edit→Step Forward or ⌘-Shift-Z (Shift+Ctrl+Z on a PC).

Note: Photoshop lets you undo up to 20 changes, back to the point when you first opened the document, meaning you can't close a document and then undo changes you made *before* you closed it.

Changing How Far Back You Can Go

If you think you might someday need to go back further than your last 20 steps, you can make Photoshop remember up to *1,000* steps by changing the program's preferences. Here's how:

1. **Open the Preferences dialog box.**

 On a Mac, choose Photoshop→Preferences and then, in the resulting dialog box, click Performance in the left-hand column to see the history preferences.

 On a PC, choose Edit→Preferences and, from the resulting submenu, choose Performance.

2. **Look for the History States field in the upper right corner of the Preferences dialog box and then pick the number of Undo steps you want Photoshop to remember.**

 You can enter any number between 1 and 1,000. While increasing the number of history states might help you sleep better, doing so means Photoshop has to keep track of that many versions of your document, which requires memory and processing power. If you increase this setting and notice that the program is running like molasses, try lowering it.

3. **Click OK when you're finished.**

Turning Back Time with the History Panel

The History panel is like your very own time machine. Whereas the Undo and Step Backward commands let you move back through changes one step at a time, the History panel (see Figure 1-10) kicks it up a notch and lets you jump back *several* steps at once. (You can step back through as many history states as you set in Photoshop's preferences.) The History panel is much quicker than undoing a long list of changes one by one, and it gives you a nice list of *exactly* what you've done to your image—in chronological order from top to bottom—letting you pinpoint the exact state you want to jump back to. You can also take snapshots of your image at various points in the editing process to make it easier to jump back to the state you want (as explained in a moment).

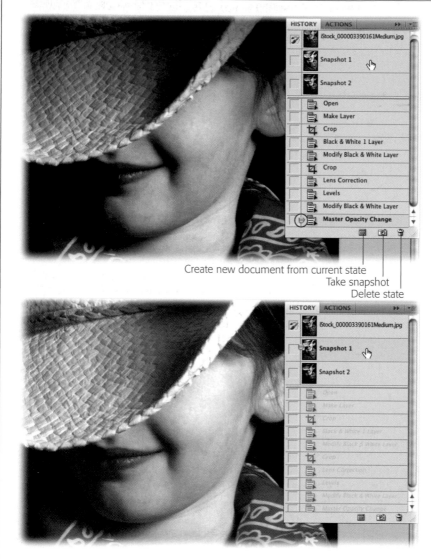

Figure 1-10:
Top: The History panel keeps track of everything you do to your images, beginning with opening them. The tiny pointer (circled) lets you know which editing step you're on. You can also take snapshots of your image at crucial points during the editing process like when you convert it to black and white and add a color tint.

Bottom: If you take a snapshot, you can revert to that state later with a single click. For example, if you've given your image a sepia (brown) tint and later changed it to blue, you can easily go back to the sepia version by clicking the snapshot you took, as shown here, without having to step back through all the other changes you made. What a timesaver!

Create new document from current state
Take snapshot
Delete state

After you make a few changes to your image, pop open the History panel by choosing Window→History to see a list of everything you've done to the image, including opening it. To jump back in time, click the step you want to go back to and Photoshop returns your image to the way it looked at that point. The tiny pointer in the panel's left column (circled in Figure 1-10, top) shows which step you selected (and the step itself is highlighted). If you stepped back further than you meant to, just pick a more recent step in the list.

If you'd like to see a thumbnail preview at the top of the History panel showing what your image looks like every time you save your document, choose History Options from the History panel's menu, and then turn on Automatically Create New Snapshot When Saving. Clicking the thumbnail is a fast and easy way to jump back to the last saved version of your document without having to close and reopen it.

Tip: You can also get back to the last saved version of your document by choosing File→Revert (page 31).

Taking *snapshots* of your image along the way lets you mark key points in the editing process. A snapshot is more than a preview of your image because it also includes all the edits you've made up to that point. Think of snapshots as milestones in your editing work: When you reach a critical point that you may want to return to, take a snapshot so you can easily get back to that particular version of your document. To take a snapshot, click the little camera icon at the bottom of the History panel (shown in Figure 1-10). Photoshop adds the snapshot to the top of the panel, just below the saved-state thumbnail. The snapshots you take appear in the list in the order you took them.

Note: History states don't hang around forever: As soon as you close your document, they're history (ha!). If you think you'll ever want to return to an earlier version of your document, use the "Create new document from current state" button at the bottom of the History panel. That way, you've got a brand-new document to return to so you don't have to recreate it.

The History Brush

The History Brush takes the power of the History panel and lets you focus it on specific parts of your image. Instead of sending your *entire* image back in time, you can use this brush to paint your edits away *selectively*, revealing the previous state of your choosing. For example, you could blur the heck out of a portrait with the Gaussian Blur filter (page 445) and then use the History Brush to revert to the original, sharp version of your subject's face, as shown in Figure 1-11. Of course, you paint away other edits, too, like color changes, filter effects, or any other changes you made in between.

Note: The Art History Brush works similarly, but it adds bizarre, stylized effects as it returns your image to a previous state, as shown in the box on page 536.

Figure 1-11:
By using the History Brush set to your image's Open state—see step 4 on this page—you can undo all kinds of effects, including a severe Gaussian Blur.

Here's how to use the History Brush to undo a serious Gaussian Blur you've applied:

1. **Open an image—in this example, a photo of a person—and run the Gaussian Blur filter.**

 You'll learn all about opening images on page 51, but, for now, choose File→Open and then navigate to where the image lives on your computer. Then choose Filter→Blur→Gaussian Blur. (Chapter 15 tells you all about using filters.)

2. **In the resulting dialog box, enter a radius of 20 and then click OK.**

 Depending on the size of your image, this setting blurs your image pretty severely, giving you a *lot* to undo with the History Brush.

3. **Grab the History Brush by pressing Y and then choose a brush from the Options bar.**

 Once you've grabbed the History Brush, hop up to the Brush Preset picker in the Options bar and pick a large, soft-edged brush (one that's pretty big and blurry around the edges). You'll learn about brushes in Chapter 12.

4. **Open the History panel (choose Window→History) and then click a saved state or snapshot.**

 This is where you pick which version of the image you want to go back to. Since all you've done is open the image and run the Gaussian Blur filter, choose the Open state. Just click within the panel's left-hand column next to that state to pick it (you'll see the History Brush's icon appear in the column).

5. **Mouse over to your image and paint over the person's eyes to reveal the unblurred eyes of the original image.**

 If you keep painting in the same place, you'll expose more and more of the original image (it's a gradual change). For example, a quick swipe over the eyes reveals traces of the original while a good scrubbing back and forth in one area reveals the original in its full glory.

As you can see, you can use the History Brush to easily undo anything you've done; just pick the state you want to revert to in the History panel and then paint away!

POWER USERS' CLINIC

Erasing to History

At some point, you'll realize that the perfect fix for your image is something you zapped about 10 steps ago. For example, you may change the color of an object only to decide later that it looked better the way it was. Argh.

Thanks to Photoshop's "Erase to History" feature, you can jump back in time and paint away the edits you no longer want. First, grab the Eraser tool by pressing E and then turn on the "Erase to History" checkbox in the Options bar. Next, click the layer you want to edit in the Layers panel and then start erasing the areas you want to restore to their former glory.

Erasing to history is a really handy way to leave *some* changes in place while recovering your original image in other areas.

Revert Command

If you've taken your image down a path of craziness from which you *can't* rescue it by using Undo or the History panel, you can revert back to its most recent saved state by choosing File→Revert. This command opens the previously saved version of your image, giving you a quick escape route back to square one.

Note: If you haven't made any changes to your image since it was last saved, you can't choose the Revert option; it's grayed out in the File menu.

Tweaking Photoshop's Preferences

As you learned earlier in this chapter, Photoshop is pretty darn customizable. In addition to personalizing the way your tools behave and how your workspace looks, you can make lots of changes using the program's preferences, which control different aspects of Photoshop and let you turn features on or off, change how tools act, and fine-tune how the program performs on your computer.

To open the Preferences dialog box, choose Photoshop→Preferences (Edit→ Preferences→General on a PC), or press ⌘-K (Ctrl+K). When you choose a category

on the left side of the dialog box, you see tons of settings related to that category appear on the right. In the following pages, you'll get an idea of the kind of goodies each category contains.

General

The General section in the Preferences dialog box (Figure 1-12) is a sort of catchall for preferences that don't fit anywhere else. Most of these options are either self-explanatory (Beep When Done, for example) or covered elsewhere in this book. A few, however, are worth taking a closer look at.

Unless you tell it otherwise, Photoshop displays the Adobe Color Picker (see page 493) anytime you choose a color. If you're more comfortable using your operating system's color picker instead, you can select it from the Color Picker pop-up menu. If you download and install third-party color pickers like Painter's Picker (page 493), they show up in this menu, too. However, since the Adobe Color Picker is designed to work with Photoshop and all its built-in options, using another color picker may mean losing quick access to critical features like Color Libraries (page 495).

Figure 1-12:
The General section of Photoshop's Preferences dialog box is home to the History Log settings. If you turn on the History Log checkbox, Photoshop keeps track of everything that happens to your images. This is an invaluable tool for folks who need to prove what they've done to an image for billing clients or to produce legal documentation of all the edits they've made to an image (think law enforcement professionals and criminal investigators).

Note: Trashing Photoshop's preferences file can be a useful troubleshooting technique. Download Appendix B, online, for step-by-step details.

Note: Photoshop CS5 has two new options in the General section: Pop-up menu control over the new Heads Up Display (HUD) Color Picker that you'll learn about on page 506, and the option to "Place or Drag Raster Images as Smart Objects". As you'll learn on page 123, you'll want to leave the latter option turned on for good!

Another notable option in this dialog box involves a couple of cool features called animated zoom and flick-panning (both covered in Chapter 2). If your computer is running at a snail's pace, try turning off one or both features by turning off their checkboxes (both features can *really* tax slower video cards).

Interface

The Interface preferences control how Photoshop looks on your screen. You can squeeze a little more performance out of slower computers by setting the Border pop-up menus at the top of the dialog box to None. That way, Photoshop won't waste any processing power generating those pretty drop shadows around your images or around the Photoshop window itself.

Also, if you're familiar with all of Photoshop's tools and don't care to see the little yellow tooltips that appear when you hover over tools and field labels (page 15), turn off the Show Tool Tips checkbox in the middle of the dialog box below the pop-up menus. If you'd like new documents to open in separate windows instead of in new tabs, turn off the "Open Documents as Tabs" checkbox.

Note: If you use Photoshop on a Mac laptop, there's a new setting in the Interface section that'll make you jump for joy. Gesture support for Mac trackpads (page 62) was a new and coveted feature in CS4; however, with no way to turn it off, folks were constantly zooming and rotating their canvases with their trackpads by accident. The only fix was to download a plug-in to disable it and few people even knew that existed. Happily, all you have to do in CS5 is turn off the Enable Gestures checkbox in the Interface preferences. Yay!

File Handling

The File Handling settings control how Photoshop opens and saves files. If you're a Mac person and you plan on working with images that'll be opened on both Macs and PCs, make sure Append File Extension is set to Always and that Use Lower Case is turned on. These settings improve the chances that your files will open on *either* type of computer without a hassle. (PC users can leave their File Handling settings alone because Mac users can open their Photoshop files just fine.)

Straight from the factory, Photoshop is set to display a dialog box each time you save a file that asks if you want to save your images for maximum compatibility with *PSD* and *PSB* files (the native Photoshop format and the format for really big files, respectively; see page 51). Saving your documents with maximum compatibility improves

the chances that they can be understood by other programs like Adobe InDesign. If that pesky dialog box annoys you, change the "Maximize PSD and PSB File Compatibility" pop-up menu to Always and you'll never see the dialog box again (plus you'll have the peace of mind that comes with knowing your images will play nice with other programs).

Another handy option lies at the very bottom of the dialog box where you can change the number of documents Photoshop remembers in its Recent files menu (found by choosing File→Open Recent). This field is automatically set to 10, but feel free to change it.

Performance

The Performance preferences (Figure 1-13) control how efficiently Photoshop runs on your computer. For example, the amount of memory the program has to work with affects how well it performs. In the Memory Usage section's Let Photoshop Use field, Photoshop's factory setting tells the program to use up to 70 percent of your machine's available memory. If you're tempted to increase it to 100 percent for better performance, don't. Other programs need to use your computer's memory, too, and leaving it set to 70 percent ensures that all of them get their fair share (after Photoshop takes the biggest chunk, of course).

Figure 1-13:
To add one or more scratch disks (page 35), click the "Active?" column next to each hard drive you want to use, and then drag the hard drives up or down into the order you want Photoshop to use them.

Avoid using USB-based hard drives as they tend to be sluggish and can actually make Photoshop run slower.

Note: A new feature of Photoshop CS5 is that you can let the program set optimal Cache Levels and Tile Sizes *for* you. All you have to do is pick the kind of document you work on the most. Your options include "Tall and Thin", "Default", and "Big and Flat".

The Performance category is also where you can change the number of history states that Photoshop remembers, as explained on page 27. If your computer's hard drive is running low on space, consider adding another drive that Photoshop can use as a *scratch disk*—the place where it stashes the bazillions of temporary files it makes when you're editing images like those various history states. (If you don't have a separate scratch disk, Photoshop stores those temporary files on your computer's hard drive, taking up space you could be using for other documents.) When you add a new internal hard drive or plug in an external drive, that drive appears in the Scratch Disks list shown in Figure 1-13. You can give Photoshop the green light to use it by putting a checkmark in the disk's "Active?" column, and dragging it upward into the first position. If you go this route, Photoshop will run a little zippier because it'll have *two* hard drives reading and writing info instead of one!

If you need to squeeze a little more performance out of your machine, turn off the Enable OpenGL Drawing checkbox (see the box on page 64). The drawback to turning off this setting is that you won't be able to use features that rely on it like flick-panning (page 64) and Rotate View (page 65).

Note: When it comes to Photoshop's scratch disk, speed matters, and faster is better. Since the speed at which the disk spins plays a big role in scratch disk performance, stick with disks rated 7200 RPM (revolutions per minute) or faster. Slower 5400 RPM disks can take a toll on Photoshop's performance, and 4200 RPM drives slow…Photoshop…to…a…crawl.

Cursors

These preferences control how your cursors look when you're working with images. There are no right or wrong choices for you to make here, so try out the different cursor styles and see what works for you. Photoshop includes two types of cursors: painting cursors and everything else. When you choose different options, Photoshop shows you a preview of what each cursor looks like. At the bottom of the dialog box is a Brush Preview color swatch that controls the color of the brush preview when you resize your brush by Ctrl-Option-dragging (Alt+right-click+dragging on a PC) to the left or right. To change the swatch's color, click the color chip, choose a new color from the Color Picker dialog box, and then click OK. (See page 501 to learn how these options affect the Brush tool.)

Transparency & Gamut

The Transparency settings let you fine-tune what the Background layer looks like when part of your image is transparent. Like the cursor settings, these options are purely cosmetic, so feel free to experiment. (You'll learn more about transparency and the Background layer in Chapter 3.) The Gamut Warning option lets you set a highlight color showing where colors in your image fall outside the safe range for the color mode you're working in or the printer you're using. (Chapter 16 has more about all these advanced color issues.)

Units & Rulers

The Units & Rulers preferences (Figure 1-14) let you determine the unit of measurement Photoshop uses. The Rulers pop-up menu, not surprisingly, controls the units displayed in your document's rulers (see page 69); your choices are pixels, inches, centimeters, millimeters, points, picas, and percent. If you work on a lot of documents destined for print, inches or picas are probably your best bet. If you create images primarily for the Web, choose pixels. Leave the Type pop-up menu set to points unless you need to work with type measured in pixels or millimeters, which can be handy if you need to align text for a web page layout.

POWER USERS' CLINIC

Customizing Keyboard Shortcuts and Menus

Keyboard shortcuts can make the difference between working fast and working at warp speed. They can drastically reduce the amount of time you spend taking your hands off the keyboard to use your mouse to do things like choose menu items or grab tools. Photoshop has a ton of built-in keyboard shortcuts and menu groups, but that doesn't mean you're stuck with 'em. You can reassign shortcuts, add new ones, and show or hide menu options. Here's how to add or change keyboard shortcuts:

1. Choose Edit→Keyboard Shortcuts to open the "Keyboard Shortcuts and Menus" dialog box.

2. Choose which type of shortcuts you want to add or change from the Shortcuts For pop-up menu. You options are Application Menus (like the File and Edit menus), Panel Menus (the menus on the program's various panels), and Tools.

3. In the list below the Shortcuts For menu, select the shortcut you want to change.

4. Enter a new shortcut in the Shortcut field and then click Accept.

5. To save your new shortcut set, click the floppy-disk icon near the top of the dialog box to the right of the Set pop-up menu. In the resulting dialog box, give your custom set of shortcuts a name and then click Save.

To help you remember the new shortcuts, Photoshop lets you print a handy chart to tack up on the wall. In the "Keyboard Shortcuts and Menus" dialog box, select your custom set from the Set pop-up menu and then click Summarize. In the resulting Save dialog box, give the keyboard shortcut list a name, choose where to save it, and click Save. Photoshop creates an HTML file that you can open in any Web browser and then print. When you're finished, you can impress your colleagues by telling them that you *reprogrammed* Photoshop to do your bidding; unless they've been in this dialog box themselves, they'll have no idea how easy this stuff is to change.

In the "Keyboard Shortcuts and Menus" dialog box, you can also modify the program's menus by clicking the Menus tab near the top of the box. In the Menu For pop-up menu, choose Application Menus or Panel Menus, depending on which ones you want to tweak. Click the little flippy triangle next to each menu to see the items it includes. To hide a menu item, select it and then click its visibility eye; to show a hidden item, click within its Visibility column. You can even colorize menu items so they're easier to spot. To do that, select the item you want to highlight, click the Color column, and then choose a color from the resulting pop-up menu. Click OK and enjoy your new customizations.

Figure 1-14:
To really save some time, take a moment to adjust the settings in the New Document Preset Resolutions section. From that point on, Photoshop automatically fills in the New Document dialog box with the settings you entered here (you'll learn about creating new documents on page 41).

The Column Size settings are handy when you're designing graphics to fit into specific-sized columns in a page layout program like Adobe InDesign. Just ask the person who's creating the InDesign layout which measurements to use.

Guides, Grid & Slices

These preferences let you choose the colors for your guides (page 68), gridlines (page 70), and slice lines (page 733). You can also set your gridlines' spacing and the number of subdivisions that appear between each major gridline with the "Gridline every" and Subdivisions fields, respectively.

Plug-ins

You can make Photoshop do even more cool stuff by installing third-party programs called *plug-ins*. There are so many useful plug-ins that this book has an entire chapter devoted to them (Chapter 19). The preferences in this category let you store plug-ins somewhere other than the Photoshop folder, which can help you avoid losing your plug-ins if you have to reinstall Photoshop. Leave both checkboxes in the Extension Panels section turned on so Photoshop can connect to the Internet if a plug-in or panel needs to grab information from a website. For example, the Kuler panel (page 490) lets you use color themes posted on the Web by folks in the Kuler community. If you turn off these checkboxes, Photoshop can't connect to the Internet and you can't use Kuler!

Type

Photoshop has an amazing type engine under its hood, and you'll learn all about it in Chapter 14. The preferences here let you toggle Smart Quotes (the curly kind) on or off, as well as control the Font Preview Size used in the Options bar's font menu and in the Character panel (page 603). Because seeing a font in its typeface is so handy when you're choosing fonts, in CS5 this option is turned on right out of the box. If you don't want to see typeface previews, turn off Font Preview Size to make Photoshop display only the typeface names (yawn).

If you work with Asian characters, turn on the Show Asian Text Options checkbox and make sure the Enable Missing Glyph Protection checkbox is also turned on. That way you won't end up with weird symbols or boxes if you try to use a letter or symbol that isn't installed on your machine.

The Preset Manager

Once you get comfortable in Photoshop, you can customize most every tool in the Tools panel: the Crop tool, selection tools, healing brushes, the Type tool, gradients, and so on. The Preset Manager handles loading, saving, and storing your personalized goodies, as well as all the *presets* (built-ins which you can think of as tool recipes, such as gradients, patterns, and so on) that came with the program. You can open it by choosing Edit→Preset Manager or by clicking the right-facing triangle at the top right of any tool's Preset picker menu in the Options bar, and then choosing Preset Manager. (You can also open a tool's Preset picker by choosing Window→Tool Presets.)

Each group of settings, like a category of brushes, is called a *preset library*. To see a certain preset library, choose it from the Preset Type pop-up menu at the top of the Preset Manager dialog box (Figure 1-15).

Clicking the button that's circled in Figure 1-15 lets you set the category of presets you're viewing to the factory-fresh settings (choose "Reset [name of category]" and then click OK). You can make these adjustments when you're using the tools themselves, but the Preset Manager gives you a bigger preview space, which makes these organizational chores a little more tolerable.

Note: In CS5, brushes have a brand-spankin' new preset panel of their very own. Flip ahead to page 503 to see it in action!

Sharing Presets

Once you've made your own recipes for tools, styles, or what have you, feel free to share them with the masses. You can share them with other computers (which is handy when the whole team needs to use the same color swatches or brushes) and upload them to the Web (for the whole world to download).

Figure 1-15:
You can open the Preset Manager panel's menu by clicking the right-facing triangle (circled). This menu lets you change the size of the previews you see in Photoshop's Preset picker menus, as well as reset, replace, and otherwise manage presets for all categories.

To save your eyesight, it's a good idea to set the preview size to Large List so you can actually see what your options are.

To create a preset library of your own, open the Preset Manager and click the Save Set button. In the resulting Save dialog box, give your custom library a name. Photoshop automatically saves it in the folders where it stores *all* custom settings unless you pick a different location on your hard drive (which is handy if you plan on sharing the library with other folks). When everything looks good, click Save.

Tip: If you're saving a custom preset to share with others, save it in a spot that's easy for you to find. For example, if you plan on emailing your preset library, your desktop may be a good option. If you're sharing your presets with coworkers who work in the same office, your local file server works well.

Once you've saved your custom preset library, you can email it to folks or upload it to a website for others to download. If you're uploading to the Web, make sure the file doesn't have any spaces in its name. For example, instead of calling your file "Dragon Scales Brush", name it "DragonScalesBrush".

If you're on the receiving end of a new preset library, open the Preset Manager by choosing Edit→Preset Manager and then click the Load button. Navigate to where the library lives and click Load. The next time you use a tool that has custom presets, you'll see the new library's options in the tool's Preset picker menu.

To add to the fun, you can also rename preset libraries. In the Preset Manager dialog box, select the relevant library from the Preset Type pop-up menu and click Rename; type a new name in the Name field and click OK. To delete a preset library you never use, select it from the Preset Manager's Preset Type pop-up menu and click Delete.

Tip: If you've managed to mess up one of Photoshop's built-in preset libraries by adding items that don't work the way you want, you can easily restore the original libraries: Open the Preset Manager and choose the library you want to reset. From the panel's menu (click the button that's circled in Figure 1-15), choose "Reset [type of preset]". Photoshop asks if you want to replace the current brushes or append (add to) them instead. Click OK to replace the brushes and you'll be back to the factory-fresh settings.

Opening, Viewing, and Saving Files

Chances are good that if you're holding this book, you're spending a lot of time in Photoshop. So the ability to shave off a minute here and there from routine stuff can really add up. Heck, if you're lucky, you'll save enough time to read a book, ride your bike, or catch an episode of *The Big Bang Theory*

One way to steal back some of that time is to work more efficiently, and that means learning a slew of tricks for the less glamorous stuff like opening, viewing, and saving files. And since you'll be doing these things so often, it's important to form good habits so your documents are set up properly from the get-go. (Indeed, it would be truly heartbreaking to find the artwork you've spent weeks creating is too small to print, or you saved the file in such a way that you can't change it later on.) Finally, since a key part of working with images is navigating vast pixel landscapes, this chapter teaches you some handy ways to move around within your images onscreen.

Creating a New Document

Photoshop gives you a variety ways to accomplish most tasks, including creating a new document. Sure, you can choose File→New, but it's faster to press ⌘-N (Crtl+N on a PC). Either way, you'll be greeted with the New dialog box shown in Figure 2-1.

You'd think naming your document would be simple: Just type something in the Name box and you're done, right? Not quite. Here are a few things to keep in mind:

- If you're working on a Mac, don't start your file names with periods. Files whose names start with periods are invisible in Mac OS X (meaning neither you nor Photoshop can see them), which makes 'em darn hard to work with.

Figure 2-1:
The New dialog box (top) is where life begins for any Photoshop file you create. The settings here let you pick, among other things, your document's size, resolution, and color mode, all of which affect the quality and size of your image; you'll learn more about all these options in the following pages. Whatever you type in the Name box appears in the document's title bar (bottom).

- If folks need to open your files on both Mac and Windows machines, don't put slashes (/), colons (:), angle brackets (<, >), pipes, (|), asterisks (*), or question marks (?) in the file names, either.

- Leave *file extensions* (the period and three letters at the end of the file name, like .psd, .jpg, and so on) on the file name. The file extension tells other programs what kind of file it is so they can open it.

Photoshop's Ready-Made Documents

After you've named your document, you need to pick a size for it. You've got two choices here: Enter the dimensions you'd like in the Width and Height boxes or pick one of Photoshop's canned choices (4"×6" landscape photo, 640×480–pixel web page, and so on) from the Preset and Size menus shown in Figure 2-2.

The advantage of picking a canned option is that, in addition to filling in the dimensions for you, Photoshop plugs in resolution and color mode settings. You'll learn more about these two options in a minute, but if you're new to the program, these *presets* (document recipes) are a great way to make sure you're starting off with a well-configured document. Besides, the presets can be helpful even if they're not *exactly* what you need. For example, if you find one that's the right size but the wrong resolution, just select it, adjust the resolution, and you're on your way.

Note: One document preset worth remembering is Clipboard: If you copy all or part of an image, choosing this preset tells Photoshop to grab that image's settings for you, making it super simple to match a document's settings without having to copy them first. Who knew?!

Figure 2-2:
Once you make a selection from the Preset menu (which includes different types of paper, electronic formats, and recently used document sizes), Photoshop fills the Size menu and its related fields with the appropriate settings—including Width, Height, Resolution, and Color Mode (page 46). Presets are great timesavers, and they help you avoid mistakes when you're making new documents.

UP TO SPEED

Stealing Document Settings

Need to create a document that's the same size and resolution as an existing document? No problem—just snag one file's settings and use them to make another. You can swipe a document's settings in several ways:

- Open the existing document and press ⌘-N (Ctrl+N on a PC) to open the New dialog box. Click the Preset pop-up menu, which lists the names of all open documents. When you pick the one you want, Photoshop adjusts all the dialog box's settings to match.

- With the existing document open, press ⌘-A (Ctrl+A) to select everything in it and then press ⌘-C (Ctrl+C) to copy the document's contents to your computer's memory. Next, choose File→New or press ⌘-N

(Ctrl+N on a PC) and Photoshop automatically fills in the document's settings for you.

- If you want to base your new document on the *last* document you created, hold Option (Alt on a PC) while you choose File→New or press ⌘-Option-N (Ctrl+Alt+N).

- To create a new document that's the same size and resolution as your current selection, create the selection, copy the contents to your computer's memory, and then choose File→New or press ⌘-N (Ctrl+N on a PC). Photoshop creates a document that matches your selection's dimensions perfectly. (See Chapter 4 for the full story on selections.)

Setting Size and Resolution

In Photoshop, size refers to two different things: file size (640 kilobytes or 2.4 megabytes, for example) and dimensions (like 4"×6" or 640×480 pixels). You'll find plenty of advice throughout this book on how to control file size, but here you're concerned with the size of your document's *canvas*.

Photoshop can measure canvas size in pixels, inches, centimeters, millimeters, points, picas, and columns. Just pick the one that's appropriate for your project—or the easiest for you to work with—from the pop-up menus to the right of the Width and Height fields. If you're designing a piece for the Web or a slideshow presentation, pixels are your best bet. If you're going to print the image, inches are a common choice. Columns come in handy when you're making an image destined for a page-layout program, like Adobe InDesign, that has to fit within a specific number of columns.

Note: Photoshop assumes you want to use the same unit (say, inches) to measure width and height, so it automatically changes both fields when you adjust one. If you really *do* need to work with different units, just hold the Shift key while you pick the second unit to make Photoshop leave the other field alone.

The Resolution field controls the number of pixels per inch or per centimeter in your document. High-resolution documents contain more pixels per inch than low-resolution documents of the same size. (You'll learn all about resolution in Chapter 6, starting on page 238.)

For now, here's some ready-to-use guidance if you haven't yet mastered the fine art of resolution just yet: If you're designing an image that will be viewed only onscreen (in a web browser or a slideshow presentation, for example) enter *72* in the Resolution field—it's really only the pixel dimensions that matter in this situation, but you'll learn more about that later. If you're going to print the image at home, set the resolution to at least 150 pixels per inch (if it's headed to a professional printer, enter *300* instead).

Once you enter values in the Width, Height, and Resolution fields, Photoshop calculates the document's *file size*—the amount of space it takes up on your hard drive—and displays it in the New dialog box's bottom-right corner (in Figure 2-1, for example, the file size is 2.25 megabytes).

Tip: If you don't know the exact size your document needs to be, it's better to make it really big; you can always shrink it down later. See page 236 for more info.

Understanding Bit Depth

You may have heard the terms "8-bit" and "16-bit" tossed around in graphics circles (and neither has anything to do with Photoshop being a 64-bit program, as the box on page 6 explains). When people refer to bits, they're talking about how many colors an image file contains. Photoshop's color modes (page 46) determine whether your document is an 8- or a 16-bit image (other, less common options are 1-bit and 32-bit). Since you'll run into these labels fairly often, it helps to understand more about what these numbers mean.

A *bit* is the smallest unit of measurement that computers use to store information. Each pixel in an image has a *bit depth*, which controls how much color information that pixel can hold. So an image's bit depth determines how much color info the image contains. The higher the bit depth, the more colors the image can display. And the more colors in your image, the more info (details) you've got to play with in Photoshop.

Understanding bit depth also means you need to know a little about *channels*, where Photoshop stores your image's color info (see Chapter 5) on separate layers (Chapter 3). For example, in an RGB image you have three channels: one each for red, green, and blue. If you combine the info contained in each channel, you can figure how many colors are in your image.

With all that in mind, here's a quick tour of your various bit choices in Photoshop:

- In Bitmap color mode, your pixels can be only black or white. Images in this mode are called 1-bit images because each pixel can be only one color—black or white (they're also known simply as *bitmap* images).
- An 8-bit image can hold two values in each bit, which equals 256 possible color values. Why 256? Since each of the eight bits can hold two possible values, you get 256 combinations. (For math fans: it's two to the eighth power, which equals 256). Images in Grayscale mode contain one channel, so that's 8 bits per channel, equaling 256 colors. Since images in RGB

mode contain three channels (one each for red, blue, and green), folks refer to them as 24-bit images (8 bits per channel \times 3 = 24), but they're still really just 8-bit images. With 256 combinations for each channel (that's $2^8 \times 2^8 \times 2^8$), you can have over 16 million colors in your RGB image. Since CMYK images have four channels, folks refer to them as 32-bit images (8 bits per channel \times 4 = 32), but again, these are *still* 8-bit images. Over 200 combinations per channel and four channels add up to a massive number of possible color values, but since you're dealing with printed ink, your color range in CMYK is dictated by what can actually be reproduced on paper, which reduces it to about 55,000 colors.

- 16-bit images contain 65,536 colors in a single channel and are produced by some high-end digital cameras (digital single-lens reflex, or dSLR, cameras) shooting in Raw format (page 57) or by really good scanners. These files don't look any different from other images on your screen, but they take up twice as much hard drive space. Photographers really like them because the extra colors give them more flexibility when they're making Curves and Levels adjustments (see Chapter 9), even though the larger file sizes can *really* slow Photoshop down. Also, not all of Photoshop's tools and filters work with 16-bit images, but that list of tools grows with each new version of the program.

- 32-bit images, referred to as high dynamic range (HDR), contain more colors than you can shake a stick at. See page 414 for more info.

For the most part, you'll deal with 8-bit images, but if you've got a camera that shoots at higher bit depths, by all means, take a weekend and experiment to see if the difference in quality is worth the sacrifice of hard drive space (and editing speed). And if you're restoring a really old photo, it may be helpful to scan it at a high bit depth so you have a wider range of colors to work with. See the box on page 57 for more scanning tips.

Just because you make a document a certain size doesn't mean you can't have artwork in that file that's bigger than the document's dimensions. Photoshop is perfectly fine with objects that extend beyond your document's edges (also called *document boundaries*), but you can't see or print those parts. It may sound odd, but if you paste a photo or a piece of vector art (page 52) that's larger than your document, those extra bits will dangle off the edges. To resize your document so you can see everything—even the stuff that doesn't quite fit—choose Image→Reveal All to make Photoshop modify your document's dimensions so everything fits.

Choosing a Color Mode

The New dialog box's Color Mode field (see Figure 2-1) determines which colors you can use in your document. You'll spend most of your time working in RGB mode (which stands for red, green, and blue), but you can switch modes whenever you like (see Chapter 16 for more info). The pop-up menu to the right of the Color Mode field controls your document's *bit depth*, which is explained in the box on page 45.

Unless you choose a different color mode, Photoshop automatically uses RGB mode. The Color Mode menu gives you the following choices:

- **Bitmap** restricts you to two colors: black and white. (Shades of gray aren't welcome at the Bitmap party.) This mode is useful when you're scanning high-contrast items like black-and-white text documents or creating graphics for handheld devices that don't have color screens.

- **Grayscale** expands on Bitmap mode by adding shades between pure black and pure white. The higher the document's bit depth, the more shades of gray—and so the more details—it can contain. Eight-bit documents include 256 shades of gray, 16-bit documents extend that range to over 65,000, and 32-bit documents crank it up to 16.7 million (see the box on page 45 for more on bit depth).

- **RGB Color** is the color mode you'll use the most, and it's also the one your monitor and digital camera use to represent colors. This mode shows colors as a mix of red, green, and blue light (page 187), with each having a numeric value between 0 and 255 that describes the brightness of each color present (for example, fire-engine red has an RGB value of 250 for red, 5 for green, and 5 for blue). As with Grayscale mode, the higher your document's bit depth, the more details it can contain. In this mode, you can choose among 8-, 16-, and 32-bit documents. (See Chapters 5, 9, and 16 for more on RGB mode.)

- **CMYK Color** simulates the colors used in printing and its name stands for cyan, magenta, yellow, and black ink. It doesn't have as many colors as RGB because it's limited to the colors a printer—whether it's an inkjet, commercial offset, or digital press—can reproduce with ink and dyes on paper (you'll learn more about CMYK in Chapters 5 and 16). Chapter 16 explains if and when you should switch to CMYK mode.

- **Lab Color** mode, which is based on the way humans see color, lets you use all the colors human eyes can detect. It represents how colors *should look* no matter which device they're displayed on, whereas RGB and CMYK modes limit a file's colors to what's visible onscreen or in a printed document, respectively. The downside is that many folks have a hard time learning to create the colors they want in Lab mode. You'll find various techniques involving Lab mode sprinkled throughout Part 2 of this book.

Choosing Your Background

The New dialog box's Background Contents pop-up menu lets you choose what's on the Background layer—the only layer you start out with in a new document. Your choices are White, Background Color (which uses the color that the background color chip is set to [page 24]), and Transparent (which leaves the background completely empty).

What you choose here isn't that crucial—if you change your mind, you can turn off the Background layer's visibility (see page 82). Picking a color is handy if you plan to use images that share a background color, so you can preview your artwork. In that case, make sure your background color chip is set to the right color *before* you create your new document and then choose Background Color from this menu. The Transparent option is handy if your document is part of a bigger project where it'll be placed in front of other documents or images; when you choose this option, you see a gray-and-white checkerboard pattern in the Background layer, as explained in the box below.

FREQUENTLY ASKED QUESTION

Seeing Transparency

Dude, what's up with the gray-and-white checkerboard pattern in my new document? I thought it was supposed to be blank!

When you tell Photoshop to make your background layer transparent, it fills your new document with a checkerboard pattern. Don't worry: That checkerboard is just what the program uses to represent transparency on the Background layer. In other words, the checkered pattern is just a reminder that there aren't any pixels on that layer to hide what's behind your image if you add it to another document later on.

You can change how the checkerboard pattern looks by choosing Photoshop→Preferences→Transparency & Gamut (Edit→Preferences→Transparency & Gamut on a PC). In the Transparency Settings area, tweak the settings to make the squares bigger or smaller or change their colors.

If you can't stand seeing the checkered pattern no matter what it looks like, turn it off by setting the Grid Size field to None.

Advanced Options

A quick click of the Advanced button at the bottom of the New dialog box reveals a couple of pop-up menus:

- **Color Profile.** A *color profile* is a set of instructions that determine how computer monitors and printers display or print your document's colors. This menu reflects the profile you pick in the Color Settings dialog box, which, unless you changed it, is set to "sRGB IEC61966-2.1". Leave this setting alone unless you know you need to use a specific color profile for your project; otherwise, your colors may not look the way you expect them to on other computers or when they're printed. You'll learn about color profiles in Chapter 16.

- **Pixel Aspect Ratio.** This setting determines the shape of your pixels by changing their size or aspect ratio. This setting gets its name from the term *aspect ratio*—the relationship between an image's width and height. (For example, a widescreen television has an aspect ratio of 16:9.) Out of the box, Photoshop's pixels are set to Square. Although square pixels are fine for photos, printed images, and onscreen use, they look funky and distorted in video, which has a tendency to make everything look short and fat (including people). So if you're using Photoshop to work on a movie, try to find out which video format the filmmakers are using and then select it here.

Saving your custom settings

If you've gone to the trouble of getting your document's settings just right and you expect to create lots of similar documents, save those settings as a preset. Click the Save Preset button to open the dialog box shown in Figure 2-3. If you save your settings *before* you click the New dialog box's OK button to create your new document, you can choose a descriptive name for your new preset.

Figure 2-3:
Use these checkboxes to tell Photoshop which settings you want it to remember. When you create a new document, the program grabs the settings you don't include from the last new document you made. For example, if you don't include the color profile (by turning on the Profile checkbox shown here), Photoshop assigns the currently active color profile (from Color Settings) to your new image.

Saving Files

After you've put a ton of work into whipping up a lovely creation, don't forget to save it or you'll never see it again. As in any program, be sure to save early and often so your efforts don't go to waste if your computer crashes or the power goes out.

The simplest method is to choose File→Save or press ⌘-S (Ctrl+S on a PC). If you haven't previously saved the file, Photoshop summons the Save As dialog box so you can pick where to save the file, give it a name, and select a file format. If you *have* already saved the file, Photoshop replaces the previously saved version with the *current* version without asking if that's what you want to do. In some situations, that's fine, but it can be disastrous if you were planning to keep more than one version of your image.

You can play it safe by using the Save As dialog box instead; it *always* prompts you for a new file name (see Figure 2-4), which is handy when you want to save another version of your document or save it in a different format. Choose File→Save As or press ⌘-Shift-S (Ctrl+Shift+S on a PC) to open the dialog box. From the factory, the Format pop-up menu is set to Photoshop, which is good because that format keeps all of your layers intact, as you'll soon learn. But, as the next section explains, you can save files in lots of other formats, too.

POWER USERS' CLINIC

Going Mobile with Device Central

If you're designing graphics for use on cellphones or other portable devices, you can see what your graphics will look like on many of 'em by using Device Central, a program that comes with Photoshop. (You need an active Internet connection to use it since it downloads handheld device profiles stored online.) It lets you preview all kinds of files on a bunch of different simulated gadget screens, and even lets you test interactive elements and record videos showing how your images look on specific devices. You can use Device Central from the get-go to make sure your file is set up properly and take the guesswork out of which size to make your images. Here's how:

1. Choose File Device Central and Photoshop opens the big Device Central dialog box.

2. Select a gadget from the Local Library list on the left side of the Device Central window (or Shift-click to choose more than one). If the device you're designing for isn't in that list, select it in the Online Library list, drag it into the Local Library list, and then select it there.

3. Click the Create button at the top right of the Device Central dialog box to open a new file in Photoshop tailored to the device(s) you picked. If you picked more than one, the dimensions are set to best work on all of them.

4. When you're finished editing your mobile masterpiece, choose File→Save For Web & Devices (page 248). Be sure to pick a file format from the Preset pop-up menu and then click the Device Central button at the bottom of the dialog box to preview your document on the device (see the figure on page 724).

Figure 2-4:
The Save As dialog box lets you save a copy of your file with a different name in a different location and even in a different format.

Note: When you choose Save As in Photoshop CS5, it automatically assumes you want to save the document in the original folder from whence it came, instead of, say, the last folder you saved a file to. To change this behavior, choose Photoshop→Preferences→File Handling (Edit→Preferences→File Handling on a PC) and turn off the "Save As to Original Folder" checkbox.

File Formats

You'll learn much more about file formats in Chapters 16 and 17, but here's a quick overview. If you remember nothing else, remember to save your images as PSD files (Photoshop documents) because that's the most flexible format (see the box on page 51). That said, sometimes you need to save your document in other formats because of where the file is *headed*. For example, Adobe InDesign (a popular page-layout program) is adept at handling PSD files, but QuarkXPress is a little different. While Quark can open Photoshop documents, not everyone is comfortable working *with* PSD files in Quark. In that case, try saving your document as a TIFF file because nearly every image-handling program ever invented can open flattened TIFF files just fine (see page 112 for more on flattening your documents).

Note: If you need to save a Photoshop document that's bigger than two gigabytes, save it as a PSB file instead. That format lets you get past Photoshop's two-GB limit on file sizes.

Graphics destined for the Web are a different animal because they're specially designed for onscreen viewing and faster downloads. Here's a quick cheat sheet to tide you over until you've got time and energy to make your way to Chapter 17:

- **JPEG** is commonly used for graphics that include a wide range of colors like photos. It compresses images so they take up less space, but the smaller file size comes at a price: loss of quality.

Note: Photoshop CS5 automatically saves 16-bit JPEGs as 8-bit files. If that sentence is as clear as mud to you, flip back to the box on page 45 to learn more about image bit depth.

- **GIF** is a popular choice for graphics that include a limited number of colors (think cartoon art), when you need to save a transparent background, or when you're creating an animation (page 725).

- **PNG** is the up-and-comer because it offers true transparency and a wide range of colors. It produces a higher-quality image than a JPEG, but it generates larger files.

For more on creating and preparing images for the Web, hop over to Chapter 17. If your image is headed for a professional printer, visit Chapter 16 instead.

UP TO SPEED

Save Your Master

Experimenting with your image is fine—until you accidentally ruin the original and don't have a backup. To avoid losing a critical file and having to explain to your boss, coworkers, or client why the project is behind schedule, save your master file as a PSD file so all of your image layers, Adjustment layers (page 77), Smart Objects (page 123), and so on remain intact. It's also a good idea to save a copy somewhere other than your hard drive in case something happens to your computer; burn it onto a CD or DVD, save it on a Flash drive, or use an online storage service. That way, if something goes wrong while you're working on the project, you've always got the original to fall back on.

If something *does* go wrong, duplicate the master file again and then work on the copy. There's no point in tempting fate!

Opening an Existing Document

In most programs, opening files is simple and that holds true in Photoshop, too. But Photoshop gives you a few more options than you'll find in some other programs because it can open files saved in its own format (PSD files) as well as a slew of other formats both common and obscure (a feature that makes Photoshop amazingly versatile at working with a wide range of images). Even better, if the program doesn't recognize a particular format, there's a good chance someone has developed a plug-in (companion program) that can. (See Chapter 19 for more than you ever wanted to know about plug-ins.)

Photoshop knows how to open Adobe Illustrator, Camera Raw (page 57), JPEG, GIF, PNG, TIFF, EPS, and PDF files (page 56), along with Collada DAE, Google Earth 4 KMZ, Scitex CT, Targa, and several other file types most folks have never heard of.

You can open files in Photoshop in several ways, including:

- Double-clicking the document's icon, no matter where it's stored on your computer.

Raster Images vs. Vector Images

The images you'll work with and create in Photoshop fall into two categories: those made from pixels and those made from paths. It's important to understand that they have different characteristics and that you can open them in different ways:

- **Raster** images are made from tiny blocks of color called *pixels*, the smallest element of a digital image. The number of pixels in an image depends on the device that captured it (a digital camera or scanner) or the settings you entered when you created the document in Photoshop (page 44). The size of the pixels depends on the image's *resolution* (see page 238), which specifies the number of pixels in an inch. Usually pixels are so small that you can't see them individually; but, if you zoom in on a raster image, the pixels appear bigger, and the image starts to look like a bunch of blocks instead of a smooth image.

- **Vector** images are made up of points and paths that form shapes; these shapes are filled and stroked (outlined) with color. You can create vector images in Photoshop, but they're more commonly made with drawing programs like Adobe Illustrator and Corel-Draw. The paths are based on mathematical equations that tell monitors and printers how to draw the image. Because there aren't any pixels involved, you can make vector images as big or small as you want, and they'll still look as smooth and crisp as the original. Photoshop can open vector images, but unless you open them as Smart Objects (discussed later in this chapter on page 54), Photoshop will turn them into pixel-based raster images. (This process is called *rasterizing*.)

In the figure below, the upper image is a vector image (the right-hand version shows the paths it's made from) and the bottom image is a raster image. Vectors are handy when you're designing logos and other illustrations that you might need to make bigger at some point. You'll end up working with rasters more often than not because *photos* are raster images and because Photoshop is a pixel-based program (as are all image-editing and painting programs). That said, you can use some of its tools to draw vectors (see Chapter 13), and it lets you open vector files, discussed in the next section. You can also create some amazing artwork by combining raster and vector images as described on page 315.

- Dragging the document's icon into the Photoshop program window.

- Dragging the document's icon onto the Photoshop program icon (the blue square with "Ps" on it).

- Ctrl-clicking (right-clicking on a PC) the document's icon and choosing Open With→Photoshop CS5 from the resulting shortcut menu.

- Launching Photoshop and then choosing File→Open or pressing ⌘-O (Ctrl+O) to rouse the Open dialog box, discussed in the next section.

You can also use Adobe Bridge—or CS5's new Mini Bridge (page 759)—to preview and open your documents. Head over to Appendix , online, to learn about Bridge.

The Open Dialog Box

When you choose File→Open (Ctrl+O on a PC) or press ⌘-O (Ctrl+O), Photoshop brings up the dialog box shown in Figure 2-5. All you need to do is navigate to a file on your hard drive and then click the Open button.

Figure 2-5: The Open dialog box lets you navigate to the image you want to open. The Format pop-up menu at the bottom left automatically changes to match the format of the document you select.

Note: PC users don't get as many options in the Open dialog box as Mac users do. Instead of the Enable pop-up menu, PC folks get a "Files of type" menu, and the Format pop-up menu doesn't appear at all. Also, the PC version of the Open dialog box hides any files you can't select.

In addition to helping hunt through the murky depths of your hard drive, the dialog box lets you limit the files you can open via the Enable pop-up menu. If you use this menu to select just the format you want to see, Photoshop will dutifully dim everything else (you can't select dimmed items), which is handy when you've saved the same image in several different formats—like PSD, JPEG, and TIFF.

Tip: To open more than one file, ⌘-click (Ctrl-click) to select files that aren't next to each other in the list or Shift-click to select files that are. When you click Open, Photoshop opens each file in a separate tab if you've got the Application Frame turned on (page 13), and you've kept Photoshop's Interface preferences set to "Open Documents as Tabs" (page 33).

If you leave the Enable pop-up menu set to All Readable Documents (set the "Files of type" menu to All Formats on a PC), you're telling Photoshop it's okay to open *any* file format it recognizes. If you try to open a format Photoshop should know how to open but for some mysterious reason thinks it doesn't (see page 52 for a list of formats Photoshop recognizes), someone may have saved the document with the wrong file extension. (Since all programs, including Photoshop, rely on the file extension to figure out which type of document they're looking at, be careful not to change these multi-letter codes that appear after a document's name.) If you run into this problem, Mac users can use the Format pop-up menu (PC users can choose File→Open As instead) to tell Photoshop which format the document *should* be, and the program will ignore the file's extension and try to open it based on the format you pick.

Tip: If you're looking for a specific image but can't remember its name, try using Bridge, or CS5's new Mini Bridge (Appendix C, online at *www.missingmanuals.com/cds*) to find it. Bridge shows you a preview of each image along with a ton of other info like keywords, ratings, and more. It also gives you filtering and search options to help hunt down the image you want.

Opening Files as Smart Objects

Smart Objects are one of those glorious features that make Photoshop truly amazing. You'll learn a lot more about Smart Objects in Chapter 3, but here's a quick overview: Smart Objects are basically containers that can store raster, vector, or Camera Raw files (page 57) in their original formats. Smart Objects keep track of the original file so you can undo any changes you make to them (this process, called *nondestructive* editing, is discussed at length in Chapter 3). In addition to the image types just mentioned, you can also import TIFF, PDF, and JPEG files as Smart Objects.

To open an image as a Smart Object, choose File→"Open as Smart Object". In the resulting dialog box, choose the file you want to open. When you click Open, Photoshop opens it as a Smart Object layer in a new document. See Chapter 3 for more about layers and page 254 for the skinny on resizing Smart Objects.

Tip: In CS5 you can make Photoshop open some images as Smart Objects automatically. Just choose Photoshop→Preferences→General (Edit→Preferences→General on a PC) and turn on the "Place or Drag Raster Images as Smart Objects" checkbox (shown in Figure 1-12, page 32). From then on, anytime you choose File→Place, or drag a raster image into the Photoshop window or an open document (also new in CS5), it'll open as a Smart Object without you having to think twice about it.

Opening Recent Files

This one's a real timesaver. Like many programs, Photoshop keeps track of the documents you've recently opened. Choose File→Open Recent to see a list of the last ten documents you worked on, with the latest one at the top of the list (see Figure 2-6). If you've moved or renamed the file since you last opened it in Photoshop (put it in a different folder on your hard drive, say), the program will try to find it for you when you select it from this list. If the document isn't on your hard drive anymore, Photoshop displays a message box letting you know it can't find the file.

Figure 2-6:
The Open Recent menu option is a handy shortcut for getting at files without traipsing through the Open dialog box. If you want to erase the list, click Clear Recent.

Tip: If you want Photoshop to remember more (or fewer) than ten files, choose Photoshop→Preferences→File Handling (Edit→Preferences→File Handling on a PC) and change the number in the "Recent file list contains" field at the bottom of the Preferences dialog box. You can set it as low as 2 or as high as 30. Just remember that a higher number means a longer list of recent documents to sift through!

Working with PDFs

Saving a document as a PDF file is like taking a picture of it so others can open the file without needing the program you used to create it—they just need the free Adobe Reader (or any other PDF-viewing program, like Preview on the Mac). PDFs can store text, images, and even video at a variety of quality settings. PDFs are also *cross-platform*, which means they play nice with both Macs and PCs. It's an amazingly useful file format that will only become more common (see Chapter 16 for a peek into the future).

You can open PDFs the same way you open any file: by choosing File→Open, selecting the PDF you want, and then clicking the Open button. If someone created the PDF in Photoshop, it opens right up. If someone created it in another program, Photoshop displays the Import PDF dialog box (Figure 2-7) where you can choose which parts of the document you want to import (full pages or just the images), set resolution, dimensions, and so on.

Figure 2-7:
If you decide to import multiple pages (as shown here), Photoshop creates a new document for each one. If you're lucky and the person who created the document was a PDF pro, she may have included size-specification goodies like crop size, bleed area, trim, and art size (you'll learn about most of these terms in Chapter 16). If so, you can eliminate some resizing work on imported files by choosing one of the size elements from the Crop To pop-up menu (shown here, right).

Working with Scanned Images

The Open dialog box isn't the only way to get images into Photoshop. If you have a scanner that knows how to talk to Photoshop, you can use it to import images straight into the program. But, first, you need to install your scanner's software

and the Photoshop plug-in for your scanner. (Check the owner's manual to learn how to install the software, and then read Chapter 19, which covers plug-ins in detail. To find the plug-in for your scanner, check the manufacturer's website for the most recent version.) Once everything is all set, you can start importing scanned documents.

To import an image from a scanner into Photoshop, choose File→Import and then select your scanner from the resulting list. Each scanner has its own software, so there's no standard set of steps to work through—they're all different. Unfortunately, that means you have to read the documentation that came with your scanner to figure out how to your import files (the nerve!). Nevertheless, the box on page 57 has some scanning tips for your reading pleasure.

Note: The TWAIN plug-in, which lets Photoshop communicate with your scanner so you can see it when you choose File→Import, has been updated for CS5. Because it's an optional plug-in for both Macs and Windows, you'll need to fetch it from the Optional plug-ins folder on your installation CD (or installation folder, if you downloaded the program) in order to install and use it. If you're on a Mac running Snow Leopard (OS X 10.6), it'll work with the 64-bit version of Photoshop. If you're running Leopard (OS X 10.5), you'll need to open Photoshop in 32-bit mode instead (see the box on page 6).

> **UP TO SPEED**
>
> ### Scanning 101
>
> Just because all scanning software is different doesn't mean there aren't a few guidelines you can follow to produce good scans. Keep these things in mind the next time you crank open your scanner's lid:
>
> - **Scan at a higher bit depth than you need for the edited image.** Yes, your files will be larger, but they'll contain more color info, which is helpful when you're editing them. (See the box on page 45 for more on bit depth.)
> - **Scan at a higher resolution than you need for the finished image so your files include more details.** You can always lower the resolution later,
>
> but you can't increase it…or, rather, you *shouldn't* increase it without knowing the trick (see the box on page 244 for the scoop).
>
> - **If you can use your scanner software to adjust your image's color before you import the file into Photoshop, do it.** Making adjustments before you import the image lets you take advantage of all of the info your scanner picked up. The amount of information your scanner passes along to Photoshop when you import the file is almost *always* less than the amount of info in the original image.

Working with Raw Files

Of all the file formats Photoshop can understand, *Raw* is the most useful and flexible. Professional-grade digital cameras (and many high-end consumer cameras, too) use this format. The info in a Raw file is the exact information your camera recorded when you took the picture. (Other file formats, like JPEG, compress images and in

the process slightly reduce the image's quality.) Raw files contain the most detailed information you can get from a digital camera, including what's known as *metadata* (info on all the settings your camera used to capture the image like shutter speed, aperture, and so on). You can edit Raw files using a Photoshop plug-in called *Adobe Camera Raw* (shown in Figure 2-8), which you'll learn more about in Chapter 9.

Figure 2-8:
Raw files get their own editing program called Camera Raw, which launches automatically when you open a Raw file in Photoshop, Bridge, or CS5's new Mini Bridge. Camera Raw is one of the most frequently updated plug-ins known to man—good news, because manufacturers release new camera models faster than photographers can buy 'em! If you've got a brand-new camera, you may have to update the Camera Raw plug-in before you can open your file, which means it's time for a trip to the Adobe Updater program. To run it, choose Help→Updates (Appendix A, online, has more on checking for updates). If there's a newer version of Camera Raw, Photoshop lets you know so you can download and install it.

Opening Raw files

Opening a Raw file in Photoshop is no different from opening any other kind of image except that it opens in the Camera Raw window instead the main Photoshop window. You can open Raw files by:

- Double-clicking the Raw file's icon. Your computer launches Photoshop (if it wasn't running already) and then opens the Camera Raw window.

- Ctrl-clicking (right-clicking on a PC) the Raw file's icon and choosing Open With→Photoshop. (Since Camera Raw is a plug-in that runs inside Photoshop and Bridge, it doesn't get listed separately, but your computer knows to open the file in Camera Raw.)

- Using Bridge to select the file you want to open and then choosing File→"Open in Camera Raw" or pressing ⌘-R (Ctrl+R on a PC). You can also Ctrl-click (right-click) the file in Bridge or CS5's new Mini Bridge and then choose "Open in Camera Raw" from the resulting shortcut menu. (Bridge and Mini Bridge are covered in Appendix C, online.)

Tip: If you've got a bunch of Raw images that need similar edits (cropping, color-correcting, and so on), you can open them all at once by Shift or ⌘-clicking (Ctrl-clicking on a PC) them in Bridge or Mini Bridge, or by selecting multiple files on your desktop and then double-clicking or dragging them onto the Photoshop icon. When you click the Select All button in the top-left corner of the Camera Raw window, any edits you make from then on affect all your open images. See the box on page 422 for more on editing multiple files.

POWER USERS' CLINIC

Opening Images as a Stack

If you sprang for Photoshop CS5 Extended (see the Note on page 1), you've got a bonus feature called *Stacks* that lets you open multiple images on separate layers within the same document. It's a *huge* timesaver when you need to combine several images to make a collage or when you want to make several group shots into one perfect shot where everyone's eyes are open and they're all smiling, when you're editing individual frames of a video, and so on.

To open a group of images as a Stack, choose File→Scripts→"Load Files into Stack". In the resulting Load Layers dialog box, tell Photoshop where the images are stored on your hard drive and then click OK.

The Load Layers dialog box's Use pop-up menu lets you choose what you want to open: individual images or whole folders of images. If you're combining several shots into one, turn on the "Attempt to Automatically Align Source Images" checkbox. To convert all the layers into a single Smart Object (page 126) so you can resize the image later, turn on the "Create Smart Object after Loading Layers" checkbox.

Duplicating Files

If your client or boss asks you to alter an image and you suspect they'll change their mind later, it's wise to edit a *copy* of the image instead of the original file. That way, when they ask you to change everything back, you don't have to sweat bullets hunting for a backup of the original or try to recreate the earlier version. Duplicating files is also handy when you want to experiment with a variety of different effects.

You can duplicate a file by choosing File→Save As and renaming the image, but there's a faster way: Make sure the file you want to copy is in the currently active window (just click the window to activate it), and then choose Image→Duplicate. In the Duplicate Image dialog box (Figure 2-9), give your file a new name and then click OK. You've just set yourself up to be the office hero.

Figure 2-9:
A duplicate file is exactly the same as the original including layers, layer styles, and so on. If you need to create a single-layer (flat-tened) version of a file, turn on the Duplicate Merged Layers Only checkbox. (Page 112 has more about flattening files.)

Changing Your Image View

Photoshop gives you a variety of ways to look at your images; different views are better for doing different things. For example, you can get rid of the Application Frame (page 13), view images full screen, zoom in and out, or rotate your canvas to view images at an angle. This section teaches you how to do all that and more.

Zooming In and Out

Being able to zoom closely into your image is crucial; it makes fixing imperfections, doing detailed clean-up work, and drawing accurate selections a hundred times easier. One way to zoom is to click with the Zoom tool, which looks like a magnifying glass. You can find it at the bottom of the Tools panel or you can grab it by pressing Z (see Figure 2-10); simply click repeatedly to get as up close and personal to your pixels as you want. When you're ready to zoom back out, just Option-click (Alt-click on a PC) instead. You can also zoom using your keyboard, which is faster: press ⌘ and the + or – key (Ctrl + or –). To zoom in on a specific area, using the Zoom tool, turn off the Scrubby Zoom (Figure 2-10) checkbox in the Options bar and then drag with the Zoom tool to draw a box around the pixels you want to look closely at. As soon as you let go of your mouse button, Photoshop zooms in until the area you selected fills your document window.

Tip: In Photoshop CS5, you can turn off the pixel-grid that you see when you're zoomed in 501 percent or more by choosing View→Show→Pixel Grid.

Figure 2-10:
Top: New in Photoshop CS5 is the Scrubby Zoom option, shown here. Instead of clicking like a maniac to zoom in on your image, you can turn it on to simply click and drag left to zoom out, or drag right to zoom in. You can also zoom by selecting an item from the Zoom preset menu in the Application bar (page 14) or by typing a percentage into the lower-left corner of your document window (not shown).

Bottom: If you zoom in to 501 percent or closer, you'll get this handy pixel-grid view that lets you edit precisely, pixel by pixel. If you're moving items around, this grid makes it easy to see whether pixels are perfectly aligned horizontally and vertically.

If your computer can handle *OpenGL* (see the box on page 64), you can hold down your mouse button—while the Zoom tool is active to *fly* into your image, zooming to a maximum of 3,200 percent; simply Option-click (Alt-click) and hold down your mouse button to zoom back out. This animated zooming makes you feel like you're flying into and out of your image—and it saves you several mouse clicks along the way.

When you have the Zoom tool active, the Options bar gives you the following choices:

- **Resize Windows To Fit.** If you want Photoshop to resize your document window to accommodate the current magnification level, turn on this checkbox. You can also access it by choosing Photoshop→Preferences→General (Edit→Preferences→General on a PC) and turning on the Zoom Resizes Window checkbox; however, as of this writing the two settings cancel each other out.

- **Zoom All Windows.** Turn on this checkbox to use the Zoom tool to zoom in on all open windows by the same amount simultaneously. This setting is helpful if you've opened a duplicate of your image as described in the steps on page 437. You can also use the Window→Arrange menu to do pretty much the same thing. Your options there include:

 — **Match Zoom.** Zooms all open windows to the same magnification level.

 — **Match Location.** Zooms to the same spot in each window.

— **Match Rotation.** Rotates each window's canvas to the same angle.

— **Match All.** Does all of the above.

- **Scrubby Zoom.** New in Photoshop CS5, this option lets you click and drag to
do your zooming. Once you turn it on, click and hold down your mouse button
while dragging left to zoom out of your image, or right to zoom in.

Tip: If you've got a scroll wheel on your mouse, you can use that to zoom, too. Just choose
Photoshop→Preferences→General (Edit→Preferences→General on a PC), turn on "Zoom with Scroll
Wheel" in the Options section, and then click OK.

POWER USERS' CLINIC

Zooming with Mac Gestures

If you use a MacBook, MacBook Air, or MacBook Pro with
a multitouch trackpad, you've got yet *another* way to zoom
in or out of your images: use the finger pinch gesture even
if the Zoom tool isn't active. You can also flick left or right
with two fingers to move across your image or twist with
your finger and thumb to rotate the canvas.

If your Mac includes a multitouch trackpad, you can see
examples of each of these gestures in the Keyboard &
Mouse Preference Pane. From the menu, choose Sys-
tem Preferences→Keyboard & Mouse, and then select the

Trackpad tab. Click an item in the action list on the left side
of the dialog box to see that gesture in action.

Zooming with gestures is all well and good…that is, un-
til you accidentally zoom or rotate your canvas (page
65) by accident. That's why Adobe added the abil-
ity to turn this behavior *off* in Photoshop CS5. Choose
Photoshop→Preferences→Interface (Edit→Preferences→
Interface on a PC) and turn off "Enable Gestures" as de-
scribed in the note on page 33.

- **Actual Pixels.** Click this button to see your image at 100 percent magnification.
You can do the same thing by pressing ⌘-1 (Ctrl+1 on a PC), by double-clicking
the Zoom tool, by entering *100* into the zoom percentage field at the bottom-left
corner of the document window, or by choosing View→Actual Pixels.

- **Fit Screen.** Clicking this button makes Photoshop resize the active image win-
dow to fit the available space on your screen and fit the image inside the docu-
ment window. You can also press ⌘-0 (Ctrl+0) or choose View→"Fit on Screen".
This is incredibly handy when you're using Free Transform (pages 95 and 263)
on an image that's larger than your document size—it's tough to grab bounding-
box handles if you can't see 'em!

- **Fill Screen.** This button enlarges your image to the largest possible dimensions
within the window. Clicking Fill Screen makes your image a little bigger than
it gets when you use Fit Screen because it uses all the available vertical space.

- **Print Size.** If you click this button, Photoshop makes your image the size it'll
be when you print it; you can do the same thing by choosing View→Print Size.

Keep in mind that the resolution settings for your monitor can make the print size sample look bigger or smaller than it really will be, so use this feature only as an approximation.

Tip: If your image is smaller than the document window (meaning you see a gray border around the edges of the image) or if the document window itself is smaller than the available space in the Application Frame (page 13), you can double-click the Hand tool in the Tools panel to make Photoshop enlarge your image to fill the document window.

The Status Bar: Document Info Central

At the bottom of each document window is the *status bar*, shown in the figure below, which gives you a quick peek at important info about your document. When you first start using Photoshop, the status bar shows the size of your document (K stands for kilobytes and M for megabytes). If you don't see any status information, your document window may be too small. Just drag outward from the lower-right edge of the window so it's big enough for you to see it.

Click the little triangle to the status bar's right (circled) and you get a menu that lets you control what the bar displays. Here's what you can choose from:

- **Adobe Drive** connects to Version Cue servers. Version Cue is Adobe's method of attaching versions and enabling asset management throughout all of its programs. However, Adobe discontinued Version Cue in Photoshop CS5.

- **Document Sizes** displays the approximate size of your image for printing (on the left) and the approximate saved size of your image (on the right).

- **Document Profile** shows the color profile (page 669) for your image.

- **Document Dimensions** displays the width and height of your image.

- In Photoshop CS5 Extended, **Measurement Scale** shows the scale of pixels compared with other units of measurement. For example, an image from a microscope can measure objects in microns, and each micron can equal a certain number of pixels.

- **Scratch Sizes** tells you how much memory and hard disk space is being used to display your open images.

- **Efficiency** lets you know if Photoshop is performing tasks as fast as it possibly can. A number below 100 percent means Photoshop is running slowly because it's relying on scratch-disk space (page 34).

- **Timing** shows how long it took Photoshop to perform the most recent activity.

- **Current Tool** displays the name of the selected tool.

- **32-bit Exposure** lets you adjust the preview image for 32-bit HDR images (see page 414).

Zoom percentage

Status bar

Adobe Drive
✓ Document Sizes
Document Profile
Document Dimensions
Measurement Scale
Scratch Sizes
Efficiency
Timing
Current Tool
32-bit Exposure

Moving Around in Your Image

Once you've zoomed in on your image, you can use the Hand tool to move to another area without zooming back out. Grab this tool from the Tools panel or the Application bar, or just press and hold the space bar on your keyboard (unless you're typing with the Type tool—then you'll just type a bunch of spaces). When your cursor turns into a hand, hold your mouse button down and then drag to move your image. When you get to the right spot, just let go of your mouse button.

Tip: If you press and hold the Shift key while you're using the Hand tool, Photoshop moves all of your open window content at the same time. (You can do the same thing by turning on the Scroll All Windows checkbox in the Options bar.)

In Photoshop CS5, you get a couple of other ways to move around your document: *flick-panning* and the *birds-eye view* feature. If you've got a computer that can run OpenGL (see the box on page 64), you can use these fast and efficient ways to move around your image. Here's how they work:

- **Flick-panning** lets you "toss" an image from one side of the document window to the other. Just grab the Hand tool, click your image, and hold down the mouse button. Then, quickly move your mouse in the direction you want to go and then release your mouse button—the image slides along and slowly comes to a stop. You can do the same thing by holding your space bar and moving your mouse quickly while you hold the mouse button down.

Tip: If you're not a fan of flick-panning, you can turn it off by choosing Photoshop→Preferences→ General (Edit→Preferences→General on a PC) and, in the resulting dialog box, turn off the Enable Flick Panning checkbox.

UP TO SPEED

Understanding OpenGL

OpenGL is a technology that helps newer computers draw graphics faster and more efficiently. (To learn more about it, go to *www.opengl.org*.) You can tell whether your computer uses OpenGL by going to Photoshop→Preferences →Performance (Edit→Preferences→Performance on a PC). If the Enable OpenGL Drawing checkbox is turned on, you're all set. If it's not checked but you *can* turn it on, then do it. If the checkbox is grayed out (meaning you can't turn it on), then your computer's video card isn't fast enough or doesn't have enough memory to run OpenGL—bummer.

If your computer can't run OpenGL, some Photoshop features will take a long time to run, and others, like flick-panning, canvas rotating, and pixel-grid overlay (Figure 2-10), won't work at all. Other nifty CS5 features that require OpenGL include the new "heads-up display" Color Picker (page 506), the Eyedropper tool's Sample Ring (page 495), and the ability to resize a brush and change its hardness using the same keyboard shortcut (see the Tip on page 117).

- **Birds-eye view** lets you zoom out of your document quickly to see the whole thing. To use it, just press and hold the H key and click your image: you'll get an instant aerial view of your image with a box marking the area you're zoomed in on. Let go of the H key (and your mouse button) to zoom back in.

Zooming with the Navigator Panel

You can think of the Navigator panel as your one-stop zooming shop. If you want to know *exactly* which part of an image you're zoomed in on, it can show you. To open it, choose Window→Navigator. The panel displays a smaller version of your image called a *thumbnail* and marks the area you're zoomed in on with a red box called the *proxy preview*. At the bottom of the panel, the zoom field shows your current magnification level. You can zoom into or out of your image by clicking the zoom buttons at the bottom of the panel (they look like little mountains) or by using the slider nestled between them (see Figure 2-11). To zoom to a specific level, enter a number in the zoom field.

Proxy preview
(your current
viewing area)

200%

Drag to increase
panel size

Zoom Zoom Zoom
out slider in

Figure 2-11:
As you zoom in on your image, the proxy preview box shrinks because you're looking at a smaller area. You can also drag the box around to cruise to another spot in your image.

To make the Navigator panel bigger, drag its bottom-right corner downward. You can change the color of the proxy preview box by choosing Panel Options from the top-right corner of the Navigator panel's menu: just click the red color swatch, pick another color from the resulting Color Picker, and then click OK.

Rotating Your Canvas

If you're an artist, you're gonna love this feature! The Rotate View tool rotates your canvas—without harming any pixels—so you can edit, draw, or paint at a more natural angle (see Figure 2-12). It's like shifting a piece of paper or angling a painting canvas, but it doesn't rotate the actual image—just your *view* of the image. If you're using a graphics tablet (see the box on page 520) and you skipped upgrading to CS4, this feature alone may be worth the price of CS5. Bear in mind, though, that your computer needs to be able to run OpenGL (page 64) for this feature to work. To use it, select it from within the Hand tool's toolset at the bottom of the Tools panel.

Note: MacBook, MacBook Air, and MacBook Pro users with multitouch trackpads (see the box on page 62) can rotate the canvas by using the two-finger rotate gesture.

Figure 2-12:
Grab the Rotate View tool, mouse over to your image, and then drag diagonally up or down to rotate it. When you start to drag, you see a compass that shows how far from "north" you're rotating the canvas. If you're not the dragging type, you can type a number into the Options bar's Rotation Angle field or spin the little round dial to the field's right. To straighten your canvas, click the Reset View button in the Options bar. To rotate all open images, turn on the Rotate All Windows checkbox.

In CS5, if you rotate your canvas and then paint with the Brush tool (or any tool that uses a brush cursor), your brush won't rotate like it used to. Yay!

Arranging Open Images

The Application Frame (page 13) and tabbed document workspace help you keep track of several open documents. If you turn off the Application Frame, your documents can get scattered across your screen. However, you can herd those open windows together by using the list of commands that appears when you choose Window→Arrange (see Figure 2-13). Here are your choices:

- **Cascade** stacks your windows on top of each other, putting the largest one on the bottom and the smallest on the top.

- **Tile** resizes your windows to identical sizes and arranges them in rows and columns.

Figure 2-13:
You can use the Arrange command to create order out of chaos by tiling (top) or cascading (bottom) your windows. You can also use the Arrange Documents menu (shown opened here) in the Application bar to view your windows in a variety of ways.

You can't cascade tabbed documents because they're attached (or rather, docked) to the top of your Photoshop workspace. The fix is to choose Window→Arrange→Float in Windows first, and then choose Cascade.

Document Size vs. Canvas Space

One thing that's super confusing to Photoshop beginners is the difference between document size (also known as image size) and canvas size. In Photoshop, the *canvas* is the amount of editable area in your document (it's the same as your document's dimensions) and you can add to or subtract from it anytime. By doing so, you'll add or subtract pixels from your image, which either increases or decreases the document size.

For example, say you're designing a poster for a chili cook-off and you're experimenting with the design. Instead of limiting your work area to the final size of the poster, you can make your canvas bigger than that (page 257) so you have room to spread out and try different design ideas. Once you've nailed down the final design, you can crop (page 219) or trim (page 231) it back down to size.

- **Float in Window** puts the current document in its own window if it's part of a tabbed group of documents that share the same window.

- **Float All Windows** splits all tabbed documents out into their own windows and cascades the new windows.

- **Consolidate All to Tabs** groups your open images in a single, tabbed window (as shown in Figure 2-14, top left).

Figure 2-14:
Photoshop's tabbed document feature is a handy way of organizing open windows. You can slide the tabs left or right to rearrange them or drag a tab out of the window group to create a floating window (top). To redock a floating window, just drag its tab back into the main tab area (middle).

You can close all tabbed documents by choosing File→Close All. If the program sees that you've edited some or all of the images, it asks if you'd like to save the images before closing them. New in CS5 is the option to apply your answer to all images by turning on the new "Apply to all" checkbox, shown here (bottom).

Tip: You can cycle through all your open documents by using the ⌘-~ keyboard shortcut (Ctrl+Tab on a PC). To cycle through documents in the reverse order, press Shift-⌘-~ (Shift+Ctrl+Tab). This is especially handy when you're in Full Screen Mode, as described on page 16.

Guides, Grids, and Rulers

Placing all the components of your design in just the right spot can be challenging, and if you're a real stickler for details, close enough isn't good enough. This section

teaches you how to use Photoshop's guides, grids, and rulers to get everything positioned *perfectly*. Adobe calls these little helpers *Extras* and you can access them in the Application bar's Extras pop-up menu, shown on page 15 in Chapter 1.

Rulers and Guiding Lines

Positioning objects on your canvas properly can make the difference between a basic design and a masterpiece. The quickest way to position and align objects is by drawing a straight line to nestle them against. You can do just that using Photoshop's nonprinting *guides*—vertical and horizontal lines you can place anywhere you want (see Figure 2-15).

Figure 2-15:
Guides help you position items exactly where you want 'em. Here the green guides help you make sure all the text is the same width and the edges of the poster are kept free of clutter. The guides won't show up when you print the image, so you don't have to worry about deleting them.

To create a guide in a certain spot in your document, choose View→New Guide and enter the position in the resulting dialog box.

If you have trouble grabbing a guide, try making your document window bigger than your canvas (drag any edge of the document window, or its lower-right corner, diagonally). That way your guides extend beyond the canvas so they don't overlap other elements that you might accidentally select and move.

Before you can create guides, you need to turn on Photoshop's rulers. The fastest way to do that is by pressing ⌘-R (Ctrl+R on a PC), but you can also turn them on by choosing View→Rulers or selecting Rulers from the Extras pop-up menu in the Application bar. Whichever method you use, the rulers appear on the top and left

edges of your image window. The units you see on the rulers are controlled by the settings in the Units & Rulers preferences (page 36).

Once you've turned rulers on, you can add a guide by clicking in either the horizontal or vertical ruler, and then dragging it into your document as shown in Figure 2-15. After you've drawn a guide, you can:

- **Move a guide** by grabbing the Move tool (see Appendix D, online) from the Tools panel or by pressing V, and then dragging the guide to a new position (your cursor turns into a double-sided arrow like the one circled in Figure 2-15).

- **Snap objects to your guides** by turning on Photoshop's *snap* feature. This feature makes it super easy to align objects because, when they get close to one of your guides, they jump to it as if they were magnetized. To turn on this behavior, choose View→Snap To→Guides. You can tell that an object has snapped to the nearest guide because it pops into place. After the object aligns to a guide, you can move it along that line to snap it into place with other guides, too. If you don't want an object aligned with a certain guide, just keep moving it—it'll let go of the guide as soon as you move it far enough.

Note: You can make objects snap to grids (page 70), layers (Chapter 3), slices (Chapter 17), and the edges of your document. Just go to View→Snap To and choose the elements you want objects to align with. For example, choosing both Guides and Layers makes the object you're moving snap to guides *and* the edges of objects on other layers.

- **Hide the guides** temporarily by pressing ⌘-; (Ctrl-; on a PC).
- **Delete a guide** by dragging it back where it came from (into the ruler area).
- **Delete all guides** by choosing View→Clear Guides.

Smart Guides

Smart Guides are a little different from regular guides in that they automatically appear onscreen to show the spatial relationship between objects. For example, they pop up when objects are aligned or evenly spaced in your document. As you drag an object, Smart Guides appear whenever the current object is horizontally, vertically, or centrally aligned with other objects on other layers. To turn on Smart Guides, choose View→Show→Smart Guides. You can see them in action in on page 99.

Using the Document Grid

If you want *lots* of guides without all the work of placing them, you can add a grid to your image by choosing View→Show→Grid (see Figure 2-16). Straight from the factory, Photoshop's gridlines appear an inch apart with four subdivisions, although you can change that spacing by choosing Photoshop→Preferences→"Guides, Grid & Slices" (Edit→Preferences→"Guides, Grid & Slices" on a PC), as Figure 2-16 explains.

Figure 2-16:
*Photoshop's grid is helpful when you need to align
lots of different items, like the text shown here.*

*In the Preferences dialog box, adjust the gridline
marks by changing the "Gridline every" field and use
the pop-up menu next to it to choose the unit of mea-
surement the grid uses: pixels, inches, centimeters,
millimeters, points, picas, or percent. Just below the
"Gridline every" field is the Subdivisions field, which
you can use to set how many lines appear between
each gridline—if any.*

The Ruler Tool

In addition to the rulers you learned about earlier, Photoshop also gives you a virtual
tape measure: the Ruler tool. It lets you measure the distance between two points in
your document, and in Photoshop CS5 you can also use it to straighten your image,
as shown in Figure 2-17. To use it for measuring, grab the tool (it's hiding in the Eye-
dropper toolset and it looks like a little ruler) by pressing Shift-I repeatedly, and then
click and hold your mouse button where you want to start measuring. Drag across
the area or object with your mouse and you'll see a line appear in your document.
To draw a perfectly straight horizontal or vertical line, press and hold the Shift key
as you drag. When you release your mouse button, Photoshop displays the measure-
ment between the start and end points of the line in the Options bar. Figure 2-17 has
the scoop on how to use this tool to straighten your image.

Figure 2-17:
Top: Folks have been asking for an image straightening-tool for years, and in CS5 they get their wish. To use the Ruler tool to straighten your image, select it from the Tools panel and then drag to draw a line across an area that should be straight, such as this girl's waist.

Middle: In the Options bar, click the Straighten button to make Photoshop straighten and crop your image.

Bottom: If you want your image straightened but not cropped, Option-click (Alt-click on a PC) the Straighten button instead. Or, if you forget to press Option (Alt), you can undo the crop by pressing ⌘-Z (Ctrl+Z).

Note: You can also straighten your images using Camera Raw, as explained on page 233.

The Options bar's measurements can be a little confusing. Here's what they mean:

- **X and Y.** These *axes* mark the horizontal and vertical coordinates (respectively) at the start of your ruler line. For example, if you start your line at the 4-inch mark on the horizontal ruler and the 7-inch mark on the vertical ruler, your coordinates are X: 4 and Y: 7.

- **W and H.** Calculates the distance your line has traveled from the X and Y axes.

- **A.** Displays the angle of your line relative to the X axis.

- **L1.** Shows the length of the line you drew.

- **L2.** You see a number here only if you use a virtual *protractor*. (Thought you left protractors behind in high school, didn't you? Quick refresher: Protractors help you measure angles.) To create a protractor, Option-drag (Alt-drag on a PC) at an angle from the end of your ruler line (or just double-click the line and drag). This number represents the angle between the two lines.

- **Use Measurement Scale.** Turn on this checkbox to copy the unit of measurement set in your preferences (choose Photoshop→Preferences→Units & Rulers or Edit→Preferences→Units & Rulers on a PC). You can change the units you see in the Info panel by choosing Panel Options from the Info panel's menu.

- **Clear.** Any ruler line you draw hangs around until you tell it to go away by clicking this button in the Options bar or draw another ruler line. But the line won't print even if you forget to clear it, so don't lose any sleep over it.

Tip: To reposition a ruler line, just grab one of its end points and drag it to another position.

Layers: The Key to Nondestructive Editing

Photoshop gives you two ways to edit your files: the destructive way and the nondestructive way. *Destructive editing* means you're changing your original image—once you exceed the limit of your History panel (page 27), those changes are (gulp) permanent. *Nondestructive editing* means you're not changing the original file and you can go back to it at any time. Folks new to image editing tend to use the first method and experienced pixel-jockeys the second—and you'll likely see a tiny cloud of smugness floating above the latter.

When you're working in Photoshop, you need to keep your documents as flexible as possible. People (even you!) change their minds hourly about what looks good, what they want, and where they want it—all of which is no big deal if you're prepared for that. If not, you'll spend a ton of time *redoing* what you've done from scratch. To avoid this kind of suffering, you can use *layers*, a set of stackable transparencies that together form your whole image (see Figure 3-1). Layers are your Golden Ticket to nondestructive editing.

With layers, you can make all kinds of changes to your image without altering the original. For example, you can use one layer to color-correct your family reunion photo (Chapter 9), another to whiten Aunt Bessie's teeth (page 436), and yet another to add a photo of the Great Pyramid, making your reunion look like it was in Egypt instead of at the local park (page 282). Using layers also lets you:

- Resize an object independently of everything else in your document, without changing the document's size (page 44).

- Move an object around without moving anything else (page 96).

- Combine several images into one document to make a collage (page 100).

Figure 3-1:
You can think of layers as a stack of slides. If a layer is partially transparent, you can see through the transparent areas to the layer below. If you look down through the top of the stack (a bird's-eye view), you see a single image even though it's made from many different slides (this kind of image is called a composite*).*

- Hide parts of your image so you can see through to layers below (page 113).

- Change the opacity of a layer to make it more or less see-through (page 92).

- Change the way colors on various layers interact with each other (page 289).

- Fix the color and lighting of your whole photo (or just parts of it) without harming your original (see Figure 3-27 on page 119).

The best part about using layers is that once you save your document as a PSD file (page 56), you can close it, forget about it, and open it next week to find your layers—and all of your changes—intact. Learning to love layers is your key to a successful Photoshop career: They let you edit with maximum flexibility.

Throughout this chapter, you'll learn about the different kinds of layers, when to use them, and how to create them. You'll also find out about the fun and useful features that tag along with layers like layer styles and layer masks. By the time you're done, you'll be shouting the praises of nondestructive editing from the highest rooftop! (Whether you do it smugly is up to you.)

Layer Basics

Layers come in many flavors, all of which have their own special purpose. They include:

- **Image layers.** These layers are pixel-based (page 52), and you'll work with them *all* the time. If you open a photo or add a new empty layer and paint on it (Chapter 12), you've got yourself an Image layer.

- **Type layers.** Photoshop text isn't made from pixels, so it gets its own special kind of layer. Anytime you grab the Type tool and start pecking away, Photoshop creates a Type layer for you automatically. See Chapter 14 for the full story on creating type in Photoshop.

- **Shape layers.** These layers are vector-based (page 52), meaning they're not made from pixels. Not only can you create useful shapes quickly with these babies, you can resize 'em without losing quality, *and* you can change their fill color by double-clicking their layer thumbnails (page 78). Photoshop creates a Shape layer automatically anytime you use a shape tool, unless you change the tool's mode, as explained in Chapter 13 (page 539).

- **Fill layers.** When it comes to changing or adding color to your image, these layers are your best friends. They let you fill a layer with a solid color, gradient, or pattern (shown later in this chapter), which comes in handy when you want to create new backgrounds or fill a selection with color. Just like Shape layers, you can double-click a Fill layer's thumbnail to change its color anytime you want. The next time you're tempted to add an empty layer and fill it with color (page 91), try using one of these layers instead.

- **Adjustment layers.** These ever-so-useful layers let you apply color and lighting changes to the layer directly below them, but the actual changes happen on the Adjustment layer. For example, if you want to change a color image to black and white, you can use a Black & White Adjustment layer (page 324) and the color removal will happen on its own layer, leaving your original unharmed. These layers don't contain any pixels, just instructions that tell Photoshop what changes you want to make. You can access these handy helpers in the Adjustments panel on the right side of your screen (if you don't see it, choose Window→Adjustments) or via the Adjustment layer menu at the bottom of your Layers panel (it looks like a half-black/half-white circle), as well as in the Layer menu (choose Layer→New Adjustment layer). There are 15 kinds of Adjustment layers, and you'll learn how to use them in Part 2 of this book.

- **Smart Objects.** Adobe refers to this kind of layer as a *container*, though "miracle layer" is a better description. Smart Objects let you work with files that weren't created with Photoshop, like Raw (page 57) and vector files (page 52). The best thing about a Smart Object is that you can swap and resize its content without trashing its quality (as long as you don't exceed the file's original pixel dimensions, unless it's a vector). Flip to page 123 for more info.

- **3D and Video layers.** In the extended version of Photoshop (see the Note on page 1), you can import 3D and video files into their own special layers, which is helpful if you want to do some custom painting and transforming of individual video frames or 3D objects. For the scoop on 3D and more on video, head to this book's Missing CD page at *www.missingmanuals.com/cds*. You can also learn about video at *www.PhotoshopforVideo.com*.

The Layers Panel

No matter what kinds of layers your document contains, the one that's most important to you at any given time is the currently active layer. You can tell which layer is active by peeking at the Layers panel where Photoshop highlights the active layer,

as shown in Figure 3-2. Regardless of which tool you're wielding, your changes will affect *only* that layer (save for the Pen tool, which creates paths [see page 537]). To open the Layers panel, click its tab in the panel dock on the right side of your screen, or choose Window→Layers.

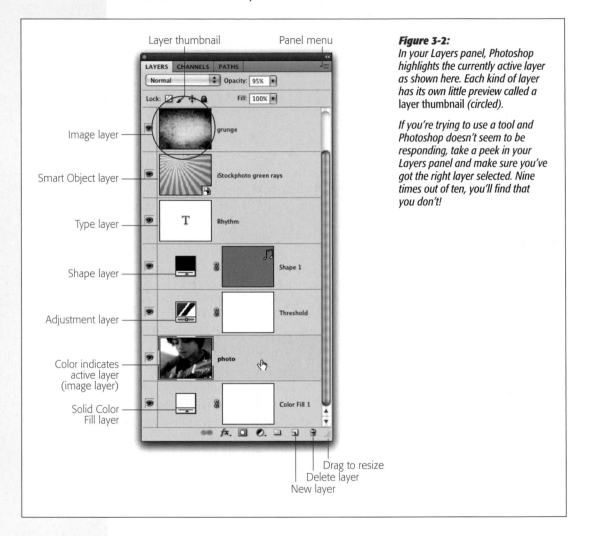

Layer thumbnail Panel menu

Image layer

Smart Object layer

Type layer

Shape layer

Adjustment layer

Color indicates
active layer
(image layer)

Solid Color
Fill layer

Drag to resize
Delete layer
New layer

Figure 3-2:
In your Layers panel, Photoshop highlights the currently active layer as shown here. Each kind of layer has its own little preview called a layer thumbnail (circled).

If you're trying to use a tool and Photoshop doesn't seem to be responding, take a peek in your Layers panel and make sure you've got the right layer selected. Nine times out of ten, you'll find that you don't!

Tip: To make the layer thumbnails bigger so they're easier to see, open the Layers panel's menu shown in Figure 3-2 and choose Panel Options. You'll see a list of thumbnail sizes to choose from; Large is a good option (but if Photoshop starts running like molasses, change it back to a smaller option).

Selecting Layers

About the easiest thing you'll ever do in Photoshop is select a layer—just mouse over to the Layers panel and click the layer you want. However, just because it's easy doesn't mean it's not important. As you learned in the last section, whatever you're doing in Photoshop affects only the *currently active layer*—the one that's selected.

As your document gets more complex and your Layers panel starts to grow (and it will), it can be hard to figure out which layer each part of your image lives on. If you want, you can make Photoshop *guess* which layer an object is on: Press V to activate the Move tool, head up to the Options bar at the top of your screen, turn on the Auto-Select checkbox, and then choose Layer from the pop-up menu to its right (the other option, Group, is discussed on page 105).

Now when you click an object in your document, Photoshop selects the layer it *thinks* the object is on (it'll do this next time you use the Move tool, too, unless you turn off the Auto-Select option). The program may or may not guess right, and it really works only if your layers don't completely cover each other up. If you've got a document full of isolated objects—ones without backgrounds—on different layers, give it a shot. If you're working on a multilayered collage, forget it. For those reasons, you usually want to leave Auto-Select turned *off*.

Tip: You can have Photoshop narrow down your layer-hunting options by prodding it to give you a list of layers it *thinks* your object is on. Press V to select the Move tool, Ctrl-click (right-click) an object in your document, and then choose one of the layers from the resulting shortcut menu. (Note that this trick works only if you click an area that's more than 50 percent opaque.)

Selecting multiple layers

You'd be surprised how often you need to do the same thing to more than one layer. If you want to rearrange a few of them in your layers stack (page 83), move them around in your document together (page 96), or resize them simultaneously (page 95), you need to select them first. Photoshop lets you select as few or as many as you want, though how you go about it depends on where they live in your Layers panel and which kind of layers they are. Here's how:

- **Consecutive layers.** To select layers that are next to each other in the Layers panel, click the first one and then Shift-click the last one; Photoshop automatically selects everything in between (see Figure 3-3, left).

- **Nonconsecutive layers.** To select layers that *aren't* next to each other, click the first one's name and then ⌘-click (Ctrl-click on a PC) the rest of them (see Figure 3-3, right).

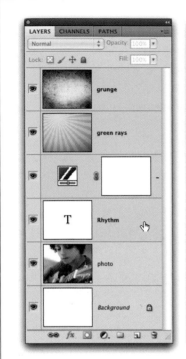

Figure 3-3:
You can select consecutive layers (left) or random layers (right). To avoid loading the layer as a selection (page 137) when you're selecting nonconsecutive layers, make sure you ⌘-click (Ctrl-click) the area to the right of the layer thumbnail, as shown here.

Click in this area to select

- **Similar layers.** To select layers similar to the active layer, choose Select→Similar Layers. This command is handy, for example, if you want to select all the Type layers so you can change the font (page 578) or all the Shape or Fill layers to change their color (page 91).

- **All layers.** To select the whole kit and caboodle, choose Select→All Layers. Choosing Deselect→All Layers (you guessed it) deselects everything.

- **Linked layers.** If you've linked any layers together (page 103), you can select them all by choosing Layer→Select Linked Layers (you can also find this command in the Layers panel's menu).

Note: Selecting a layer is *completely* different from loading a layer's contents as a selection. When you load a layer as a selection, you see marching ants running around whatever is on that layer. Selecting a layer simply makes that layer active so you can perform other edits. See Chapter 4 for more on selections.

Adding New Layers

Most of the time, Photoshop creates new layers *for* you, like when you copy and paste an image (page 90), create text (page 583), and so on. But if you want to do something like paint with the Brush tool—to colorize a grayscale image (page 358), say—you need to create a new layer. Otherwise, you'll paint on or over your original image. Photoshop CS5 gives you five ways to create a new layer:

- Click the "Create a new layer" button at the bottom of the Layers panel (it looks like a piece of paper with a folded corner).

- Choose Layer→New→Layer.

- Choose New Layer from the Layers panel's menu.

- Press Shift-⌘-N (Shift+Ctrl+N on a PC).

- New in CS5, you can drag a file from your desktop into an open Photoshop document; the item you dragged appears on its own layer in the document—as a Smart Object to boot! (See page 81 for more on this new feature.)

POWER USERS' CLINIC

Shortcuts for Selecting and Moving Layers

It's a little-known fact that you can use keyboard shortcuts to select and move layers. This trick can be a real timesaver since you don't have to lift your hands from your keyboard. It's also helpful when you're creating actions and don't want Photoshop to capture a layer's name (see Chapter 18). Here's the rather complicated list of shortcuts:

- To select the layer below the current layer, press Option-[(Alt+[on a PC). To select the layer above the current layer, press Option-] (Alt+]).

- To grab a bunch of layers in a row, select the first layer and then press Option-Shift-[(Alt+Shift+[) to select layers below the first one, or Option-Shift-] (Alt+Shift+]) to select layers above it. This shortcut lets you grab one layer at a time. Just type the shortcut again to grab another layer.

- To select the top layer in your Layers panel, press Option-. (Alt+.)—that's Option or Alt plus the period key. To select the bottom layer, press Option-, (Alt+,)—Option or Alt plus the comma key.

- To select all the layers between the currently active layer and the top layer, press Option-Shift-. (Alt+Shift+.)—Option or Alt plus Shift and the period key.

- To select all the layers between the currently active layer and the bottom layer, press Option-Shift-, (Alt+Shift+,)—Option or Alt plus Shift and the comma key.

- To select every layer *except* the locked Background layer, press ⌘-Option-A (Ctrl+Alt+A). If you've unlocked the Background layer (page 85), it gets selected, too.

- To move the current layer up one slot in your layer stack, press ⌘-] (Ctrl+]). To move it down one slot, press ⌘-[(Ctrl+[).

- To move the current layer to the top of the layer stack, press Shift-⌘-] (Shift+Ctrl+]). To move it to the bottom of the layer stack, press Shift-⌘-[(Shift+Ctrl+[).

When you click the "Create a new layer" button, Photoshop creates an empty layer called *Layer 1*. If you already have a layer called *Layer 1*, Photoshop names the new one *Layer 2*, and so on. If you use the menu options or keyboard shortcut, the program displays the New Layer dialog box (Figure 3-4) where you can name the layer, color-code it (page 102), choose its blend mode (page 289), set its opacity, and use it in a clipping mask (see the box on page 123).

Tip: If your fingers are flexible enough, you can create a new layer *and* bypass the New Layer dialog box by pressing Shift-Option-⌘-N (Shift+Alt+Ctrl+N on a PC). This shortcut is handy if you want to make new layers and don't care what they're called.

Figure 3-4:
In the New Layer dialog box (top), you can give your layer a name and a colored label. Color-coding layers makes them easier to spot in a long Layers panel (bottom). You can double-click a layer's name to rename it, and turn its visibility on or off by clicking the little eyeball to the left of its thumbnail. The new layer's thumbnail shown here is the checkerboard pattern (see the box on page 47) because the layer is empty and transparent.

Tip: If you want to create a new layer *below* the one you're currently on, ⌘-click (Ctrl-click) the "Create a new layer" button at the bottom of the Layers panel. This shortcut saves you the extra step of dragging the new layer to a lower position later. This tip, when it's used over the course of a year, has been known to produce an *entire* vacation day! (But if the only layer in your document is the locked Background layer, you've got to double-click it to make it editable before you can add a new layer below it.)

Hiding and Showing Layers

The little visibility eye to the left of each layer lets you turn that layer off and on (Figure 3-4, bottom). Photoshop calls this incredibly useful feature *hiding*. For example, hiding layers lets you:

- **See an instant before-and-after preview.** If you've spent some time color-correcting (Chapter 9) or retouching people (Chapter 10) on duplicate layers, hiding those layers is an easy way to see the effect of your handiwork.

- **Experiment with different looks.** If you're trying out different backgrounds, you can add them all to your document and turn them on one at a time to see which one looks best.

- **See what you're doing.** When you're working on a document that has a bunch of layers, some of them may hide an area you need to see or work on. The solution is to hide in-the-way layers while you're working on those parts of the image and then turn them back on when you're done.

- **Print certain layers.** Only layers that are visible in your document will print, so if you want to print only parts of your image, hide the other layers first.

To hide a layer, simply click the little eye to the left of its layer thumbnail; to show it again, click the empty square where the visibility eye used to be. To hide *all* layers except one, Option-click (Alt-click on a PC) the visibility eye of the one layer you want to see. You can show the other layers again by Option-clicking (Alt-clicking) that same layer's visibility eye again. Alternatively, you can Ctrl-click (right-click) a layer's visibility eye (or the spot where it used to be if the layer is turned off) and choose "Show/Hide this layer" or "Show/Hide all other layers" from the shortcut menu. You can also find the Show/Hide layer command in the Layer menu.

Tip: To hide or show several layers, drag up or down over the visibility eyes in the Layers panel while you hold down your mouse button.

Restacking Layers

Once you start adding layers, you can rearrange their *stacking order*—the order they're listed in the Layers panel—to control what's visible and what's not. When you think about stacking order, pretend you're peering down at your Layers panel from above: The layer at the very top can hide any layers below it. For example, if you fill a layer with color (page 91) and then place it above another layer containing a photo, the color will completely cover the photo. But if you've merely painted a swish or two with the Brush tool, your brushstrokes will cover just that part of your photo.

You can rearrange your layers manually, or make Photoshop do it for you:

- **By dragging.** Click a layer's thumbnail and drag it up or down to change its position as shown in Figure 3-5. When you get it in the right place, let go of your mouse button. (Technically, you can click *anywhere* to grab the layer, but targeting the thumbnail is a good habit to get into, lest Photoshop thinks you want to rename it instead.)

Figure 3-5:
To rearrange layers, drag a layer's thumbnail up or down. When you drag, your cursor turns into a tiny closed fist as shown here (left). When you see the dividing line between the layers darken (left), let go of your mouse button to make the layer hop into place (right).

New in Photoshop CS5, you see a ghost image of the layer you're dragging, which is helpful visual feedback.

- **Using the Arrange command.** If you've got one or more layers selected, you can choose Layer→Arrange to move them somewhere else in the layers stack. Depending on that layer's location in your Layers panel, you can choose from:

 — **Bring to Front** moves the layer all the way to the top of the layers stack. Keyboard shortcut: Shift-⌘-] (Shift+Ctrl+] on a PC).

 — **Bring Forward** moves the layer up one level. Keyboard shortcut: ⌘-] (Ctrl-]).

 — **Send Backward** sends the layer down one level. Keyboard shortcut: ⌘-[(Ctrl-[).

 — **Send to Back** sends the layer all the way to the bottom of the layers stack. Keyboard shortcut: Shift-⌘-[(Shift+Ctrl-[).

 — **Reverse.** If you've got two or more layers selected (page 79), this command inverts the stacking order of the selected layers. You probably won't use this command very often, but give it a try just for fun; it can produce some mildly interesting results (Photoshop doesn't have a keyboard shortcut for this one).

Note: If you've got a long Layers panel, these keyboard shortcuts can save you lots of time.

The only layer you *can't* move around (at least not without giving it some special treatment) is the *Background layer*. The Background layer isn't really a layer, although it looks like one. It behaves a little differently from other layers, as the box on page 85 explains, so if you want to rearrange it in your Layers panel, you have to double-click its thumbnail (circled back in Figure 3-2) and rename it in the resulting New Layer dialog box. When you click OK, it becomes a normal, everyday layer that you can put wherever you want.

The Background Layer and You

Only a handful of image file formats understand Photoshop's layer system: PSD (Photoshop) files and TIFF files are the two most popular. Most other image file formats can handle only *flat* images (unlayered files). If you save a multilayered PSD file as a JPEG, EPS, or PNG file, for example, Photoshop flattens it, smashing all the layers into one. (See page 112 for more on flattening files.)

When you open an image created by a device or program that *doesn't* understand layers, like your digital camera or desktop scanner, Photoshop opens it as a flat image named Background. Though it looks like a regular layer, it's not nearly as flexible as the layers you create in Photoshop. For example, you can paint on it with the Brush tool (page 499), make a selection and fill the selection with color (page 181), or use any of the retouching tools (Chapter 10) on it, but you can't use the Move tool to make it hang off the edges of your document or make any part of it transparent—if you try to use the Eraser tool, nothing happens other than painting with the background color (and you can almost *hear* Photoshop snickering at your efforts). Also, if you make a selection and press Delete (Backspace on a PC), Photoshop fills that area with the color of your background chip (page 24).

When you create a *new* document in Photoshop, the program opens a more universally compatible flat file containing a single Background layer. You can convert the Background layer into a fully editable and movable layer in a couple of different ways. The easiest method is to double-click the Background layer in your the Layers panel, give it a new name in the resulting New Layer dialog box, and then click OK. You can also select the Background layer in the Layers panel and then choose Layer→New→"Layer from Background". Or you can ⌘-click (right-click) the Background layer and choose "New layer from Background" from the resulting menu.

If you want, you can convert a normal layer into a Background layer by choosing Layer→New→"Background from Layer", but it's tough to think of a reason why you'd want to.

The only way to create a new document *without* a Background layer is to choose Transparent from the Background Contents pop-up menu (see page 47). Otherwise, you're doomed to double-clicking and renaming the Background layer each time you create a new document.

To *really* understand how layer stacking works, it helps to put theory into practice. Let's say you want to make a photo look like one side fades to white and then add some text on top of the white part. To do that, you need to place the photo at the bottom of the layers stack, the white paint layer in the middle, and the text layer at the top (see Figure 3-6).

Here's a quick lesson in how to softly fade your photo to white and then add some text to it:

1. **Open a soon-to-be-faded photo and add a new layer to the document.**

 To safeguard your photo, you need to put the white paint on another layer. Press ⌘-Shift-N (Ctrl+Shift+N on a PC) to create a new layer, give it a clever name like *white fade*, and then click OK.

Figure 3-6:
The stacking order of your layers determines what you can and can't see.

Top: With the Type layer at the top of the stack, you can see the text because it's sitting above everything else. And because the white fade layer is partially transparent (you can tell by the checkerboard pattern in its thumbnail), you can see through it to the photo at the bottom of the stack.

Bottom: If you drag the Type layer below the white fade layer, you can't see the text anymore because it's hidden by the white paint.

Once you get the hang of using gradient masks (page 287), you can substitute a Solid Fill Adjustment layer for the white fade image layer shown here. Because Adjustment layers automatically come with their own layer masks, you'll save the step of adding one yourself, plus you'll gain the ability to change the fade's color by double-clicking the Adjustment layer's thumbnail. Sweet!

2. **Set your foreground color chip to white.**

 Peek at the color chips at the bottom of your Tools panel (page 24). If they're black and white, just press X to flip-flop them until white hops on top. If the chips are other colors, press D to set them back to the factory setting of black and white.

3. **Grab the Gradient tool and set it to create a "Foreground to Transparent" linear gradient.**

 Press G to select the Gradient tool and then head up to the Options bar at the top of your screen. Open the Gradient picker (near the left end of the bar) by clicking the down arrow next to the gradient preview and click once on the "Foreground to Transparent" swatch (second from the left in the top row).

Move your mouse just a hair to the right in the Options bar to the gradient style buttons and click the first one, named Linear Gradient. (For more on gradients, see pages 287, 334, and 363.)

4. **Back in your document, create a white-to-transparent fade.**

 To paint a good-sized chunk of white, place your mouse near the right side of the photo (just past center) and then drag to the left for about a quarter of an inch and release your mouse button. The farther you drag, the wider the faded area. Don't worry if you don't get it right the first time; just keep clicking and dragging until you get the look you want.

Tip: If you want to start over, select all by pressing ⌘-A (Ctrl+A on a PC) and then press Delete (Backspace) to zap everything on the layer so you can start your white gradient from scratch.

5. **Press T to grab the Type tool and add some text.**

 You haven't learned about the Type tool yet, but be brave and press T to activate it and then hop up to the Options bar and pick a font and type size from the pop-up menus (see Chapter 14 for a proper introduction to the Type tool). Click once on your document where you want the text to begin and start typing. When you're finished typing, click the little checkmark at the top right of the Options bar to let Photoshop know you're done (pressing Enter on the numeric keypad—not Return—or selecting another tool works, too).

You're finished! If you want to move the text around, you can temporarily select the Move tool by holding down the V key. When your cursor turns into a little arrow, click and move your mouse to move the text.

If you followed these steps in order, you won't need to rearrange your layers in the Layers panel, but if you do, just grab the layer's thumbnail and drag it either up or down to change its position By the way, this technique is great for making your own personalized postcards and invitations.

Duplicating and Deleting Layers

Duplicating a layer comes in handy when you want to do something destructive like sharpen an image (Chapter 11) or soften Great Grandma's skin (page 445). By duplicating the layer first, you can work on a *copy* of the image instead of the original. But duplicating isn't limited to whole layers; you can duplicate just *part* of a layer. That technique comes in handy when you want to whiten teeth or make multiple copies of an object and move it around (like the hippy chicks in Figure 3-7).

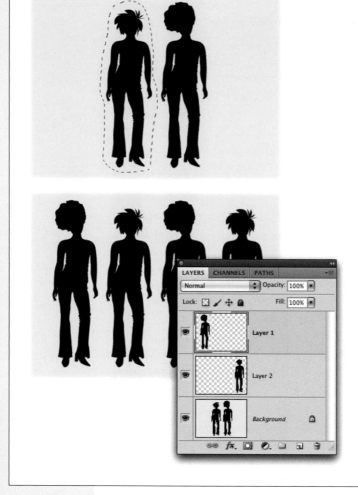

Figure 3-7:
By selecting each of the silhouettes (top) and then pressing ⌘-J (Ctrl+J on a PC), you can jump copies of them onto their own layers (bottom). To move them around in your document, select one of the new layers, press V to grab the Move tool, and then drag to reposition the selected figure. Chapter 4 has more on how to make selections.

If you'd like, you can ask Photoshop CS5 to automatically add the word "copy" to duplicated layers' names. Just open the Layers panel's menu and choose Panel Options and then turn on the "Add 'copy' to Copied Layers and Groups" checkbox at the bottom of the resulting dialog box.

Note: You can follow along by visiting this book's web page at *www.missingmanuals.com/cds* and downloading the file *Chicks.jpg*.

You can duplicate a layer in a gazillion ways:

- **Press ⌘-J (Ctrl+J on a PC) or choose Layer→New→"Layer via Copy"** to copy the selected layer onto another layer just like it.

- **Drag the original layer atop the "Create a new layer" button at the bottom of the Layers panel.** When Photoshop highlights the button (which looks like a piece of paper with a folded corner), let go of your mouse button.

- **Option-drag (Alt-drag on a PC) the layer somewhere else in your Layers panel.** Your cursor turns into a double black-and-white arrowhead as soon as you start to drag. When you let go of your mouse button, Photoshop duplicates the layer.

- **Choose Duplicate Layer from the Layers panel's menu (Figure 3-2) or choose Layer→Duplicate Layer.** This method gives you a chance to name your layer, as well as send it to a new document. If you choose to send it to a new document, pick an open document from the Destination section's Document pop-up menu or choose New to create a new document (enter a name for the new document in the Name field).

- **Ctrl-click (right-click on a PC) the layer in your Layers panel.** From the resulting shortcut menu, choose Duplicate Layer.

- **To duplicate part of layer, create a selection using any of the tools discussed in Chapter 4 and then press ⌘-J (Ctrl+J)** to move your selection onto its own layer. If you want to *delete* the selected area from the original layer and *duplicate* it onto another layer at the same time, press Shift-⌘-J (Shift+Ctrl+J). You can think of this trick as a *cut* to another layer since you'll have a hole in the original layer where the selection used to be.

Adding layers can *really* increase your document's file size, so if you have a slow computer or very little memory (RAM), you'll want to delete layers you don't need. To delete a layer, select it in the Layers panel and then:

- **Press Delete (Backspace on a PC).** This is the fastest deletion method in the West.

- **Drag it onto the trash can at the bottom of the Layers panel.** The layer vanishes before your eyes.

- **Click the trash can.** When Photoshop asks if you're *sure* you want to delete the layer, click Yes and turn on the "Don't show again" checkbox if you don't want to see this confirmation box in the future.

Tip: If you delete a layer and then wish you had it back, just use Photoshop's Undo command: Choose Edit→Undo or press ⌘-Z (Ctrl+Z on a PC).

- **Ctrl-click (right-click on a PC) near the layer's name in the Layers panel and choose Delete Layer from the shortcut menu.** Be sure to click near the layer's *name*—if you click its thumbnail you won't see the Delete Layer item in the shortcut menu. When Photoshop asks if you really want to delete the layer, click Yes to send it packin'.

- **Choose Layer→Delete or open the Layers panel's menu and choose Delete Layer.** You'll get a confirmation dialog box this way, too, so just smile sweetly, click Yes, and be on your way.

Tip: If you've hidden multiple layers (page 82), you can delete them all at once by opening the Layers panel's menu and choosing Delete→Hidden Layers (hey, if you're not using 'em, you might as well toss 'em!). Getting rid of extra layers shortens your Layers panel *and* reduces your document's file size.

Copying and Pasting Layers

You can use the regular ol' copy and paste commands to move whole or partial layers between Photoshop documents:

- **To copy part of a layer into another document,** create your selection first and then press ⌘-C (Ctrl+C on a PC) to copy it. Then open the other document and press ⌘-V (Ctrl+V); Photoshop pastes those pixels onto a new layer.

- **To copy and paste a whole layer into another document,** choose Select→All (or press ⌘-A [Ctrl+A]) to select the layer and then press ⌘-C (Ctrl+C). Next, click the other document's window and press ⌘-V (Ctrl+V) to add the layer to that document's Layers panel.

Photoshop CS5 also includes a new Paste Special option in the Edit menu, which is incredibly handy when you're combining images. It's discussed at length in Chapter 7 on page 278.

Tip: When you copy an image from another program and paste it into a Photoshop document, it lands on its very own layer. If the pasted image is *bigger* than your document, you may need to resize the layer using Free Transform (pages 95 and 263).

Filling a Layer with Color

One of the most common things you'll do with a new layer is fill it with color. If you've hidden your image's original background (page 82) or added an interesting edge effect (see Figure 12-22 on page 517), for example, you can spice things up by adding a solid-colored background. Photoshop gives you a couple of different ways to tackle this task:

- **Fill an existing layer with color.** After you've created a new layer using one of the methods listed on page 81, choose Edit→Fill. In the resulting Fill dialog box (Figure 3-8), pick a color from the Use pop-up menu and then click OK. You can also fill a layer with your foreground color by pressing Option-Delete (Alt+Backspace on a PC).

Note: If you increase your canvas size (page 257) after you've filled a layer with color, you'll need to refill the layer or it'll be smaller than your document and you'll see the contents of layers below it peeking through. To avoid this extra step, use a Fill layer, as discussed in the following bullet point.

Figure 3-8:
The Use pop-up menu lets you tell Photoshop to fill a layer with your foreground or background color (page 24) or summon the Color Picker (page 493) by choosing Color.

- **Create a Fill layer.** If you're not sure which color you want to use, choose Layer→New Fill Layer and pick Solid Color. In the New Layer dialog box that appears, name the layer and then click OK. Photoshop then displays the Color Picker so you can choose the fill color you want. If you decide to change the fill color, double-click the Fill layer's thumbnail and Photoshop opens the Color Picker so you can choose a new color or steal one from the image itself (as shown in Figure 3-9). Fill layers also come with their own layer masks, making it super simple to hide part of the layer if you need to.

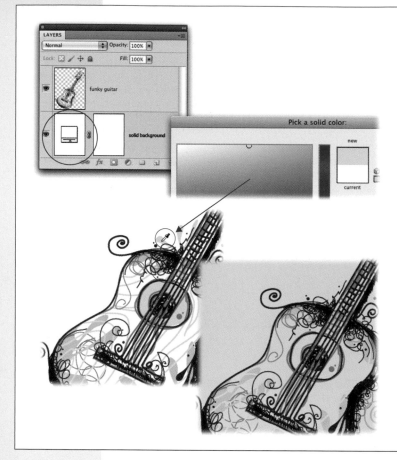

Figure 3-9:
Top: Dragging your new Fill layer to the bottom of the layers stack creates a solid-colored (in this case, white) background for your image. If you want to change the color, double-click the Fill layer's thumbnail (circled) to pop open the Color Picker.

Bottom: If you want to get super creative, you can snatch color from your image by mousing over to it while the Color Picker is open (your cursor changes into an eyedropper, circled). Click once to select the color you want and then click OK to close the Color Picker.

Finally, if you want to hide part of the new color for any reason (say, to create a color fade), just paint in the included layer mask (see page 113).

One of the many advantages of using Fill Layers is that, unlike regular layers, they fill the *whole* layer with color even if you enlarge your canvas. In addition to using Fill layers to create solid backgrounds, you can use them to fill a layer with a gradient or a repeating pattern, as shown in Figure 3-10.

Tweaking a Layer's Opacity and Fill

All layers begin life at 100 percent opacity, meaning you can't see through them (except where they're empty, as shown in Figure 3-6). If you want to make a layer semi-transparent, you can adjust its Opacity setting. Lowering a layer's opacity is a good way to lessen the strength of a color or lighting adjustment (Chapter 9), the amount of sharpening you applied to a duplicate layer (Chapter 11), and so on.

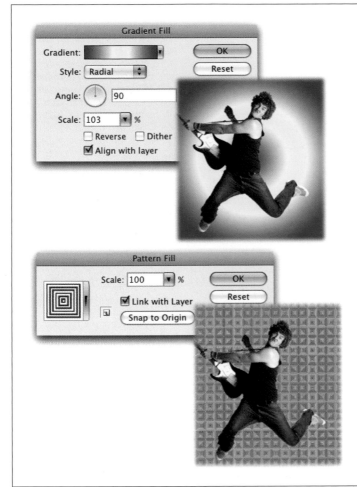

Figure 3-10:
Fill layers aren't just for adding solid color; you can use them to create a gradient- or pattern-filled background as shown here (top and bottom, respectively). If you want to change the gradient or pattern, just double-click its layer thumbnail to make Photoshop display the appropriate dialog box—Gradient Fill or Pattern Fill.

You can also add a Fill layer by using the Adjustment layer menu at the bottom of the Layers panel (it looks like a half-black/half-white circle). You'll find Solid Color, Gradient, and Pattern listed at the very top of the resulting menu.

The Opacity and Fill settings live at the top of your Layers panel (see Figure 3-11). The Fill setting is different from the Opacity setting in that it doesn't affect the whole layer. For example, if you create a Shape layer or Type layer (see pages 76–77), lowering its Fill setting will lower only the opacity of the color *inside* the shape or letters, not the opacity of any layer styles you've added (page 128).

To change Opacity or Fill, mouse over to your Layers panel, select the layer you want to tweak, and then:

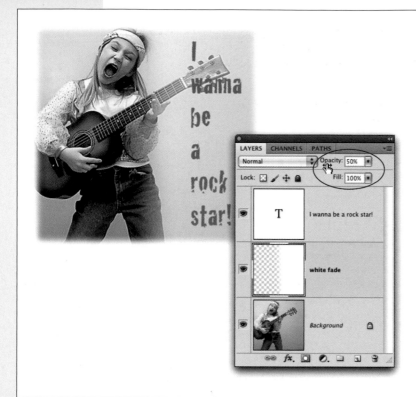

Figure 3-11:
If you lower the opacity of the white fade layer to 50 percent, as shown here, the white paint becomes partially transparent, letting you see through to the photo layer below. If you want to look like a real Photoshop pro, hover your cursor near the word Opacity. You'll get a little scrubby cursor that you can drag to the left or right to lower or raise the layer's opacity (you can even drag the scrubby cursor off the Layers panel if you want to).

This trick works for any setting in the program with similar controls, too, including the Fill setting, most everything in the Options bar (no matter which tool is active), the Character and Paragraph panels, and more!

Tip: In Photoshop CS5 you can change the opacity and/or fill of multiple layers at once; just Shift- or ⌘-click (Ctrl-click on a PC) to select more than one layer and then adjust the Opacity or Fill settings.

- **Enter a new value in the Opacity or Fill field.** Double-click the current value in either field to highlight it, enter a new value, and then press Return (Enter on a PC).

- **Use the field's slider.** Click the down arrow to the right of the Opacity or Fill field (on a PC, the arrow points to the right) and drag the resulting slider to the left or right to decrease or increase that setting, respectively.

- **Use your keyboard.** Press V to activate the Move tool (think "moVe") and change the Opacity by typing *1* for 10 percent, *2* for 20 percent, *35* for 35 percent, and so on (type *0* for 100 percent). If you've got any other tool selected besides the Move tool, you'll change the opacity setting for that particular *tool* instead. (You can use the same keyboard trick to adjust the Opacity settings for the Fill tool, too; just hold down the Shift key while you type the numbers.

Resizing and Rotating Layers

If you want to resize the contents of a layer—or many layers—*without* changing the size of your document, you can use the Free Transform tool (shown in Figure 3-12). (You'll learn a lot more about this tool in Chapter 6, so consider this a sneak peek.) To resize or rotate a layer, follow these steps:

1. **In the Layers panel, select the layers you want to adjust (see page 79 for the scoop on selecting multiple layers).**

2. **Press ⌘-T (Ctrl+T on a PC) to summon the Free Transform tool.**

 Photoshop puts a box (called a *bounding box*) lined with small square white handles around the content of your layer(s) (Figure 3-12).

Note: If you're resizing a Smart Object (page 254), the little handles are black instead of white. The difference is purely cosmetic–they work exactly the same.

Figure 3-12:
You can drag any of the bounding box's square handles to resize your object. To adjust all four sides of the box simultaneously, hold down Option (Alt on a PC) as you drag a corner handle.

Don't forget to press Return (Enter) when you're finished because Photoshop won't let you do anything else while you've got an active bounding box.

3. **Drag one of the corner handles inward to make the layers smaller.**

 Grab any of the white corner handles and drag diagonally inward to make the layers smaller. If you want to resize the object proportionately so it doesn't get squished or stretched, hold down the Shift key as you drag.

4. To rotate the layers, position your cursor outside the bounding box and when it turns into a curved, double-head arrow, drag up or down in the direction you want to turn the layers.

5. Press Return (Enter on a PC) or double-click inside the bounding box to let Photoshop know you're done.

Tip: To see the Free Transform tool's resizing handles all the time, press V to grab the Move tool and then turn on the Show Transform Controls checkbox in the Options bar. Seeing the handles is handy if you're jumping between layers to resize or rotate objects and don't want to stop and summon Free Transform each time.

Do you risk reducing your image's quality by resizing layers this way? Sure. Anytime you alter pixel size, you change the quality a little bit, too, whether it's a single layer or your whole document. But as long as you *decrease* the layer's size, you won't lose much quality (though you don't want to decrease its size *repeatedly*—try to do it once or twice and be done with it). You definitely risk losing quality if you *increase* the size of a pixel-based Image layer because when pixels get bigger, they also get blockier.

That said, if you're working with a Smart Object (page 123), Shape layer (page 540), or Type layer (Chapter 14), you've got no worries; you can resize those babies all day long—larger or smaller, as many times as you want—and you won't affect the quality, which is why you want to use those kinds of layers whenever you can. (However, you don't want to enlarge a raster-based Smart Object beyond its original dimensions; page 255 explains why.)

Tip: The rest of the transform tools, including Skew, Distort, and so on, work on layers, too. See page 263 for details.

Moving and Aligning Layers

One of the many advantages of using layers is that you can scoot 'em around independent of everything else in your document. To move a layer, you have to select it in your Layers panel first. Press V to grab the Move tool and drag the layer wherever you want. For example, if you want to move the text in Figure 3-11 a bit to the left, press V and drag it to a new spot. To move the layer in a perfectly vertical or horizontal line, hold down the Shift key while you drag. You can also nudge the layer by using the arrows on your keyboard (holding down the Shift key while you press the arrow keys scoots the layer by 10 pixels per keystroke).

Note: In Photoshop CS5, it's easier than ever to *see* what you're doing as you move layers in your document. As soon as you start dragging, you'll see a slightly transparent, dark gray border around the item appear atop your document—it moves as you drag. This is extremely helpful when you're moving items that are really small, and thus easy to lose sight of.

If you want to move only *part* of a layer, select that portion first using one of the methods explained in Chapter 4. Then you can grab the Move tool and move just the selected bits.

Aligning layers

When you need to position layers, Photoshop has several tools that can help you get them lined up just right. If you're trying to align one layer perfectly with the layer below, it's a good idea to lower the top layer's opacity temporarily (page 92) so you can actually *see* the layer below.

Photoshop tries to help you align layers by *snapping* the one you're moving to the *boundaries* (content edges) of other layers. As you drag a layer with the Move tool, Photoshop tries to pop the layer into place when you get near another layer's edge (if you want to make the program stop popping them into place, choose View→Snap). If you'd like to *see* the boundaries of your layer, press V to activate the Move tool, hop up to the Options bar, and turn on the Show Transform Controls checkbox (Figure 3-13).

Figure 3-13:
Most folks have never seen these alignment tools, but they're there! If you forgot what each button is for, hover your cursor over it and, within a second or two, Photoshop displays a yellow tooltip telling you what that button does. Figure 3-14 shows you what these buttons do.

In addition to snapping and showing you boundaries, Photoshop offers you the following alignment helpers:

- **Alignment tools.** If you need to align the edges of more than one layer, these tools come in handy. You'll see them in the Options bar at the top of your screen when the Move tool is active *and* you have more than one layer selected (see Figure 3-13 for details). You can also find them by choosing Layer→Align (you still need to have more than one layer selected, but you don't have to activate the Move tool). Figure 3-14 shows you what each alignment button does.

Align top edges

Align vertical centers

Align bottom edges

Figure 3-14:
Each of these guitars lives on its own layer, so you can see the effect of Photoshop's various alignment tools.

Align left edges

Align horizontal centers

Align right edges

- **Distribute tools.** Nestled snugly to the right of the alignment tools are the distribute tools (Figure 3-13) Their mission is to evenly space the contents of the selected layers based on each layer's horizontal or vertical center (you need to have at least *three* layers selected to use them). For example, these options are handy when you're designing buttons for website navigation because you can distribute space between them equally.

- **Smart Guides.** Unlike the regular guides you learned about in Chapter 2 (page 68), Smart Guides show up automatically anytime you drag a layer near another layer's boundaries (see Figure 3-15). They're extremely helpful when you're manually aligning layers with the Move tool since they make it easier to position layers precisely in relation to each other. To turn them on, choose View→Show→Smart Guides.

Figure 3-15:
When you turn on Smart Guides, Photoshop alerts you with a thin red line anytime you approach the boundaries of another layer so you know if you're about to move past its edge.

- **Auto-alignment.** If you choose Edit→Auto-Align Layers, Photoshop does the aligning for you by looking at the corners and edges of objects on the selected layers. This command is really handy when you're combining images into a panorama (see page 308), but it doesn't work on Adjustment layers, Smart Objects, or Vector layers.

WORKAROUND WORKSHOP

When Layers Won't Align

If you try to align the bottoms of two Type layers using the Align Bottom Edges command, you may run into trouble. If there's a *descender* (a letter that goes below the baseline, like the letters *y* and *p*) in one layer but not the other, the two layers won't align properly because their bottoms aren't even. The fix is to replace the troublesome letter(s) temporarily with one that doesn't have a descender and *then* click the Align Bottom Edges button. Once the layers are aligned, you can change the letter(s) back. It's not elegant, but it works.

Photoshop can also do strange things when you're using the alignment tools on layers that have layer masks (page 113). Instead of aligning the layers according to what you've hidden with the mask (which is probably what you're trying to do), Photoshop tries to align the layers using the actual pixel information (it pays no attention to the mask). In that case, you may need to turn on Rulers (page 69), create a few guides (page 68), and manually align the layers with the Move tool (page 96).

Moving layers between documents

In addition to copying and pasting layers from one document to another (as described back on page 90), you can also drag and drop them straight from your Layers panel to another document, as shown in Figure 3-16. Photoshop leaves the layer in your original document and places a *copy* in the target document, so you don't have to worry about losing anything from either file. This technique is really helpful if you want to create a collage (Chapter 7), swap backgrounds, or share color corrections across documents. Here's how to move a layer from one document to another:

1. **Open the documents you want combine.**

2. **Click the Arrange Documents button at the top of your screen (page 67) and choose one of the 2-Up display options or "Float All in Windows" from the pop-up menu.**

 To drag from one document to the other, it's often easier if you can *see* both documents, as explained in Figure 3-16. Choosing either the 2-Up display options or "Float All in Windows" makes Photoshop rearrange your document windows so you can see them both at the same time. (Page 67 has more on display options.)

3. **Click the document that contains the layer you want to move and then drag the layer's thumbnail onto the other document.**

 As you drag, your cursor turns into a tiny closed fist, as you can see in Figure 3-16. When Photoshop highlights the inside border of the destination window with a faint black outline, let go of your mouse button to make Photoshop add the layer to that document.

Tip: To center the moved layer perfectly in its new home, hold the Shift key as you drag the layer between documents.

Exporting layers to separate files

If you've got a bunch of layers that you want to separate into individual files (with each layer in its own file), choose File→Scripts→"Export Layers to Files". In the resulting dialog box (Figure 3-17), use the Destination field to tell Photoshop where you want it to save the files. In the File Name Prefix box, create a naming scheme (Photoshop uses whatever you enter in the prefix field as the first part of your file names), and, in the File Type pop-up menu, choose a file format. When you're finished, click Run and sit back while Photoshop does all the work.

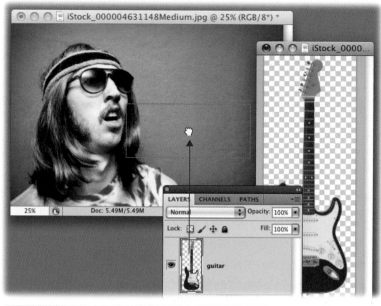

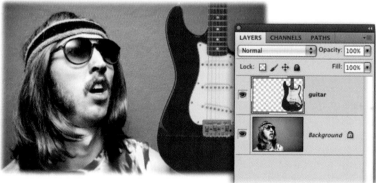

Figure 3-16:
Top: To combine two images into one document, first arrange your workspace so that you can see both windows. Then drag one layer's thumbnail from your Layers panel into the other document.

Bottom: When you release your mouse button, the new layer appears in the other document's Layers panel, as shown here. In Photoshop CS, you also drag from your document area onto another open document's tab.

Managing Layers

If there's one thing for certain in Photoshop, it's that your Layers panel will get long and unwieldy in a hurry. Now that you've seen a smidgeon of the increased editing flexibility layers give you (moving, resizing, and so on), you'll want to put *everything* on its own layer—and you *should*. However, learning a wee bit of layer organization can keep you from spending ages digging through your Layers panel to find the layer you want. This section gives you the lowdown.

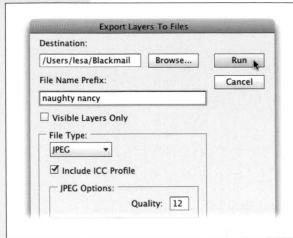

Figure 3-17:
The Export Layers To Files dialog box lets you choose where to put the new files and what to name them. If you want to exclude any hidden layers (page 82), turn on the Visible Layers Only checkbox. In the File Type pop-up menu, you can choose any of the following file formats: BMP, JPEG, PDF, PSD, TARGA, TIFF, PNG-8, or PNG-24 (all of which are discussed on pages 50–52). Each format gives you different options; for example, JPEG lets you pick a quality setting. Photoshop includes your document's ICC profile (see the Note on page 682) in each file unless you turn off the lower checkbox shown here.

Naming and Color-Coding Layers

The simplest way to organize layers is to name the darn things something other than Layer 1, Layer 2, and so on. If you didn't name them when you made them, you can always double-click a layer's name in your Layers panel and rename it right there (Photoshop highlights the name when you double-click it, so you can just start typing). When you're done, press Return (Enter on a PC).

Tip: If you double-click in the Layers panel *near* the layer's name but not directly on it, Photoshop opens the Layer Style dialog box (shown on page 130) instead of highlighting the layer's name. No problem: Just close the dialog box and try again.

Another renaming option is to open the Layer Properties dialog box where you can give the layer a new name *and* assign it a color. When you assign a color to a layer, its visibility control (page 82) changes to the highlight color. Color-coding is useful when you've got a ton of layers because it lets you distinguish them at a glance. For example, you could color-code sections of a poster like the header, footer, body, and so on. You can open the Layer Properties dialog box in a few different ways:

- Open the Layers panel's menu and choose Layer Properties.

- Ctrl-click (right-click on a PC) the layer in the Layers panel and choose Layer Properties from the shortcut menu.

- Press Option (Alt) as you double-click near the layer's name (but not directly on it) in the Layers panel.

Next, choose a highlight color from the Color pop-up menu in the Layer Properties dialog box. Click OK to close the dialog box and apply the color label.

Linking and Locking Layers

Editing layers can be a lot of work, and once you get them just right, you want to make darn sure they stay that way. You can protect yourself by linking layers together or locking down certain aspects of them. Read on to learn how.

Linking layers

If you need to move something in your image that's made from several layers, it'd be a real pain to move each layer individually and then reconstruct the image. Fortunately, you can *link* layers before you grab the Move tool; Figure 3-18 shows you how. Linked layers move together as if they were one unit. Linking related layers can help you avoid accidentally misaligning layers with a careless flick of the Move tool. For example, if you're working with a headshot that has some Adjustment layers associated with it, linking the photo layer with those Adjustments layers will ensure that they stay perfectly aligned.

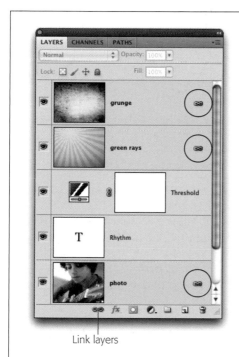

Figure 3-18:
Once you've got more than one layer selected (page 79), you can link them by clicking the tiny chain at the bottom of the Layers panel. The same chain appears to the right of each layer's name (circled) to show that the layers are linked. To unlink them, select a layer and then click the chain at the bottom of the Layers panel again. Easy, huh?

Link layers

Locking 'em down

You can add a more serious level of protection to layers by using *layer locks*, which prevent layers from being edited or moved. Take a peek at the top of the Layers panel and you'll spot a row of four buttons (Figure 3-19) that you can use to lock various aspects of your layers. First select the layer you want to lock and then click the appropriate lock button to prevent any changes.

Tip: Unfortunately, you can't select multiple layers and then lock them using the layer locks at the top of the Layers panel. One workaround is to select the layers in the Layers panel and then choose Layers→Lock Layers or choose Lock Layers from the Layers panel's menu. Select the appropriate lock style from the resulting dialog box and then press OK. Alternatively, you can create a Layer Group (discussed in the next section) and then open the Layers panel's menu and choose "Lock All Layers in Group".

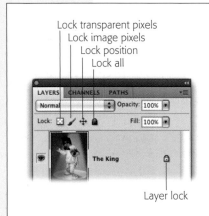

Lock transparent pixels
Lock image pixels
Lock position
Lock all

Layer lock

Figure 3-19:
Use the lock buttons at the top of the Layers panel to protect your layers from accidental editing or repositioning. Your keyboard's forward slash key (/) acts like a switch; tap it once to unlock a locked layer; tapping this key while you have an unlocked layer selected makes Photoshop apply the transparent lock. You'll see the padlock to the right of a locked layer's name no matter which lock you apply.

You can choose from several kinds of layer locks:

- **Lock transparent pixels.** This protects the layer's transparent pixels so they don't change *even* if you paint across them or use the Edit→Fill command. For example, if you created the faded-color effect shown on page 86, you could apply this lock to change the fade's color without affecting the layer's see-through bits. Its button looks like the transparency checkerboard pattern.

- **Lock image pixels.** This won't let you do *anything* to a layer but nudge it around with the Move tool. The button for this lock looks like the Brush tool.

- **Lock position.** If you've carefully positioned a layer and want to make sure it stays put, click this button, which looks like a four-headed arrow. You can still *edit* the layer; you just can't move it.

- **Lock all.** This is your deadbolt: Use it to prevent the layer from being edited *or* moved. You know this lock means business because its icon is a solid black padlock (the other layer locks are gray).

Tip: If you've taken the time to create a layer group (page 105), you can lock all the layers in the group at once by selecting the group and then choosing Layers→"Lock All Layers in Group". (You can also find this same menu item in the Layers panel's menu.) Photoshop pops open a dialog box where you can turn on any of the locks listed above. Click OK to apply them.

Grouping Layers into Folders

You can rein in a fast-growing Layers panel by tucking layers into folders called *layer groups*. You can expand and collapse layer groups just like the folders on your hard drive, and they'll save you a heck of a lot of scrolling when you're layer hunting, as you can see in Figure 3-20.

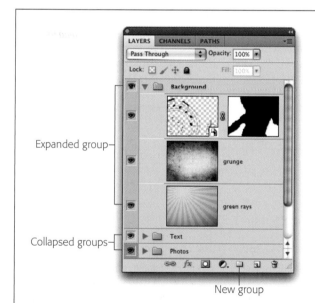

Expanded group—

Collapsed groups—

New group

Figure 3-20:
Layer groups not only help you shorten your Layers panel, they also let you apply masks to all the layers in the group simultaneously. The down-pointing flippy triangle next to the Background group's folder shows that it's expanded. The Text and Photos groups are collapsed. Just click a layer group's flippy triangle to expand or collapse that group.

Here's an example of how useful layer groups are: Say you're building a concert poster, and you've got several layers that comprise the background, some photos of the band, some text, and so on. You can put all the layers associated with the background in a group cleverly named *Background*, the photos in a group called *Photos*, and the Type layers in a group called *Text*. By adding some color-coding (blue for background, red for photos, and so on), you can quickly spot the layer group you want to work with instead of wasting time scrolling through your Layers panel.

Here are the different ways you can group layers:

- **Create the group first** by clicking the "Create a new group" button at the bottom of the Layers panel (it looks like a tiny folder) or by choosing New Group from the Layers panel's menu. If you make a new group by using the menu option, you'll get a dialog box where you can name the group (and pick a color, if you want). Photoshop adds the group to your layers panel; just drag the layers you want to group together into it. You can add layers to the group any time you want, so you don't have to add everything at once.

- **Select your layers first** and then press ⌘-G (Ctrl+G on a PC) or choose "New Group from Layers" in the Layers panel's menu. Photoshop adds a group named *Group 1* to your Layers panel; double-click its name to rename it.

- **Option-drag (Alt-drag on a PC) layers** onto the "Create a new group" button at the bottom of the Layers panel.

You can do the same things to layer groups that you can to regular layers: duplicate them, hide them, lock them, and so on. You can also create nested groups by dragging and dropping one group into another (see the box below for more info).

To split apart grouped layers, select the group and then choose Layer→Ungroup Layers or press Shift-⌘-G (Shift+Ctrl+G on a PC). You can also run this command by Ctrl-clicking (right-clicking) the group and choosing Ungroup Layers from the shortcut menu. Photoshop deletes the group but leaves your layers intact.

POWER USERS' CLINIC

Nesting Layer Groups Deeply

In Photoshop CS5, you can nest layer groups more than five levels deep, meaning you can put a layer group inside of another layer group that lives inside yet *another* layer group that lives…well, you get the picture. This kind of nesting is helpful if you're a stickler for organization or when you're working on a complicated file and have a Layers panel that's a mile long. (Photographers, for example, might have a layer group named *retouching* with another group inside it named *healing*, which houses another layer group named *nose*, and so on.) It works great until you have to share the file with someone using an *earlier* version of Photoshop.

If you open the file with Photoshop CS3 or CS4, you'll be greeted with a dialog box stating, among other things, that it encountered "unknown data" and that "groups were altered." At this point, the program gives you two choices (you can also click Cancel to close the document, but what fun is that?):

- **Flatten** makes Photoshop preserves the appearance of the original document (provided the document was saved using the Maximum Compatibility option discussed on page 33) but none of the layers, which makes further editing impossible.

- **Keep Layers** makes Photoshop try to keep all the layers intact and make the document look like it did, though it doesn't always work. For example, if you've changed a layer group's blend modes (page 289) or used advanced blending options (page 303), they'll be history when the document finally opens.

Once you've crossed your fingers and made a choice, Photoshop opens your document (which can take a little while). If you choose to Keep Layers, you'll see empty layers where the nested layer groups used to be.

Layer Comps: Capturing Different Document Versions

Speaking of that hypothetical concert poster, you'll probably want to show your client different versions so she can pick the one she likes best. Photoshop can help by saving multiple versions of your document as *layer comps*—snapshots of your Layers panel in various states (see Figure 3-21). It's much better than having to juggle multiple files you could lose track of. Layer comps can record the position and visibility of your layers, as well as the blend modes (page 289) and layer styles (page 128) you've applied.

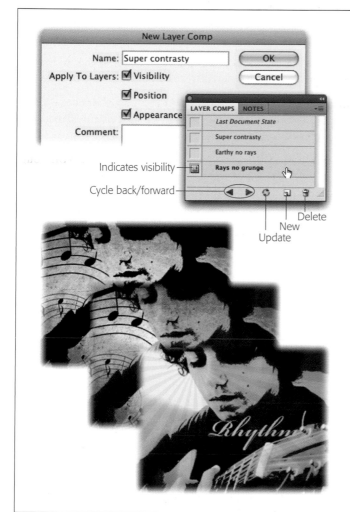

Figure 3-21:

Top: Give each of your layer comps a name that describes that version of your design. To cycle through each comp using the arrow buttons at the bottom of the Layer Comps panel, first summon the panel by choosing Window→Layer Comps.

Bottom: Showing, hiding, and rearranging layers lets you quickly produce several versions of the same design.

Indicates visibility

Cycle back/forward

Delete
New
Update

Note: Like layer groups, layer comps work only if your document has more than one layer.

You capture layer comp "snapshots" as you're working. For instance, you could start off with a baseline version and record what it looks like, then make some changes and record that new version, and so on. When you're ready to save your first layer comp, follow these steps:

1. **Choose Window→Layer Comps to summon the Layer Comps panel, and then click the Create New Layer Comp button at the bottom of the panel.**

 The button looks like the New Layer button—a piece of paper with a folded corner.

2. **In the New Layer Comp dialog box, give your snapshot a meaningful name and then tell Photoshop which attributes you want to save.**

 The dialog box has three settings you can turn on or off:

 — **Visibility** captures the current visibility status of your layers (whether they're on or off).

 — **Position** captures your layers' positions within the document (think layer location, not layer stacking order).

 — **Appearance** captures blend modes (page 289) and layer styles.

 It's a good idea to turn on all three of these settings *just in case* you decide to tweak that stuff later. Add a comment if you'd like and then click OK.

3. **Back in the Layers panel, rearrange, show, or hide layers, add layer styles, or change blend modes to produce another version of your image.**

 Unfortunately, if you change a layer's color, opacity, or fill, Photoshop can't capture that in a layer comp. But there is a workaround: Duplicate those layers, make the changes, and then show or hide them when you save the next layer comp.

4. **Click the Create New Layer Comp button at the bottom of the Layer Comps panel to create another layer comp and give it a name.**

 Repeat these steps as many times as you want to save lots of different layout versions in your document.

When you're ready stroll through the different versions of your document, click the little forward and back arrows at the bottom of the Layer Comps panel as shown in Figure 3-21. To get back to the way your document looked when you last tweaked it (or when you saved your last layer comp), at the top of the Layer Comps panel, click the visibility eye to the left of the words "Last Document State."

You can duplicate and delete layer comps just like layers and layer groups. If you want to *change* a layer comp, select it in the Layer Comps panel and then change whatever you want in the Layers panel. When you're finished, click the Update button at the bottom of the Layer Comps panel.

Some edits, like cropping, deleting a layer, or changing a layer's color, opacity, or fill—and basically any edit that's beyond the layer-comp feature's tracking capabilities—cause Photoshop to cross its arms and lock you out of your layer comps. You can tell which Layer Comps are affected because they'll have little warning triangles to the right of their names (see Figure 3-22). These triangles mean Photoshop needs you to update the layer comp(s) because it can't keep track of every change you made. (Don't worry, it's not a sign that it lost your changes.) Fixing the problem is easy: Just select the affected layer comp(s) and then click the update button shown in Figure 3-21.

Figure 3-22:
If you click the little warning triangle next to your layer comp (circled), you see this dialog box, which gently chastises you for messing up the layer comp. Click Clear to get rid of the warning. If you turn on the "Don't show again" checkbox, Photoshop won't display the message any more, but you'll still have to update your layer comps when you see that warning triangle.

Exporting layer comps

When you're ready for your client to see the layer comps, you can export them by choosing File→Scripts→"Layer Comps to Files" to create a separate file for each layer comp in whatever format you choose (you get the same options as when you export layers to files; see Figure 3-17).

Previous versions of Photoshop (CS3 and earlier) let you export layer comps as both PDF files *and* Web Photo Gallery (WPG) files right from the Scripts menu, but in CS4, that kind of stuff was handed off to the *Output* panel over in Bridge (see Appendix C, online at *www.missingmanuals.com/cds*), which adds a few extra steps to the export process. Figure 3-23 explains how to export your layer comps into a single PDF file; creating a web gallery is covered on page 743.

Save template

Figure 3-23:
Once you've exported your layer comps as separate files (File→Scripts→"Layer Comps to Files"), you can use Bridge to turn them into a single PDF file. Launch Bridge (Appendix C), click the Output button at the top of the window (circled, top) and then choose "Output to Web or PDF". Next, navigate to the files you've exported by using the Folder or Favorites panel on the left of the Bridge window. Then, in the Content panel toward the bottom of the window (circled, bottom), ⌘-click (Ctrl-click on a PC) to select your files (also circled).

In the Output panel, click the PDF button (where the cursor is here) to make Photoshop display a host of options on the right side of the window that let you set paper size, quality, background color, and so on. If you choose a black background and add a watermark in the center, you can create a professional-looking PDF ready to fire off to your client (foreground). When you've got all the settings just right, scroll to the bottom of the Output panel, click the Save button, and give your file a name.

New in Bridge CS5 is the ability to save your settings as a template you can use later. Just click the Save Template button (labeled here), and then give it a meaningful name. The next time you want to use those settings, choose your custom template from the Template pop-up menu.

Rasterizing Layers

If you try to paint (Chapter 12) or run a filter (Chapter 15) on a vector layer, Photoshop puts up a fuss: It displays a dialog box letting you know—in no uncertain terms—that you've got to *rasterize* that layer first. Why? Because as you learned back in Chapter 2 (page 52), vectors aren't made of pixels, and to use pixel-based tools—like the Brush, Eraser, and Clone Stamp—on a vector-based layer, you have to convert it to pixels first. This process is called *rasterizing*.

Beware: There's no going back once you've rasterized a layer. You can't resize former Smart Objects or Shape layers without losing quality, you can't double-click a former Fill layer and change its color, and you can't edit a rasterized Type layer. That's

why it's a good idea to do your rasterizing on a duplicate layer—that way, you can always go back to the original. Just duplicate the layer (page 87) before you rasterize and then turn off the original layer's visibility so you don't accidentally rasterize the wrong layer.

Rasterizing is easy: Just select a vector-based layer and then choose Layer→Rasterize. From the resulting menu, pick the kind of layer you want to rasterize (Type, Shape, Fill Content, and so on) or choose Layer to rasterize the layer you're on or All Layers to rasterize everything (shudder).

Merging Layers

Layers are supremely awesome, but sometimes you need to squash them together. Yes, this goes against what you've learned in this chapter so far—that you should keep everything on its own layer—but in some situations you have no choice but to *merge* or *stamp* layers—or worse, completely *flatten* your file. Here's what those scary-sounding features mean, along with how and why you might need them:

- **Merge.** If you've whipped pixels into perfection and know that you'll *never* want to change them, you can merge two or more layers into one (see Figure 3-24). Not only does that reduce the length of your Layers panel, it knocks a few pounds off the file's size, too. Photoshop gives you several ways to merge layers:

 — **Merge down.** If you want to merge two layers that live next to each other in your Layers panel—and the bottom one is a pixel-based layer—select the top layer and then select Layers→Merge Down, choose Merge Down from the Layers panel's menu, or press ⌘-E (Ctrl+E on a PC).

Note: You can merge any kind of layers, but you need to have a *pixel-based* layer selected in your Layers panel to use the merge commands (or else they'll be grayed out). Photoshop merges everything onto the selected layer.

 — **Merge visible.** To merge just some of your layers, hide the ones you *don't* want to squash, select a pixel-based layer as your target, and then go to Layers→Merge Visible, choose Merge Visible from the Layers panel's menu, or press Shift-⌘-E (Shift+Ctrl+E).

 — **Merge selected.** Select the layers you want to merge (either pixel or vector-based) as explained on page 79 and then go to Layers→Merge Layers, choose Merge Layers from the Layers panel's menu, or press ⌘-E (Ctrl+E).

 — **Merge linked.** If you've linked layers together (page 103), you can merge them in one fell swoop (though you've got to select them first) by choosing Select Linked Layers from the Layers panel's menu and then following the instructions for merging selected layers (above). You can also run this command by choosing to Layers→Select Linked Layers.

- **Stamp.** You can think of stamping as a safer version of merging because it combines the selected layers on a *new* layer, leaving the original layers intact. This command is great when you need to edit *more* than one layer with tools that affect only *one* layer at a time (like filters and layer styles). (An alternative is to use layer groups [page 105] or create a Smart Object from multiple layers [page 126].) Here are your stamping options:

 — **Stamp selected.** Choose the layers you want to stamp and then press ⌘-Option-E (Ctrl+Alt+E).

 — **Stamp visible.** Turn off the layers you *don't* want to stamp by clicking their visibility eyes and then press ⌘-Shift-Option-E (Ctrl+Shift+Alt+E). You can also hold Option (Alt) as you choose Merge Visible from the Layers panel's menu to make Photoshop merge everything onto a new layer.

- **Flatten.** This command makes your file flatter than a pancake, giving you a locked background that, as you know from the box on page 85, doesn't allow for transparency (any areas that were transparent become white instead). Alas, you have no choice but to flatten the file if you're exporting it to a format that doesn't *support* layers (like JPEG, PNG, and so on—see page 51); just be sure to save your document as a PSD file *first* so you can go back and edit it later. You've got three flattening options:

 — **Flatten image.** To flatten your whole file, go to Layers→Flatten Image or choose Flatten Image from the Layers panel's menu.

Warning: Danger, Will Robinson! After flattening a file, be sure to choose File→Save As, instead of File→Save to avoid saving over your original.

 — **Flatten All Layer Effects.** Instead of flattening a whole file, you can flatten just its layer styles (page 128) so they become one with the layer they're attached to. But be aware that, if you've applied any layer styles to vector-based layers (like Type or Shape layers), those layers will get rasterized in the process. To flatten your layer styles, choose File→Scripts→Flatten All Layer Effects.

 — **Flatten All Masks.** You can also flatten layers that you've applied layer masks to (page 113) so the mask is permanently applied by choosing File→Scripts→Flatten All Masks.

Layer Blending

In Photoshop, *blending* refers to the way colors on one layer interact with colors on other layers. You get some pretty powerful blending options with layers in the form of general blend modes, advanced blending, and "blend if" sliders. You can do some amazing stuff with these tools, and since they're used in combining images, you'll learn all about them in Chapter 7, beginning on page 303.

Figure 3-24:
*If you need to edit a multilayer file using tools that affect one layer at
a time, you can stamp your layers into a merged-layer copy (circled
here) to avoid having to flatten your file.*

*If you flatten your document by accident, you can get your layers back
using your History panel (page 27) or by pressing ⌘-Z (Ctrl+Z on a
PC). Whew!*

Layer Masks: Digital Masking Tape

Remember the last time you gave your walls a fresh coat of paint? You probably
broke out a roll of masking tape and taped up your baseboards and molding so you
wouldn't get paint all over them. Sure, you could've have taken the baseboards *off*
and put them back on once the paint dried, but, *dadgum*, that's a lot of work. Besides,
masking tape covers everything just fine. Hiding and protecting is masking tape's
special purpose in life and—what luck!—you've got its digital equivalent right in
Photoshop: *layer masks*.

A layer mask lets you hide the content on a layer, whether it's a pixel-based image
layer, Smart Object, Shape layer, Fill layer or—in the case of Adjustment layers—a
color or lighting change (page 76 covers all the layer types). Learning to use masks
will keep you from having to *erase* parts of your image to produce the effect you
want. Once you erase, there's no going back, and if your hand isn't steady enough
to erase around detailed areas, you can start hunting for a paddle on eBay now. So,
for example, instead of *deleting* your background to swap it with another one, you
can use a layer mask to *hide* it, as shown in Figure 3-25. (You'll find all kinds of
other uses for layer masks sprinkled throughout this book.) As long as you save your
document as a PSD file, you can go back and edit the mask anytime.

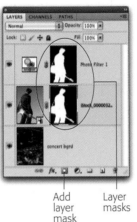

Add layer mask

Layer masks

Figure 3-25:
Left: Wanna be a rock star? No problem: A layer mask can make it happen. Here you can see the original, boring blue background, as well as the new, exciting, clamoring crowd.

Right: If you peek at the Layers panel, you can see that the original background wasn't deleted—it was hidden with a mask instead. (To make the color of the guitarist and the crowd match a bit more, you can add an Adjustment layer—page 77—that uses the same mask.)

Adding Layer Masks

You can add a mask to any layer, though some layers come with them automatically, like Fill and Adjustment layers (page 77) and Shape layers (page 540). As you can see in Figure 3-25, the mask shows up in your Layers panel as a thumbnail to the right of the layer thumbnail.

Note: You can't add a layer mask to a locked Background layer; you first have to double-click the background to make it editable *and then* add a mask.

Layer masks are grayscale creatures, so when you're dealing with them you work only in black, white, and shades of gray, depending on what you want to do. A black mask hides your layer completely and a white mask reveals it completely. A gray mask falls somewhere in between—it's partially transparent. All this is easy to remember if you memorize the rhyme, "Black conceals and white reveals." Masks can also be pixel- or vector-based. In this section, you'll learn about pixel-based masks; vector-based masks are covered on pages 148 and 572.

To add a layer mask, choose Layer→Layer Mask and then pick one of the following:

- **Reveal All.** Creates a solid white mask that shows everything on your layer, so it doesn't change anything in your image. You can also add a white (or empty) mask by clicking the Add Layer Mask button at the bottom of the Layers panel (it looks like a circle within a square, as you can see in Figure 3-25). If you want

to hide just a *little* bit of your layer, Reveal All is the way to go; after you add the mask, you can paint the areas you want to hide with a black brush.

- **Hide All.** Creates a solid black mask that conceals everything on your layer. (Option-clicking [Alt-clicking on a PC] the Add Layer Mask button does the same thing.) If you want to hide the majority of your layer, the fastest way is to hide everything and then go back with a white brush to reveal specific areas.

- **Reveal Selection.** Choose this option if you've created a selection and want to hide everything else. Photoshop makes your selected area white and the background black. (You'll learn all about selections in Chapter 4.)

- **Hide Selection.** This command makes your selected area black and the background white.

Tip: You can also add a pixel- or vector-based layer mask by using the Masks panel (shown on page 120).

- **From Transparency.** New in Photoshop CS5, you can create a layer mask from the transparent pixels in your image (handy if you're working with an image that has no background, like a vector [page 52]). Just select the partially transparent layer, and then choose Layer→Layer Masks→From Transparency. Photoshop adds a layer mask with black in the transparent (empty) areas. That said, this command has a nasty habit of adding back multicolored, garbled-looking pixels that you thought were previously erased, as well as tacking on a white background if you change your mind and delete the mask later on. Yikes!

Using Layer Masks

You can use any painting tool you want to add black, white, or gray paint to your mask, although the Brush tool is especially handy (Chapter 12 covers all your brush options), and the Gradient tool is great if you want to create a smooth transition from black to white (see the color to black & white effect on page 334). Selection tools (Chapter 4) also work in masks, and once you have a selection you can fill it with black, white, or shades of gray by choosing Edit→Fill.

One of the simplest uses for layer masks is to hide bits of text, as shown in Figure 3-26, so the text looks like it's behind a person or object in a photo. Here's how to create the text-behind effect:

1. **Open a photo and press T to select the Type tool.**

 Don't worry about double-clicking the Background layer to make it editable; you don't need to touch your original image in this technique.

2. **From the Options bar at the top of your screen, pick a font, a size, and a color.**

 For this technique, select a nice thick font like Impact and set it to a fairly large size, like 84 points. (You'll learn all about text formatting in Chapter 14.)

3. **Mouse over to your document and type some text.**

 Click where you want the text to begin and start typing. If you want to move the text around, mouse away from the text and your cursor turns into a little arrow; at that point, you can drag the text anywhere you'd like in your document.

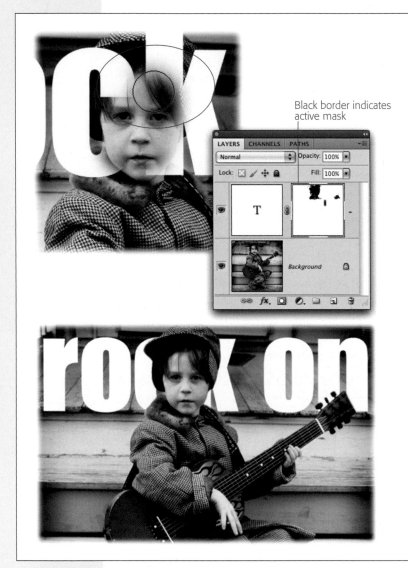

Black border indicates active mask

Figure 3-26:

Top: Here you can see that this boy and some text live on different layers. If you add a layer mask to the text layer and then paint within the mask with a black brush (circled), you can hide parts of the text, revealing the boy's face. Over in the Layers panel, the little black border lets you know which part of the document is active: the layer or, in this case, the mask.

Bottom: Magazines use this trick all the time on their covers to make text look like it's behind people.

4. **Add a layer mask to your Type layer by clicking the circle-within-a-square button at the bottom of the Layers panel.**

 In the Layers panel, you'll now see the mask thumbnail next to the Type layer's thumbnail. See the thin black border around the mask thumbnail? That means it's active and you're about to paint on the mask (good) instead of the photo (bad).

Tip: One of the biggest mistakes folks make is not paying attention to which thumbnail they've selected in the Layers panel (it takes a single click to activate either thumbnail). The little black border always lets you know which part of the layer is active: the mask or the layer content.

5. **Press B to select the Brush tool and pick a soft-edge brush set to black.**

 After you activate the Brush tool, head up to the left side of the Options bar and open the Brush Preset picker (page 499) by clicking the down-pointing triangle next to the little brush preview. Pick a soft-edge brush that's about 60 pixels. Since you want to *hide* bits of text (remember, black conceals and white reveals), you need to choose black as your foreground color. To do that, take a peek at your color chips at the bottom of the Tools panel (page 24) and press X until black hops on top. Now you're ready to start painting.

6. **Mouse over to your document and paint the parts of the text you want to hide.**

 In the example in Figure 3-26, position your mouse over the little boy's face and click to start painting (and hiding) parts of the *c* and *k*. When you release your mouse button—you don't have to do all your painting with one brushstroke— you'll see black paint on the layer mask in the Layers panel.

7. **If you accidentally hide too much of the text, press X to swap color chips so you're painting with white and then paint that area back in.**

 When you're working with a layer mask, you'll do tons of color-chip swapping (from black to white and vice versa). You'll also use a variety of brush sizes to paint the fine details as well as large areas. To keep from going blind when you're doing detailed work like this, zoom in or out of your document by pressing ⌘ and then the + or – key (Ctrl and then the + or – key on a PC).

Tip: You can change your brush cursor's size and hardness by dragging with your mouse, which is handy when it comes to painting on layer masks. To resize your brush, Ctrl-Option-drag (Alt+right-click+drag on a PC) to the left to decrease brush size or to the right to increase it. In CS5 you can change brush hardness with the same keyboard shortcut by dragging vertically: drag up to soften it or down to harden it. Inside your brush cursor, you'll see a red preview of what your new brush will look like—if your computer supports OpenGL (page 64). If you want to change that color to something other than red, flip to page 35. If you're a creature of habit, you can still decrease your brush size by pressing the left bracket key ([) and increase it by pressing the right bracket key (]).

That wasn't too bad, was it? You just learned *core* Photoshop skills that you'll use over and over. The more you use masks, the more natural this stuff will feel.

Fixing exposure with masks

Masks are especially handy for quickly fixing an over- or underexposed image (one that's too light or too dark). This trick is important to have up your sleeve if you're short on time, or if other lighting fixes (see Chapter 9) aren't working. Here's what you do:

1. **Open your image and add a Levels Adjustment layer by clicking the "Create a new fill or adjustment layer" button at the bottom of the Layers panel (the half-black/half-white circle).**

 Don't panic! You're not actually going to adjust Levels (page 390); you're merely adding an empty Adjustment layer so you can quickly swap blend modes and then use the mask that tags along with it. Sure, you could duplicate your image layer and then add a layer mask, but this method is faster and won't bloat the document's file size. The reason you're using Levels is because it's the first item in the Adjustment layer menu at the bottom of the Layers panel (page 78) that doesn't *do* anything to your image the second you apply it.

2. **Change the empty Adjustment layer's blend mode from Normal to Multiply using the pop-up menu at the top of the Layers panel.**

 Blend modes control how color on one layer interacts with colors on other layers, which is terrific when it comes to combining images (you'll learn all about blend modes in Chapter 7). For now, you'll focus on two blend modes that you'll use often because they let you quickly darken or lighten an image, respectively: Multiply and Screen (see Figure 3-27). For this example, pick Multiply from the menu at the top of the Layer's panel to darken your image dramatically. You'll hide the too-dark bits with the Adjustment layer's mask in the next step.

3. **Press B to grab the Brush tool and set your foreground color chip to black.**

 Make sure the Adjustment layer's mask is selected (it will be unless you clicked on another layer). To hide the over-darkened areas, you can paint them with black because—all together now!—black conceals and white reveals. Peek at your color chips, and if black isn't on top, press X. Now you're ready to paint.

4. **With a big soft brush, paint the areas that are too dark.**

 Those keyboard shortcuts for resizing and changing the hardness of your brush come in handy here (see the Tip on page 117). Remember, if you mess up and hide too much of the darkened part of your image, simply flip-flop your color chips by pressing X and then reveal the dark part by painting it with white.

Figure 3-27:
You can darken or lighten an image by using a brush to fine-tune the mask. Photo-editing veterans call this technique "painting with light."

Top: This guy's shirt and arms are too light in the original image (left). If you change the Adjustment layer's blend mode to Multiply, his face and guitar are too dark (middle). But if you hide his face and guitar using the layer mask, he looks much better (right).

Bottom: You can do the same thing to a photo that's too dark. On the left is the super dark original. The middle image shows what happens when you change the Adjustment layer's blend mode to Screen. You can use the accompanying layer mask to hide the overlightened areas (mainly the background) as shown on the right. Now you can see the rocker dude's face (on second thought, maybe that isn't such a good idea after all!).

5. If your image is still a little too dark, lower the empty Adjustment layer's opacity (page 92).

Editing a Mask

Once you add a mask, you'll undoubtedly need to fine-tune it, turn it off or on, and so on. In pre-CS4 versions of the program, you had to mouse *all* over the Photoshop workspace to do that stuff. Thankfully, all of your mask tasks are now consolidated in the Masks panel (Figure 3-28).

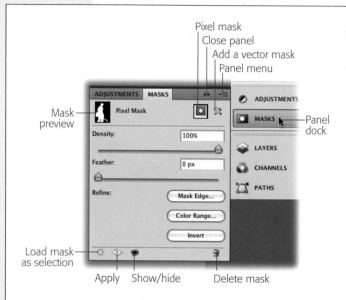

Pixel mask
Close panel
Add a vector mask
Panel menu

Mask preview

Load mask as selection

Apply Show/hide Delete mask

Panel dock

Figure 3-28:
The Masks panel is your one-stop shop for working with layer masks. Heck, you can even add a layer mask right from this panel!

Unlinking a Layer from Its Mask

Photoshop assumes that if you reposition the contents of your layer, you want its mask to come along for the ride. But, that's not always the case. For example, if you use a mask to frame your photo (see the oval vignette instructions on page 142), you may want to move what's *inside* the mask (your photo) independent of the mask itself, or vice versa. No problemo—you just need to unlink them first.

Over in the Layers panel, you'll see a tiny chain between the layer's thumbnail and the mask's thumbnail (you can see this chain in Figure 3-27). Click the chain once or

choose Layer→Layer Mask→Unlink to unlink the layer from the mask (you'll know you got it right when the chain disappears). Then press V to grab the Move tool, click the thumbnail of the piece you want to move (the layer or the mask), and then drag. Once you've got everything where you want it, click where the chain used to be (between the layer and mask thumbnails) or choose Layer→Layer Mask→Relink to relink them. Easy, huh?

You'll find the following controls roosting comfortably in the Masks panel:

- **Density.** Photoshop sets the opacity for new layer masks to 100 percent, which means you can't see through them. If you want to make your mask semitransparent so the contents of the layer (like the original background) start to show through, drag this slider to the left. Dragging it *all* the way to the left makes your mask completely transparent.

- **Feather.** If you want to soften the edges of the mask so that it blends into the background a little better, this slider will get it done. Drag it to the right to soften the mask's edges and to the left to sharpen them (new layer masks don't have any automatic feathering, so their edges are always sharp).

- **Mask Edge.** When you click this button, Photoshop opens the Refine Mask dialog box where you can smooth mask edges, make the mask smaller or bigger, and so on. Page 166 has the details on this dialog box, and, boy howdy, it sure improved in CS5!

- **Color Range.** This button opens the Color Range dialog box where you can add to or subtract from your mask based on the colors in your image. You can use this button to help create a selection that you make a mask *from*. Page 154 has more info.

- **Invert.** This button lets you flip-flop your mask so what *was* masked isn't and what *wasn't* masked is.

- **Load Selection from Mask.** Once you've created a layer mask, you can load it as a selection that you can use somewhere else like in an Adjustment layer (see Figure 3-25, right).

- **Apply Mask.** Once you get the mask just right, you can permanently (eek!) apply it to your layer by clicking this button. Applying a mask permanently alters the layer and limits the changes you can make later, so don't use this option unless you're *certain* you won't need to change the mask down the road. If you click this button by accident, use the History panel or undo command to get the mask back (⌘-Z or Ctrl+Z on a PC) or you won't be able to edit it ever again.

- **Disable/Enable Mask.** This visibility eye works just like the one in the Layers panel (page 82): Click it to turn your mask off or on.

- **Delete.** If you decide you don't want the mask, you can kick it to the curb by clicking the little trash can at the bottom of the Masks panel.

Tip: If you want to copy a mask to another layer, press and hold Option (Alt on a PC), click the mask in the Layers panel, and then drag it to another layer. (You have to press Option or Alt *before* you click the mask or you'll merely move it from one layer to the other.) Your cursor turns into a double black-and-white arrowhead when you start to drag and, in CS5, you see a ghosted image of the mask while you're dragging it.

Opening the Masks panel's menu by clicking the panel's upper-right corner reveals these goodies (see Figure 3-28):

- **Mask Options.** When you're editing masks, you've got a few different viewing options. Which one you choose depends on the colors in your image and the area you're trying to select. Pick a color that makes it easy for you to distinguish the mask from the unmasked parts of your image. In the masking examples discussed earlier, the mask was edited while the image was viewed in full color. However, as Figure 3-29 shows, you can also work on a mask while you're looking at a grayscale version of your image or turn the mask into a color overlay. If you choose the color overlay and Photoshop's standard red isn't doing it for you, use the Mask Options dialog box to pick another color.

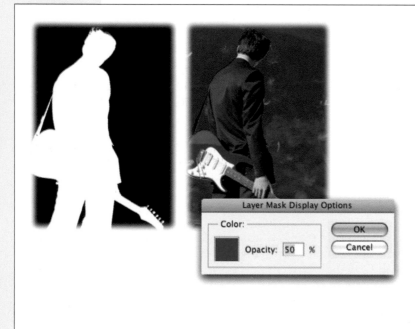

Figure 3-29:
Left: If you want to edit a grayscale version of your mask—a good option if your image has lots of colors—Option-click (Alt-click on a PC) the mask's thumbnail in the Layers panel. Now you can copy and paste pixels—including text—right into your layer mask. (Page 625 has a cool example involving textured text.) When you're finished editing the mask, click the layer's thumbnail.

Right: To edit your mask with a red overlay, press the backslash key (\). To change the overlay's color, open the Masks panel's menu and choose Mask Options. In the Layer Mask Display Options dialog box (shown here), click the color square and pick a new color. Press the backslash key again to see your full-color image.

- **Add Mask to Selection.** If you have an existing selection (see Chapter 4), you can choose this option to add the mask to your selection. This is an easy way to expand the currently selected area to include the mask in one quick step.

- **Subtract Mask from Selection.** This option deletes the shape of the mask from your selection.

- **Intersect Mask with Selection.** To select only areas where your selection and mask overlap (if you need to add a color or pattern only to those places, for example), choose this option.

Using Smart Objects

A *Smart Object* is a container-like layer into which you can plop all kinds of stuff like Raw files (page 57), vectors (drawings) from programs like Adobe Illustrator (Chapter 13), whole PSD files, and even other layers. Smart Objects are smart because Photoshop remembers the original content and what program created it, which lets you:

- **Transform or resize without losing quality.** Instead of resizing the *instance* (a copy) of the content that you inserted into your document, Photoshop remembers info about the *original*, resizes that, and then places that information back into your image (without altering the original file). It doesn't matter whether that original lives elsewhere on your hard drive or right there in your Photoshop document (on another layer, say). In the blink of an eye, Photoshop updates your document with the newly resized content *without* making it look blocky (so long as you don't exceed the file's original dimensions—unless it's a vector, of course). You can also use the full range of transform tools (page 263) on Smart Objects, too.

FREQUENTLY ASKED QUESTION

Clipping Masks

What the heck is a clipping mask? Is it similar to a layer mask?

Clipping masks and layer masks are similar in that they both hide parts of an image, but that's about all they have in common. Clipping masks are like Photoshop's version of stencils: they let you take one layer's contents (like bluebonnets) and shove it through the contents of the layer directly below (for example, text that says "Texas"). The result? The image on the top layer is "clipped" so that you see the bluebonnets inside the text. Hop on over to page 629 for step-by-step instructions on this technique.

You can give clipping masks a spin by opening a photo and double-clicking the Background layer to make it editable (page 85). Next, add a new layer below it by using one of the methods described on page 81. Press B to grab the Brush tool and then paint a big ol' brushstroke across the new layer. In the Layers panel, select the photo layer

(which should be on top of your layers stack) and then choose Layer→Create Clipping Mask or press ⌘-Option-G (Ctrl+Alt+G on a PC), and Photoshop makes your photo visible *only* through the brushstroke.

When you use a clipping mask, you don't get another thumbnail in your Layers panel like you do with a layer mask. Instead, the photo layer's thumbnail scoots to the right and you see a tiny down arrow letting you know that it's clipped to the layer below. You can clip as many layers together as you want.

To release a clipping mask, select the clipped layer (the top layer—in this example, that's the brushstroke layer), go to Layer→Release Clipping Mask, choose Release Clipping Mask from the Layer panel's menu, or press ⌘-Option-G (Ctrl+Alt+G). You should see your entire photo again.

Note: Smart Objects are especially useful when you're working with Raw files because you can double-click them in Photoshop to open them in Camera Raw (page 58). However, placing multiple Smart Objects in a single document—especially one that contains Raw files—will bloat your file size in a hurry and cause Photoshop to run as fast as molasses.

- **Compress a bunch of layers into a single layer nondestructively.** Unlike merging layers (page 111), converting several layers into a single Smart Object preserve the original layers. This ability is super helpful if Photoshop is choking on the number of layers in your document or if you want to edit several layers as if they were one (great for masking several layers at once)—which you may want to do if you're applying layer styles (page 128)—or to use tools that work only on one layer at a time.

- **Run filters nondestructively.** When you run a filter on a Smart Object, you get an automatic layer mask, plus the filtering happens on *its* own layer (similar to layer styles, page 128) so you can tweak, hide, or undo the filter's effects. See Chapter 15 (page 634) to learn how to run filters on Smart Objects.

- **Update multiple instances of the same content.** If you've placed the same content in several places in your document—like a big logo in one spot and a smaller version of the same logo somewhere else—and you make changes to the original file, Photoshop automatically updates it for you wherever it appears in your document.

- **Swap content.** Once you've formatted a Smart Object just right, you can swap its contents for another image, and the new image takes on the original's attributes. This content swapping is powerful magic when it comes to making creative templates that you can use over and over with different images (photographers love this kind of thing). Figure 3-30 has the details.

The following sections teach you how to create and manage Smart Objects.

Creating Smart Objects

How you create a Smart Object depends on two things: Where the original content lives and which document you want to put it in. Here are your options:

- **To create a new document containing a file that lives on your hard drive, choose File→"Open as Smart Object".** In the resulting Open dialog box, navigate to the file and click Open to make Photoshop create a new document containing a single Smart Object (without a Background layer). The image you've opened appears at its original size, and you'll see the Smart Object badge on its layer thumbnail (circled in Figure 3-30).

Figure 3-30:
You can create some pretty amazing templates using Smart Objects. Just open an image as a Smart Object (described later in this section) and make all the changes you want like giving it a sepia tint (page 327), adding a dark-edge vignette (page 656), and sharpening it (Chapter 11). To swap the photo for another one, select the Smart Object layer (note the little badge that indicates it's a Smart Object, circled) and then choose Layers→Smart Objects→Replace Contents. Navigate to another photo on your hard drive, click Open, and it'll take on the same characteristics automatically! Thank ya, thank ya very much.

Tip: You can Shift-click multiple files in the Open dialog box to open more than one file as a Smart Object. Each file opens as its own document with a single Smart Object layer.

- **To import a file into a document that's currently open, choose File→Place.**
 You get the same Open dialog box so you can navigate to the file, but this time the file opens as a Smart Object *inside* the current document. Photoshop puts little handles around the object so you can resize it. When you press Return (Enter on a PC) to accept the object, you'll see the Smart Object badge appear on the new layer's thumbnail.

Note: Photoshop CS5 includes a new preference setting that automatically opens dragged or placed files as Smart Objects (see the figure on page 32). If you haven't turned it off (and you shouldn't), it's the only way to roll. If you've got a document open, the Smart Object appears on a new layer inside that document; if you don't, it opens as a Smart Object in a new document.

- **Copy and paste an Adobe Illustrator file.** If you copy Illustrator art into your computer's memory, you can paste it into an open Photoshop document using ⌘-V (Ctrl+V on a PC). You'll be asked whether you want to paste it as a Smart Object, pixels, path (page 537), or Shape layer (page 540).

- **In Bridge, choose File→Place→In Photoshop.** If you're using Bridge to peruse your files, this command pops 'em open as Smart Objects in Photoshop (see Appendix C, online, for more on Bridge).

- **To turn existing layers into a Smart Object in the current document, choose Layers→Smart Objects→"Convert to Smart Object", or choose "Convert to Smart Object" from the Layers panel's menu, or choose Filter→"Convert for Smart Filters".** If you're working with an image that has a bunch of Adjustment layers associated with it (to change stuff like color and lighting), you can use this command to group the whole mess into a single Smart Object. That way, you can apply additional changes to all those layers at *once* with tools that work only on individual layers (like filters and layer styles). Figure 3-31 has the details.

Note: You can apply a mask to Smart Objects just like you can to any other layer. Photoshop automatically *links* (see the box on page 120) the mask to the layer so you can move them around together. If you want to unlink them, just click the little chain between their thumbnails in the Layers panel.

Managing Smart Objects

Once you've created a Smart Object, you can duplicate it, edit it, and export its contents. You'll find the following options in both the Layers→Smart Objects menu and the Layer panel's menu:

- **New Smart Object via Copy.** When you choose this command, Photoshop makes a duplicate of your Smart Object that's *not linked* to the original, so if you edit the content of the original Smart Object, the duplicate won't change. This unlinked copy is helpful if you want to create more than one instance of the same Smart Object in a single file and edit them in different ways. You can also mouse over to the Layers panel and Ctrl-click (right-click on a PC) near—but not on—the existing Smart Object's name and then choose "New Smart Object via Copy" from the pop-up menu.

Tip: To create a duplicate Smart Object that *is* linked to the original, (you can drag the Smart Object onto the "Create a new layer" button at the bottom of the Layers panel, or just select the Smart Object in the Layers panel and duplicate it by pressing ⌘-J (Ctrl+J on a PC). This is handy if you've repeated a graphical element in your design—if you edit that element in the original Smart Object, Photoshop updates all the copies of that Smart Object in your document.

Figure 3-31:

Top: To convert multiple layers to a Smart Object, select them in the Layers panel and then choose "Convert to Smart Object" from the Layers panel's menu.

Bottom: Photoshop converts all those layers into a single Smart Object that you can run filters on nondestructively. The filter shows up on its own layer as shown here. If you want to edit the Smart Object's contents, choose Edit Contents from the Layers panel's menu and Photoshop opens a new document containing your original layers. When you're finished editing, press ⌘-S (Ctrl+S on a PC) to save your changes and then close the document. Photoshop updates your Smart Object in the original document automatically. How cool is that?

- **Edit Contents.** Choose this option or double-click the Smart Object's thumbnail in the Layers panel if you want to edit the original file in the program that created it (for example, Adobe Illustrator).

- **Export Contents.** This command pulls the contents of the selected Smart Object out of the current document and puts it into a new file that's the same format as the original. If it began life as a Raw file, for example, Photoshop will save it in Raw format. When you choose this command, Photoshop displays a dialog box where you can name the new file and choose where to save it.

- **Replace Contents.** As you learned back in Figure 3-30, you can use this command to swap the contents of a Smart Object so the new image takes on the appearance of the old one.

- **Rasterize.** You can't paint or edit directly on a Smart Object like you can on its contents. But if you're ready to give up all the goodness that comes with using a Smart Object, you can choose this option to rasterize it and make it behave like any other layer.

Layer Styles

After all that hard work learning about layers, you're probably ready for some fun. This section is all about *layer styles*: a set of ten fully adjustable, ready-made special effects for layers that you can apply in all kinds of cool ways. Consider this section your reward for sticking with the chapter till the bitter end.

Layer styles are a lot of fun and, since they appear on their own layers, they're non-destructive *and* they remain editable as long as you save the document as a PSD file. Layer styles are great for adding finishing touches to your designs, and they can really make text and graphical elements pop off the page (see Figure 3-32). They also change as your layer content changes.

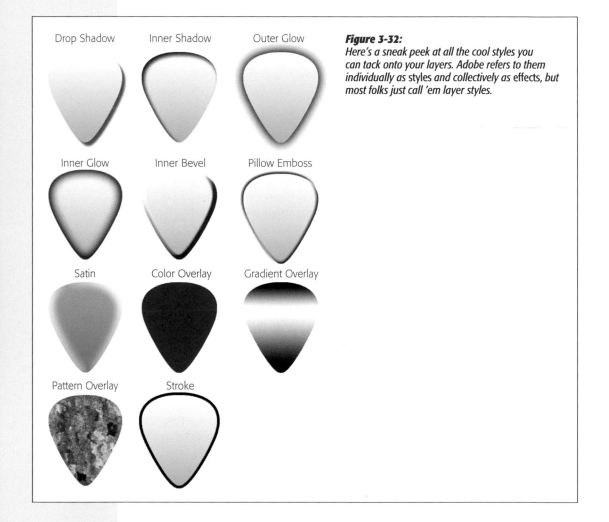

Drop Shadow Inner Shadow Outer Glow

Inner Glow Inner Bevel Pillow Emboss

Satin Color Overlay Gradient Overlay

Pattern Overlay Stroke

Figure 3-32:
Here's a sneak peek at all the cool styles you can tack onto your layers. Adobe refers to them individually as styles *and collectively as* effects, *but most folks just call 'em layer styles.*

Here's how to add The Lord of All Styles, the drop shadow, to your layer:

1. **Select the soon-to-be-shadowed layer in the Layers panel.**

 Photoshop limits you to selecting just one layer when you're adding a style.

2. **Click the "Add a layer style" button at the bottom of the Layers panel and choose Drop Shadow (see Figure 3-33, top).**

 The button looks like a tiny cursive *fx*.

3. **In the Layer Style dialog box that appears, adjust the settings to produce a respectable (soft)—not overly gaudy (black and 10 feet away from the object)—drop shadow.**

 There are a bazillion options for each style in the Layer Style dialog box, as Figure 3-33 shows (middle), and it's a good idea to experiment with all of 'em so you know how they work.

Tip: You can also open the Layer Style dialog box by double-clicking a layer's thumbnail or double-clicking near the layer's name.

4. **Click OK when you're satisfied with what you see in your document and then marvel at your very first drop shadow. Whee!**

WORKAROUND WORKSHOP

Nested Smart Objects

If you've got a Smart Object that contains several layers and you try to apply a layer style to it, you'll run into some difficulty. For example, if you apply a drop shadow (page 129) to a Smart Object full of layers, Photoshop tacks a drop shadow onto *every* layer. So instead of a nice, subtle shadow, you end up with a shadow on top of a shadow on top of a shadow–yuck. The fix is to convert your Smart Object into *another* Smart Object inside the original before you add the layer style.

In your Layers panel, select the Smart Object you want to convert and then choose Layers→Smart Objects→"Convert to Smart Object". Photoshop creates a new Smart Object within the original one (which is why it's called a *nested* Smart Object). Now you can apply the layer style to the new Smart Object and your layer style will look like you expect it to.

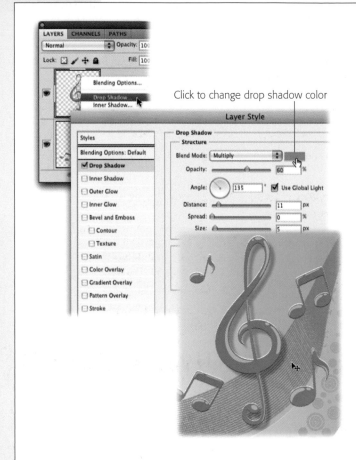

Figure 3-33:
When it comes to drop shadows, the classiest ones are rarely black—instead they pick up a color from your image. Just click the color swatch labeled here (middle), and Photoshop summons the Color Picker (page 493). To snatch a color that already lives in your image, mouse over to your image and, when your cursor turns into an eyedropper, click once and your shadow takes on that color.

You'll also likely need to lower the shadow's opacity so it's nice and soft, and use the Spread and Size sliders to make it wider. Don't bother messing with the Angle dial or the Distance slider because you can change those settings visually by heading over to your document and dragging the shadow around with your mouse, as shown here (bottom).

Once you get the drop shadow just right, click CS5's new Make Default button at the bottom of the Layer Style dialog box. The next tine you need to add a drop shadow, Photoshop will use those settings instead.

If you want to edit the style later on, just double-click it in the Layers panel. If you want to move it to another layer, just grab it and drag (in CS5, you see a big *fx* as you drag). You can add as many styles to a layer as you want, all from the Layer Style dialog box. Just turn on the options you want (they're all in the Styles column on the left) and then click a style's name to see its options. And remember the Fill setting discussed back on page 92? You can use it to make the *contents* of your layer see-through while the *style* remains 100 percent solid.

Managing Layer Styles

Once you've tacked on a layer style or two, you'll undoubtedly want to apply them to other layers and turn them off or on. Here's how:

- **To copy a style from one layer to another,** hover your cursor above the style in the Layers panel and then Option-drag (Alt-drag on PC) the style to the new layer. Your cursor turns into a double black-and-white arrowhead when you drag, and in CS5 you see a big, ghosted *fx*, too.

- **To turn a style off,** click the visibility eye to the style's left in the Layers panel.

If you Ctrl-click (right-click) a style in the Layers panel, you see a shortcut menu with these options:

- **Disable Layer Effects** turns off all the styles on that layer. To turn them back on, open the menu again and choose Enable Layer Effects.

- **Copy Style** copies all the styles you've applied to the selected layer so you can apply them to other layers. After you select this command, Shift- or ⌘-click (Ctrl-click on a PC) to select the layers you want to apply the styles to and then Ctrl-click (right-click) to open the shortcut menu again and choose Paste Style.

- **Clear Layer Style** deletes the style from the selected layers. You can also drag a style to the trash can at the bottom of the Layers panel to remove it from a layer.

FREQUENTLY ASKED QUESTION

Hiding Styles with Masks

Help! I have a mask on my layer and Photoshop is showing the styles through the darn mask! How do I hide those pesky styles?

Ah, you seek the elusive style cloak. To summon it, you must boil the stalk of a West Texas tumbleweed, season it with eye of toad, and drink it from the shell of an armadillo three days dead…just kidding.

To hide styles with a layer mask, you've got to change the layer's blending options. Double-click the style in the Layers panel and, in the Layer Style dialog box, click Blending Options at the top left.

In the Advanced Blending section in the center of the dialog box (shown here), you'll see a list of checkboxes that includes Layer Mask Hides Effects and Vector Mask Hides Effects.

Turn on the appropriate option for the kind of layer you're working with (Vector Mask [page 572] for vector-based layers, and Layer Mask for all other layers) and then click OK. Back in your document, your mask should hide any styles you've applied to that layer.

Now, back to that magic potion….

- **Global Light** tells Photoshop to use the same lighting angle in every style you add, which is useful when you're applying drop shadows or inner shadows. If you've got more than one drop shadow in your document, turn on this option so the lighting stays consistent.

- **Create Layer** takes the style applied to the selected layer and converts it into a regular image layer, but you lose the ability to edit the style later. Though it sounds limiting, you can use this option to further customize a layer style into your own personal vision; once it's a regular layer, you can run filters on it, use the painting tools, and so on.

- **Hide All Effects** turns off the styles applied to *every* layer. After you've hidden them, this menu item changes to Show Effects so you can select it to turn them back on.

- **Scale Styles** lets you resize the style itself, independent of the layer's contents, by entering a percentage. This option is useful if you want to fine-tune drop shadows and glows by making them slightly larger or smaller.

Using the Styles Panel

Photoshop comes with all kinds of styles made from some pretty psychedelic style combinations. You'll find a couple of them useful, but most of them are just funky. To get at them, open the Styles panel by clicking its tab in the panel dock on the right side of your screen or by choosing Window→Styles (see Figure 3-34).

Admittedly, the preloaded styles aren't anything to write home about, but if you open the Styles panel menu, you'll see ten *more* sets you can load: Abstract Styles, Buttons, and so on. To load another set, just choose it from the panel's menu; Photoshop asks if you'd like to add them to the existing styles or replace the existing ones. If you're a web designer, you may find the Glass Buttons and Web Styles sets useful for that clear, plastic look. Otherwise, you probably won't find much use for many of these styles.

To apply one of these styles, simply select the layer you want to use it on and then click once on the style's thumbnail. You can tweak the style by double-clicking the style's layer in the Layers panel or by choosing it from the Layer Style dialog box. You can also drag and drop a style thumbnail onto your layer, but that style replaces any styles already applied to that layer. To add a saved style on *top* of existing styles, hold down the Shift key as you drag and drop or as you click the style's thumbnail.

Tip: To make the style thumbnails larger or to view them in a list, open the Styles panel's menu and choose Text Only, Small Thumbnail, Large Thumbnail, Small List, or Large List.

Close panel
Panel menu
Panel dock

Clear style Delete style
New style

Figure 3-34:
You'll find all manner of weird and wacky presets in the Styles panel (top), some more useful than others (middle). You can add your own creations to the mix by selecting the layer where your styles are and then clicking the "Create new style" button shown here or choosing New Style from the Styles panel's menu.

In the resulting dialog box (bottom), give your style a name, turn on the Include Layer Effects checkbox to make sure you don't lose any of your changes, and if you've changed any layer blending options (page 303), turn on Include Layer Blending Options checkbox, too. When you click OK, Photoshop saves your style for posterity in the Styles panel (though it's a good idea to safeguard your presets, as online Appendix B explains). If you want to bypass this dialog box next time, Option-click (Alt-click on a PC) the New Style button. You'll get a new Style called Style that you can rename later, but you don't get to change any other settings.

Exporting and loading styles

If you're really proud of the styles you've created and want to share them with the masses (or at least load them onto another computer), here's what you do: From the Styles panel's menu, choose Save Styles, give your style a name, and tell Photoshop where you want to save it. You can take the resulting file to another computer, launch Photoshop, and pick one of the following options from the Styles panel's menu:

- **Load Styles** adds the new styles to the ones currently in your Styles panel.

- **Replace Styles** zaps the ones you've got in favor of the new ones.

- **Reset Styles** returns your styles to the factory settings.

Selections: Choosing What to Edit

L ife is all about making choices, and the time you spend in Photoshop is no exception. Perhaps the biggest decision you'll make is which part of an image to edit—after all, your edits don't have to affect the *whole* thing. Using a variety of Photoshop tools, you can tell the program exactly which portion of the image you want to tinker with, right down to the pixel, if you so desire. This process is called making a *selection*.

As you'll learn in this chapter, Photoshop has a bunch of tools that you can use to create selections based on shape, color, and other attributes. You can also draw selections by hand, although that requires a bit of mouse prowess. True selection wisdom lies in learning which selection tool to start with, how to use the tools together, and how to fine-tune your selections quickly and efficiently. The following pages will help you with all that and then some.

Selection Basics

What's so great about selections, anyway? Lots. After you make a selection, you can do all kinds of neat things with it, like:

- **Fill it with color or pixels from the image's background.** Normally, the Edit→Fill command (page 91) floods an entire layer with color, but by creating a selection first, you can color just that area. In CS5, you can use the Fill command in conjunction with a selection to delete a person from your photo as if they were never there (see page 181).

- **Add an outline.** You can add a *stroke* (Photoshop's term for an outline) to any selection. For instance, you can use selections to give your photo a black border (page 183) or to circle yourself in a group photo (page 184).

- **Move it around.** To move part of an image, you need to select it first. You can even move selections from one document to another, as discussed on page 177. For example, a little head swapping is great fun after family reunions and break-ups. If you want to stick your ex's head onto a ballerina's body, hop on over to page 179.

- **Resize or transform it.** Need to change the size or shape of your selection? No problem: Just make a selection and then transform it into whatever size or shape you need (page 174). Photoshop won't reshape any pixels that are in your selected area, just the selection itself.

- **Use it as a mask.** When you create a selection, Photoshop protects the area outside it—anything you do to the image affects only the selected area. For example, if you move the Eraser tool (page 284) across the edge of a selection, it erases only the area *inside* the selection. Likewise, if you create a selection before adding a layer mask (page 113), Photoshop loads the selected area into the mask automatically, letting you adjust only that part of the image. So selections are crucial when you need to correct the lighting in just one area (Chapter 9), or change the color of an object (page 342).

This chapter discusses all these options and more. But, first, you need to understand how Photoshop marks selections.

Meet the Marching Ants

When you create a selection, Photoshop calls up a lively army of animated "marching ants" (shown in Figure 4-1). These tiny soldiers dutifully march around the edge of the selected area, awaiting your command. You can select part of an image, everything on a single layer, or a whole document. Whenever you have an active selection (that is, whenever you see marching ants), Photoshop has eyes only for that portion of your document—any tool you use (except the Type and Shape tools) will affect only the area *inside* the selection.

Note: Selections don't hang around forever—when you click somewhere else on your screen (outside the selection) with a selection tool, your original selection disappears, forcing you to redraw it. If you want to save a selection to use again later, flip to page 180.

Figure 4-1:
To let you know an area is selected, Photoshop surrounds it with tiny, moving dashes that look like marching ants. Here you can see the ants running around the armadillo. (FYI, the nine-banded armadillo is the state animal of Texas. Aren't you glad you bought this book?)

Here are the commands you'll use most often when you make selections:

- **Select All.** This command selects your whole document and places marching ants around the perimeter, which is helpful when you want to copy and paste an entire image into another program or create a border around a photo (see page 183). To run this command, go to Select→All or press ⌘-A (Ctrl+A on a PC).

- **Deselect.** To get rid of the marching ants after you've finished working with the selection, choose Select→Deselect or press ⌘-D (Ctrl+D). Alternatively, if you've got one of the selection tools activated in the Tools panel, you can click once outside the selection to get rid of your selection.

- **Reselect.** To resurrect your last selection, choose Select→Reselect or press ⌘-Shift-D (Ctrl-Shift-D). This command reactivates the last selection you made, even if it was five filters and 20 brushstrokes ago (unless you've used the Crop and Type tools, which render the Reselect command powerless). Reselecting is helpful if you accidentally deselect a selection you've been working on for a long time. (The Undo command [⌘-Z or Ctrl+Z] can also help you in that situation.)

- **Inverse.** This command, which you run by going to Select→Inverse or pressing ⌘-Shift-I (Ctrl-Shift-I), lets you flip-flop a selection to select everything you *didn't* select before. You'll often find it easier to select what you *don't* want and then inverse the selection to get what you *do* want (see the box on page 155).

- **Load a layer as a selection.** When talking to people about Photoshop, you'll often hear the phrase "load as a selection," which is (unavoidable) Photoshop-speak for activating a layer that contains the object you want to work with and then summoning the marching ants so they run around that object; that way,

whatever you do next affects *only* that object. To load everything that lives on a single editable layer as a selection, mouse over to the Layers panel and ⌘-click (Ctrl+click) the layer's thumbnail (page 78); you don't need to have the layer selected. Photoshop responds by putting marching ants around everything on that layer. Alternatively, you can Ctrl-click (right-click on a PC) the layer's thumbnail and then choose Select Pixels from the resulting shortcut menu.

Tip: Although you can find most of the commands in this list in the Select menu at the top of your screen (except for loading a layer as a selection), you should memorize their keyboard shortcuts if you want to be smokin' fast in Photoshop.

These next three items live in the Select menu, but they don't actually call up marching ants. Instead, they tell Photoshop to select entire layers (for the lowdown on layers, see Chapter 3):

- **All Layers.** Use this command if you want to select every layer in your document (so you can move several layers at once, for example). To select all layers, choose Select→All Layers or press ⌘-Option-A (Ctrl+Alt+A).

- **Deselect Layers.** This command does the exact opposite of the previous one: It deselects all the layers in your Layers panel, leaving nary a layer highlighted. To run it, choose Select→Deselect Layers.

- **Similar Layers.** Choose this command if you want to select all layers of the same kind (page 76 lists the different types of layers). For example, say you want to change the font in all the Type layers in your document. Just select a Type layer and then choose Select→Similar. Photoshop selects all your Type layers and highlights them in the Layers panel so you can modify them all at once. (See Chapter 14 for more on Type layers.)

Tip: When you move objects around with the Move tool, you can enlist Photoshop's help in selecting individual layers by turning on Auto-Select in the Options bar. With this setting on, as you click an object in your document, Photoshop tries to guess which layer it's on and select that layer for you.

Now it's time to discuss the tools you can use to make selections. Photoshop has a ton of 'em, so in the next several pages, you'll find them grouped according to which *kind* of selections they're best at making.

Selecting by Shape

Selections based on shape are probably the easiest ones to make. Whether the object you need to grab is rectangular, elliptical, or rectangular with rounded corners, Photoshop has just the tool for you. You'll use the first couple of tools described in this section often, so think of them as your bread and butter when it comes to making selections.

The Rectangular and Elliptical Marquee Tools

Photoshop's most basic selection tools are the Rectangular and Elliptical Marquees. Anytime you need to make a selection that's squarish or roundish, reach for these little helpers, which live at the top of the Tools panel, as shown in Figure 4-2.

Figure 4-2:
You'll spend loads of time making selections with the Rectangular and Elliptical Marquee tools. To summon this pop-up menu, click the second item from the top of the Tools panel and hold down your mouse button until the menu appears.

To make a selection with either marquee tool, just grab the tool by clicking its icon in the Tools panel or by pressing M and then mouse over to your document. When your cursor turns into a tiny + sign, drag across the area you want to select (you'll see the marching ants appear as soon as you start to drag). Photoshop starts the selection where you clicked and continues it in the direction you drag as long as you hold down the mouse button. When you've got marching ants around the area you want to select, release the mouse button.

You can use a variety of tools and techniques to modify your selection, most of which you can find in the Options bar (Figure 4-3). For example, you can:

- **Move the selection.** Click anywhere within the selected area and drag to another part of your document (your cursor turns into a tiny arrow) to move the selection where you want it.

Tip: You can move a selection as you're drawing it by moving your mouse while pressing the mouse button *and* the space bar. When you've got the selection where you want it, release the space bar and continue drawing the selection.

- **Add to the selection.** When you click the "Add to selection" button in the Options bar (see Figure 4-3) or press and hold the Shift key, Photoshop puts a tiny + sign beneath your cursor to let you know it'll add whatever you select to your current selection. This mode is handy when you've selected *most* of what you want but notice that you missed a spot. Instead of starting over, you can switch to this mode and draw around that area as if you were creating a new selection. You can also use this mode to select areas that don't touch each other, like the irises in your dog's eyes (see page 456).

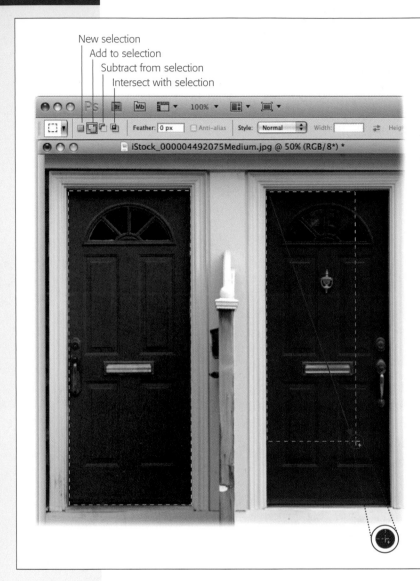

New selection
Add to selection
Subtract from selection
Intersect with selection

Figure 4-3:
Using the buttons in the Options bar, you can add to or subtract from a selection, as well as create a selection from two intersecting areas. Since all selections begin at the point where you first click, you can easily select one of these doors by dragging diagonally from the top-left corner to the bottom right as shown here. You can tell from the tiny + sign next to the crosshair-shaped cursor that you're in "Add to selection" mode, so this figure now has two selections: the blue door and the red door.

- **Subtract from the selection.** Clicking the Options bar's "Subtract from selection" button (also shown in Figure 4-3) or pressing and holding the Option key (Alt on a PC) has the opposite effect. You see a tiny – sign beneath your cursor to let you know you're in this mode. Mouse over to your document and draw a box (or oval) around the area you want to deselect.

- **Intersect one selection with another.** If you click the "Intersect with selection" button after you draw a selection, Photoshop lets you draw another selection that overlaps the first; the marching ants then surround only the area where the two selections overlap. It's a little confusing, but don't worry because you'll

rarely use this mode (if at all). The keyboard shortcut is Shift-Option (Shift+Alt on a PC). Photoshop puts a tiny multiplication sign (×) beneath your cursor when you use this mode.

- **Feather.** If you want to soften the edges of your selection so that it blends into the background or another image, use *feathering*. You can enter a value in pixels in this field *before* you create the selection. As you'll learn later in this chapter, feathering a selection lets you gently fade one image into another. See the box on page 145 for more on feathering.

- **Anti-alias.** Turn on the Anti-alias checkbox to make Photoshop smooth the color transition between the pixels around the edges of your selection and the pixels in the background. Like feathering, anti-aliasing softens your selection's edges slightly so that they blend better, though you can't control the *amount* of softening Photoshop applies. It's a good idea to leave this checkbox turned on unless you want your selection to have super crisp—and possibly jagged and blocky—edges.

- **Style.** If you want to constrain your selection to a fixed size or aspect ratio (so that the relationship between its width and height stays the same), you can select Fixed Width or Fixed Ratio from the Style pop-up menu and then enter the size you want in the resulting width and height fields. (Be sure to enter a unit of measurement into each field, such as *px* for pixels.) If you leave the Normal option selected, you can draw any size selection you want.

Here's how to select two doors in the same photo, as shown in Figure 4-3:

1. **Click the marquee tool icon in the Tools panel and choose the Rectangular Marquee from the pop-up menu (shown in Figure 4-2).**

 The Tools panel remembers which marquee tool you last used, so you'll see that tool's icon on top of the selection tools pop-up menu. If that's the one you want to use, just press M to activate it. If not, in the Tools panel, click and hold whichever marquee tool is showing until the pop-up menu appears and then choose the tool you want.

Tip: To cycle between the Rectangular and Elliptical Marquee tools, press M to activate the marquee toolset and then press Shift-M to activate each one in turn. If that doesn't work, make sure that a gremlin hasn't turned off the preference that makes this trick possible. Choose Photoshop→Preferences→General (Edit→Preferences→General on a PC) and make sure the "Use Shift Key for Tool Switch" checkbox is turned on.

2. **Drag to draw a box around the first door.**

 To select the blue door shown in Figure 4-3, click its top-left corner and drag diagonally toward its bottom-right corner. When you get the whole door in your selection, release the mouse button. Don't worry if you don't get the selection in exactly the right spot; you can move it around in the next step.

3. **Move your selection into place if necessary.**

 If you need to move the selection, just click *inside* the selected area (your cursor turns into a tiny arrow) and drag the selection box where you want it. You can also use the arrows on your keyboard to nudge the selection in one direction or another (you don't need to click it first).

4. **Press the "Add to selection" button in the Options bar and then select the second door by drawing a selection around it.**

 Photoshop lets you know that you're in "Add to selection" mode by placing a tiny + sign beneath your cursor. Once you see it, mouse over to the second door and drag diagonally from its top-left corner to its bottom right, as shown in Figure 4-3.

 If you need to move this second selection around, do that *before* you release the mouse button or you'll end up moving both selections instead of just one. To move a selection while you're drawing it, hold down your mouse button, press and hold the space bar, and then move your mouse to move the selection. When you've got the selection in the right place, release the space bar—but keep holding the mouse button—and continue dragging to draw the selection. This maneuver feels a bit awkward at first, but you'll get used to it with practice.

Congratulations! You've just made your first selection and added to it. Way to go!

Tip: To draw a perfectly square or circular selection, press and hold the Shift key as you drag with the Rectangular or Elliptical Marquee tool, respectively. If you want to draw the selection from the center outward (instead of from corner to corner), press and hold the Option key (Alt on a PC). If you want to draw a perfectly square or circular selection from the center outward, press and hold Shift-Option (Shift+Alt) as you drag with either tool. Whew—that's a lot of keys! Be sure to use this trick only on new selections—if you've already got a selection, the Shift key pops you into "Add to selection" mode.

Creating a soft vignette

The Elliptical Marquee tool works just like the Rectangular Marquee tool except that it draws round or oval selections. It's the perfect tool for selecting eyes, circling yourself in a group photo (page 184), or creating the ever-popular, oh-so-romantic, soft oval vignette shown in Figure 4-4.

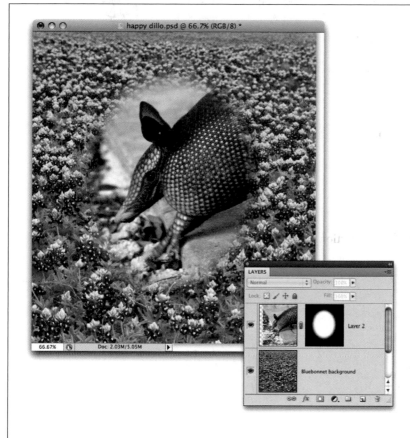

Figure 4-4:
Figure 4-4:
By feathering a selection you've made with the Elliptical Marquee tool and adding a layer mask (page 113), you can create a quick two-photo collage like this one. Wedding photographers and moms—not to mention armadillo fans— love this kind of thing!

If you forget to feather your selection before you add a layer mask, not to worry: you can always use the Masks panel (page 120) to do it after the fact. Just click to select the mask thumbnail and then choose Window→Masks. When the Masks panel opens, drag the Feather slider slightly to the right to give it a soft edge.

Once you get the hang of this technique, try creating it using the Ellipse Shape tool set to draw in path mode instead, as described in the section on shape tools later in this chapter. It's a little bit quicker and slightly more efficient!

Here's how to create a soft oval vignette:

1. **Open two images and combine them into one document.**

 Simply drag one image from its Layers panel into the other document's window, as shown on page 101.

2. **Reposition the layers so the soon-to-be-vignetted photo is at the top of the Layers panel.**

 Over in the Layers panel, make sure that both layers are editable so you can change their stacking order. If you see a tiny padlock to the right of either layer's name, double-click that layer in the Layers panel to make it editable. Then drag the layer containing the photo you want to vignette (in Figure 4-4, that's the picture of the armadillo) to the top of the Layers panel.

3. **Grab the Elliptical Marquee tool and select the part of the image you want to vignette (here, the armadillo's head).**

 Peek at your Layers panel to make sure the correct photo layer is selected (the armadillo) and position your mouse near the center of the image. Press and hold the Option key (Alt on a PC), mouse over to the image, and drag to draw an oval-shaped selection from the inside out. When you've got the selection big enough, release the Option (or Alt) key and your mouse button.

4. **Feather the selection's edges by clicking the Refine Edge button in the Options bar.**

 In the resulting dialog box, make sure all the sliders are set to 0 and then drag the Feather slider to the right. If you want to see what the feathered edge will look like, release your mouse button and take a peek at your document—you'll see the newly softened edge against a temporary white background. If you want to preview the feather against a different background, click any of the other preview buttons toward the bottom of the dialog box. (Page 166 covers the Refine Edge dialog box in greater detail.) When it looks good, click OK to close the dialog box.

5. **Hide the area outside the selection with a layer mask.**

 You *could* simply inverse the selection (page 155) and then press the Delete key (Backspace on a PC) to zap the area outside the selection, but that'd be mighty reckless. What if you changed your mind? You'd have to undo several steps or—curses—start over completely! A less destructive and more flexible approach, which you learned about back on page 113, is to *hide* the area outside the selection with a layer mask. Over in the Layers panel, make sure you have the correct layer selected (in this case, the armadillo) and then add a layer mask by clicking the tiny circle-within-a-square icon at the bottom of the Layers panel (you can also use the Mask panel's Feather slider to soften the mask's edge, if you happened to skip the previous step of feathering the selection). Photoshop hides everything outside the selection area, letting you see through to the bluebonnet layer below. Beautiful!

That armadillo looks right at home, doesn't he? You'll want to memorize these steps because this method is perhaps the easiest—and most romantic!—way to combine two images into a new and unique piece of art (although starting on page 146 you'll learn how to use the vector Shape tools to do the same thing).

The Single Row and Column Marquee Tools

The Marquee toolset also contains the Single Row Marquee and Single Column Marquee tools, which can select exactly one row or one column's worth of pixels, spanning either the width or the height of your document. You don't need to drag with your mouse to create a selection with these tools; just click once in your document and the marching ants appear.

Now, you may be asking, "When would I want to do that?" Not often, it's true, but consider these circumstances:

- **Mocking up a web page design.** If you need to simulate a column or row of space between certain areas in a web page, you can use either tool to create a selection that you fill with the website's background color, or you can just delete the existing pixels by pressing the Delete key (Backspace on a PC).

FREQUENTLY ASKED QUESTION

The Softer Side of Selections

How come my selections always have hard edges? Can I make them soft instead?

When you first install Photoshop, any selection you make has a hard edge, but you can apply *feathering* to soften it up. Feathered selections are perfect for blending one image—or a portion of an image—into another, as in the soft oval vignette effect, an oldie but goody shown on page 142. You can also feather a selection when you re-touch an image, so the retouched area fades gently into the surrounding pixels, making it look more realistic. This technique is especially helpful when you're whitening teeth (page 436), fixing animal white-eye (page 456), or swapping heads (page 179). You can feather a selection, either before or after you've created it, in a variety of ways:

After you choose a selection tool from the Tools panel—but *before* you draw your selection—hop up to the Options bar and enter a Feather amount in pixels (you can enter whole numbers or decimals, like *0.5*). Feathering by just a few pixels blurs and softens the selection's edges only slightly, whereas increasing the Feather setting creates a wider, more intense blur and a super-soft edge.

After you draw the selection, you can change the Feather setting either by choosing Select→Modify→Feather and then entering a number of pixels or by Ctrl-clicking (right-clicking on a PC) the selection and choosing Feather from the resulting shortcut menu.

However, by far the best method is to use the Refine Edge dialog box, which lets you *see* what the feathered edge will look like before you commit to it. To use this method, draw a selection and then head up to the Options bar and click the Refine Edge button. The dialog box that appears has five preview buttons that show a loopy metallic ring. Click one of these buttons to put a temporary background behind your selection (making its edges more visible) and then adjust the Feather slider to your liking. Once you've got the feather just right, press OK to dismiss the dialog box.

Note that the settings in the Refine Edges dialog box are "sticky," meaning that once you change them, they stay changed until you modify them again. For that reason, you should set the other sliders to 0 to keep your selection from changing in unexpected ways. (Page 166 has more about the Refine Edge dialog box.)

You won't notice a change to your marching ants (unless you enter a *huge* amount of feathering on a rectangular selection, which makes the corners look rounded), but, rest assured, Photoshop has indeed feathered your selection. Once you delete the rest of the image (or hide it with a layer mask, as shown on page 143), you'll see the newly softened edges.

- **Stretching an image to fill a space.** If you're designing a web page, for example, you can use these tools to extend the image by a pixel or two. Use either tool to select a row of pixels at the bottom or side of the image, grab the Move tool by pressing V, and tap the arrow keys on your keyboard while holding the Option key (Alt on a PC) to nudge the selection in the direction you need and duplicate it at the same time. However, a better option might be to use Content-Aware Scale (see page 258).

- **Making an image look like it's melting or traveling through space at warp speed.** You can use either tool to create a selection and then stretch it with the Free Transform tool (see Figure 4-5).

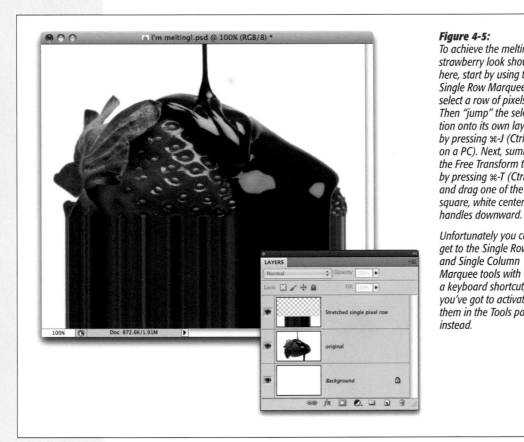

Figure 4-5:
To achieve the melting strawberry look shown here, start by using the Single Row Marquee to select a row of pixels. Then "jump" the selection onto its own layer by pressing ⌘-J (Ctrl+J on a PC). Next, summon the Free Transform tool by pressing ⌘-T (Ctrl+T), and drag one of the square, white center handles downward.

Unfortunately you can't get to the Single Row and Single Column Marquee tools with a keyboard shortcut; you've got to activate them in the Tools panel instead.

The Vector Shape Tools

Okay, *technically*, vector shapes aren't selection tools at all, but you can use them to create selections (turn to page 551 to learn more about vector shapes). Once you get the hang of using them (as this section shows you) you'll be reaching for 'em all the time.

Perhaps the most useful of this bunch is the Rounded Rectangle tool. If you ever need to select an area that's rectangular but has rounded corners, the Rounded Rectangle tool is your best bet. If you're creating an ad for a digital camera, say, you can use this technique in a product shot to swap the image shown on the camera's display screen with a different image. Or more practically, you can use it to give your photos rounded corners, as shown in Figure 4-6.

Figure 4-6:
If you're tired of boring, straight corners on your images, use the Rounded Rectangle tool to produce smooth corners like the ones shown here.

Here's how to round the corners of your photos:

1. **Open a photo and double-click the Background layer to make it editable.**

 Because you'll add a mask to the photo layer in step 6, you need to make sure the Background layer is unlocked or Photoshop won't let you add the mask.

2. **Select the Rounded Rectangle tool from the Tools panel.**

 Near the bottom of the Tools panel is the Vector Shape toolset. Unless you've previously selected a different tool, you'll see the Rectangle tool's icon. Click the icon and hold down your mouse button until the pop-up menu appears and then choose the Rounded Rectangle tool.

Tip: To cycle through all the shape tools, press Shift-U repeatedly.

3. **In the Options bar, click the Paths mode button and change the Radius field to 40 pixels.**

 As you'll learn on page 551, the vector Shape tools can operate in various modes, which you set in the Options bar. For this particular technique, you need to make sure that the Rounded Rectangle tool is in Paths mode (the button looks like a square with a tiny dot on each corner with a pen in the center). Next, change the number in the Options bar's Radius field, which controls how rounded the image's corners will be: the lower the number, the less rounded; the higher the number, the more rounded. This field was set to 40 pixels to create the corners shown in Figure 4-6.

4. **Draw a box around the image.**

 Mouse over to your image and, starting in one corner, drag diagonally to draw a box around it. When you let go of the mouse button, Photoshop creates a thin gray line that appears atop your image called a *path* (you'll learn more about paths in Chapter 13). If you need to move the box, while you're drawing it, press and hold the space bar. If you want to move it after you've drawn it, press A to grab the Path Selection tool (it looks like a black arrow and lives below the Type tool in the Tools panel), click the path to select it, and then drag to move it wherever you want.

5. **Hide the area outside the path by adding a layer mask.**

 Over in the Layers panel, click the photo layer once to select it and then add a *vector* layer mask by ⌘-clicking (Ctrl-clicking) the tiny circle-within-a-square icon at the bottom of the Layers panel. Photoshop hides the old, boring square photo edges. Why a vector mask, you ask? Because the path you drew with the Shape tool is *vector* in nature, not pixel-based. As you learned on page 52, you can resize a vector without losing quality anytime you want by selecting it and using Free Transform (page 263). Sweet! For more on vector masks, skip ahead to page 572.

Who knew that giving your photo rounded corners was so simple?

Tip: You can use the same technique with the Ellipse Shape tool to create the vignette shown in the previous section. You can also feather the mask after you've made it by choosing Window→Masks to open the Masks panel, and then dragging the Feather slider to the right.

Selecting by Color

In addition to giving you tools to select areas by shape, Photoshop lets you select areas by color. This option is helpful when you want to select a chunk of an image that's fairly uniform in color, like someone's skin, the sky, or the paint job on a car. Photoshop has lots of tools to choose from, and in the next several pages, you'll learn how to pick the one that best suits your needs.

The Quick Selection Tool

The Quick Selection tool is shockingly easy to use and lets you create complex selections with a few strokes of an adjustable brush. As you paint with the Quick Selection tool, your selection expands outward to encompass pixels similar in color to the ones you're brushing across. It works insanely well if there's a fair amount of contrast between what you want to select and everything else. This tool lives in the same toolset as the Magic Wand (page 151), as you can see in Figure 4-7.

Add to selection
New Selection | Subtract from selection

Figure 4-7:
When you activate the Quick Selection tool, the Options bar sports buttons that let you create a new selection and add to or subtract from the current selection.

You can press the W key to activate the Quick Selection tool. To switch between it and the Magic Wand, press Shift-W.

To use this wonderfully friendly tool, click anywhere in the area you want to select or *drag* the brush cursor across it, as shown in Figure 4-8. When you do that, Photoshop thinks for a second and then creates a selection based on the color of the pixels you clicked or brushed across. The size of the area Photoshop selects is proportional to the size of the brush you're using: a larger brush creates a larger selection. You can adjust the Quick Selection tool's brush size just like any other brush: by choosing a new size from the Brush Preset picker in the Options bar, or by using the keyboard shortcut discussed in the Tip on page 117. (Chapter 12 covers brushes in detail.) For the best results, use a hard-edged brush to produce defined edges (instead of the slightly transparent edges produced by a soft-edge brush) and turn on the Auto-Enhance setting shown in Figure 4-7 and discussed in the box on page 151.

Figure 4-8:
If the color of the objects you want to select differs greatly from the color of their background, like these chili peppers, take the Quick Selection tool for a spin. With this tool activated, you can either single-click the area you want to select or drag your cursor (circled) across the area as if you were painting. When the tool is in "Add to selection" mode, you see a tiny + sign inside the cursor, as shown here. This mode lets you add to an existing selection or make multiple selections.

When you activate the Quick Selection tool, the Options bar offers three modes (see Figure 4-7):

- **New selection.** When you first grab the Quick Selection tool, it's automatically set to create a brand-new selection, which is helpful since creating a new selection is sort of the whole point.

- **Add to selection.** Once you've clicked or made an initial brushstroke, the Quick Selection tool automatically goes into "Add to selection" mode (indicated by the tiny + sign inside the cursor, as shown in Figure 4-8). Now Photoshop adds any additional areas you brush over or click to your current selection. If you don't like the selection Photoshop has created and want to start over, press ⌘-Z (Ctrl+Z on a PC) to undo it, or click the Options bar's "New selection" button and then brush across the area again. (The old selection disappears as soon as you start to make a new one.) To get rid of the marching ants altogether, choose Select→Deselect.

- **Subtract from selection.** Adding to a selection can make Photoshop select more than you really want it to. If you have this problem, click the "Subtract from selection" button (a tiny – sign appears in your cursor) and then simply paint across the area you *don't* want selected to make Photoshop exclude it.

Note: To get the most out of the Quick Selection tool, you'll probably need to do a fair amount of adding to and subtracting from your selections. Keyboard shortcuts can help speed up the process: Press and hold the Shift key to enter "Add to selection" mode. Press and hold the Option key (Alt on a PC) to enter "Subtract from selection" mode. If these shortcuts sound familiar, they should—they're identical to the marquee tools' keyboard shortcuts.

- **Brush Size.** Use a larger brush to select big areas and a smaller brush to select small or hard-to-reach areas. As explained earlier, you'll get better results with this tool by using a hard-edged brush instead of a soft-edged one.

Tip: You can change a brush cursor's size by dragging: press Ctrl-Option and drag to the left or right (right-click+Alt on a PC). You can also decrease the brush size by pressing the left bracket key ([) or increase it by pressing the right bracket key (]).

- **Sample All Layers.** This setting is initially turned off, which means Photoshop examines only the pixels on the active layer (the one that's selected in your Layers panel). If you turn on this setting, Photoshop examines the whole enchilada—everything in your document—and grabs all similar pixels no matter which layer they're on.

- **Auto-Enhance.** Because the Quick Selection tool makes selections extremely fast, their edges can end up looking blocky and imperfect. To tell Photoshop to take its time and think more carefully about the selections it makes, turn on the Options bar's Auto-Enhance checkbox. This feature gives your selections smoother edges, but if you're working with a really big file, you could do your taxes while it's processing. The box below has tips for using this feature.

WORKAROUND WORKSHOP

Smart Auto-Enhancing

The Quick Selection tool's Auto-Enhance feature is pretty cool, but it's a bit of a processing hog and you need a fast computer to use it on anything but the smallest images. If you have an older computer, you may have better luck using the Refine Edge dialog box (page 166) to create selections with smooth edges.

That being said, you don't have to avoid Auto-Enhance altogether. When you're working with a large file (anything over 5 MB), try leaving the Options bar's Auto-Enhance checkbox turned off until you're *almost* finished making the selection. When you've got just one or two brushstrokes left to complete your selection, turn on the checkbox to make Photoshop re-examine all the edges it's already created for your selection to see if it needs to extend them. That way, you get the benefit of using Auto-Enhance and keep your computer running quickly until the last possible moment.

The Magic Wand

The Magic Wand lets you select areas of color by clicking (rather than dragging). It's in the same toolset as the Quick Selection tool, and you can grab it by pressing Shift-W (it looks like a wizard's wand, as shown back in Figure 4-7). Use the Magic Wand to select solid-colored backgrounds or large bodies of similar color, like a cloudless sky, with just a couple of clicks. The Quick Selection tool, in contrast, is better at selecting objects rather than big swaths of color.

When you click once with the Magic Wand in the area you want to select, Photoshop magically (hence the name) selects all the pixels on the currently selected layer that are both similar in color *and* touching one another (see page 153 to learn how to tweak this behavior). If the color in the area you want to select varies a bit, Photoshop may not select all of it. In that case, you can add to the selection either by pressing and holding the Shift key as you click nearby areas or by modifying the Magic Wand's *tolerance* in the Options bar as described later in this section and shown in Figure 4-9. To subtract from your selection, just press and hold the Option key (Alt on a PC) while you click the area you don't want included.

Figure 4-9:
With its tolerance set to 32, the Magic Wand did a good job of selecting the sky behind downtown Dallas.

You've got several ways to select the spots it missed like the area circled at the bottom left: You can add to the selection by pressing the Shift key as you click in that area, increase the tolerance setting in the Options bar and then click the sky again to create a new selection, or skip to page 154 to learn how to expand your selection with the Grow and Similar commands.

When you activate the Magic Wand, the Options bar lets you adjust the following settings:

- **Tolerance.** This setting controls the Magic Wand's sensitivity—how picky the tool is about which pixels it considers similar in color. If you increase this setting, Photoshop gets less picky (in other words, more tolerant) and selects every pixel that could possibly be described as similar to the one you originally clicked. If you decrease this setting, Photoshop gets pickier and selects only pixels that closely match the original.

 Out of the box, the tolerance is set to 32, but it can go all the way up to 255. (If you set it to 0, Photoshop selects only pixels that *exactly* match the one you clicked; if you set it to 255, the program selects every color in the image.) It's usually a good idea to keep the tolerance set fairly low (somewhere between 12 and 32); you can always click an area to see what kind of selection you get, increase the tolerance if you need to, and then click the area again (or add to the selection using the Shift key, as described above).

Note: When you adjust the Magic Wand's tolerance, Photoshop won't automatically rethink your current selection. You have to click the area again to make Photoshop recalculate its selection.

- **Anti-alias.** Leave this setting turned on to make Photoshop soften the edges of your selection ever so slightly. If you want a super-crisp edge, turn it off.

- **Contiguous.** You'll probably want to leave this checkbox turned on; it makes the Magic Wand select pixels that are adjacent to one another. If you turn this setting off, Photoshop goes hog wild and selects all similar-colored pixels no matter where they are.

- **Sample all layers.** If your document has multiple layers and you leave this checkbox turned off, Photoshop examines only pixels on the active layer and ignores the pixels on other layers. If you turn this setting on, Photoshop examines the whole image and selects all pixels that are similar in color, no matter which layer they're on.

GEM IN THE ROUGH

Changing the Magic Wand's Sample Size

Did you know you can change the way the Magic Wand calculates which pixels to select? Of course, you didn't; that's because the setting that controls the Magic Wand's selections appears only when you have the *Eyedropper tool* selected. (Makes perfect sense, doesn't it?) You can read about the Eyedropper tool on page 495, but here's what you need to know about it to tweak the Magic Wand:

Over in the Tools panel, select the Eyedropper tool (its icon, not surprisingly, looks like an eyedropper; it lives beneath the Crop tool). When you do that, a Sample Size pop-up menu containing a slew of settings appears in the Options bar.

From the factory, the Sample Size menu is set to Point Sample, which makes the Magic Wand look only at the color of the pixel you clicked when determining its selection.

However, the menu's other options cause it to look at the original pixel *and* average it with the colors of surrounding pixels.

Depending on which option you choose, you can make the Magic Wand average the pixel you clicked plus the eight surrounding pixels (by choosing "3 by 3 Average") or as much as the surrounding 10,200 pixels (by choosing "101 by 101 Average"). The "3 by 3 Average" setting works well for most images. If you need to select a really big area, you can experiment with one of the higher settings like "31 by 31 Average".

After you make your selection, simply activate the Magic Wand and then click somewhere in your image to see the effect of the new setting. It's that simple.

Expanding your selection

Sometimes the Magic Wand makes a *nearly* perfect selection, leaving you with precious few pixels to add to it. If this happens, it simply means that the elusive pixels are just a little bit lighter or darker in color than what the Magic Wand's tolerance setting allows for. You could Shift-click the elusive areas to add them to your selection,

but the Select menu has a couple of options that can quickly expand the selection for you:

- **Choose Select→Grow** to make Photoshop expand your selection to all similar-colored pixels adjacent to the selection (see Figure 4-10, top).

- **Choose Select→Similar** to make Photoshop select similar-colored pixels throughout the *whole* image even if they're not touching the original selection (see Figure 4-10, bottom).

Note: Because both these commands base their calculations on the Magic Wand's tolerance setting (page 152), you can adjust their sensitivity by adjusting that setting in the Options bar. You also can run these commands more than once to get the selection you want.

Figure 4-10:
Top: Say you're trying to select the red part of this Texas flag. After clicking once with the Magic Wand (with a tolerance of 32), you still need to select a bit more of the red (left). Since the red pixels are all touching each other, you can run the Grow command a couple of times to make Photoshop expand your selection to include all the red (right).

Bottom: If you want to select the red in these playing cards (what a poker hand!), the Grow command won't help because the red pixels aren't touching each other. In that case, click once with the Magic Wand to select one of the red areas (left) and then use the Similar command to grab the rest of them (right). Read 'em and weep, boys!

The Color Range Command

The Color Range command is similar to the tools in this section in that it makes selections based on colors, but it's much better at selecting areas that contain lots of details (for example, the flower bunches in Figure 4-11). The Magic Wand tends to select *whole* pixels, whereas Color Range is more fine-tuned and tends to select more partial pixels than whole ones. This fine-tuning lets Color Range produce selections

with smoother edges (less blocky and jagged than the ones you get with the Magic Wand) and get in more tightly around areas with lots of details. As a bonus, you also get a handy preview in the Color Range dialog box, showing you which pixels it'll select before you commit to the selection (unlike the Grow and Similar commands discussed on page 154).

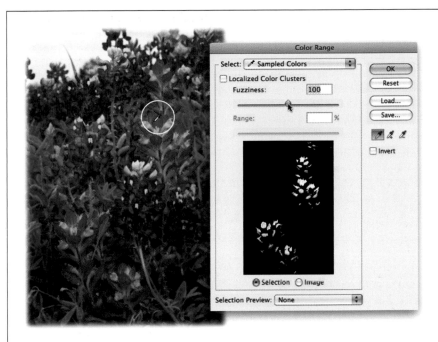

Figure 4-11:
The Color Range command is handy when you need to select an area with a lot of details, like the red and blue petals of these flowers. The image in the dialog box's preview area shows the part that Photoshop will select when you click the OK button.

UP TO SPEED

Selecting the Opposite

You'll often find it easier to select what you *don't* want in order to get the selection you really *do* want. For example, look back at the photo of the Dallas skyline shown in Figure 4-9 (page 152). If you want to select the buildings, it's easier to select the sky because its color is practically uniform. (It'd take you a lot longer to select the buildings because they're irregularly shaped and vary so much in color.)

After grabbing the sky, you can inverse (flip-flop) your selection to select the buildings instead. Simply choose Select→Inverse or press Shift-⌘-I (Shift+Ctrl+I on a PC). The lesson here is that it pays to spend a few moments studying the area you want to select and the area *around* it. If the color of the surrounding area is uniform, reach for one of the tools described in this section and then inverse your selection to save yourself tons of time!

Open the Color Range dialog box by choosing Select→Color Range, either before or after you make a selection. If you already have a selection, Photoshop looks only at the pixels within the selected area, which is helpful if you want to isolate a certain area. For example, you could throw a quick selection around the red flower shown in the center of Figure 4-11 and use Color Range's subtract from selection capabilities (explained later in this section) to carve out just the red petals. By contrast, if you want to use Color Range to help expand your selection, press and hold the Shift key while you choose Select→Color Range. If you haven't yet made a selection, Color Range examines your entire image.

Use the Select pop-up menu at the top of the Color Range dialog box to tell Photoshop which colors to include in your selection. The menu is automatically set to Sampled Colors, which lets you mouse over an image (your cursor turns into a tiny eyedropper; see Figure 4-11) and click the color you want to select. If you change the Select menu's setting to Reds, Blues, Greens, or whatever, Color Range will examine your image and grab that range of colors all by itself—once you click OK.

Note: As mentioned in the box on page 155, it's sometimes easier to select what you *don't* want in order to get the selection you need. The Color Range dialog box lets you select what you don't want by turning on the Invert checkbox.

If you're trying to select adjacent pixels, turn on Localized Color Clusters. You can tweak the area Photoshop selects by adjusting the Fuzziness setting. Its factory setting is 40, but you can change this number to anything between 0 and 200. If you increase it, Photoshop includes more colors and makes larger selections. If you lower it, Photoshop creates a smaller selection because it gets pickier about matching colors. As you move the Fuzziness slider (or type a number in the text box), keep an eye on the dialog box's preview area—all the parts of the image that Photoshop will include in your selection appear white (see Figure 4-11).

Use the eyedroppers on the dialog box's right side to add or subtract colors from your selection; the eyedropper with the tiny + sign adds to your selection and the one with the – sign subtracts from it. (Use the plain eyedropper to make your initial selection.) When you click one of the eyedroppers, mouse over to your image, and then click the color you want to add or subtract, Photoshop updates the Color Range dialog box's preview area to show what the new selection looks like. It sometimes helps to keep the Fuzziness setting fairly low (around 50 or so) while you click repeatedly with the eyedropper.

Tip: You can use the radio buttons beneath the Color Range dialog box's preview area to see either the selected area (which appears white) or the image itself. But there's a better, faster way to switch between the two views: With Selection turned on, press the ⌘ key (Ctrl on a PC) to switch temporarily to Image preview. When you let go of the key, you're back to Selection preview.

The Selection Preview pop-up menu at the bottom of the dialog box lets you display a selection preview on the image itself so that, instead of using the dinky preview in the dialog box, you can see your proposed selection right on your image. But you'll probably want to leave this menu set to None because the preview options that Photoshop offers (Grayscale, Black Matte, and so on) get really distracting!

The Background and Magic Erasers

These two tools let you erase parts of your image based on the color you touch with your cursor. You're probably thinking, "Hey, I want to create a selection, not go around erasing stuff!" And you have a valid point except that, after you've done a little erasing, you can always *load* that area as a selection. All you have to do is think ahead and create a duplicate layer before you start erasing, as this section explains.

Say you have an image with a decent amount of contrast between the item you want to keep and its background, like a dead tree against the sky. In that case, Photoshop has a couple of eraser tools that can help you erase the sky super fast (see Figure 4-12). Sure, you could use the Magic Wand or Quick Selection tool to select the sky and then delete or mask it (page 113), but using the Background Eraser lets you erase more carefully around the edges and then add a layer mask to hide the rest of it.

Figure 4-12:
You may never see these tools because they're hidden inside the same toolset as the regular Eraser tool. Just click and hold the Eraser tool until the little pop-up menu appears. Pick an eraser based on how you want to use it: You drag to erase with the Background Eraser (as if you were painting, which is great for getting around the edges of an object), whereas you simply click with the Magic Eraser.

Tip: The Eraser tool's keyboard shortcut is the E key. To switch among the various eraser tools, press Shift-E repeatedly.

The Background Eraser

This tool lets you delete an image's background by painting (dragging) across the pixels you want to delete. When you activate the Background Eraser by choosing it from the Tools panel, your cursor turns into a circle with a tiny crosshair in its center. This crosshair controls which pixels Photoshop deletes, so be extra careful and let it touch *only* the pixels you want to erase. Up in the Options bar, you can tweak the following settings for this tool (see Figure 4-13):

- **Brush Preset picker.** This is where you choose the shape and size of your brush. For best results, stick with a soft-edged brush. Just click the down-pointing triangle next to this menu to grab one.

Continuous sample | Sample once | Sample background swatch | Tablet pressure controls brush size

Limits: Contiguous | Tolerance: 50% | Protect Foreground Color

Santa Fe tree.psd @ 66.7% (Layer 0, RGB/8*) *

Figure 4-13:
Even though the Background Eraser is destructive because it erases pixels, you can use it in a nondestructive way by remembering to duplicate the soon-to-be-erased layer first. Then load the erased layer as a selection and use it as a layer mask on the original layer. As you can see here, Photoshop pays attention only to the color you touch with the crosshair in the center of the brush; even though the tree's branches are within the brush area (the circle), Photoshop deletes only the blue pixels.

If you want to practice erasing this background, download DeadTree.jpg from this book's Missing CD page at www.missingmanuals.com/cds.

- **Sampling.** Made up of three buttons whose icons all include eyedroppers, this setting controls how often Photoshop looks at the color the crosshair is touching to decide what to erase. If your background has a lot of color variations, leave this set to Continuous so Photoshop keeps a constant watch on what color pixels the crosshair is touching. If the color of background you're erasing is fairly uniform, change this setting to Once and Photoshop then checks the color the crosshair touches just once and resolves to erase only pixels that closely match it. If you're dealing with an image with only a small area for you to paint (like a tiny portion of sky showing through a lush tree), you can change this setting to Background Swatch, which instructs Photoshop to erase only the color of your current background color chip. To choose the color, click the background color chip at the bottom of your Tools panel (page 24), mouse over to your image, and then click an area whose color is similar to the color you want to erase.

- **Limits.** When you first launch Photoshop, you'll find this field set to Contiguous, which means you can erase only pixels adjacent to those that you touch with the crosshair. If you want to erase similar-colored pixels elsewhere in your image (for example, the background behind a really thick tree or a bunch of flowers), change this setting to Discontiguous. Find Edges also erases adjacent pixels, but it does so while preserving the sharpness of the object's edge.

- **Tolerance.** This setting works just like the Magic Wand's Tolerance setting (page 152): Choosing a lower number makes the tool pickier about the pixels it selects, whereas a higher number makes it less picky.

- **Protect Foreground Color.** If you can't seem to get the Tolerance setting high enough and you're still erasing some of the area you want to keep, turning on this checkbox can help. When it's on, you can tell Photoshop which area you want to keep (the foreground) by Option-clicking (Alt-clicking on a PC) that area. If the area you want to keep is a different color in different parts of your image, you can turn this setting off or Option-click (Alt-click) to resample the foreground area.

Here's how to use the Background Eraser to erase the sky behind a dead tree *without* harming the original pixels, as shown in Figure 4-13:

1. **Open a photo and double-click its Background layer to make it editable (page 85) and then duplicate the Background by pressing ⌘-J (Ctrl+J on a PC).**

 Since you'll add a layer mask to the original layer in the last step of this list, you need to unlock the Background to make it editable. And because you'll do your erasing on the duplicate layer, you don't need to see the original layer. Over in the Layers panel, click the little visibility eye to the left of the original layer's thumbnail to turn it off.

2. **Grab the Background Eraser tool and paint away the background.**

 The Background Eraser tool is in the same toolset as the Eraser tool (see Figure 4-12). Once you've activated it, mouse over to your document and your cursor morphs into a circle with a tiny crosshair in the center. Remember that the trick is to let the crosshair touch *only* the pixels you want to erase (it doesn't matter what the circle part of the cursor touches, as Figure 4-13 shows). If you need to, you can increase and decrease your brush size by pressing the left and right bracket keys on your keyboard, respectively.

3. **If the tool is erasing too much or too little of your image, tweak the Tolerance setting in the Options bar (also shown in Figure 4-13).**

 If an area in your image is *almost* the same color as the background, lower the tolerance to make the tool pickier about the colors it's erasing; that way, it erases only pixels that closely match the ones you touch with the crosshair. Likewise, if it's not erasing enough of the background, raise the tolerance to make it less picky about the pixels it zaps.

Tip: It's better to erase small sections at a time instead of painting around the entire object in one continuous stroke. Hold your mouse button to erase a bit of the area around the object, let go of the button, click again to erase a little more, and so on. That way, if you need to undo your erasing using the History panel (page 27) or the Undo command (⌘-Z; Ctrl+Z on a PC), you won't have to watch *all* that erasing unravel before your eyes.

4. **Once you get a clean outline around the object, switch to the regular Eraser tool (page 284) or the Lasso tool (page 162) to get rid of the remaining background.**

 After you erase the hard part—the area around the edges—with the Background Eraser, you can use the regular Eraser tool, set to a large brush, to get rid of the remaining background quickly. You can also use the Lasso tool to select the remaining areas and then press the Delete key (Backspace on a PC) to get rid of them.

5. **Load the erased layer as a selection and turn off its visibility.**

 Over in the Layers panel, ⌘-click (Ctrl-click on a PC) the thumbnail of the layer you did the erasing work on to create a selection around the tree. When you see the marching ants, click the layer's visibility eye to turn it off.

6. **Select the original layer, turn on its visibility, and then put a layer mask over it.**

 In the Layers panel, click once to select the original layer (the unlocked Background) and then click the area to the left of its thumbnail to make it visible again. While you have marching ants running around the newly erased area, add a layer mask (page 113) to the original layer by clicking the circle-within-a-square icon at the bottom of the Layers panel.

You're basically done at this point, but if you need to do any cleanup work (if the Background Eraser didn't do a perfect job getting around the edges, say), now's the time to edit the layer mask. To edit the mask, click its layer thumbnail over in the Layers panel. Then press B to grab the Brush tool and set your foreground color chip to black (page 24). Now, when you brush across your image, you'll hide more of the sky. If you need to reveal more of the tree, set your foreground color chip to white, and then paint the area you want to reveal. (See page 113 for a detailed discussion of creating and editing layer masks.)

Sure, duplicating the layer you're erasing takes an extra step, but that way you're not deleting any pixels—you're just hiding them with a layer mask, so you can get them back if you want to. How cool is that?

Note: Ever heard the expression, "Out with the old and in with the new"? Well, that's sort of what happened to the Extract filter. Honestly, you're better off learning to use Photoshop CS5's enhanced Refine Edge dialog box (page 166), but you can wrestle the old Extract filter back into the 32-bit version of the program if you can't live without it. Visit this book's Missing CD page at *www.missingmanuals.com/cds* to learn how.

The Magic Eraser

This tool works just like the Background Eraser except that, instead of a brush cursor that you paint with, you get a cursor that looks like a cross between the Eraser tool and the Magic Wand. Just as the Magic Wand can select color with a single click, the

Magic Eraser can *zap* color with a single click, so it's great for erasing big areas of solid color instantly. Since this tool is an eraser, it really will delete pixels, so you'll want to duplicate your Background layer before using it.

You can alter the Magic Eraser's behavior by adjusting these Options bar settings:

- **Anti-alias.** Turning this checkbox on makes Photoshop slightly soften the edges of your selection.

- **Contiguous.** If you want to erase pixels that touch each other, leave this checkbox turned on. If you want to erase similar-colored pixels no matter where they are in your image, turn it off.

- **Sample All Layers.** If you have a multilayer document, you can turn on this checkbox to make Photoshop look at the pixels on all the layers instead of just the active layer.

- **Opacity.** If you want to control how strong the Magic Eraser is, you can enter a value (as a percent) here. For example, entering *50* makes it wipe away 50 percent of the image's opacity, entering *100* removes the image entirely, and so on.

WORKAROUND WORKSHOP

Erasing Every Bit of Background

Now that you know how to use the Background and Magic Erasers, keep in mind that you can't always believe what you see onscreen. Most of the time, you'll use these tools to erase to a transparent (checkerboard) background like the one shown in Figure 4-13. And while it may *appear* that you've erased all the background, you may not have. The checkerboard background is notorious for making it hard to see if you've missed a pixel or two here and there, especially if the background you're trying to delete is white or gray (like clouds).

Fortunately, it's easy to overcome this checkered obstacle. The next time you're ready to use one of these eraser tools,

first create a new Solid Color Fill Adjustment layer and pick a bright color that contrasts with what you're trying to delete and then place it at the bottom of the layers stack. That way, you can see whether you've erased everything you wanted to.

Here's how: Click the "Create new fill or adjustment layer" icon at the bottom of the Layers panel (the half-black/half-white circle; see page 114), and choose Solid Color from the pop-up menu. Select a bright color from the resulting Color Picker and then press OK. Drag the new layer beneath the layer you're erasing, and you're good to go. (See Chapter 3 for more on Fill layers.)

Selecting Irregular Areas

As you might imagine, areas that aren't uniform in shape *or* color can be a real bear to select. Luckily, Photoshop has a few tools in its arsenal to help you get the job done as easily as possible. In this section, you'll learn about the three lassos and the Pen tool, as well as a few ways to use these tools together to select hard-to-grab areas.

Using the Lasso Tools

The Lasso toolset contains three freeform tools that let you draw an outline around the area you want to select. If you've got an amazingly steady mouse hand or if you use a graphics tablet (see the box on page 520), you may fall in love with the plain ol' Lasso tool. If you're trying to select an object with a lot of straight edges, the Polygonal Lasso tool will do you proud. And the Magnetic Lasso tries to create the selection *for* you by examining the color of the pixels your cursor is hovering above. The following sections explain all three lassos, which share a toolset at the top of the Tools panel (see Figure 4-14).

Figure 4-14:
So many lassos, so little time! The regular Lasso tool is great for drawing a selection freehand, the Polygonal Lasso is good for drawing selections around shapes that have a lot of straight lines, and the Magnetic Lasso is like an automatic version of the regular Lasso—it tries to make the selection for you.

Lasso tool

The regular Lasso tool lets you draw a selection completely freeform as if you were drawing with a pencil. To activate this tool, simply click it in the Tools panel (its icon looks like a tiny lasso—no surprise there) or press the L key. Then just click your document where you want the selection to start and drag to create a selection. Once you stop drawing and release your mouse button, Photoshop automatically completes the selection with a straight line (that is, if you don't complete it yourself by mousing over your starting point) and you see marching ants.

Tip: It's nearly impossible to draw a straight line with the Lasso tool, unless you've got the steady hand of a surgeon. But if you press and hold the Option key (Alt on a PC) and then release your mouse button, you'll temporarily switch to the Polygonal Lasso tool so you can draw a straight line (see the next section). When you release the Option (Alt) key, Photoshop completes your selection with a straight line.

The Options bar (shown in Figure 4-14) sports the same settings whether you have the Lasso tool or the Polygonal Lasso tool active. Here's what it offers:

- **Mode.** These four buttons (whose icons look like pieces of paper) let you choose among the same modes you get for most of the selection tools: New, "Add to selection", "Subtract from selection", and "Intersect with selection". They're discussed in detail back on pages 139–140.

- **Feather.** If you want Photoshop to blur the edges of your selection, enter a pixel value in this field. Otherwise, Photoshop won't do any feathering. (See the box on page 145 for more on feathering.)

- **Anti-alias.** If you leave this setting turned on, Photoshop slightly softens the edges of your selection, making them less jagged—page 141 has the details.

Polygonal Lasso tool

If your image has a lot of straight lines in it (like the star in Figure 4-15), the Polygonal Lasso tool is your ticket. Instead of letting you draw a selection that's any shape at all, the Polygonal Lasso draws only straight lines. To use it, click once to set the starting point and move your cursor along the shape of the item you want to select; click again where the angle changes. Simply repeat this process until you've outlined the whole shape. It's super simple to use, as Figure 4-15 illustrates. To close your selection, hover above the first point you created. When a tiny circle appears below your cursor (it looks like a degree symbol), click once to close the selection and summon the marching ants.

Figure 4-15:
The Polygonal Lasso tool is perfect for selecting geometric shapes and areas that have a lot of angles. However, if you want to temporarily switch to the regular Lasso tool, press and hold Option (Alt on a PC) to draw freehand.

Tip: To bail out of a selection you've started to draw with the Polygonal or Magnetic Lasso tools, just press the Esc key.

Magnetic Lasso tool

This tool has all the power of the other Lasso tools, except that it's smart—or at least it tries to be! Click once to set a starting point, and from there the Magnetic Lasso tries to *guess* what you want to select by examining the colors of the pixels your cursor is hovering above (you don't even need to hold your mouse button down). As you move your cursor over the edges you want to select, it sets additional *anchor points* for you (think of anchor points as fastening points that latch onto the path you're tracing; they look like tiny, see-through squares). To close the selection, hover above your starting point. When a tiny circle appears below your cursor, click once to close the selection and summon the marching ants (or you can close the selection with a straight line by triple-clicking).

As you might imagine, the Magnetic Lasso tool works best when there's good contrast between the item you want to select and the area around it (see Figure 4-16). However, if you reach an area that doesn't have much contrast—or if you reach a sharp corner—you can give the tool a little nudge by clicking to set a few anchor points of your own. If it goes astray and sets an erroneous anchor point, just hover over the bad point with your mouse and press the Delete key (Backspace on a PC). Then move back to the troubled area of your selection and click to set more anchor points until you reach an area of greater contrast where the tool can be trusted to set its own points.

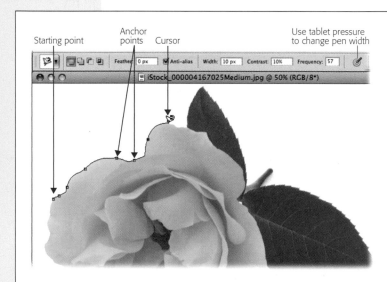

Starting point · Anchor points · Cursor · Use tablet pressure to change pen width

Figure 4-16:
If you're trying to select an object on a plain, high-contrast background, the Magnetic Lasso works great because it can easily find the edge of the object. For best results, glide your cursor slowly around the edge of the item you want to select (you don't need to hold your mouse button down). To draw a straight line, you can temporarily switch to the Polygonal Lasso tool by Option-clicking (Alt-clicking on a PC) where you want the line to start and then clicking where you want it to end. Photoshop then switches back to the Magnetic Lasso and you're free to continue gliding around the rest of the object's jagged edges.

Tip: If you're not crazy about the Magnetic Lasso's cursor (which looks like a triangle and a horseshoe magnet), press the Caps Lock key and it changes to a brush cursor with a crosshair at its center. Press Caps Lock again to switch back to the standard cursor. Alternatively, you can use Photoshop's preferences to change it to a precise cursor; page 35 shows you how.

You can get better results with this tool by adjusting the Options bar's settings (see Figure 4-16). Besides the usual suspects like selection modes, feather, and anti-alias settings (all discussed on pages 139–140), the Magnetic Lasso also lets you adjust the following:

- **Width** determines how close your cursor needs to be to an edge for the Magnetic Lasso to select it. Out of the box, this field is set to 10 px, but you can enter a value between 1 and 256. Use a lower number when you're trying to select an area whose edge has a lot of twists and turns and a higher number for an area with fairly smooth edges. (To select the yellow rose in Figure 4-16, you'd use a higher setting around the petals and a lower setting around the leaves because they're so jagged.)

Tip: You can change the Width setting in 1-pixel increments as you're drawing with the Magnetic Lasso by pressing the open and close bracket keys. You can also press Shift-[to set the width to 1 and Shift-] to set it to 256.

- **Contrast** controls how much color difference there needs to be between neighboring pixels before the Magnetic Lasso recognizes it as an edge. You can try increasing this percentage when you want to select an edge that isn't well defined, but you might have better luck with a different selection tool. If you're a fan of keyboard shortcuts, you can press > or < to increase or decrease this setting in 1% increments. Press >-Shift or <-Shift to set it to 1% or 100%, respectively.

- **Frequency** determines how many anchor points the tool lays down. If you're selecting an area with lots of details, you'll need more anchor points than for a smooth areas. Setting this field to 0 makes Photoshop add very few points, and 100 makes it have a point party. The factory setting—*57*—usually works just fine. Press the ; or ' key to increase or decrease this setting by 1, respectively; add the Shift key to these keyboard shortcuts to jump between 1 and 100.

- **Use tablet pressure to change pen width.** If you have a pressure-sensitive graphics tablet, turning on this setting—whose button looks like a pen tip with circles around it—lets you override the Width setting by pressing harder or softer on your tablet with the stylus. (The box on page 520 has more about graphics tablets.)

Selecting with the Pen Tool

Another great way to select an irregular object or area is to trace its outline with the Pen tool. Technically, you don't draw a selection with this method; you draw a *path* (page 537), which you can then *load* as a selection (page 566) or use to create a *vector mask* (page 572). This technique requires quite a bit of skill because the Pen tool isn't your average, everyday, well...*pen*, but it'll produce the smoothest-edged selections this side of the Rio Grande. Head on over to Chapter 13 to read all about it.

Creating Selections with Channels

As you'll learn in Chapter 5, the images you see onscreen are made up of various colors. In Photoshop, each color is stored in its own *channel* (which is kind of like a layer) that you can view and manipulate. If the object or area you're trying to select is one that you can isolate in a channel, you can load that channel as a selection with a click of your mouse. Chapter 5 discusses this incredibly useful technique in detail, starting on page 205.

Note: You can also paint selections by using Quick Mask Mode, which is discussed in this chapter starting on page 176.

Using the Tools Together

As wonderful as the aforementioned selection tools are *individually*, they're much more powerful if you use them *together*.

Remember how every tool discussed so far has an "Add to selection" and "Subtract from selection" mode? This means that, no matter which tool you start with, you can add to—or take away from—the active selection with a completely different tool. Check out Figure 4-17, which gives you a couple of ideas for using the selection tools together. And thanks to the spring-loaded tools feature (see the tip on page 24), switching between tools is a snap.

Modifying Selections

As you've learned in this chapter, some tools are better at making certain types of selections than others. However, no matter which tool(s) you use, your selection will probably need some fine-tuning. Photoshop gives you lots of ways to modify, reshape, and even save your selections, all explained in the following pages. But before you do any of those things, you'll likely want to fine-tune your selection's *edges*. The difference between a pretty-good-around-the-edges selection and a perfect one is what separates Photoshop pros from mere dabblers. Read on to learn some simple edge-polishing techniques.

Refining Edges

The best selection modifier in town is the Refine Edge dialog box (Figure 4-18), which got a complete overhaul in Photoshop CS5, making it easier than ever to select the tough stuff like hair and fur. It combines several edge-adjustment tools that used to be scattered around on different menus into one spot and includes an extremely useful preview option. Anytime you have a selection tool active and some marching ants on your screen, you'll see the Refine Edge button sitting pretty up in the Options bar; simply click it to open the dialog box. You can also open it by choosing Select→Refine Edge, pressing ⌘-Option-R (Ctrl+Alt+R on a PC), or clicking the Mask panel's Mask Edge button (see Figure 3-28 on page 120).

Figure 4-17:
Top: It's worth taking a moment to try to see the shapes that make up the area you want to select. For example, you can select the circular top of this famous Texas building (shown in red) using the Elliptical Marquee, and then switch to the Rectangular Marquee set to "Add to selection" mode to select the area shown in green.

Bottom: Another way to use the selection tools together is to draw a rectangular selection around the object you want to select, and then switch to the Magic Wand to subtract the areas you don't want. Hold down the Option key (Alt on a PC) so you're in "Subtract from selection" mode and then click the areas you don't want included in your selection, like this grayish background. With just a couple of clicks, you can select the prickly pear.

The Refine Edge dialog box now gives you *seven* different ways to preview your selection (compared to five in CS4). Because the preview appears in the main document window, you'll want to move the Refine Edge dialog box aside so it's not covering your image. Depending on the colors in your image, one of these backgrounds will let you see the selection better than the rest:

Tip: You can cycle through the preview modes by pressing the F key repeatedly when you have the Refine Edge dialog box open. To see your original image temporarily, press the X key.

- **Marching Ants.** This option just shows the selection on the image itself. Keyboard shortcut: M.

- **Overlay.** As the name indicates, this option displays your selection overlaid with the Quick Mask (see page 176). Unless you've changed its color, the overlay is light red; to change that color, see the box on page 178. Keyboard shortcut: V.

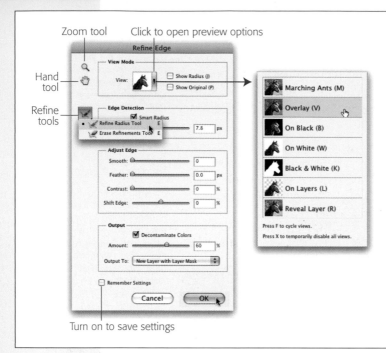

Zoom tool Click to open preview options

Hand
tool

Refine
tools

Figure 4-18:
The Refine Edge dialog box is much improved in Photoshop CS5. Not only does it let you see a live, continuously updated preview of what your selection will look like after fine-tuning, you also get seven different views to choose from, along with two new tools you can use to refine your selection before you click OK.

If you forget what the dialog box's various settings do, never fear: Just hover above each setting and a tooltip appears explaining what each item does.

Turn on to save settings

- **On Black.** This option displays the selection on a black background, which is helpful if your image is light colored and doesn't have a lot of black in it. Keyboard shortcut: B.

- **On White.** Choose this option if your image is mostly dark. The stark white background makes it easy to see your selection and the *object* you're selecting while you're fine-tuning it using the dialog box's tools. Keyboard shortcut: W.

- **Black & White.** This option displays your selection as an *alpha channel* (pages 189 and 201). Photoshop shows your selection in white and the mask in black; transitions between the two areas are subtle shades of gray. The gray areas let you see how detailed your mask has become, so you'll spend a fair amount of time in this mode. Keyboard shortcut: K.

- **On Layers.** To see your selection atop the gray-and-white transparency checkerboard, choose this mode. Keyboard shortcut: L.

- **Reveal Layer.** This mode displays your image without a selection, as it appears in your document. Keyboard shortcut: R.

Once you've chosen a View Mode, you can tweak the following settings (and for best results, Adobe suggests you adjust them in this order):

- **Smart Radius.** Turn this checkbox on to make Photoshop look closely at the edges of your selection to determine if they're hard (like the outline of your subject's body) or soft (like your subject's hair or fur). It's a good idea to turn it on each time you open this dialog box; if you turn on the Remember Settings option at the bottom of the dialog box, Smart Radius will *stay* on until you turn it off.

- **Radius.** This setting controls the size of the area affected by the settings in this dialog box, or rather how far beyond the edge of your selection Photoshop analyzes. You might find it helpful to think of this setting as the selection's degree of difficulty. For example, if your selection is really complex, like the horse's mane in Figure 4-19, increase this setting to make Photoshop look beyond the selection boundary for the really wispy stuff (which also makes the program slightly softening the selection's edge). If your selection is fairly simple, lower this setting so Photoshop analyzes just the selection's boundary, which creates a harder edge. There's no magic numbers for this setting; it'll vary from image to image, so you'll need to experiment in order to get your selection just right.

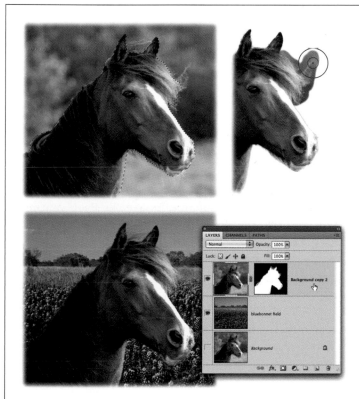

Figure 4-19:
Top: After creating a rough selection with the Quick Selection tool (left), you can use the Refine Edge dialog box's Refine Radius tool to brush across the areas you want to add to your selection (right).

Bottom: Within minutes, you can settle this mare onto a new background, as shown here. What horse wouldn't be happier hanging out on a field of bluebonnets?

To follow along, trot on over to this book's Missing CD page at www. missingmanuals.com/cds and download the files Horse.jpg and Field.jpg.

- **Refine Radius.** Once you've adjusted the Radius setting, you can use this tool to paint over the edges of your selection to make Photoshop fine-tune them even more. This is where the Refine Edge dialog box really works its magic: As you drag with the brush, you can extend your selection beyond the boundaries Photoshop can see, creating a more precise selection of fine details. This tool is also intuitive: as you brush across the edges of your selection, it pays attention and tries to *learn* how you want it to behave. Wow, indeed!

- **Erase Refinements.** If Photoshop gets a little overzealous and includes too much of the background in your selection, you can use this tool to let it know you don't want to include those areas.

Tip: To switch between the Refine Radius and Erase Refinements tools, press Option (Alt on a PC). You can also grab 'em by clicking their respective icons at the far left of the Options bar.

- **Smooth.** Increasing this setting makes Photoshop smooth the selection's edges so they're less jagged. But if you increase it too much, you risk losing details (especially on selections of hair and the like). To bring back some details without decreasing this setting, try increasing the Radius and Contrast settings.

- **Feather.** This setting controls how much Photoshop blurs the edges of your selection, which is useful when you're combining images, as discussed in the box page 145.

- **Contrast.** This setting sharpens your selection's edge, even if you softened it by increasing the Radius setting as mentioned above. A higher number creates a sharper edge and can actually reduce the noisy or grainy look that sometimes comes from a high Radius setting. (If you spend some quality time with Smart Radius and its refinement tools, you probably won't use this slider much, if at all.)

- **Shift Edge.** You can tighten your selection (make it smaller) by dragging this slider to the left, which is a good idea if you're dealing with hair or fur. To expand it your selection and grab pixels you missed when you made your initial selection, drag this slider to the right.

- **Decontaminate Colors.** This option helps reduce *edge halos*: leftover colored pixels around the edges of your selection that you see only *after* you put the object on a new background (as shown on page 173). Once you turn it on, Photoshop tries to replace the color of selected pixels with the color of pixels *nearby* (whether they're selected or not). Drag the Amount slider to the right to change the color of more edge pixels, or to the left for fewer. To see the color changes for yourself, choose Reveal Layer from the View Mode (or just press R).

- **Output To.** This is Photoshop's way of asking what you'd like it to *do* with your new and improved selection. Here are your options:

 — **Selection** adjusts your original selection, leaving you with marching ants on your original layer just like you started with.

 — **Layer Mask** adds a layer mask to the current layer according to the selection you just made. You'll use this option most of the time.

 — **New Layer** deletes the background and creates a new layer containing only the selected item; no marching ants.

 — **New Layer with Layer Mask** adds a new layer complete with layer mask.

 — **New Document** deletes the background and sends only the selected item to a brand-new document.

 — **New Document with Layer Mask** sends the selected item to a new document complete with editable layer mask.

Whew! Those settings probably won't make a whole lot of sense until you start using 'em. To get you off and running, here's how to select a subject with wispy hair:

1. **Open an image and select the item using the Quick Select tool.**

 Press W to grab the Quick Select tool and paint across the object you want to select (Figure 4-19, top left). Don't worry about the quality of the selection because you'll tweak it in a moment.

2. **Open the Refine Edge dialog box.**

 Hop up to the Options bar and click the Refine Edge button.

3. **Choose the On White View Mode.**

 To see the horse's mane a little better—in all its wispy goodness—press W to view it atop a white background.

4. **Turn on the Smart Radius checkbox and drag the slider to the right.**

 How far should you drag the Radius slider, you ask? It depends on your image. Your goal is to drag the slider as far to the right as you can get away with, while still maintaining some hardness in your selection's edges. The amount varies with every single image because there's no magic Radius setting that'll work on every selection (a setting of 3.2 was used here).

5. **Use the Refine Radius tool to brush across the soft edges of your selection (Figure 4-19, top right).**

 Press E to grab the Refine Radius tool, or click its icon near the top left of the Refine Edge dialog box (it looks like a tiny brush atop a curved, dotted line).

Then mouse over to your image and brush across the soft areas you want to add to your selection, like the wispy bits of the horse's mane. Try to avoid any areas that are correctly selected (such as the horse's nose), as Photoshop tends to over-analyze them and exclude parts it shouldn't. If you end up adding too much to the selection, press Option (Alt) to switch to the Eraser Refinement tool and brush across the areas you *don't* want included in your selection.

6. **Turn on the Decontaminate Colors checkbox and adjust its slider accordingly.**

 Once you turn this option on, drag the slider slightly to the right to shift the color of *partially* selected edge pixels so they more closely match pixels that are *fully* selected. Once again, this value varies from image to image (15% was used for this image).

7. **From the Output To pop-up menu, chose Layer Mask.**

 Photoshop adds a layer mask to the active layer reflecting your selection, as shown in Figure 4-19 (bottom).

Exhausted yet? This kind of thing isn't easy, but once you master using Refine Edges, you'll be able to create precise selections of darn near anything!

Note: You can also use the new Refine Edge dialog box to add creative edges to photos. For example, grab the Rectangular Marquee tool and draw a box around your image about half an inch inside your document's edge. Then click the Options bar's Refine Edge button and, in the resulting dialog box, drag the Radius slider to about 40 pixels for a cool painterly effect. Be sure to choose Layer Mask from the Output To menu to keep from harming your original image.

Fixing Edge Halos

When you're making selections, you may encounter *edge halos* (also called *fringing* or *matting*). An edge halo is a tiny portion of the background that stubbornly remains even after you try to delete it (or hide it with a layer mask, page 113). They usually show up after you replace the old background with something new (see Figure 4-20).

Here are a few ways to fix edge halos:

- **Contract your selection.** Use the Refine Edge dialog box (page 166) or choose Select→Modify→Contract (though the latter method won't give you a preview) to contract your selection. Use this technique while you still have marching ants—before you delete the old background (or, better yet, hide the background with a layer mask [page 113]).

- **Run the Minimum filter on a layer mask.** Once you've hidden an image's background with a layer mask, you can run the Minimum filter on the mask to tighten it around the object. Page 655 explains this super-useful trick.

Figure 4-20:
Here you can see the intrepid cowboy on his original green background (top) and on the new background (bottom). The green pixels stubbornly clinging to his hat are an edge halo.

This aggravatingly tiny rim of color—a sure sign that an image has done time in Photoshop—can be your undoing when it comes to creating realistic images. Edge halos make a new sky look fake and don't help convince anyone that Elvis actually came to your cookout.

- **Use the Defringe command.** Run this command after you delete the background (alas, it doesn't work on layer masks or while a selection is active). Choose Layer→Matting→Defringe and then enter a value in pixels. Photoshop analyzes the active layer and replaces the color of the pixels around the object's edge with the color of nearby pixels. For example, if you enter *2 px*, it'll replace a 2-pixel rim of color all the way around the object.

- **Remove Black/White Matting.** If Photoshop has blessed you with a halo that's either black or white, you can make the program try to remove it automatically. After you've deleted the background, select the offending layer and then choose Layer→Matting→Remove Black Matte or Remove White Matte. (Like Defringe, this command doesn't work on layer masks or while you have an active selection.)

Creating a Border Selection

If you peek at the Select→Modify menu, you'll find the same options as in the Refine Edge dialog box (but without a preview). There is, however, one addition: the Border option, which lets you turn a solid selection into a hollow one. Let's say you drew a circular selection with the Elliptical Marquee tool (page 139). You can turn that selection into a ring by choosing the Border option (which is handy if you want to

make a neon sign or select the outer rim of an object). Just enter a pixel width, press OK, and poof! Your formerly solid selection is now as hollow as can be.

Transforming a Selection

Have you ever tried to make a slanted rectangular selection like the one shown in Figure 4-21? If so, you may have found the experience a little frustrating. Sure, you can try using one of the Lasso tools, but it's quicker to *transform*—meaning reshape—a rectangular selection instead. (Page 263 in Chapter 6 has more on the Transform tools.)

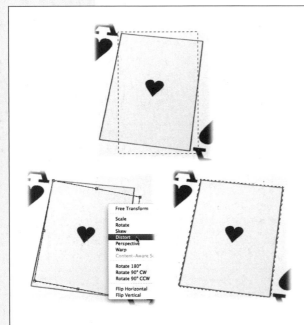

Figure 4-21:
Top: You can easily select the center part of this playing card with the Rectangular Marquee tool (page 139). Once you see marching ants, choose Select→Transform Selection and rotate the resulting bounding box to get the angle you need.

Bottom Left: Next, Ctrl-click (right-click on a PC) inside the bounding box and choose Distort from the shortcut menu, as shown here. Then drag each corner handle so it meets up with a corner of the yellow box on the card.

Bottom Right: When you're all finished, press Return (Enter on a PC) to accept the transformation.

Note: When you transform a selection (as opposed to part of your image), Photoshop won't mess with any of your image's pixels. Instead, the program simply changes the shape of the *selection*—in other words, the shape of the marching ants.

Once you've made a selection, choose Select→Transform Selection or Ctrl-click (right-click on a PC) inside the selection and, from the shortcut menu that appears, choose Transform Selection. Photoshop puts a rectangular box with little, square resizing handles on its four sides around your selection (it's called a *bounding box*).

You can move the selection around by clicking inside the bounding box and dragging in any direction. (If you want to exit the bounding box without making any changes, press the Esc key.) The resizing handles let you:

- **Scale (resize).** Drag any handle to change the size and shape of your selection. Drag inward to make it smaller and outward to make it bigger.

- **Rotate.** If you position your cursor outside one of the bounding box's corners, your cursor turns into a curved, double-headed arrow. That's your cue that you can drag to rotate your selection (just drag up or down in the direction you want to rotate).

If you need to change the shape of your selection, just Ctrl-click (right-click on a PC) inside the bounding box and you'll get yet another shortcut menu with the following options (see Figure 4-21, bottom left):

- **Free Transform** lets you apply any of the transformations listed below freely and in one action (instead of having to choose and apply them one at a time).

- **Scale** and **Rotate** work as described in the previous list.

- **Skew** lets you slant your selection by dragging one of the bounding box's side handles.

- **Distort** lets you drag any handle to reshape your selection.

- **Perspective** lets you drag any corner handle to give your selection a one-point perspective—that is, a vanishing point where it seems to disappear into the distance.

- **Warp** makes Photoshop place a grid over your selection that lets you reshape it in any way you want. Drag any *control point* (the two evenly spaced points on all four sides of the selection) or line on the grid to twist your selection however you like, or choose a ready-made preset from the Options bar's Warp pop-up menu.

Tip: Using the Warp option is your ticket to a quick page-curl effect. Visit this book's Missing CD page at *www.missingmanuals.com/cds* to learn how.

- **Content-Aware Scale** can intelligently resize the unimportant background areas of your image while the subject of your image remains unchanged. You can learn all about it on page 258.

- **Rotate 180°, Rotate 90° CW,** and **Rotate 90° CCW** turn your selection 180 degrees, 90 degrees clockwise, or 90 degrees counterclockwise, respectively.

- **Flip Horizontal** and **Flip Vertical** flip your selection either horizontally (like it's reflected in a mirror) or vertically (like it's reflected in a puddle).

When you're finished transforming your selection, press Return (Enter on a PC) to accept the changes.

Using Quick Mask Mode

If you'd rather fine-tune—or even create—selections by painting with a brush (see Chapter 12), no problem; in fact, you can create a selection from scratch using this method. Just enter Quick Mask mode and you'll find all of Photoshop's painting tools (even filters!) waiting to help you tweak your selection. Quick Mask mode gives you the freedom to work on selections with almost any tool you want.

You can enter Quick Mask mode by clicking the button at the bottom of the Tools panel that looks like a circle within a square or by pressing the Q key. When you do, Photoshop looks to see whether you have an active selection. If you do, it puts a red overlay over everything *but* the selection. (If you don't, you won't see any change but you can still use the directions in this section to *create* a selection.) This color-coding makes it easy to edit your selection visually by painting.

While you're in Quick Mask mode, you can use the Brush tool (page 499) to:

- **Deselect a portion of your selection**—in other words, to add an area to the mask—by making black your foreground color chip (page 24) and then paint the area.

- **Extend the area covered by your selection** by painting the area you want to add white (you may need to press X to flip-flop your color chips).

- **Create a soft-edged selection or semi-transparent area** by painting with gray. For example, by painting with 50 percent gray—lower a black brush's opacity in the Options bar to 50 percent—you'll create a selection that's half see-through. You can create a similar effect by painting with a soft-edge brush.

All the usual tools and document tricks work while you're in Quick Mask mode: You can zoom in or out by pressing ⌘ and the + or – key (Ctrl and + or – on a PC), press and hold the space bar to move around within the document once you're zoomed in, and use any of the selection tools covered in this chapter. Even the Marquee and Lasso tools work in this mode. You can also fill the entire mask, or your selection, with black or white (see page 181), which is helpful when you have a large area to paint or when you want to paint the entire selection by hand. You can run filters in this mode to create interesting edges (page 643) or use the Gradient tool, set to a black-to-white gradient, to create a fade (page 334).

Once you finish fine-tuning your selection, press the Q key to exit Quick Mask mode and the marching ants come rushing back, as shown in Figure 4-22, so you can see your newly edited selection.

Figure 4-22:
Top left: Start by selecting the white background with the Magic Wand tool (page 151).

Top right: When you pop into Quick Mask mode, Photoshop leaves the area you've selected in full color (in this case, white) and puts a red overlay over everything else. Now you can quickly clean up problem areas— like the drop shadow peeking out from beneath the badge— because they're so easy to spot with the red overlay. Use the Brush tool set to paint with black or white, or the Polygonal Lasso tool (fill the selection area with black or white).

Bottom: Once you're finished, exit Quick Mask mode by pressing Q, and you see the fine-tuned selection marked by marching ants.

Moving Selections

If you create a selection that's not exactly in the right spot or you've got several objects of the same shape to alter, you may need to move the selection itself. Or maybe you need to move the pixels *underneath* the selection, or onto their own layer. In any of those cases, you've got plenty of options, including:

- **Moving the selection (the marching ants) within the same layer.** Make sure you have a selection tool active (it doesn't matter which one), and then, click inside the selection and drag to move it to another part of the document. You can also nudge the selection into place with the arrow keys on your keyboard.

Tip: To move a selection as you're drawing it, press and hold the space bar while you still have the mouse button pressed. Drag to move the selection, release the space bar, and then continue dragging to draw the selection.

- **Moving the selected object (the actual pixels) within the same document.** Press V to select the Move tool and then drag with your mouse to reposition the object. Be aware that a big, gaping hole will appear where the object used to be! (If you're on a Background layer, the hole will be filled with the color your foreground color chip is set to.)

- **Moving the selected object onto its own new layer within the same document.** Press ⌘-J (Ctrl+J on a PC) to "jump" the selected pixels onto their very own layer, just above the current layer. That way, whatever you do to the selected area won't harm the original image. If you don't like your changes, you can throw the extra layer away. Or, if you create an effect that's a little too strong—maybe you overwhitened a set of teeth—you can reduce the layer's opacity (page 92) to lessen the effect. (Flip back to Chapter 3 for more on using layers.)

FREQUENTLY ASKED QUESTION

Changing Quick Mask's Color

Why is Quick Mask red? Am I stuck with red? And while we're at it, why does the mask mark unselected areas? Can I make it mark the selected areas instead?

Whoa, now! Just hold your horses; one question at a time.

First, a bit of history: The Quick Mask's default setting is red because of its real-world counterpart, rubylith plastic, which came in sheets like paper. Back in the days before desktop publishing, this red plastic was cut with X-Acto knives and placed over the parts of images that needed to be hidden. Because the plastic didn't register with the printing presses, those parts of the images didn't appear in the printed publication. It was a neat trick at the time.

Printing technology has come a long way since then—there's no need for X-Acto knives when you've got Photoshop. And since you're working with modern printers and not old-fashioned printing presses, you're not stuck with using a red mask; you can change Quick Mask's color to anything you want (which is quite helpful when the area you're trying to select has red in it). So if the red overlay isn't working for you, with Quick Mask mode active (press Q), double-click the circle-within-a-square button at the bottom of the Tools panel. In the Quick Mask Options dialog box that opens, click the color swatch and choose any color you like from the resulting Color Picker. You can also make the overlay more or less intense by changing the dialog box's Opacity setting.

And, yes, you can make Quick Mask mark the areas you've selected instead of the unselected areas. Simply open the Quick Mask Options dialog box and, in the Color Indicates section, turn on the Selected Areas option and then press OK.

- **Moving the selected object to another document.** Press ⌘-C (Ctrl+C on a PC) to copy the pixels and then open the other document and press ⌘-V (Ctrl+V) to paste the pixels in. The object appears on its very own layer that you can reposition with the Move tool. This technique is essential for performing the classic head swap, shown in Figure 4-23. A less memory-intensive (RAM-intensive) method is to ⌘-drag (Ctrl-drag) the selection from your document window onto another open document's tab.

- **Moving the selected object to a new document.** Copy it as described above and then choose File→New. Photoshop opens a new document, sized to match the object on your Clipboard, into which you can paste the object.

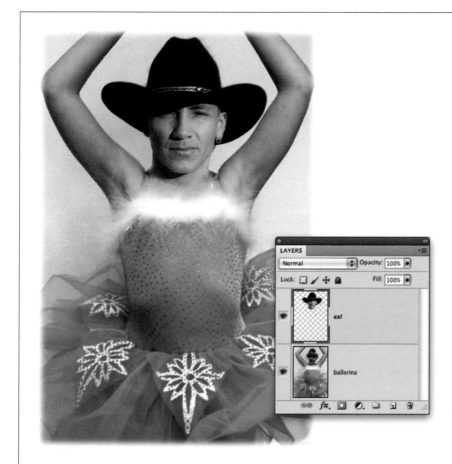

Figure 4-23:
Here's a fun little prank to pull on your family, friends, and exes. Open a photo of someone and select their head using any of the selection tools discussed in this chapter (the Quick Selection tool was used here). Be sure to feather the selection so it doesn't have a hard edge (page 145) and then copy it (press ⌘-C [Ctrl+C on a PC]). Open the document that contains the new body and paste your selection into that document (⌘-V [Ctrl+V]). You can use the Move tool to reposition it onto the new body and, if you need to, use the Clone Stamp tool (see page 311) to hide parts of the original head. Good times!

Saving a Selection

If you'd like Photoshop to remember your selection so you can use it again later, it's happy to do so. After you create the selection, choose Select→Save Selection. In the resulting dialog box, give your selection a meaningful name (like *handsome devil*) and then press OK (see Figure 4-24). When you're finished working with that document, be sure to save it as a native Photoshop file (page 51).

When you're ready to use the selection again, pop open the document and choose Select→Load Selection. In the resulting dialog box, click the Channel pop-up menu and pick your selection from the list (if you've saved only one selection in this particular document, Photoshop chooses it automatically). Leave the Operation section of the dialog box set to New Selection to bring back the saved selection as a whole (instead of adding to or subtracting from another selection). Press OK and the marching ants reappear, just like you saved them.

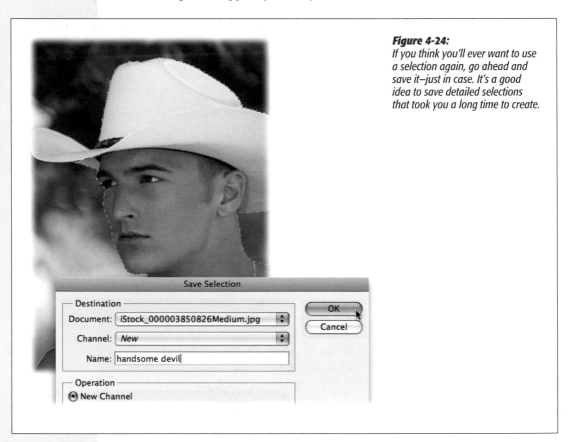

Figure 4-24:
If you think you'll ever want to use a selection again, go ahead and save it–just in case. It's a good idea to save detailed selections that took you a long time to create.

Although the radio buttons in the Operation section of the Load Selection dialog box let you add, subtract, or intersect with your saved selection, it's easier just to load the selection, close the dialog box, and edit it using the selection tools discussed in this chapter.

Filling a Selection with Color

Filling selections with color is a great way to create shapes and add colorful photo borders to images. After you've created the selection of your dreams, you can fill it with color in a couple of ways. One option is to choose Edit→Fill and, from the Use pop-up menu, choose Color. Pick something nice from the resulting Color Picker and then press OK twice to dismiss the dialog boxes. Photoshop fills your selection with the color you picked. Your other option is explained in Figure 4-25.

Figure 4-25:
A more flexible way to fill a selection with color is to create a Solid Color Fill Adjustment layer (it's vector in nature so it doesn't add fat to your file size). After you've made a selection using the Rectangular Marquee tool, click the "Create new fill or adjustment layer" icon at the bottom of the Layers panel (the half-black/half-white circle) and choose Solid Color. Then grab a color from the resulting Color Picker and press OK to make a colorful photo border. For a bit of extra pizzazz, you can add an inner shadow to the photo layer using layer styles (page 128).

Using Content-Aware Fill

In Photoshop CS5, you have another option for filling selections called Content-Aware Fill. It works with the Fill command and the Spot Healing brush (page 425) by comparing your selection, or brushstroke, to nearby pixels. Photoshop then fills the area so it blends seamlessly with the background.

Which option should you use when, you ask? If you've got plenty of good pixels on either side of the pixels you want to delete, try the Spot Healing brush. If you want to be more *precise* with your pixel zapping—say, if the item you want to delete is super close to something you want to keep—create a selection first and then use Content-Aware Fill (if possible, it's best to include some of the background in your selection). For example, you can follow these steps to break up a perfectly good boy band, as shown in Figure 4-26.

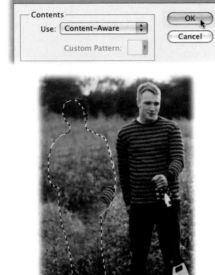

Figure 4-26:
Once you've created a selection (left), you can use the new Content-Aware Fill option to fill the selected pixels with those nearby. As you can see here, it does an amazing job! With a few quick clicks of the Spot Healing Brush (set to Content-Aware [page 427]), this band member is history.

The voodoo Photoshop uses to fill your selection is random and changes each time you use the command. In other words, if at first you don't succeed, try choosing Edit Fill again—you'll likely get different results!

Note: Want to follow along? Visit this book's Missing CD page at *www.missingmanuals.com/cds* and download the image *BoyBand.jpg*.

1. **Open your image and duplicate the Background layer by pressing ⌘-J (Ctrl+J).**

 Since there's no way to tell the Fill command to sample all layers (bummer!), it won't work on an empty layer.

2. **Use the selection tool of your choice to select the band member on the left.**

 Because there's a decent amount of contrast between the boy and the grassy meadow, the Magnetic Lasso (page 164) does a great job. Grab it from the Tools panel by pressing Shift-L repeatedly until you see it appear. Mouse over to your image and click once to set a starting point, and then drag around the boy, clicking to add anchor points here and there. (For more on using the Lasso tools, flip back to page 162.)

3. **Choose Edit→Fill and, from the Use pop-up menu, choose Content Aware.**

 As soon as you press OK, Photoshop fills your selection with pixels from the surrounding area.

To fix the remaining outline of the missing bandmate, just switch back to the Spot Healing Brush by pressing K (in the Options bar, make sure Content Aware is turned *on*). With a quick brushstroke here and there, you can clean up the final image quite nicely and it won't take hours like it did in previous versions of the program. Until you can actually *wish* an object out of a photo, this new tool ought to suit you just fine.

Stroking (Outlining) a Selection

Sometimes you'll want to give your selection a *stroke* (as in outline, not the medical condition). While you can stroke selections of any shape, this technique comes in really handy when you use it in conjunction with the marquee tools. For example, you can combine a stroke with the Rectangular Marquee tool to add a thin black outline to your photo or with the Elliptical Marquee to circle yourself in a group picture.

When it comes to adding a bit of class to a photo, few effects beat a thin black outline. Whether you're floating the image within text or posting it in your blog, adding an outline gives the edge a little definition, making the design look nicely finished. Here's how to add an outline around the edge of your image:

1. **Open your image and select it.**

 If your image is the same size as the document, choose Select→Select All. If it's smaller than the document and lives on its own layer, ⌘-click (Ctrl-click on a PC) the layer's thumbnail in the Layers panel instead.

2. **Choose Edit→Stroke and tell Photoshop how thick, which color, and where you want the stroke to be.**

 In the Stroke dialog box, enter a pixel dimension in the Width box and then click the little color swatch. Choose a color from the resulting Color Picker and then press OK. Back in the Stroke dialog box's Location section, choose Inside to make the outline appear just inside the image's border.

3. **Click OK to see your new outline.**

To circle someone in a photo, as shown in Figure 4-27, you follow basically the same steps:

1. **Open a photo and select the Elliptical Marquee tool (page 139) from the Tools panel.**

 Drag to draw an oval around the person's head. Remember that you can press the Shift key while you drag to draw a perfect circle, or press the Option key (Alt on a PC) to draw the oval from the inside out. Move the selection if you need to by clicking inside it and dragging with your mouse.

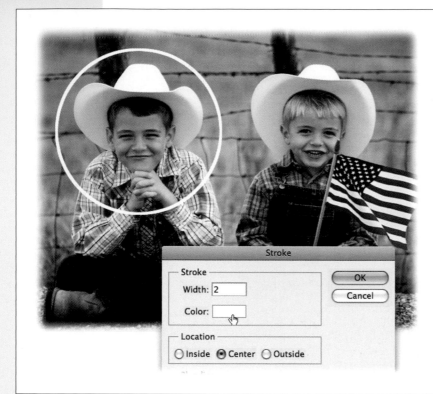

Figure 4-27:
Once you've created a selection, you can outline it by choosing Edit→Stroke. In the resulting dialog box (shown here), pick a width, color, and location for the outline and then press OK. If you want to play it safe, you can add the stroke on its own layer. Just add a new layer to your document (page 81) before choosing Stroke from the Edit menu and then make sure that layer is active. That way, when you add the stroke, it'll appear on the new layer instead of the original image.

2. **Choose Edit→Stroke, enter the stroke width, and pick a color.**

 In the Stroke dialog box, tell Photoshop how thick you want the stroke to be. You want it to be at least 2 pixels wide so the circle is thick enough to see. Click the color swatch, choose a color from the resulting Color Picker, and then click OK. In the Location section, turn on the Center option so Photoshop will center the stroke over the marching ants. If you've entered a width of 2 pixels, for example, the program will put one pixel of the stroke on the outside of the selection and one on the inside (in other words, the stroke will straddle your selection).

3. **Press OK to see your newly circled head.**

 At this point you can get rid of the marching ants by pressing ⌘-D (Ctrl+D on a PC) to deselect.

Controlling Color
with Channels

At the heart of any Photoshop file lie *channels*—storage containers for all your image's color information, saved selections (page 180), and instructions regarding special printing inks. Channels sound intimidating at first, and folks have been known to shudder at their mention and avoid them completely. But to really understand Photoshop, you need to understand channels. Luckily, you don't need a PhD to do that—just a little patience.

This chapter gets a little technical at times, but if you soldier through, you'll be rewarded with wisdom that'll help you perform some amazing pixel wizardry. You'll get that warm, fuzzy, enlightened feeling as you learn to:

- Use channels to make complex selections (page 205).

- Perform highly targeted color adjustments (see the figure on page 412).

- Create stunning grayscale conversions (page 329).

- Map one image to the contours of another (page 319).

- Sharpen your images without introducing *noise* (page 214).

- Save a selection so you can use it later (page 180).

And that's just the tip of the iceberg. *Everything* you do in Photoshop involves channels (well, save for paths, which you'll learn about in Chapter 13), so it's important to get to know them. If you understand *how* Photoshop does what it does, you can make it do even *more* in less time and with less effort. That's called working smarter, not harder—which is why, dear Grasshopper, you're reading this book.

To understand how channels work, you first need to learn a bit about the two color systems you'll encounter during your Photoshop career: *additive* and *subtractive*. The additive system is at play in any image that appears onscreen; it explains how lights combine to generate color. Printed images, by contrast, are created by mixing inks together according to the subtractive system. Once you've got all *that* under your belt (and fear not, there's plenty more ahead about how both systems work), you'll dive into the color channels themselves to see what kind of info is hiding there and how it can help you improve your images. Last but not least, you'll explore an entirely different kind of channel that can help you create the toughest selections this side of the Rio Grande: *alpha channels*. Read on!

How Color Works

The images you see on your computer monitor (or TV, for that matter) are made of light. While your eyes are sensitive to hundreds of wavelengths (each associated with a different color), it takes just three—red, green, and blue—to produce all the colors you see onscreen. The screen's blank canvas is darkness (in other words, an absence of light), and to create color, the monitor *adds* individual pixels of colored light. That's why the onscreen color system is called "additive." Each tiny pixel can be either red, green, or blue—or, more often, some combination of all three. All image-capture devices—like digital cameras, video cameras, and scanners—use the additive color system, as do all digital-image display devices.

Note: Onscreen images are called *composite* images because they're made up of a combination of red, green, and blue light (also known as *RGB*).

In the additive color system, areas where red, green, and blue light overlap appear white (see Figure 5-1). Does that sound crazy, or does it ring a bell from high school physics? Think about it this way: If you aimed red, green, and blue spotlights at a stage, you'd see white where all three lights overlap. Interestingly, you'd also see cyan, magenta, or yellow where just *two* of the three lights overlap (see Figure 5-1 for a visual). Areas where no light is shining appear black.

So that's how computer monitors and TVs create onscreen color. Now it's time to talk about printed color, which—brace yourself—works in a totally different way. Printing presses use what's called a *subtractive* color system. In that system, the colors result from a combination of light that's reflected (which you see) and light that's absorbed (which you don't see).

In a printed photo, magazine, or the pages of this book, that system operates as kind of a joint venture between the inks used (cyan, magenta, yellow, and black, all of which absorb color) and the paper the ink is printed on (a reflective surface). The ink serves as a filter by absorbing part of the light that hits the paper. The paper, in turn, bounces the light back at you; the whiter the paper, the truer the colors will look when they're printed.

Figure 5-1:
If you overlap red, green, and blue spotlights, you see white light. This is a prime example of the additive color system, which starts with black and adds light to produce different colors. Notice how cyan, magenta, and yellow appear where just two lights overlap.

You can try this spotlight experiment in Photoshop yourself by creating red, green, and blue circles on separate layers on a black background. Make the circles overlap, switch the blend mode (page 289) of each layer to Lighten and voilà—the other colors appear where the circles overlap.

In the subtractive system, different-colored inks absorb different-colored light. For example, cyan ink absorbs red light and reflects green and blue light back to you, so you see a mix of green and blue—in other words, cyan. Similarly, magenta ink absorbs green light and reflects red and blue light; in other words, magenta. One last example: A mix of cyan, magenta, and yellow ink absorbs *most* of the primary colors—red, green, and blue—and displays what's left over: dark brown.

Note: To produce true black, grays, and shades of color (colors mixed with black to produce darker colors), the folks who ran printing presses decided to add black as a fourth printing ink. They couldn't abbreviate it with B because they were afraid it'd be confused with blue (as in RGB), so they used K instead—as in "blacK." That's where the abbreviation CMYK comes from.

To sum it all up: Subtractive color is generated by light hitting an object and bouncing back to your eye, whereas additive color is generated by different-colored light mixing together *before* you see it.

RGB Mode vs. CMYK Mode

Photoshop stores all the color information that gets relayed to your monitor, your printer, and so on, in separate *channels*. The channels' names change depending on which *color mode* you're using for a particular file. As a rule of thumb, you should use RGB mode for images destined for onscreen viewing or inkjet printing and CMYK mode for images you plan on sending to a commercial printing press. (To find out what color mode your image is in, choose Image→Mode. The current mode has a little checkmark to the left of its name.)

Note: Spend enough time around Photoshop veterans and you'll almost certainly hear talk of "color modes" and "image modes." Don't get confused—both terms mean the same thing.

In *RGB mode*, your file has red, green, and blue color channels. If you look at each channel individually (which you'll learn how to do on page 189), you actually see a grayscale representation of where and at what strength that particular color appears in your image. ("Why doesn't Photoshop display them in color" you ask? The box on page 190 has the answer.) One of the best things about RGB mode is that it can display an enormous range of colors.

If you're preparing an image for a commercial printing press, on the other hand, the printed image gets created by mixing cyan, magenta, yellow, and black inks. Enter *CMYK mode*, where your file's color channels are—you guessed it—cyan, magenta, yellow, and black. The drawback to working in this mode is that ink can reproduce far fewer colors than light. But never fear: Even if you need to *end up* in CMYK mode, there's no harm in starting off in RGB mode. (Chapter 16 explains more than you ever wanted to know about when and how to change color modes.)

As you discovered in Chapter 2 (page 46), there are other color modes, including Grayscale and Lab, that you can use for specific tasks that you'll learn about throughout this book. However, you'll spend the bulk of your time in RGB mode.

Whew! Now that the really confusing stuff is out of the way, it's time to focus on where in Photoshop you can *see* channel information and the different types of channels you can find there.

The Channels Panel and You

To peek inside a channel, you need to open Photoshop's Channels panel (see Figure 5-2). It looks and works like the Layers panel, which you learned about in Chapter 3. You'll find the Channels panel's tab lurking in the Layers panel group (page 189) on the right side of your screen. (If you don't see it, choose Window→Channels.)

Just like in the Layers panel, when you click once to select a channel, Photoshop highlights that channel to let you know it's selected. Anything you do from that point on affects only that channel. If you want to select more than one channel, Shift-click each one. You can use this trick if you want to, say, sharpen two channels at once (see page 214). To toggle a channel's visibility on and off, click the visibility eye to the left of the channel's name (see Figure 5-2) or drag down over the eyes to turn them all on or off (you can't turn off every channel, though, since at least one has to be visible at all times).

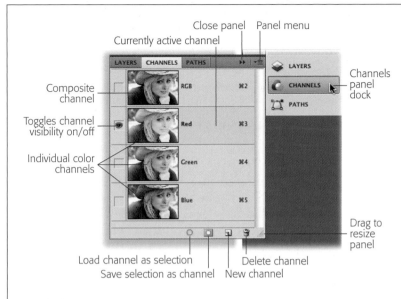

Close panel · Panel menu
Currently active channel

Figure 5-2:
The Channels panel is your gateway to the color info that makes up your image. The composite channel at the top of the panel (here it's the one labeled "RGB") shows what the image looks like with all the channels turned on.

Composite channel

Toggles channel visibility on/off

Individual color channels

Channels panel dock

Your Channels panel dock may look different than what's shown here depending on how you've set up your workspace. See Chapter 1 (page 19) for the skinny on customizing panels.

Drag to resize panel

Load channel as selection
Save selection as channel · New channel
Delete channel

Photoshop has several kinds of channels, all of which this chapter covers in detail:

- **Composite channels.** Technically, this isn't really a channel; it's for your viewing pleasure only. When you're using a mode that contains more than one color channel (like RGB, CMYK, and Lab—all discussed later in this chapter), the composite channel shows all the channels simultaneously, revealing your image in its full-color glory. The name of the composite channel depends on which mode you're in. In RGB mode, for example, the composite channel is named RGB (creative, huh?). But no matter what Photoshop calls it, the composite channel is always at the top of your Channels panel.

- **Color channels.** As explained earlier, if you're working in RGB mode, your color channels are Red, Green, and Blue. In CMYK mode, they're Cyan, Magenta, Yellow, and Black. In Lab mode (page 47), they're Lightness, a, and b. In all other image modes, you'll find only a single channel, named after the mode you're in.

- **Alpha channels.** If you've ever saved a selection so you can use it again later (page 180), you've created an alpha channel. They're basically grayscale representations of saved selections that come in handy when you've made a tough selection you might need to use again (like when you're changing someone's hair color at the request of a finicky client). See page 201 for a detailed explanation of alpha channels.

- **Spot channels.** These store instructions for using special premixed inks, like Pantone colors. If, say, you're a graphic designer creating an ad for a hot new scooter that has to be Ferrari red, you can create a spot channel containing that color to make sure it prints correctly. Page 197 has details on when to use spot channels and how to create them.

FREQUENTLY ASKED QUESTION

Why Are Channels Gray?

With all this talk about color, how come Photoshop shows color channels in black and white?

Although you *can* make Photoshop display individual color channel info in color, you really don't want to. The channel colors would be so bright and distracting that it'd be hard to see anything useful. It's much easier to see a particular color's strength (called *luminosity*) when it's represented in shades of gray. That's why Photoshop displays color channels in grayscale as you can see in the Channels panel shown below.

For example, in the figure's Red channel, the lighter-colored pixels represent high concentrations of red, whereas the darker pixels represent almost no red at all. In RGB mode, absolute white areas indicate a color at its full luminosity, and black areas indicate the color at its weakest. (In CMYK mode, the reverse is true—black indicates full strength and white indicates the weakest concentration.) Just glancing at grayscale channel information lets you *see* where a certain color is at full strength, where it's completely lacking, and what lies somewhere in between.

That said, if you're determined to see color channel info in full color, choose Photoshop→Preferences→Interface (Edit→Preferences→Interface on a PC). Then turn on the "Show Channels in Color" option and see if you can make heads or tails out of anything!

There's actually one situation where you see channels displayed in color—in your document, at least—whether you

like it or not: If you select more than one channel, Photoshop previews your image in just those colors (see the figure on page 216). The reason? If the program displayed multiple channels in grayscale, you wouldn't be able to tell *which* shades of gray represented which color.

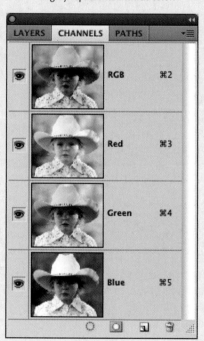

At the bottom of the Channels panel, you'll find a row with the following buttons:

- **Load channel as selection.** This button, which looks like a tiny circle made of dots, selects whatever's in the active channel. This is handy when you're using channel info to create tough selections (page 205). You can also load a channel as a selection by ⌘-clicking (Ctrl-clicking on a PC) the channel's thumbnail icon.

- **Save selection as channel.** When you have an active selection, you can press this button to save it as an alpha channel so you can use it again later (page 180). You can also choose Selection→Save Selection, which lets you name your new channel, as does Option- (Alt-) clicking the button.

- **Create new channel.** This button looks like a tiny piece of paper with an up-turned corner. When you click it, Photoshop creates a new, empty alpha channel (page 201). Photoshop names selections you create as Alpha 1, Alpha 2, Alpha 3, and so on. If you want a more memorable name, simply double-click the channel's name and change it to something like "Tony's toupee" or "Lesa's Lambo." If you drag an existing channel onto this button, Photoshop duplicates it—helpful when you're modifying a channel to create a selection (page 205) or making an edge mask to sharpen your image (page 475) since you don't want to risk destroying your original image.

- **Delete current channel.** Clicking this tiny trash can deletes the currently active channel (you can also drag and drop a channel onto it to do the same thing). After you've tweaked a duplicate or an alpha channel to create the perfect selection or edge mask, you can toss it by clicking this button (or you can keep it hanging around but get it out of sight by turning off its visibility eye).

Tip: It's okay to keep extra channels in your Photoshop files if you think you might use them again later. Channels don't increase your file size as much as layers do, so you can have lots of channels in an image and still maintain a reasonable file size. In fact, you can have up to 56 channels in one document.

Just like every other panel in Photoshop, the Channels panel has a menu tucked into its top-right corner (it looks like a down arrow next to four little lines). This handy menu includes some of the same commands mentioned earlier and a few all its own:

- **New Channel.** This command creates a brand-new alpha channel, just like clicking the "Create new channel" button at the bottom of the panel. The difference is that by going this route, you get a nifty dialog box that asks you to name your new channel and tell Photoshop how you want it to display the channel's information (see the figure on page 203). However, it's quicker to Option- (Alt-) click the new channel button, as described in the previous section.

- **Duplicate Channel.** If you want to create a copy of a channel so you can edit it, choose this command. When you do, Photoshop displays a dialog box so you can name your new channel and choose its destination (the same document or a new one). The destination option is helpful when you're creating a displacement map (page 319) or using channels to make a high-contrast, black-and-white image (page 195).

- **Delete Channels.** This command deletes the current channel or, if you've Shift-clicked to select more than one channel, all the selected channels. You have to keep one channel, though, so if you've selected all of 'em, Photoshop grays out this command.

- **New Spot Channel.** This option lets you create a new channel for a premixed, specialty printing ink called a *spot color*. Read all about it on pages 197 and 688.

- **Merge Spot Channel.** Only commercial printing presses can understand spot channels, so if you need to print a proof on a regular desktop printer, you first have to use this command to merge your spot channels. See the box on page 695 for details.

- **Channel Options.** This menu item is available only if you have an alpha channel selected. When you're creating or editing an alpha channel, you can use Channel Options to change the way Photoshop displays masked and selected areas. Page 203 has the scoop.

- **Split Channels.** If you need to split each channel in your image into its own document, choose this command. Photoshop grabs each channel and copies it into a new, grayscale document (page 46 has info on Grayscale mode). This technique is useful when you're creating a grayscale image based on one of the color channels.

- **Merge Channels.** You might think this command merges more than one channel into a single channel. Negative, good buddy: It merges the channels of up to four open Grayscale documents into a single RGB document (if you've got three open documents) or CMYK document (if you've got four open documents). You can also have Photoshop merge all the open documents' channels into a Multichannel document (see page 198). This command can come in handy if you've used the Split Channels command to work on each channel separately and now you want to reunite them into one document.

- **Panel Options.** In the Channels panel, Photoshop automatically displays a thumbnail preview of each channel. If you want to turn off this preview or choose a different thumbnail size, select this menu item. If you've got a decent-sized monitor (17" or larger), go for the biggest preview possible (see Figure 5-2).

- **Close and Close Tab Group.** Choose Close to make the Channels panel disappear, or Close Tab Group to get rid of a whole group of related panels (like Channels, Layers, and Paths). See Chapter 1 for more on panels.

In the next section, you'll find out about the different kinds of information stored in each mode's color channels.

Meet the Color Channels

Understanding what you're seeing in each channel gives you the know-how to create complicated selections and fine-tune your images. In this section, you'll look inside the different color channels, beginning with the most common image mode: RGB.

Note: This section doesn't cover alpha channels. They're so important, they get their very own section, which starts on page 201.

RGB Channels

Unless you're preparing an image that's headed for a commercial printing press (as opposed to the inkjet printer you've probably got at home), RGB mode is the place to be. After all, your monitor is RGB, as are your digital camera and scanner. But as the box on page 190 explains, Photoshop doesn't display individual channels in red, green, and blue—they're in grayscale so you can easily see where the color is most saturated. Because colors in RGB mode are made from light (page 186), white indicates areas where the color is at full strength, black indicates areas where it's weakest, and shades of gray represent everything in between (see Figure 5-3).

Tip: No matter which color mode you're in, you can cycle through the channels by pressing ⌘-3, 4, 5, and 6 (Ctrl+3, 4, 5, and 6 on a PC) though you'll only use that last one if you're in CMYK mode, which has four channels instead of three, or if you're trying to select an alpha channel in RGB mode. To go back to the composite channel (page 189) so you can see the image in full color, press ⌘-2 (Ctrl+2). When you use these shortcuts, be sure to hold down the ⌘ or Ctrl key; otherwise, typing numbers will change the layer's opacity instead (see page 94). These keyboard shortcuts changed in CS4, but if you'd like to go back to the old ones, you can; just choose Edit→Keyboard Shortcuts and turn on Use Legacy Channel Shortcuts.

As you can see in Figure 5-3, each channel holds different information:

- **Red.** This channel is typically the lightest of the bunch and shows the greatest difference in color range. In this example, it's very light because there's a lot of red in the woman's skin, hair, and hat. This channel can be *muy importante* when you're correcting skin tones (page 405).

- **Green.** You can think of this channel as "contrast central" because it's usually the highest in, well, contrast. (This makes sense because digital cameras have twice as many green sensors as red or blue ones.) Remember this channel when you're creating an edge mask for sharpening (page 475) or working with displacement maps (page 319).

Composite

Red

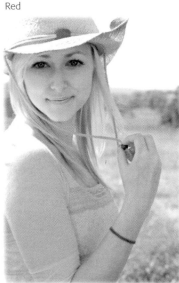

Green

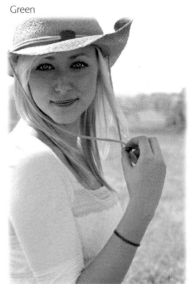

Blue

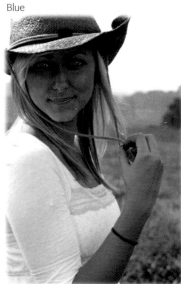

Figure 5-3:
See how the red, green, and blue channels differ in this cute cowgirl portrait? White areas show where the color on that channel is most concentrated, and black areas show where the color is weakest.

Most likely, your image is already in RGB mode, especially if it came from a digital camera or a stock image company. You can set an image's color mode when you create a new document [page 46]). For info on switching color modes, see Chapter 16.

Note: Back in the old days (in earlier versions of Photoshop), if you wanted to generate a grayscale version of a color photo, you typically picked the channel with the highest contrast and used that as your grayscale image. Now, Photoshop gives you much better ways to convert from color to grayscale like the Black & White (page 324), Gradient Map (page 363), and Channel Mixer Adjustment layers (page 481).

- **Blue.** Typically the darkest of the group, this channel can be useful when you want to create complex selections to isolate an object (page 205). It's also where you'll find problems like *noise* and *grain*. See the box on page 462 to learn how to run the Reduce Noise filter on this channel.

CMYK Channels

Though you'll probably spend most of your time working with RGB images, you may also need to work with images in CMYK mode. Its name, as you learned earlier, stands for the cyan, magenta, yellow, and black inks commercial printing presses use in newspapers, magazines, product packaging, and so on. It, too, has a composite channel at the top of the Channels panel, and you can pop into this mode by choosing Image→Mode→CMYK Color.

If you plan to print your image on a regular laser or inkjet printer you don't need to be in CMYK mode (unless you need to create a quick, high-key effect as described in a moment). Also, this mode limits you to precious few filters (Chapter 15) and adjustments (Chapter 9). (You'll learn all about converting images from one mode to another in Chapter 16.) A professional printing press, on the other hand, separates the four CMYK channels of your image into individual *color separations* (see page 702). Each separation is a perfect copy of the color channel you see in Photoshop, printed in its respective color (cyan, magenta, yellow, or black). When the printing press places these four colors atop each other, they form the full-color image. (This technique is known as *four-color process* printing.)

Because CMYK channels represent ink rather than light (as explained back on page 187), the grayscale information you see in your Channels panel represents the *opposite* of what it does in RGB mode. In CMYK mode, black indicates color at full strength and white indicates color at its weakest (see Figure 5-4). Does your brain hurt yet?

Creating a high-key portrait effect

Even if you're not sending your image to a printing press, you can still have some fun in CMYK mode. For example, you may have noticed that the Black channel in Figure 5-4 looks pretty darned neat. It resembles a popular portrait effect called *high-key* lighting, in which multiple light sources are aimed at the victim, er, subject to create a dazzling image with interesting shadows. Some folks labor long and hard to create this look in Photoshop when they could simply resort to a bit of channel theft instead. To create this effect fast, just extract the Black channel from a CMYK version of the image. Here's how:

1. **If your image is in RGB mode, make a copy of it by choosing Image→Duplicate.**

 Because you're going to change color modes in the next step, it's a good idea to do that on a copy of your image since you lose a bit of color info when you go from one mode to another. If your image is already in CMYK mode, skip ahead to step 3.

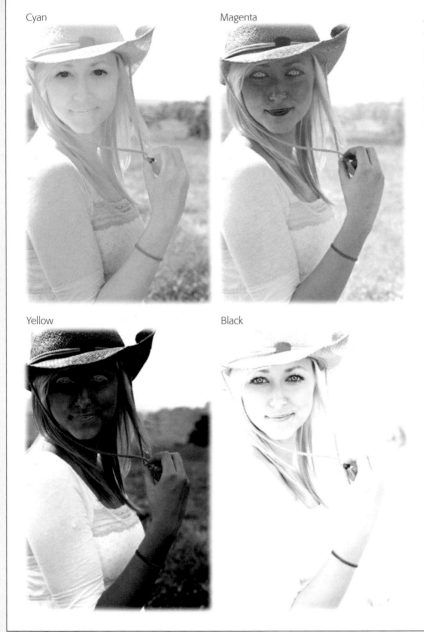

Cyan

Magenta

Yellow

Black

Figure 5-4:
*Here's the same cowgirl
you met back in Figure
5-3, but this time she's in
CMYK mode. The yellow
channel is almost solid
black because she's got so
much yellow in her skin,
hat, and hair.*

2. **In the duplicate image, choose Image→Mode→CMYK.**

 If your document includes more than one layer, Photoshop asks if you want to combine them into one by flattening your image (see page 112 for more on flattening). If those additional layers affect the way your image looks, click Flatten and if not, well, it doesn't really matter because you're working with a duplicate of your original document. If you see another dialog box asking about color profiles, just click OK. You'll learn about profiles in Chapter 16. For now, all you need to know is that, since you'll end up back in your original RGB document in step 5, the CMYK profile won't affect anything.

3. **In the duplicate image's Channels panel, select the Black channel.**

 When you click to activate the Black channel, Photoshop automatically turns off the other channels' visibility.

4. **Copy the Black channel.**

 With the Black channel active, press ⌘-A (Ctrl+A on a PC) to select everything in the channel. Then copy the channel by pressing ⌘-C (Ctrl+C).

5. **Select your original RGB document and paste the Black channel into your Layers panel.**

 Click the document tab or inside the window of your original RGB image. Next, open your Layers panel by clicking its icon in the panel dock on the side of your screen or by choosing Window→Layers. Then paste the Black channel into the Layers panel by pressing ⌘-V (Ctrl+V). You don't have to create a new layer; Photoshop does it for you.

6. **Close the duplicate document because you don't need it anymore.**

That's it! (Told ya it was fast.) You've now got yourself a beautiful, high-contrast look that took you minutes to make.

Spot Channels

In the realm of CMYK printing, there's a special kind of premixed ink called a *spot color*, which requires a special kind of channel called a *spot channel*. If you're a graphic designer working in prepress (see the Note below), in packaging design, or at an ad agency, you need to know this stuff and page 688 has all the details. If you're a photographer or Web designer, save your brainpower and don't bother learning about it—really.

Note: The word *prepress* refers to preparing images and documents—usually in a page layout program like Adobe InDesign—for printing on a commercial printing press.

Lab Channels

Lab mode (which gets its name from the channels it includes—they're listed later in this section) separates the lightness values (how bright or dark the image is) from the color information. This color mode isn't used for output like RGB and CMYK modes; instead, it's useful when you want to alter only the lightness values of an image (when you're sharpening or brightening, for instance) without shifting colors. Likewise, you can adjust only the color information (say, to get rid of a color cast) without affecting the lightness values. You can pop into Lab mode by choosing Image→Mode→Lab Color, and if you peek at the Channel's panel, you'll see X-rayish images like the ones shown in Figure 5-5.

In Lab mode, you have the following channels:

- **Lightness.** Here you'll find the color-drained details of your image; it looks like a really good black-and-white version. Some folks swear that by splitting this channel into its own document and then making a few adjustments, you can create a black-and-white image worthy of Ansel Adams. See page 329 for the scoop on how to do that and then judge for yourself.

- **a.** This channel contains half of your color information: a mixture of magenta (think "red") and green.

- **b.** Here's the other half: a mixture of yellow and blue.

You'll see techniques that involve Lab mode sprinkled throughout Part 2 of this book.

Multichannel Mode

Unless you're preparing an image for a commercial printing press, you'll never use this mode—although you may put yourself into it accidentally. If you delete one of the color channels in an RGB, CMYK, or Lab document, Photoshop plops you into Multichannel mode without even asking. If that happens, just use your History panel to go back a step or press ⌘-Z (Ctrl+Z on a PC) to undo what you did and bring back the channel you accidentally deleted.

Multichannel mode doesn't have a composite channel. It's strictly for two- or three-color print jobs, so when you enter this mode—by choosing Image→Mode→Multichannel—Photoshop converts any existing color channels to spot channels (page 197).

When you convert an image to Multichannel mode, Photoshop promptly does one of the following (depending on which color mode you were in before):

- **Converts your RGB channels** to cyan, magenta, and yellow spot channels.

- **Converts your CMYK channels** to cyan, magenta, yellow, and black spot channels.

Lightness

a (red and green)

Figure 5-5:
*Here's that cowgirl again,
now in Lab mode. In the
a channel, lighter areas
represent greens and darker
areas represent magentas
(reds). In the b channel,
lighter areas represent blues
and darker areas represent
yellows.*

b (yellow and blue)

- **Converts your Lab channels** to alpha channels named Alpha 1, Alpha 2, and Alpha 3.

- **Converts your Grayscale channel** to a black spot channel.

These radical channel changes cause radical color shifts, but you can edit each channel individually—both its contents and its spot color—to create the image you want. When you're finished editing, save the image as a Photoshop (PSD) file (page 51) or as a DCS 2.0 file if you need to pop it into page-layout software (described on page 694).

Single-Channel Modes

The rest of Photoshop's image modes aren't very exciting when it comes to channels since they each have just one. They include Bitmap, Grayscale, Duotone, and Indexed Color mode, and they're all discussed back on page 46 in Chapter 2.

The Mighty Alpha Channel

Photoshop has one other type of channel: *alpha channels*. Their job is to store your selections so you can use or edit them again later.

These channels get their name from a process called *alpha compositing*, which combines a partially-transparent image (one that has see-through areas) with another image; this is how filmmakers create special effects and fake backdrops. But the information about the shape of the transparent area and the pixels' level of transparency has to be stored somewhere, and that somewhere is an alpha channel.

This is powerful stuff because the same technology lets you save your selections. And, as you've learned, making selections can take a *ton* of time. Heck, you may not have the stamina to finish creating a particularly challenging selection in one sitting. And since clients change their minds occasionally—"Put the model in front of *this* bush. And change her hair color while you're at it!"—the ability to save selections so you can mess with them later is a lifesaver. As long as you save your document as a PSD file (page 51), that alpha channel will always be there for you to use. That ought to make you sleep better at night!

Tip: You can drag alpha channels between documents as long as the documents have the same pixel dimensions.

Folks sometimes refer to alpha channels as *channel masks* because, once you've made an alpha channel (as explained in the next section), you can use it to help you adjust certain portions of your image—kind of like when you use a layer mask (page 113). In fact, creating a layer mask by loading an alpha channel as a selection is the most common use for alpha channels. That's because, as you'll learn on page 205, you can use channels to make incredibly detailed selections that you can't get any other way.

Note: When you're in Quick Mask mode (page 176), you're actually working on a temporary alpha channel. Who knew?

Creating an Alpha Channel

It can be helpful to think of an alpha channel as a grayscale representation of your selection. Unless you change Photoshop's settings, the black parts of the channel are the unselected part of your image—also referred to as the *protected* or *masked* part—and the white parts are the selection (see page 203 to learn how to reverse these colors). And, just like in a layer mask (page 113), shades of gray represent areas that are only partially selected, which means they're partially see-through.

You can create an alpha channel by doing any of the following:

- **Click the "Create a new channel" button at the bottom of the Channels panel** (see Figure 5-2 on page 189). Clicking this button makes Photoshop create an empty alpha channel named Alpha 1 and stick it at the bottom of the Channels panel. The channel is solid black because it's empty. To create a selection, grab your Brush tool (page 499) and paint with white (think of this process as painting a hole through the mask so you can see—and therefore select—what's below it). If you Option-click (Alt-click) this button, you can name your new alpha channel.

Note: Though you can certainly start with an empty alpha channel, it's often easier to create your selection (or at least a rough version of it) on the full-color image *before* adding the alpha channel. Then you can fine-tune the alpha channel using the methods explained in the box on page 211.

- **Choose New Channel from the Channels panel's menu** (see Figure 5-2). When you choose this command, Photoshop opens a dialog box where you can name your new channel and tell the program how to display the channel's info. Out of the box, Photoshop shows selected areas (the parts of your image inside the marching ants) in white and unselected areas in black. Partially selected areas, which have soft edges, appear in shades of gray.

 If you'd rather see your selections in black and everything else in white, turn on the dialog box's "Selected Areas" option. If you want to edit your alpha channel using Quick Mask mode (as described later in this section), you can change the Quick Mask's color and opacity here. When you've got everything the way you want it, click OK to make Photoshop create your new alpha channel.

- **Create a selection and then choose Select→Save Selection** (see page 180).

- **Create a selection and then click the "Save selection as channel" button at the bottom of the Channels panel.** It looks like a circle within a square; it's circled in Figure 5-6.

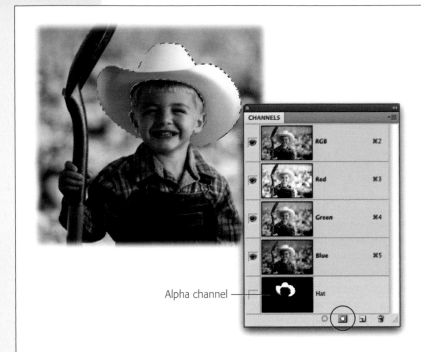

Figure 5-6:
In most cases, you'll find it easier to create a selection first (even if it's rough) and then *add your alpha channel as shown here (that way, you see the full-color image instead of a screen full of black). To do that, select something in your image and then, once you've got marching ants, click the "Save selection as channel" button (circled). Photoshop adds an alpha channel—which includes your selection—to the bottom of the Channels panel.*

Alpha channel

Tip: If you Option-click (Alt-click on a PC) the "Save selection as channel" button instead of just clicking it, Photoshop displays the same dialog box you get if you choose New Channel from the Channels panel's menu so you can name your sparkling new alpha channel. Of course, you can rename a channel at any time by double-clicking its name.

Editing Alpha Channels

Once you've got yourself an alpha channel, you can fine-tune it just like you would a layer mask (page 113). You can paint with the Brush tool or use any selection tool to modify it. If you want to use a selection tool, choose Edit→Fill and pick black or white from the Use pop-up menu, depending on what you want to do—add to or subtract from your selection (selected areas are white and everything else is black). If you want to reverse the way Photoshop displays the channel's info—if you'd rather have your selection appear in black instead of white—just double-click the alpha channel's thumbnail in the Channels panel and, in the resulting Channel Options dialog box, turn on the Selected Areas option. When you do, Photoshop flip-flops your mask's colors, as shown in Figure 5-7.

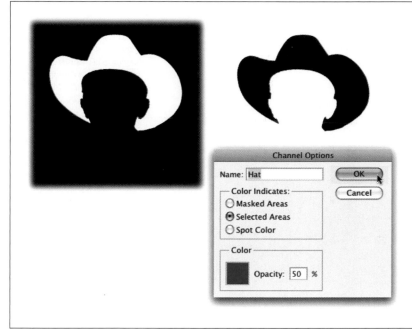

Note: It doesn't matter whether you use black to mark the masked (protected) or selected (unprotected) areas of your image—it's a personal preference. Just remember to pay careful attention to what the ants are marching around when you load an alpha channel as a selection, as *that's* the part you'll modify when you start making changes. And keep in mind that, as you learned in the box back on page 155, sometimes it's easier to select what you *don't* want and then use Select→Inverse to flip-flop your selection to get what you *do* want.

You can also edit your alpha channel using Quick Mask mode (page 176). To do that, in the Channels panel, select the alpha channel and then click the composite channel's visibility eye, as shown in Figure 5-8. When you do, Photoshop puts Quick Mask mode's signature red overlay atop your image. (If you're editing an alpha channel in an image with a lot of red in it, you can't see diddly through the mask. In that case, you need to change the overlay color: Open the Channel Options dialog box by double-clicking the alpha channel's thumbnail, click the red color swatch, pick a new color from the resulting Color Picker, and then click OK and continue editing your alpha channel.)

You can also run filters on your alpha channel, just like you can with a layer mask. Among the most useful ones are Gaussian Blur for softening the selection's edge (helpful if you're trying to select a slightly blurred area) and the Brush Stroke set (for giving your mask creative edges). Chapter 15 shows these filters in action.

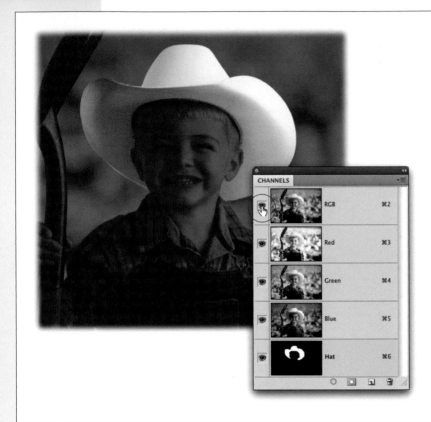

Figure 5-8:
If you select your alpha channel and turn on the composite channel's visibility eye, you can edit in Quick Mask mode. In this example, the Brush tool (the black circle) is being used to touch up the area around the little cowboy's forehead. If you mess up and add too much to the mask, press X to flip-flop your color chips and paint that area with white just like you would with a layer mask (page 113).

Loading an Alpha Channel as a Selection

Once you're finished editing your mask, you can transform it into a selection so you can actually *do* something with it. You can summon the marching ants in several ways:

- **⌘-click (Ctrl-click on a PC) the alpha channel's thumbnail** in the Channels panel.

- **Click the "Load channel as selection" button** at the bottom of the Channels panel (it looks like a tiny dotted circle) while you've got the alpha channel selected.

- **Drag the alpha channel onto the "Load channel as selection" button** (let go of your mouse as soon as Photoshop highlights the button).

Now you can perform all the amazing color and lighting adjustments explained throughout this book, and they'll affect only the area you've selected. Pretty sweet, huh?

Deleting Alpha Channels

When you're finished using an alpha channel (or if you want to start over with a new one), you can get rid of it by dragging it to the Delete icon (the little trash can) at the bottom right of the Channels panel. Or just click the trash can while the alpha channel is selected and click Yes when Photoshop asks if you're *sure* you want to throw it away.

Note: Unless you're a panel neat freak, you don't have to throw out old alpha channels. They don't add much to your file size because they're black and white (if they contain a lot of gray, they'll add slightly more to the file size, but not enough that it's worth tossing them). If there's the slightest chance you'll ever use them again, save your document as a PSD file to keep the alpha channels intact.

Basic Channel Stunts

Now that you know what channels are all about, it's time to learn some of the cool things you can do with them. This section covers a few of the most practical channel tricks, but you'll find techniques involving channels strewn throughout this book.

Selecting Objects with Channels

As you learned in Chapter 4, true selection wisdom lies in knowing which tool to start with so you'll have the least fine-tuning to do later. If you have an image with a decent amount of contrast between the object you want to select and its background, you can give channels a spin. All you need to do is create an alpha channel that contains only black-and-white objects, load it as a selection, and then use it to make a layer mask. For example, here's how to use channels to select all the balloons in Figure 5-9 in mere minutes:

1. **Open an image that's in RGB mode and has a background you want to get rid of.**

 If your image came from a scanner or digital camera, it's already in RGB mode. To check, choose Image→Mode. If necessary, choose RGB Color to switch modes.

2. **Find the channel where the objects you want to select look darkest.**

 Open your Channels panel and click each channel to find the one where the balloons appear darkest. (You can also cycle through channels by pressing ⌘-3, 4, and 5 [Ctrl+3, 4, 5 on a PC].) The objects will usually be darkest on the blue channel, as is the case here.

Note: Want to follow along? Visit this book's Missing CD page at *www.missingmanuals.com/cds* and download the practice file *Balloons.jpg*.

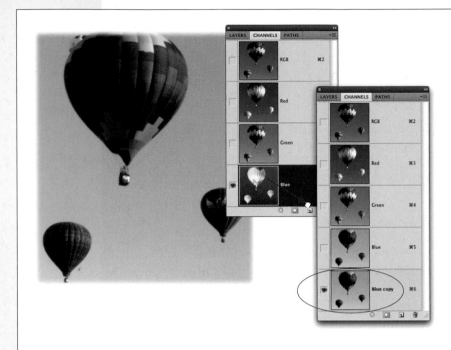

Figure 5-9:
Once you find the channel where the objects appear darkest (typically the blue channel), make a copy of that channel so you don't mess up your original photo. To copy a channel, simply drag it onto the "Create new channel" button, as shown in the middle image. Photoshop adds the copy to the bottom of your Channels panel, as shown on the right here.

3. **Duplicate the blue channel so you don't destroy your original image.**

 To duplicate a channel, either Ctrl-click (right-click on a PC) the channel in the Channels panel and select Duplicate Channel from the shortcut menu or drag the channel onto the "Create new channel" button. (You can also choose Duplicate Channel from the Channels panel's menu, but the dragging method is quicker.) Whichever method you use, Photoshop puts the duplicate channel at the bottom of your Channels panel and cleverly names it "Blue copy."

4. **Adjust the duplicate blue channel's Levels to make the balloons black and the background white.**

 Chapter 9 covers Levels in detail, but this exercise gives you a sneak peek at how useful they are. Choose Image→Adjustments→Levels or press ⌘-L (Ctrl+L on a PC) to summon the Levels dialog box. To make the balloons darker, in the Input Levels section of the dialog box, drag the shadows slider (the little black triangle that's circled in Figure 5-10) to the right until the balloons turn *almost* black. (The farther you drag the slider, the darker the background gets, too. That's okay because you'll fix the background in the next step.) Don't close the Levels dialog box just yet!

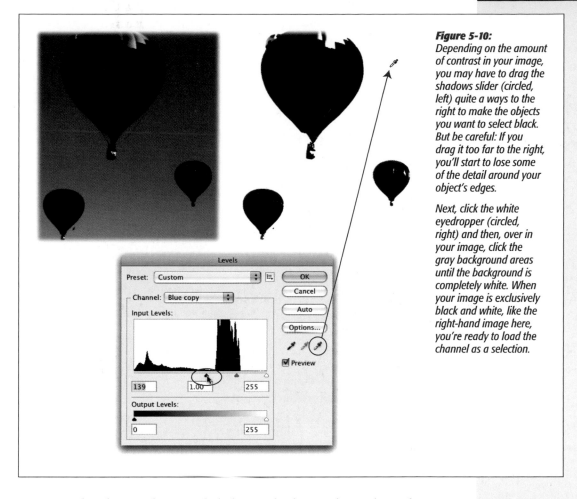

Figure 5-10:
Depending on the amount of contrast in your image, you may have to drag the shadows slider (circled, left) quite a ways to the right to make the objects you want to select black. But be careful: If you drag it too far to the right, you'll start to lose some of the detail around your object's edges.

Next, click the white eyedropper (circled, right) and then, over in your image, click the gray background areas until the background is completely white. When your image is exclusively black and white, like the right-hand image here, you're ready to load the channel as a selection.

5. **Using the white eyedropper, click the gray background to make it white.**

 You can use the little white eyedropper on the right side of the dialog box to tell Photoshop to change what it thinks should be white (pros call this technique "resetting the white point"). Click once to select the eyedropper (circled in Figure 5-10), mouse over to your document, and then click a gray part of the background. Keep clicking on different gray areas until the background is completely white (or as close to white as you can get it). When you're finished, click OK to close the Levels dialog box.

6. **If necessary, touch up the inside of the balloons with black paint and the background with white paint.**

 If adjusting the shadows slider in step 4 didn't make the balloons *completely* black (see Figure 5-10), you can use the Brush tool to touch them up by hand (otherwise the balloons will be partially selected). Press B to grab the Brush tool and then set your foreground color chip to black (press D to set the color chips to black and white, and then press X until black hops on top), and then mouse over to the balloons and paint them solid black. And if resetting the white point in step 3 didn't get rid of all the gray in the background (like the bit of gray at the upper-right corner of this image), use the Brush tool to paint those areas white. When you're finished, you should have a pure black-and-white image.

7. **In the Channels panel, load the duplicate blue channel as a selection by ⌘-clicking (Ctrl-clicking on a PC) the channel's thumbnail or clicking the "Load channel as selection" button (the dotted circle) at the bottom of the panel.**

 Now that you've got a perfectly black-and-white image (it looks just like a layer mask or alpha channel, doesn't it?), you can load it as a selection. When you do, Photoshop will put marching ants around the *background* of your image, which is the opposite of what you want. No worries! You'll solve that problem in the next step.

8. **Invert the selection to select the balloons instead of the background.**

 Choose Select→Inverse or press ⌘-Shift-I (Ctrl+Shift+I on a PC) to flip-flop your selection so the marching ants run around the balloons instead of around your whole document.

9. **In the Channels panel, turn on the composite channel and hide the duplicate blue channel.**

 Scroll to the top of your Channels panel and click the visibility eye of the composite channel (the one named RGB) to turn it back on so you can see the full-color version of your image again. Also, turn off the visibility of the duplicate blue channel or delete it by dragging it to the tiny trash can at the bottom right of your Channels panel.

10. **Open your Layers panel, make the Background layer editable, and then add a layer mask.**

 Use the panel dock (page 19) on the right side of your screen to open the Layers panel or choose Window→Layers. If the Background layer still has a little padlock next to it, double-click it to make the layer editable. If you like, type a name for the Background layer in the resulting dialog box and then click OK (if you're working with an image you've edited before, you may have already named your Background layer something other than "Background"). To add a layer mask, click the circle-within-a-square button at the bottom of the Layers panel. Photoshop adds a layer mask that hides the photo's original background (the sky), as shown in Figure 5-11, left. Sweet!

You're all finished! At this point you can edit the layer mask (page 113) if you need to by selecting it in the Layers panel and then painting it with either black or white. Or you can copy and paste a new background into the Layers panel and then drag it to the bottom of the layers stack to put the balloons on a new sky as shown in Figure 5-11.

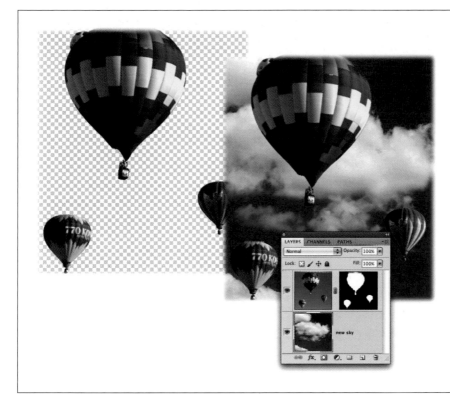

Figure 5-11:
Look, Ma, no selection tools! Whenever you have an image like this one that's got a decent amount of contrast between its subject and its background, using channels is an easy way to create an accurate selection fast.

Creating a Silhouette Effect

Attention anyone interested in creating iPod-style ads: You can use the *exact* same channel-selection technique described on the previous section to create a silhouette effect. However, instead of adding a layer mask, you'll add a new layer and then fill your selection with black. That way, the silhouette will live on its own layer, making it easier for you to edit or change it later, as the Apple-esque images in Figure 5-12 show.

To create a quick silhouette, follow steps 1–9 in the previous section (page 205) so that you've got your basic selection and you're looking at the full-color image, and then:

1. **Add a new layer at the top of your layers stack.**

 When you see marching ants running around your subject, you're ready to create a new layer and fill your selection with black. To do that, open the Layers panel and add a new layer by clicking the "Create a new layer" button at the bottom of the panel. Then drag the new layer to the top of the layers stack and turn off the visibility eye (page 82) of the original photo layer (which may or may not be named Background).

Tip: In Photoshop CS5, you've got a new way to create difficult selections: the Edge Detection section in the Refine Edge dialog box. See page 166 for the lowdown.

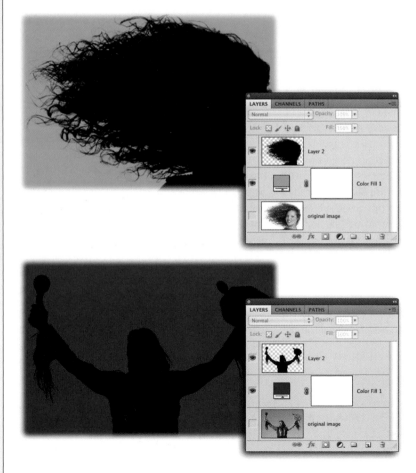

Figure 5-12:
Using channels to make a selection lets you create a silhouette effect in no time flat. You can even get a clean selection of curly hair (top) and dangling feathers (bottom).

When you're dealing with delicate edges like these, be careful not to drag the Levels dialog box's shadows slider too far to the right or the edges will disappear. You'll have a little more touch-up work to do with a black brush before you're finished, but it's worth it, and these images require less touching up than the balloons back in Figure 5-11.

Touching Up Alpha Channels

When you're editing an alpha channel to make a selection, it's important that you end up with a *nearly* pure black-and-white channel with very little shades of gray. (The alpha channel shown in Figure 5-10 is almost there but needs a tiny bit of touch-up on the balloons). If you've got any gray areas around the edge of the object, those edges will look soft—as if you've feathered them (page 145). If you've got gray in the center of the object, those pixels will be partially selected; and if you've got white areas, they won't be selected at all. Adjusting your alpha channel's levels usually gets your image *close* to pure black and white, but that method can only do so much: You're often left with stray gray pixels hiding here and there, a selection that isn't quite solid black or white, or some stuff in the background that you don't need. Your only choice at that point is to touch up your image by hand.

Sure, this kind of touch-up work is tedious, but it goes much faster if you use one of the following methods. Remember that when you're in Channels Land, you've got most (but not all) of Photoshop's tools at your command. With that in mind, here are a few tricks for touching up alpha channels:

- **Fill the background with black or white.** If you've managed to make your object pure black, you can use a selection tool to grab everything else in the channel and make it white. For example, use the Lasso tool to draw a rough selection around your black object and then choose Select→Inverse to flip-flop the selection and select the background. Next, choose Edit→Fill and pick white from the Use pop-up menu and then click OK. Now, your background is solid white and your touch-up work is limited to the area right around your object. If the object you want to select is solid white, use this trick to fill the background with black instead.
- **Fill in the object with black or white.** When the object you want to select isn't *quite* solid black or white, your best bet is to set the Brush tool to either black or white and then paint the object by hand. But if the area is square or oval, you're better off using the Rectangular and Elliptical Marquee tools (page

139) to select it—yep, they work here, too!—and then choose Edit→Fill and pick black or white from the Use pop-up menu. When you click OK, Photoshop fills that area with color.

- **Get rid of stray gray pixels inside a black object.** If you've cleaned up the rest of your alpha channel but still see a few gray pixels in your black object, use Levels to turn them black. Remember how you used Levels to turn gray pixels white by resetting the white point (page 207)? You can do the same thing to make Photoshop turn gray pixels black. Just open the Levels dialog box by pressing ⌘-L (Ctrl+L on a PC), select the *black* eyedropper, mouse over to your image, and then click one of those pesky gray pixels. Photoshop turns all the gray pixels in your document black.
- **Get rid of stray gray pixels next to a black object.** If you end up with a few gray pixels near the object you want to select, use a white Brush set to Overlay mode (see page 298) to paint them white. Press B to select the Brush tool and set your foreground color chip to white (page 24). Then hop up to the Options bar and set the Mode menu to Overlay. In this mode, the Brush tool *completely* ignores the color black and turns gray pixels white, letting you brush away gray pixels near black areas without fear of messing up the black. Even if you paint right over the black area, nothing happens to it!
- **Turn gray pixels in delicate edges black.** If you're dealing with hair or fur, some of the wispier edges may end up more gray than black. If that happens, grab the Brush tool and set your foreground color chip to black. Then trot up to the Options bar and change the Mode menu to Soft Light (page 298). Now, when you paint over the hair or fur, Photoshop turns the gray pixels black. However, you may not want to turn those delicate parts *completely* black or they'll have a hard edge and won't blend into the background very well. You'll have to experiment on your image to see what looks best.

Note: Try this silhouette technique by visiting this book's Missing CD page at *www.missingmanuals.com/ cds* and downloading the practice file *Indian.jpg*.

2. **Fill your selection with black.**

 With the new layer selected, choose Edit→Fill and pick black from the Use pop-up menu, and then click OK to close the Fill dialog box. Your silhouette is finished, but you still need to add a vivid background.

3. **Add a new Solid Color Fill layer and pick a bright color.**

 This layer is for your brand-new background. Take a peek at the bottom of your Layers panel and click the Adjustment layer icon (it looks like a half-black/half-white circle). Choose Solid Color from the menu that appears to make Photoshop open the Color Picker; pick a bright color and then click OK. (Sure you could create a regular ol' image layer and fill it with color, but this way is faster; see page 91 for the full story on Fill layers).

4. **Drag the new Fill layer below the silhouette layer in the layers stack.**

 This step keeps the new background from covering the silhouette.

That's it! If you need to edit the silhouette—maybe you want to erase something or do a little touch-up with a black brush—select that layer and have at it. Likewise, if you want to change the background color, simply double-click the Solid Color Fill layer and pick a new color from the resulting Color Picker. Now you're starting to see the power of using channels to help make selections!

FREQUENTLY ASKED QUESTION

Selecting with the Lightest Channel

How come I always have to make objects black and the background white when I'm using channels to create a selection? Can I do it the other way around instead?

Trying to buck the system, are ya? Lucky for you, the answer is yes—you can make the object white and the background black instead if you prefer. It doesn't matter whether the area you want to select is black or white; all that matters is what the marching ants surround once you load that channel as a selection.

For example, if you're trying to select a light object that lives on a dark background, it's *much* easier to make the object white and the background black. In that case, search for the *lightest* channel (which, in RGB mode, is usually red). Once you find it, duplicate that channel and then use Levels to make it pure black and white (see page 206, step 4). You won't even need to inverse your selection; you'll see marching ants around your object as soon as you load the channel as a selection (page 208, step 7).

Lightening and Darkening Channels

There will be times when you wish a channel were lighter or darker so you'd have an easier time making your selection. Remember back in Chapter 3 when you learned how to quickly lighten and darken photos using blend modes? While there's no blend mode pop-up menu in the Channels panel, you can make your channel lighter or darker by using the *Apply Image* command. Folks mainly use this command to blend two images together (see the Note on page 305)—which is why the Apply Image dialog box has a blend mode pop-up menu—but you can also use it to apply a channel to *itself* (as if the channel were duplicated) and change its blend mode at the same time.

To lighten or darken a channel, select it in the Channels panel and then create a copy of it (see page 192) so you don't destroy your original image. Then choose Image→Apply Image and, at the bottom of the resulting dialog box (shown in Figure 5-13), choose either Screen (to lighten) or Multiply (to darken) from the Blending pop-up menu. When you click OK, Photoshop applies the channel to itself using the blend mode you picked. Depending on the image you're working with, your channel will lighten or darken by about 15 to 30 percent. If it needs to be even lighter or darker, simply run the Apply Image command as many times as you need to.

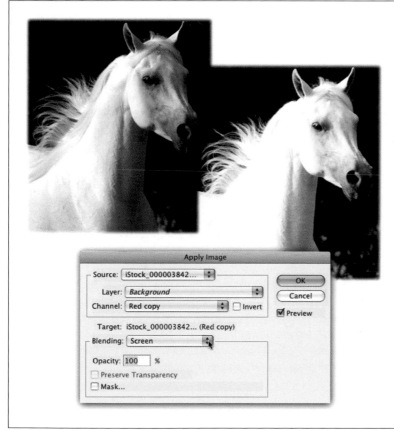

Figure 5-13:
With the Apply Image command, you can apply a channel to itself but with a different blend mode. As you can see here, applying the Screen blend mode to a duplicate of the red channel made this horse quite a bit whiter, so it's easier to turn the horse solid white in an alpha channel (page 201).

Tip: If the Apply Image command isn't lightening or darkening your duplicate channel enough to make a good alpha channel, you can always pump up the contrast by adding a temporary Curves or Levels Adjustment layer to your Layers panel (pages 406 and 390, respectively). By using an Adjustment layer, the temporary contrast boost happens on its own layer, so you can throw it away after you've created the alpha channels.

Combining Channels

Not all your images will have enough contrast to let you make a good alpha channel by using just one channel—sometimes you'll have to use *two*. This process takes a bit more time, but the steps are essentially the same.

For example, if you want to select the hat and guitar in Figure 5-14, a quick glance at the Channels panel tells you that the hat is darkest in the red channel, but the guitar is darkest in the green channel. So your best bet is to build your selection one channel at a time, using the optimal channel for each part. You can duplicate the red channel and adjust it by using Levels, the Brush tool, and so on until you make the hat solid black. Next, duplicate the green channel and work on the guitar while you erase (or paint over) the parts of that channel you don't need (the hat). When you're finished, you may want to merge them, but, alas, Photoshop won't let you. But you *can* combine them into a brand-new channel using the *Calculations* command.

Choose Image→Calculations to bring up the Calculations dialog box. From the pop-up menus in the Source 1 and Source 2 areas, pick the channels you want to combine as shown in Figure 5-14. This dialog box also lets you set the blend mode, so if you're working with a black object and a white background as shown in the figure, set the blend mode to Multiply so Photoshop keeps the darkest parts of both channels and gets rid of everything else. If you're working with a white object and a black background, use the Screen blend mode instead so Photoshop keep the *lightest* parts of both channels.

Note: You can also use the *Channel Mixer* to simulate combining channels to create grayscale images. It doesn't actually combine channels, but it makes your image *look* like you did. Skip ahead to page 328 to learn how.

Sharpening Individual Channels

As you'll learn in Chapter 11, if you sharpen an image that has a lot of noise in it, you'll sharpen the noise and grain too, making it look ten times worse than it did before (see the box on page 462). That's why it's important to get rid of—or, at the very least, reduce—those nasties *before* you sharpen an image.

Note: What's the difference between "noise" and "grain"? They both describe tiny flecks on your image, but, technically speaking, noise occurs in digital images, whereas grain occurs in analog prints, film, and transparencies. In other words, grain becomes noise once you scan the image.

However, let's say you're in RGB mode and you dutifully followed the instructions on page 462 and ran the Reduce Noise filter on your blue channel (which typically has the most noise, though sometimes noise can hide out in the red channel) and it didn't do squat. What do you do? You can try bringing out some of the details in your image by sharpening *only* the red and green channels, as shown in Figure 5-15.

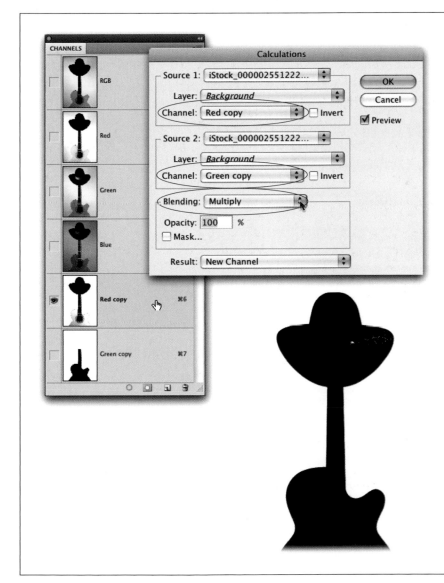

Figure 5-14:
Photoshop doesn't let you merge two channels into one, but you can combine them into a new channel with the Calculations command: Choose Image→Calculations and, in the dialog box shown here, set the Source 1 section's Channel pop-up menu to "Red copy" and the Source 2 section's menu to "Green copy". Choose Multiply from the Blending pop-up menu at the bottom of the dialog box if you want to create a black object or Screen if you want to create a white onc. When everything's set, click OK.

Tip: The next time you need to sharpen a portrait of someone who's sensitive about his or her appearance, try sharpening only the red channel to avoid bringing out unwanted details in the person's skin. (As you learned earlier in this chapter, most of the fine details live in the high-contrast green channel.)

Here's how to sharpen without making noise any worse than it already is:

1. **Open your image and make a copy of the layer(s) you're going to sharpen.**

 If you're working with a document that has just one layer, select it in your Layers panel and duplicate it by pressing ⌘-J (Ctrl+J on a PC). If you like, double-click the layer's name and rename it *Sharpen*.

 If you're working on a multilayer document, press and hold the Option key (Alt on a PC) while choosing Merge Visible from the Layers panel's menu (see the figure on page 78). Photoshop combines all the layers into a new layer. Drag this new layer to the top of your Layers panel and name it *Sharpen*.

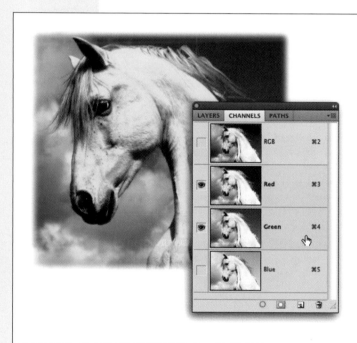

Figure 5-15:
If you select the red and green channels before running a sharpening filter, you restrict the sharpening to those channels. That helps you avoid sharpening, and therefore accentuating, any noise.

2. **Open the Channels panel (page 189) and select the red and green channels.**

 Click to select one channel and then Shift-click to select the other one, so they're both highlighted in your Channels panel. Don't panic if your image turns a weird color (like the horse in Figure 5-15); Photoshop is just showing you the image using only those two color channels.

3. Choose Filter→Sharpen→Unsharp Mask (page 463).

When you run a filter while you've got only certain channels selected, Photoshop applies the sharpening to just those channels. In this case, it won't apply any sharpening to the blue channel. Click OK to close the Unsharp Mask dialog box.

4. **In the Channels panel, turn on the composite channel (here, that's RGB) to see your new and improved full-color image.**

You're done! If you want to see before and after versions of your image, open the Layers panel and toggle the Sharpen layer's visibility eye (page 82) off and on.

Tip: Another, more advanced way to sharpen your image is to use the channel with the highest contrast to create an intricate edge mask. You can read all about that process on page 475.

Cropping, Resizing, and Rotating

Cropping and resizing images are among the most basic edits you'll ever make, but they're also among the most important. A bad crop—or no crop—can ruin an image, while a good crop can improve it tenfold by snipping away useless or distracting material. And knowing how to resize an image—by changing either its file size or its overall dimensions—can be crucial when it's time to email an image, print it, or post it on a website. Cropping is pretty straightforward; resizing, not so much. To resize an image correctly, you first need to understand the relationship between pixels and resolution—and how they affect image quality. (That can of worms gets opened on page 238.) Rotating images, on the other hand, is just plain fun.

In this chapter, you'll learn more than you ever wanted to know about cropping—from general guidelines to the many ways of cropping in both Photoshop and Camera Raw (a powerful photo-correcting application that comes with Photoshop—see Chapter 9). You'll also discover how to resize images *without*—and this is crucial—losing image quality. Perhaps most important, you'll understand once and for all what resolution really is, when it matters, and how to change it without trashing your image. Finally, you'll spend some quality playtime with the various Transform commands.

Cropping Images

There's a reason professional photos look so darn good. Besides being shot with fancy cameras and receiving some post-processing fluffing, they're also composed or cropped extremely well (or both). *Cropping* means eliminating distracting elements in an image by cutting away unwanted bits around the edges. Good crops accentuate the subject, drawing the viewer's eye to it; and bad crops are, well, just bad, as you can see in Figure 6-1.

Figure 6-1:
Left: A poorly cropped image can leave the viewer distracted by extraneous stuff around the edges, like the wall and window reflection here.

Right: A well-cropped image forces the viewer to focus on the subject by eliminating distractions (in this case, the empty space in the background). This crop also gives the subject a little breathing room in the direction she's facing, which is always a good idea (see the next figure for more examples).

Technically, you can crop *before* you take a photo by moving closer to the subject (also called "cropping with your feet") and repositioning the subject within the frame. However, if you don't get the shot right when you're out in the field, Photoshop can fix it after the fact. But before you go grabbing the Crop tool, you need to learn a few guidelines.

The Rule of Thirds

Once you understand the rule of thirds, a compositional guideline cherished by both photography and video pros, you'll spot it in almost every image you see. The idea is to divide every picture into nine equal parts using an imaginary tic-tac-toe grid. If you position the image's horizon on either the top or the bottom line—never the center—and the focal point (the most important part of the image) on one of the spots where the lines intersect, you create a more interesting shot. It's simpler than it sounds—just take a look at Figure 6-2.

Note: In Photoshop CS5, the Crop tool actually *comes with* a rule-of-thirds grid, making this rule easier than ever to grasp and follow!

Figure 6-2:
Top: Imagine a tic-tac-toe grid atop every image. Notice that the interesting bits of the photos are positioned where the lines intersect. Most digital cameras let you add such a grid to the camera's screen to help you compose your shots. To figure out how to turn it on, you may have to root through your camera's menus or (shudder) dig out the owner's manual.

Bottom: Before you crop, notice the direction your subject is facing. A good crop gives the subject room to move—or, in this case, fly—through the photo. If the image were cropped tightly to the boy's face on the right side, it'd look weird because he'd (theoretically) smack into the edge of the image if he flew away.

Creative Cropping

Along with applying the rule of thirds, pros also crop in unexpected ways, as Figure 6-3 shows. Unconventional cropping is yet another way to add visual interest to catch the viewer's eye.

Creative cropping is especially important when you're dealing with super-small images, such as those in a thumbnail gallery or on a website where several images vie for attention. In such small images, people can see few, if any, details; and, if the photo contains people, you can *forget* being able to identify them. Here are some tips for creating truly enticing, teensy-weensy images:

- **Recrop the image.** Instead of scaling down the original, focus on a single element in the image. You often don't need to include the whole subject for people to figure out what it is (Figure 6-3, middle, is a good example).

- **Sharpen again after resizing.** Even if you sharpened (digitally enhanced the focus of) the original, go ahead and resharpen it post-resizing using the Unsharp Mask filter (page 463). Chapter 11 has the full story on sharpening.

- **Add a border.** To add a touch of class to that tiny ad or thumbnail, give it an elegant hairline border (page 183) or rounded edge (page 147).

Figure 6-3:

Top: Challenge yourself to think outside the box and crop in unexpected ways. You may not think cropping someone's face in half is a good idea, but here's an example where it works.

Middle: When you're close-cropping, you often don't need to reveal the whole subject. For example, this piece of zebra is more visually interesting than the whole animal, and it's still obvious what it's a photo of.

Bottom: Here's proof that you can't always trust what you see! Cropping can easily alter the perceived meaning of an image. For example, the left-hand photo has been creatively cropped to suit the headline, "Sea Muffin Wins by a Mile!" But the original photo on the right reveals another story.

Now that you've absorbed a few cropping guidelines, you're ready to read about the many ways you can crop in Photoshop, starting with the most common.

The Crop Tool

Photoshop tools don't get much easier to use than the good ol' Crop tool. Press C to grab it from the Tools panel and then drag diagonally to draw a box around the bits of the image you want to keep. As you can see in Figure 6-4, CS5's Crop tool comes with its own rule-of-thirds grid. To move the crop box *as* you're drawing it, press and hold the space bar while dragging. When you've got the crop box where you want it, let go of the space bar and continue drawing the box.

Tip: If you draw a crop box and then decide you don't want to crop your photo after all, no problem. You can bail out of a crop-in-progress by pressing the Esc key, or clicking the Cancel button in the Options bar (the circle with a slash through it).

As soon as you let go of the mouse, Photoshop helpfully darkens the outer portion of the image to give you an idea of what's destined for the trash bin. (This darkened portion is called a *shield*.) Grab any square handle to resize the box or click inside the box and drag to reposition it (your cursor turns into a tiny arrow). When you like what you see, press Return (Enter on a PC) or double-click inside the crop box to accept it.

Keep in mind, though, that when you accept a crop, Photoshop *deletes everything in the shielded area permanently*—unless you undo the deletion right away. So if you change your mind immediately after wielding the crop axe, press ⌘-Z (Ctrl+Z on a PC) to undo it or step backwards in the History panel (page 27). Better yet, if you like the crop but want to make sure you keep a copy of the original, uncropped version, go to File→Save As right after you crop the photo and give it a new name.

Tip: You can toggle the crop shield off and on by pressing the forward slash key (/). You can also change the shield's color and transparency using the Options bar (see Figure 6-5) but these settings are visible only when a crop box is active. Better yet, leave the shield on and change the opacity to 100 percent for a slick, solid-black background that lets you *really* see what the cropped image looks like.

Cropping and hiding

Normally when you crop an image, Photoshop deletes the outer edges—they're gone forever. But if you're cropping a *layered* file (see Chapter 3 for the scoop on layers) or a single-layered file that has an unlocked Background, you can tell Photoshop not to vaporize the cropped material, making it easy to retrieve if you change your mind. To do that, head up to the Options bar and, in the Cropped Area section, turn on the Hide radio button shown in Figure 6-5; Photoshop politely *hides* the cropped area outside the document's margins instead of deleting it. That way, even though you won't see it onscreen, it's still part of your file.

If you want to resurrect the cropped portion, choose Image→Reveal All to make Photoshop resize the canvas and reveal anything that's loitering outside the edges of the document (in this case, the bits you cropped). If you want to bring back just a portion of the cropped area, press V to grab the Move tool (see page 178) and drag the image back into view.

Figure 6-5:
The Delete and Hide radio buttons appear after you draw a crop box, and they're active only when you're cropping a file that doesn't have a locked Background or when you're cropping a multilayered file (they're grayed out any other time).

If you want to hide the portion of the canvas covered by the crop shield (rather than permanently delete it), turn on the Hide radio button. After you crop, the cut bits dangle beyond the document's new margins—so you can bring them back if you want to. For fickle folks, this is the only way to roll.

Cropping with perspective

If you shoot an image at an angle and then find you need to straighten it (like the frame shown in Figure 6-6, left), you can crop the image *and* change its perspective at the same time using the Crop tool's Perspective setting.

Note: Photoshop won't let you crop with perspective if you've turned on the Hide option discussed in the previous section. In that case, set the Cropped Area to Delete and *then* turn on the Perspective setting.

Figure 6-6:
Left: Cropping to perspective can instantly (and painlessly) straighten objects shot at an angle, like this painting.

Right: This trick doesn't work so well on living creatures, however, as it can leave them a bit distorted, as shown here.

To crop with perspective, first draw a crop box around the object you want to straighten. (The box doesn't have to be exactly aligned with the object, but you do want to grab the whole object.) Next, turn on the Perspective checkbox in the Options bar and then drag the corner handles so the lines of the crop box are parallel to (or on top of) the angled lines in your image. When everything's lined up, press Return (Enter on a PC) or double-click inside the box to accept the crop. If the planets are properly aligned, the cropped image looks nice and straight (Figure 6-6, bottom left). Be careful, though: This tool distorts images and can leave living creatures looking like they were photographed in a funhouse mirror (Figure 6-6, bottom right).

Cropping to a specific size

Sometimes you'll want to crop precisely, like when you're cropping a photo to fit in a 4"×6" frame. In that case, you can use the Options bar to enter the width, height, and resolution (page 238) of the final image to restrict the crop to a certain size so that it prints perfectly.

Note: As with most of Photoshop's dialog boxes and panels, any changes you make in the Options bar *stay* changed until you change them back. So the next time you crop an image to a specific size, remember to click the Clear button (shown at the far right of Figure 6-7) to empty the dimension fields so your crop boxes won't be restricted to the last measurements you used.

Tool Preset picker

Figure 6-7:
If you know the exact dimensions you want your final, cropped image to be, type them into the Options bar's Width and Height fields (circled). If you want to copy another image's dimensions (so that you can base a crop on those measurements), open that model image and then click the Front Image button (also circled) to snag its dimensions. When you click in the document you want to crop, the copied dimensions appear in the Options bar, ready for you to use.

To enter custom dimensions, press C to grab the Crop tool and then head up to the Options bar and enter measurements in the width and height fields (be sure to include units—see the Note below). Alternatively, you can choose one of the generic sizes listed in the Crop tool's Preset menu, shown in Figure 6-7. If you plan to print the final result, you'll also need to enter a resolution (page 238); otherwise, you can leave this box blank.

Note: When you enter a custom crop size, be sure to include a unit of measurement, such as *px* for pixels or *in* for inches. Otherwise, Photoshop assumes you mean the unit of measurement that's set in your preferences, which may not be what you want (see page 36 to learn how to change this setting).

Now, when you "draw" the crop box—actually, you just need to click your image— it's constrained to the *aspect ratio* (the relationship between width and height) of the dimensions you entered. Once you accept the crop, the area *inside* the box perfectly matches the dimensions you entered.

If the image gets *bigger* inside the document window after you crop to a specific size, that means you've enlarged the pixels by entering too high a resolution for the box you drew (flip to page 238 to learn about resolution). In that case, press ⌘-Z (Ctrl+Z on a PC) to undo the crop and then draw a smaller crop box, or, in the Options bar, enter smaller dimensions or a lower resolution (or both).

Zooming in by cropping

The Crop tool's flexibility is all well and good, but what if you want to preserve the original width-to-height relationship (the aspect ratio) of an image? Say you've been out shooting in the Texas plains and, once you're parked back at your computer, you decide to zoom in on that prairie dog you photographed by cropping out all the dirt around him. Sure, you can draw a crop box around the little rodent, but you have no way of preserving the *shape* of the original photo—Photoshop doesn't have any presets for cropping to specific aspect ratios (see Figure 6-8). You can work around this problem in two ways, both of which involve selecting the whole photo first. Here's how to zoom into a photo without losing its original shape:

- **Open a photo and press C to grab the Crop tool.** Draw a box around the entire image and, while holding the Shift key, drag one of the corner handles inward. Then click inside the box and drag it into the right position. When you've got it in just the right spot, press Return (Enter on a PC) to accept the crop.

- **Open a photo, select its layer, and then press ⌘-A (Ctrl+A on a PC) to select everything on that layer.** This creates a selection around the entire photo that you can resize and then use to crop. Choose Select→Transform Selection, and, while holding down the Shift key (to preserve the selection's aspect ratio), drag one of the square corner handles inward. If you want, reposition the bounding box by dragging it just like you would a crop box. When you get the bounding box where you want it, press Return (Enter on a PC) or double-click inside the box to accept it. Now, choose Image→Crop to get rid of the portion outside the selection and then dismiss the selection by pressing ⌘-D (Ctrl+D).

Either way, you've just zoomed in on an item in the photo and cropped it to the same aspect ratio as the original. Give yourself a gold star!

Figure 6-8:
Here you can see the original photo (top), along with the kind of crop you might perform freehand (bottom left) and a crop that preserves the aspect ratio of the original (bottom right).

Preserving the aspect ratio is handy when you're preparing photos for a slideshow and they all need to be the same shape.

Adding Polaroid-style photo frames

The Crop tool isn't all work and no play; you can use it for fun stuff like creating a Polaroid-style photo frame like the one in Figure 6-9. Besides being a fast way to add a touch of creativity to your image, this kind of frame lets you add a caption to commemorate those extra-special moments. Here's how to add a frame to your photo:

Note: To practice the Polaroid maneuver on your own computer, visit this book's Missing CD page at *www.missingmanuals.com/cds* and download the practice file *Trekkers.jpg*.

1. **Open an image and double-click its Background layer to make it editable.**

 Remember, the Background layer is initially locked for the reasons explained in the box on page 85. Until you unlock it, Photoshop restricts what you can do with it. Just give it a quick double-click to unlock it, and—if you want—give it a new name in the resulting dialog box.

2. **Enlarge the document window so you can see the gray work area all the way around the image.**

 To enlarge the window, drag its bottom-right corner until you've got a few inches of gray space on all four sides of your image. This bit of window resizing makes it easier to see what you're doing in the next step.

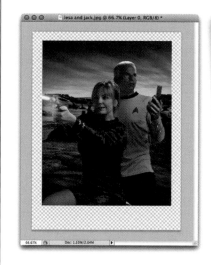

Playing dress-up with Jack

Figure 6-9:
Left: To create the look of a Polaroid, use the Crop tool (page 222) to add canvas space around your photo as shown here. Be sure to add a little extra room at the bottom for a caption!

Right: When you add a solid white layer and then add even more canvas space, the Polaroid really starts to take shape. Next, add a caption, merge the layers, and then rotate your image. Finish off the effect by adding a drop shadow (page 129) large enough to show around all four edges. Engage!

3. **Add canvas space with the Crop tool.**

 Draw a box around the image and, while you hold down the Option key (Alt on a PC), drag one of the crop handles outward about one-quarter inch and then release the key.

Tip: Holding down Option (Alt) while you drag the corner handles of a crop box forces *all four sides* of the box to expand or shrink simultaneously by the same amount. (Otherwise, you'd have to move each handle one after another.) Press and hold the Shift key to resize the box as a perfect square.

 Next, drag the bottom-middle crop handle down another one-quarter inch (that's where the caption goes). Finally, press Return (Enter on a PC) to tell Photoshop you want to keep the new canvas space. You should see a checkerboard background around the photo (see Figure 6-9).

Note: If you don't make the Background layer editable before you increase the canvas space, the area around the photo ends up the color of your background color chip instead of transparent, so you can't see the checkerboard pattern. If you have this problem, press ⌘-Z (Ctrl+Z on a PC) and start over with step 1.

4. **Create a new layer and drag it below the original photo layer.**

 At the bottom of the Layers panel, click the new layer icon (it looks like a piece of paper with a folded corner). To keep from covering up the whole photo in the next step, drag the new layer's thumbnail *below* the original layer. Alternatively, you can ⌘-click (Ctrl-click) the icon to make Photoshop add the new layer below the currently active layer.

5. **Fill the new layer with white to form the Polaroid edges.**

 Choose Edit→Fill, pick "white" from the Use pop-up menu, and then click OK. Now you've got a Polaroid-style frame around your photo. (For this technique, it's better to use an image layer than a Solid Color Fill layer—see page 91—because the latter automatically resizes to fill your canvas, making the Polaroid effect impossible.)

6. **Increase your canvas space again so you have room to rotate the image and add a drop shadow.**

 Press C to grab the Crop tool and draw a box around the image yet again. Add equal space on all four sizes by dragging any corner handle while you hold down the Option key (Alt on a PC). Press Return (Enter) to accept the crop.

7. **Add a caption with the Type tool.**

 Press T to select the Type tool (page 583) and add a caption toward the bottom of the frame. Here's your big chance to use a handwriting typeface! Bradley Hand is one good option.

8. **Select all three layers.**

 When you have everything just right, hop over to the Layers panel and ⌘-click (Ctrl-click) to select the image layer, Type layer, and white Polaroid-frame layer so you can rotate the whole mess in the next step.

9. **If you like, rotate the image just a bit to give it more character.**

 Summon the Free Transform command by pressing ⌘-T (Ctrl+T on a PC) and then rotate your photo by positioning your cursor just below the bottom-right handle. When the cursor turns into a double-sided curved arrow, drag slightly up or down. Press Return (Enter) to accept the rotation or press Esc to reject it and try again.

10. **Select the white background layer and add a drop shadow (page 129).**

 Since you selected all three layers in order to rotate them, click the white background layer to select just that one. Click the tiny cursive *fx* at the bottom of the Layers panel and choose Drop Shadow (page 129), and then increase the shadow's size quite a bit so it's visible on all four sides of your new Polaroid frame. Move the shadow around by dragging in your document and soften it by lowering the opacity in the Layer Style dialog box. Click OK when you're finished.

When you're all done, you can add a solid white Fill layer to the bottom of your layer stack to make your image look like Figure 6-9, right. Fun stuff!

Cropping with Selection Tools

You can also crop an image within the boundaries of a selection. This technique is helpful if you've made a selection and then need to trim the image down to roughly that same size. The Rectangular Marquee tool (page 139) works best for this kind of cropping—though all the selection tools work—because Photoshop, bless its electronic heart, can crop only in rectangles.

After you draw a selection, choose Image→Crop. Because you're not using the Crop tool, you won't get resizing handles, a shield, or the ability to hide the crop, but the document still gets reduced to the edges of your selection. If you're attempting to crop with an irregular or elliptical selection, you'll *still* end up with a rectangular image that encompasses the area you selected.

Trimming Photos Down to Size

If your image has a solid-colored or transparent (checkerboard) background, you may find yourself chipping away at its edges to save space in the image's final destination (a website, a book—whatever). The *trim* command is incredibly handy for those situations, especially when you're trying to tightly crop an image that has a drop shadow or reflection. Such embellishments make the image's *true* edges hard to see—and therefore tough to crop—because they fade into the background. So it's easy to, say, accidentally chop a drop shadow in half when you're cropping. Fortunately, you can enlist Photoshop's help in finding the edges of an image and have it do the cropping for you.

To whittle down your photo, choose Image→Trim and, in the resulting dialog box (shown in Figure 6-10), use the radio buttons to tell Photoshop whether you want to zap transparent pixels or pixels that match the color at the document's top left or bottom right. Next, choose which sides of the image you want to trim by turning their checkboxes on or off and clicking OK. Photoshop trims the document down to size with zero squinting—or error—on your part.

Note: The Trim command was used on every screenshot in this book to crop the images as closely as possible. It's a massive timesaver if you work in production!

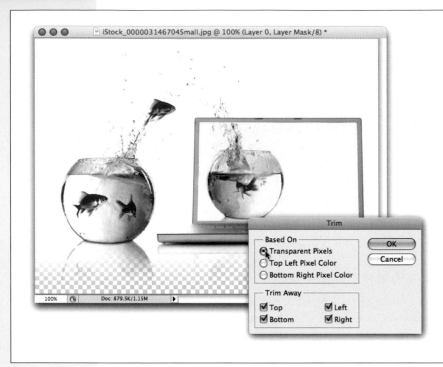

Figure 6-10:
If you have a hard time seeing the edges of an image you want to crop tightly, let Photoshop do it for you by using the Trim dialog box. In this example, the goal is to get rid of the extra transparent space at the bottom so the photo is as small as possible. You can do that by choosing Transparent Pixels in the dialog box shown here.

Cropping and Straightening Photos

In Photoshop CS5, you can use the Ruler tool to straighten individual images in a snap; just flip back to page 71 to learn how. However, if you've painstakingly scanned a *slew* of photos into a single document, you can save yourself a lot of work by having Photoshop crop, straighten, and split them into separate files for you—all with the flick of a single menu command.

With the page of photos open, choose File→Automate→"Crop and Straighten Photos". Photoshop instantly calculates the angle of the overall image's edge (that is, the edge of the photo bits) against the white background, rotates the images, and then duplicates all the photos into their own perfectly cropped and straightened documents, as shown in Figure 6-11. It's like magic!

Note: The "Crop and Straighten Photos" command also works on documents that contain just *one* image, provided the picture has white space on all four sides (like the white space you'd have between photos if you scanned several at once). It also works on layered files (see Chapter 3). Just select the layer of the image you want to extract, run the command, and Photoshop strips that layer out into its own document and deletes it from the original document. If that layer contains several images, they'll get stripped out into their own individual documents.

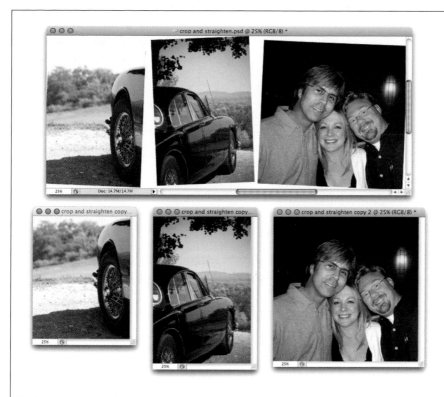

Figure 6-11:
It's tough to get a bunch of photos perfectly straight when you're scanning (heck, just putting the lid down moves 'em!). This is a prime opportunity to use the "Crop and Straighten Photos" command. In one fell swoop, the photos (top) get straightened, cropped, and copied into their own individual documents (bottom) right before your eyes.

Tip: If you want Photoshop to crop and straighten a *few* photos that all reside on a single layer (but not all of them), draw a selection around each of them before you run the command (use any selection tool and hold the Shift key to add to the selection). Photoshop processes only those photos, provided they (and their individual selection boxes) are next to each other. If they're not, Photoshop crops and straightens everything in between, forcing you to close the new, unwanted documents.

Cropping and Straightening in Camera Raw

Camera Raw is an amazing piece of software that photographers use to edit the color and lighting of images (you'll learn loads more about it in Chapter 9). It gets installed with Photoshop, so you don't have to download it or pay for it separately. Using Camera Raw to crop and straighten your photos has two big advantages:

- **You can undo the crop or straighten (or both) at any time**—whether the file you're working on is Raw, JPEG, or TIFF. In Chapter 9, you'll learn how to use Camera Raw for all three file formats.

- **If you have several photos that need to be cropped in a similar manner, you can crop them all at once.** Talk about a timesaver!

To open an image in Camera Raw, select the image in Bridge or CS5's new Mini Bridge (see Appendix C, online) and then choose File→"Open in Camera Raw", or press ⌘-R (Ctrl+R on a PC). Then follow the instructions in the next section to crop one or more images.

Cropping images

You follow the exact same steps to crop images in Camera Raw as you do with Photoshop CS5's Ruler tool (page 71). With an image open, select the Crop tool at the top of the Camera Raw window and draw a box around the image, as Figure 6-12 illustrates. Then click the Crop tool and hold down the mouse button to reveal a handy pull-down menu that lists aspect ratios as well as a Custom option. If you pick Custom, a dialog box appears so you can enter a specific ratio or dimensions in pixels, inches, or centimeters. Whichever method you use, Camera Raw places a crop box atop your image, which you can resize by dragging any resulting handle or the box itself.

Tip: You can exit the crop box by pressing the Esc or Delete key (Backspace on a PC) while the Crop tool is active or by choosing Clear Crop from the Crop tool's pull-down menu.

When you're finished, press Return (Enter on a PC) to see what the newly cropped image looks like. If you need to edit or undo the crop, just grab the Crop tool to make the crop box reappear for your editing pleasure.

If you have several images that need to be cropped in the same way, the steps are almost identical. Just open the images in Camera Raw by selecting them in Bridge or Mini Bridge (see Appendix C, online) or simply by finding them on your hard drive and opening them from there. When the thumbnails appear in the filmstrip on the left side of the Camera Raw window, click the Select All button and then use the Crop tool as described in this section. *All* the photos get cropped simultaneously, and each filmstrip thumbnail updates according to how you cropped the first image. (A tiny Crop tool icon, circled in Figure 6-12, also appears at the bottom left of each thumbnail.)

At this point, you can click:

- **The Save Images button** to convert, rename, or relocate the file(s)—or any combination of those tasks—so you don't overwrite the original. If you save them in Photoshop format, you can tell Camera Raw to preserve the cropped pixels in case you want to resurrect them later (see Figure 6-13 for details).

- **The Open Images button** to apply the changes and open the photo(s) in Photoshop.

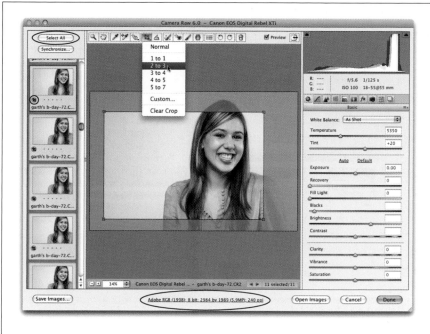

Figure 6-12:
Open one or more images in Camera Raw and use the Crop tool just like you would in Photoshop. (Remember, Camera Raw is actually a separate program.) Simply drag across the image to draw a box and then press Return (Enter on a PC) to accept the crop.

If you've opened multiple images (as shown here), you see their thumbnails in the filmstrip on the left side. To crop all the images at once, click the Select All button in the upper left (circled) and draw the crop box. You'll see the crop, along with a tiny Crop tool icon (circled, left), applied to all selected thumbnails. The blue, underlined text below the preview window (circled) changes to reflect the size of the crop box as you draw.

- **Cancel** to exit Camera Raw without applying the changes.

- **Done** to apply the changes (which you can edit the next time you open the image in Camera Raw) and exit the Camera Raw window.

Tip: You can use keyboard shortcuts to change how the Save, Open, Cancel, and Done buttons at the bottom of the Camera Raw window behave: To open a copy of the image in Photoshop without updating the original Raw file, Option-click (Alt-click on a PC) the Open button. To open the image as a Smart Object (page 123), Shift-click the Open button. To skip the Save As dialog box and make Camera Raw use the same location, name, and format you used last time you saved the file, Option-click (Alt-click) the Save Image button. To change the Camera Raw settings back to what they were originally, Option-click (Alt-click) the Cancel button.

Figure 6-13:
To see and work with your original, pre-cropped image in Photoshop, click Camera Raw's Save Images button, choose Photoshop from the Format pop-up menu, and then turn on the Preserve Cropped Pixels checkbox.

Next time you open that file in Photoshop, the photo appears on its own layer. If you want to see the hidden, cropped bits, use the Move tool to drag them back into view or choose Image→Reveal All.

Straightening images

If you need to straighten a bunch of images at a similar angle, Camera Raw can handle them all at once, too. Open the images and grab the Straighten tool (it's just to the right of the Crop tool) and draw a line across the horizon—or anything in the image that's supposed to be straight—as shown in Figure 6-14, top.

The image won't straighten immediately—instead you see what looks like a rotated crop box so you can check the angle (Figure 6-14, bottom). If it's okay, press Return (Enter on a PC) and Camera Raw straightens the photo. If you didn't get it perfectly straight, you can have another go by choosing the Straighten tool again or by opening the image in Camera Raw again (if you closed it).

Resizing Images

No matter what you've whipped up in Photoshop, there will come a time when you need to change the size of your masterpiece. For example, if you want to print, email, or post an image on a website, you need different-sized versions for each of those tasks. Changing an image's size isn't hard; Photoshop gives you oodles of options. The challenge lies in doing it *without* sending its quality down the tubes.

Sure, you can let the "Save for Web & Devices" dialog box (page 248) or the Print dialog box (page 678) do the resizing for you, but if you're aiming to be a serious pixel-pusher, you'll want *far* more control. That, my friend, brings you up against the grand-daddy of Photoshop principles: Image Resolution—the measurement that determines the size of the pixels in your image, which in turn controls the quality of your prints.

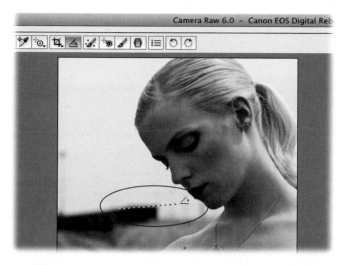

Figure 6-14:

Top: Camera Raw can't take a document full of images and then crop, straighten, and split them out into individual documents automatically like Photoshop (page 232). But you can use it to straighten one or more images simultaneously. Just activate the Straighten tool and draw a line across a part of the image that's supposed to be straight (circled).

Bottom: You'll see what looks like a rotated crop box (shown here). Just press Return (Enter on a PC) to accept it and Camera Raw straightens the image.

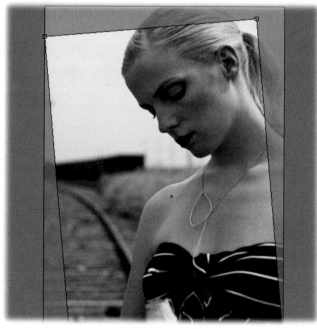

Arguably, resolution is one of the toughest digital-image editing concepts to wrap your brain around. Many people grapple with questions like "What the heck is resolution?" "How do I change an image's resolution?" and "What's the minimum resolution I need to print good-looking photos?" In the following pages, you'll learn all the nitty-gritty you need to answer these—and other—questions.

Note: Resolution doesn't mean a hill of beans unless you're sending your image to a printer. If you're not going to print it, don't worry about resolution—focus on the pixel dimensions instead.

Pixels and Resolution

As you learned in Chapter 2 (see the box on page 52), the smallest element of a raster image is a pixel. When they're small enough and viewed together, these tiny blocks of color form an image (see Figure 6-15).

Note: Some digital images aren't comprised of pixels—they're made up of *vectors*, a series of points and paths. One of the best things about working with vectors is that none of the size-versus-quality challenges you run into with pixel-based images apply: You can make vectors as big or as small as you like and they'll always look great. To learn more about using vectors, trot on over to Chapter 13.

Figure 6-15:
Raster images are comprised of individual blocks of color called pixels. To see them, zoom into the image by pressing ⌘-+ (Ctrl-+ on a PC) repeatedly or use the Zoom tool in the Tools panel. (Press ⌘ or Ctrl and the – key to zoom out.) At 3,200 percent magnification, you can see the individual pixels that make up a tiny section of this sunflower.

Pixels have no predetermined size, which is where *resolution* enters the, uh, picture. Resolution is a measurement that determines how many pixels get packed into a given space, which in turn controls how big or small the pixels are. It's helpful to think of resolution as pixel density—how closely the pixels are packed together. In fact, it's measured in terms of pixels per inch—or *ppi*, as folks tend to call it.

Note: You'll also hear resolution referred to as *dpi*, which stands for "dots per inch." This usage isn't strictly accurate because dpi is technically a measurement used by printers (since they actually print dots). Nevertheless, many folks mistakenly say "dpi" when they mean "ppi."

One helpful way to understand resolution is to relate it to something in the real world. Imagine you're baking cookies (hang in there; it'll make sense in a minute). When you pour brown sugar into a measuring cup, the sugar reaches the one-cup line. But after you pack the granules firmly into the cup, the sugar reaches only the half-cup line. You still have the same number of granules (which are like pixels), they're just smaller because they're packed more tightly together (they have a higher resolution) in the confines of the measuring cup (the Photoshop document). The loosely packed granules you started with are like low resolution, and the firmly packed granules are like high resolution. (Hungry yet?)

Since increasing image resolution—from, say, 72 ppi to 300 ppi—makes the pixels smaller and packs them together more tightly, it results in a physically smaller but smoother and better-looking printed image. Lowering image resolution, on the other hand, means enlarging and loosening the pixels, which results in a physically larger image that, as you might suspect, looks like it was made from Legos because the pixels are so big you can see each one individually.

A printer is one of the few devices capable of modifying its output (that is, the print) based on an image's resolution. In other words, send your inkjet printer a low-res version and a high-res version of the same picture and it'll spit out images that differ vastly in size and quality. The resolution on a computer monitor, on the other hand, is handled by the video driver (the software that controls what you see on the monitor), not the resolution specified in the image. That's why an 85 ppi image looks identical to an 850 ppi image onscreen. The bottom line: Printers can take advantage of higher resolutions (scanners can, too, but that's a story for page 57), but monitors can't.

The Mighty Image Size Dialog Box

If you can't trust your monitor to show your image's true resolution, who can you trust? Why, the Image Size dialog box, shown in Figure 6-16, which not only displays the current resolution of any open document, but also lets you *change* it.

To summon this dialog box and check your document's resolution, choose Image→Image Size. The dialog box reveals all kinds of info about your image: its file size (that is, how much space it takes up on your hard drive), its pixel (onscreen) dimensions, how big it would be if you printed it, and its resolution. If you're preparing an image to email or post on the Web, you only need to worry about the *pixel dimensions* at the top of the dialog box. If you're going to print the image, focus your attention on the Document Size portion in the middle instead.

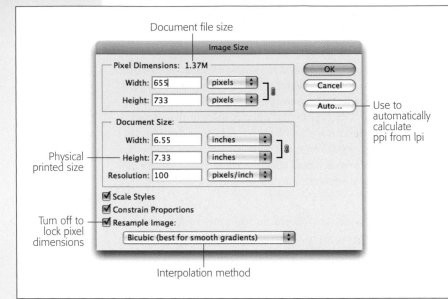

Document file size

Image Size

Physical
printed size

Turn off to
lock pixel
dimensions

Interpolation method

Use to
automatically
calculate
ppi from lpi

Figure 6-16:
*This particular image
is 655 pixels wide by
733 high and has a
file size of 1.37 MB.
If you were to fire
it off to your trusty
inkjet printer, the
resulting print would
be 6.55" × 7.33" with
a resolution (pixel
density) of 100 ppi. As
you'll learn from the
chart on page 243,
anything printed at
that resolution looks
blocky—like a bad
Xerox that someone
keeps enlarging.*

Tip: You can summon the Image Size dialog box by pressing ⌘-Option-I on a Mac or Ctrl+Alt+I on a PC.

The checkboxes at the bottom of the dialog box control how Photoshop resizes your image if you make changes in this dialog box. Here's what each one does:

- **The Scale Styles checkbox** determines whether Photoshop scales any layer styles (page 128) you've applied to the image along with the image itself. It's a good idea to leave this setting turned on; otherwise, that pretty drop shadow you added might end up bigger or smaller than the image itself.

- **The Constrain Proportions checkbox** locks the aspect ratio (page 48) of the image so it doesn't get squashed or stretched when you resize it. You'll want to leave this setting turned on, too.

- **The Resample Image checkbox** is your key to changing resolution *without* changing image quality. *Resampling* is a process in which Photoshop responds to your size-change request either by adding or subtracting pixels. The problem, as you'll learn in a moment, is that resampling involves guesswork on Photoshop's part, which can obliterate image quality.

When you first launch Photoshop, the Resample Image setting is turned on, which tells Photoshop to increase or decrease the number of pixels in your image—processes that reduce image quality because it either invents pixels or picks which ones to eliminate, respectively. By turning Resample Image *off* you protect your image's quality by *locking* the pixel dimensions. If you plan to print

the image, turning this setting off lets you fiddle with the resolution for hours without altering the quality because you're only changing pixel size, and how closely together they're packed. (Take a peek at Figure 6-19 on page 246 to see this concept in action.)

When you turn the Resample Image checkbox *on*, you get to choose a resample method from the pop-up menu below it. Why would you want to go this route? Well, sometimes you need Photoshop's help in making an image bigger or smaller than it originally was. For example, if you've got a 200-ppi image that's going to print at 4"×6" but you *need* a 5"×7" print *and* you want to maintain that 200-ppi resolution, you can turn on this checkbox to make it so. On the flip side, if you've got a honkin' big image that's too large to email, you can have Photoshop reduce its pixel dimensions (and thus file size) in a way that doesn't destroy image quality.

Note: There are two kinds of resampling: If you delete pixels, you're *downsampling* (see page 247); if you add them, you're *upsampling* (the box on page 244 has tips for that). When you upsample, Photoshop adds pixels that weren't originally there through a mathematical process called *interpolation*, in which it uses the pixels that *are* there to guess what the new ones should look like.

The options below the Resample Image checkbox determine which kind of mathematical voodoo Photoshop uses to either add or delete pixels. Since better image quality means more work for Photoshop, the better the image, the more time Photoshop takes to perform the aforementioned voodoo. Here are your choices, listed in order of quality (worst to best) and speed (fastest to slowest):

- **Nearest Neighbor.** Though this method gives you the lowest image quality, it can be useful because it produces the smallest files, which is great if you're transferring files over the Internet and either you or the person on the other end has a slow connection. Nearest Neighbor works by looking at the colors of surrounding pixels and copying them. It's known for creating jagged edges, so you'll only want to use it on images with hard edges like illustrations that aren't anti-aliased (see Chapter 13).

- **Bilinear.** If you choose this method, Photoshop guesses at the color of new pixels by averaging the colors of the pixels directly above, below, and to the left and right of the one it's adding. It produces slightly better results than Nearest Neighbor and is still pretty fast, but you're better off using one of the next three methods instead.

- **Bicubic.** This method tells Photoshop to figure out the colors of new pixels by averaging the colors of the pixels directly above and below the new one and the *two* pixels to its left and its right. This method takes longer than the previous two but produces smoother transitions in areas where one color fades into another.

- **Bicubic Smoother.** Similar to Bicubic in the way it creates new pixels, this method blurs pixels slightly to blend the new ones into the old ones, making the image smoother and more natural looking. Adobe recommends this method for enlarging images.

- **Bicubic Sharper.** This method is also similar to Bicubic in the way it creates new pixels, but instead of blurring whole pixels to improve blending between the new and old like Bicubic Smoother, it softens only the pixels' *edges*. Adobe recommends this method for downsizing images, though some Photoshop gurus report that it also produces better *enlargements* than Bicubic Smoother.

If you know your printer's *lpi* (lines per inch—see the box below), you can click the Image Size dialog box's Auto button to bring up the Auto Resolution dialog box (see Figure 6-17). Just enter the lpi, pick a quality setting, and let Photoshop calculate the proper resolution for a good print.

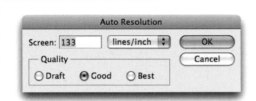

Figure 6-17:
If you know the lpi of the printer you're using, enter it in the Screen field and Photoshop calculates the resolution (ppi) for you. You've got a choice of three different quality settings: Draft gives you a resolution of 72 ppi, Good multiplies the lpi by 1.5, and Best multiplies it by 2.

FREQUENTLY ASKED QUESTIONS

Understanding LPI

What the heck is lpi? I thought all I had to worry about was ppi!

Laser printers and professional printing presses print a little differently than inkjet and dye-sublimation printers. Inkjets spray dots of color onto paper and simulate shades of gray by using wide or narrow dot dispersal patterns. Dye-subs use a process that involves fusing color dyes—including shades of gray—onto paper through a heating process (they tend to produce higher-quality, water- and smudge-proof prints than inkjets but are more expensive).

Professional printing presses use yet another printing method: If you hold a magnifying glass to a professionally printed newspaper or magazine, you see that the image is comprised of a gazillion tiny shapes (typically circles,

though they can be diamonds or squares, depending on the printer). If the shapes are small enough, you'll never see them with your naked eye (although some folks have been quite successful enlarging them to galactic proportions and calling it pop art—think Lichtenstein and Warhol).

The setting that determines how many lines of little shapes get printed in an inch of space is called *lines per inch*, or lpi. (It's also referred to as screen frequency, line screen, or half-tone screen.) It's important to understand lpi because there may come a day when you're forced to figure the appropriate ppi (page 238) from lpi (also helpful in scanning, see page 57). When this happens, breathe deeply, smile smugly, and proceed to Table 6-1 on page 243. Or just click the Auto button in the Image Size dialog box and let Photoshop figure out the ppi from lpi *for* you, as Figure 6-17 explains.

Resolution guidelines for print

Now that you understand what resolution is and how it works, the question becomes how much resolution do you need when you print? Because printers print in different ways—inkjets spray, dye-subs fuse, laser printers or professional presses print shapes, and so on—the resolution you need for a beautiful print depends on the *printing device* itself.

Sure it's tempting to practice resolution overkill just to be on the safe side, but doing that makes your files larger so they take up more hard drive space and take longer to process, save, *and* print. Instead, rein yourself in and consider the resolution guidelines listed in Table 6-1.

Note: When you send files off to a professional printshop, it's always a good idea to ask how much resolution they want. If they don't know, find another printer…fast!

Table 6-1. Resolution guidelines for print

Device	Paper	Resolution	Use For
Desktop laser printer	Any kind	Resolution should match the dpi of the printer (which is listed in the owner's manual). Some folks call this resolution 1:1, which is another way to say ppi matches dpi exactly. For color or grayscale images (continuous tone images), ppi should be 1/3 of the printer's dpi.	Business documents or line art
Inkjet printer	Regular or textured	150–240 ppi	Color or grayscale images, black-and-white documents
Inkjet printer	Glossy or matte photo	240–480 ppi. Use the upper end of this range only for large images (13"×19" and up).	Color or grayscale images
Dye-sublimation printer	Any kind	Resolution should match the printer's dpi.	Color or grayscale images
Web offset press	Newsprint or uncoated stock	1.5–2 times the lpi, depending on how detailed you want the print to be (use 2 if your image has a slew of sharp edges in it).	Newspaper ads or community papers (like *Auto Trader* and *The Village Voice*)
Commercial printing press	Uncoated or coated stock	2–2.5 times the lpi.	Magazines, coffee table books, fancy brochures, business cards, and line art

Resizing Images for Print

Throughout your Photoshop career, you'll need to resize and change the resolution of images so they'll print well. Perhaps the most common situation where you'll need to do this is when you download stock photography or import a snapshot from a digital camera. Unless the stock photographer has changed the resolution, the images you download from stock-image companies will be 72 ppi. Similarly, most digital-camera files arrive on your computer with their resolution set to 72 ppi (roughly the standard for onscreen display).

Keep in mind that today's digital cameras can capture *tons* of info: Consumer-level, 10-megapixel cameras produce images packed with around 3648 (width) × 2048 (height) pixels, and pro-level, 21-megapixel models capture images in excess of 4080×2720 pixels. That's a veritable smorgasbord of pixels, letting you crop the image (page 222) and alter resolution however you like.

POWER USERS' CLINIC

Upsampling Without Losing Quality

If you leave the Image Size dialog box's Resample Image checkbox (page 240) turned on and increase an image's resolution, Photoshop adds information (in the form of pixels) that wasn't originally there. Increasing the resolution this way is usually a bad idea because fake pixels never look as good as real ones. However, there may come a time when you've got no choice.

For example, maybe you've snatched an image from the Web that you need to print (page 250) or your image needs to be printed in an *extremely* large format (like a billboard). If you find yourself in such a pickle, you've got a few options (happily, the first two are free):

Method 1. For some reason, adding pixels 5 to 10 percent at a time doesn't damage quality quite as much (it causes some quality loss, sure, but not as much as increasing the size by 900 percent all at once). Here's what you do: Open the Image Size dialog box, make sure both the Resample Image checkbox and the Constrained Proportions check- box at the bottom of the dialog box are turned on, and then choose Bicubic Smoother from the method pop-up menu. Then, in the dialog box's Document Size section, change either the Width or Height pop-up menu to Percent

(the other field changes automatically). Enter a number between 105 and 110 into the Width field and then click OK (the Height field changes to the same number auto- matically). Repeat the process as many times as necessary to enlarge the image to the dimensions you need.

Method 2. Some Photoshop pros (Scott Kelby and Vin- cent Versace, for example) swear by this method for large-format printing: Open the Image Size dialog box and make sure the Resample Image and Constrain Proportions checkboxes are turned on. In the dialog box's Document Size section, enter *either* the width or the height of the de- sired print. Enter your desired resolution, choose Bicubic Sharper from the pop-up menu at the bottom of the dialog box, and then click OK. The pros swear this method gives them terrific results, though it defies the resizing guidelines discussed so far. Give it a shot and see what happens.

Method 3. Buy a third-party plug-in specifically designed to help you upsample, like Genuine Fractals by onOne Software (*www.ononesoftware.com*) or PhotoZoom Pro by BenVista (*www.benvista.com*). Both plug-ins manage to pull off some serious pixel-adding witchery with truly amaz- ing results. See Chapter 19 for more on third-party plug-ins.

Resizing your images is a snap, but the risk of reducing image quality in the process is high. As you learned in the previous section, the key to preserving quality lies in turning on the Resample Image checkbox shown in Figure 6-18.

Note: If you're printing a generic-size image (like 8"×10" or 5"×7") straight from Photoshop, you can use the Print dialog box's "Scale to Media" option to recalculate the resolution for you, according to the paper size you pick. In most cases, you'll end up with resolution overkill; head on over to page 243 for the details.

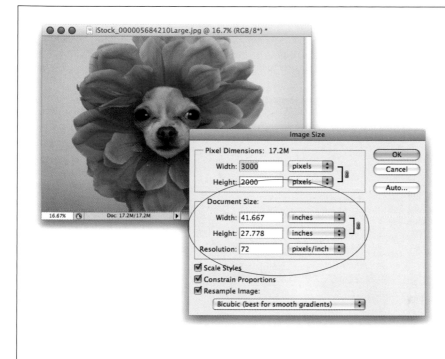

Figure 6-18:
Say you want to print this image and the largest paper size your printer can use is 8"×10". A peek in the Image Size dialog box reveals that if you tried to print it at its current resolution, you'd need a huge piece of paper—one larger than 41"×27"! Even worse, at the current resolution of 72 ppi, that massive print would look like it was made from blocks. But don't panic: You can use the settings in this dialog box to change the resolution so your image prints at a more manageable size.

Here's how to use the Resample Image checkbox to resize your image for printing without sacrificing quality:

1. **Open a photo and then choose Image→Image Size to open the Image Size dialog box, or press ⌘-Option-I (Ctrl+Alt+I on a PC).**

 The image shown in Figure 6-18 weighs in at 3000×2000 pixels at a resolution of 72 ppi. If you wanted to print it, you'd need a ridiculously big piece of photo paper (over 41"×27"). Luckily, those dimensions come way down once you increase the resolution. Remember, increasing resolution is very much like that brown sugar analogy back on page 238: You're packing all those pixels more tightly together, resulting in a smaller image but one whose quality (that is, resolution) is much higher.

2. **Lock the image's quality by turning off the Resample Image checkbox at the bottom of the dialog box.**

Take a look at Figure 6-19. Notice how the pixel dimension text boxes disappeared once the Resample Image option was turned off? Now, the only info you can change is the document's size and resolution, which affect how tightly the pixels are packed together. You can't change the *number* of pixels contained in your image, which means Photoshop isn't adding or deleting pixels. See how the tiny black line on the right side of the Document Size section now connects width, height, and resolution? That line means that changing one of these fields affects the other two.

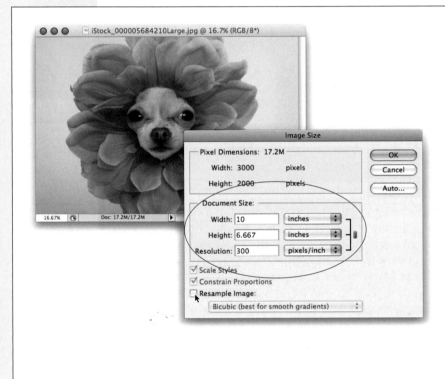

Figure 6-19:
Turning off the Resample Image checkbox lets you lock your pixel dimensions to protect image quality. After that, you can increase resolution without worrying how your image will print—it'll get physically smaller, sure, but it won't be blocky and pixelated. Think about it this way: As the resolution goes up, the print size of the document goes down because Photoshop is making the pixels smaller and packing them more tightly together. For example, at 300 ppi this image produces a print that's 10"×6.667". Compare that to the file's original settings of 72 ppi and 41.667"×27.778". Wow!

3. **Increase the resolution.**

The value you enter here depends mostly on which kind of printer you're using; see Table 6-1 for some recommended resolution settings and then do some tests yourself to see which ones work best for you. If you know your printer does a

respectable job printing at 240 ppi, enter that amount in the Resolution field and the document dimensions decrease to 10"×6.667" as Figure 6-19 shows. The pixel dimensions and file size, however, remain the same—the image is still 3000×2000 pixels and 17.2 MB; only the resolution changes.

Note: Popping into the Image Size dialog box is a handy way to learn what size print you can make with the pixel dimensions you have. If you know your printer does a decent job at 240 ppi, for example, type that amount into the Resolution field and see how big a print that'll make. If it's a funky size, you can always crop the image to a specific, more common size as explained on page 226.

4. **Click OK when you're done.**

 Now you can print your image and it'll look great (though you may need to do a tiny bit of trimming).

Did you notice how much the onscreen image changed when you tweaked the resolution? That's right: Not at all. That's part of the reason resolution is so confusing. The 72 ppi image looks just like the 300 ppi version because our eyes can't see pixels that small onscreen. The lesson here is that, as long as you turn off the Resample Image checkbox, you can tweak an image's resolution 'til the cows come home and you won't alter the image quality. Sure, you'll change the image's printed size, but you won't add or delete pixels that weren't there in the first place.

Resizing for Email and the Web

Not everyone has a high-speed Internet connection…at least, not yet. Some poor souls are doomed to live with dial-up for the foreseeable future, and even wireless hot-spots don't exactly provide warp-speed connections (especially when a lot of people are trying to use them). That's why it's important to decrease the file size of that monster photo from Debra's divorce party *before* emailing it to your pals—if you don't, it might take them forever to download it. The same goes for images you plan to post online: The smaller their file size, the faster they'll load in a web browser. (You'll learn a lot more about posting images online in Chapter 17, but the info in this section will get you started.)

To make an image smaller, you have to decrease its pixel dimensions. This process is called *downsampling*, and you can go about it in a couple of ways. Read on to learn both methods.

Note: If you'd rather resize your image visually by entering a percentage instead of pixel dimensions, see page 713.

Using the "Save for Web & Devices" dialog box

If you want to see a preview of your new, smaller image and maybe experiment with different file formats (if you're torn between a JPEG and a PNG, say), you'll want to use the "Save for Web & Devices" dialog box. ("Devices" refers to portable gadgets like cellphones and smart phones.) This method is a great way to reduce file size while you monitor image quality. Here's how:

1. **Open a photo and then choose File→"Save for Web & Devices".**

 The dialog box shown in Figure 6-20 takes over your screen. It lets you choose from a variety of file formats and quality levels that Photoshop can use to make your image Web- or email-friendly. You can see up to four previews of what your image will look like in various formats before you commit to one, which is why the dialog box is so darn big.

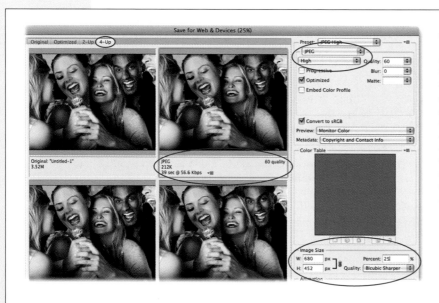

Figure 6-20:
The quickest way to resize an image for emailing or posting on the Web is to head straight for the "Save for Web & Devices" dialog box. It lets you reduce the image's size and save it in a different format in one fell swoop, complete with up to four previews.

2. **In the upper-left part of the dialog box, click the 4-Up tab (circled in Figure 6-20) and then pick an appropriate file type from the format pop-up menu in the upper-right corner (also circled).**

 When you first pop open this dialog box, you'll see the 2-Up tab, which is fine if you don't want to do a lot of experimenting with format or quality. However, if you want to see the size and quality difference between the original image and, say, a JPEG at low, medium, and high quality, you'll need extra preview windows. (As you learned on page 51, JPEG is the best choice for photos, and that's the format selected in the figure.)

3. To keep the photo's quality relatively intact while you reduce the file size, choose High from the Compression Quality pop-up menu (also circled in Figure 6-20, upper right).

 To make the file smaller, Photoshop throws away image details and then compresses what's left. If you set the quality level to High (which has a numeric equivalent of 60), Photoshop tosses out some details, but the overall quality won't suffer much. But if you choose a quality level of Low (numeric equivalent: 10), Photoshop throws away *significantly* more details and the result is a low-quality image. (See page 51 for a more about the JPEG format.)

4. **Reduce the image's size.**

 At the bottom right of the dialog box lies a section called Image Size. If you know the dimensions you want the image to be, enter the width or height. If you don't know what size you want and are just concerned with making the *file size* smaller, you can enter a percent reduction like 25 percent. (That's a good percentage if you're emailing an image captured on a 10-megapixel camera at a high-quality setting.)

5. **Choose a resample method.**

 In the dialog box's lower-right Image Size section, choose Bicubic Sharper from the Quality pop-up menu. This method (explained on page 242) works particularly well when you're downsampling. Some folks say it even works great for enlargements—see the box on page 244. As you can see in the middle of Figure 6-20, the resulting file is 212 KB at a quality setting of 60. That's more than 300 percent smaller than the original 3.52 MB file!

6. **Click the Save button at the very bottom of the dialog box (not shown in Figure 6-20) and then give the file a new name so you don't overwrite the original.**

Tip: It's a good idea to run the Unsharp Mask filter after you downsample images because they tend to get blurry from both losing details and getting compressed. See Chapter 11 for more on sharpening.

Using the Image Size dialog box

Choose this method when you need to make the file as small as possible—for example, if you're designing a Web banner ad that has to be 40 KB or less. Resizing your image (changing its pixel dimensions) with the Image Size dialog box first, and then using the "Save for Web & Devices" dialog box produces a smaller file than the method you learned in the previous section (see Figure 6-21, bottom). Just follow these steps:

1. **Open a photo and choose Image→Image Size.**

 Up pops the Image Size dialog box shown in Figure 6-20.

2. **In the dialog box, make sure the Resample Image checkbox is turned on, and then choose Bicubic Sharper from the resample method pop-up menu.**

 Bicubic Sharper is your best bet for getting a high-quality image when you downsample, as explained on page 242.

3. **In the top portion of the dialog box, enter a new pixel dimension for either width or height.**

 If the Constrain Proportions checkbox is turned on, the other measurement changes automatically so Photoshop resizes the image proportionately. If it's not turned on, you'll have to enter both width and height, which can potentially make your image look narrow or stretched if you don't maintain its original aspect ratio (page 48).

 In Figure 6-21, the new width is 680, which is also the width of the image in Figure 6-20. Notice how much smaller a file you can get using this method than with the "Save for Web & Devices" dialog box.

4. **Click OK to close the dialog box.**

 The program pops you back into the main Photoshop window.

5. **Choose File→"Save for Web & Devices".**

 That's right, you still need to enlist the help of *another* dialog box to finish up your compression work. In this new dialog box, choose JPEG at a compression quality of High, as explained in steps 2 and 3 on pages 248–249.

6. **Finally, click Save at the bottom of the dialog box and give your resized file a new name.**

As Figure 6-21 shows, this method can strip a 3.52 MB file down to a mere 71.86 KB, which is substantially smaller than the 212 KB file created solely with the "Save for Web & Devices" dialog box on page 248.

Resizing Web Images for Print

Unfortunately, there will come a time when you need to print an image snatched from the Web. The problem is that Web images are usually fairly small so they'll load quickly in web browsers, but that also means they contain precious few pixels for you to work with. Most of them are 72 ppi—a resolution so low that that the individual pixels are big enough to see when you print the images—which means that, unless you like that blocky look, you *have* to increase the resolution before you print it. And, as you learned earlier in this chapter, when you bump up the resolution, you wind up with a print the size of a postage stamp. It's a lose-lose situation.

Tip: A good rule of thumb is that Web images print decently at about half the size they appear onscreen. So if you start with an image that's about 2"×2" onscreen, it prints decently at 1"×1".

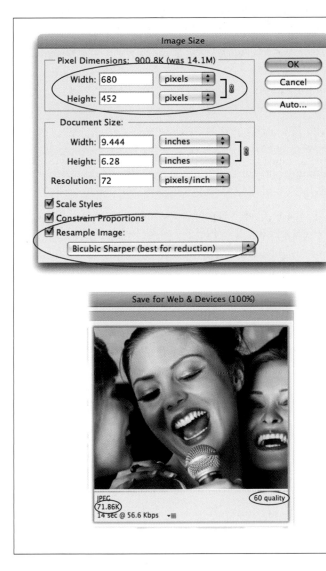

Figure 6-21:
Top: To reduce your image's file size, make sure the Resample Image checkbox is turned on and that Bicubic Sharper is selected in the resample method pop-up menu. At the top of the dialog box, enter the new pixel dimensions in either the Width or Height field (the other field changes automatically based on what you enter). Remember, the smaller the pixel dimensions, the smaller the file size.

If you're designing an image for a website, you'll probably need to fit the image into a fixed space. If you're emailing the image, shoot for 800 pixels or less in width.

Bottom: Once you resize the image, you can use the "Save for Web & Devices" dialog box to select JPEG with a compression of 60. By taking the time to resize your image in the Image Size dialog box first, you produce a smaller file. As you can see here, the resulting file is a mere 71.86 KB.

For all those reasons, printing a Web image isn't ideal, but if that's the only image you've got, you have to make do. In that case, follow these steps to beef up its print quality:

1. **Save the image to your hard drive.**

 Find the image on the Web and Control-click (right-click on a PC) it to summon your web browser's shortcut menu and then choose "Save Image to Desktop" (Save Image As or Save Picture As on a PC). Or you can choose Copy Image from the shortcut menu and paste the image into a new Photoshop document.

Tip: If you're on a Mac and want to save the image somewhere other than your desktop, press and hold the Option key while Control-clicking and the "Save Image to Desktop" menu option becomes Save Image As, so you can choose where to save it and give it a meaningful name (though some browsers, like the latest version of Firefox, give you this option automatically). On a PC, you automatically get a Save As option.

2. **Open the image in Photoshop and then choose Image→Image Size.**

 Photoshop displays the now-familiar Image Size dialog box shown in Figure 6-21.

3. **At the bottom of the dialog box, turn off the Resample Image checkbox, enter 150 in the Resolution field, and then click OK to close the dialog box.**

 A resolution of 150 ppi works okay if you're printing to an inkjet printer. The resulting print may not be frame-worthy, but it'll be identifiable.

4. **Back in the main Photoshop window, save the resulting file in TIFF format.**

 Choose File→Save As and then select TIFF from the Format pop-up menu (for more on the TIFF format, see page 670). The photo is now primed and ready for popping into Word, InDesign, or any other word-processing or page-layout program.

If the image is just too small after you follow these steps, visit the box on page 244 for tips on upsampling.

NOTE FROM THE LAWYERS

Thou Shalt Not Steal

This whole "snatching images from the Web" business opens a copyright can of worms. You're actually committing image theft if you download an image created by someone else and then use it in another format—except in these situations:

- You've obtained express permission from the photographer or artist (or other copyright holder) who created it.
- The image is clearly designated as being in the public domain.

- The image was published under a Creative Commons license (*www.creativecommons.org*).
- You're grabbing the image purely for personal use.

That said, if you're promoting a book raffle at your computer club and snatch cover art from the publisher's website or if you need a headshot to promote your camera club's speaker and you snag one from her blog, the chances of finding the image police at your front door are slim to none.

Resizing Images for Presentations

You're probably thinking, "I thought this book was about Photoshop and here you are talking about *presentations*. What gives?" The fact is, you may be asked to prepare presentation graphics one day and if you are, the info in this section can save your skin. Luckily, you don't have to worry about resolution; since your audience will view the images onscreen, it's the pixel dimensions that matter most.

Some folks claim to be more afraid of public speaking than they are of death. Standing before an expectant audience *can* be unnerving; obviously, you want everything to run smoothly and the graphics to look perfect. That's why it's smart to resize images *before* you stick them into Microsoft PowerPoint or Apple Keynote. Oversize images bloat the presentation's file size and can cause it to run very slowly, or worse, crash. On the flip side, small images may look fine on your computer monitor but terribly blocky when you project them on a larger screen.

The solution to both problems is to decide how big your images need to be and resize them *before* you import them into PowerPoint or Keynote. It's okay to resize images a little bit in those programs, but you don't want to put a dozen ginormous, 10 MB photos in your presentation—that's just asking for trouble.

If you want an image to fill a whole slide, find out the pixel dimensions of the projector you'll be presenting on (the slides should be that size, too). If you don't know, find out how big the slides are. Here's how to sniff out (and change) slide dimensions in the two most popular presentation programs:

Tip: Most projectors have a resolution of 1024×768 pixels, although high-definition projectors, which have a resolution of 1280×720 pixels, are becoming more common. If you've got no clue which kind of projector you'll be using, 1024×768 is a good bet. If you're really paranoid, go with 1280×720 to be on the safe side. Honestly, though, these dimensions are so close that you probably won't see any difference either way.

- **Microsoft PowerPoint.** Choose File→Page Setup and look for the Width and Height fields. Now, here's where things get tricky: For some unknown reason, PowerPoint lists slide dimensions in inches instead of pixels. This peculiarity poses a challenge because, to ensure that your image fills the slide perfectly, you have to convert the inches to pixels. Luckily, Table 6-2 lists the most common conversions.

- **Apple Keynote.** Open the Inspector palette by clicking View→Show Inspector. Then open the Document Inspector by clicking the icon on the far left of the Inspector palette (it looks like a piece of paper with a folded corner) and peek at the Slide Size pop-up menu at the bottom of the palette, which lists the slide dimensions in pixels; those are your magic numbers. Back in Photoshop, grab the Crop tool, enter those numbers in the Options bar—leave the resolution blank because the image won't be printed—crop your image, and then save it as a JPEG or PNG (as discussed on page 52).

Table 6-2. *Slide size conversions*

Pixel Dimensions	PC Slide Size	Mac Slide Size
800×600	8.33"×6.25"	11.11"×8.33"
1024×768	10.66"×8"	14.22"×10.66"
1280×720	13.33"×7.5"	17.77"×10"

Once you know the slide dimensions, hop on over to page 253 for step-by-step instructions on how to crop your image so that it fits your slide perfectly.

Note: Because the Mac and Windows operating systems handle pixels a little differently (they're slightly bigger in Windows), you have to enter a resolution of 96 ppi when you resize images in Photoshop for use on a Windows machine. If you're designing presentation graphics on a Windows machine for use on a Mac, enter a resolution of 72 ppi instead. If you're designing graphics on a Mac for use on a Mac, you can leave the resolution field blank—honest!

Resizing Smart Objects

When you're designing a document—a poster, a magazine cover, whatever—you'll probably do a fair amount of resizing before you get the layout just right. What if you shrink a photo down only to realize it worked better at its original size? Can you enlarge the image without lessening its quality? Negative, good buddy. That is, not unless it was opened or placed as a Smart Object.

As you learned in Chapter 3, Smart Objects are the best thing since sliced bread. They let you apply all kinds of transformations to your files, including decreasing and then increasing their size—all without affecting the quality of that image as it appears in your document. Here's how to resize a Smart Object that contains an image:

- **To decrease the size of a Smart Object,** select the relevant layer in the Layers panel and then choose Edit→Free Transform. Grab any of the resulting square handles and drag diagonally inward to reduce its size (remember to hold down the Shift key as you drag if you want to resize it proportionately). Let Photoshop know you're finished resizing by pressing Return (Enter on a PC).

Note: If you've used the Place command to import the Smart Object (page 123), or if you drag and drop a raster image into an open Photoshop document (new in CS5, see page 81), then resizing handles appear *automatically* when the image opens in your document—on its very own layer, of course.

- **To increase the size of a Smart Object,** make sure you've got that layer selected in the Layers panel and then choose Edit→Free Transform. This time, drag any of the resulting corner handles diagonally outward (again, hold down the Shift key if you want to preserve the image's proportions). If you don't enlarge the image beyond its original pixel dimensions, its quality remains pristine. Unfortunately, there's no quick and easy way to *return* the Smart Object to its original size if you forget what it was.

Automated Resizing with the Image Processor

As you'll learn in Chapter 18, you can record a series of steps into a replayable *action* that resizes and saves a batch of images en masse. But Photoshop has a niftier automatic resizing feature built in: the Image Processor. This little program within a program (called a *script*) was developed specifically to convert images' file formats and change their size—fast (see Figure 6-22). It can save you tons of time whenever you need to convert files to the JPEG, PDF, or TIFF format (it doesn't convert PNGs or GIFs). Here's how to run the Image Processor script:

1. **Choose File→Scripts→Image Processor.**

 Photoshop opens the aptly named Image Processor dialog box.

2. **In the top section of the dialog box, tell Photoshop which images you want to run the Image Processor on.**

 Your options are to run it on the images you currently have open (Use Open Images) or on a folder of images (Select Folder). You can also make Photoshop include all subfolders (if any exist) and open the first image Photoshop changes—just to make sure everything is okay—by turning on the appropriate checkbox(es).

3. **Pick where you want to save the images.**

 You can save the images in the same folder they're currently in or click the radio button next to Select Folder and pick a new one. If you're sending the files somewhere new, turn on the "Keep folder structure" checkbox to make Photoshop organize the files the same way you had them. For example, if you're the ultra-organized type, you may store your images in a nested directory (a folder containing other folders). The main folder might be named by date and contain other folders such as Raw, Masters, Processed, Prints, and so on. If you turn on the "Keep folder structure" checkbox, Photoshop resizes and reformats the images, plops them into the new folder, and organizes them the same way you did originally.

Figure 6-22:
Russell Brown, Adobe's chief evangelist, developed the Image Processor a few years back. If you run this clever little script on a folder of images, Photoshop automatically saves them in the format you choose or resizes them instantly—or both. It's amazingly cool.

You can also access this dialog box within Adobe Bridge or CS5's new Mini Bridge (though in that case it doesn't work on folders, only multiple documents). See Appendix C, online, for more on using Bridge and Mini Bridge.

4. **Enter the file type(s) you want Photoshop to save your files as and, if you want to resize them, enter a new size in pixels.**

 Here's where the real magic lies. You have three options:

 - **Save the file as a JPEG** and choose a quality setting (see page 249); you can also convert the color profile to sRGB (as page 669 describes, this is a good idea).

 - **Save as a PSD file** and maximize the file's compatibility with other versions of Photoshop so you can open it with an earlier version of the program.

 - **Save as a TIFF**, with or without compression (see page 252).

 You can choose one option or all three. No matter what the original format, Photoshop converts your files to match the options you choose. You can also

have Photoshop resize your files while it's at it; just turn on the "Resize to Fit" checkbox and enter a maximum pixel value for either width or height.

5. **In the Preferences section, enter custom settings, if you want.**

 Here's your opportunity to run an additional action. Just pick an action category from the first pop-up menu and then choose an action from the second menu. You can also include copyright info if you like. Unless you turn off the ICC profile checkbox, Photoshop automatically includes an ICC profile in your files (see the Note on page 682 for more about them).

Tip: You can save all the settings you enter in the Image Processor dialog box as an XML file so you can use them again later or share them by clicking the Image Processor dialog box's Save button. Likewise, you can load an existing XML file by clicking the Load button.

6. **When you've got all the settings just right, click the Run button to make the Image Processor work its magic.**

It may take Photoshop a while to run this script, depending on how many files you selected and how big they are. However, it certainly won't take as long as it would for you to do all this stuff yourself!

Resizing the Canvas

In addition to resizing images, you can also resize your canvas to make room for more artistic goodness. As you learned on page 67, this extra room is called canvas space, and you can add it visually by using the Crop tool (page 229, step 3) or manually by choosing Image→Canvas Size. The manual method lets you enter specific dimensions, as Figure 6-23 shows.

Figure 6-23:
Using the Canvas Size dialog box, you can increase canvas space by entering dimensions or a percentage change.

Use the Anchor option (circled) to determine where the existing image lands within the newfound space. If you don't select anything here, your image lands in the middle.

The Canvas Size dialog box gives you the following options:

- **Current Size** and **New Size.** Ever informative, Photoshop lets you know how big the document is now and how big it'll be once you click OK. These sections give you info on both file size and physical dimensions (width and height).

- **Width** and **Height.** When you enter width and height dimensions, Photoshop assumes you want to measure them in pixels, but you can use the pop-up menus to change them to percent, inches, cm, mm, points, picas, or columns (change either the width or height setting and the other changes automatically).

- **Relative.** Turning on this checkbox makes Photoshop add the existing image size to the new canvas size that you specify. If you know the exact size you want the canvas to be, leave this option turned off. If you're just trying to create some extra elbow room in which to work and you've already got an image in your document, turn it on.

- **Anchor.** Choose where you want Photoshop to put your existing image when you click OK. (If you don't choose anything, it ends up in the middle of the canvas.)

- **Canvas extension color.** If you want the new space to be a certain color, you can set that color here. If you don't pick a color—and the Background layer is locked (page 85)—Photoshop uses your current background color (page 24). If the Background layer is *unlocked*, the new space is the gray-and-white checkerboard pattern that indicates transparency (which is typically what you want).

If your image is in landscape orientation and needs to be portrait instead (or vice versa), you can rotate the canvas by choosing Image→Image Rotation→90° CW (clockwise) or 90° CCW (counterclockwise). Be careful when you use this command on a document that includes text—it may end up backwards!

The Content-Aware Scale Tool

Once in a blue moon, a software company adds a feature that works almost like magic. Adobe did exactly that in CS4 with *Content-Aware Scale* (affectionately known in nerdy circles as CAS). CAS examines what's in your image and intelligently adds or removes pixels from unimportant areas as you change the size of the overall image. The magic part? It knows enough to leave the important bits—such as people—unchanged. For example, think of web pages you've used that resize themselves smoothly and fluidly as you make your browser window bigger or smaller. Now imagine doing the same thing with an image.

With this technology, Photoshop doesn't squash or stretch the whole image; instead, the program adds or deletes chunks of, say, that big ol' sky in the background or the grassy lawn in the foreground, leaving the important parts—like the three frolicking friends—unscathed. A picture really is worth a thousand words when it comes to CAS, so take a peek at Figure 6-24 to see what this feature can do.

Note: To test-drive CAS using the images shown in this section, head to this book's Missing CD page at *www.missingmanuals.com/cds* and download the file *CAS.zip*.

Figure 6-24:
As you can see, CAS does an amazing job of resizing only the unimportant background in this image.

You can use CAS in all kinds of situations. For example, say you want to put your all-time favorite family picture in an 8"×10" frame but the aspect ratio (page 48) isn't quite right, the background isn't big enough, or the photo's subjects need to be a little bit closer together. In any of these circumstances, CAS can help. You can use it on layers and selections in RGB, CMYK, Lab, and Grayscale image modes (page 46) and at all bit depths (see the box on page 45). However, you *can't* use it on Adjustment layers, layer masks, channels, Smart Objects, 3D layers, or Video layers.

When you're ready to take CAS for a spin, here's what to do:

1. **Open an image, unlock its Background layer (if necessary), and then press Q to pop into Quick Mask mode.**

 Content-Aware Scaling won't work on a locked Background layer (unless you Select All first; see page 85); nor is it perfect—you'll get better results if you help it out by masking the areas you want to protect. Quick Mask mode (page 176) is the fastest way to do that.

2. **Press B to grab the Brush tool and then set your foreground color chip to black.**

 Peek at the color chips at the bottom of the Tools panel. Press D to set them to the factory-fresh black and white, then press X until black is perched happily on top.

3. **Mouse over to your image and paint the areas you want to protect.**

 When you start painting, you'll see the red overlay of Quick Mask Mode (see Figure 6-25, top). When everything you want to protect is covered with red (like the grass and the happy dude shown in Figure 6-25, top), press Q to exit Quick Mask Mode. You'll see marching ants appear around everything *except* those areas, which you'll fix in the next step (see Chapter 4 for a refresher on selections and marching ants).

4. **Flip-flop your selection by pressing ⌘-Shift-I (Ctrl+Shft+I on a PC).**

 Since Photoshop selected everything *except* the area you painted in the previous step, you need to invert it. (You can also choose Select→Inverse.)

5. **Save your selection as an alpha channel (page 201).**

 As you learned in Chapter 5, alpha channels are a great way to save your selection. Open your Channels panel by choosing Window→Channels. When you save your selection as an alpha channel by clicking the little circle-within-a-square icon at the bottom of the panel (circled in Figure 6-25, top), Photoshop adds a channel called Alpha 1 to the bottom of the panel.

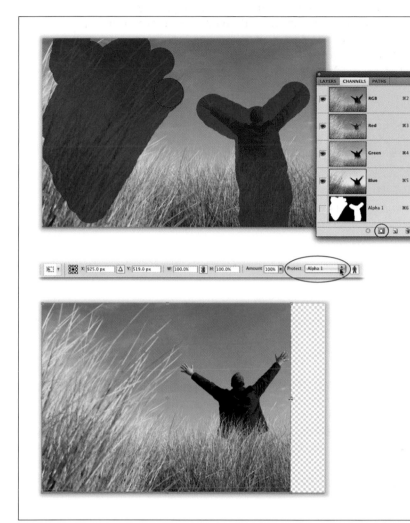

Figure 6-25:

Top: The areas you paint in Quick Mask mode turn red, as shown here. This mode is one of the fastest ways to make a selection, and you don't have to be super careful about the area you paint; anything you touch with the brush is protected. Once you exit Quick Mask mode and flip-flop your selection, click the "Save selection as channel" button at the bottom of the Channels panel (circled).

Middle: Once you've activated the Content-Aware Scale tool, you can choose your protective alpha channel from the Protect pop-up menu in the Options bar (circled).

Bottom: Because you protected the tall grass and the man, Photoshop leaves them alone and resizes everything else.

6. **Tell Photoshop you want to resize your image by choosing Edit→Content-Aware Scale or pressing ⌘-Option-Shift-C (Ctrl+Alt+Shift+C on a PC).**

 Photoshop puts white, square resizing handles all around your image; but don't grab any of the handles just yet!

7. **From the Options bar's Protect pop-up menu, choose Alpha 1 (Figure 6-25, middle).**

 Choosing the alpha channel you just created shows Photoshop which areas you want to protect. If your image contains people, you can preserve their skin tones by clicking the little silhouette icon to the right of the Protect menu.

If you want to make your image smaller or larger by a certain percentage, enter numbers in the W (width) and H (height) fields or the Amount field. (Most of the time, you won't mess with these fields because it's easier to resize your image visually, as you'll do in the next step.)

8. **Mouse over to your image, grab one of the resizing handles, and drag it toward the center of your image.**

 As you can see in Figure 6-25 (bottom), the image has been narrowed, but the tall grass and the happy dude remain unchanged. CAS resized only the unimportant parts of the image, and it did a great job.

Is this amazing technology? Yes. Is it still in its developmental phase? Heck yes! Even so, it has lots of practical uses. For example, if you have to fit an image into a small space (like wedging a photo into a tiny spot for a magazine article), you won't necessarily have to crop it. Or if you've created a panorama, you can stretch out the sky a little to fill it back in. Just don't expect CAS to work on images that don't have plain backgrounds like a portrait or other close-up image. Nevertheless, this exciting tool just keeps getting better in each new version of Photoshop. And just wait till you see what this feature's cousin, Content-Aware Fill, can do! See pages 181 and 427 for the lowdown.

Rotating, Distorting, and Other Creative Madness

Photoshop gives you lots of ways to rotate, distort, and otherwise skew images, all mighty useful techniques to have in your bag of tricks. By rotating an image, you can add visual interest (see the Polaroid technique on page 228), convert vertical elements to horizontal ones (or vice versa), and straighten crooked items. Distorting comes in handy when you want to make an object or text slanted or turned slightly on its side, or if you want the object or text to fade into the distance with perspective. And the new Puppet Warp tool lets you distort specific objects in an image while leaving the rest of it unchanged.

This chapter has touched on rotation here and there; you've learned how to rotate a crop box (page 223), rotate an image with the Free Transform command (page 95), and rotate your whole canvas (page 65). In this section, you'll learn about simple rotations as well as the tougher stuff.

Simple Rotations

As you probably suspect, the Image Rotation command rotates images. You can spin your whole document—layers and all—180 or 90 degrees (clockwise or counter-clockwise) or by an arbitrary amount that you specify (see Figure 6-26). You can also flip the canvas (or layer) horizontally or vertically, as you learned on page 258.

Figure 6-26:
Choose Image→Image Rotation to view this handy menu of image- and document-rotation options (Photoshop doesn't get any simpler than this). You can also rotate and flip images with the Free Transform command, as the next section explains.

The Transformers

Another way to resize and rotate (not to mention flip, skew, and distort) images is to use the Transform commands, which can help you make a single selected object or an entire layer bigger or smaller without altering the size of your document. If you hop up to the Edit menu, you'll see the Free Transform and Transform options about halfway down the list. Using the Free Transform Command, discussed later in this section, you can perform all the tasks listed on the Transform submenu (see Figure 6-27).

Note: If you're trying to transform a shape or a whole path (see page 537), the Edit menu item changes to Transform Path. If you're trying to transform just *part* of a path, the menu item reads Transform Points.

Selecting one of these commands summons a bounding box that looks and works just like a crop box (page 223), with tiny square handles on all four sides of the image. You can use Transform commands on objects you've selected (Chapter 4), on individual layers, or across many layers (see page 79 to learn more about selecting layers). The Transform commands resize the layer or selection but not the whole document; the only way to resize the whole document is by changing the image size (page 239) or canvas size (page 257).

Note: You may find yourself wondering, "Why does Photoshop have both a Free Transform command *and* a Transform menu if I can use them to do the exact same things?" Good question! The only real difference between these two options is that choosing an item from the Transform menu locks you into performing just that particular task (using the Scale tool, for example), whereas the Free Transform command lets you perform some of the transformations at the same time (without having to press Return or Enter between transformations).

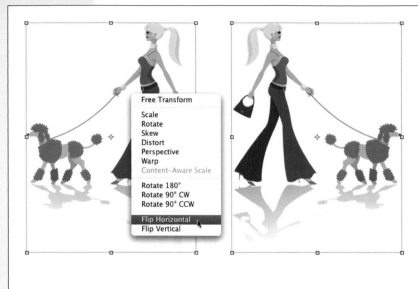

Figure 6-27:
When you activate one of the Transform commands by choosing it from the Edit menu (or activate all of 'em by choosing Free Transform), you'll get a bounding box surrounded by tiny, draggable handles.

Left: Another way to access all the options found in Edit→Transform is to Control-click (right-click on a PC) inside the bounding box to bring up the Free Transform command's shortcut menu, shown here.

Right: By choosing Flip Horizontal, you can make this girl and her poodle travel in the opposite direction.

You can transform any objects you wish. Vectors, paths, Shape and Type layers, and Smart Objects are especially good candidates for transformation because they can all be resized without harming (pixelating) the image. But you don't want to enlarge raster images very much because you have no control over resolution, resampling, or any of the other important stuff mentioned back on page 52. To play it really safe, resize an image using the Transform commands only for the following reasons:

- **To decrease the size of a selection on a single layer.** (Page 174 has more info about transforming a selection without altering any pixels on that layer.)

- **To decrease the size of everything on a single layer or multiple layers.** (See page 79 for details on selecting multiple layers.)

- **To increase the size of a vector, path, portion of a path, Shape layer, Type layer, or Smart Object on one layer or across several layers.**

To use the Free Transform command, in the Layers panel, choose the layer you want to transform and then press ⌘-T (Ctrl+T on a PC) or choose Edit→Free Transform. Photoshop puts a bounding box around your image, complete with handles that let you apply any or all of the following transformations to your object (they're all illustrated in Figure 6-28):

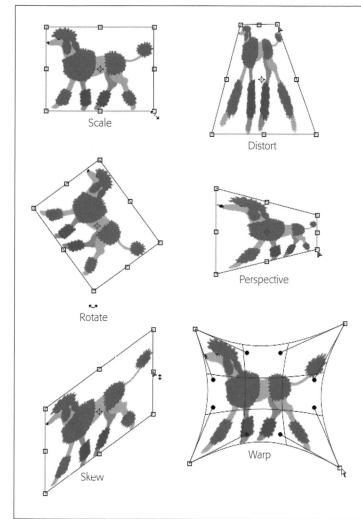

Figure 6-28:
The Transform commands let you scale, rotate, skew, distort, apply perspective, and warp objects in all kinds of interesting ways.

You can apply several transformations in a row if you like; just keep choosing different transformation types from the Transform menu or use the keyboard shortcuts listed on pages 265–266. To undo the last change you made without exiting the bounding box, press ⌘-Z (Ctrl+Z on a PC).

- **To scale (resize) an object,** grab a corner handle and drag diagonally inward to decrease or outward to increase the size of the object. Press and hold the Shift key while you drag to resize proportionately (meaning the object won't get distorted). You can drag one handle at a time or press and hold the Option key (Alt on a PC) to scale from the center outward (meaning that all four sides of the bounding box move simultaneously).

Tip: If you summon the Free Transform command to resize something big, the transform handles may end up outside your document's edges (or margins), making them impossible to see, much less grab. To bring them back into view, choose View→"Fit to Screen" or press ⌘-0 (that's the number zero, not the letter O) or Ctrl+0 on a PC.

- **To rotate an image,** hover your cursor outside any corner handle. When the cursor turns into a curved, double-headed arrow, drag up or down in the direction you want the image to turn. To rotate in 15-degree increments, press and hold the Shift key while you drag.

- **To skew (slant) an object,** press ⌘-Shift (Ctrl+Shift on a PC) and drag one of the side handles (your cursor turns into a double-headed arrow).

- **To distort an image freely,** press Option (Alt) while you drag any corner handle.

- **To alter an object's perspective,** press ⌘-Option-Shift (Ctrl+Alt+Shift) and drag any corner handle (your cursor turns gray). This maneuver gives the object a one-point perspective (in other words, a single vanishing point).

- **To warp an image,** click the "Switch Between Free Transform and Warp" button in the Options bar (page 267). Photoshop puts a warp mesh over your image so you can reshape it in any way you want. Drag any control point or line on the mesh to warp the image or choose a ready-made preset from the Warp pop-up menu at the far left of the Options bar. See page 598 for the scoop on warping text. To learn how to warp part of an image, skip ahead to page 270 to read about CS5's new Puppet Warp tool.

Note: The warp mesh grid can help you create the slickest page-curl effect you've ever seen. Head on over to this book's Missing CD page at *www.missingmanuals.com/cds* for the scoop!

- **To rotate or flip your image,** choose one of these preset options. Flip and Rotate are covered on page 263. If you choose one of these little jewels, you won't get a bounding box; Photoshop just rotates or flips your image.

When you're finished with your transformations, press Return (Enter on a PC), double-click inside the bounding box, or click the checkmark icon at the far right of the Options bar to accept them.

If you apply a transformation only to realize that it's not quite enough, you can repeat the transformation by choosing Edit→Transform→Again. You don't get a bounding box—instead, Photoshop reapplies the same transformation (for example, if you rotated the image by 90 degrees, Photoshop rotates it another 90 degrees). If you're resizing raster images, try to transform the object only once: The more you transform a pixel-based image, the blurrier and more jagged it can become.

If you want more precise transformations than the ones you get by dragging handles around, you can use the Options bar to enter specific dimensions for scaling, rotating, and skewing (see the list beginning on page 265), as Figure 6-29 illustrates.

Tip: All transformations are based on a tiny *reference point* that appears in the center of a transform box—it looks like a circle with crosshairs. You can drag it or set your own point by heading up to the Options bar and either clicking one of the reference point locator squares (shown in Figure 6-29) or entering X and Y coordinates.

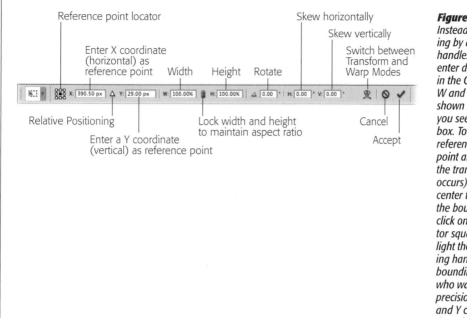

Reference point locator

Enter X coordinate
(horizontal) as
reference point Width Height Rotate

Skew horizontally

Skew vertically

Switch between
Transform and
Warp Modes

Relative Positioning

Enter a Y coordinate
(vertical) as reference point

Lock width and height
to maintain aspect ratio

Cancel

Accept

*Figure 6-29:
Instead of resiz-
ing by dragging
handles, you can
enter dimensions
in the Options bar's
W and H boxes, as
shown here, anytime
you see a bounding
box. To change the
reference point (the
point around which
the transformation
occurs) from dead
center to a point on
the bounding box,
click one of the loca-
tor squares to high-
light the correspond-
ing handle on the
bounding box. Folks
who want a bit more
precision can enter X
and Y coordinates for
the reference point.*

Tip: To put the Free Transform bounding box at your beck and call, press V to activate the Move tool (page 178) and then, in the Options bar, turn on the Show Transform Controls checkbox. (The only problem with this tactic is that you might end up resizing something when you don't mean to.)

Creating a reflection

A great little trick you can perform with the Transform command is adding a simple image reflection (see Figure 6-30). Though this technique takes a few steps, it's well worth the effort. Besides adding depth to an otherwise flat photo, a reflection can make an object look like it was shot on another surface, like a table (handy for making product shots without a proper studio setup).

Note: To follow along, visit this book's Missing CD page at *www.missingmanuals.com/cds* and download the file *Reflection.jpg*.

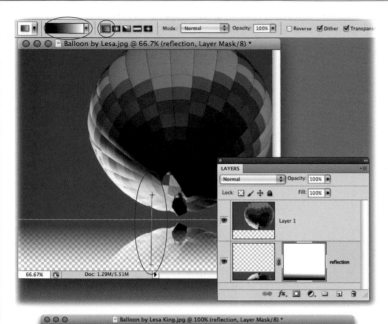

Figure 6-30:
Top: To add a reflection, duplicate the image layer (in this case, the balloon layer), flip it vertically with the Transform command, and then apply a gradient layer mask (page 287) to create the fade. Here you can see that a black-to-white, linear gradient (circled at top) did the trick. By dragging upward with the Gradient tool from the bottom of the document toward to the bottom edge of the photo (also circled), you can make the reflection appear to fade away.

Bottom: Here's what the image looks like after you place the final reflection on a black background and lower the opacity slightly to soften the effect. Adds a bit of visual interest, don't you think?

Here's how to create a simple reflection:

1. **Open a photo and duplicate the layer where the photo lives (most likely, the Background layer).**

 Duplicate the layer by pressing ⌘-J (Ctrl+J on a PC). While you're at it, double-click the original Background layer so that it's editable, if you haven't done so already. Name the duplicate *Reflection*, just to keep your layers straight.

Tip: You can duplicate an item *while* you transform it by pressing Option (Alt) while you choose Edit→Free Transform or Edit→Transform. That way, the transformation takes place on a duplicate item on a duplicate layer.

2. **Add some canvas space.**

 To make room at the bottom of the document for the reflection, you need to add some canvas space. Press C to select the Crop tool, draw a box around the image, and then drag the bottom handle down about two inches. Press Return (Enter on a PC) to accept the Crop. (Page 257 has more about adding canvas space.)

3. **Flip the reflection layer.**

 With the reflection layer selected, press ⌘-T (Ctrl+T on a PC) to summon the Free Transform command. Control-click (right-click) inside the bounding box and, from the resulting shortcut menu, choose Flip Vertical. When the layer is upside-down, press Return (Enter on a PC) or double-click inside the bounding box to accept the transformation.

4. **Move the reflection below the other photo.**

 Press V to select the Move tool (see page 178) and then hold down the Shift key while you drag the reflection toward the bottom of the document. Use the down arrow key to nudge the two layers slightly apart. They should *almost* touch, as Figure 6-30 shows.

Tip: Holding down the Shift key while you move a layer locks the layer into place horizontally or vertically, depending on the direction you're dragging. In this case, holding the Shift key ensures that the reflection lines up perfectly with the original photo.

5. **Add a gradient mask to fade the reflection.**

 Add a layer mask (page 113) to the reflection layer and then press G to select the Gradient tool (see page 287). In the Options bar, click the tiny downward-pointing triangle next to the gradient preview to open the Gradient Preset picker. Choose "Black to White" from the pop-up menu and then choose Linear as the gradient type (both circled in Figure 6-30, top).

6. **Draw the gradient.**

 Back in your document, press and hold the Shift key as you drag from the bottom of the image upward to roughly the height you'd like the reflection to be (circled in Figure 6-30, top). Holding down the Shift key locks the gradient vertically while you drag so it doesn't move from side to side. If you're not pleased with your dragging attempt, just give it another go; Photoshop keeps updating the mask as you drag.

7. **Add a new Solid Color Fill Adjustment layer for your new background.**

 Click the "Create new fill or adjustment layer" icon at the bottom of your layers panel (it looks like a half-black/half-white circle) and choose Solid Color. From the resulting Color Picker, choose black and then press OK. Drag the new layer to the bottom of your layers stack.

Tip: By using a Solid Color Fill Adjustment layer as your new background (in lieu of an image layer *filled* with color), you can experiment with the background color to see what looks best by double-clicking the Adjustment layer's thumbnail in the Layers panel to reopen the Color Picker. While this example uses black, fuchsia may be more your speed!

8. **Finally, soften the reflection by lowering its layer opacity to about 50 percent.**

 This final step is really about personal preference: If you want your reflection to be very faint, lower the reflection layer's opacity to about 50 percent (the opacity slider is at the top right of the Layers panel). If you want the original image to look like it's hovering above a mirror, go with an opacity of 75 percent or higher.

Now you've got yourself a professional-looking reflected image without all the hassle of setting up a reflective table. That's called working smarter, not harder!

Puppet Warp

New in Photoshop CS5, the Puppet Warp tool lets you distort individual objects in your image while leaving the rest of it unscathed (though you can also use it to warp your whole image, if you like). You can use it to make subtle changes such as repositioning your subject's hair or do more drastic stuff like repositioning an arm, leg, or tail.

To warp an item, you begin by dropping a series of markers (called *pins*) onto the object to let Photoshop know *that's* what you want to move (though you can warp a whole image *without* dropping pins). Photoshop then places a grid-like mesh atop your image that contains handles you can push and pull (by dragging) to distort the object. Once you finish moving the object, Photoshop tries to adjust the rest of the image so it matches, making your alteration look real. While you certainly won't need to use this tool daily, it can come in handy for changing the curvature of a sidewalk (see Figure 6-31), moving a fashion model's leg or arm into a more visually pleasing position, and so on.

Note: You can go to this book's Missing CD page at *www.missingmanuals.com/cds* and download the practice file *Road.jpg*.

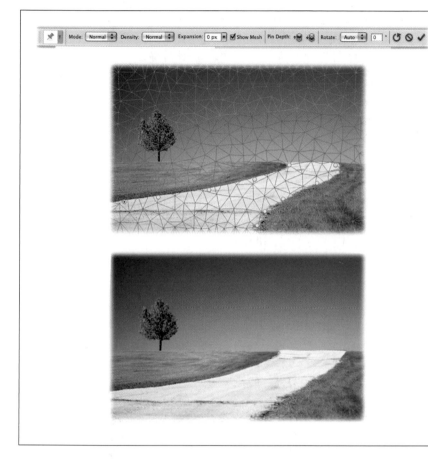

Figure 6-31:
Top: When you summon the Puppet Warp tool, these settings appear in the Options bar.

Middle: To alter the curve of this road, you need to drop a slew of pins around its edges and then click and drag them individually to their new positions. If everything seems to go to heck in a handbasket and you want to start over, click the Options bar's Remove All Pins button.

Bottom: Once you press Return (Enter) Photoshop tries to alter the rest of the image to match the changes you made. As you can see here, the curvature of the road has drastically changed.

Note: You can use Puppet Warp on image, Shape, and Type layers (though the latter two need to be rasterized first); Smart Objects (a good choice because you can distort them nondestructively); as well as pixel- and vector-based layer masks.

When you choose Edit→Puppet Warp, you'll see the following settings perched in the Options bar:

- **The Mode pop-up menu** lets you tell Photoshop how *elastic* (stretchable) you want the mesh to be. Your choices include Distort (great for warping an image shot with a wide-angle lens or creating an interesting texture for mapping onto another image [page 319]), Normal (your general-purpose mode), and Rigid (great for more precise warping of objects you've marked with pins).

- **The Density setting** controls the spacing of mesh points. Adding more points will make your change more accurate, though it'll take Photoshop longer to process. Fewer points will speed up the process, though depending on the object you're warping, it might not look as real.

- **The Expansion field** lets you expand or contract the outer edge of the mesh by a pixel value. Higher numbers expand the outer edge (even beyond your document's edge) and lower values shrink it. Entering a negative value shrinks the mesh so it's inside your document's edges, but also shrinks the image itself.

- **The Show Mesh checkbox** turns the mesh on or off. If you turn this setting off, you'll see only the pins you dropped on top of the image. A better idea is to temporarily hide the mesh by pressing ⌘-H (Ctrl+H on a PC); use the same keyboard shortcut to turn it back on.

- **The Pin Depth setting** lets you determine how deep the warping goes. For example, a deeper pin depth means you're warping the image at the background level, whereas a shallower pin depth lets you change the position of objects that lie on *top* of the background.

- **The Rotate setting** lets you rotate the item you've dropped pins onto while you're pushing and pulling it into a new shape or position by dragging with your mouse.

It's next to impossible to grasp how this tool works until you try it for yourself. Follow these steps to change the curvature of your favorite dirt road:

1. **Open an image and make sure the Background layer is editable.**

 Puppet Warp won't work on locked Background layers, so give the layer a quick double-click to make it editable.

2. **Choose Edit→Puppet Warp.**

 Photoshop plops a grid-like mesh on top of your image.

3. **In the Options bar, set the mode to Normal and then click to drop pins on the item you want to move.**

 Generally speaking, it's better to set more pins than fewer so you have more control. That being said, you can add pins while you're dragging other pins. You can also delete pins by pressing Option (Alt) and clicking the pin (your cursors turn into a tiny pair of scissors). If you try to add a pin too close to an existing one, Photoshop displays an error dialog box to let you know. The fix is to change the Options bar's Density pop-up menu's setting to More Points.

 As you drag to move the pins, you'll notice the mesh rotate in response. If you want to alter the rotation angle of the mesh around a specific pin, press Option (Alt on a PC) and hover your cursor near the pin (but not over it); when a circle appears, drag to visually rotate the mesh (you'll see the degree of rotation appear in the Options bar).

Tip: You can select more than one pin by Shift-clicking or Ctrl-clicking (right-clicking on a PC) and choosing "Select All Pins on Object" from the resulting shortcut menu. To delete multiple pins, select them and then press Delete (Backspace). You can also Ctrl-click (right-click) the mesh itself to summon a shortcut menu that lets you add a pin, select all the pins, delete all the pins, or hide the mesh.

4. **When you're finished, press Return (Enter).**

 Photoshop tries to adjust the rest of your image so the changes you made look real. This can include rotating your image, if necessary. If you end up with some transparent pixels around the edges after you're finished (due to the rotating Photoshop had to do to adjust the image's background to match your changes), you can use Content-Aware Scaling (page 258) to fill those areas back in, or zap 'em with the Crop tool (page 222).

As you might imagine, you'll need to do a lot of trial and error using Puppet Warp; but, hey, isn't that what Photoshop is all about? Just imagine what you could do with this tool on those photos of your ex!

Combining Images

One of the most rewarding projects you can tackle in Photoshop is combining images. Whether you're swapping skies, creating a complex collage, or building a panorama, this is where things start getting mighty fun. This chapter teaches you *all kinds* of techniques for mixing images together, from simply chopping a hole through one layer so you can see what's on the layer below it to a trick used by Photoshop heavyweights: mapping one image to the curves and contours of another.

Along the way, you'll learn how *layer blend modes* and *blending sliders* can help turn the images you have into the images you want. You'll also find out how to make Photoshop align and blend layers, as well as stitch multiple images into a big honkin' one.

However, if you've got an older computer or limited space on your hard drive, you may want to combine images using the Clone Source panel so you don't have to bulk up your Layers panel (and your file size). This chapter walks you through that process, too. Finally, you'll get tips on combining illustrations and photos into unique pieces of art that marry the real and the imaginary. The techniques discussed in the following pages draw on *everything* you've learned so far—layers, selections, resizing, and so on—so get ready to put your new skills to work.

Cut It Out

The easiest way to combine two images is to start with the images on different layers in the same document and simply chop a hole through one layer so you can see what's on the layer below. It's not elegant, but it works. For example, if you long to replace a dull window scene with something more exciting, like the sunbathing dude shown in Figure 7-1, you can just cut a hole through the window so the new object fills the void.

Note: To practice this combining maneuver yourself, visit this book's Missing CD page at *www.missing-manuals.com/cds* and download the file *View.zip*.

Figure 7-1:
The simplest way to combine images: Cut a hole in one so you can see through to the other. Once you've selected the hole (top left), you can delete it and try out new vistas.

Here's how to get yourself a brand-new view:

1. **Open an image and double-click the Background layer to make it editable (page 85) if you haven't done so already.**

 Choose any picture you'd like to see *another* picture appear inside of: a window like the one shown in Figure 7-1, a picture frame, a friend's face, and so on.

2. **Select the area you want to delete.**

 To cut a hole in the image shown in Figure 7-1, you'd use the Rectangular Marquee tool since the window is square. Press M to grab the tool and draw a box just inside the window frame. (See page 139 for more on the marquee tools; Chapter 4 has the full scoop on selection tools.)

3. **Use the Refine Edge dialog box to soften the selection's edges slightly.**

Softening the edges makes the combined images blend better. After you make your selection, click the Refine Edge button in the Options bar and, in the dialog box that appears, use the sliders to smooth your selection by 1–2 pixels and then feather it by 0.5–1 pixel. (See page 166 for more on using Refine Edge.)

Tip: If your selection is larger or smaller than the area you want to cut, adjust the Contract/Expand slider near the bottom of the Refine Edge dialog box.

4. **Press Delete (Backspace on a PC) to cut the hole.**

Once your selection is all set, you're ready to send it packin'. Peek in your Layers panel to make sure you're on the right layer before you perform this part of the surgery. Once you press Delete (Backspace), you see the transparent checkerboard pattern through the hole, letting you know that area doesn't contain any pixels.

5. **Add other images to your document by copying and pasting from another file or by dragging them over from your Layers panel.**

Here's where you add the image that you want to appear inside the original image. As you learned on page 90, you can copy and paste from other Photoshop documents or from other programs. Once you've copied the image, paste it into your Photoshop document and it'll land on its own layer. Or you can open the other image in Photoshop and then drag it from one document's Layers panel into another document's window, or drag from one document window onto the tab of another open document (both discussed on page 81). When you've got all the images added, position them *below* the original layer so you can see them *through* the hole you made in step 4.

Remember, as you learned in Chapter 3, whatever's at the top of the layers stack can hide what lies below. Cutting a hole inside the window frame in Figure 7-1 lets you see through to the image on the layer underneath. To see the whole image through the window frame, you may need to resize it by following the directions in the next step.

6. **Use the Move tool to position the glorious new vistas within your window frame.**

Press V to grab the Move tool, select the layer you want to move and drag the layer into place. If you need to resize it so you can see all of it through the window frame, use Free Transform (page 95): Just press ⌘-T (Ctrl+T on a PC) and Shift-drag one of the corner handles inward to make the image smaller or outward to make it larger.

Note: You can make the image just a *hair* larger by using the Free Transform command, but if you increase it too much, it'll end up badly pixilated. In that case, you need to hunt for a different or bigger image to use instead.

7. **Preview the new vistas by turning your layers' visibility on or off.**

 For example, in Figure 7-1, you could compare dude vs. chick vs. plain beach. Click each layer's visibility eye to turn it on or off to see which view you prefer.

Pasting into a Selection

Instead of cutting a gaping hole through your window frame, you can combine two images by using the new *Paste Special* menu in CS5 (named Paste Into in previous versions). With this handy new menu item, you get to tell Photoshop exactly where to put the copied image. Your choices include:

- **Paste in Place.** Use this command when you want to paste the image in the exact same position it lived within the document you copied it *from*. For example, if the image you copied was flush left in the original document, it'll be flush left when you paste it into the *new* document. The keyboard shortcut for this command is Shift-⌘-V (Shift+Ctrl+V on a PC).

- **Paste Into.** Use this command when you want to paste an image *inside* the selection you've made (in other words, inside your marching ants). Photoshop puts the pasted image on its own layer and creates a layer mask for you, as Figure 7-2 illustrates. You see the pasted image only in the selected area; the layer mask hides the rest. Keyboard shortcut: Option-Shift-⌘-V (Alt+Shift+Ctrl+V on a PC).

- **Paste Outside**. If you want Photoshop to paste the image *outside* your selection, choose this option. You'll get an automatic layer mask, although this time the area *inside* your selection is hidden; the pasted image shows only on the outside. Paste Outside is useful for swapping an image frame or border. (Apparently Adobe was running short on keyboard shortcuts because this command doesn't have one.)

Note: If you're using an earlier version of Photoshop, you can access the Paste Outside command by holding down the Option key (Alt on a PC) while choosing Edit→Paste Inside. Who knew?

Here's how to use Paste Into to combine two images without deleting any pixels:

1. **Open one image and select the area where you want the other image to appear.**

 As you learned in Chapter 4, it's wise to spend a few minutes looking at the area you want to select so you can pick the best tool for the job. For example, in Figure 7-2, the picture frame has a solid white interior. That means you can easily select it based on color. Press W to grab the Magic Wand (page 151) and click once in the white area to summon the marching ants.

Figure 7-2:
The Paste Into command tells Photoshop to create a layer mask that hides the outer bits of the pasted image so you can see it only through the selection. This image was created using Paste Into to place the couple inside a gaudy gold frame. Add a well-placed layer style or two (for example, drop and inner shadows) and the photo of the couple looks right at home in its new digs.

2. **Use Refine Edge to soften the selection slightly.**

 Once you see the selection box's marching ants, click the Refine Edge button in the Options bar. The edges of Magic Wand selections tend to be a little rough, so you can use the Refine Edge dialog box to smooth them, as well as contract or expand them, if you need to.

3. **Open the image you want to put into the frame and copy it.**

 Press ⌘-A (Ctrl+A on a PC) to select the whole image and then copy it by pressing ⌘-C (Ctrl+C).

4. **Jump back to the frame document and choose Edit→Paste Special→Paste Into or press Option-Shift-⌘-V (Alt+Shift+Ctrl+V).**

 Over in the Layers panel, Photoshop plops the pasted image onto its own layer, complete with a layer mask. In the document window, you see a portion of the pasted image peeking out at you through the frame.

5. **If necessary, resize the pasted photo and position it inside the frame.**

 If the photo is bigger than the frame (as in this example), you can make it smaller by using Free Transform: Press ⌘-T (Ctrl+T) and then Shift-drag one of the corner handles inward, as shown in Figure 7-3, to shrink the image proportionally.

Next, position your mouse inside the bounding box; your cursor turns into an
arrow that lets you drag the photo around inside the frame. When you're done
adjusting the photo, press Return (Enter).

Figure 7-3:
*If your photo is too
big for the frame, you
can always resize it
using Free Transform
(page 95). Just make
sure to press and
hold Shift as you drag
so you don't squash
or distort the image!*

Tip: If the Free Transform bounding box hangs off the edges of your document, press ⌘-0 (Ctrl+0) to
make Photoshop resize your window *just* enough so you can see all four corners of the box. This key-
board shortcut is worth memorizing 'cause you'll use it *all* the time.

6. **Lock the pasted photo and the mask together.**

 Once you get the photo sized and positioned just right, lock it to the layer mask
 that Photoshop created in step 4 so everything stays in place. Over in the Layers
 panel, click the space between the layer and mask thumbnails. When you do, a
 little chain appears (you can see it in the highlighted layer in Figure 7-2). You're
 basically finished with this image-combining technique now, but you can add
 even more visual interest by rotating the frame, adding a nice drop shadow and
 inner shadow, and giving it a new background. The next few steps explain how.

7. **Delete the white area around the frame.**

 The frame shown in Figure 7-2 was originally on a white background. To get rid
 of this background, select the frame layer in the Layers panel and double-click
 it to make it editable. Then press W to grab the Magic Wand and click the white

area outside the frame to select it. (If you've chosen a frame with all kinds of nooks and crannies around the edges, you can choose Select→Similar to make sure you've got *all* the white areas selected.) Once you've got a good selection, use the Refine Edge dialog box to smooth the selection's edges. Finally, press Delete (Backspace) to get rid of the white area for good, or hide it with a layer mask as explained on page 113.

8. **Use the Crop tool to make your canvas bigger.**

 In order to rotate the frame and add a nice, fluffy drop shadow, you need some extra canvas space. The menu command for increasing canvas size is discussed on page 257, but it's quicker to use the Crop tool. Press C to grab the Crop tool, and then drag to draw a box around your image. Option-drag (Alt-drag on a PC) one of the crop box's corner handles outward to make it bigger on all four sides, and then press Return (Enter). Now you've got all kinds of room to work.

9. **Select the frame and photo layers and rotate them with Free Transform.**

 In the Layer's panel, Shift-click to select both layers and then press ⌘-T (Ctrl+T) to summon Free Transform. Position your cursor outside the bounding box that appears and, when it turns into a curved double arrow, drag upward slightly to rotate the frame and photo. Press Return (Enter) when you've got them at an angle you like.

10. **Add an inner shadow to the photo layer.**

 To make the photo look like it's really *inside* the frame, you need an inner shadow. First, make sure that only the photo layer is selected in the Layers panel. Next, click the *fx* button at the bottom of the Layers panel and, from the pop-up menu, choose Inner Shadow. Tweak the settings in resulting the Layer Style dialog box to your liking (layer styles are discussed on page 128) and then click OK.

11. **Add a drop shadow to the frame layer.**

 To add a little depth and make it look as if the frame were really hanging on a wall, select the frame layer in the Layers panel, click the panel's *fx* button, and choose Drop Shadow. (See page 129 for more on drop shadows.)

12. **Add a Solid Color Fill layer named New Background and pick a color.**

 To complete the design, you need a new colored background for the frame. The easiest way to do this is to add a Solid Color Fill Adjustment layer by clicking the "Create new fill or adjustment layer" button at the bottom of the Layers panel (it looks like a half black/half white circle), and then pick Solid Color from the pop-up menu. In the resulting Color Picker, select the color you want for the frame's background and then click OK. If you decide to change the color later on, double-click the Fill layer's thumbnail to summon the Color Picker again.

Tip: If you mouse over to your image while the Color Picker is open, the cursor turns into a little eyedropper, which lets you click anywhere in the image to select a color. Snatching a color that's already in your image is a *great* way to pick a background color that matches because the new color already *lives* within the image.

13. **Drag the New Background layer to the bottom of the layers stack.**

 In your document window, the background appears behind your newly framed image.

 Whew! That was a lot of steps, but you're done. Now go find a place to digitally hang your new creation.

Sky Swapping

You can also use the Paste Into technique described in the previous section to replace a bland sky with a more pleasing vista, as shown in Figure 7-4. Sure, using the Paste Into command makes Photoshop add the layer mask *for* you, but it's just as easy to add the mask yourself, as described in the following steps (either method gets you the same result). Here's how to do it:

1. **Open an image with an area that you want to replace (like the sky) and double-click its Background layer to make it editable (page 85).**

 Photoshop won't let you add a layer mask to the Background layer unless you unlock it (which converts it to a normal layer that supports transparency). If you've worked with this particular image before, your layer may already be unlocked or named something else entirely. In that case, onward ho!

2. **Select the sky.**

 You can use any of the bazillion selection techniques you learned in Chapter 4. The channels method—discussed on page 205 and used to create the image shown in Figure 7-4—is a good one.

3. **Add a layer mask to hide the old sky.**

 Once you've selected the sky, add a layer mask by clicking the circle-within-a-square button at the bottom of your Layers panel.

Tip: If the mask hides the *opposite* of what you want it to hide, open the Masks panel (page 120) and click the Invert button at the bottom to flip-flop the mask. You can also use the other options in the Masks panel to refine your mask.

4. **Open the image with the replacement sky and copy it.**

 Press ⌘-A (Ctrl+A on a PC) to select the whole image and then press ⌘-C (Ctrl+C) to copy it.

Figure 7-4:
Instead of deleting the sky in the original image, you can hide it with a layer mask. Swapping skies makes this rider's accomplishment a bit more impressive, don't you think?

5. **In your other document (the one with the mask), paste the new sky onto its own layer by pressing ⌘-V (Ctrl+V).**

 If copying and pasting isn't your thing, arrange your workspace so you can see both open documents (page 67) and then drag the sky layer from the Layers panel into the other document's window (see page 101). In Photoshop CS5 you can also drag the image from your document window onto a document's tab.

6. **Position the sky at the bottom of the layers stack.**

 In your Layers panel, drag the new sky to the bottom of the layers stack and you're done.

You just swapped your first sky! If you want to try out other skies, just paste or drag them into the document and position them below the layer with the layer mask. Then hide the first new sky by clicking its visibility eye in the Layers panel.

Fading Images Together

So far, you've learned how to combine images with relatively hard edges such as a rectangular headshot wedged into a frame or adding a brand-new sky. But if your soon-to-be combined images don't have such stark boundaries, then you're better off using big, soft brushes to do your erasing or, better yet, hiding parts of your image with a layer mask (similar to what you just saw in the previous section). You can also use the Gradient tool to create a gradual transition from one image to another. Read on to learn all these methods.

Soft Erasers

Because you can set the Eraser tool to use a brush, you can use a soft brush to erase part of an image so you can see another image on the layer below, as shown in Figure 7-5. This technique gets the job done, but it's just as destructive as cutting a hole—if you change your mind about how you want to combine the images, you have to start over. (See the next section for a nondestructive alternative.)

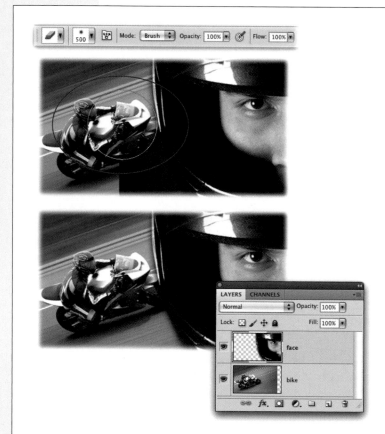

Figure 7-5:

Top: Use the Options bar's Mode pop-up menu to morph the Eraser into a brush. From the Brush Preset picker, choose a big, soft brush (a 500-pixel brush was used here).

Middle: Using a big, soft-edged brush (circled) you can erase the left side of the helmet image (which is just a dark gray background), letting you see through to the bike image on the layer below. The soft brush gives you a nice transition from one image to another.

Bottom: A quick peek at the Layers panel reveals that half your original image is gone. Now you know why it makes sense to copy your original image or better yet, use a layer mask as described in the next section.

Once you've wrangled the two images you want to combine into the same document (each on its own layer), follow these steps:

1. **Drag the image layer you want to partially erase to the top of the Layers panel.**

 Dragging the layer to the top of your layers stack should activate that layer, but it doesn't hurt to make *triple* sure you're on the correct layer before you grab the Eraser tool. Triple-checking may sound obsessive, but when it comes to *erasing* your image, it's better to be safe than sorry.

Note: It's a good idea to duplicate the image layer you'll be erasing in case you don't like the results (press ⌘-J or Ctrl+J on a PC to duplicate the layer). If you turn the duplicate layer's visibility off, it won't be in your way. (You can always turn it back on if you need to.)

2. **Grab the Eraser tool by pressing E and set it to Brush mode.**

 Head up to the Options bar and set the Mode pop-up menu to Brush. Then, from the Brush Preset picker, choose a big soft brush (Figure 7-5, top). While you're up there, make sure the Opacity and Flow fields are both set to 100 percent (see Chapter 12 for more on brush options).

Tip: For an even *more* subtle fading effect, experiment with reducing the Eraser's opacity in the Options bar. That way, you can brush repeatedly over the area you want to erase for a more gradual effect that you can build with multiple brush strokes.

3. **Mouse over to your image and erase the part you don't want.**

 As shown in Figure 7-5 (middle), you can brush away the part of the image you want to erase (like the background to the left of the helmet). If you mess up or change your mind, use the History panel (page 27) to go back a few brush-strokes or undo a step by pressing ⌘-Z (Ctr+Z on a PC).

4. **When you're finished, save your image as a Photoshop (PSD) file.**

 You've just erased your way to a very cool collage.

Soft Brushes and Layer Masks

A nondestructive alternative to using the Eraser tool is to paint on a layer mask with a big fluffy brush. That way you're merely *hiding* part of the image instead of deleting it. For example, let's say you want to really highlight—or completely fake—how fast the motorcyclist in Figure 7-6 is going. You can simulate a speeding effect by adding a bit of motion blur to your image and then hiding part of the blur using a layer mask.

Here's how to create the speeding effect:

1. **Open your image and then duplicate the original layer by pressing ⌘-J (Ctrl+J on a PC).**

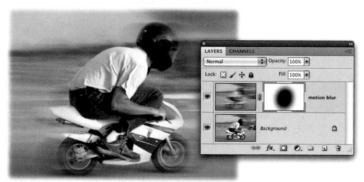

Figure 7-6:
Combining images isn't just about using different *images; there's opportunity aplenty to combine different versions of the same image, as shown here.*

Top: This freeze-frame version of the rider shows little evidence of his speed.

Bottom: Now the rider looks nice and speedy! As you can see in the Layers panel, a motion-blurred version of the original image is perfect for combining with the original shot.

2. **Choose Filter→Blur→Motion Blur to apply a pretty severe motion blur (page 638) to the duplicate layer to make it look like your subject is going really fast.**

 Since the motion blur makes your *whole* image blurry, it's hard to see the subject (in this case, the biker), so you'll want to hide some of the blurry layer by adding a layer mask, as shown in Figure 7-6, bottom left.

3. **Position the blurry layer at the top of the layers stack and add a layer mask.**

 Drag the blurry layer to the top of your Layers panel. Then, at the bottom of the panel, click the circle-within-a-square button to add a layer mask to it.

4. **Press B to grab the Brush tool and pick a big, soft brush.**

 Up in the Options bar, use the Brush Preset picker to choose a big (500-pixel, say), soft-edged brush.

5. **Set the foreground color chip to black.**

 As you learned in Chapter 3 (page 113), in the realm of layer masks, painting with black *conceals*, which is exactly what you want to do here. Peek at the color chips at the bottom of your Tools panel and, if they're black and white, press X until black hops on top. If they're any other color, press D to reset them to black and white and then press X until black is on top.

6. **Mouse over to your image and paint to hide part of the blurry layer.**

 If your brush is big enough, you can get away with clicking a few times on the area you want to hide (like the biker in Figure 7-6). If you mess up and hide too much, press X to flip-flop your color chips (so white is on top) and reveal that area again by painting with white.

7. **Save your image as a PSD file so you can go back and tweak it later on.**

 Heck, after seeing or printing the final version, you may decide to add a little more motion blur! If that's the case, you can pop open this document, select the blurry layer, and run the Motion Blur filter again. You won't have to recreate the layer mask because it's still there. Whee!

Gradient Masks

All that soft-brush business aside, the way to create the smoothest fades of all between two images you're combining is to use a *gradient*—a soft, gradual transition from one color to another. The steps for combining two images using a gradient are basically the same as the soft-brush methods in that you're combining the images into one document and then adding a layer mask to the top layer. But instead of painting on the layer mask with a black or white brush, you use a black-to-white gradient for a smooth and seamless fade from one image to another, as shown in Figure 7-7.

Once you've put two images into one document (each on its own layer), take a spin through these steps:

1. **Drag the image you want on the top of your collage to the top of the Layers panel and then add a layer mask to it.**

 In this example, you want the speedometer on top, so drag it to the top of your Layers panel. Then add a layer mask to it by clicking the circle-within-a-square button at the bottom of the panel. The layer mask thumbnail appears in the Layers panel, but your document doesn't change yet because the mask is empty. (Technically the mask is white, but if you remember the rhyme "black conceals, white reveals," a white mask reveals the layer fully.)

Gradient picker Gradient type

Figure 7-7:
Adding a black-to-white linear gradient to your layer mask is an easy and nondestructive way to blend images together gradually.

And remember that you can also rotate a layer to get the image in the right spot (here, the speedometer has been rotated slightly). The funky-looking layer in the middle of the Layers panel is a Black & White Adjustment layer that drains color from the image; you'll learn all about 'em in Chapter 8 (page 324).

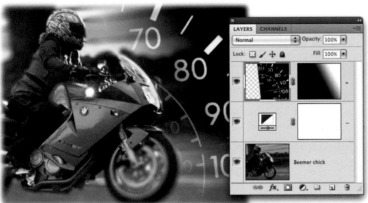

2. **Press G to grab the Gradient tool and choose a black-to-white, linear gradient.**

 In the Options bar, click the down-pointing triangle next to the gradient picker (the second menu from the left). Choose the black-to-white gradient from the pop-up list (third from left in the top row) and, in the row of gradient types, click the linear gradient button (it's circled in Figure 7-7, top).

3. **Mouse over to your image, click once where you want the fade to begin, drag slightly upward and to the right for one or two inches, and then let go of your mouse.**

 As you drag, Photoshop draws a line that represents the width of the fade: The shorter the line (the distance you drag), the narrower the fade and the harsher the transition (it won't be a hard edge, but it'll be close); the longer the line, the wider the gradient and the softer the fade. As soon as you release your mouse, Photoshop plops the gradient into the layer mask, which effectively fades your images together. If you're not happy with the gradient, just keep clicking and dragging until you get it right; Photoshop updates the mask automatically. Be sure to experiment with dragging different distances and at different angles. If you want to empty the mask and start over, click the mask's thumbnail in your Layers panel and select the whole thing by pressing ⌘-A (Ctrl+A on a PC); then press Delete (Backspace) and you're back to square one.

4. **Save your document as a PSD file (page 56).**

 This file format preserves your layers so you can go back and edit the gradient mask later.

Not bad, eh? Incidentally, this technique is a *great* example of how to use your own imagery in conjunction with stock photos. Just think of the possibilities: A wedding photo faded into a bouquet of flowers, piano keys faded into a sheet of music, Captain Kirk faded into a shot of the Starship Enterprise, and so on.

Layer Blend Modes

Perched in the upper-left corner of your Layers panel is a pop-up menu of *blend modes*. You may have clicked it already and been startled by the number of items listed, which range from modes that darken everything to modes that lighten everything to modes that don't seem to do a darn thing.

Blend modes control how pixels on different layers interact with each other. For example, when layers overlap, the top one can either block the bottom one completely or the layers can blend together in some way (these effects, and many more, are shown in Figure 7-8). You can control exactly *how* they blend together by using blend modes. As you might imagine, they're worth their weight in gold when you're combining images, whether you're using them to produce a darker or lighter version (see page 119) or joining up lots of different images to create a complex collage (as shown on page 295).

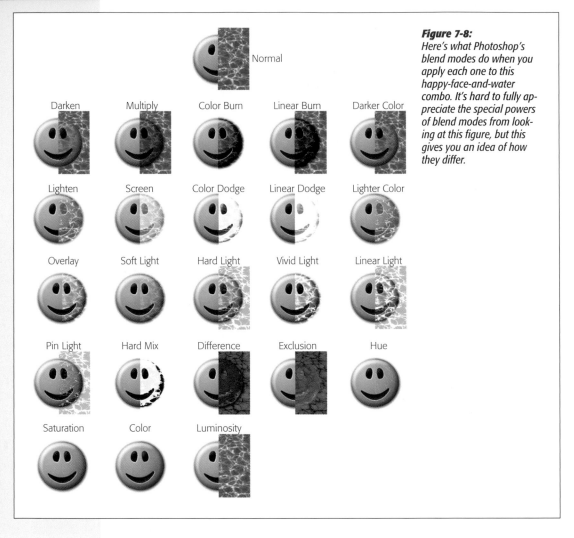

Figure 7-8:
Here's what Photoshop's blend modes do when you apply each one to this happy-face-and-water combo. It's hard to fully appreciate the special powers of blend modes from looking at this figure, but this gives you an idea of how they differ.

This section covers how to use blend modes to work with layers, but you can find other blend mode menus all over the place in Photoshop, including:

- In the Layer Style dialog box, where you can add effects like drop shadows, glows, and so on (page 129).

- In some filters' dialog boxes (see Chapter 15).

- In the Edit→Fade dialog box, which you access after you run a filter (see the box on page 467), apply any of the adjustments in the Image→Adjustments menu, and so on.

- In the Fill and Stroke dialog boxes (pages 183–184).

- In the Options bar when you're using a tool you can paint with like the Brush, Paint Bucket, Healing Brush, Pencil, Clone Stamp, History Brush, Gradient, Blur, Sharpen, and Smudge tools.

- In the Calculations (page 214) and Apply Image (see the Note on page 305) dialog boxes.

When you're dealing with blend modes, it's helpful to think of the colors on your layers as being made up of three parts:

- **Base.** This is the color you start out with, the one that's already in your image.

- **Blend.** This is the color you're adding to the base color, whether it's in an image on another layer or one you're painting onto another layer with the Brush tool.

- **Result.** This is the color you get after mixing the base with a blend color using a blend mode.

To help you make sense of Photoshop's growing set of blend modes (and you'll need all the help you can get), they're divided into categories based on their *neutral color*—the color that causes *no* change in that particular mode. For example, some modes ignore white, some ignore black, and so on. This info doesn't mean a hill of beans to you just yet, but it'll start making sense as you learn more about the various modes in the next few pages. Here's a quick tour of the layer blend mode menu.

Normal and Dissolve Blend Modes

These two modes are at the very top of the blend mode menu. Here's what they do:

- **Normal.** When you first use Photoshop, it's set to use this mode, which doesn't actually cause any blending at all; as Figure 7-8 shows, the pixels on the top layer totally block what lies below. Its keyboard shortcut is Shift-Option-N (Shift+Alt+N on a PC).

Note: Photoshop includes lots of keyboard shortcuts you can use to change the current layer's blend mode. However, if you're using one of the painting tools listed at the top of this page, these shortcuts change the blend mode of that particular *tool* instead of changing the layer's blend mode.

- **Dissolve.** This mode turns semi-transparent pixels into a spray of dots (if you don't have any semi-transparent pixels, your image won't change). Dissolve isn't very useful unless you want to make a drop shadow look coarse instead of soft (see Figure 7-9). Keyboard shortcut: Shift-Option-I (Shift+Alt+I on a PC).

My brain hurts.
My brain hurts.

Figure 7-9:
To create the spatter effect shown here, add a drop shadow with layer styles (page 129) and then, in the Layer Style dialog box, change the shadow's blend mode to Dissolve. Photoshop changes the formerly see-through drop shadow into a spray of pixels.

Darken Blend Modes

The modes in this category have the power to darken, or *burn*, your image (see Chapter 9 [page 376] and Chapter 10 [page 447] for more on using the Burn tool). Simply put, when you apply these modes, the base and blend colors go to war and the darkest color wins. These modes are incredibly useful when you want to swap a light-colored background for something darker. The neutral color in this category is white, which means that white has no effect on the blend at all, and any white parts of your images disappear.

- **Darken.** In this mode, Photoshop analyzes the base and blend colors and combines the darkest ones to create the result color. Any colors on the top layer that are darker than the colors on the layer below get to stay, and any lighter colors on the bottom layer disappear. Figure 7-10 has the details on using this mode to eliminate a white background with nary a selection tool. Keyboard shortcut: Shift-Option-K (Shift+Alt+K on a PC).

- **Multiply.** In Multiply mode, Photoshop multiplies (increases) the base color by the blend color. You can think of this mode like a double coat of ink since the result color will always be darker than the base. Multiply does a lot of cool things, including fixing images that are too light or overexposed (see page 119), removing white backgrounds (a technique sometimes called "knocking out"), or creating an *overprint* effect in which the graphic on the top layer looks like it's been printed on the layer below (like the fake tattoo shown in Figure 7-11). Keyboard shortcut: Shift-Option-M (Shift+Alt+M on a PC).

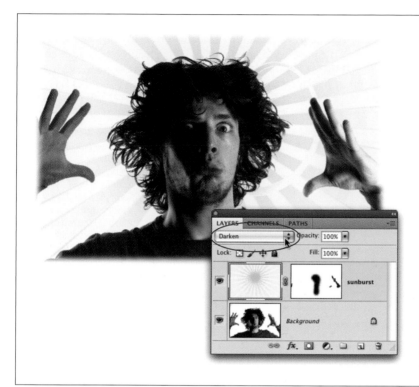

Figure 7-10:
By placing two images on separate layers, you can use Darken mode to zap a white background. Here, the top layer has a fairly dark sunburst and the bottom layer has a crazy guy on a white background. If you change the blend mode of the sunburst layer to Darken, the white background on the layer below it seems to disappear.

Since parts of the crazy guy's face and hand are lighter than the sunburst—the sunburst wins the color war explained on page 292 and covers him up in those spots—you can hide those parts of the sunburst to keep him whole. Simply add a layer mask and paint with a Brush set to black (see page 113 for more on layer masks).

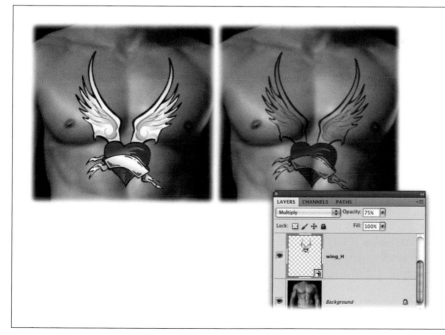

Figure 7-11:
By changing the blend mode of the tattoo layer to Multiply, its white background disappears so you can see through to the skin below.

All you need to do now is use the Type tool to put your name on the little banner across the heart!

- **Color Burn.** This mode darkens your image by increasing the overall contrast. When you use it on 50 percent gray, it intensifies color on the layers below, which can beautify an ugly sky in a hurry (see Figure 7-12). You can also use it to colorize a grayscale image, though the paint will be really dark and high contrast (it's better to use Hue mode, discussed on page 301). Keyboard shortcut: Shift-Option-B (Shift+Alt+B on a PC).

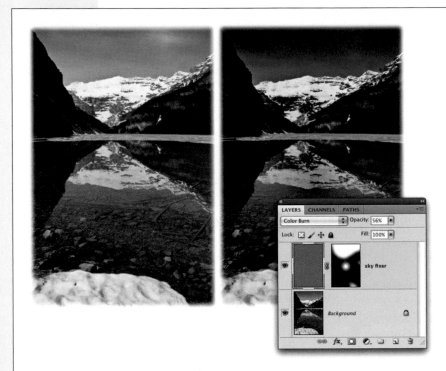

Figure 7-12:
Ain't nothing like a dull sky to ruin a perfectly decent photo. Happily, you can whip the sky into shape by adding a layer to the top of your layers stack, filling it with 50 percent gray, and changing its blend mode to Color Burn. If the effect is too strong, you can lower the gray layer's opacity, as shown here. To apply the color change only to certain areas of your image, add a layer mask (page 113).

Tip: An easy way to fill a layer with 50 percent gray is to make a new layer, go to Edit→Fill, and then choose 50% Gray from the Use pop-up menu. Those Adobe programmers think of everything!

- **Linear Burn.** In this mode (which is actually a combination of Multiply and Color Burn), Photoshop darkens your image by decreasing brightness. Linear Burn produces the darkest colors of any Darken blend mode, though with a bit more contrast than the others. It has a tendency to turn dark pixels solid black, which makes it ideal for grungy, textured collages like the one in Figure 7-13. Keyboard shortcut: Shift-Option-A (Shift+Alt+A on a PC).

Figure 7-13:
In this Layers panel, you can see the original image near the bottom followed by a Threshold Adjustment layer (page 337). Popping in three pieces of art (circled) and changing their blend modes to Linear Burn created this trendy collage. The opacity of the sunbeam and grunge texture was lowered to about 60 percent, and the sunbeam was positioned over the boy's eye. That's it!

- **Darker Color.** This mode compares the base and blend colors and keeps the darkest pixels. No blending going on here—the lighter colors just vanish.

Note: You may have noticed that Photoshop doesn't have a keyboard shortcut for Darker Color mode. That's because this mode didn't come around until Photoshop CS3 when Adobe started running out of keyboard shortcut combos. Same goes for Lighter Color mode (page 297).

Lighten Blend Modes

These modes, the opposite of the Darken modes, have the power to lighten, or *dodge*, your image (see Chapters 9 [page 376] and 10 [page 447] for more on using the Dodge tool). Black is the neutral color for this group; it disappears in all but one of the following modes:

- **Lighten.** In this mode, the lightest pixels win the war of colors. Photoshop compares all the colors and keeps the lightest ones from the base and the blend, and then combines them to produce the result color. Everything else is nixed (including black), which makes this mode perfect for removing a black background (see Figure 7-14). Keyboard shortcut: Shift-Option-G (Shift+Alt+G on a PC).

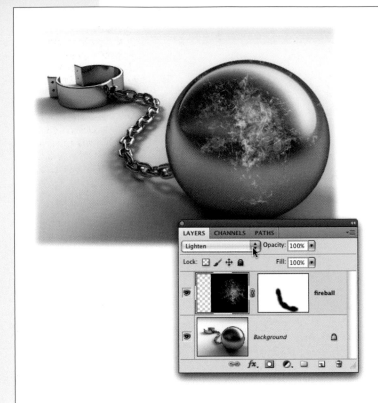

Figure 7-14:
To zap the black background of this fireball (the top layer), change its blend mode to Lighten. Now the flames are visible only where they're lighter than the colors in the steel ball.

A layer mask was added to hide a few rogue flames underneath the ball.

- **Screen.** In this mode, Photoshop multiplies the *opposite* of the blend and base colors, making everything a lot lighter as though a bottle of bleach was spilled on it. It's great for fixing images that are too dark or underexposed (like when your camera's flash doesn't fire; see page 119). Keyboard shortcut: Shift-Option-S (Shift+Alt+S on a PC).

- **Color Dodge.** This mode lightens your image by decreasing contrast. It has a tendency to turn light pixels solid white, and, unlike the other Lighten modes, it keeps black pixels, so the dark parts of your image don't change. You can use this mode with 50 percent gray to brighten your image—a great way to give hair some instant highlights (see Figure 7-15). Keyboard shortcut: Shift-Option-D (Shift+Alt+D on a PC).

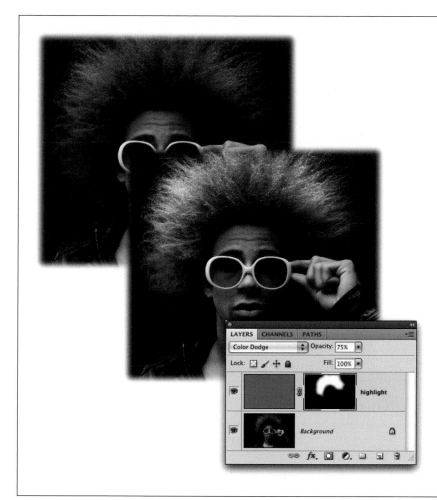

- **Linear Dodge (Add).** This mode lightens your image by increasing brightness. It's a combo of Screen and Color Dodge modes, so it'll lighten your image more than any other blend mode. But since it tends to turn *all* light colors white, it can make your image look unnatural. Keyboard shortcut: Shift-Option-W (Shift+Alt+W on a PC).

- **Lighter Color.** With this mode, Photoshop compares the base and blend colors and keeps only the lightest pixels. Unlike Lighten mode, it doesn't combine any colors; it just keeps the lightest ones. (The Note on page 295 explains why this mode doesn't have a keyboard shortcut.)

Lighting Blend Modes

In contrast to the Lighten and Darken modes, Lighting blend modes do a little darkening *and* a little lightening to increase the contrast of your image. They have a neutral color of 50 percent gray, which doesn't affect the result color; it just disappears.

- **Overlay.** In this mode, if the blend color is darker than 50 percent gray, Photoshop multiplies its color value with the base color. If the blend color is lighter than 50 percent gray, Photoshop multiplies its color value with the *inverse* of the base color (like it does in Screen mode). And if the blend color is exactly 50 percent gray, Overlay has no effect on the result color at all. You can use this mode to increase contrast or colorize a grayscale image. Keyboard shortcut: Shift-Option-O (Shift+Alt+O on a PC).

- **Soft Light.** As the name suggests, this mode is the equivalent of shining a soft light on your image. It makes bright areas brighter (as if they were dodged) and dark areas darker (as if they were burned). If you paint with black in this mode, you'll darken the underlying image; if you paint with white, you'll lighten it. You can use this mode to add texture to an image or to make an image look like it's reflected in metal (see Figure 7-16). Seasoned Photoshop jockeys use Soft Light with the Dodge and Burn tools to retouch portraits nondestructively (see page 447). Keyboard shortcut: Shift-Option-F (Shift+Alt+F on a PC).

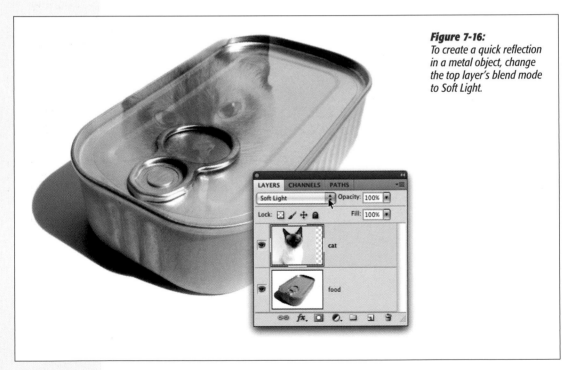

Figure 7-16:
To create a quick reflection in a metal object, change the top layer's blend mode to Soft Light.

- **Hard Light.** This mode, which is equivalent to shining a harsh light on your image, combines Multiply and Screen modes: if the blend color is lighter than 50 percent gray, the image gets lighter (like Screen mode); if it's darker than 50 percent gray, the image gets darker (like Multiply). If you paint with black or white in this mode, you simply get black or white. If you *really* want to increase the level of detail in an image, you can use this mode in conjunction with the Emboss filter. Keyboard shortcut: Shift-Option-H (Shift+Alt+H on a PC).

- **Vivid Light.** In this mode, Photoshop applies Color Burn to increase the contrast of colors darker than 50 percent gray and Color Dodge to decrease the contrast of colors lighter than 50 percent gray. Use Vivid Light to make an image pop or to add texture. Keyboard shortcut: Shift-Option-V (Shift+Alt+V on a PC).

- **Linear Light.** This mode combines the Linear Burn and Linear Dodge modes: It uses Linear Burn to decrease the brightness of colors darker than 50 percent gray and Linear Dodge to increase the brightness of colors lighter than 50 percent gray. Linear Light is great for adding texture to images, as shown in Figure 7-17. Keyboard shortcut: Shift-Option-J (Shift+Alt+J on a PC).

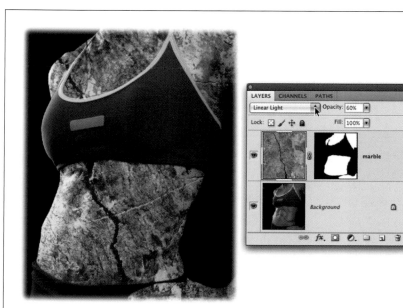

Figure 7-17:
Want to turn a loved one to stone? No problem! Simply use the Quick Selection tool (page 149) to select the person's skin and then add a layer mask to a layer containing marble or stone (the top layer here). Change the marble layer's blend mode to Linear Light and you've got an instant statue.

- **Pin Light.** This mode combines Lighten and Darken: If the blend color is *lighter* than 50 percent gray, it replaces areas of the base color darker than 50 percent gray with the blend color; pixels lighter than 50 percent gray don't change at all. But if the blend color is *darker* than 50 percent gray, Pin Light replaces lighter areas of the base color with the blend color and darker areas don't change. You'll rarely use this mode because it can produce odd results (or none at all), but feel free to experiment with it—especially with filters (see Chapter 15). Keyboard shortcut: Shift-Option-Z (Shift+Alt+Z on a PC).

- **Hard Mix.** This mode greatly reduces the range of colors in your image (an effect known as *posterizing*), so you end up with large blocks of super-bright colors like red, green, or blue. In this mode, Photoshop analyzes the sum of the RGB values in the blend color and adds them to the base color. For example, if the value of the red, green, or blue channel is 255, Photoshop adds that value to the base; and if the value is less than 255, Photoshop adds a value of 0. (See page 46 for more on color values.) You can reduce the effect of this mode by lowering the Fill setting at the top of your Layers panel (see page 78). You won't use Hard Mix very often, but it's fun for the occasional special effect, as you can see in Figure 7-18. Keyboard shortcut: Shift-Option-L (Shift+Alt+L on a PC).

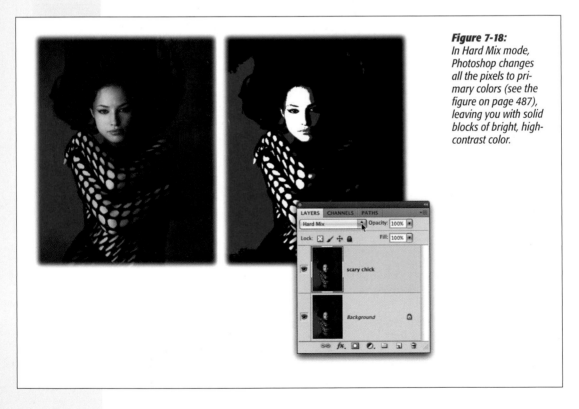

Figure 7-18:
In Hard Mix mode, Photoshop changes all the pixels to primary colors (see the figure on page 487), leaving you with solid blocks of bright, high-contrast color.

Comparative Blend Modes

This category should really be called "psychedelic." Its two modes are similar, and they both produce freaky results that are useful only on Halloween or in grungy collages (discussed earlier in this chapter). However, as you'll soon find out, they can be *temporarily* useful. Black is the neutral color in both modes.

- **Difference.** This mode analyzes the brightness of both the base and the blend colors and subtracts the brightest pixels. If you use white as your blend color, Photoshop inverts (flip-flops) the base color, making the image look like a film negative. If you use black as your blend color, Photoshop doesn't change anything. You wouldn't want to use this mode on your image for keeps, but you can use it temporarily to locate the midtones (see the box on page 400 for details). You can also use it to align two layers of the same image (if, say, they were shot at different exposures): just change the top layer to Difference mode and use your arrow keys to move the image until you no longer see the odd engraved look. Keyboard shortcut: Shift-Option-E (Shift+Alt+E on a PC).

- **Exclusion.** This mode is similar to Difference but results in a little less contrast. Blending with white inverts the base color and blending with black doesn't do anything. You can also use Exclusion to align images; just follow the steps for aligning images with Difference mode. Keyboard shortcut: Shift-Option-X (Shift+Alt+X on a PC).

Hue Blend Modes

All the modes in this category relate to color and luminance (brightness) values (see page 488 for more on brightness). Depending on the colors in your image, Photoshop applies one or two of these modes to the image (they don't have a neutral color like the other blend modes). Hue blend modes are extremely practical because you can use them to change, add, or intensify the colors in your image.

- **Hue.** This mode keeps the lightness and saturation (color intensity) values of the base color and adds the *hue* (another word for "color") of the blend color. If you want to change an object's color without changing how light or dark it is, use this mode (see page 342). However, Hue can't introduce a color that isn't already there to colorize grayscale images, so you have to use another mode (like Color, which is explained later in this list). Keyboard shortcut: Shift-Option-U (Shift+Alt+U on a PC).

- **Saturation.** This mode keeps the luminance and hue of the base color and picks up the saturation of the blend color. If you want to increase an image's color intensity, this mode can help you out (see Figure 7-19). You can also use Saturation to drain color from part of an image by painting that area black. Because black has no saturation value, it *desaturates* intersecting colors. Keyboard shortcut: Shift-Option-T (Shift+Alt+T on a PC).

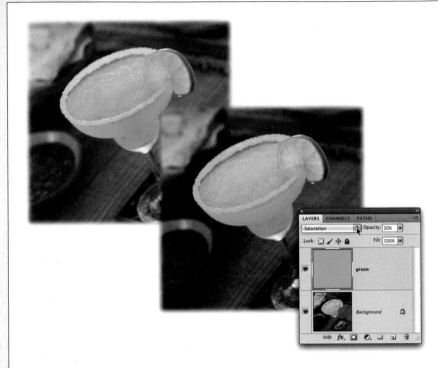

Figure 7-19:
If you've ever been to Texas, you know the margaritas there are much brighter than the one in the original image (left).

To boost the color saturation, add a new layer filled with a color that has the saturation value you want (it doesn't matter which color) and then change its blend mode to Saturation. The image takes on only the blend color's saturation value, not its hue.

- **Color.** In this mode, Photoshop keeps the luminance of the base color and picks up the hue and saturation of the blend color, which makes it handy when you're colorizing a grayscale image (see page 358). Keyboard shortcut: Shift-Option-C (Shift+Alt+C on a PC).

- **Luminosity.** This mode keeps the base color's hue and saturation and picks up the blend color's luminance. Use Luminosity when you're sharpening an image (see page 463), and when you're using curves or levels Adjustment layers (see Chapter 9). Keyboard shortcut: Shift-Option-Y (Shift+Alt+Y on a PC).

UP TO SPEED

Pass Through Mode

When you create a layer group (page 105), Pass Through appears at the top of the blend mode pop-up menu. In this mode, Photoshop makes sure that any blend modes, blending slider settings (page 303), opacity settings, and fill settings you've applied to layers in the group trickle down to layers *below* the group.

Let's say you've created a layer group consisting of several image layers set to Linear Burn mode to create a grunge collage. Pass Through mode lets the Linear Burn effect trickle down to any background or text on layers below the group. If you don't want the blending to affect the layers below the group, change the layer group's blend mode to Normal.

Zapping Backgrounds with Blending Sliders

If the subject of your image is radically brighter or darker than its background, you'll want to sit up and pay attention to this section. While blend modes are pretty powerful in their own right (and several of them can pulverize a white or black background instantly), *another* set of blending options in the Layer Style dialog box (page 128) can eat backgrounds for lunch—nondestructively!

Photoshop gives you a few different ways to open the Layer Style dialog box (Figure 7-20). Once you've selected the image layer you want to work with by clicking it, open the dialog box using one of the following methods:

- **Double-click its layer thumbnail in the Layers panel.**

- **Click the little *fx* button at the bottom of the Layers panel and choose Blending Options.**

- **Choose Layer→Layer Style→Blending Options.**

Note: The Blending sliders won't work on a locked Background layer; you have to double-click the layer first to make it editable.

At the bottom of the resulting dialog box lie two pairs of sliders (they look like triangles): one set for the This Layer bar and another for the Underlying Layer bar, as shown in Figure 7-20 (top). Each slider lets you make parts of your image transparent based on the brightness value of the pixels. The left slider represents the shadows (blacks) in your image and the right one represents the highlights (whites). If you want to affect the currently active layer, then tweak the This Layer slider (you'll learn about the Underlying Layer slider in a moment).

For example, if the background of your currently active layer is black and the subject (or object in the foreground) is much brighter, you can hide the black part by dragging the shadow slider (the one on the left) toward the middle until the black part is transparent. If you want to hide a white background, drag the highlight slider (the one on the right) toward the middle until the white part is transparent.

Note: If you save your document as a PSD file, you can adjust these sliders anytime you want by activating the layer and summoning the Layer Style dialog box.

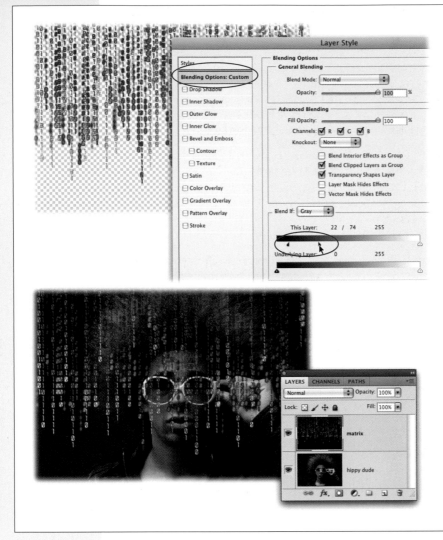

Figure 7-20:
Top: You can use the blending sliders to make short work of removing solid-colored backgrounds. In this image, the black background has been hidden by dragging the shadow slider toward the middle. To soften the edges of the bits that remain, you can split the slider in half (as described lower on this page) and then drag its left half back to the left.

Bottom: Once you've hidden the black in this Matrix-like background, you can see through to the image on the layer below, which makes for a quickie collage.

To soften your subject's edges once you've hidden the background, you can make the edge pixels partially transparent by splitting the shadow or highlights slider in half. To soften the edge pixels after you've hidden a black background, Option-click (Alt-click on a PC) the left half of the shadows slider and drag it slightly back to the left (circled in Figure 7-20). Likewise, if you've hidden a white background, you can Option-click (Alt-click) the right half of the highlights slider and drag it slightly to the right to tell Photoshop to make pixels with that particular brightness value partially transparent.

You can perform this pixel-hiding magic on colors, too. Just pick the channel (see Chapter 5) you want to work with from the Blend If pop-up menu above the sliders, and that particular color appears in the slider instead of black and white.

The Underlying Layer sliders let you control the range of visible colors on layers *below* the currently active layer. As you drag the sliders, parts of the image on underlying layers appear *through* the pixels on the active layer as if you'd cut a hole out of it. If you drag the shadows slider toward the middle, you'll begin to see the darkest parts of the underlying image show through the active layer. If you drag the highlight slider toward the middle, you'll start to see the lightest parts of the underlying image.

As you can see in Figure 7-20, the blending sliders can do an amazing job of hiding backgrounds based on color. But if your *subject* contains some of the colors in the background, the blending sliders will zap those areas, too. In that case, you'll have to use a different method to hide your background, like another blend mode or a layer mask (discussed earlier in this chapter).

> **Note:** To learn how to combine two images using the Apply Image command, which lets you pick which channel Photoshop uses to do the blending, head to this book's Missing CD page at *www.missingmanuals.com/cds*.

Auto-Aligning Layers and Photomerge

If you've ever needed to combine a few group shots to get an image where everybody is smiling and everybody's eyes are open, you'll appreciate Auto-Align Layers. Sure, you can manually align layers, but when you run this command, Photoshop does all the hard work for you by examining the selected layers and aligning them so identical areas overlap (see Figure 7-21).

> **Note:** The Auto-Align feature isn't magic; the angle and the distance from the subject in both shots need to be the same for it to work. However, in Photoshop CS5, this command takes a look at the lens correction profiles specified in the new and improved Lens Correction filter (page 655), which helps this tool do a better job of aligning layers.

Once you've gotten your images into the same document (on different layers), select at least two layers by Shift- or ⌘-clicking them (Ctrl-clicking on a PC), and then choose Edit→Auto-Align Layers (this menu item is grayed out unless you have at least two layers selected). In the resulting dialog box (Figure 7-21, top), you can choose from these alignment methods:

- **Auto.** If you're not sure which method will work best to align your images, let Photoshop decide. When you choose this option, Photoshop picks either Perspective or Cylindrical, depending on which one it thinks will create the best composition. It usually does a good job aligning your images, though you may notice some distortion (as explained in the next two bullet points).

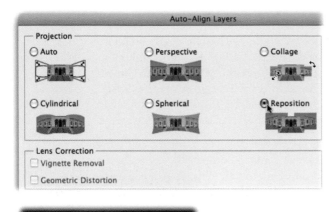

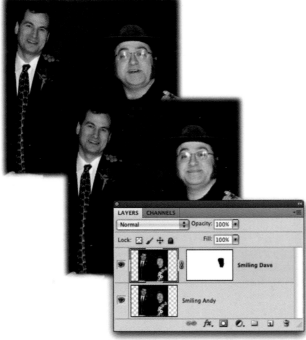

Figure 7-21:
Top: When you're trying to align multiple group shots, the Auto-Align Layers dialog box's Reposition option is your best bet.

Bottom: The Auto-Align layers command is great for merging a few imperfect shots into one perfect shot (or rather, one where each subject is smiling). To do that, combine the images into one document and place the non-smiling layer atop the smiling layer. After you run the Auto-Align layers command, just add a layer mask to the top layer and then paint the non-smile away with a black brush so your smiling pal shows through!

- **Perspective.** When you choose this method, Photoshop adjusts the four corners of your layers and repositions, stretches, and skews each one so any overlapping areas match in perspective. The final image looks slightly warped—both ends are a little larger than the center of the image, as if they were closer to you. This method can also make one of your layers look like it's coming out of the screen toward you, which can be visually interesting.

Tip: Photoshop picks its own *reference layer* (the layer it tries to align all the other layers with) unless you designate one yourself using the Lock All layer lock, discussed on page 103.

- **Cylindrical.** If you're combining several images into a panorama (see Figure 7-22, top), choose this option. Along with repositioning, stretching, and skewing your layers, Cylindrical helps get rid of any bow-tie lens distortion (where the subject looks like it's being pinched inward) by curving the images slightly (see Figure 7-22, middle).

Figure 7-22:
Top: If you want to stitch these forest images together, you can use the Auto-Align Layers command or Photomerge to get it done.

Middle: To compensate for bow-tie lens distortion, the Cylindrical alignment method curves your final image slightly (notice that the bottom and top edges of the image aren't straight).

Bottom: The Spherical method gives you a perfectly rectangular panorama.

- **Collage.** This method tells Photoshop to scale, rotate, and reposition the layers to align them with overlapping content without changing their shape. Choose Collage if you don't want your images to become distorted in any way.

- **Spherical.** Like Cylindrical, Spherical repositions, stretches, and skews layers to match up overlapping areas. It also tries to correct barrel distortion (where the subject looks rounded) by making your panorama perfectly rectangular (see Figure 7-22, bottom).

- **Reposition.** If you're aligning a group shot to hide a frown or closed eyes, choose this option. It won't stretch or skew your layers; it'll just reposition them so they line up.

The Auto-Align Layers dialog box also gives you two ways to correct camera lens distortions. Turn on the Vignette Removal checkbox to get rid of darkened or soft edges caused by wide-angle lenses, or the Geometric Distortion checkbox to make Photoshop warp your image slightly to reduce the spherical look also caused by wide-angle lenses or being too close to your subject with a regular lens.

Note: In Photoshop CS5, Auto-Align Layers now uses the camera profiles you set up in the Lens Correction filter, which should give you more accurate panoramas. See the box on page 658 to learn more about the new options in the Lens Correction dialog box.

Once you've aligned your images, flip to page 309 to see how you can make Photoshop blend them together seamlessly using the Auto-Blend command.

Building Panoramas with Photomerge

Photoshop has an automatic photo-stitcher called Photomerge that gives you all the same options as the Auto-Align Layers dialog box, but you don't have to combine your images into the same document first—Photoshop does that for you. This is really helpful when you're merging images into a wide shot, though Photoshop CS4 and later, unlike previous versions, doesn't let you manually arrange your images into a panorama (see the box on page 310).

To use Photomerge, choose File→Automate→Photomerge. In the resulting dialog box's Use pop-up menu (at the very top), tell Photoshop whether you want to use individual files or a whole folder. Click the Browse button to find the images on your hard drive, or, if you've already opened the documents, click the Add Open Files button. On the left side of the dialog box, you can pick an alignment method or leave it set to Auto and let Photoshop decide for you. If you want Photoshop to use layer masks to help cover up any seams, leave the Blend Images Together checkbox at the bottom of the dialog box turned on (this setting has the same effect as running the Auto-Blend command discussed on page 309). The Vignette Removal and Geometric Distortion checkboxes work the same way here as they do in the Auto-Align dialog box (see page 305).

When you've got all the settings the way you want them, click OK. Photoshop combines your images into a new document with each image on its own layer, rotated and positioned to fit with all the others. All you need to do is crop the image (page 222) to get rid of any transparent bits around the edges, or you can recreate that portion of the image by hand using the Clone Stamp tool (see page 311 and Appendix D online) or, even simpler, Content-Aware Scale (page 258).

Tip: You'll find cropping and cloning easier if you flatten (page 112) the image first, though be sure to choose File→Save As and give the image another name so you can flatten it without worrying about saving over the original. Also, you can choose Edit→Content-Aware Scale (page 258) to slightly "stretch" your image so you don't have to crop it quite so much.

Auto-Blending Layers

The Auto-Blend Layers command, which was designed to be used after the Auto-Align Layers command (page 305), helps you blend images for a panorama or collage, or combine multiple exposures of the same image to create an extended *depth of field* (see page 310) so more of an object looks like it's in focus. When you use this command, Photoshop creates complex layer masks to blend your images, saving you a lot of hard work.

UP TO SPEED

Shooting Panoramas

If you're taking photos specifically to make a big honkin' panorama, here are a few things to think about while you're snapping away:

- **Use a tripod.** A tripod or some other stabilizing surface (like your mate's shoulder) helps you take steadier shots. You don't want your panorama to be blurry, right?

- **Include an overlapping element in each shot.** If you're taking three shots, make sure you include some of what's in the first shot in the second, and some of the second shot in the third. That way you have overlapping bits that Photoshop can use to align your images.

- **Keep the lighting (exposure) consistent.** Though Photomerge is pretty darn good at blending images, you're going to notice if you took one of your shots in the shade and the other in direct sunlight. For the best results, keep your lighting constant by exposing for the brightest portion of the image manually (even if it means consulting your camera's manual).

- **Make sure the angles are the same.** Photoshop has one heck of a time matching up images shot at different angles, but mismatched shots can make for some interesting creative possibilities.

Note: You can use the Auto-Blend Layers command only when you're working in RGB or Grayscale mode (see page 46 for more on color modes).

To get the best results, start with the Auto-Align Layers command and then choose Edit→Auto-Blend Layers. In the resulting dialog box, choose one of the following blending options:

- **Panorama.** Select this option to have Photoshop search for overlapping areas in your images to piece them together into a single image.

- **Stack Images.** If you've fired off several shots of an object with different parts in focus (known as different *depths of field*) and you want to combine them into a single shot that looks like the *whole object* is in focus, choose this option. Let's say you shot a tiger—with a big zoom lens, of course—that was stretched out lengthwise and facing you. If you shot one image with his head in focus, another with the middle of his body in focus, and a third with his tail in focus, you can choose Stack Images to make Photoshop combine the three images into a single shot with the *whole* tiger in focus.

- **Seamless Tones and Colors.** Turn on this checkbox to make Photoshop smooth any noticeable seams and color differences between your images during the blending process.

As mentioned earlier, this command has a ton of potential uses. One visually interesting possibility is to make a collage of two or more action shots to create a stop-motion effect. Figure 7-23 has the details.

Tip: You can also use the Auto-Blend Layers command to help you scan really big images. For example, if the image is too big to fit onto your scanner in one piece, scan different sections of it—being careful to create overlapping areas—and then let Photoshop piece it together for you by running the Auto-Align Layers command and then running Auto-Blend Layers.

FREQUENTLY ASKED QUESTION

Interacting with Photomerge

Dude, where's my interactive Photomerge dialog box? I used to use it all the time to hand-place images into a panorama!

Sadly, that dialog box is gone; Adobe removed it back in Photoshop CS4.

Previous versions of Photoshop had an Interactive Layout option at the bottom of the Photomerge dialog box that opened a huge window where you could manually arrange images into a panorama. This wildly useful option let you control exactly how Photoshop stitched your panorama together, and let you create nonrectangular panoramas that went off in all directions instead of just left to right.

Because the out-of-date programming code behind this dialog box would have required all manner of reworking to get it to work in recent versions of Photoshop, Adobe decided to nix it. However if you squeeze your eyes shut real tight and click your heels together three times, it might come back. (Kidding!)

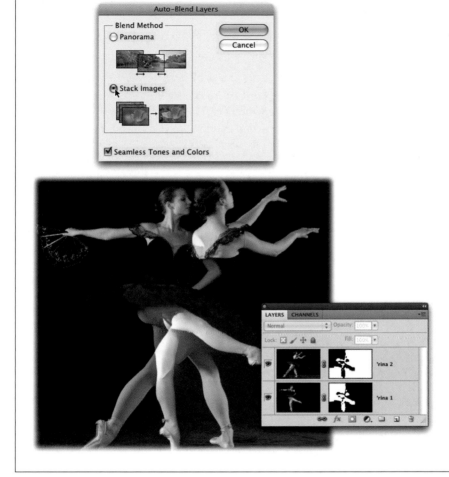

Cloning Between Documents

All this combining-images-into-the-same-document business can cause your Layers panel to get long and unwieldy. And as you learned back in Chapter 3, loading a document with layers can increase its file size and even slow Photoshop down (especially if you've got an older computer or very little memory). Fortunately, if the images you want to combine use the same color mode (page 46), there's a solution.

Sure the Clone Stamp tool is great for tricks like banishing blemishes (page 434) or giving someone a third eye, but it has other uses, too. To prevent your Layers panel from becoming overcrowded, use this tool to copy bits and pieces of an image from

one open document to another. Using the Clone Source panel—the *clone source* is the object you're copying—you can clone from up to five different sources whether or not they're in the same document.

Here's how to clone from one open image into another:

1. **Open the source (the image[s] you're cloning from) and the target (the image you're cloning to).**

 To choose clone sources in documents other than the current image, open the source documents. Click the Arrange Documents button in the Application Bar (page 67) to choose a preview method that lets you see all your open documents or just click each document's tab to activate it (see Chapter 2, page 68, for more on working with tabbed documents).

2. **Press S to grab the Clone Stamp tool, and then open the Clone Source panel.**

 Choose Window→Clone Source or click the panel's icon in the panel dock. (Full coverage of the Clone Source panel's many options starts on page 311.)

3. **Set the clone source.**

 Click the tab of the image you want to clone from (like the cats in Figure 7-24, top left). Then Option-click (Alt-click on a PC) the area you want to copy to set it as your clone source.

Figure 7-24:
Top: By cloning the kitties from one image onto the birdhouses in another, you can create a mischievously cute collage.

Bottom: The brush preview is extremely helpful in positioning the cloned art (left). If you mess up and clone in a little too much (middle), grab the History brush (page 29) and paint to reveal that part of the original image (right). If you're cloning onto a new layer, you can also use the Eraser tool.

4. **Create a new layer.**

 Unless you want to clone the new image on top of your original image (and you
 don't!), head back to your target document and add a new layer by clicking the
 "Create a new layer" button at the bottom of the Layers panel. That way, if you
 don't like the result, you can simply toss the new layer instead of having to start
 over.

5. **Paint to clone the item.**

 As shown in Figure 7-24 (bottom left), Photoshop displays a preview of the im-
 age you're about to paint inside the brush cursor. If you don't want your clone
 source point to move as your brush cursor moves—because you want to create
 multiple instances of an object, for example—turn off the Options bar's Aligned
 checkbox.

Tip: To change brush size and hardness, you can use the Options bar—or keyboard shortcuts. In Photo-
shop CS5, you can alter brush size and hardness by Ctrl-Option-dragging (Right-click+Alt+dragging) in
horizontal/vertical strokes, respectively.

You need a pretty steady hand when you're working with the Clone Stamp tool be-
cause it's easy to clone too much and cover up parts of your image. You can solve that
problem by first selecting an area to restrict your brush strokes to that part of the
image. This technique is handy when you want to fill an area with another image, as
shown in Figure 7-25.

Figure 7-25:
*If you select the
destination area first,
you don't have to be
as careful with your
brush. As you can see
here, the brush ex-
tends past the edges
of these digital busi-
ness dudes (circled),
but Photoshop
applies the Matrix-like
background only
within the selection.*

You can also clone from one document to another by following the steps just described, but your clone target and destination will be in different images. If you want to get a little fancy and start doing things like pulling source points from *multiple* images and changing the angle of your cloned objects, then you need to enlist the help of the Clone Source panel (Figure 7-26).

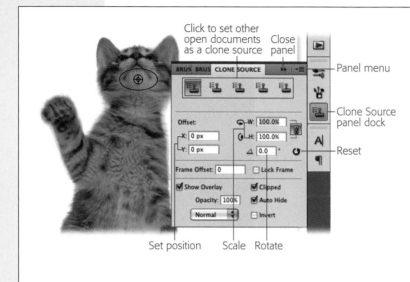

Click to set other open documents as a clone source
Close panel
Panel menu
Clone Source panel dock
Reset
Set position Scale Rotate

Figure 7-26:
Assigning multiple clone sources is handy when you want to clone items between open documents or when you're trying to create a complex scene from different elements. For example, if you're trying to remove a cow that's standing in front of a fence, one clone source can be the fence and another can be the grass. Once you've activated the Clone Stamp tool, you can use the five source buttons shown here to switch quickly between different source points without having to reset them manually each time. To set a source point, just Option-click (Alt-click on a PC) the area you want to clone, and your cursor turns into a crosshair like the one circled here.

Note: You can use the Frame Offset and Lock Frame options shown in Figure 7-26 (available only in Photoshop Extended) to clone content in video or animation frames.

In the Clone Source panel, you can tweak the following settings:

- **Offset.** Use this section of the Clone Source panel to move, resize, or rotate the object you're copying (the clone source). If you want to move your clone source, you can change its X and Y coordinates (measured in pixels) here. If you've got the Show Overlay checkbox (explained next) turned on, you see a preview of the source point on your image that moves as you tweak these settings. To clone the object at a different size, enter new percentages in the W and H fields (for width and height). To rotate your clone source—so the cloned item is turned—enter a number of degrees in the field next to the little triangle. To reset all these options, click the little curved arrow button.

Tip: You can position your cursor above any of the field labels in the Offset section—X, Y, W, and so on—to get the handy scrubby cursor (see the figure on page 94). Drag left to decrease the setting and right to increase it. You can Shift-drag to change it in larger increments or Option-drag (Alt-drag on a PC) for smaller increments. If you're a fan of keyboard shortcuts, press Option-Shift-[(Alt+Shift+[on a PC) to decrease your clone source's width and height proportionally and Option-Shift-] (Alt+Shift+]) to increase them. To rotate your source, press Option-Shift-< (Alt+Shift+<) to turn it counterclockwise or Option-Shift-> (Alt+Shift+>) to turn it clockwise.

- **Show Overlay.** With this checkbox turned on (it's on automatically), you see a preview of what you're about to paint *inside your brush cursor*. This handy feature shows you exactly what the cloning will look like before you commit to it.

- **Opacity.** You can use this field to adjust the opacity of the overlay preview. To change the opacity of what you're *cloning* (your actual brushstrokes), you have to change the Opacity setting in the Options bar instead.

- **Clipped.** This checkbox restricts the preview overlay to the area inside your brush cursor. For Pete's sake, leave this setting turned on. If you don't, Photoshop previews the *entire* clone source image right underneath your cursor, which keeps you from seeing anything *except* the preview.

- **Auto Hide.** If you turn on this checkbox, the overlay preview disappears as soon as you click to start painting. It's a good idea to turn it on so you can see how much you've painted so far.

- **Invert.** Turning on this checkbox makes Photoshop invert the overlay preview so it looks like a film negative, which can be helpful if you're trying to align the cloned area with something that's already in your image.

- **Blend Mode.** You can use this pop-up menu to change the blend mode of the overlay preview. Your choices—Normal, Darken, Lighten, and Difference—are explained earlier in this chapter, starting on page 291. To change the blend mode of the *cloned pixels*, use the Options bar's Mode pop-up menu instead.

Combining Vectors and Rasters

A fun trend in the design world is to combine vectors with rasters (page 52 explains the difference); in other words, to combine illustrations with photographs, a technique that provides an interesting look and lets you get creative. Because you can load vectors as Smart Objects (page 123), they remain infinitely resizable, letting you experiment with them as backgrounds, artful embellishments, and even ornamental photo frames.

As you can see in Figure 7-27, adding vectors to photos is a ton of fun. It's as if you're blending real images with imaginary ones. Even if you can't draw these little goodies yourself, stock-image companies like iStockphoto (*www.istockphoto.com*) sell affordable vector images so you can still participate in the trend.

Figure 7-27:
As you can see here, a dash of vector art can spice up any photo.

You can add vector art to your images in a couple of ways:

- **Place it.** With a document open, choose File→Place and navigate to the vector file on your hard drive. This inserts the file as a Smart Object (page 123). Since you'll most likely need to resize the artwork, Photoshop considerately surrounds it with the Free Transform bounding box and resizing handles (page 95). Just Shift-drag any corner to make the art bigger or smaller. If you need to rotate it, place your mouse outside the bounding box and drag in the direction you want to rotate. Press Return (Enter on a PC) when you're finished.

- **Paste it.** If you're working in a vector-based program like Adobe Illustrator, you can copy artwork and paste it into your Photoshop document by choosing Edit→Paste or pressing ⌘-V (Ctrl+V on a PC). When you do, Photoshop displays the dialog box shown in Figure 7-28, asking *how* you want to paste it. If you choose Smart Object, you can resize the artwork as much as you want without losing quality (see page 123).

Framing a photo with an illustration is not only fun, it's also incredibly flexible because you can continually resize the frame without starting over. Here's how to do it:

1. **Open the photo you want to frame and, if necessary, double-click the Background layer and give it another name to make it editable (page 85).**

 If your Background layer isn't locked, or if you've already worked with the photo and renamed this layer, you can skip this step.

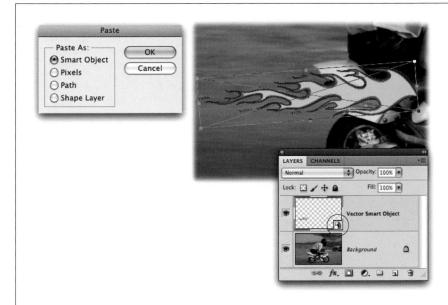

Figure 7-28:
When you paste a piece of vector art, Photoshop lets you decide how to paste it (left). If you choose Smart Object, the object appears in your document with helpful resizing handles, as shown here (right). It also carries the special Smart Object badge (circled) over in the Layers panel.

2. **Choose File→Place to import the illustration you want to use as the frame.**

 Selecting the photo layer first ensures that Photoshop puts the Smart Object layer at the top of your layers stack. Navigate to the EPS (Encapsulated PostScript) or AI (Adobe Illustrator) file on your hard drive and then click the Place button.

3. **Resize the illustration.**

 Conveniently, the illustration appears in your document with resizing handles around it, which you'll probably need to use to make it bigger or smaller. Grab a corner handle and drag until the frame is big enough to hold the photo. (To resize all four sides of the illustration at once, press and hold Shift-Option [Shift+Alt] as you drag a corner handle.) Click inside the bounding box to move it around. When it's just right, press Return (Enter).

4. **Load the illustration as a selection, as shown in Figure 7-29 (top).**

 In your Layers panel, ⌘-click (Ctrl+click) the Smart Object's layer thumbnail to load it as a selection (you'll see marching ants). Then turn off the Smart Object's visibility eye; you won't need that layer again unless you want to resize it later.

5. **Select the photo layer and add a mask.**

 Click the circle-within-a-square button at the bottom of the Layers panel to add a mask (make sure you're on the right layer first). Photoshop fills the mask with black around the shape of your selection to hide the edges of the photo. (As you'll remember from Chapter 3, when you're dealing with a layer mask, black conceals and white reveals.)

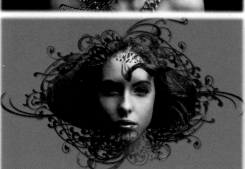

Figure 7-29:
This detailed illustration makes a gorgeous photo frame. After you place it as a Smart Object and resize it, just load it as a selection (top) and then add a mask to the photo layer (bottom).

6. **Use the Move tool to position the photo and frame on your page.**

 Press V to grab the Move tool and reposition the photo-and-frame layer. If you want to move the photo and mask independently, you've got to unlock them first: Click the tiny chain icon between the layer and mask thumbnails and then click the thumbnail of the bit you want to move (the photo or the mask). Use the Move tool to position the photo or mask and then click between them to lock them together again.

7. **Add a Fill layer to create a colorful background for your new frame.**

 At the bottom of your Layers panel, click the "Create new fill or adjustment layer" icon (the half-black/half-white circle) and choose Solid Color from the resulting pop-up menu. Once the Color Picker opens, mouse over to your image and click to grab a color from the photo (such as the copper color in the mermaid's hair). Then press OK to close the Color Picker.

8. **Save your document as a PSD file.**

 You're done! To resize the illustration, Ctrl-click (right-click on a PC) the mask thumbnail and choose Delete Layer Mask from the resulting shortcut menu. Then select the Smart Object layer and turn its visibility back on. Summon Free Transform by pressing ⌘-T (Ctrl+T) and use one of the corner handles to resize the illustration.

Press Return (Enter) when you're finished and follow steps 4–6 again to load the illustration as a selection and add a layer mask. To give the frame a little depth, you can tack on a drop shadow using layer styles (page 128) and use a Solid Color Fill layer for a new background (page 91).

Mapping One Image onto Another

You can combine two images in an impressive way by wrapping one around the contours of another so the first image follows every nook and cranny of the second. To perform this feat, you need to create a *displacement map*—a grayscale image that Photoshop uses to warp and bend one image to the curvature of another. Trying this technique on photos of friends and family is great fun. For example, you can take a circuit board and wrap it around a body or a face, as shown in Figure 7-30.

Figure 7-30:
With a displacement map, you can apply all kinds of wild textures to skin.

Know anyone who needs to be turned into a reptile? I'll bet you do!

Note: Want to follow along with this tutorial? Visit this book's Missing CD page at *www.missingmanuals. com/cds* and download the practice file *Map.zip*.

1. **Open the image you want to map another image *onto* (like a face) and hunt down the channel with the greatest contrast.**

 To make the best displacement map possible, you need to find the channel with the highest contrast. If you're in RGB mode (and you probably are), you can cycle through your channels by pressing ⌘-3, 4, and 5 (Ctrl+3, 4, and 5 on a PC). Because digital cameras have so many more green sensors than red or blue ones, you'll most likely pick the green channel.

2. **Duplicate that channel and send it to a new document.**

 Open your Channels panel (page 189) by clicking its icon in the panel dock or choosing Window→Channels. From the Channels panel's menu, choose Duplicate Channel. In the resulting dialog box, choose New from the Destination pop-up menu and name it something memorable like *Map*. When you click OK, Photoshop opens the displacement map document that contains the grayscale channel you picked in step 1.

3. **Blur the displacement map slightly.**

 With the map document active, choose Filter→Blur→Gaussian Blur. Enter a value of 1–4 pixels (for low-resolution images, enter 1; for high-resolution ones, enter 4) and then click OK. The goal here is to blur the image just a bit so the map is slightly smooth. (Page 445 has more on the Gaussian Blur filter.)

4. **Save the map and close the file.**

 Choose File→Save As and choose Photoshop from the Format pop-up menu at the bottom of the dialog box. Make sure the Alpha Channel option is turned on and then click Save. Close the file by pressing ⌘-W (Ctrl+W).

5. **Go back to the original document and turn the composite channel back on.**

 When you cycled through the different channels in step 1, Photoshop temporarily turned off the composite channel (the one that shows your image in full color). Go back to the original face document (the one you opened in step 1) and turn all the channels back on by pressing ⌘-2 (Ctrl+2 on a PC).

6. **Select the face.**

 In the image shown at the bottom of Figure 7-30, it's simple to select the face because it's on a solid background. Grab the Magic Wand by pressing W, click once in the white area, and then Shift-click to select the other white parts until you have everything *except* the face selected.

7. **Invert your selection by pressing ⌘-Shift-I (Ctrl+Shift+I on a PC) or choosing
 Select→Inverse.**

 Photoshop flip-flops your selection so the face is surrounded by marching ants.

8. **Feather the edges of your selection slightly.**

 Click the Options bar's Refine Edge button and feather your selection by 1 pixel.
 (See page 145 for more on feathering.)

9. **Save your selection by choosing Select→Save Selection.**

 Name it *Face* and then click OK. Get rid of the marching ants by pressing ⌘-D
 (Ctr+D) to deselect.

10. **Add the soon-to-be-a-map image to the face document.**

 Pop open the image you want to map onto the face (like the circuit board in Fig-
 ure 7-30, bottom), and either copy and paste the image into the face document
 or drag it from the Layers panel of one open document into the other.

11. **Choose Filter→Distort→Displace.**

 In the resulting Displace dialog box, leave the factory settings alone and click
 OK. If you're not sure if the settings have ever been tampered with, press and
 hold the Option key (Alt on a PC) to change the Cancel button so it reads *Reset*;
 click it and you're back to the original settings.

12. **In the resulting Open dialog box, navigate to the Map document you saved a
 few moments ago and then click OK.**

 If you peek at your document as you click OK, you'll see the circuit board shift
 to the contours of the face. It's extremely cool.

13. **Load the face selection.**

 Choose Select→Load Selection→Face. You should see marching ants around
 the shape of the face (you can't see the actual face because it's behind the circuit
 board).

14. **Add a layer mask by clicking the circle-within-a-square button at the bottom
 of the Layers panel.**

 Select the Brush tool by pressing B and, with black as your foreground color
 chip (page 24), paint over the guy's eyes and teeth to hide them, as shown in
 Figure 7-30 (bottom).

15. **Change the circuit board layer's blend mode to Multiply (page 292).**

 You should see the face through the circuit board. If the circuit board is too
 dark, lower the opacity setting at the top of the Layers panel.

Congratulations! You've just mapped one image to the contours of another, one of
the slickest Photoshop tricks ever.

Draining, Changing, and Adding Color

Whenyou want to make a big difference with one simple change to your photo, you can't beat converting it from color to black and white. The Ansel Adams approach doesn't just evoke nostalgia; it puts the focus back on the subject in a powerful way. Going grayscale also lets you salvage an image that you can't color-correct, or beautify a subject whose teeth need heavy-duty whitening or whose skin needs fixing. Those problems all but disappear when you enter the realm of black and white.

But does that mean you should set your digital camera to shoot in black and white? Heck, no! It's *much* better to photograph in color and then drain the color in Photoshop. That way, you have a truckload of artistic options like bringing back just a touch of the original color for a partial-color effect. And, speaking of color, Photoshop has several tools that let you change the color of anything, whether it's a car or the hair on your head. You can also breathe new life into vintage photographs by adding a dash of color.

This chapter teaches you how simple it is to drain, change, or add color to your photos in a variety of ways. You'll find the following pages packed with creative color techniques you'll use time and time again.

Draining Color

You've probably heard the saying, "You get what you pay for!" In Photoshop, that saying translates to, "The quickest method ain't always the best!" In other words, some techniques just take a little extra time, and converting a color image to black and white is one of 'em—but it's well worth the effort.

To drive that point home, open a colorful image—download *Dragon.jpg* from this book's Missing CD page (*www.missingmanuals.com/cds*) if you need a good sample—and then choose Image→Adjustments→Desaturate. (*Desaturating* means draining your image of all color.) Photoshop converts your image to black and white all right, but the results are less than inspiring (see Figure 8-1, top). You can also glance through your channels (page 189), select the one with the best contrast, and then choose Image→Mode→Grayscale. Photoshop keeps the currently active channel, tosses the rest, and you're left with a black-and-white image. But unless you're using an old, pre-CS version of Photoshop, neither method is much good. As you're about to find out, the program has come a long way when it comes to black-and-white conversions.

Figure 8-1:
Top: True, the Desaturate command provides a one-step approach to black-and-white conversions, but as you can see, this method produces a fairly lame dragon.

Bottom: A Black & White Adjustment layer let's you introduce all kinds of contrast, making it a much better option for black-and-white conversions and for producing a respectably menacing creature.

Black & White Adjustment Layers

Having made its debut back in Photoshop CS3, the Black & White Adjustment layer is hands down the easiest way to convert your color image into beautiful black and white. It couldn't be simpler to use, and, best of all, it's nondestructive. As Chapter 3 (page 77) explains, when you use Adjustment layers, Photoshop makes the changes on *another* layer—not on your original image—letting you tweak the opacity, toggle

the visibility on or off, and so on. Though you'll learn about other kinds of Adjustment layers throughout this book, this section focuses on Black & White Adjustment layers, which let you create really nice black-and-white images in no time flat.

To create a black-and-white image, follow these steps:

1. **Pop open your soon-to-be-colorless image.**

 Since you're using an Adjustment layer, you don't need to bother double-clicking the Background layer to make it editable because you won't be messing with the original image.

2. **Create a Black & White Adjustment layer (see Figure 8-2).**

 Open the Adjustments panel by choosing Window→Adjustments and then click the Black & White Adjustment layer icon (it's the half-black/half-white square circled in Figure 8-2). You can also click the half-black/half-white circle icon at the bottom of your Layers panel to open the "Create new fill or adjustment layer" menu, and then choose Black & White from there.

 Whichever method you use, Photoshop turns your image black and white and displays several sliders and controls in the Adjustments panel that you can use to fine-tune your creation (Figure 8-3).

Panel menu
Close panel

Switch panel to expanded view
Click to apply adjustment to current layer only

Figure 8-2:
The Adjustments panel gives you access to all the Adjustment layers and their presets (one-click, canned settings). Instead of having dialog boxes for various adjustments open up atop your image as in previous versions of Photoshop, you can make all your adjustments in this panel.

If you want the Adjustment layer to affect only the currently active layer—instead of all the layers underneath it—click the button at the panel's bottom right, labeled here.

If the Black & White Adjustment layer icon in the Adjustments panel (circled) or the "Create new fill or adjustment layer" icon at the bottom of the Layers panel is grayed out (unavailable), check your image's color mode by choosing Image→Mode (see page 46 for the scoop on color modes). Choose RGB from the resulting menu and you're good to go.

Figure 8-3:
Instead of adjusting a bunch of sliders, you can use the Targeted Adjustment tool, circled here (it used to be called "on-image") to tweak a certain range of colors by dragging on the image itself. Click this button at the top left of the Adjustments panel and then mouse over to your image (your cursor temporarily turns into an eyedropper, which lets you know you're about to sample a color). Next, position your cursor atop the area you want to adjust, click and hold your mouse button, and then drag to the left to make that area darker or to the right to make it lighter. Your cursor turns into a pointing hand with an arrow on each side (also circled) to indicate that you can drag from side to side to adjust that range of color. With this method, you can edit your image visually instead of playing the "Which slider do I tweak?" guessing game.

Return to adjustment layer list
Expanded panel view
Apply to all layers
Show/Hide adjustment

Delete adjustment
Reset adjustment
Show previous state

3. **Move the Adjustments panel's various color sliders until you have a nice, contrasty black-and-white image.**

Even though Photoshop has drained the color from your image, there's always room for improvement. Try dragging the various color sliders around to make things look even better. Dragging to the right turns areas that previously were the color of that particular slider a lighter shade of gray; dragging to the left turns them a darker shade of gray. Also, the pop-up menu at the top of the Adjustments panel has a slew of canned settings—just click each one to see what

it looks like applied to your image (unfortunately, you can't cycle through them with your arrow keys to get a preview). Some of the panel's other controls are shown in Figure 8-3, and the Tint checkbox is explained in the next section. If you click the Auto button, Photoshop shows you what it thinks your grayscale image should look like.

4. **Save your document as a PSD file (page 51).**

If you want to change the Black & White Adjustment layer's settings later and the Adjustment panel is closed, just double-click the Adjustment layer's thumbnail in your Layers panel (it's the familiar half-black/half-white circle icon). If the Adjustment panel is open, just click once to select the layer and you'll see the sliders reappear. If you print the image and then decide it needs more contrast, being able to edit the existing Adjustment layer is a real time-saver.

Warp-speed tinting

You've probably spotted the Tint checkbox lurking near the top of the Adjustments panel whenever you create a Black & White Adjustment layer. When you turn on this checkbox (circled in Figure 8-4), Photoshop adds a brown tint (called a *sepia tone*) to your whole image, as shown in Figure 8-4 (bottom right). If you want to use a different color, click the colored square to the right of the checkbox to summon the Color Picker (page 493). This technique produces what's known as a *fake duotone*; the real ones are explained on page 339.

Figure 8-4:
Left: After you add a Black & White Adjustment layer to an image, you can give it a sleek color overlay by turning on the Tint checkbox (circled).

Right: Draining the color from your image and/or adding a color tint dramatically changes the image's mood. Here you see the original, full-color image (top), a black-and-white version (middle), and a brown-tinted sepia version (bottom).

Note: Gradient Map Adjustment layers can also make beautiful black-and-white images. The tip on page 363 tells you how to get it done.

Channel Mixer Adjustment Layers

Black & White Adjustment layers are the quickest, easiest way to drain images of their color, but you can also use the Channel Mixer. There's no real advantage to using this method over, say, a Black & White or a Gradient Map Adjustment layer (page 363), but it's been around for years so some folks still rely on it.

First, make sure you've got the Background layer selected in your Layers panel (or the image layer you want to work with), click the half-black/half-white circle at the bottom of the Layers panel, and then choose Channel Mixer from the resulting menu. Once the Adjustments panel opens, turn on the Monochrome checkbox near the top of the panel, and then tweak the Red, Green, and Blue sliders to your liking, or pick one of the presets in the pop-up menu at the top of the panel (shown in Figure 8-5). If you want to darken or lighten your overall image, drag the Constant slider at the bottom of the panel to the left or right (why it's not simply called *Brightness* is anyone's guess).

Presets menu

Figure 8-5:
When you turn on the Monochrome checkbox, the Output Channel pop-up menu changes to Gray, letting you know you're mixing channels to produce a grayscale image.

As you adjust the sliders, keep an eye on the Total percentage near the bottom of the panel (circled). If you keep it around 100 percent, you'll produce a grayscale version of your image with the same brightness as the original. If you go over or under 100 percent, a tiny gray warning triangle lets you know you're headed into the dreaded over- or underexposure zone. In that case, take a peek at your document to see if the image still looks good.

The Lightness Channel

As you learned back on page 47, Lab mode gets its name from its three channels. The "L" stands for the Lightness channel where Photoshop stores all the light values and therefore the visible contours and details of your image. (The "a" and "b" stand for the a and b channels, which store the color info.) This means the Lightness channel makes for a lovely black-and-white version of your image (see Figure 8-6). To see what your Lightness channel looks like, open your image and choose Image→Mode→Lab Color. Over in the Channels panel (page 189), select the Lightness channel, tilt your head contemplatively, and see what you think. If you like the image, choose Image→Mode→Grayscale, and then click Discard when Photoshop asks if it's okay to toss your color information.

Note: If you need to darken or lighten your new grayscale image, you can use the Screen and Multiply blend mode tricks mentioned back on page 119 or any of the adjustments explained in Chapter 9.

Figure 8-6:
Because the Lightness channel holds all your image's details with none of the color, it makes a nice black-and-white version of your image all by itself.

Going Grayscale in Camera Raw

If you're shooting photos in Raw format, you may as well use the Camera Raw plug-in (page 58) to convert images to grayscale. It's easy to use and it does a nice job with the conversion, to boot. To open a Raw image, just double-click its file icon and it opens in Camera Raw automatically. If you're using Adobe Bridge (Appendix C, online) to peruse your images, double-click the image's thumbnail or Ctrl-click (right-click on a PC) it and then choose "Open in Camera Raw" from the resulting shortcut menu.

Tip: You can also open JPEGs and TIFFs in Camera Raw: Choose File→Open (Open As on a PC) and navigate to the file on your hard drive. In the Format pop-up menu at the bottom of the Open dialog box (Open As pop-up), choose Camera Raw and then click Open. (See Chapter 9 for more on editing images in Camera Raw.)

Once you've opened your image in Camera Raw, follow these steps to convert it to a gorgeous grayscale image:

1. **In the Camera Raw window, open the HSL/Grayscale panel.**

 To open the panel, click the button circled in Figure 8-7, top, and then turn on the panel's "Convert to Grayscale" checkbox. A set of color sliders appears on the right side of the Camera Raw window. To introduce more contrast into your image, you can lighten a specific color by dragging its slider to the right, or darken it by dragging its slider to the left.

UP TO SPEED

Preparing Grayscale Images for a Printing Press

If your color image is part of a document headed for a professional printing press and you've been assigned the task of transforming it into a grayscale image, you need to take one additional step: To make it a real, live grayscale image, you have to change the document's color mode to Grayscale. (If the image is headed for an inkjet printer or destined for posting on the Web, you can stop reading this box now and skip to something more interesting.)

That's right: Even though your image *looks* grayscale onscreen, it's still made from colors that have had their saturation values lowered to zero (saturation is the degree of color strength; see page 488). If you're shaking your head in disbelief, open your Channels panel by choosing Window→Channels and you'll find color channels peering back at you (what those channels are depends on which color mode you're working in).

If you don't change the mode to Grayscale before you send the image off to a printing press, your image will print with the colors found in your Channels panel instead of with black ink alone. While the result still *looks* like a grayscale image, it's actually made from color, which costs a lot more to print (the more colors you use on press, the higher the cost).

To prepare a grayscale image for a printing press, start by using one of the methods in this chapter to get rid of the color. Otherwise, Photoshop does it for you—with mediocre results like those you'd get using the Desaturate command discussed on page 324. Next, save your document as a PSD file by choosing File→Save As to preserve any Adjustment layers (like a Black & White Adjustment layer) you may have made when you created your grayscale image. Now you're ready to change the document mode to Grayscale by choosing Image→Mode→Grayscale.

Photoshop pops open a dialog box to let you know your document has other layers and asks what you'd like to do about them. To make Photoshop use the grayscale version of your image that you've created, click Flatten. (Clicking anything else causes Photoshop to convert the image to grayscale for you whether you like it or not.) In the next dialog box, click Discard to throw away all the color info in your document. You're left with a grayscale document that contains a single channel named Gray.

To save the image for use in a page-layout program like InDesign, choose File→Save As and then, from the Format pop-up menu near the bottom of the Save As dialog box, choose TIFF or PSD (see page 670 in Chapter 16 for more on when to use which file format). Then close the document by pressing ⌘-W (Ctrl+W on a PC).

2. **Open the Basic panel and adjust the Exposure slider to fine-tune your grayscale image.**

 To get back to the Basic panel that greeted you when you first opened Camera Raw, click the button that's circled in Figure 8-7, bottom (it looks like a camera lens iris). To brighten your image, drag the Exposure slider slightly to the right until you see just a few red areas in your image. (If you don't see any red, turn on the highlight clipping warning by clicking the triangle labeled in Figure 8-7, bottom.) The red is Camera Raw's way of telling you that you're *clipping* or *blowing out* an image, which means you're losing details in your image's highlights.

3. **Drag the Recovery slider to the right to bring back details in the highlights.**

 You can use this slider to get back some of the highlight details that disappeared when you increased the exposure. Just drag the slider to the right until all (or most) of the red goes away.

4. **Drag the Blacks slider a tiny bit to the right to make the shadows in your image a little darker.**

 If you see blue areas appear on your image, don't worry—it's just a warning that you're losing details in the shadows. (If you don't see any blue, click the shadow clipping triangle labeled in Figure 8-7, bottom.) Losing a few details in your shadows isn't as critical as losing details in the highlights because, hey, shadows are mostly black, anyway. If your shadows *do* contain important details, you can skip adjusting this slider. Only one more slider adjustment to go!

5. **Drag the Clarity slider to the right to boost contrast.**

 By performing some serious behind-the-scenes voodoo, this slider increases the contrast in the midtones (grays) in your image, giving it extra oomph. Most images look better if you increase the Clarity setting to at least 30.

6. **When you're finished, click Done to close the Camera Raw window or click Open Image to proceed on to Photoshop.**

You've now got yourself a lovely grayscale version of your image with loads of detail. At this point, feel free to skip ahead to Chapter 11 to learn all about sharpening.

Partial Color Effect

One of most creative ways to accentuate part of an image is to colorize that area and make everything else black and white. You can do that easily by using a Black & White, Channel Mixer, or Gradient Map Adjustment layer (see pages 324, 328, and 363, respectively) to convert your image to black and white and then use a layer mask (page 113) to hide the conversion from the parts you want to remain in color. This technique is a wonderfully nondestructive way to add creativity to your image.

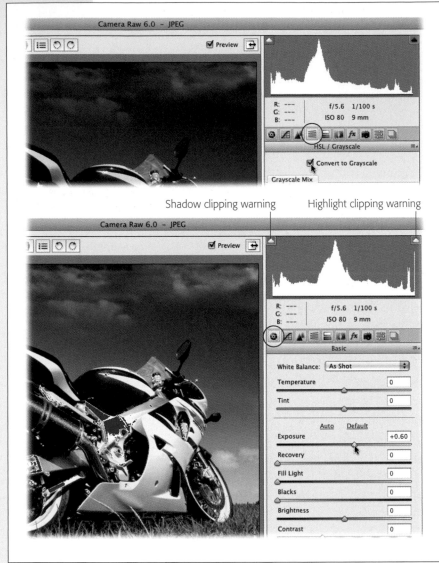

Figure 8-7:
Top: In the Camera Raw window, click the HSL/Grayscale button (circled) to see the "Convert to Grayscale" option.

Bottom: Back in the Basic panel (click the circled button to get to it), Camera Raw warns you if your exposure adjustments are clipping your image's highlights by marking those areas in red. The term "clipping" refers to light pixels that have been forced to pure white, and/or dark pixels that have been forced to pure black, thus stripping them of all detail. You can use the Recovery slider to bring detail back to your highlights, but there's no such fixer-upper for shadows.

As luck would have it, *all* Adjustment layers come with a mask; the mask (which starts out empty) automatically appears in your Layers panel to the right of the Adjustment layer's thumbnail, as you can see in Figure 8-8, right. So just pick whichever conversion method you like best to make your image black and white and then follow these steps:

1. **In the Layers panel, click the Adjustment layer's mask thumbnail.**

 Photoshop puts a tiny black outline around the mask thumbnail (circled in Figure 8-8) as soon as you click it to let you know it's active.

Tip: If the thumbnails in your Layers panel are *really* small, you may not see the black outline around the mask thumbnail. Thankfully, you can make the thumbnails bigger by choosing Panel Options from the Layers panel's menu. Select the biggest thumbnail size and then click OK. *Now* you should be able to see the thumbnail without squinting.

Figure 8-8:
All Adjustment layers come with a layer mask that lets you hide the adjustment from certain parts of your image. By painting with black to mask certain areas from the Black & White Adjustment layer, you can hide the adjustment and bring back the color (the brush cursor is circled here on the left). Just make sure you've got the mask selected before you start painting or you'll add a nice coat of black paint to your original image.

2. **Press B to grab the Brush tool and set your foreground color chip to black; then hide part of the Adjustment layer by painting atop your image.**

 Remember the layer mask rhyme "black conceals and white reveals?" When you're about to work with a mask, take a moment to think about what you want to do: To *hide* parts of the Adjustment layer, you need to paint with black, so find the color chips at the bottom of your Tools panel and press X until black pops on top. Press B to grab the Brush tool, and then mouse over to your image and paint. When you start painting, the original color of your image shows through the layer mask, as shown in Figure 8-8. If you reveal too much of the color, don't panic; just swap color chips by pressing X so that white is on top and then repaint that area to reveal the adjustment. (When you're working with masks, it's helpful to keep a finger poised over the X key.)

Tip: To make sure you're painting only what you want to colorize, you can zoom in on your image by pressing ⌘-+ (Ctrl-+ on a PC). To zoom out again, press ⌘ (Ctrl) and the minus key [–]. When you're zoomed in, you can toss your image from side to side with the Hand tool (page 64)—very helpful if you need to view a different portion of your image. To grab the Hand tool, just press the space bar and drag, or choose the Hand tool from the bottom of your Tools panel. (For more tips on viewing your images at close range, see page 60.)

3. **When you're finished painting the mask, save your document as a PSD file.**

 Saving your document as a PSD file makes Photoshop keep all your layers; that way you can go back and edit the mask later if the mood strikes.

To see a quick before-and-after preview of your image, mouse over to the Layers panel and turn off the Adjustment layer's visibility eye.

Fading Color to Black and White

You can use a technique similar to the one in the previous section to create a soft fade from full color to black and white (Figure 8-9). After you've made your image black and white using one of the methods described earlier, follow these steps:

1. **Over in the Layers panel, select the Adjustment layer's mask thumbnail (circled back in Figure 8-8, right).**

2. **Press G to fire up the Gradient tool and, in the Options bar, choose the black-to-white linear gradient.**

 In the Options bar, you can open the Gradient Preset picker by clicking the down arrow next to the large gradient preview (circled in Figure 8-9), and then click the "Black, White" gradient thumbnail (also shown in Figure 8-9, top left) to choose a black-to-white gradient. If you've got Photoshop's Show Tool Tips preference turned on (page 15), you can hover over each gradient preview to see its name. (If your foreground and background color chips are set to black and white, you can also choose the "Foreground to Background" gradient, which appears first in the preview list.) To the right of the Gradient Preset picker, find the first gradient style (Linear Gradient) and make sure it's turned on (it should be selected unless you've changed gradient styles recently). You can hover your cursor over each gradient style button to see its name.

Note: Want to follow along? Visit this book's Missing CD page at *www.missingmanuals.com/cds* and download the practice file *Facepaint.jpg*.

3. **Mouse over to your document and click where you want the color to start fading out and then drag in any direction for an inch or two.**

 The beauty of using a mask for this technique is that if you're unhappy with your first gradient dragging attempt, you can have another go at it…and another, and another until you get it right—Photoshop graciously keeps updating the mask. Try dragging from corner to corner or top to bottom and see what you get—depending on your image, one gradient angle may look better than another. For this particular image, a horizontal gradient works just fine.

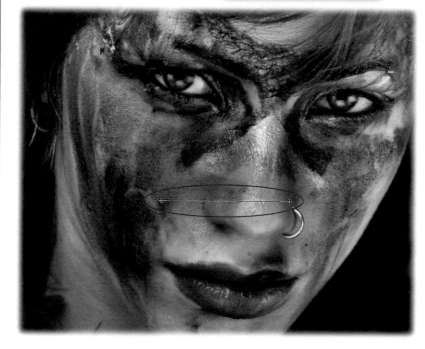

4. When you're finished, save your document as a PSD file and marvel at your handiwork.

Tip: If you start editing a mask and then decide you want to clear it out and start over, just press ⌘-A (Ctrl+A on a PC) to select everything you've done so far and then press Delete (Backspace). Photoshop empties your mask so you can try again.

High-Contrast Black and White

The highest contrast black-and-white images are *just* black and white, with no shades of gray, like the one in Figure 8-10 (right). It's a striking yet versatile effect that gives your image a very edgy look. In Photoshop, you can create this effect with a Threshold Adjustment layer, which lets you specify a brightness threshold in which all the lighter-colored pixels become pure white while the darker pixels become pure black. Put more simply, Photoshop turns your shadows black and your highlights white.

Note: To practice the following technique at home, download the image *Girl.jpg* from this book's Missing CD page at *www.missingmanuals.com/cds*.

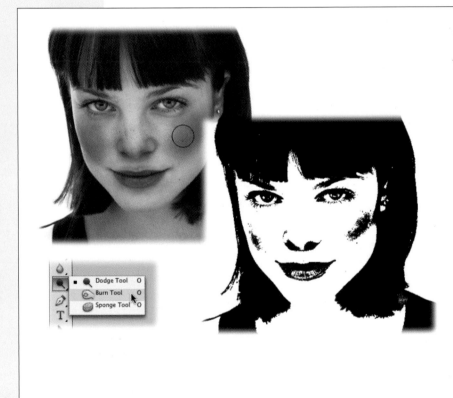

Figure 8-10:

Left: Threshold Adjustment layers make shadows pure black and highlights pure white. If you want to use one on an image of a face that doesn't have many shadows around the cheeks, nose, or lips, you'll end up with a solid white face that's pretty creepy. The fix is to grab the Burn tool (page 376) and do some darkening on the image layer either before or after you add the Threshold Adjustment layer (it's easier to do it afterward because you can see what you're doing). If you darken too much, you can always switch to the Dodge tool (page 376) to lighten that area back up.

Right: You can't get any contrastier than this, baby! As you can see, the effect is eye-catching and unique.

Tip: If you've ever wanted to create Andy Warhol–style pop art portraits, applying a Threshold Adjustment layer to your image is the first half of the technique. You'll learn the second half later in this chapter on page 360.

Before you get started, it's worth noting that this technique works better if your subject is on a solid white or other light-colored background. If it is, the background disappears when you make the adjustment. If the background is dark, you may have to clean it up later with the Brush tool set to paint with white.

Here's how to use a Threshold Adjustment layer to make a pure black-and-white image:

1. **Pop open a photo and duplicate its Background layer by pressing ⌘-J (Ctrl+J on a PC).**

 If your image is lacking in the shadow department, you might want to do a little darkening with the Burn tool; if not, you can skip this step. And if you like, you can turn off the original layer's visibility.

2. **Create a Threshold Adjustment layer.**

 Click either the Threshold icon (it looks like a rectangle with a couple of diagonal black stripes across it) in the Adjustments panel, or the half-black/half-white circle at the bottom of the Layers panel and then choose Threshold. Either way, Photoshop displays a histogram (page 390) with a single slider in the Adjustments panel. Drag the slider to the right to increase the amount of shadows in your image (making it more black), or to the left to increase highlights (making it more white). Your goal is to achieve a nice level of detail in the image, while maintaining the ability to make out what it used to be.

Tip: If you have trouble remembering what all the icons in the Adjustments panel are for, just hover above each one to make Photoshop display its name at the top of the panel.

3. **If necessary, press O to grab the Burn tool, select the image layer, and then touch up your image.**

 The lady in Figure 8-10 has pale skin, so you need to darken her lips, nose, and cheeks with the Burn tool (page 376) to make sure her features don't completely disappear. If parts of the image become too dark, switch to the Dodge tool (page 376) and lighten them. You're basically finished at this point, but with a couple more steps you can put your high-contrast face on a bright red background for a Che Guevara look, as shown in Figure 8-11.

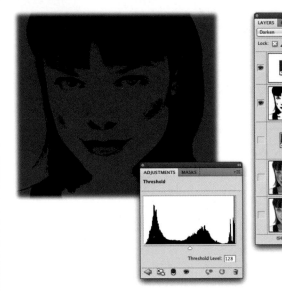

Figure 8-11:
By adding a layer of solid color, you can create another popular look.

4. **Merge (page 111) the face layer and the Adjustment layer onto a *new* layer.**

 In the Layers panel, Shift-click to select both layers. Next, open the Layers panel's menu (page 471), and then press and hold the Option key (Alt on a PC) while you click the Merge Layers menu item. When you hold down this modifier key, Photoshop adds a *new* layer to the top of your Layers panel that contains a merged version of the face and threshold layers. (If you don't see a new layer, press ⌘-Z [Ctrl+Z on a PC] and have another go at it. Make sure to press Option [Alt] *before* you open the Layers panel's menu and choose Merge Layers.)

5. **Select the new layer and soften it slightly with a Gaussian Blur filter.**

 The high-contrast version of the image is a little too sharp (too many hard edges), but you can easily soften it up with a blur filter. In the Layers panel, select the merged layer and then choose Filter→Blur→Gaussian Blur (page 445 explains this filter). Enter a pixel value of .5–1.5 depending on the pixel dimensions of your image (use a lower number for smaller images and a higher number for bigger images) and then click OK.

6. **Create a new layer for the red background.**

 Click the "Create new fill or adjustment layer" button at the bottom of your Layers panel and choose Solid Color. Photoshop opens the Color Picker (page 493), where you can pick a nice, bright red. Click OK to close the Color Picker and Photoshop adds the new layer to the top of your layer stack. (If the new layer appears lower in your Layers panel, just drag it to the top.) If you decide to change the color of the Fill layer later on, just double-click the Solid Color layer's thumbnail to summon the Color Picker.

7. **Change the red layer's blend mode to Darken.**

 With the red layer active, use the pop-up menu at the top of your Layers panel to change its blend mode to Darken. As you learned on page 292, blend modes in the darken category tell Photoshop to look at the colors on the active layer and the layers below it and keep the darkest colors. In this case, those colors are black and red, so you end up with the black face on a red background. Pretty neat, huh?

8. **Save your document as a PSD file and rejoice at your creativity.**

 Choose File→Save As and in the resulting dialog box, pick Photoshop from the Format pop-up menu.

The High-Key Effect

Another nifty black-and-white effect is known as *high key*. In the real world, you can create a high-key effect by aiming *tons* of lights at your subject (or, in this case, victim) and shooting a picture. This gives you a high-contrast image (though not quite as high-contrast as the technique explained in the previous section) where the shadows are shades of gray and everything else is almost pure white. Mosey back to page 195 for the scoop.

Delicious Duotones

There are a couple of big reasons you may be interested in learning to create duotones like those showcased in this section: to save on professional printing costs and to create some *seriously* high-end looking black-and-white prints like the ones on display in Figure 8-12. (Hint: Most black-and-white images displayed in galleries actually contain a bit of color!) To understand what's going on, you first need a quick primer on duotones (they're covered in more detail in Chapter 16) and a *brief* excursion back into some of the color mode nitty-gritty you learned in Chapter 5.

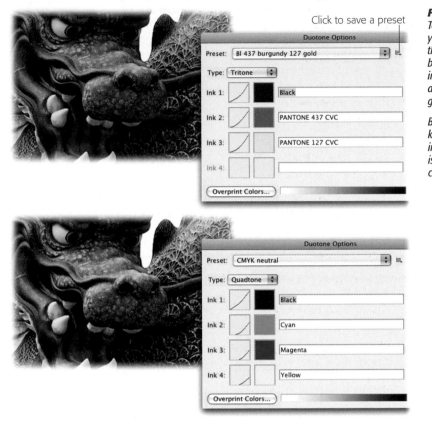

Figure 8-12:
Top: At first glance, you might mistake this image for a black-and-white only image, but it's actually made from black, gray, and yellow.

Bottom: You wouldn't know it just by looking, but this image is comprised of four colors.

Duotone refers to an image that's made from two colors (black is usually one of them). Photoshop's Duotone mode lets you add special colors to genuine grayscale images. (See the box on page 330 for the story on what qualifies as true grayscale.) If you add one color to a true grayscale image, you get a duotone. If you add another color, you get a *tritone* (grayscale plus two colors), and if you add one more you get a *quadtone* (grayscale plus three colors). For the purposes of this discussion and as far as Photoshop is concerned, duotones include tritones and quadtones (as confusing as that may sound).

As you learned back in Chapter 5, printing presses use CMYK ink that prints on four separate plates, which correspond to the four channels in CMYK mode. A duotone or tritone has fewer channels, so it prints on fewer plates—grayscale plus one or two special inks (for duotone and tritone, respectively)—and *that* reduces your printing costs. So if your document is headed for a printing press, making a duotone is an affordable way to produce a striking, one-of-a-kind image. (See page 697 for the scoop on preparing duotone images for print.)

Another reason to love duotones is that, because they're used so much in professional printing, Adobe has spent beaucoup bucks concocting color combinations that produce some of the most amazing images you've ever seen—and you can access these color combos only in Duotone mode. In fact, most (if not all) award-winning black-and-white photos hanging in galleries aren't black and whites at all—they're duo-, tri-, and quadtones with subtle color tints that give them extra depth and richness (see Figure 8-12).

Even if your image *isn't* headed for a professional printer, you want to get your paws on Photoshop's built-in color combos. You can get at them by popping into and then back out of Duotone mode. Here's how:

1. **Convert your image to black and white using one of the methods described in this chapter and then save your document as a PSD file.**

 It doesn't matter which method you use; just don't let Photoshop do the conversion for you because you'll end up with a drab grayscale image like the one you saw back on page 324.

2. **Change your image's mode to Grayscale and let Photoshop flatten the file.**

 Choose Image→Mode→Grayscale and, when Photoshop asks if you want to flatten or preserve your layers, take a deep breath and click Flatten. Then, when it asks if you want to discard your color information, steel yourself and click Discard.

3. **Trot back up to the menu bar and choose Image→Mode→Duotone.**

 Now you're ready to pick out one of those built-in duotone color combos, though you need to pop into Duotone mode to get to them.

4. **At the top of the resulting Duotone Options dialog box, choose the color combination you want.**

 Photoshop has *hundreds* of duo-, tri-, and quadtones in the Preset menu. (You could spend a whole evening looking through all the options.) When you choose one of these settings, Photoshop flips the dialog box's Type pop-up menu to the appropriate option. If you'd rather have a go at mixing colors yourself, choose Duotone, Tritone, or Quadtone from the Type menu and then click the little color wells below the menu to pick your inks (remember, Duotone mode thinks you're sending your files to a professional printing press that uses ink).

 If you want to save the combination you create, click the button to the right of the Preset menu (see Figure 8-12, top) and give your combo a name to make Photoshop add it to the Preset menu. Click OK when you're finished to close the Duotone Options dialog box. (Page 698 has more on creating custom duotone combos and the printing concerns that go along with them.)

5. **Go back to the color mode from whence you came by choosing Image→ Mode→RGB.**

 Because Duotone mode is a special document mode for printing (it's not meant for editing), you don't want to hang around there. When you go back to RGB mode, you won't notice anything different—except the awesome new color of your image.

That's it! You've just snatched your first color combo from Duotone mode. It's like bank-robbing for Photoshop jockeys.

Changing Color

Photoshop is the ultimate recolorizing tool because it gives you the power to put a fresh coat of paint on *anything*. You can repaint your car, change the color of your cabinets, and even recolor your hair. You can also create cartoonish pop art (page 353) or reverse the color in your image (page 356). The next few pages describe all that and more.

Hue/Saturation Adjustment Layers

If you're experimenting with color, start by creating a Hue/Saturation Adjustment layer, which offers you a friendly set of sliders that lets you change either the overall color of your image or a specific range of colors (see page 345). Because you're working with an Adjustment layer, any color changes take place on a separate layer, leaving your original image unharmed. And since a layer mask automatically tags along with the Adjustment layer, you can use it to hide the color change from certain parts of your image.

If you select an object or specific area of your image before creating a Hue/Saturation Adjustment layer, you can change the color in just that one spot. Here's how:

1. **Open an image and create a selection using one of the techniques discussed in Chapter 4.**

 For example, if you want to change the color of your car, you could use the Quick Selection tool to select just the car. Once it's surrounded by marching ants, you're ready for the next step.

2. **Create a Hue/Saturation Adjustment layer.**

 To do so, open the Adjustments panel and click the Hue/Saturation icon, which looks like three rectangles stacked on top of each other. Photoshop fills your Adjustments panel with the three sliders shown in Figure 8-13, top.

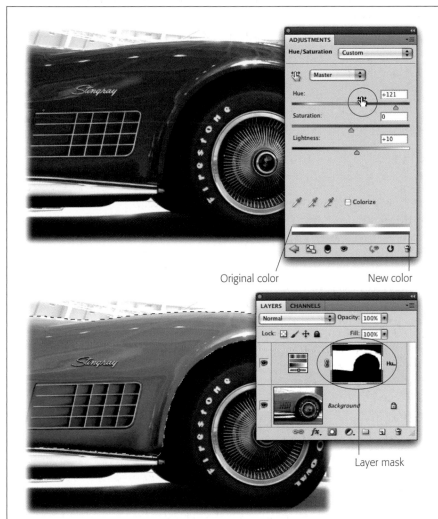

Original color New color

Layer mask

Figure 8-13:
Top: To change the colors in your image, grab the triangle-shaped Hue slider and drag it in either direction. If you hover your cursor above the rainbow-colored Hue slider, it turns into a scrubby cursor (circled), which you can drag to the left or right. The scrubby cursor does the same thing as the triangular sliders, but it's a bit easier to control.

Bottom: If you select an object (like the car body shown here) before you add a Hue/Saturation Adjustment layer, Photoshop automatically fills the mask (circled) with your selection, limiting the color change to that area.

3. **To change the color of your selection—like the car shown in Figure 8-13— drag the Hue slider to the left or right.**

 Hue is really a graphic geek's way of saying "color" (though technically it refers to specific tints or shades of color, such as dark red, pale blue, and so on). If you know exactly which color you want the car to be (say, purple) you can drag the triangular slider until it reaches purple on the rainbow-colored slider beneath the word "Hue". As you drag the slider, the selected area's color changes. If you watch closely, you can see one of the rainbow-colored bars at the bottom of the

Adjustments panel change, too. The top rainbow bar shows you the color in your original image and the bottom one shows you what you're changing that color *to*. (In Figure 8-13, you can see the turquoise of the original Corvette at the far left of the top bar and the purple it's been changed to at the far right of the bar below it.) It's helpful to think of these rainbow-colored bars as flattened-out color wheels; flip ahead to page 487 in Chapter 12 to see a real live color wheel.

Note: This color-changing trick works only on colored areas; anything that's black, white, or gray remains unchanged.

4. **To adjust the color's intensity, drag the Saturation slider to the left or right.**

 To decrease the intensity, drag this slider to the left (if you drag it all the way to the left, you'll completely desaturate the image, making it grayscale). To increase the intensity, drag it to the right (if you drag it too far to the right, your colors become so vivid you'll need sunglasses, and skin tones become an otherworldly hot pink). To get an idea of what this adjustment does, look closely at the color slider beneath the word "Saturation" in Figure 8-13, top, which ranges from gray on the left to a vivid red on the right.

5. **To adjust the color's brightness, drag the Lightness slider.**

 Lightness is what civilians call "brightness;" think of it as the amount of light shining on your colored object. Drag this slider to the left to darken the color or to the right to lighten it.

6. **When you're finished, save your image as a PSD file.**

 Back in your Layers panel, notice how Photoshop filled in the Adjustment layer mask based on the area you selected before it added the Adjustment layer (Figure 8-13, bottom). If you don't make a selection before you create the Adjustment layer, the mask stays empty—meaning the color change affects your whole image.

 If you save your document as a PSD file, you can go back and edit your color changes anytime by double-clicking the Hue/Saturation Adjustment layer's thumbnail in the Layers panel. This is extremely handy if you're recoloring an object for a nitpicky client (even if that client is you!).

There are a few other settings lurking in the Adjustments panel for Hue/Saturation Adjustment layers:

- **Targeted Adjustment tool.** This tool lets you choose a range of colors to adjust and then change the saturation of those colors by clicking directly on your image instead of using the sliders. In the top left of the Adjustments panel, give the tool a click (it looks like a pointing hand with a double-headed arrow) and then mouse over to your image (your cursor turns into an eyedropper). Click the color in your image that you want to change to make Photoshop select the appropriate color channel for you from the Edit pop-up menu (described later in

this list). Then drag to the left to decrease the saturation, making the color less intense, or to the right to increase the saturation, making the color more vivid.

- **Preset menu.** This pop-up menu (which lives at the top of the panel) lets you choose from a few canned settings called presets. Once you start tweaking the sliders, the menu changes to read "Custom" as shown in Figure 8-13, top.

- **Edit pop-up menu.** This menu, which doesn't have a label, lets you choose the color channels you want to adjust. When you first use Photoshop, it's set to Master, which means you're changing the composite channel and affecting all the colors in your image. If you want to target a specific color channel, pick it from this menu so any changes you make affect *only* the colors in that channel. For example, say you've got an image with too much red in it (a common problem in photos of people). You can choose the red channel from this menu and then drag the Saturation slider to the left to desaturate just the reds without affecting the other colors (a great way to zap color casts that you can't get rid of any other way!). If you don't know which color channel to pick, use the Targeted Adjustment tool described earlier in this list to click a color in your image and let Photoshop pick the channel for you. Once you've selected the color, you can use the sliders like you normally would.

- **Eyedroppers.** The eyedroppers toward the bottom of the panel also let you pick the colors in your image that you want to change. You'll see these guys in action in the next section.

- **Colorize checkbox.** This checkbox lets you use the Hue slider to add color to an image that doesn't have any, like a black-and-white photo. If you're working with an image that does have color, you'll add a color tint much like the kind you can make with a Black & White Adjustment layer (page 324).

Targeting a specific range of colors

When you add a Hue/Saturation Adjustment layer, Photoshop assumes you want to change all the colors in your image, which is why the Edit pop-up menu just mentioned is set to Master. If you want Photoshop to change just the reds, yellows, greens, or whatever, choose them from the Edit pop-up menu first. To narrow your focus even *more*, you can use the Targeted Adjustment tool button along with the eyedroppers near the bottom of the Adjustments panel to target very specific *ranges* of color for your adjustments.

Let's say you're thinking about changing your hair color. If it's fairly light, you can do your experimenting in Photoshop rather than on your head. Follow these steps to take a trip to the virtual salon:

1. **Open your image and leave the Background layer locked.**

 If you're experimenting on an image that you've worked with before, this layer may be named something besides Background.

2. **Add a Hue/Saturation Adjustment layer as described in the previous section.**

3. **Use the Targeted Adjustment tool to choose the range of colors you want to adjust.**

 Click the Targeted Adjustment tool (the hand with the two arrows poking out of it), mouse over to your image, and then click the colors you want to change (for example, click the hair). Photoshop picks the predominant color channel in the Edit pop-up menu (in Figure 8-14, top, this menu is set to Reds).

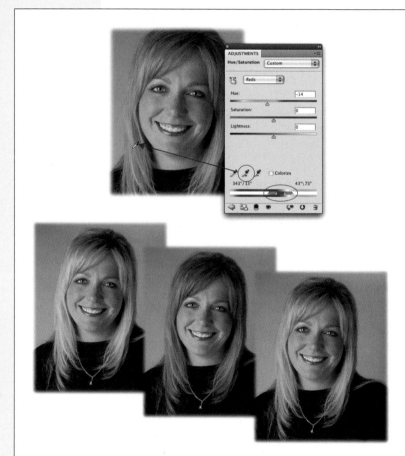

Figure 8-14:
Top: Instead of changing all the colors in your image, you can use the Targeted Adjustment and Eyedropper tools to target a certain color range instead. When you click the Targeted Adjustment tool, the Edit pop-up menu near the top of the Adjustments panel changes to reflect the color channel (page 189) of the part of the image you clicked (in this case, Red), and the color range is indicated by the gray bar toward the bottom of the panel (circled here).

Bottom: If you duplicate the Adjustment layer using one of the methods described on page 87, you can experiment with all kinds of hair colors before you head to the salon.

4. **Edit the range of colors using the eyedroppers.**

 Once you click a color in the previous step, Photoshop marks that color range with a small gray bar that appears in the white area between the two rainbow-colored bars at the bottom of the Adjustments panel (circled in Figure 8-14, top). To edit that range, use the + and – eyedroppers near the bottom of the panel to add or subtract colors from the targeted range. To expand the range

to catch all the hair colors, grab the eyedropper with a + sign, mouse over to your image, and click another part of the hair (you'll see the gray bar get a little wider). To narrow the range of hair colors, use the eyedropper with a – sign to subtract the colors you don't want.

As usual, Photoshop gives you several ways to do the same thing; you can also edit the color range by dragging the tiny sliders on the tiny gray bar, which, you may have noticed—if your eyesight is really good!—is two different shades of gray. The dark gray part in the middle represents the hues that change completely once you make a change (to see those hues, just look at the rainbow-colored bars directly above and below the gray one). The lighter gray parts on either end of the gray bar represent hues that *partially* change. If you want to narrow the range of colors, drag the little half triangles on the end inward toward the middle of the gray bar. To widen the range, drag them outward.

Tip: If the gray bar representing your targeted color range gets split across the left and right ends of the rainbow bars, press ⌘ (Ctrl on a PC) and drag the pieces to the left or right until the range indicator is one solid bar again.

5. **Recolor your hair by tweaking the Hue, Saturation, and Lightness sliders as discussed in the previous section.**

 Photoshop reflects your changes in real time, so you can watch as your hair changes from green to blue to magenta. Good times!

6. **If necessary, use the Adjustment layer's mask to hide the color change from other parts of your image.**

 When you start moving the Hue, Saturation, and Lightness sliders, you may notice that your hair isn't the *only* thing that changes color. If your skin color is similar to your hair color, parts of your skin may change, too. In that case, you can use the Adjustment layer's mask to keep your skin from getting a makeover. Just select the mask thumbnail in your Layers panel, press B to grab the Brush tool, and set your foreground color chip to black (press X if you need to flip-flop color chips). Then mouse over to your image and paint the parts of your skin that resemble your hair to hide them from the adjustment. If you hide too much, flip-flop your color chips by pressing X and paint that area white. To create the images shown in Figure 8-14, bottom, black paint was added to the mask to hide the color change from your author's face.

Tip: If you want to go back and edit your Hue/Saturation Adjustment layer later—and you've saved the image as a PSD document—you have to remember to change the Adjustment panel's Edit pop-up menu first. While Photoshop remembers all the changes you made with the sliders, it can't remember which color channel you used, so it resets the menu to Master every time you double-click the Hue/Saturation Adjustment layer in your Layers panel. Bummer.

Hue Blend Mode

Another easy way to repaint an object is to put the paint on a separate layer and change the paint layer's blend mode to Hue. As you learned in Chapter 7, blend modes control how color on one layer interacts with color on another. (Page 301 explains how the Hue blend mode works.)

To give this method a spin, open an image and create a new layer using one of the techniques listed on page 81. Then, in the pop-up menu at the top of the Layers panel, change the new layer's blend mode to Hue (it's at the bottom of the list). Next, press B to grab the Brush tool, click the foreground color chip, and then pick a color from the resulting Color Picker and click OK. Then, with the new layer selected, start painting over the object as shown in Figure 8-15.

If you end up changing too much color, you can temporarily switch to the Eraser tool by pressing and holding the E key on your keyboard (the tool's keyboard shortcut). Or you can prevent the problem by adding a layer mask (page 113) to the paint layer and then hiding the areas you want to leave unchanged with black paint.

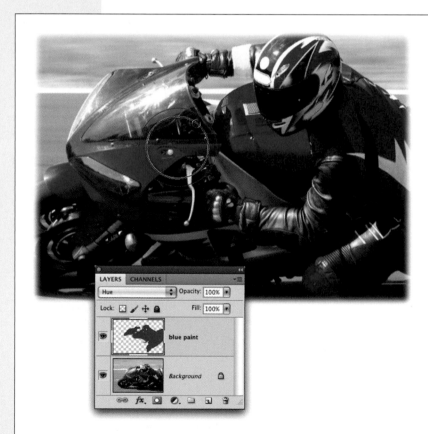

Figure 8-15:
The goal here is to repaint this red motorcycle blue. If the area you want to repaint has a lot of black, white, and gray around it (like this bike), you can paint right over those areas and they won't change a bit (note the brush cursor circled here). That's because, in Hue blend mode, the new paint affects only areas that previously contained color.

Replacing Color

Remember the Color Range command you learned about in Chapter 4 (page 154)? You can use a similar command—Replace Color—to select one color and replace it with another. This command works really well if the color you want to change is fairly consistent and concentrated in one area, like the car body in Figure 8-16. It's also a little easier to choose a paint color from the friendly Color Picker than to mix the color yourself using a bunch of sliders.

When you choose Image→Adjustments→Replace Color, you see the Replace Color dialog box shown in Figure 8-16. The Eyedropper tool is already active, so just click in your image to tell Photoshop what color you want to change, and then that color appears in the Color square in the Selection area toward the top right of the dialog box. In the Replacement area toward the bottom of the dialog box, click the color square above the word "Result" to choose a new color from the Color Picker. When you click OK, the new color appears in the square. If you need to make further adjustments to the color, you can use the Hue, Saturation, and Lightness sliders (also in the Replacement area).

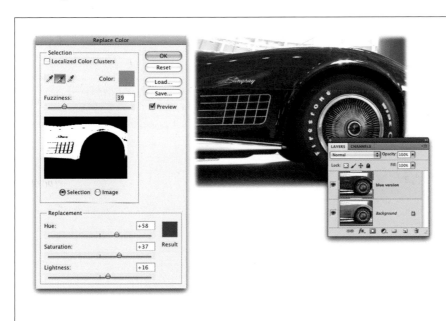

Figure 8-16:
You can use the eyedropper tools to add to or subtract from the range of colors you want to change. Click the Result color swatch at the dialog box's bottom right to open the Color Picker and choose a replacement color.

Since the Replace Color command isn't available as an Adjustment layer, it affects your original image, so it's a darn good idea to duplicate your image layer before you use this command.

Selective Color Adjustment Layers

Selective Color Adjustment layers are gloriously useful because they let you make a single color in your image brighter or darker, which is helpful when you need to make your whites whiter or your blacks blacker. You can also use them to shift

one color to another, but that technique can be a bit challenging if you don't know anything about color theory (that is, mixing certain colors together to create other colors).

To add a Selective Color Adjustment layer to your image, click the Selective Color icon in the Adjustments panel (it looks like a square divided into four triangles). From the Colors pop-up menu at the top of the Adjustments panel, choose the color closest to the one you want to change. For example, if you want to change the color of the bike and the matching leathers shown in Figure 8-17, choose Reds. Next, you can use the Cyan, Magenta, Yellow, and Black color sliders to change that color to something else entirely. (Don't let it throw you that these sliders represent the CMYK color mode—they work just fine on RGB images.)

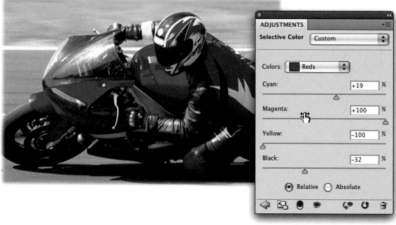

Figure 8-17:
With a well-placed Selective Color Adjustment layer, you can change the red bike and matching leathers to hot pink in seconds. Just hover above one of the sliders in the Adjustments panel until your cursor turns into a handy scrubby cursor and then drag left and right.

The direction you drag each slider determines exactly how the color you've chosen in the pop-up menu changes. By dragging a color's slider to the left, you decrease the percentage of that color. For example, if you choose Reds from the pop-up menu and then drag the yellow slider all the way to the left, you drain all the yellow out of the reds, making them look hot pink (as shown in Figure 8-17). If you drag a slider to the right, you increase the percentage of that color. And how do you know what color you'll end up with after some quality slider-dragging? By learning to read a color wheel. Luckily, you can flip over to page 487 for a short lesson that'll get you started.

Matching Colors

The Match Color command makes the colors in one image resemble those in another. It's a huge time-saver when you're working with several images in a magazine spread or book and need to make the colors somewhat consistent (see Figure 8-18). Since this command isn't available as an Adjustment layer, be sure to duplicate your image layer first by pressing ⌘-J (Ctrl+J on a PC).

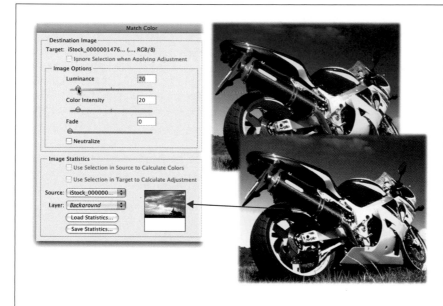

Figure 8-18:
The Match Color dialog box lets you copy the colors from a source image (the gold where the arrow is pointing) onto a target (the top bike image). The result? The golden-hued bike shown at bottom. You can use the Luminance (lightness) and Color Intensity (saturation) sliders to make the colors match a little better, and adjust the Fade slider to use more or less of the source document's original color. If your target image has a bit of a color cast, turn on the Neutralize checkbox to make Photoshop try to get rid of it for you.

To get started, open two images in RGB mode: the one whose color you're trying to match (the *source*) and the one whose color you want to change (the *target*). Click within the target document to activate it and then choose Image→Adjustments →Match Color. In the resulting dialog box, Photoshop automatically picks the current document as the target (which is why you activated it first). Next, tell Photoshop the name of the source document by choosing it from the Source pop-up menu toward the bottom of the dialog box (you'll see a thumbnail preview of the image at the bottom right).

If the source document has several layers, you can choose the one you want from the Layer pop-up menu or choose Merged if you want Photoshop to combine those layers into one (handy if you've used several Adjustment layers to create the color you want). If the source document only has one layer, Photoshop chooses it automatically.

If you want to confine your match to specific spots in the source and target images, create selections in each document before you open the Match Color dialog box. If the dialog box detects an active selection, it lets you turn on the "Use Selection in Source to Calculate Colors" and "Use Selection in Target to Calculate Adjustment" checkboxes, both of which can be helpful when you're trying to match colors in two different images—skin tones, for example.

Tip: If you've got a source color that you might want to use on other images, you can save your Match Color settings as a preset. When you get everything just right, click the Save Statistics button at the bottom of the dialog box and then give your preset a name. The next time you want to use those settings, you won't have to open the source image—just open the Match Color dialog box, click the Load Statistics button, and navigate to your preset. Sweet!

Photo Filter Adjustment Layers

To adjust the colors in an image gently, you can use a Photo Filter Adjustment layer. For example, you can quickly warm your image with golden tones like those in the "after" photo in Figure 8-19. The effect is fairly subtle, making your image look like it's been lightly tinted with a color rather than having its color changed completely.

To get started, click the Photo Filter icon in the Adjustments panel (it looks like a camera with a circle above it). In the resulting Filter pop-up menu, choose from a list of 20 presets that range from warming and cooling filters to shades of red, violet, and so on. If you want to choose your own color instead, turn on the Color option and click the square color swatch to its right; choose a color from the resulting Color Picker and then click OK. You can use the panel's Density slider to soften or strengthen the effect (just pretend the slider is called "intensity" if the "Density" label confuses you) and keep the Preserve Luminosity checkbox turned on to keep Photoshop from lightening or darkening your image.

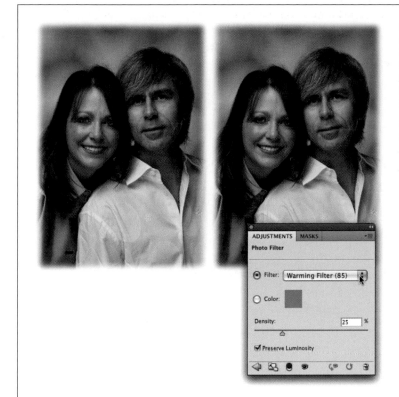

Figure 8-19:
A Photo Filter Adjustment layer is really handy when you've combined images whose color doesn't quite match or when you want to add a warming tone to an image, as shown here.

(Portrait by Kevin Ames, www.amesphoto.com.*)*

Tip: You can also use a Photo Filter Adjustment layer to reduce a color cast. For example, if your image has a strong blue cast, you can introduce a little orange with a Photo Filter adjustment to neutralize the cast (orange is opposite blue on the color wheel). If your image has a yellow cast, use purple to even it out. Flip to Chapter 12 to learn more about color wheels (page 487).

Posterizing: Your Ticket to Cartoon Art

You'll use this adjustment once in a blue moon, but if you need to make your image look like a cartoon, a Posterize Adjustment layer is just the thing. In the Adjustments panel, click the Posterize icon (the striped gray one) or choose it from the "Create new fill or adjustment layer" menu at the bottom of the Layers panel. When you do, Photoshop analyzes your image's colors and throws out the majority of them, leaving you with big ol' blocks of solid color. On some images, posterizing has interesting results as the examples in Figure 8-20 illustrate. On other images, not so much.

Figure 8-20:
Posterizing doesn't work well on portraits, but on images with relatively solid colors, like those shown at left, the results are pretty neat, as you can see on the right.

Adjustment Layer Blend Modes

When you're introducing or shifting colors with Adjustment layers, experiment with changing their blend modes, too. (See page 289 for more on blend modes.) For example:

- The **Hue** blend mode alters your image's color but doesn't change its brightness (how dark or light it is) or saturation (how intense the colors are). This mode is useful when you want to change an object's color as described on page 348.

- The **Color** blend mode changes your image's color and saturation but leaves its brightness alone—handy when you're adding color to an image (page 358).

- The **Luminosity** blend mode changes your image's brightness but not its color—helpful when you need to lighten or darken an image.

If you want to change the blend mode *before* you add the Adjustment layer—so you can actually see what the adjustment looks like as you're making it—Option-click (Alt-click on a PC) the half-black/half-white circle at the bottom of the Layers panel. Photoshop opens the New Layer dialog box so you can change the blend mode of the Adjustment layer you're about to add.

Inverting Colors

Graphic designers, this one's for you! If you need to reverse the colors in your image—turning orange to blue, yellow to purple, and so on—you can add an Invert Adjustment layer.

Tip: To find out the reverse (or opposite) of a color, you can to use a color wheel like the one on page 487.

If you're a photographer, you'll use this adjustment even *less* often than Posterize because it turns most images into a negative (which might be useful on Halloween). That said, if you've got an image of a black silhouette that you want to make white, this Adjustment layer can do it in one click (see Figure 8-21). To add an Invert Adjustment layer, open your Adjustments panel and click the icon that shows two small squares with shapes inside them.

Adding Color

There will be times when you want to add color that wasn't originally part of your image, and Photoshop gives you lots of ways to do that. The techniques in this section will serve you well if you're colorizing a black-and-white image, and if you're painting on an existing color image or an empty canvas.

Variations

If you want to add a quick color tint to a black-and-white image, use the Variations command. It's not available as an Adjustment layer, so, to be safe, duplicate your image layer first by pressing ⌘-J (Ctrl+J on a PC).

Warning: The Variations adjustment only works when you launch Photoshop in 32-bit mode. Flip back to the box on page 6 to learn how!

Choose Image→Adjustments→Variations, and in the center of the honkin' big dialog box that appears (Figure 8-22), you see a slew of previews surrounding your original image. Each preview has one of the six basic colors added to it: green, yellow, red, magenta, blue, and cyan. To add a blue tint to your image, for example, click the More Blue preview and Photoshop applies its effect to your current pick in the center of the dialog box. If you want to add even more blue, click the blue preview again (the clicks are cumulative). Over on the right side of the dialog box, you can click the Lighter or Darker preview to lighten or darken your current pick (these clicks are cumulative too, so if you want the tint to be even lighter or darker, keep clicking away).

Figure 8-21:
An Invert Adjustment layer turns black into white, blue into orange, and so on. For graphic designers, this is an incredibly useful trick. The images on the left are the originals.

Just for fun, try running various Smart Filters (page 634) on your image—pick any one of 'em—and then add an Invert Adjustment layer to see what it does. You can use the included layer mask to hide the adjustment from certain areas of your image to create some pretty wacky, and sometimes wonderfully weird, results!

The options at the top of the dialog box let you choose what to change: the shadows, midtones, highlights, or just the saturation levels. If you want to colorize a black-and-white image, leave the Midtones option turned on because the majority of what you *have* in a grayscale image is midtones. Beneath those options lies a slider that you can use to change the intensity of the color tint (don't let the oddly chosen slider labels—Fine and Coarse—fool you). Drag the slider to the left toward Fine to lower the intensity or to the right toward Coarse to increase the intensity.

Figure 8-22:
If you like choosing from a bunch of previews better than tweaking sliders, Variations is for you!

A super secret way to run a Variation adjustment non-destructively is to convert the image layer into a Smart Object first (Smart Objects are explained on page 123). Just open the image file, choose Filter→"Convert for Smart Filters", and then choose Image→Adjustments→Variations. When you click OK, the adjustment runs on its own layer as if it were a filter. To learn more about using Smart Filters, skip ahead to page 634

Tip: Flip to page 371 to learn how fix an image with a color cast using Variations. It doesn't do a *great* job, but it's a relatively easy alternative to the more complicated methods you'll learn about later in that chapter. Honestly, the only thing the Variations command does *really* well is add a color tint to a black-and-white image.

Color Balance Adjustment Layers

You can think of Color Balance as an Adjustment layer version of Variations but with sliders instead of image previews (see Figure 8-23). When you add a Color Balance Adjustment layer, you can use sliders to shift the colors in your image toward one side of the color wheel or the other (see page 487). Or, if you're working with a black-and-white image, you can use it to add a color tint. You can add a Color Balance Adjustment layer to your image by clicking its icon in the Adjustments panel (it looks like a set of scales—get it?).

Figure 8-23:
If you don't mind using sliders, a Color Balance Adjustment layer is more flexible than the Variations command if only because you can double-click the Adjustment layer and edit it again later.

Colorizing Images

If you want to scan some vintage photos, Photoshop can help you give them a little color. Colorizing a black-and-white (or true grayscale) photo *seems* straightforward— just grab a brush and paint the image. Unfortunately, with that method, while you succeed in adding color, you also cover up all the details, as shown in Figure 8-24, left.

Note: To follow along, visit this book's Missing CD page at *www.missingmanuals.com/cds* and download the file Dress.jpg.

Figure 8-24:
Unless you change the blend mode of the paint layer, the paint covers up all the details of this girl's cute little dress (left). Once you set the blend mode to Color (right), the details come shining through.

Tip: Before you colorize a black-and-white image, choose Image→Mode and make sure your document is set to RGB Color. If it's in Grayscale mode, Photoshop doesn't let you add any color no matter *how* hard you try.

Fortunately, you can use blend modes to add color while keeping your image's details intact. Here's how:

1. **Add a new layer for the paint.**

 Since you don't want to mess up your original image by painting directly on it, you need to add a new layer. Click the "Create a new layer" button at the bottom of the Layers panel, name the layer *pink paint*, and then position it above the photo layer in your layers stack.

2. **Set the paint layer's blend mode to Color.**

 Select the new layer and then use the pop-up menu at the top of the Layers panel to change the blend mode (page 289). As explained in the box on page 354, this mode not only keeps the brightness of the gray tones in your photo, it adds the hue and saturation values from the pink paint, letting the details of the image show through the paint.

3. **Grab the Brush tool and set it to whatever color you want to paint the dress.**

 Press B to activate the Brush tool. Then, in the Tools panel, click the foreground color chip, pick a nice pastel color from the Color Picker, and then click OK.

4. **Paint the part of the image that you want to colorize.**

 Be sure to paint *only* the areas you want to colorize—since the paint layer is on top, there's nothing to mask any parts you don't want colored. If you need to, zoom in and out of your image using the techniques described on page 60.

5. **Use the Eraser tool to fix any mistakes.**

 Press and hold E to switch temporarily to the Eraser tool to fix your mistakes, and then let go of the key to switch back to the Brush tool.

6. **When everything looks good, save your document as a Photoshop (PSD) file.**

 Saving the document in PSD format lets you go back and change the paint later. For example, after you print the colorized photo you might decide to change the little girl's dress to yellow instead of pink. If you've saved the document with all its layers intact (as a PSD file lets you do), you can load the paint layer as a selection by ⌘-clicking (Ctrl-clicking on a PC) the layer's thumbnail and then use a Hue/Saturation Adjustment layer to change the color (page 342). That's a heck of a lot quicker than repainting the dress! But don't tell anyone—let 'em think it took you hours and hours.

Just think how much fun you can have using this technique with a graphics tablet and the Rotate View tool (page 65)! Even if you paint the color onto your image using the Brush tool, you can load a selection of the paint layer and then use the Fill command (page 91) to change its color. Another option is to add a Solid Color Fill layer (page 91) and then use the included layer mask to hide the paint from areas that don't need it. So which method should you use? It's one of those "six of one, half a dozen of the other" kind of things—just pick the one you like best.

Adding Solid Blocks of Color

Remember the high-contrast face from earlier in this chapter (page 336)? With just a little modification and a few well-placed blocks of color, you can turn that face into an Andy Warhol–style portrait like the one in Figure 8-25.

Figure 8-25:
You can create all kinds of interesting art by adding your own color to images.

If you downloaded the practice image file for the high-contrast face tutorial back on page 336, you can use that edited image for the maneuver described in the following list.

Once you've used a Threshold adjustment to make a high-contrast face (see steps 1–3 on page 336), follow these steps:

1. **Merge the Threshold Adjustment layer with the photo layer.**

 To add bunches of color blocks to the image, you need to isolate the black parts of the face onto their own layer. First, merge the Threshold and face layers so you can select all the black bits at once. Over in the Layers panel, click the Threshold Adjustment layer and then choose Merge Down (page 111) from the Layers panel's menu. Now you should have a *single* face layer instead of two: the Threshold Adjustment layer and the photo layer.

2. **Select all the black areas in the merged face layer you created in the previous step.**

 Grab the Magic Wand tool (page 151), click one black area, and then choose Select→Similar to make Photoshop select *all* the black bits (you could select them yourself, but Shift-clicking each black area with the Magic Wand would take days).

3. **Jump the selection onto its own layer.**

 To isolate the selected black parts onto their own layer, press ⌘-J (Ctrl+J on a PC). Then double-click the layer's name in your Layers panel and rename it *face*. (Since you're about to add a bunch of layers, it's helpful to give each one a descriptive name.) Turn the original photo layer's visibility off because you don't need it anymore. Now you're ready to start painting!

4. **Add a new layer below the face layer.**

 Click the "Create a new layer" button at the bottom of the Layers panel and name the new layer *skin*. Make sure this layer is *below* the face layer.

5. **Grab the Polygonal Lasso tool (page 163) and draw a selection around the woman's face and shoulders (see Figure 8-26, top left).**

 Since the Polygonal Lasso tool uses straight lines, it's perfect for creating blocks of color. Just click once where you want the selection to start and then click again each time you need to change angles. Don't worry about being precise; the point is to make it blocky. When you're finished, close your selection by hovering your cursor over the starting point. When you see a tiny circle (it looks like a degree mark) next to your cursor, click once to complete your selection.

6. **Fill your selection with color.**

 Click the foreground color chip at the bottom of the Tools panel, pick a nice peachy color for the woman's skin, and then click OK. Fill the selection with color by pressing Option-Delete (Alt+Backspace on a PC) and then get rid of the marching ants by pressing ⌘-D (Ctrl+D) to deselect.

7. **Add another new layer above the skin layer but below the face layer, and name it *lips*.**

 Repeat steps 5 and 6 to give her some hot-pink lipstick. Remember, you want to make the colored areas blocky, so don't be afraid to make your selection go outside of her lips.

Tip: Instead of changing the color of the blocks, you can change their opacity by using the setting at the top of the Layers panel (see page 78).

8. **Keep adding new layers and repeating steps 4–6 to give her some eye shadow and add color to the iris of each eye.**

 When you're all done, your Layers panel should look something like the one in Figure 8-26, right.

Figure 8-26:
If you want to make five more versions of this portrait, select all the layers that make up this version and stuff them into a group by choosing "New Group from Layers" from the Layers panel's menu (see page 105 for more on layer groups). This not only helps you keep track of each version, it also makes creating additional versions easier: Simply duplicate the layer group instead of each individual layer.

And because you wisely placed each block of color on its own layer, changing those colors is as simple as loading a layer as a selection. Just ⌘-click (Ctrl-click on a PC) its thumbnail, and then fill it with a new color. Because your duplicated layers are all sitting on top of each other, you can toggle the visibility of each group off or on while you're changing colors. Once you've created several versions of the portrait, you can increase your canvas size (page 257) and then use the Move tool to position the layer groups next to each other in order to create the artwork shown in Figure 8-25.

9. **Add a Solid Color Fill layer (page 91), pick a bright color from the resulting Color Picker, and make it your new background.**

 Drag this layer below the skin layer so it becomes the background of the whole piece of art you're building.

Congratulations—you've just finished your first Warhol-style portrait! The really fun thing about this technique is how creative it lets you be (not to mention that you're using almost every skill you've learned in the preceding chapters). Oh, sure, you *could* seek out Warhol's pop-style art online and use the same colors he did, but what fun is that? By using your own vision, you're creating something unique. Also, try experimenting with images of people who have light-colored hair. If the model for this portrait were blonde, you could color her hair, too. The possibilities are endless!

Gradient Map Adjustment Layers

If you need to turn a mediocre sunrise photo into something spectacular, use a Gradient Map Adjustment layer. Rather than letting you add one color to your image like the Photo Filter Adjustment layer (page 352), a Gradient Map Adjustment layer lets you add as many colors as you want. Behind the scenes, Photoshop turns your image black and white and then maps the shadows (blacks) to one end of the gradient of your choosing and the highlights (whites) to the other. To reverse those colors, turn on the Reverse option in your Adjustments panel (see Figure 8-27).

To add a Gradient Map Adjustment layer, follow these steps:

1. **Open your image, set your color chips to black and white by pressing D, and then add a Gradient Map Adjustment layer.**

 Because the Gradient Map Adjustment layer you're about to add uses your foreground and background color chips, the layer's effect is less startling if you set them back to factory-fresh black and white first. Next, open the Adjustments panel and click the Gradient Map icon, which looks like a vertical white-to-black fade. Photoshop applies a black-to-white gradient so your image looks like it's grayscale and changes the panel so you see options for tweaking the new gradient.

Tip: Adding a Gradient Map Adjustment layer generates a pretty amazing black-and-white version of your image. However, if you want to get even more creative with this technique, you can use the Gradient Editor (discussed later in this section) to create a black-to-gray-to-white gradient, which adds depth to your black-and-white image.

2. **In the Adjustments panel, click the gradient preview to open the Gradient Editor.**

 In the resulting dialog box, you can choose a preset gradient (best for newcomers) or make one of your own by following the next couple of steps (which requires a bit of patience and practice). You can load even more ready-made gradients by clicking the tiny right arrow circled in Figure 8-28.

Figure 8-27:
With a Gradient Map Adjustment layer, you can apply a gradual blend of colors to your image. This is a great way to conjure a beautiful sunrise or sunset from a big ol' boring sky.

3. **Edit the gradient's color stops to create a yellow-to-orange-to-red gradient.**

In the middle of the Gradient Editor dialog box are little colored squares called *color stops* (see Figure 8-28) that you can drag around to control the width of the color fade. When you click a color stop, its color appears in the Color field (also called a *color well*) at the bottom of the dialog box. If you want to change the color, click the color well to make Photoshop open the Color Picker so you can choose something else. If you click *between* existing color stops, you'll add a new stop. You can also drag the tiny white diamonds beneath the gradient left and right to determine where one color stops and another one starts.

Tip: If you create the perfect sunset gradient, you can save it by clicking the Save button and then giving it a name. Photoshop adds it to the preset previews, giving you easy access to it in the future.

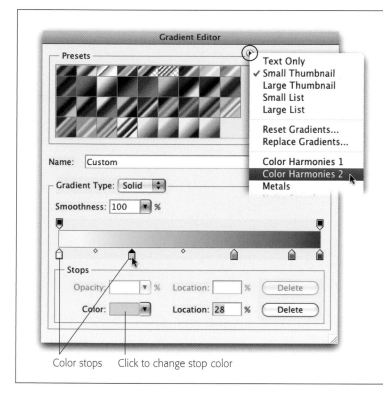

Figure 8-28:
The Gradient Editor lets you choose from tons of existing gradients, or you can create your own by editing any of the presets and adding color stops.

Color stops Click to change stop color

4. **In your Layers panel, change the Gradient Map Adjustment layer's blend mode to Color.**

 To keep the Gradient Map from changing your image's lightness (brightness), change the pop-up menu at the top of the Layers panel to Color. That way, the gradient affects only the image's color values and not its lightness values (the box on page 354 has more on the Color blend mode).

Tip: If you want to keep any part of your image from being affected by the Gradient Map, click the Adjustment layer's mask thumbnail, grab the Brush tool, and then paint those areas with black.

You're all finished! Nothing like a beautiful sunset, is there?

Correcting Color and Lighting

Most digital photos could stand to have their colors and lighting adjusted. When you think about all the variables that come into play when you're capturing images, it's a wonder any photos turn out halfway decent! You're dependent on Mother Nature or the quality of artificial lighting, and, even then, it's easy to over- or underexpose an image. You need a good camera that can snap the shot before you miss it, a high-quality lens, and so on. Even if the stars are aligned and you get all that right, the camera itself may introduce a *color cast*, making your image look like it has overdosed on one particular color.

All these variables mean you need to spend some time correcting both the color and the lighting of your images. Not to worry: You've got an arsenal of tools at your disposal in Photoshop and its trusty sidekick, Camera Raw. In this chapter, you'll learn how to use all the automatic fixer-uppers (and there's a slew of 'em) like Auto Color, Variations, and so on. Then, you'll dive headfirst into professional-level adjustments such as Levels, Curves, and merging High Dynamic Range images (the latter is now easier in CS5). Next, you'll explore the glorious realm of Camera Raw for the easiest adjustments in the West, and, finally, you'll learn some tricks for saving images you can't fix any other way.

Quick Fixer-Uppers

Before you dive into the murky waters of manual adjustments using Levels (page 390) and Curves (page 406), it's worth trying to make Photoshop do some of this stuff automatically. As luck would have it, Photoshop has lots of auto fixer-uppers, but you need to do a wee bit of setup to make them work better.

A Word on Workflow

Every adjustment you make can reduce the quality of your image a bit, so the order in which you work—known among those in the biz as *workflow*—is important. Because some techniques are more destructive than others (like sharpening), it's wise to save those techniques for last. Here's a quick cheat sheet to follow when it comes to adjustment order:

1. Import pictures using Adobe Bridge (see Appendix C online) or another program.

2. Have Bridge save copies of your images to an external hard drive and then burn your originals to a DVD for off-site safekeeping.

3. View your photos, rate the best ones, and mark the bad ones as rejected (see—you guessed it—Appendix C).

4. Crop, resize, and (if necessary) straighten your image. There's no point in fixing pixels you're not going to keep! See Chapter 6 for the scoop.

5. Fix whatever you can in Camera Raw (white balance, exposure, contrast, and so on). As you'll discover later in this chapter, corrections are a *breeze* in Camera Raw (you can use it to fix TIFFs and JPEGs, too).

6. Fix the remaining problems in Photoshop (like reducing wrinkles, enhancing eyes, correcting colors, and so on) using Adjustment layers, duplicate layers, and layer masks as described in this chapter.

7. Apply special effects like fancy edges, head swapping, filters, and so on.

8. Sharpen your image using the techniques you'll learn in Chapter 11.

9. Print the image (Chapter 16) or save it for the Web (Chapter 17).

If you make your adjustments in this order, you'll end up with the sharpest, highest-quality images possible.

Note: While you may get satisfactory results using combinations of the following adjustments, they're nothing compared to what you can do if you master Levels or, better yet, Curves (both covered later in this chapter). In other words, use the methods in this section only while you're learning or as quick-and-dirty fixes.

Setting Target Colors

Photoshop needs some guidance before it can fix the colors and lighting in your image. You can tell it what you want those colors to look like by setting targets for the three categories of color in any image:

- **Shadows** are created when light is blocked (you knew that). Rarely, jet black, shadows can be different colors depending on how much light is blocked.

- **Highlights** represent the lightest or brightest parts of your image where the light is at full strength. When an image is overexposed, the highlights are described as *blown out*.

- **Midtones** are tonal values that fall between the darkest shadows and lightest highlights. By enhancing midtones, you can increase the contrast and the details in your image.

Setting target colors is a bit of a pain, but if you do it just once and save the settings, you can run these auto-fixers on any image and know your target colors are set correctly (see Figure 9-1).

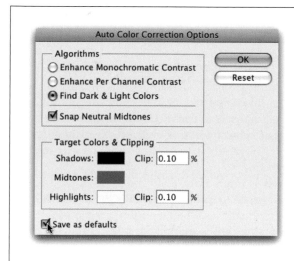

Figure 9-1:
The Auto Color Correction Options dialog box (now that's a mouthful!) lets you adjust several settings to help Photoshop do a better job correcting your images. Anytime you use an auto-correction method like the ones covered in this section or make a manual adjustment using either Levels or Curves, Photoshop refers to the target colors you set here.

Follow these steps to set Photoshop's target shadow, midtone, and highlight colors:

1. **Click either the Levels or Curves icon in your Adjustments panel—it doesn't matter which.**

 Open the Adjustments panel by clicking its panel dock icon on the right side of your screen or by choosing Window→Adjustments. The Levels icon looks like fire with three triangles under it, and the Curves icon looks like a graph with an S-curve on it. When you click either one, Photoshop changes the Adjustments panel to show options related to Layers or Curves.

2. **Open the Auto Color Correction Options dialog box.**

 In the Adjustments panel, Option-click (Alt-click on a PC) the Auto button to open this dialog box.

3. **Choose the Find Dark & Light Colors algorithm.**

 The Algorithms menu at the top of the Auto Color Correction Options dialog box has three options. Straight from the factory, the algorithm (a set of instructions) is set to Enhance Per Channel Contrast, which makes Photoshop adjust the red, green, and blue channels individually so the highlights get a little lighter

and the shadows get a little darker. You get more noticeable results with this algorithm than with the other two options, but your colors may shift. The Auto Tone adjustment (page 375) uses this algorithm.

If you don't want your colors to shift, choose Enhance Monochromatic Contrast to make Photoshop apply the exact same amount of lightening and darkening to each channel. The Auto Contrast adjustment (page 375) uses this algorithm.

Perhaps the best algorithm of all is Find Dark & Light Colors, which locates the average lightest and darkest pixels and then uses them to increase the image's contrast. The Auto Color adjustment (page 371) uses this algorithm.

4. **Turn on the Snap Neutral Midtones checkbox.**

 This setting, which is at the bottom of the Algorithms section, makes Photoshop hunt for a nearly neutral color—one that has the same level of brightness in all color channels—and then adjust it so that it really *is* neutral. It works like a charm for fixing color casts. (The Auto Color adjustment uses this setting.)

5. **Set a target shadow color.**

 In the Target Colors & Clipping section of the dialog box, click the black rectangle labeled Shadows. In the resulting Color Picker, enter *10* in the R, G, and B fields (you'll work in RGB mode most of the time). Ten is a good choice because, on the 0–255 brightness scale (see the box on page 406), 10 is a dark gray. Once you start using the auto fixers, this setting gives you nice, dark shadows that aren't *so* black you can't see details. Click OK when you're finished to close the Color Picker.

6. **Make sure the Clip field next to the black rectangle is set to 0.10 percent.**

 Clipping is the term Photoshop uses when it turns a light pixel pure white or a dark pixel pure black, stripping the pixel of all its details. Keeping this field set to 0.10 percent means Photoshop won't clip your image's pixels much more than your camera did.

Note: As you might imagine, clipping is more worrisome in your image's highlights, which usually contain more important details than the shadows.

7. **Set your target midtone color.**

 Click the gray rectangle labeled Midtones. In the Color Picker, enter *133* in the R, G, and B fields to get a nice, charcoal gray just a touch lighter than 50 percent. Click OK to close the Color Picker.

8. **Set a target highlight color.**

 Click the white Highlights rectangle and, when the Color Picker opens, enter *245* in the R, G, and B fields so your highlights are pale gray instead of pure, blinding white.

9. **Turn on the "Save as defaults" checkbox and then click OK.**

 Since the settings listed here are good for almost every color correction, you can tell Photoshop to use them as its defaults. That way you don't have to reset all this stuff every time you use one of the auto correctors or a Levels or Curves adjustment (both discussed later in this chapter).

10. **Close the Adjustments panel and throw away the Adjustment layer.**

 To close the Adjustments panel, click the dark gray bar at the top of the panel. Since you created the Adjustment layer just to get at the target color settings, you can throw it away by selecting it in your Layers panel and then pressing Delete (Backspace on a PC).

Once you've set your target colors, you're ready to start using the correction methods discussed in the next few sections.

Tip: A handy way to get rid of distractions so you can focus on fixing your image is to go up to the Application bar at the top of your screen (see page 14), click the Screen Mode icon, and choose Full Screen Mode With Menu Bar. You can also press the F key repeatedly to cycle through the screen modes.

Fixing Color

If your image looks flat (like it has no contrast) or has a noticeable color cast, give the following methods a spin. And if your image is in pretty good shape to begin with, the following tools can fix its color in no time flat:

- **Auto Color.** If your image has a noticeable color cast (everything looks a little green, say), this command can help. When you run it, Photoshop hunts down the shadows, highlights, and midtones in your image and changes their color values to the target colors you set earlier. You can also use this command to tone down oversaturated images, where all the colors look too intense. To run it, choose Image→Auto Color or press Shift-⌘-B (Shift+Ctrl+B on a PC). This command works only on images that are in RGB mode, so if the menu item is grayed out, choose Image→Mode→RGB Color first.

Tip: You can run Auto Color nondestructively as an Adjustment layer by following steps 1–2 in the previous section. If you'd kept the Adjustment layer hanging around when you finished setting your target colors, you would have *applied* the Auto Color adjustment to your image.

- **Variations.** Besides using a Variations adjustment to add color to black-and-white images (page 355), you can also use it to fix color (see Figure 9-2). Choose Image→Adjustments→Variations and then click one of the six previews—More Green, More Yellow, and so on—that represent various changes in color balance, contrast, and saturation (your current pick appears in the middle). Your

clicks have a cumulative effect: Each time you click the More Red preview, for example, Photoshop adds more red to your image. As you click the previews, Photoshop updates all the images. To adjust the brightness, click either the lighter or darker preview on the right side of the dialog box as many times as you need to get the lighting you want.

Tip: In Photoshop CS5, the Variations adjustment doesn't work in 64-bit mode, so don't panic if you can't find it. The fix is to switch to 32-bit mode (see the box on page 6) and then it'll reappear in the Image→Adjustments menu.

Since you can't use Variations as an Adjustment layer (meaning it'll affect your original image), it's a darn good idea to duplicate your original layer by pressing ⌘-J (Ctrl+J on a PC) before you apply this adjustment. Better yet, select the image layer and then choose Filter→"Convert for Smart Filters" so the adjustment runs on its own layer instead (this method also creates an automatic layer mask!). See page 634 for more on using Smart Filters.

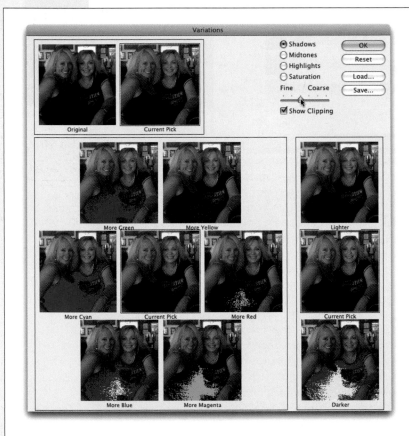

Figure 9-2:
A Variations adjustment is a very visual way to fix your image, though it works only on 8-bit images (see the box on page 45). Click one of the six color previews on the left side of the dialog box as a starting point and then use the Fine to Coarse slider to change the intensity of the adjustment (Fine lowers the intensity and Coarse increases it, which makes you wonder why the slider isn't named Intensity instead). Moving the slider one tick mark doubles the strength of the adjustment.

If you choose Shadows or Highlights and then turn on the Show Clipping checkbox, Photoshop indicates the clipped areas of your image (page 385) with funky neon colors (they won't show up in the printed version of the image).

- **Color Balance.** This adjustment changes the overall mixture of colors in your image or selection by shifting the highlights, midtones, and shadows to opposite sides of the color wheel (see page 486 for a quick lesson on color theory). It's also handy for adding color to a black-and-white image (page 357) or for fixing a problem area (like a dull sky) fast.

The only drawback to Color Balance is that you have to know *which* color you want to shift your image *toward* (which is why color theory comes in handy). That said, Photoshop gives you sliders to adjust, making Color Balance fairly easy to play with (see Figure 9-3). Because it's available as an Adjustment layer, it's nondestructive and you can use the layer mask that tags along with it to limit the adjustment to certain parts of your image (see page 113 for more on masks). Photoshop gives you lots of ways to summon the Color Balance controls:

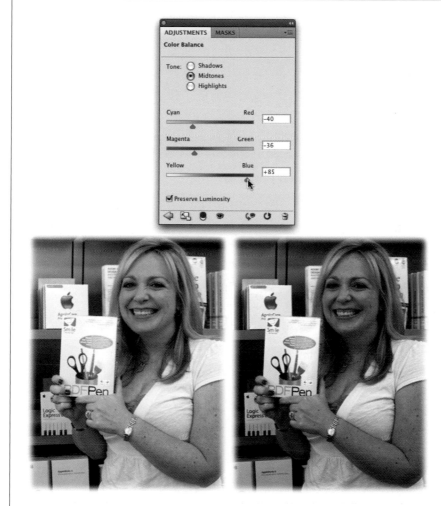

Figure 9-3:
A Color Balance Adjustment layer can zap a color cast instantly. Dragging the top and bottom sliders toward Cyan and Blue and the middle slider toward Magenta to introduce a little red gets rid of the nasty yellow cast shown at left.

Incidentally, PDFPen is a really handy program that lets you fill in and sign PDF forms; if you use a Mac, visit www. smileonmymac. com to learn more about it.

Note: To preserve your image's brightness values, be sure to leave the Adjustments panel's Preserve Luminosity checkbox turned on.

— Choose Color Balance from the Adjustments panel (click the button that looks like a scale).

— Click the half-black/half-white circle at the bottom of your Layers panel and then choose Color Balance from the pop-up menu.

— Choose Image→Adjustments→Color Balance or press ⌘-B (Ctrl+B on a PC) to make Photoshop apply Color Balance to the currently active layer (your original image) without creating an Adjustment layer.

- **Photo Filter.** To add a tint to your image, you can add a Photo Filter Adjustment layer to warm it up with a golden tint or cool it off with a bluish tint. If your image has a color cast, you can neutralize it by adding the opposite color (again, a little color theory comes in handy here). Though it's much safer to run Photo Filter as an Adjustment layer, you can also run it (gasp) directly on your image by choosing Image→Adjustments→Photo Filter. See page 352 for more about Photo Filter.

Tip: You don't have to apply these adjustments to your whole image. If you make a selection ahead of time, the adjustment affects only the selected area. And if the adjustment is available as an Adjustment layer, you can use the included layer mask to keep the layer from affecting areas that don't need adjusting. For adjustments that *aren't* available as Adjustment layers, you can duplicate your original layer, run the adjustment on it, and then add a layer mask (page 114).

POWER USERS' CLINIC

Fixing Colored Edge Fringe

If you see a slight blue or purple fringe loitering around the edges of near-black objects in your image, you've got a dreaded *edge halo* (page 172). They're especially noticeable when the object is on a white background. For example, if you take a picture of a white clock face, you may see a purplish or bluish tinge around the edges of the numbers and hands. Fortunately, you can use the Gaussian Blur filter to get rid of the tinge, though there's a trick to it. Flip to page 445 for the step-by-step scoop.

Fixing Lighting

Unless you're carting around your own light kit with your camera, you're totally dependent on ambient light, which is less than perfect on a good day. Nevertheless, Photoshop has several tools that can help fix almost any lighting problem:

- **Auto Tone.** This adjustment (called Auto Levels in CS3 and earlier) brightens your image, adding a bit more contrast. Auto Tone resets both the black and the white pixels to the target values you set earlier in this chapter—see page 368. (It's essentially the same as clicking the Auto button in either a Levels or Curves adjustment—or at least it was until you changed the algorithm back on page 369!) If your image needs a *little* lighting boost, this adjustment can get it done. You can apply it to the current layer by pressing Shift-⌘-L (Shift+Ctrl+L on a PC).

 Better yet, you can run Auto Tone as an Adjustment layer. Click the Levels or Curves button in the Adjustments panel—or click the half-black/half-white circle button at the bottom of your Layers panel and choose Levels or Curves—and then Option-click (Alt-click) the Auto button. Choose the Enhance Per Channel Contrast algorithm and then click OK.

- **Auto Contrast.** This adjustment is an automatic version of the Brightness/Contrast adjustment discussed on page 376. It increases the contrast in your image by lightening and darkening pixels. It doesn't adjust channels individually, so if your image has a color cast, it'll still have one after you make this adjustment. And if your image is flat to begin with, it'll still be flat afterwards. But if you have a decent amount of contrast, this adjustment can boost it a little. To run Auto Contrast on the currently active layer, press Option-Shift-⌘-L (Alt+Shift+Ctrl+L on a PC).

 To run it as an Adjustment layer, click the Adjustments panel's Levels button or click the half-black/half-white circle at the bottom of the Layers panel and choose Levels. In the dialog box that opens, Option-click (Alt-click) the Auto button. Choose the Enhance Monochromatic Contrast algorithm and then click OK.

- **Shadows/Highlights.** If you need to quickly lighten the shadows or darken the highlights in your image, this tool can do an *amazing* job in no time flat. It's discussed in detail on page 377.

- **Equalize.** This adjustment evens out your pixels' brightness by turning the lightest ones white (or the color you've set as your target white—see page 368) and the darkest ones black (or your target black). It's handy when some areas of your photo are decently lit. It's not available as an Adjustment layer, so you'll definitely want to duplicate your original layer by pressing ⌘-J (Ctrl+J on a PC) before you run this adjustment. To apply it, choose Image→Adjustments→Equalize.

 Be careful when you run Equalize, as it can make your image look washed out by lightening it too much. But if you keep your wits and immediately choose Edit→Fade, you can lessen its effect by choosing Luminosity from the Blending pop-up menu (so it affects only the lightness values, not the color values) and lowering the opacity to about 50 percent, as shown in Figure 9-4 (bottom).

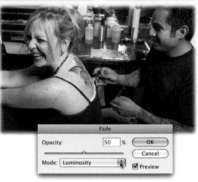

Figure 9-4:
Top: Here's the original image (left) and the equalized version (right). As you can see, the lighting in the image on the right has been evened out, but it's also completely washed out.

Bottom: After reducing the adjustment with the Edit→Fade command, the results are more visually pleasing.

- **Dodge and Burn tools.** These tools are useful when you need to lighten or darken detailed areas of your image by hand, and back in CS4 they were both redesigned so they're not as harmful to your image as they used to be (especially on skin tones). For example, you can use the Burn tool to selectively darken your subject's eyes and the Dodge tool to lighten deep wrinkles. But unless you duplicate your original layer first, there's no way to use these tools nondestructively. Luckily, there's a trick that lets you use the Brush tool so it *behaves* like the Dodge and Burn tools. Flip over to Chapter 10 (page 447) for step-by-step instructions.

Brightness/Contrast Adjustment layers

These Adjustment layers do exactly what you'd think: They brighten your image or increase the contrast in it—or both. In days of old, these adjustments didn't work worth a darn because they adjusted your whole image by the same amount, which usually resulted in nice-looking shadows but blown-out highlights. Thankfully, Brightness/Contrast got a much-needed overhaul back in CS3 so now it's a useful tool, especially on black-and-white images. (Just be sure to leave its Use Legacy checkbox turned off, or it'll behave like it used to!)

You can choose Brightness/Contrast from your Adjustments panel (its button looks like a sun) or by clicking the half-black/half-white circle at the bottom of your Layers panel and choosing Brightness/Contrast from the pop-up menu. In your Adjustments panel, drag the Brightness slider to the left to darken your image or to the right to brighten it as shown in Figure 9-5. If you want to increase your image's contrast, drag the Contrast slider to the right. To decrease it, drag the slider to the left and watch as your image becomes flatter than a pancake (tonally speaking!).

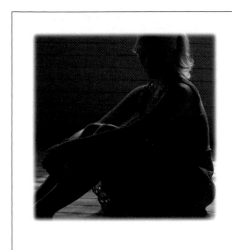 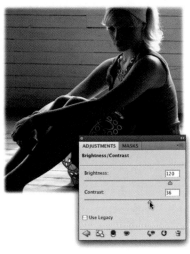

Figure 9-5:
The revamped Brightness/Contrast Adjustment layers do a much better job of adjusting the lighting in your image than they used to. But since the brightening focuses mainly on the highlights (it leaves the shadows alone for the most part), you need to be careful that they don't get too light. For a quick lighting fix, though, this adjustment does a fantastic job.

Shadows/Highlights adjustments

The most useful of all the quick-fix adjustments is Shadows/Highlights. If your camera's flash didn't fire and your subject is way too dark, this command can bring your photo back to life by analyzing each pixel and then adjusting it according to the lightness values of neighboring pixels. This is a big deal because even the much lauded Levels and Curves adjust lightness values *equally* among all pixels, whether they need it or not.

You can apply this adjustment by choosing Image→Adjustments→Shadows/Highlights, but because it's destructive, you may want to duplicate your image layer first (or better yet, convert it for Smart Filters as described in the steps below). At first you see just two sliders in the dialog box that appears: Shadows and Highlights. Because Photoshop assumes you want to lighten the shadows—and you usually do—it automatically sets the Shadows slider to 35 percent (it leaves the Highlights slider set to 0 percent). To get the most out of this adjustment, you need to turn on the Show More Options checkbox at the bottom of the dialog box (the following numbered list explains all your options).

Note: In previous versions of Photoshop, the Shadows slider was automatically set to 50 percent, which is *way* too much. Thankfully, Adobe decided to lower the factory setting to 35 percent in CS5. (See? They really do listen to customer feedback!)

Here's how to lighten overly dark shadows in your image using a Shadows/Highlights adjustment:

1. **Select the image layer and choose Filter→"Convert for Smart Filters".**

 Since the Shadows/Highlights adjustment is destructive (it's not available as an Adjustment layer), it'll affect your original image. To use it nondestructively, you can either duplicate the layer first by pressing ⌘-J (Ctrl+J on a PC) or convert it for Smart Filters. The second method forces Photoshop to make the adjustment on a separate layer as if you had run a Smart Filter (see page 634). Both methods let you hide parts of your image with a mask, though the Smart Filter method won't bloat your file's size as much as duplicating the layer.

2. **Choose Image→Adjustments→Shadows/Highlights.**

 In the Shadows/Highlights dialog box that appears, turn on the Show More Options checkbox (circled in Figure 9-6) so you can see all the settings.

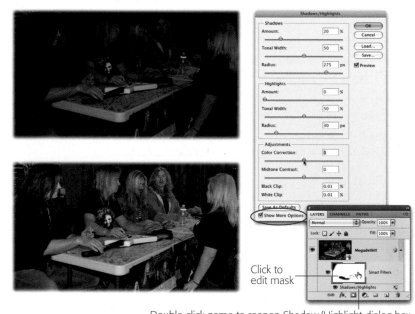

Click to edit mask

Double-click name to reopen Shadow/Highlight dialog box

Figure 9-6:
Left: Here's an image before (top) and after (bottom) using the Shadows/Highlights adjustment.

Right: Turning on Show More Options (circled) gives you a slew of sliders. When you click OK to close the dialog box, you'll see the adjustment happen on its own layer (shown here at bottom right). By painting with black within the mask that comes from running Shadows/Highlights as a Smart Filter, you can protect certain parts of your image from the effect.

3. **Set the Shadows section's Amount slider to between 20 and 35 percent.**

 That's really as high as you want to go, or you'll start to see noise (graininess) in your image.

4. **Leave the Shadows section's Tonal Width slider set to 50 percent.**

 This slider lets you control which shadows Photoshop adjusts. If you lower this number, the program changes only the darkest shadows; if you raise it, Photoshop changes a wider range of shadows. The factory setting of 50 percent usually works fine, but you may want to lower it if your image looks grainy.

5. **Increase the Shadows section's Radius slider to between 250 and 300 pixels.**

 Since the Shadows/Highlights adjustment works by looking at the brightness values of neighboring pixels, you can use this setting to determine how big that neighborhood is. Pump this baby up to make Photoshop analyze more pixels.

Tip: If your shadows are okay but your highlights need darkening, apply these same settings to the Highlight portion of the dialog box instead of the Shadows portion (they work the same way). Just be sure to set the Shadows section's Amount slider to 0 percent to turn that section off if you don't need to use it.

6. **In the Adjustments section at the southern end of the dialog box, set the Color Correction field to 0.**

 Lowering this setting keeps Photoshop from shifting your colors and introducing funky pinks into skin tones.

7. **Leave the Adjustments section's Midtone Contrast setting at 0.**

 Photoshop makes dark pixels a little darker and light pixels a little lighter to increase contrast. Since the whole point of a Shadows/Highlights adjustment is usually to lighten shadows, increasing this setting pretty much cancels out what you're trying to accomplish. To avoid that conflict, leave this slider set to 0.

Note: If you need more contrast in your image, you can always add a Curves Adjustment layer (as described later in this chapter) and change its blend mode to Luminosity—which affects only pixel brightness (page 302)—so you won't risk a color shift.

8. **In the Adjustments section, leave the Black Clip and White Clip fields set to 0.01 percent.**

 Leaving these fields alone keeps your light and dark pixels from getting clipped (forced to pure white or black). Page 385 has the full story on clipping.

9. **Click the Save As Defaults button.**

 Photoshop saves your settings so you don't have to reset everything the next time you use this adjustment.

10. **Click OK to close the Shadows/Highlights dialog box.**

 In the Layers panel, you'll see a new layer called Smart Filters above the Shadows/Highlights adjustment (Figure 9-6), indicating that Photoshop ran the adjustment as a Smart Filter instead of applying it to your original image.

11. **If necessary, hide the adjustment from a portion of your image by painting within the mask that came with the Smart Filter.**

 When you click the Smart Filter mask's thumbnail to select it, Photoshop puts a tiny black border around it. Press B to grab the Brush tool, press D to set your color chips to black and white, and then press X until black hops on top. Mouse over to your image and paint the areas you don't want adjusted. Pretty cool, huh? You can think of this technique as Smart Shadows.

12. **For a quick before-and-after comparison, turn the Smart Filters layer's visibility eye off and on.**

As Figure 9-6 shows, this adjustment does a bang-up job of lightening shadows without introducing a funky color cast. To get even *better* results, you can run the Shadows/Highlights adjustment on the Lightness channel in Lab mode. It sounds really difficult, but it's not. Just follow these steps:

1. **Duplicate your original layer by pressing ⌘-J (Ctrl+J on a PC).**

 For reasons known only to the Lords of Adobe, you can't run the Shadows/Highlights adjustment on one channel if your original layer has been converted to a Smart Object to run the adjustment as a Smart Filter. So to keep this adjustment from running in Super Destructo mode, you've got to duplicate the layer first. Bummer!

2. **Switch to Lab mode temporarily.**

 Choose Image→Mode→Lab Color. (It doesn't matter whether you were originally in RGB or CMYK mode; as you know from Chapter 2, page 46, you'll *usually* be in RGB mode.) When Photoshop asks if you want to flatten layers, click Don't Flatten. If you've got any Smart Objects in your document, it'll also ask if you want to rasterize them; in that case, click Don't Rasterize.

3. **Select the Lightness channel.**

 Open your Channels panel by choosing Window→Channels and click once to select the Lightness channel. As you learned back in Chapter 5 (page 198), one of the great things about Lab mode is that it separates your image's light info from its color info. Since you want to lighten the shadows without shifting color, you can run the Shadows/Highlights adjustment on the Lightness channel, which makes the adjustment work *noticeably* better.

4. **Choose Image→Adjustments→Shadows/Highlights.**

 Turn on the Show More Options checkbox and enter the following settings: Shadows Amount 20 percent; Shadows Tonal Width 50 percent; Shadows Radius 275 pixels. Click OK when you're finished.

5. **Switch back to RGB (or CMYK) mode.**

 Choose Image→Mode→RGB (or CMYK) to go back to the color mode you started out in.

6. **To see before and after versions of your image, turn the duplicate layer's visibility off and on.**

Sure, this method takes two extra steps, but the results are well worth it. And remember, if you need to adjust the highlights instead of the shadows, you can use the same magic numbers in the Highlights section—just be sure to set the Shadows section Amount slider to zero.

Note: In Photoshop CS5, you'll spot a new item lurking in the Image→Adjustments menu: HDR Toning. It has to do with creating High Dynamic Range imagery, which you'll learn all about on page 414.

Fixing Lighting with Blend Modes

If your image is *still* too dark or too light after you run a Shadows/Highlights adjustment, you can fix it with blend modes. The technique is described in step-by-step glory back on page 118, but it's so important that it deserves a mention here, too.

To darken your image, create an empty Adjustment layer by clicking the half black/half white circle at the bottom of the Layers panel and choosing Levels (it's the first one in the list that doesn't actually do anything to your image). Then change the new Levels Adjustment layer's blend mode to Multiply using the pop-up menu at the top of the

Layers panel. Finally, using the layer mask that automatically tags along with every Adjustment layer, paint with a black brush to hide the darkened bits from areas that don't need darkening.

To lighten your image, add another empty Adjustment layer and change its blend mode to Screen. Use the provided layer mask to hide the *light* bits if you need to.

If your image needs to be darker or lighter still, you can duplicate the empty Adjustment layer. To reduce the effect of the darkening or lightening layer, lower its opacity using the field at the top of the Layers panel.

Correcting Images in Camera Raw

As you learned in Chapter 2, Camera Raw is a powerful plug-in that lets you correct the color and lighting of images shot in Raw format, as well as JPEGs and TIFFs. Since most of the settings in Camera Raw are slider-based, it's hands down the easiest place to fix your images (that's why this section comes before the ones covering Levels and Curves, which are, truth be told, 100 times more confusing).

The adjustments you make in Camera Raw are also nondestructive; instead of applying them to your image, Camera Raw keeps track of them in a list it stores within the image or in a file called *Sidecar XMP* (could that name be more cryptic?). Simply put, you can undo anything you've done in Camera Raw whenever you want.

Tip: You can zoom in/out of the Camera Raw preview window just like you can in Photoshop (press ⌘-+/– or Ctrl-+/– on a PC). To move around within your image, press and hold the space bar as you drag with your mouse. You can see a preview of your image by turning on the Preview option at the top right of the window or by pressing the P key.

The Camera Raw plug-in is covered in several places throughout this book; here's a handy cheat sheet:

- Learning more about the Raw format (page 57)
- Opening files in Camera Raw (page 234)
- Cropping and straightening in Camera Raw (page 233)
- Going grayscale in Camera Raw (page 329)
- Editing multiple files in Camera Raw (see the box on page 422)
- Removing dust spots in Camera Raw (page 428)
- Fixing red eye with Camera Raw (page 455)
- Sharpening in Camera Raw (page 480)

In this section, you'll learn how to use various sliders in Camera Raw to fix both color and lighting, plus you'll pick up some tricks to make your images leap off the page with color. And when you're finished adjusting your image in Camera Raw, you can use the buttons at the bottom of the Camera Raw window to do the following:

- Click **Save Images** to convert, rename, or relocate your file(s)—or any combination of those options—so you don't overwrite the original(s).
- Click **Open Images** to apply the changes you've made and open the image in Photoshop, or Shift-click this button to open it as a Smart Object (page 54) in Photoshop.
- Click **Cancel** to bail out of Camera Raw without saving or applying changes.
- Click **Done** to apply the changes (which you can edit the next time you open the image in Camera Raw) and exit the Camera Raw window.

If you use Camera Raw's adjustments in the order they're presented in this section (which is also the order they appear in the Camera Raw window—how handy!), you'll be amazed at the results.

Changing White Balance

When you set the white balance, you're telling Camera Raw which color the light in your image *should be*. As you might suspect, changing the light's color changes *all* the colors in your image, as shown in Figure 9-7. Because each light source gives off its own special color cast—whether it's a light bulb (Tungsten), fluorescent light, a cloudy sky, and so on—most digital cameras let you adjust the white balance based on the current source (though you may have to dig out your owner's manual to find where that setting lives).

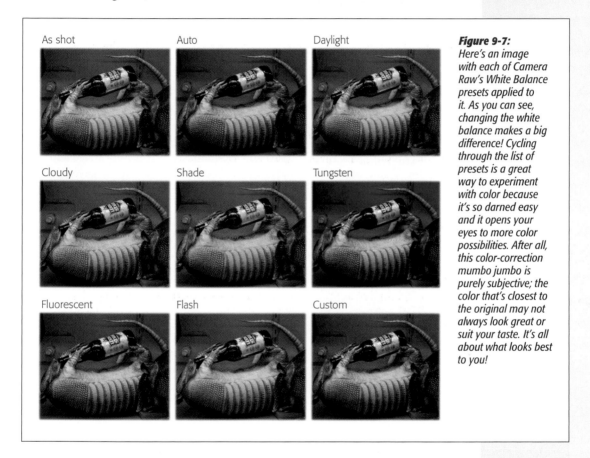

Figure 9-7:
Here's an image with each of Camera Raw's White Balance presets applied to it. As you can see, changing the white balance makes a big difference! Cycling through the list of presets is a great way to experiment with color because it's so darned easy and it opens your eyes to more color possibilities. After all, this color-correction mumbo jumbo is purely subjective; the color that's closest to the original may not always look great or suit your taste. It's all about what looks best to you!

Note: Want to follow along? Visit this book's Missing CD page at *www.missingmanuals.com/cds* and download the practice file *Armadillo.zip*.

One of the big advantages of shooting in Raw format is that if you get the white balance wrong in your camera, you can always reset it using Camera Raw. For example, if you're shooting in an office using a white balance of Fluorescent and then walk outside and shoot in the courtyard, the light's color will be off in the outdoor images. Another advantage is that Raw files store more color info than JPEGs because they're not compressed (which is why Raw files are so much bigger). The point is that if you *can* shoot in Raw, you *should*.

Note: Raw files are like raw cookie ingredients: Before you mix and roll cookie dough into balls and bake it, you've got all kinds of flexibility; you can change the ingredients, add nuts or chocolate chips, and form the cookies into interesting shapes. A JPEG, on the other hand, is like a *baked* cookie; there's very little you can do to it because it's already cooked. Sure you can add a topping or two, but it's much less flexible than the raw (pun intended!) ingredients.

In Camera Raw, you can change the white balance by using the presets in the Basic tab's White Balance pop-up menu. Or you can set it manually (and maybe more accurately) using Camera Raw's White Balance tool (see Figure 9-8). Press I to grab the tool (which looks like an eyedropper) and then mouse over to your image and click an area that *should be* white or light gray. Just keep clickin' till the image looks right, and then adjust the Temperature and Tint sliders until you get the color you want.

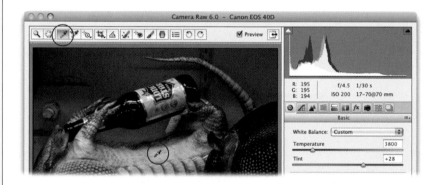

Figure 9-8:
When you're using the White Balance tool, be careful not to click a white reflection, like the one on the Lone Star bottle here. For more accurate color, click an area that's really supposed to be white (or light gray), like this armadillo's underbelly. If you can't seem to get the color quite right, tweak the Temperature slider; dragging it to the right warms up your image and dragging it to the left cools it off. Use the Tint slider to adjust the balance of green and magenta.

Note: You don't have as much flexibility when resetting the white balance of JPEGs or TIFFs because those file formats have already been processed a bit by the camera or scanner that captured them—the only presets Camera Raw gives you are As Shot and Auto. Nevertheless, you can still tweak it by adjusting the Temperature and Tint sliders (doing so changes the White Balance menu to Custom).

Fixing Exposure

The next group of sliders in Camera Raw's Basic tab lets you adjust your image's *exposure* and *contrast* (the difference between light and dark pixels). Exposure is determined by how much light your camera's sensor captures. As you learned on page 368, each image consists of three categories of color: highlights, midtones, and shadows. Problems can arise in one of those categories or all three; luckily, you can fix them all in Camera Raw as the following list explains. If you're not up to fiddling with these six sliders, you can make Camera Raw adjust the image for you by clicking the word Auto above the Exposure slider. But you'll get better results if you adjust the following settings by hand:

Note: If you'd like to follow along, visit this book's Missing CD page at *www.missingmanuals.com/cds* and download the practice file *Keywest.zip*.

- **Exposure.** Drag this slider to the right to lighten your image or to the left to darken it. Be careful not to drag it *too* far either way or you'll start to lose details. For that reason, it's a good idea to turn on Camera Raw's clipping warnings (they look like triangles and are shown at the top right of Figure 9-9) so you can see if you're destroying details. (Press U to turn on the shadow clipping warning and O—that's the letter *o*, not the number zero—to turn on the highlight clipping warning.) It's okay to lose a few details because you can bring them back with the very next setting.

Tip: If you're not a fan of the highlight clipping warnings and don't want to see them all the time, you can *temporarily* see clipped highlights by Option-dragging (Alt-dragging on a PC) the Exposure slider to the right. Your image preview turns black and the clipped areas appear in bright colors as you drag.

- **Recovery.** This aptly named slider recovers lost details in overexposed highlights. If you drag it to the right, you can make the red clipping warnings in your image disappear and get some details back in those areas. If you can't get rid of all the red, drag the Exposure slider a little ways to the left.

- **Fill Light.** This setting is like a digital fill flash (an additional flash that you aim at shadows when you're taking a photo): it lightens the shadowy areas of your image but leaves the highlights alone. Don't get carried away with this adjustment; if you lighten the shadows too much, you'll end up with an image *so* evenly lit that it looks boring and flat.

- **Blacks.** To darken your image's shadows, drag this slider *slightly* to the right. You'll get a bit of a contrast boost, too, though it's best not to go much past 6 (if at all). If you do, the details in your shadowy areas disappear into a big ol' black hole. You can turn on the shadow clipping warning by clicking the triangle at the top left of the histogram (also shown in Figure 9-9) or pressing U. From then on, Camera Raw highlights any clipped areas in blue.

Tip: Just like with the highlight clipping warnings, you can temporarily see clipped *shadows* (while leaving the shadow clipping warning off) by Option-dragging (Alt-dragging on a PC) the Blacks slider to the right. Your image preview turns white, and the clipped areas appear in bright colors as you drag.

- **Brightness.** You can use this slider to adjust the midtones in your image. If you darkened the image by dragging the Exposure setting to the left, drag this one to the right to brighten it back up.

- **Contrast.** Drag this slider to the right to increase your image's contrast (the difference between light and dark pixels) or to the left to decrease it. Increasing contrast makes the light pixels in your image lighter and the dark pixels darker.

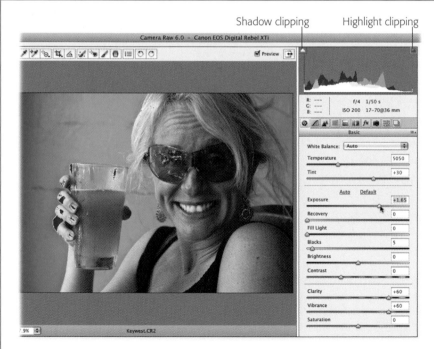

Shadow clipping Highlight clipping

Figure 9-9:
When you turn on the highlight clipping warning by clicking its icon (top right), areas that are losing details—like this woman's hand and her glass—turn bright red. The farther you drag the Exposure slider to the right, the more red areas you see. Don't let this worry you too much because the Recovery slider can bring back most (if not all) of the lost details.

A little known fact is that both clipping warnings appear black if no pixels are being clipped; however, if the shadow clipping triangle turns blue or the highlight clipping triangle turns red, some clipping has occurred.

Making Colors Pop

If you want to intensify your image's colors, give the next three sliders in Camera Raw's Basic tab a tug:

- **Clarity.** This slider boosts contrast in the midtones, increasing the depth so your image looks clearer. You'd be hard-pressed to find an image that wouldn't benefit from dragging this slider almost all the way to the right.

- **Vibrance.** Use this slider to intensify colors without altering skin tones (it has more of an effect on bright colors and less on light colors, like skin tones). If you've got people in your image, this is the adjustment to use (see Figure 9-10).

- **Saturation.** Intensifies *all* the colors in your image, including skin tones. Don't use it on people pictures unless you like fluorescent skin.

Figure 9-10:
As you can see, Camera Raw can greatly improve the color and light in your image. The original, under-exposed image is on top and the end result is on the bottom. That's an impressive result from just dragging a few sliders back and forth!

Tip: To reset *any* slider in Camera Raw back to its original setting, simply double-click the slider.

Camera Raw's Adjustment Brush

The Adjustment Brush lets you selectively adjust certain areas of your images by painting them (see Figure 9-11). When you activate the Adjustment Brush by pressing K, you see a host of adjustments appear on the right side of the Camera Raw window. They're the same adjustments you've learned about so far, along with an extra one called Color that lets you paint a tint onto your image.

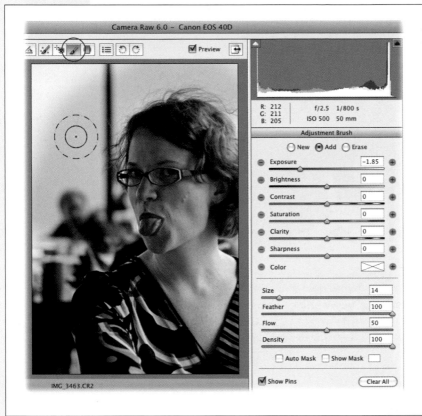

Figure 9-11:
See the dotted line around the brush cursor? It indicates the feather amount, which softens the edge of your adjustment to make it blend in with the rest of the image. The solid line indicates the brush size, and the crosshair lets you know where you're applying the adjustment.

The Flow slider (near the bottom of the window on the right) controls the strength of the adjustment, and the Density slider (just below it) controls the transparency of your brushstroke (think of it as the brush's opacity).

To use the Adjustment brush, choose the type of adjustment you want to make using the sliders on the right, mouse over to your image, and then paint to apply the adjustment. A little green pushpin appears to mark the area you adjusted (though on a PC it looks more white than green); press V to show or hide the pin(s). Behind the scenes, Camera Raw creates a mask that hides the rest of your image so you can continue to tweak the adjustment sliders even after you've finished painting. Camera Raw updates the area you painted to reflect those changes.

You can click the little + and – signs on either end of the adjustment sliders to strengthen or lessen the adjustment (respectively) by a preset amount (.5 on Exposure, whose scale ranges from –4 to +4, and 25 on most other sliders, which range from –100 to +100 [though Brightness ranges from –200 to + 200]). If you want to

see the mask, turn on the Show Mask checkbox beneath the sliders or press Y. You can change the color of the mask's overlay by clicking the little white square to the right of the Show Mask checkbox and then choosing a new color from the resulting Color Picker. Turn on the Auto Mask checkbox to limit your adjustment to brush-strokes that fall on similar-colored areas.

To undo part of the mask, turn on the Erase radio button near the top of the window and then paint that area of your image to remove the adjustment. Likewise, to add to the mask, turn on the Add radio button and then paint your image. To apply a new adjustment to an existing mask, turn on the New radio button. To select the mask, click the pushpin. And if you want to delete the mask, click its pushpin and then press Delete (Backspace on a PC).

Camera Raw's Graduated Filters

The Graduated Filter tool lets you apply adjustments much like a real graduated filter you screw onto the end of your camera lens (the filter is a thin piece of glass that fades from gray to white so it darkens overly bright parts of the scene you're shooting). When you select this tool by clicking its button at the top of the Camera Raw window (it's circled in Figure 9-12) or pressing G, you get the same set of ad-justments you do with the Adjustment Brush (though there's no erase mode). The difference is that, with the Graduated Filter tool, you apply them by dragging rather than painting, as shown in Figure 9-12. This adjustment is great for fixing over-exposed skies because Photoshop gradually applies it across the full width or height of your image in the direction you drag.

Behind the scenes, this tool creates a gradient mask (page 287), which restricts the adjustment to specific parts of your image. You can continue to make adjustments using the sliders at the right of the window even after you've used the tool, and use the little + and – signs on either end of the sliders to strengthen or lessen the adjust-ment, respectively. To draw a perfectly vertical or horizontal mask, press and hold the Shift key as you drag.

More Fun with Camera Raw

As you can see, the Camera Raw plug-in is crazy powerful and each new version is bursting with new features. You can use it to adjust Curves (page 406), softly darken the edges of your image (called *vignetting*; see page 656 to learn how to add a dark vignette with a filter in Photoshop), and much more. Camera Raw deserves a whole book all to itself, and there are plenty of 'em out there. When you're ready to learn more, pick up *Getting Started with Camera Raw, Second Edition* by Ben Long (Peach-pit Press, 2009), a great guide for beginners. Or check out *Real World Camera Raw with Adobe Photoshop CS4* (Peachpit Press, 2008) by Jeff Schewe and Bruce Fraser. If you'd rather learn by watching a video, check out Ben Willmore's *Mastering Camera Raw* DVD available at *www.digitalmastery.com*.

Using Levels

The adjustments you've seen so far are okay when you're starting out with Photoshop, and they're darn handy when you're pressed for time. But to become a real pixel wrangler, you've got to kick it up a notch and learn to use *Levels* and *Curves*. With a single Levels adjustment, you can fix lighting problems, increase contrast, and—in some cases—balance the color in your image. (If you've got *serious* color problems, you need to use Curves; skip ahead to page 406 to learn how.) Levels adjustments change the intensity levels—hence the tool's name—of your shadows, midtones, and highlights. They're a very visual and intuitive way to improve your images. And because they're available as an Adjustment layer (yay!), they're non-destructive and won't harm your original image.

In this section, you'll learn how to use Levels adjustments in a few different ways so you can pick the one you like best. But, first, you need to get up close and personal with the mighty *histogram*, your secret decoder ring for interpreting problems in your images.

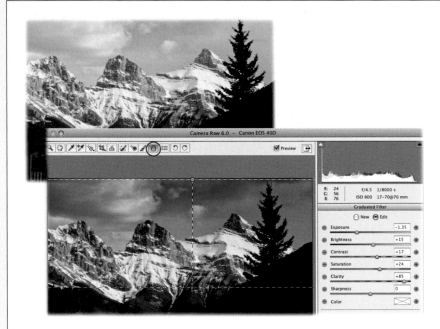

Figure 9-12:
You can use the Graduated Filter tool to darken and intensify this sky gradually. The horizontal dotted line that runs through the green dot represents the start of the mask, and the similar line running through the red dot represents the end. To delete the mask, click the red dot and then press Delete (Backspace on a PC).

To move the midpoint of the mask (where the adjustment begins to fade), drag the red dot up or down.

Histograms: Mountains of Information

A histogram (Figure 9-13) is a visual representation—a collection of bar graphs, to be specific—of the info contained in your image. Once you learn how to read it, you'll gain an immensely valuable understanding of why your image looks the way

it does. More importantly, you'll learn how to tweak the histogram itself or, more commonly, other tools—all of which lets you use the histogram's changing readout to monitor the vibrancy of your image. It sounds complicated, but once you watch it in action, you'll see it's actually pretty straightforward…and tremendously powerful.

Photoshop automatically displays an editable histogram when you create either a Levels (page 390) or Curves (page 406) Adjustment layer. You can also summon one by choosing Window→Histogram to open the Histogram panel shown in Figure 9-13.

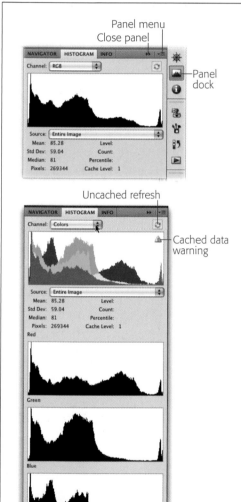

Panel menu
Close panel
Panel dock

Uncached refresh
Cached data warning

Figure 9-13:
Photoshop gives you three different ways to view the histogram (each of which is listed in the Histogram panel's menu): Expanded View (top), honkin' big All Channels View (bottom), Compact View (not shown).

In All Channels View (bottom), you can see your image's individual channels in their respective colors by choosing "Show Channels in Color" from the panel's menu. (In this figure, the channels appear in black.) You can also control how the histogram looks by using the Channel pop-up menu at the top of the Histogram panel. Choosing RGB turns the histogram black (top), and choosing Colors puts it in full color (bottom). You can choose the other options (Red, Green, and Blue) to see info in just those channels.

The cached data warning triangle (labeled) means that the histogram's info isn't based on the current version of your image (the cache is part of your computer's memory). You'll see this warning periodically when you're editing large files (it's Photoshop's way of redrawing the histogram more quickly). Just click the triangle to make Photoshop update the histogram; clicking the Uncached Refresh button at the top right does the same thing.

The histogram looks like a mountain range, which is a perfectly fine way to think about it (more on that metaphor in a moment). Its width represents your image's *tonal range*—the range of colors between the darkest and lightest pixels—on a scale of 0 to 255. Pure black (0) is on the far left and pure white (255) is on the far right. All told, the histogram measures 256 values. If that number sounds familiar, it should— it's the same 256-value range you learned about back in Chapter 2 (page 46), which represents the minute gradations between a total absence of light (black) and full-on illumination (white). The histogram's height at any particular spot represents how many pixels are at that particular level of brightness. Using the mountain analogy, a noticeable cluster of tall and wide mountains means that particular brightness range makes up a good chunk of your image. Short or super-skinny mountains mean that brightness range doesn't appear much. And a big, flat prairie means there are few or no pixels in that range. A glance at the histogram, in other words, can tell you whether you've got a good balance of light and dark pixels, whether the shadows or highlights are getting clipped (page 386), whether the image is over- or underexposed (see Figure 9-14), and whether it's been adjusted before.

Figure 9-14:
The histograms in the bottom row can help tell you whether an image is underexposed (left), has a good balance of color (middle), or is overexposed (right).

Note: The histogram's width is also referred to as the image's *dynamic range*. You'll learn more about it in the High Dynamic Range (HDR) section later in this chapter (see page 414).

Here are a few tips for understanding your histogram:

- An extremely jagged mountain range means your color info is unbalanced. Your image may contain a decent amount of some colors but very little of others.

- A narrow mountain range means you've got a narrow tonal range and little difference between the darkest and lightest pixels. Your whole image probably looks rather flat and lacks both details and contrast.

- If you see a sharp spike at the left of the histogram, your shadows have probably been clipped (by the camera or scanner). If the spike is at the right end of the histogram, your highlights may have been clipped instead.

- If the mountain range is bunched up against the left side (toward black, a.k.a 0) with a vast prairie on the right, your image is underexposed (too dark); see Figure 9-14, left.

- If the mountain range is snug against the right side (toward white, a.k.a 255) with a vast prairie on the left, your image is overexposed (too light); see Figure 9-14, right.

- An image that has a good balance of light and dark colors has a wide mountain range—one that spans the entire width of the histogram—that's fairly tall and pretty uniform in height. Basically, you want your histograms to look like the older, eroded Appalachians (Figure 9-14, middle) instead of the newer, super-jagged peaks of the Himalayas (Figure 9-14, right).

- If your histogram looks like a comb—with a bunch of gaps between spikes (see Figure 9-16)—it's either a really lousy scan or the image was adjusted at some point in the past. Anytime you shift the brightness values of pixels, you introduce gaps.

All this histogram and correction business is subjective; if your histogram looks terrible but the image looks great to you, that's fine—in the end, that's all that matters.

Thankfully, you can fix a lot of the problems listed above using the correction methods discussed in this chapter. You can smooth the height of the histogram's mountains to balance color and widen the mountain range to expand your tonal range and increase contrast. And by keeping the Histogram panel open, you can see before and after histograms of any adjustment whose dialog box has a preview checkbox (Shadows/Highlights, Color Balance, Variations, and so on). If you choose RGB from the Channel pop-up menu at the top of the Histogram panel, you see the original histogram in light gray and the new one in black.

If the whole histogram concept is clear as mud, don't fret—it'll make more sense once you start using Levels. If you've got a little free time, you can use the Dodge and Burn tools to help you understand the relationship between what you see in your image and how the histogram looks. With an image and the Histogram panel open, use the Dodge and Burn tools on different areas of your image (be sure to set the tools' Exposure fields to about 20 percent). Use the Dodge tool to lighten dark areas and see how the histogram changes, and then use the Burn tool to darken light areas and see how that affects it. With a little experimentation, you can get a clearer idea of what your histograms are telling you.

Tip: Many digital cameras can also show you a histogram, though you may have to root through your owner's manual to learn how to turn it on. Once you get comfy with histograms, you can use them to see whether the shot you're about to take will have good exposure.

POWER USERS' CLINIC

Histogram Statistics

If you choose Expanded View or All Channels View from the Histogram panel's menu, you'll see a bunch of cryptic info below the histogram. The most useful thing that appears is the Source pop-up menu, which lets you see the histogram of your whole image, a selected layer, or an *adjustment composite*. If your document contains Adjustment layers, that last option displays a histogram based on the selected Adjustment layer and all the layers below it. (See page 77 for more on Adjustment layers.)

The stuff that appears below the Source menu is pretty heady, but here's the gist of what each item means:

- **Mean** represents the average intensity value of the pixels in your image.
- **Standard Deviation** (abbreviated as Std. Dev.) shows how widely the intensity values vary.
- **Median** is the midpoint of the intensity values.
- **Pixels** tells you how many pixels Photoshop analyzed to generate the histogram.

- **Cache Level** shows the current image cache Photoshop used to make the histogram. When this number is higher than 1, Photoshop is basing the histogram on a representative sampling of pixels in your image rather than on all of them. You can click the Uncached Refresh button (shown in Figure 9-13) to make the program redraw the histogram based on the actual image.

If you position your cursor over the histogram (or drag across part of it), you also see values for the following:

- **Level** displays the intensity level of the area beneath your cursor.
- **Count** shows the total number of pixels that are at the intensity level beneath your cursor.
- **Percentile** indicates the cumulative number of pixels at or below the level beneath your cursor, expressed as a percentage of all the pixels in your image.

Math geeks, bless their hearts, love this kind of stuff.

The Levels Sliders

Now that you know how to read histograms, you're ready to make a Levels adjustment, which lets you use a set of three sliders to reshape and expand the information in your histogram. You can create a Levels Adjustment layer by clicking the Levels button in the Adjustments panel (it looks like a tiny histogram) or clicking the half-black/half-white circle at the bottom of the Layers panel and choosing Levels from the resulting list. Either way, Photoshop displays a black histogram in the Adjustments panel, as shown in Figure 9-15.

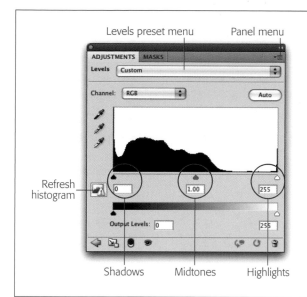

Levels preset menu Panel menu

Refresh histogram

Shadows Midtones Highlights

Figure 9-15:
The simplest way to apply a Levels adjustment is by using the Input Levels sliders circled here. You'll also find a slew of presets in the Levels pop-up menu at the very top of the panel. Feel free to give them a spin to see what they do and how they change your histogram.

You can also add a Levels adjustment by pressing ⌘-L (Ctrl+L on a PC) or by choosing Image→Adjustments→Levels, though in both cases the adjustment happens on your original image instead of on an Adjustment layer. Yikes!

As shown in Figure 9-15, the black slider at the far left of the histogram represents the shadows in your image. It starts out at 0, the numeric value for pure black. The white slider on the far right, which represents highlights, starts out at 255—pure white.

To give your image the greatest tonal range and contrast, move the shadows and highlights sliders so they point to wherever your histogram's values begin to slope upward (at the foot of your mountains, so to speak). In other words, if there's a gap between the shadows slider and the beginning of the histogram, drag that slider to the right. If there's a gap between the highlights slider and the right end of the histogram, drag the slider to the left. Figure 9-16 should make all this repositioning stuff crystal clear.

When you move the sliders, Photoshop adjusts the tonal values in your image accordingly. For example, if you drag the highlights slider inward to 183, Photoshop changes all the pixels in your image that were originally at 183 or higher to 255 (pure white). Translation: They get brighter (see Figure 9-16). Similarly, if you move the shadows slider inward to 7, Photoshop darkens all the pixels with a brightness level of 7 or lower to 0 (pure black). The pixel levels in between get redistributed, too, boosting your image's overall contrast by increasing its tonal range (widening your mountain range).

The gray slider in the middle (midtones) lets you brighten or darken the image by changing the intensity of the middle range of grays (check out the box on page 406 to learn why you're dealing with grays instead of color). Drag it to the left to lighten your image or to the right to darken it. Because the gray slider focuses on the midtones, it won't make your highlights too light or your shadows too dark—unless you go hog wild and drag it all the way left or right!

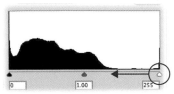

RGB (composite) channel

Red channel

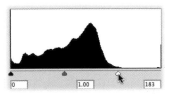

Green channel

Figure 9-16:
Left: Near the top of the Histogram panel is the Channel pop-up menu, which lets you view and adjust the composite channel (page 189) or each channel individually. If each channel's histogram differs, it's worth adjusting each one separately; if the histograms are almost identical, you can get away with adjusting only the composite channel. Here you see the composite and color channel histograms for an RGB image. Since the gaps on the right side vary quite a bit, you should adjust each channel separately. Be careful not to drag the sliders too far in, or you'll make parts of your image pure black or pure white. (Unfortunately the Levels sliders don't refer to the target values you set back on page 397.)

Right: Here you can see the before (top) and after (bottom) versions of the image, along with the new composite channel histogram. Notice how the mountain range has become flatter and much wider overall; that means the image's tonal range has expanded. You can tell this image has been adjusted from its original state because the new histogram looks like a comb: lots of vertical lines with gaps in between.

Tip: If you hold down the Option key (Alt on a PC) as you drag the shadows or highlights sliders, you can see which parts of your image you're forcing to pure black or white. When you Option-drag (Alt-drag) the shadows slider to the right, your image turns completely white. The darkest parts of the image begin to reappear as you drag, first in black and then in other colors.

If you Option-drag (Alt-drag) the highlights slider to the left, the opposite happens: Your image turns completely black, and the lightest parts are the first ones to reappear, first in white and then in color. Option-dragging is a great way to tell if you're dragging the sliders too far because whatever areas are visible while you Option-drag (Alt-drag) are the areas that will be pure black or pure white. It's also a great trick for finding the lightest highlights and darkest shadows, as the next section explains.

Output levels

The black-and-white bar near the bottom of the Levels Adjustments panel (shown in Figure 9-15) includes a couple of sliders you can use to control the color of the black pixels and white pixels in your image. Drag the black slider to the right to lighten the pure-black pixels or the white slider to the left to dim the pure-white pixels. These adjustments used to be crucial if you were sending grayscale images to a commercial press because the printing process was notorious for making highlights too light and shadows too dark. Nowadays, if you use good-quality color profiles (page 667), these adjustments aren't such a big deal, but knowing how to change the way your blacks and whites look when they're printed is still useful if you can't trust your printer to print highlights and shadows properly.

The Levels Eyedroppers

Another way to adjust Levels is to use the eyedroppers on the left side of the Levels Adjustments panel (see Figure 9-15). Instead of dragging the sliders directly below the histogram, you can use the eyedroppers to sample pixels that should be black (the darkest shadows that contain details), those that should be white (the lightest highlights that contain details), or neutral gray (midtones). If you use this method, Photoshop adjusts the sliders for you. The only problem is that it can be darn tough to figure out which pixels to sample, but you can use a couple of tricks to solve this problem, as you'll learn shortly. With an image open, follow these steps:

1. **Grab the Eyedropper tool and change the Sample Size pop-up menu to "3 by 3 Average".**

 Press I to activate the Eyedropper tool. Because you're about to use the eyedroppers to reset your black and white points, you need to change the way the tool measures color (the eyedroppers in Levels and Curves adjustments use the main Eyedropper tool's settings). In the Options bar, the Sample Size pop-up menu is automatically set to Point Sample, which means the Eyedropper samples exactly one pixel when you click with it. By changing the sample size to "3 by 3 Average", you tell Photoshop to average several pixels around the spot where you click, which is much better for color-correcting.

Tip: If you have the Eyedropper or Color Sampler tool (see Appendix D) selected, you can open a Sample Size shortcut menu by Ctrl-clicking (right-clicking on a PC) anywhere in your image. If you're working with extremely high-resolution files, the pixels are so tiny and so tightly packed that you may want to increase the sample size to, say, 51 by 51 or higher. See page 238 in Chapter 6 for more on resolution.

2. **Create a Levels Adjustment layer.**

 Click the half-black/half-white circle at the bottom of the Layers panel and choose Levels from the pop-up menu that appears. Photoshop adds an Adjustment layer to your Layers panel and opens the Adjustments panel.

3. **In the Levels Adjustments panel, click the black eyedropper.**

 The left side of the Levels Adjustments panel sports three eyedroppers. The black one resets your image's black point (shadows), the gray one resets the gray point (midtones), and the white one resets the white point (highlights). Simple enough!

4. **Mouse over to your image and click an area that should be black.**

 Though in most cases, it's pretty obvious which parts of your image should be black, sometimes it's hard to tell, and you need to consider a few things before you click. First, you want to pick an area near your image's focal point (the spot you want your viewer to focus on). For example, if you're correcting a portrait, find a dark shadow near your subject's face. Second, try to pick an area with some details in it instead of one that's pure black; if it's pure black, there's probably nothing there!

 If you need help figuring out where the darkest pixels in your image live, click to select the black eyedropper first, and then hold down the Option key (Alt on a PC) as you drag the Levels Adjustments panel's shadows slider (see Figure 9-17) to the right. At first, your image turns completely white, but as you continue to drag, Photoshop displays neon-looking color in some areas. The first colored area that appears is the darkest spot in your image. While holding down the Option key (Alt), mouse over to your image and then click that spot with the black eyedropper. When you mouse away from the Adjustments panel, your image goes back to its regular color, but as soon as your cursor hovers over your actual image in the document window, it'll go back to funky neons.

Note: If you'd like to play around with the image shown in Figure 9-17, download the file *Bridge.jpg* from this book's Missing CD page at *www.missingmanuals.com/cds*.

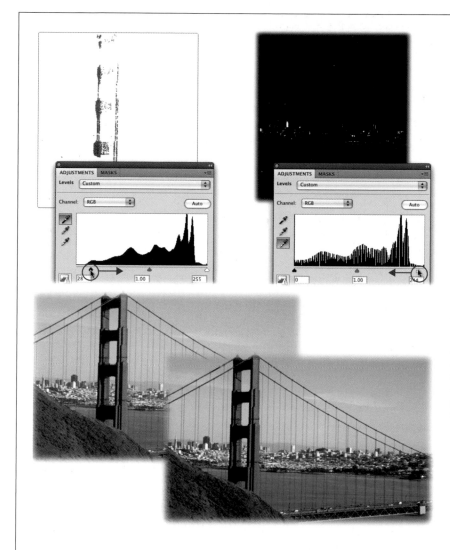

Figure 9-17:
Top: Here's a trick you can use to find the darkest and lightest pixels in your image: In the Adjustments panel, Option-drag (Alt-drag on a PC) the shadows slider (remember, that's the one on the left) to the right. The first areas to appear in your image are the darkest. Likewise, when you Option-drag (Alt-drag) the highlights slider to the left, the first colors to appear are the lightest. Just don't forget to drag the sliders back where they were when you're done!

Bottom: As you can see, a little Levels adjusting can go a long way toward improving your image's color and contrast.

Tip: You can also use the Info panel to see the value of the dark pixels in your image so you can pick one that's not pure black (which is zero). Skip to the next section (page 401) for details.

When you click, you'll probably see the colors in your image shift a bit. If you don't like the results, click somewhere else to set a *new* black point or undo your click by pressing ⌘-Z (Ctrl+Z on a PC).

5. **In the Adjustments panel, click the white eyedropper and then click an area in your image that should be white.**

The same rules apply when it comes to choosing a new white point as choosing a black one: Try to pick an area that's close to the focal point and not pure white (because a pure white one doesn't have any details). You also don't want to pick a reflection from a light source as your white point because it's not a true white. You can use the same Option-drag (Alt-drag on a PC) trick to find the lightest highlights, though this time you'll need to click to select the white eyedropper and the image turns completely black. As you drag the highlight slider to the left, the first areas that appear in color are what you're after.

WORKAROUND WORKSHOP

Good Gray Hunting

Alas, if you're looking for a neutral gray to click with the gray Levels or Curves eyedropper and nothing in your image is gray, there's no quick trick for finding a good gray. Some images don't even *have* any neutral grays.

One way to look for them is to open the Info panel (Figure 9-18) and then hover over areas that appear gray with the Eyedropper tool (see Appendix D) and look for nearly equal RGB values (like R: 222, G: 222, B: 224, for example). When you find matching RGB values, you've found a neutral gray.

The Info panel method works just fine if you've got a few extra hours to spend mousing around your image checking pixel values. But if you're pressed for time, here's a foolproof way to hunt them down—if they actually exist in your image. Photoshop guru Dave Cross (*www.davecross.blogspot.com*) came up with this technique—and he's graciously given permission to include it here for your reading enjoyment. With the image you want to search open, follow these steps:

1. Create a new layer by clicking the "Create a new layer" button at the bottom of the Layers panel. Make sure this layer sits *above* the image layer.

2. Fill the new layer with gray by choosing Edit→Fill and then choosing 50 percent Gray from the Use pop-up menu and clicking OK.

3. Use the pop-up menu at the top of the Layers panel to switch the gray layer's blend mode from Normal to Difference (page 301). Your photo now looks really funky, but don't panic; this layer won't live long.

4. Create a Threshold Adjustment layer by clicking the half-black/half-white circle at the bottom of the Layers panel and choosing Threshold from the resulting list.

5. In the Adjustments panel, drag the Threshold slider all the way to the left until the image turns solid white and then slowly drag it back to the right. The first areas that appear black are your neutral grays. As soon as you see a good-sized black spot, stop dragging.

6. Mark the spot with the Color Sampler tool (see online Appendix D): Press Shift-I to activate the tool (it looks like an eyedropper with a tiny circle above it), and then click once in the black spot. A tiny circle with the number 1 next to it appears where you clicked. Feel free to mark more than one spot if you'd like; the Color Sampler tool lets you set up to four markers.

7. Delete both the Threshold adjustment layer and the gray layer (you don't need them anymore). Shift-click to select them both and then press Delete (Backspace on a PC).

That's it! With the neutral gray point marked, you don't have to wonder where to click with the gray eyedropper in a Levels or Curves adjustment. To delete the marker once you've set your gray point, grab the Color Sampler tool, mouse over the marker, and Option-click (Alt-click) it. Your cursor turns into the tiniest, cutest pair of scissors you've ever seen.

6. **Select the gray eyedropper and then click an area that should be neutral gray, meaning the pixels are about 50 percent gray and have nearly equal color values.**

 Unfortunately, the Option-drag (Alt-drag) trick doesn't work on midtones, but if you're willing to jump through a few hoops, you can track down your neutral gray. The box on page 400 has the details.

7. **To see before and after versions of your image, turn off the Levels Adjustment layer's visibility.**

 In the Layers panel, click the visibility eye to the left of the Levels Adjustment layer to turn it off and see whether your adjustment made a difference.

Correcting by the Numbers

Ever heard the phrase, "Numbers don't lie"? That old adage applies to color correction in Photoshop, too: Using numbers helps you take the guesswork out of it. Instead of relying on what looks good to your naked (and possibly sleepy) eye, you can use the pixels' color values to balance your image's color perfectly.

To see pixels' color values, you need to open the Info panel (page 26) by choosing Window→Info. Once you open this panel, which lists all kinds of data about the pixels in your image, you can mouse over your image with any tool to see (in the left-hand quadrant of the panel) a numeric value for the particular pixel your cursor is hovering over (see Figure 9-18). For RGB images (page 193), you'll see a value for R, G, and B. If you're in CMYK mode (page 195), you see C, M, Y, and K values; in Lab mode you get L, a, b; and so on. (You also see C, M, Y, and K values in the right-hand quadrant when you're in RGB mode, which is useful if you need to keep an eye on the values of one mode while you're working in another.)

In RGB mode (which is where you spend the majority of your time), these values correspond to the 0–255 scale you learned about earlier in this chapter and in Chapter 2 (page 46). Depending on the color of the area you hover your cursor over, the numbers may lean more toward one channel than the others. For example, when you hover over a pixel in a sky, your B (blue) value spikes higher than the R or G (red or green) values. When you hover over reddish skin, the R value is higher than the B or G values. This info is useful in several situations:

- **You can use it to figure out what's causing a color cast.** For example, if you're hovering over a white cat and the blue value is really high, you have a problem in the blue channel. If the green value is off the charts, then that's where the problem is.

- **The Info panel can help you find the darkest and lightest pixels when you're making a Levels (page 390) or Curves (page 406) adjustment.** As you learned in the previous pages, you don't want to choose shadows or highlights that are pure black or pure white because they lack details. If you hover over the area you're considering, you can see if it's really pure black (0, 0, 0) or pure white (255, 255, 255).

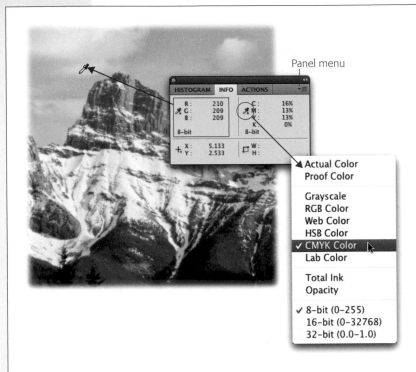

Panel menu

Figure 9-18:
The Info panel has four quadrants that you can change to display values in other color modes. Click one of the little eyedroppers (circled) to summon this pop-up menu and then click the color mode you want to see info for. If you happen upon a gray area with (nearly) equal RGB values like the ones shown here, congratulations—you've found a neutral gray!

Tip: If you're mousing around a shadowy area and the numeric values in the Info panel keep changing, that means there are details lurking in that spot. If you lighten the shadows (page 378), you may be able to bring them out.

- **Monitoring these values can keep you from overadjusting your image and losing details.** For example, since you know that three 0s means pure black and three 255s means pure white, you can take care that pixels in the important parts of your image don't reach those values when you're making an adjustment. You can use the Color Sampler tool, with the Info panel, to monitor the original and adjusted values of up to four sample points by following the steps below.

Here's how to correct an image in RGB mode by the numbers:

1. **Open the Info panel by choosing Window→Info or pressing F8.**

 As you hover your cursor over various parts of your image, watch how the Info panel's numbers change to reflect the pixel underneath the cursor.

2. **Grab the Color Sampler tool and make sure the Sample Size is set to "3 by 3 Average".**

 Press I to activate the Eyedropper tool and then press Shift-I to switch to the Color Sampler tool (it lives in the same toolset). Take a peek in the Options bar and make sure the Sample Size pop-menu is set to "3 by 3 Average".

3. **Create a Levels Adjustment layer.**

 Click the half-black/half-white circle at the bottom of the Layers panel and choose Levels, or click the Levels button in your Adjustments panel. Technically, you don't *have* to create this layer just yet, but if you've already got a Levels adjustment open, you can use the Option-drag (Alt-drag on a PC) trick (page 399) to help you find the highlights and shadows points in the next two steps.

4. **Mark the lightest highlight in your image.**

 Following the guidelines explained in the previous section (starting on page 397), locate the lightest highlight and click it once with the Color Sampler tool. Photoshop adds a marker to your image like the ones shown in Figure 9-19.

Tip: Strictly speaking, you don't have to choose the Color Sampler tool to set sample point markers. If you're using the Eyedropper tool, you can Shift-click to set a marker and Option-Shift-click (Alt-Shift-click on a PC) the marker to delete it.

5. **Mark the darkest shadow in your image.**

 Again, use the criteria described on page 397 to choose a shadow point and then click once to mark it (you'll see a little 2 next to the mark, as shown in Figure 9-19).

6. **Using the Levels histogram, adjust each channel's highlight value.**

 Your goal in fixing the highlights is to make all three channels' values match the *optimal* highlight value, which—as you know from step 8 on page 370—is 245. To balance your channels' highlight values, you have to adjust the highlight in *each* channel. Over in your Adjustments panel, use the Channel pop-up menu to pick a channel and, while watching the numbers in the Info panel, drag the highlights slider (Figure 9-15, page 395) to the left until it reaches 245, or just type *245* into the slider's text field. Repeat this step for the other channels. When all three channels' highlight values are nearly or exactly equal, you've got yourself a balanced image (well, in the highlights at least!).

7. **Adjust each channel's shadow value.**

 Use the same process to balance your shadows: Choose each channel in your Adjustments panel and drag the shadows slider inward until it reaches 10, or type *10* into the slider's text field.

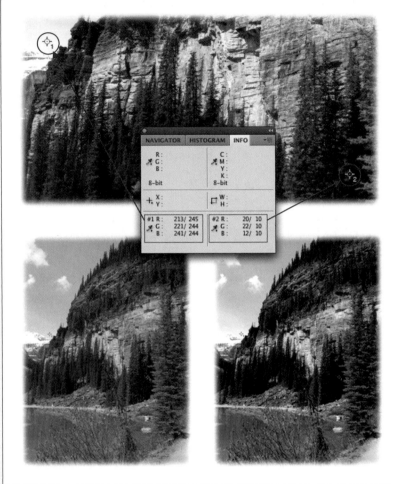

Figure 9-19:
Top: By setting sample point markers (circled), you can monitor the value of your pixels before and during an adjustment (in your Info panel, the two values are separated by a slash).

Bottom: As you can see in these before (left) and after (right) versions, making adjustments based on the Info panel's data took care of the image's blue color cast and improved its contrast.

8. **Adjust your image's midtones, if necessary.**

You don't always have to adjust your midtones since your image may look just fine the way it is (though you may not realize how much better it *could* look!). In your Adjustments panel, select the composite channel (RGB) and drag the gray slider to the left to lighten your image, or to the right to darken it.

9. **Take a peek at the "before" version of your image by turning off the Levels Adjustment layer's visibility.**

In the Layers panel, click the Levels Adjustment layer's visibility eye to hide that layer so you can see what a difference your changes have made.

If you need to go back and make further adjustments, just double-click the Adjustment layer in the Layers panel. As you can see in Figure 9-19, this technique makes a big difference.

Tip: When you're using the Info panel, it can help to rearrange the various panels in your workspace. If you really dig having the Info and Histogram panels open—and you will once you get used to using them—you can create a custom workspace so they automatically open and appear wherever you'd like. Flip back to page 18 to find out how.

Color-Correcting Skin

You're not limited to monitoring the Info panel's values of highlights and shadows; you can slap sample points anywhere you want. If you're correcting a people picture, you most certainly want to monitor the values of skin tones. While you won't find any magic target values that work for *every* skin type, here are a few tips that can help you make sure your skin tones at least look human, which is (hopefully!) your goal:

- When you're color-correcting photos of women, place sample points on your subjects' necks if you can. Women don't typically put makeup on their necks, so you get a more accurate reading of the woman's *real* skin tone based on her neck than you would on, say, her cheek.

- Skin tones should have red values greater than their green values and green values greater than their blue values. This rule is easy to remember because that's the order of the letters in RGB. (To learn about switching between CMYK and RGB modes, see Chapter 16.)

- The difference between the red and green values in skin should be about double the difference between the green and blue value. For example, if the difference between the red and green values is 60, the difference between the green and blue values should be around 30.

- The fairer a person's complexion, the closer the RGB values should be to each other.

- The darker their complexion, the lower the blue value in their skin should be.

By following these guidelines, you should end up with nicely balanced skin colors in your images. And if you'd like to use a color swatch as a reference, you can find skin tone color charts lurking on the Web. An oldie but goodie is Bruce Beard's skin tone and hair color chart, available at *www.retouchpro.com/pages/colors.html*.

There Is No Color

What's all this talk about black, white, and gray? I'm trying to fix color!

Consider this concept: There *is* no color in Photoshop, so you can't use the program to *fix* color.

After you clean off the coffee you just splurted on your screen, take a moment to think about the channel information you learned about in Chapter 5. Remember how Photoshop displays it all in grayscale (page 190)? That's because the information really *is* grayscale; that is, until it hits your monitor. All color is created by output devices like your monitor, printer, and professional printing presses (which you'll learn more about in Chapter 16). Your computer (and the programs on it like Photoshop), your digital camera, and your scanner are all digital devices; all they really understand are *bits*, which represent either zero or one (see the box on page 45). When you send these bits to an output device, the device assigns color values to that information.

If you can wrap your brain around this mind-bending concept, a few things start to make sense. For example:

- **Why it's so hard to match what you see on-screen with what you print.** When you realize that the output device is responsible for how the bits are translated into color, you understand why it's such a nightmare getting colors to match across devices that work differently (like LCD and CRT monitors) or

that use different inks (like inkjet printers and printing presses). Chapter 16 has more on *color management*, the science behind matching colors.

- **Why color-correction tools like Levels and Curves focus on white, gray, and black values.** Since you're working with grayscale info, it makes sense that, to change a grayscale image, you have to change what Photoshop thinks should be black, neutral gray, or white (or change the intensity or brightness values) to alter the image. Shades of gray are all that matter when you're correcting in Photoshop.

- **Why the histogram measures color intensity (brightness) on a scale from 0 to 255.** A typical RGB image has 256 shades of gray, which correspond to brightness values of 0 percent to 100 percent gray. You see this 0–255 scale in the Info panel when you hover over pixels in an RGB image (page 46). Each pixel has a value ranging from 0–255 for each channel.

All this talk of grayscale can sound pretty abstract since we see in color, not grayscale. But what it boils down to is that your *real* goal in color-correcting images is to get the *grayscale* information right. Once you do, your output device has a much better chance of getting the colors right. Now go refill that coffee cup!

Working with Curves

The last stop on the Color Correction Express is Curves, the most powerful—and fear-inducing—adjustment in all of Photoshop. The basic idea is that, by curving a diagonal line on a grid, you change the brightness of the pixels in your image. Instead of the three main adjustment sliders you get with Levels (shadows, highlights, and midtones), Curves give you up to *16* adjustments. But that's not as scary as it sounds. If you arrived here relatively unscathed after getting through the section on Levels (page 390), you already know a *ton* about using Curves. For example:

- You can use Curves as an Adjustment layer so that it's nondestructive (whee!), which means you can also use the included layer mask to restrict the adjustment to certain areas of your image. The Curves grid shows up in the Adjustments panel, just like Levels.

- A Curves adjustment uses a histogram (page 390) and the same 256 shades of gray you saw in Levels (see the box on page 400). It also has the same shadows and highlights sliders (though no midtones slider), and it harbors the same trio of eyedroppers for resetting the black, white, and midtone points (page 397). So far so good!

- You can Option-drag (Alt-drag on a PC) the shadows and highlights sliders to find the darkest and lightest areas of your image, like you learned on page 399.

- You can use Curves to correct your image using the Info panel and the Color Sampler tool, and you can type target values into the Input field. To summon the Input field (shown in Figure 9-20), click a point on the curve. If you haven't added any points yet (which you'll learn about shortly), you can click either the shadows or highlights slider beneath the grid to activate the corresponding *curve point* at the tip of the diagonal line.

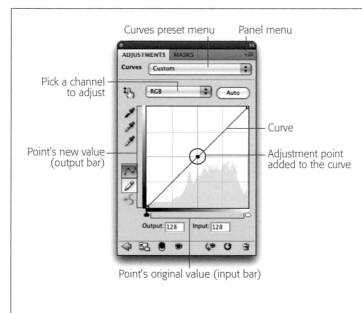

Curves preset menu Panel menu

Pick a channel to adjust

Point's new value (output bar)

Curve

Adjustment point added to the curve

Point's original value (input bar)

Figure 9-20:
Photoshop's Curves tool is incredibly flexible—and that's what scares most folks: They don't know when, how, or why to add adjustment points or in which direction to move them. Fear not: You'll learn everything you need to know about this powerful tool in the following pages.

Once you know how to add a point to the curve (which isn't actually curved yet it's a straight line here), you can use the grayscale bars on the left and bottom of the grid to figure out which direction you need to drag the point. You can follow a point down the grid to see its original brightness value (on the input bar) and you can follow it to the left to see its new brightness value (on the output bar). After you click a point on the curve, those numeric values also appear in the Output and Input fields below the curve.

- You can use the pop-up menu at the top of the Adjustments panel to the left of the Auto button (shown in Figure 9-20) to adjust individual channels with Curves, just like with Levels.

- You'll find a few presets in the pop-up menu at the top of the Adjustments panel, some of which are quite useful (also shown in Figure 9-20). It's worth taking them for a spin just to see how they affect both the curve and your image.

To create a Curves Adjustment layer, click the Curves button in the Adjustments panel (it looks like a grid with an S curve on it) or the half-black/half-white circle at the bottom of the Layers panel and choose Curves. Your Adjustments panel pops open to reveal a grid with a diagonal line running from the bottom-left corner to the top-right corner (see Figure 9-20).

The diagonal line in the middle—which is the actual *curve* even though it starts out straight—represents the original brightness values (tonal range) of your image. To adjust your image's brightness values, you can place up to 14 points along the diagonal line. (You can't delete the original points at either end of the curve, but you can adjust them like any other point.)

Add a point to the curve by clicking the line itself or by using the Targeted Adjustment tool and clicking your image (Figure 9-21 explains how that maneuver works). Each point you place on the line corresponds to a brightness value in the horizontal black-to-white gradient bar below the grid (called the *input bar*). The direction you drag a point determines whether the brightness of pixels in that tonal range increases or decreases: Drag *upward* to *increase* brightness or *downward* to *decrease* it. (Even if nothing else about Curves makes sense, that part certainly does!)

Note: To try your hand at the Curves adjustments described in this section, download the image *Hiking. jpg* (shown in Figure 9-21) from this book's Missing CD page at *www.missingmanuals.com/cds*.

Ben Willmore (*www.digitalmastery.com*) compares Curves adjustment points to a row of dimmer switches, which makes perfect sense if you think about how a dimmer switch works. Just as turning up a dimmer switch gradually turns up the light, raising a point on the curve gradually makes your image brighter and lighter. Likewise, just as lowering a dimmer switch gradually turns down the light, lowering a point on the curve makes your image darker. It's a great analogy because the adjustments you make in Curves are as gradual as using a dimmer switch; you generally don't have to move a point very far to introduce a big change. As you move a point, the diagonal line curves in the direction you drag, and you can see its new brightness level represented on the out put bar (the vertical gradient bar on the grid's left side), as shown in Figure 9-21, bottom.

Tip: Instead of dragging the adjustment points around, you can nudge them with the up and down arrow keys on your keyboard. It's easier to make precise adjustments this way, and it keeps you from accidentally changing contrast (discussed in the next section) by dragging the point to the left or right. Use the up arrow to brighten your image and the down arrow to darken it.

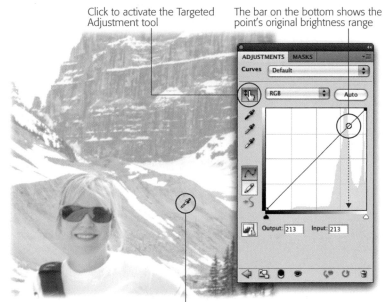

Click to activate the Targeted Adjustment tool

The bar on the bottom shows the point's original brightness range

Clicking automatically sets an adjustment point on the curve

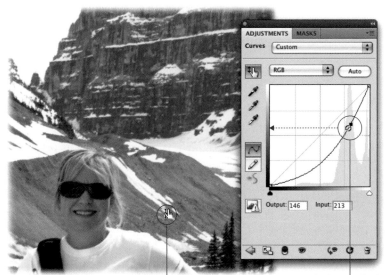

While holding down your mouse button, drag up or down to adjust the curve

The bar on the left shows the new brightness range

Figure 9-21:

Top: Curves is a lot easier to use than it used to be thanks to the Targeted Adjustment tool (circled, left), which lets you add and move adjustment points by dragging in your image (it used to be called the "on-image adjustment"). Just click the button that looks like a pointing hand (circled, top) to activate this tool and then hover your cursor over the area you want to change (your cursor turns into an eyedropper). A white preview circle appears on the curve (circled, right) that corresponds to the tonal value of the pixels you're hovering above. When you're ready to add a point to the curve, click once.

Bottom: To darken overly light gray pixels, drag downward (your cursor turns into a hand with an up-and-down arrow, circled). As you drag, the curve bends in the direction you're dragging, as shown here. Notice that the Output field's value is lower (meaning darker) than it was originally: 146 vs. 213.

The grid behind the curve is merely a visual aid to help you move points around and to determine which part of the tonal range you're affecting. It's set to a 25-percent, quarter-tone grid wherein shadows, midtones, and highlights are split into four parts: The left-hand column represents the darkest shadows, the middle two columns represent the midtones, and the far-right column represents the lightest highlights. You can change it to a 10-percent grid that displays 10 rows and columns by Option-clicking (Alt-clicking on a PC) the grid itself.

If you ever want to change it back to the 25 percent grid, just Option-click (Alt-click) the grid again. In the Curves Display Options dialog box (shown in Figure 9-22), you can switch between these two grid options by clicking the button that looks like a tiny grid.

Figure 9-22:
You can access the Curves Display Options dialog box by choosing (naturally) Curves Display Options from the Adjustments panel's menu. These options also appear at the bottom of the Curves dialog box, which you can open by pressing ⌘-M (Ctrl+M on a PC). But be careful: If you apply a regular Curves adjustment (instead of using a Curves Adjustment layer), Photoshop alters your original image.

Here's a run-down of the other settings in the Curves Display Options dialog box:

- **Show Amount of.** Unless you change it, the Light option is selected, which means your image's shadows correspond to the bottom-left corner of the Curves grid and its highlights to the top-right corner. You can turn on the "Pigment/Ink %" option to show ink percentages on the input and output bars instead of the 0–255 brightness scale. Usually, though, you'll want to leave it set to Light.

- **Show.** This menu has several options that are all turned on to start with:

 — **Channel Overlays** lets you see a separate curve for each channel in your document. If you're new to Curves and find a panel riddled with colorful diagonal lines both distracting and alarming, you can turn this checkbox off.

 — **Histogram** determines whether Photoshop displays a light-gray version of your image's histogram behind the grid. If you find the histogram distracting, turn this setting off.

 — **Baseline** tells Photoshop to display the original curve as a straight line, which is a great way to know at a glance, "Dude! That's the original curve!"

— **Intersection Line** makes Photoshop display horizontal and vertical "helper" lines when you drag a point to help you align it properly (which isn't really necessary if you use arrow keys to nudge points instead of dragging them).

Changing Contrast

The angle of the curve controls contrast. If you steepen it, you increase the contrast in your image; if you flatten it, you decrease the contrast (see Figure 9-23). Just select an adjustment point by clicking it and then use the left or right arrow key to nudge it one way or the other.

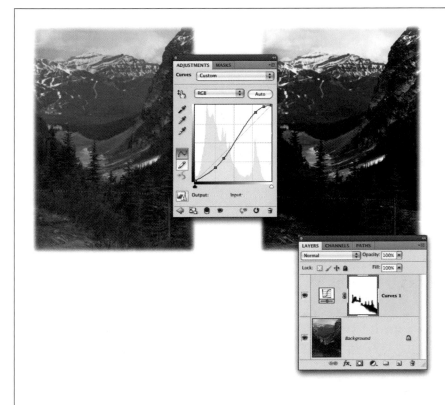

Figure 9-23:
Top: A steeper curve gives your image more contrast; you can see the original diagonal line in the background and the adjusted, steeper curve in the foreground. In fact, you can start with one of the contrast presets in the Curves pop-up menu at the top of the Adjustments panel and then use the Targeted Adjustment tool (see Figure 9-21) to add additional points and nudge them as necessary.

Bottom: To keep the trees in the foreground from getting too dark, keep the adjustment from affecting that area by painting the Curves Adjustment layer's mask with a black brush.

Another way to increase contrast is to make a subtle S curve, as shown in Figure 9-24 (top right). Here's how: Darken your shadows slightly by clicking to add an adjustment point to the lower-left grid intersection and then use the down arrow to nudge it 2–3 notches. Next, lighten your highlights by adding a point to the top-right grid intersection, and then nudge it up the same amount. Finally, lighten the midtones by adding a point to the very center of the grid and then nudge it slightly upward.

Figure 9-24:
You can create as many Curves Adjustment layers as you want in a document. For example, the image on the left definitely needs a contrast boost. You can create one Adjustment layer for the magic contrast-inducing S curve (top right), and then add another one to neutralize the suddenly sky-high red in the skin tones. If you choose the red channel from the pop-up menu above the grid, you can use the Targeted Adjustment tool to select the too-intense red and then use your down arrow key to nudge it back down to earth (bottom right).

If the effect is a little too strong, you can always lower the opacity of the Curves Adjustment layer using the pop-up menu at the top of the Layers panel. If you inadvertently intensify a color while you're making a Curves adjustment, just tweak that particular channel. Choose the appropriate channel from the pop-up menu directly above the grid and then click the Targeted Adjustment button at the top-left of the panel. Then click the color in your image that you want to adjust and use your down arrow key to neutralize it, as shown in Figure 9-24 (bottom right).

Remember that you can also change the blend mode of any Adjustment layer (see page 289). To preserve the color in your image, you can change a Curves Adjustment layer's blend mode to Luminosity so the adjustment affects only the image's lightness values and not its color balance. This is a great way to avoid color shifts.

In the end, getting good at using Curves simply takes practice. But as long as you use an Adjustment layer, you'll never harm your original image. Heck, if you're feeling really frisky, click the pencil button in the panel's lower left and draw your *own* curve by hand. If you go that route, you can click the "Smooth the curve values" button, which lives beneath the pencil, to smooth the line you drew. To go back to adding points to adjust the curve, click the button above the pencil called "Edit points to modify the curve". When you're ready to learn even more about using Curves, check out Taz Tally's training video *Photoshop for Printing* available at *www.kelbytraining.com*.

Tip: If you create a really useful or incredibly funky Curve, you can save it for use later by choosing Save Curves Preset from the Adjustments panel's menu. (You can save a favorite Levels adjustment in the same way.) From then on, it'll show up in the preset pop-up menu at the top of the panel.

POWER USERS' CLINIC

Keyboard Curves

If you're a fan of keyboard shortcuts and keyboard/mouse combinations, dog-ear this page right now—or better yet, print a copy of the shortcuts from this book's Missing CD page at *www.missingmanuals.com/cds*—because there are a slew of 'em that you can use with Curves:

- To cycle through your document's channels (starting with the composite channel), press ⌘-2, 3, 4, 5, 6 (Ctrl+2, 3, 4, 5, 6 on a PC). To cycle through your document's channels in the Curves Adjustments panel, press Opt-/Alt+2, 3, 4, 5, and 6 if in CMYK mode.

- To show clipped shadows and highlights, Option-drag (Alt-drag) the panel's shadows or highlights sliders, or click the shadows or highlights eyedropper and then press and hold Option (Alt) as you hover your cursor over the image.

- To switch between the 25 percent to 10 percent grid (page 410), or vice-versa, Option-click (Alt-click) the grid.

- To cycle forward (left to right) through curve points, press =.

- To cycle backward through curve points, press – (that's the minus sign).

- To deselect the selected point(s), press ⌘-D (Ctrl+D).

- To select multiple points, Shift-click the points.

- To delete a single point, select it and press Delete (Backspace), drag it off the grid, or ⌘-click (Ctrl-click) it.

- To nudge the selected point one unit in the standard Curves dialog box (two units in the Adjustments panel), press one of the arrow keys.

- To nudge the selected point 10 units in the standard Curves dialog box (16 units in the Adjustments panel), press and hold Shift and then use the arrow keys.

And here are a couple of shortcuts you can use only after you click the Targeted Adjustment tool (shown in Figure 9-21, page 409):

- To add a point to all channels simultaneously, Shift-⌘-click (Shift-Ctrl-click) your image.

- To delete a point on the curve, ⌘-click (Ctrl-click) an area of the image with the same Input/Output levels as the point you want to delete. When a preview circle appears around the point, (circled in Figure 9-21), you're clear to click.

Creating High Dynamic Range Images

Once you get used to peeking at your histograms (page 390), you'll notice that very few images exploit the full range of brightness values from light to dark. More often than not you'll have more info on one end of the histogram than the other, meaning the highlights or shadows look really good, but rarely both. That's because digital cameras can collect only so much data in a single shot. If you've got a scene with both light and dark areas—like a black cat on a light background—you have to choose which area to expose for: the cat or the background. To capture more info, you can shoot multiple versions of the same shot at different *exposures values* (called *EV*) by varying your shutter speed, and then combine them later in Photoshop into what's known as a *High Dynamic Range* (HDR) image.

Using Merge to HDR Pro

In Photoshop CS5, Adobe put a lot of effort into making it easier for mere mortals to create HDR images. But before you get started, you need to dig out your camera's owner's manual and hunt for a feature called auto-bracketing, which makes your camera take a series of shots with different exposure settings by varying its shutter speed (better yet, set the exposure differences up yourself manually—see your camera's manual to learn how). Bracketing lets you tell your camera how many shots to take (use a minimum of three, though the more the better) and how much of an exposure difference you want between each one (pick two if you have the choice). For example, for three shots, you'd have one at normal exposure, one that's two EV steps lighter than normal, and one that's two EV steps darker than normal. After you've taken a few series shots with these settings, you can download them to your computer (see Appendix C to learn how to import images using Bridge).

Note: As far as file formats and HDR, using Raw files (page 57) is the best approach since they contain the most info, though you can use PSD or TIF files, too. Also, be sure to use a tripod so your camera doesn't move between shots!

Here's how to merge several exposures of the same shot into one:

1. **In Photoshop, choose File→Automate→"Merge to HDR Pro".**

 In the resulting dialog box (Figure 9-25) navigate to where the images (or folder) live on your hard drive and then click OK. Photoshop combines the images into one document and auto-aligns them on separate layers. Depending on your computer, this process might take a while. When it's finished, you see the resulting image in the new "Merge to HDR Pro" dialog box (Figure 9-26).

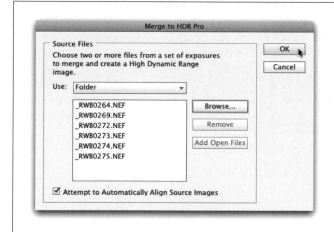

Figure 9-25:
CS5's new "Merge to HDR Pro" option lets you navigate to individual images or an entire folder. When it comes to HDR, the more exposures you use, the more realistic your final image will be.

You can also summon this dialog box in Bridge or Mini Bridge: Just Shift-click to select the images you want to merge and then choose Tools→Photoshop→"Merge to HDR Pro". For more on using Bridge, see Appendix C, online at www.missingmuals.com/cds.

2. **Turn on the "Remove ghosts" checkbox if your image's subject moved between shots or it contains a lot of soft edges.**

 Even if you used a tripod, this option is likely to improve your final image. By turning on this option, Photoshop compares all the images and tries to ignore content that doesn't match throughout the majority of the shots.

3. **From the Mode pop-up menu at the top right of the "Merge to HDR Pro" dialog box, choose a final bit-depth for your image.**

 Selecting 32-bit makes Photoshop keep all the dynamic range information captured in your original images. However, 32-bit images contain far more info than your monitor can display (plus they take up a ton of your computer's memory), so you'll only see a portion of the image's tonal range. To compress the information into something you can really use, you need to convert the images to 16- or 8-bit. This conversion process is called tone mapping: mapping one set of colors to another. (For more on bit-depth, see the box on page 45.)

 Note: *Just because you can do tone-mapping in Photoshop doesn't mean you should. Even though the process has improved in CS5, you may still find third-party plug-ins—like Photomatix (www.hdrsoft.com) or HDR PhotoStudio Pro (www.unifiedcolor.com)—faster and easier to use. Both programs work on Macs and PCs and are relatively inexpensive.*

4. **If you picked 8- or 16-bit in the previous step, choose a conversion method from the pop-up menu to the right of the Mode menu.**

 This whole HDR business is purely subjective—there's no right or wrong way to do it—so you'll want to spend some time experimenting with the various settings to make the image look right to you:

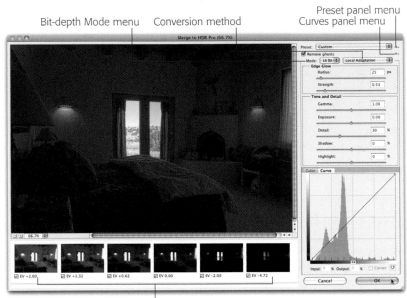

Bit-depth Mode menu Conversion method

Preset panel menu
Curves panel menu

Multiple exposures to merge

Figure 9-26:
At the bottom of the "Merge to HDR Pro" dialog box you see the seven shots that were used to create this image. Clearly, the world outside the window is much brighter than the inside. If you first expose for the outside and then shoot the same shot again with your EV 2 steps apart, and then again by 2 more EV steps apart, you eventually have a series of images that span a broader tonal range, even though it's spread out across several images.

Be sure to experiment with the canned recipes in the Preset menu, shown here. Once you've got your settings just right, you can save 'em to use later by clicking the Preset panel menu and choosing Save Preset. Using the Curves panel menu, you can even load and save Curves presets!

- **Local Adaption** gives you a slew of additional options (shown in Figure 9-26), and even lets you apply a Curves adjustment to your HDR image right there in the "Merge to HDR" dialog box. Choose this option if you've mastered Curves (page 406) and then tweak the settings in these various sections of the dialog box:

 — **Edge Glow** behaves much like the Detail slider in Camera Raw (page 482). You can use the Radius slider to control the size of the hazy glow you see around soft-edge items where there's little or no contrast. Drag it to the left to make the edge glow smaller, or to the right to make it larger. Use the Strength slider to control the glow's contrast (drag it right to increase contrast, or left to decrease it).

— **Tone and Detail** is much like the standard Camera Raw panel (page 233) with the addition of Gamma, which modifies the overall flatness and brilliance of the image.

— **Color** opens a panel that lets you tweak Vibrance and Saturation to alter the intensity of the colors in the image (see page 498).

— **Curve** opens a Curves panel where you can make a Curves adjustment. Flip back to page 406 for the scoop on using Curves.

Note: If you've opened Photoshop CS5 in 64-bit mode (see the box on page 6), you'll see a new item called HDR Toning in the Image→Adjustments menu. If you select it, Photoshop opens a dialog box with the same options discussed here, but you can apply them to normal images (ones that weren't shot with multiple exposures). If you go this route, expect some rather unusual results!

- **Equalize Histogram** compresses the dynamic range of your HDR image, while trying to maintain contrast (it gives you a peek at what your blended image looks like). It doesn't work quite as well as the other methods because it doesn't have many options, and it tends to make the darkest shadows black.

- **Exposure and Gamma** lets you adjust the image's exposure to make the highlights brighter or the shadows darker, or both. Drag the Exposure slider to the right to brighten the highlights, and use the Gamma slider to set the comparative brightness difference (across the series of shots) between shadows and the highlights. Drag it to the left to darken the shadows or to the right to brighten them.

- **Highlight Compression** makes the brightest part of your image white, even if it's brighter than white in the 32-bit file. Pick this method if you want to see details in your image's highlights without changing the image's overall contrast.

5. **Click OK to create your final HDR image.**

 Photoshop applies your tone-mapping settings and makes the final HDR image (see Figure 9-27). To produce a truly amazing image, you can continue to tweak it using all the normal tools in Photoshop—like faux Dodge and Burn (page 447), and so on.

Be warned: Once you go HDR, you may not come back. The conversion process takes time, but it can produce amazing (though sometimes unrealistic) images. Once you've recovered from pouring over this section, check out Ben Willmore's HDR Mastery course (*www.digitalmastery.com*) to learn more about HDR photography.

Figure 9-27:
Top: As you can see here, merging only three images makes the final image look surreal, and contains quite a bit of ghosting and edge glow.

Bottom: By increasing the number of images Photoshop has to work with, your results will be better and won't necessarily scream, "Hey! Look what I made in Photoshop!"

Making Colors Pop

Once you've corrected your image's color and lighting, you can have some serious fun by boosting or intensifying its colors. You've already learned how to do that in Camera Raw with the Clarity, Vibrance, and Saturation adjustments. In Photoshop, you can adjust two out of those three—sadly, there's no Clarity adjustment…yet!

Intensifying Colors

You can easily use a Vibrance Adjustment layer to intensify your image's colors. This kind of layer has less of an effect on intense colors (because they're already highly saturated) than on lighter tones—yet it manages to leave skin tones relatively unchanged. You can also use a Vibrance Adjustment layer to tweak your image's saturation (it includes a regular ol' Saturation slider), but when you do, Photoshop applies the change evenly to the whole image no matter how intense the colors are

and with no regard for skin tones. So if you've got people in your picture, you're better off increasing the Adjustment layer's Vibrance slider and leaving the Saturation slider alone. Figure 9-28 has the scoop.

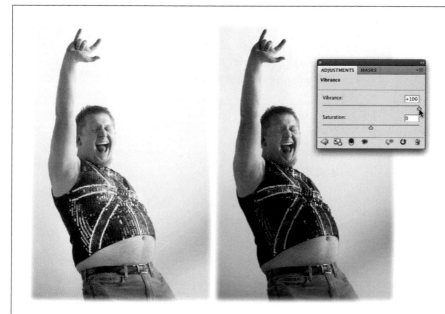

Figure 9-28:
To create a Vibrance Adjustment layer, click its button in the Adjustments panel (it looks like V-shaped triangle) or click the half-black/half-white circle at the bottom of the Layers panel and choose Vibrance. Unlike a regular saturation adjustment, a Vibrance Adjustment layer won't completely destroy skin tones, even if you boost its Vibrance slider to 100 percent, as shown here.

Tip: Since a layer mask tags along with every Adjustment layer, you can always use the Brush tool set to black to protect certain areas from the adjustment (just be sure you have the Adjustment layer's mask selected before you start painting). You can also use the Layers panel's Opacity field to lower the Adjustment layer's opacity and lessen its effect.

Adjusting Hue/Saturation

If you want to make a specific color pop, you can use a Hue/Saturation Adjustment layer to boost one color channel's contrast. It's a simple and nondestructive way to accentuate a certain range of colors.

To create a Hue/Saturation Adjustment layer, click its icon in the Adjustments panel (it looks like three gradient bars, and it's to the right of the Vibrance icon) or click the half-black/half-white circle at the bottom of your Layers panel and choose Hue/Saturation. Choose the color you want to intensify from the pop-up menu near the top of the Adjustments panel (which is set to Master until you change it) and then

drag the Saturation slider to the right. Be careful not to go hog wild or your color enters the dreaded Neon Realm. You should be fine with a 10 percent to 15 percent saturation increase. Good times!

Adding Lab Pop

Another way to make your colors really jump off the page is to creatively blend color channels in Lab mode (page 198). It's incredibly easy and the results can be amazing, as shown in Figure 9-29. With your image open in Photoshop, follow these steps:

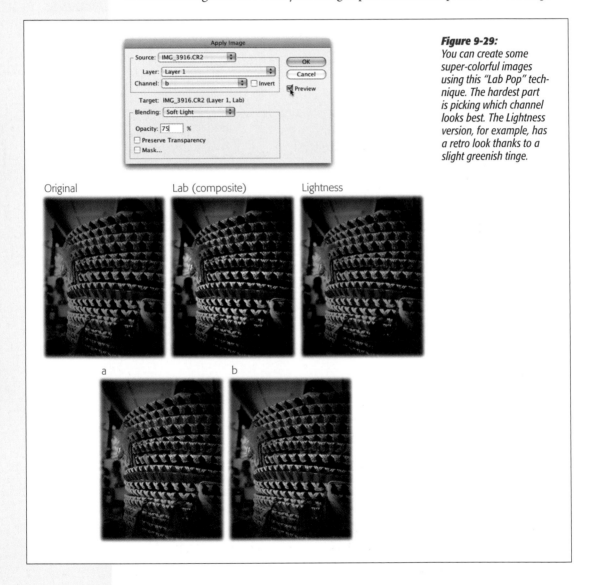

Figure 9-29:
You can create some super-colorful images using this "Lab Pop" technique. The hardest part is picking which channel looks best. The Lightness version, for example, has a retro look thanks to a slight greenish tinge.

1. Pop into Lab mode by choosing Image→Mode→Lab Color.

2. Duplicate your original layer by pressing ⌘-J (Ctrl+J on a PC).

3. Choose Image→Apply Image.

 If you're dealing with a multilayered document, choose the layer you want to adjust from (you guessed it) the Layer pop-up menu.

4. **In the Apply Image dialog box, change the Blending pop-up menu to Soft Light.**

 As you learned on page 298, this blend mode makes bright areas brighter and dark areas a little darker; it also helps make your colors pop off the page.

5. **In the Channel pop-up menu, pick the channel that makes your image look best.**

 As you choose different channels, take a peek at your image to see how it changes. Remember, this kind of color adjustment is purely subjective; there's no right or wrong channel to pick, and the channel that looks the best to you in this image may not look best on another image. Figure 9-29 shows you what this effect looks like using each channel.

6. **If necessary, lower the channel's opacity.**

 If the effect is too intense, you can lower the channel's opacity by entering a new number in the Opacity field. Click OK to close the Apply Image dialog box.

7. **Switch back to RGB mode.**

 Choose Image→Mode→RGB. If Photoshop asks whether you want to merge layers, say no.

You're done! Put your sunglasses on and smile as you enjoy your image's brilliant new colors. You can toggle the duplicate layer's visibility eye off and on to see before and after views.

Rescuing the Unfixables

Sadly, even with all the tricks you've learned in this chapter, you can't fix every image. If you run into what seems to be an unfixable photo and you're desperate to salvage it, try one of these techniques:

- Use the Lab Pop technique described on page 420 and use the Lightness channel to create unique, retro-style color.

- Create an overexposed, high-key effect (see page 195).

- Convert it to grayscale. By draining the color from your image, your color problems have no choice but to vanish (Chapter 8, beginning on page 323).

- Add a color tint using a Black & White or Photo Filter Adjustment layer (page 234 or page 352, respectively).

- Turn it into a duotone (page 339).

- Use a Threshold adjustment to create a pure black-and-white image (page 337).

- Use a combination of filters to turn your image into a pencil sketch (page 650).

- Use a plug-in like LucisArt to create a high-contrast, grungy look (page 778).

Processing Multiple Files

By now, you've probably realized how time consuming all this image-correction business can be. That's why it's important to know how to save time by correcting more than one image with a single adjustment. Happily, there are several ways to do that:

- **Open multiple files in Camera Raw.** If you're using Camera Raw, you can adjust several files at once by opening them all together, and then clicking the Select All button at the top left of the Camera Raw window. From that point on, Camera Raw applies anything you do to one image to all the others, too (see page 381).

- **Drag and drop Adjustment layers.** If you've (wisely) corrected your image using Adjustment layers, you can drag and drop them into other open images. That way, you can quickly fix a bunch of images from the same shoot that have similar lighting. Even if you have to tweak the adjustment a tiny bit, it's faster than hunting for highlights, shadows, and midtones in each photo.

- **Record repetitive tasks with actions.** While you can't record every aspect of color-correcting because it's unique to each image (or at most applies only to images taken during a single photo shoot), you can automate the little things you do over and over—like duplicating the original layer and adding an Adjustment layer—using actions. Creating a single action that performs those two steps can save you a couple of clicks. You can also automate finishing touches like making color pop (Lab Pop on page 420, for example), record an action for the sharpening techniques in Chapter 11, and so on. See Chapter 18 for more action goodness.

- **Use Adobe Bridge to copy and paste Camera Raw settings.** If you're working on photos from the same shoot that have similar lighting and you don't want to (or can't) open them all at once, you can adjust one and then copy and paste the Camera Raw settings using Bridge. See Appendix C (online) for the lowdown.

- **Use Adobe Bridge to rename a bunch of files at once.** Okay, so this one has nothing to do with correcting your images, but it can still save you some time! If you like renaming your processed files—before correcting them—and then saving them in a different location than your originals (a wise move), you can have Bridge do that for you for an entire folder of images. Appendix C shows you how.

The Beauty Salon: Photoshopping People

It's certainly no secret that the beautiful models gracing the covers of magazines have been Photoshopped to within an inch of their lives. They've had the digital equivalent of every plastic surgery you can imagine, and then some: skin smoothing, blemish banishing, tummy tucking—they get it all.

This chapter shows you all those tricks and more, but that doesn't mean you should use every technique on every photo. It's easy to get carried away with this kind of stuff, and with great editing skills comes great responsibility. The challenge is to retouch your subjects enough to *enhance* their appearance without making them look fake. For example, if you're tempted to remove a wrinkle completely, soften it instead. If you'd like to hack off 30 pounds, be content with 5 or 10.

All that aside, there's nothing wrong with a little vanity, and it's darn comforting to know you can zap a zit, whiten teeth, and fix red eye whenever you need to (and you'll never want to let photos of yourself out into the wild until you've spent some quality time with them). When you're finished with this chapter, you'll be able to fix shiny spots, remove unsightly bulges, and enhance eyes with the best of 'em. In other words, you're about to become the most popular picture-fixer-upper in your *entire* social network.

Note: For a fascinating profile of one of today's leading Photoshop-using, model-enhancing gurus, check out this *New Yorker* article: *www.tinyurl.com/57mbw3*.

The Great Healers

Some of the simplest retouching you can do is to remove dark circles and bags under eyes, as well as other blemishes. In days of old, you were stuck with cloning (copying) one area of skin onto another, which never *really* looked quite right; texture and tonal (color) differences always made the fix stick out like a sore thumb. Now, Photoshop has a set of tools *specifically* for retouching skin. Instead of grafting skin by cloning, these tools blend two patches of skin together so the texture and tones actually match (see Figure 10-1).

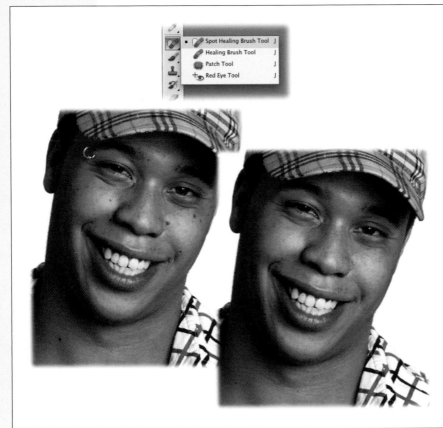

Figure 10-1:
Top: Photoshop's magical healing tools.

Bottom: As you can see here, a lot of moles—and an eyebrow ring—have completely disappeared. With a few clicks here and a few drags there, you can clean up a photo without making it look obviously retouched. Some of the guy's lighter freckles are still hanging around and the bags under his eyes aren't completely gone; they're just lightened so they're not distracting.

Note: The first three tools covered in this section—the Spot Healing Brush, Healing Brush, and Patch—live in the same toolset. Press J to activate the tool you used last or cycle through the toolset by pressing Shift-J until you get to the right one.

The Spot Healing Brush

This tool's cursor is a round brush—perfect for fixing round problem areas like pimples, moles, and so on. It's literally a one-click fixer-upper—you don't even have to drag, though you can if you want. When you click a spot with this tool, Photoshop looks at the pixels just *outside* the cursor's edge and blends them with the pixels *inside* the cursor. It's great for retouching people, fixing dust and specks in old photos, and removing anything that's roundish in shape. You can also drag with this tool to remove, say, power lines on a relatively solid background (like a sky) or to fix scratches in old photos. With the new Content-Aware Fill option (explained in a moment), the Spot Healing Brush works even better than before, and does an amazing job at zapping unwanted items in your photos.

To use the Spot Healing Brush, grab it from the Tools panel by pressing J (its icon looks like a band-aid with a circle behind it). Then hover your cursor over the offending blemish and adjust the cursor's size so it's slightly larger than the area you want to fix (see Figure 10-2). You can the size using the Brush picker at the top left of the Options bar, the new Brush Presets panel (page 503), or the square bracket keys on your keyboard: press the left bracket key ([) to go down in size, and the right bracket key (]) to go up.

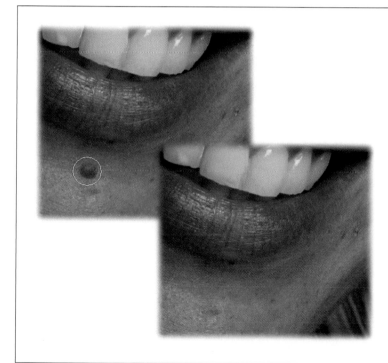

Figure 10-2:
The key to success with the Spot Healing Brush is to make your cursor a little bit larger than the area you want to fix.

Tip: You can also resize your brush by Ctrl-Option-dragging (Alt+right-click+dragging on a PC) to the left or right.

In the Options bar, you can control exactly how the Spot Healing Brush works with these settings:

- **Mode.** This field lists some of the blend modes discussed back in Chapter 7 starting on page 289: Multiply, Screen, Darken, Lighten, Color, Luminosity, and Replace. Unique to the Healing brushes (both Spot and Healing), Replace is handy if you're using a soft-edged brush because it preserves some of the texture and details around the brush's edges. However, Normal mode usually works just fine.

- **Type.** This setting controls which pixels Photoshop looks at when it's healing. You've got two options:
 - **Proximity Match.** Photoshop comes from the factory with this option selected, which tells it to use pixels just outside the edge of your cursor to fix the blemish.
 - **Create Texture.** Choose this option if the area you want to fix is surrounded by tons of details. Instead of looking at pixels outside the edge of your cursor, Photoshop tries to recreate the texture by looking at the pixels *inside* your cursor.

- **Content-Aware Fill.** New in Photoshop CS5, this option is pure magic. Turn it on when you want to remove an object from your photo such as a power line, a Texas Longhorn in the pasture, your ex-best friend, and so on. You can either single click or simply drag to remove the item and Photoshop fills in the area with surrounding pixels. Amazingly, the behind-the-scenes code can recreate complex structures like brick walls. You've got to use it to believe it, as Figure 10-3 shows.

Tip: Want to give the new Content-Aware Fill option a spin? Skip on over to this book's web page at *www.missingmanuals.com/cds* and download the image *Band.jpg*.

- **Sample All Layers.** Turn on this option to have Photoshop sample pixel info from *all layers* instead of just the one you're on. This setting also lets you do the healing on another layer instead of on your original image: Just create a new layer *above* the photo layer and make sure the new layer is active. That way, when you click to fix a spot, the fix happens on the new layer. This technique builds a lot of flexibility into your document because, if you decide you've done too much healing, you can erase those specific areas from the new healing layer or lower the opacity of that layer to soften the effect.

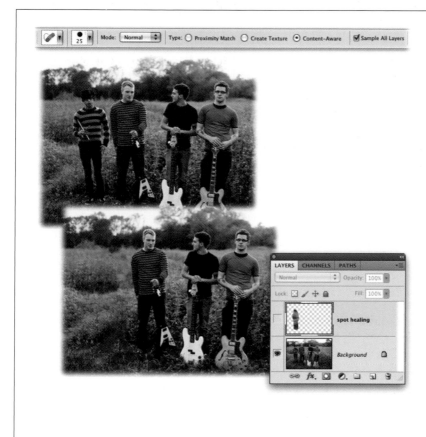

Figure 10-3:
Top: By turning on the Spot Healing Brush's new Content-Aware option as well as Sample All Layers, you can nondestructively delete a person from your band portrait—hey, break-ups happen!—even if it has a complex background like the one shown here. CS5 makes this kind of task easier than it's ever been before!

Middle: You'll need some space on either side of the soon-to–be-zapped por-tion for this trick to work well. In this photo, there's precious little background space between boys, so it took several brushstrokes to get it done (and you may need to experiment with brush size, too).

Bottom: In this Layers panel here, you can see the ex-band mate on his very own layer, and the original, untouched image, so you know Photoshop hasn't changed your original image.

- **Tablet Pressure Controls Size.** Also new in CS5, this option is for folks using graphics tablets (page 520). It lets you control the size of the Spot Healing Brush by applying pressure with your stylus (the pressure sensitive pen that comes with a graphics tablet). Press harder to increase the size of the brush, or lighten the pressure to make it smaller.

The Healing Brush

This tool also blends two areas of skin together, but you have to tell it where to find the skin that looks good. This process, called *setting a sample point*, is how you let Photoshop know which portion of skin—or fur, or whatever—you want it to *sample* (or blend the offending spot with). To set a point sample, activate the Healing Brush by pressing J (or press Shift-J to cycle through the healing tools) and then Option-click (Alt-click on a PC) an unblemished area of skin to set the sample point. Then

mouse over to the bad skin and brush it away. This tool works really well on wrinkles, scratches, and so on, and you can make the healing happen on its own layer, as explained in Figure 10-4. You also get a live preview of the sample skin right inside your brush cursor (Figure 10-4, bottom left).

Fixing Spots in Camera Raw

If you find yourself using the Spot Healing Brush repeatedly to fix a pesky speck that appears in the exact same place in every photo you take, you've got dust on your camera's sensor. You'll want to take your camera to a trustworthy shop and have them clean the sensor, or do it yourself with a bit of bravery and the right tools. But fixing the camera doesn't fix the photos you've already taken with it. Fortunately, you can make Camera Raw zap those spots automatically. Here's how:

1. **Open all the problem images in Camera Raw (see page 234 in Chapter 2).**

2. **In Camera Raw, press B to grab the Spot Removal Brush, click the offending spot, and then drag to resize your cursor.** Clicking makes the brush cursor appear (it's a red-and-white circle) and dragging resizes it. If you click once, you create a super tiny brush tip, so it's better to drag until the brush tip is big enough to see. You can also use the Radius slider on the right side of the Camera Raw window to change the brush size. The goal is to make the brush cursor slightly bigger than the spot itself.

3. **Set your sample point.** When you release the mouse button, Camera Raw displays a green–and-white circle near where you clicked, and the pesky spot should vanish. The green-and-white circle (which is connected to the red-and-white circle by a

black-and-white line) marks the *sample point* Camera Raw is using to the fix the spot. Camera Raw usually does a good job of selecting a sample point, but if you want to move it to another area that better matches the problem spot, hover your cursor inside the green-and-white circle and, when a four-headed arrow appears next to your cursor, drag it somewhere else. If you need to fix several specks, repeat this step for each one until they're all gone. Now you're ready to apply the fix to the other images you have open.

4. **Select all your open images and then click the Synchronize button to apply the changes you just made to them, too.** In the Camera Raw window's top-left corner, click the Select All button and then click the Synchronize button below it. In the resulting dialog box, choose Spot Removal from the Synchronize pop-up menu.

5. **Click OK to close the Synchronize dialog box, and then click the Done button at the bottom of the Camera Raw window to store your changes.** If you have hundreds of images open, you probably don't want to click the Open Image button. That'll pop 'em *all* open in Photoshop, which could send both your computer and Photoshop into a deep freeze (eek!).

Tip: Anytime you set a sample point, try choosing a spot that's as *near* to the problem skin as possible so the texture and color match better. For example, you wouldn't want to repair skin on Aunt Edna's nose with skin from her neck.

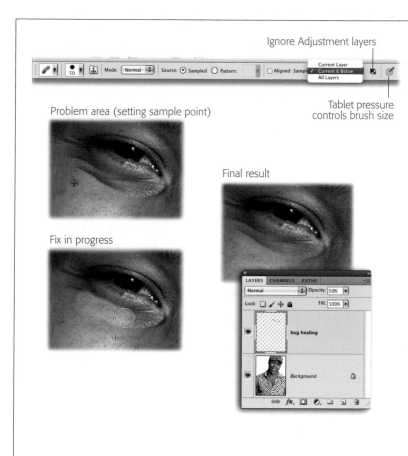

Ignore Adjustment layers

Problem area (setting sample point)

Tablet pressure controls brush size

Final result

Fix in progress

Figure 10-4:

Top: In the Options bar, set the Sample pop-up menu to Current & Below so you can make the healing happen on a new layer that you've created and placed above the image layer. If you want to sample from all the layers in your document, choose All Layers from the pop-up menu. Like the Spot Healing Brush, this tool also offers the new tablet-pressure option.

Bottom Left: When you press the Option key (Alt on a PC), your cursor turns into a target so you can click to set a sample point (top). As you start painting over the bad skin, you see a little crosshair marking your sample point (right) that moves along with your brush (in most cases, keeping the two areas together improves your chances of matching the texture and tone).

Bottom Right: By healing on another layer, you can lessen the effect of the healing by lowering that layer's opacity. Here it's set to 50 percent.

When you activate the Healing Brush tool, the Options bar gives you the following options:

- **Mode.** You get the same set of blend modes for the Healing Brush as you do with the Spot Healing Brush (page 425). Both tools work really well in Normal mode, so you probably don't need to change this setting.

- **Source.** You can use a sample (which you choose by Option-clicking [Alt-clicking on a PC]) or a pattern as your source. Photoshop assumes you want to use a sample, but if you turn on the Pattern option, you can pick from the Pattern Preset picker pop-up menu to its right. Healing from a pattern is useful if you don't have enough area in your image to heal *from*. For example, if you're using the Healing Brush to remove graffiti from a wall, you can create a new pattern from part of the wall texture and save it as a reusable pattern.

Tip: You can also sample from another open document as long as both images are in the same color mode. Just hop over to the other document, Option-click (Alt-click) to set a sample point, and then click back in your original document to do the healing (use the Arrange Documents menu in the Application bar to position both document windows so you can see them [see page 15]). This technique is handy when you want to snatch texture from one image and apply it to another. That way, you let the Healing Brush do the heavy lifting of blending the texture with existing pixels.

- **Aligned.** Turn on this checkbox to keep your sample point aligned with your cursor, even if you release your mouse button and move to another area. When this setting is *off*, Photoshop uses the original sample point each time you start to paint even if you move your cursor far away. So if your healing requires several brushstrokes, it's helpful to turn this setting on.

- **Sample.** This pop-up menu lets you choose which layers you want to sample from. To make the healing happen on a separate layer, create a new layer above the one you want to fix and then choose Current & Below. You can also sample from all visible layers by choosing All Layers. If you pick All Layers, you can make Photoshop ignore Adjustment layers by clicking the button of the same name, labeled in Figure 10-4, top, and explained next.

- **Ignore Adjustment Layers.** If you used some Adjustment layers to alter the color or lighting in your image, you can have Photoshop ignore them by clicking this icon. (Its icon is the same half-black/half-white circle as the "Create a new fill or adjustment layer" icon at the bottom of your Layers panel.)

Here's how to use the Healing Brush:

1. **Add a new layer above the layer you want to fix.**

 Click the "Create a new layer" button at the bottom of the Layers panel, and name the layer something like *Healing*. Make sure it's above the layer you're fixing and that it's active.

2. **Choose the Healing Brush from the Tools panel.**

 Press J to activate this brush, whose icon looks like an itty-bitty Band-aid.

3. **In the Options bar, set the Sample pop-up menu to Current & Below.**

 This setting tells Photoshop: "Create a sample from the current layer and any other layers that lie below it, but make the fixes happen on the layer I'm currently on." This process gives you a ton of flexibility: You can lower the layer's opacity to lessen the strength of the fix, change the layer's blend mode, or toss it in the trash if you decide you don't like it.

4. **Mouse over to your document and set a sample point by Option-clicking (Alt-clicking on a PC).**

 Photoshop has no clue where the good skin lives, so you have to tell it. Option-click (Alt-click) an area of good skin that's similar in texture to the bad skin. (It's okay if the sample skin is on the other cheek, for example, so long as the texture is the same.) Now you're ready to start healing.

5. **Click (or drag across) the area you want to fix.**

 Mouse over to the problem area and click it or drag to paint it away. You'll see a tiny crosshair marking the sample point as you drag. You also see a preview of the sample area inside your cursor as you paint. If you're fixing a small area, like the bags beneath the guy's eyes in Figure 10-4, you're probably okay with setting just one sample point. If you're fixing a larger area, you may need to set a new sample point every few brushstrokes to match the tone and texture of what you're fixing.

The Patch Tool

The Patch tool may become one of your favorite Photoshop tools because it's so easy to use and does an amazing job. It works like the Healing Brush in that you need to set a sample point, but it's often better than the Healing Brush for fixing big areas like dark circles or bags beneath tired eyes. It's also handy for removing piercings, tattoos, and shiny or shadowy spots. For the Patch tool to work on shines and shadows, you need a patch of good skin the same size as the bad skin or you'll have to patch one small area at a time. In that case, a better option is to use the Clone Stamp tool, described in the next section (page 434).

Note: With the Patch tool, you can't make the healing happen on another layer like you can with the Spot and Healing brushes (the Patch tool can't sample from other layers), so it's a good idea to duplicate your original layer first by pressing ⌘-J (Ctrl+J on a PC). That way you're not harming your original image. In CS5, it's actually quicker to use the Spot Healing Brush with the new Content-Aware option turned on. And if you turn on Sample All Layers, you can do the healing on another layer while leaving your original image intact, as shown in Figure 10-3.

To use the Patch tool, grab it from the Tools panel, mouse over to your image, and drag to draw an outline around the area you want to fix (marching ants appear when you let go of your mouse). Next, click anywhere inside the selected area and hold down your mouse button as you reposition the selection outline so it's over a *good* patch of skin (see Figure 10-5, top right). (To drag perfectly vertically or horizontally, hold down Shift as you drag.) You get a live preview of the good skin in your selection area as you drag. When you let go of your mouse, Photoshop blends the two areas together.

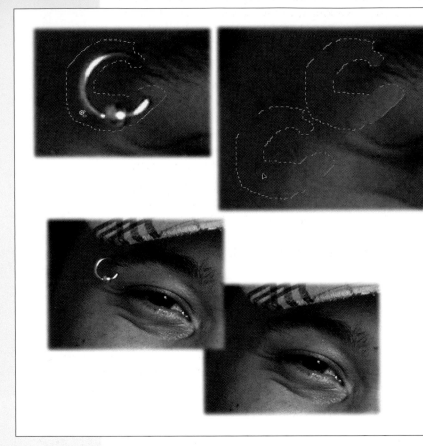

Figure 10-5:
If you need to get rid of a new piercing before the parents see it, the Patch tool can get it done fast.

Top: First, draw an outline of the offending area freehand (left). Once you see marching ants, click inside the selection and drag it to a good patch of skin and then release your mouse button (right).

Bottom: Problem solved! The Patch tool can help you keep your piercing secret for a little while longer.

Tip: If you need to adjust your selection while you're drawing it, use the buttons near the left end of the Options bar to add to or subtract from your selection or to create one from two intersecting areas. Better yet, use these keyboard shortcuts: Shift-drag to add to your selection, Option-drag (Alt-drag on a PC) to subtract from it, and Option-Shift-drag (Alt+Shift-drag) to select an intersecting area.

The Options bar gives you the following settings for the Patch tool:

- **Patch.** This setting has two options:
 - **Source.** Out of the box, Photoshop takes the texture from the good skin and tries to match it with the color and lighting of the area just outside your original selection. To produce convincing patches, leave this radio button turned on.
 - **Destination.** If you'd rather select the good skin first and *then* drag it atop the bad skin, turn on this radio button.

- **Transparent.** Turn on this checkbox if you want to copy an area's texture but not its content. For example, if you're working with a brick wall, you could use this option to copy the texture of the super grungy bricks onto those that look newer, without duplicating the grungy bricks in their entirety. This setting works best when you use it in conjunction with the Use Pattern setting, explained next.

- **Use Pattern.** If you want to apply a pattern to the area you've selected with the Patch tool, click this button and then choose a pattern from the Pattern Preset picker pop-up menu next to it. You'll rarely use this option, because instead of merely making Photoshop copy and blend pixels from one area to another, it adds the pattern you picked from the pop-up menu to the selected area. That said, it's useful if you're trying to add texture to an area that doesn't have any.

As soon as you apply a patch, check to see if the effect is too strong (like in Figure 10-6, top right) because you've got exactly *one* chance to fade it. Before you use any other tool or create Adjustment layers, choose Edit→Fade Patch Selection. Position the resulting dialog box so you can see your image and then use the dialog box's slider or Opacity field to tweak the opacity until the patch looks more realistic. Click OK when you're finished.

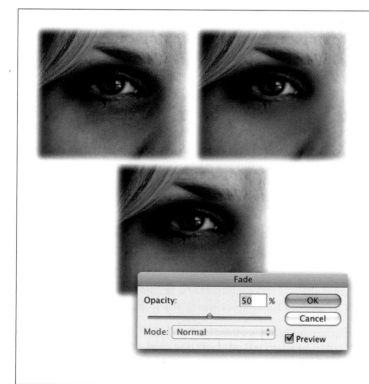

Figure 10-6:

Top: Here's what this woman's dark circles look like before (left) and after (right) using the Patch tool. As you can see, the result is too blurry.

Bottom: With the Fade dialog box, you can lower the patch's opacity to lessen the effect. If you want to hide the marching ants while you decide how much to fade the patch (which can make it easier to see how well the patch blends into the surrounding skin), press ⌘-H (Ctrl+H on a PC); press it again to bring 'em back.

Tip: It's a little known fact that you can actually select the area you want to patch *before* choosing the Patch tool. That way, you can use any selection method you want (see Chapter 4) instead of drawing the selection freehand. You can also draw straight lines with the Patch tool by holding down the Option key (Alt on a PC).

Zapping Shines and Shadows

Shiny spots, (or *hot spots*, as some folks call them) are truly evil. They can ruin a perfectly good photo by making your subject look like a big ol' sweat ball. That's okay if the person just finished a marathon—glistening is expected then—but not if she's sitting for a portrait. Fortunately, the Clone Stamp tool can get rid of shiny spots and unsightly shadows in a hurry. It works by copying pixels from one area of an image to another (see Figure 10-7).

Tip: Be careful not to erase *all* the shine and *all* the shadows in your images; you want to leave a little bit hanging around so the photo looks real. The goal is to remove just enough shine and shadows that viewers aren't distracted by them.

Here's how to reduce shine and shadows with the Clone Stamp tool:

1. **Open your photo and create a new layer and name it *Shine*.**

 Click the "Create a new layer" button at the bottom of your Layers panel, give the layer a name in the resulting dialog box, and then click OK. Make sure this layer is *above* the image layer you want to fix. By doing your skin-fixing on another layer, you're protecting the original image and giving yourself the option of reducing the strength of the fix by reducing the layer's opacity.

2. **Grab the Clone Stamp tool from the Tools panel.**

 Press S to activate this tool, which looks like a rubber stamp (in fact, it used to be called the Rubber Stamp tool).

3. **In the Options bar, choose a soft-edged brush and change the blend mode to Darken.**

 Choosing Darken from the Mode pop-up menu makes Photoshop darken any areas lighter than the sample point to darken the shiny area.

4. **Also in the Options bar, lower the Opacity setting to 20–30 percent.**

 If you leave the tool's opacity at 100 percent, you'll perform a full-on skin graft, and the retouching will be painfully obvious. Lowering the opacity lets you fix the area little by little; the more you paint, the more skin gets cloned (or copied).

5. **Set the Sample pop-up menu to All Layers.**

 To make the cloning (copying) happen on another layer, you have to tell Photoshop to sample other layers. Now you're all set to start cloning.

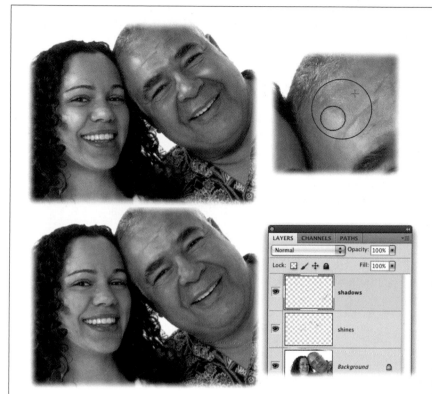

Figure 10-7:

Top: This photo would be worth framing if the subjects weren't so shiny (left). To fix that problem, grab the Clone Stamp tool and set your sample point as close to the shiny area as possible to match tone and texture (right). Be careful not to let your sample point (the crosshair) go into the shiny area itself, or you'll replicate the shine.

Bottom: Now you can print that photo with pride. No more shiny spots! The shadows on their faces and necks have also been lightened. And by setting the Sample pop-up menu to All Layers (see page 434, step 5), you haven't harmed your original image. Toggle the visibility of the layers you just added off and on for a quick before-and-after comparison.

6. **Create a sample point for the first shiny part.**

 Mouse over to your document and Option-click (Alt-click on a PC) some non-shiny skin. Make sure this sample point is as close to the shiny skin as possible so it'll match.

7. **Drag to paint away the shiny skin.**

 As you drag, you see a little crosshair representing your sample point. Keep a close eye on it because if it heads into a shiny patch, you'll paint a shine with a shine. If that happens, don't panic; just set another sample point by following step 6 again. When you've fixed one shiny spot, mouse over to another and repeat steps 6 and 7.

8. **Create another new layer and name it *Shadows*.**

 You'll use this layer for the fixes you make to the shadowed regions.

9. **In the Options bar, change the Mode setting to Lighten.**

 With this setting, the tool lightens only areas that are darker than the sample point. This technique works wonders for shadowy double chins and deep crevices—pretty much any problem area that's too dark.

10. **Set a new sample point and paint the shadow away.**

 Option-click (Alt-click) to set your sample point as close to the shadowy area as possible and drag to make it go bye-bye. Repeat steps 9 and 10 until you've taken care of all the shadow problems.

11. **Save your document as a PSD file.**

 That way, you can go back and change your fixes later.

Print that baby out and slap it into the nearest frame!

Whitening Teeth

If you've ever enjoyed a big cup of coffee or a Texas-sized glass of red wine and then had your picture taken, you'll want to bookmark this page. Stained teeth are even more embarrassing than shiny spots, but they're easy to fix (see Figure 10-8). The hardest part of whitening teeth is selecting the little buggers in the first place, but that step got easier when Adobe added the Quick Selection tool back in CS3.

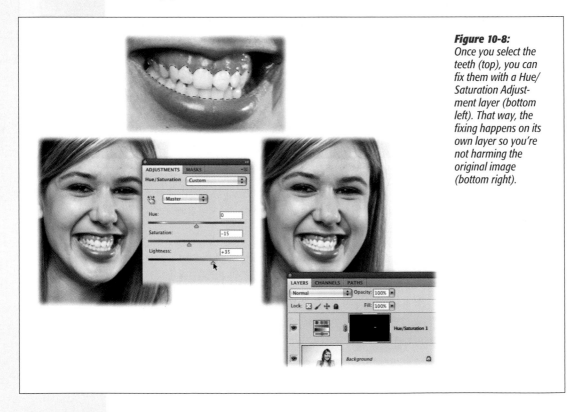

Figure 10-8:
Once you select the teeth (top), you can fix them with a Hue/Saturation Adjustment layer (bottom left). That way, the fixing happens on its own layer so you're not harming the original image (bottom right).

Here's how to make those pearly whites, well, white:

1. **Open your image and zoom in so you can see the teeth.**

 Press ⌘ and the + key (Ctrl and the + key on a PC) to zoom in on your document. Press ⌘ (Ctrl) and the – key to zoom out.

2. **Open a duplicate of your image and leave it at close to actual size.**

 Choose Window→Arrange→"New window for [your document's name]". Since it's so doggone easy to over-whiten teeth, it's helpful to keep an eye on a copy of the same image at roughly the size you plan to print it. The cool part is that Photoshop reflects what you do in one window in the other window—in real time—because it's the same document. This duplicate-window trick helps you see what kind of effect your changes have at actual size.

 It's good to get into the habit of opening a duplicate in a new window when you're doing detail work because it keeps you from getting carried away with fixing individual pixels while you're zoomed in. Nine times out of ten, when the image is at normal size, your teeny-tiny changes are barely noticeable, if you can see them at all.

3. **Select the teeth.**

 You can use any selection method you learned in Chapter 4. Since the teeth are basically white, one good option is using the Quick Selection tool (page 149) to paint across them, and then pop into Quick Mask mode (page 176) to refine your selection.

4. **Add a Hue/Saturation Adjustment layer.**

 Click the half-black/half-white circle at the bottom of the Layers panel and choose Hue/Saturation from the resulting list.

5. **Lower the Adjustment layer's saturation and increase its lightness.**

 In the Adjustments panel, drag the Saturation slider to the left and the Lightness slider to the right. Keep an eye on both document windows to make sure you don't make the person's teeth unnaturally white.

6. **Open the Masks panel by choosing Window→Masks and then soften your selection's edges by dragging the Feather slider slightly to the right (one pixel should work).**

7. **Save your document as a PSD file.**

 If you decide you want to tweak the teeth again later, just open the file again, double-click the Adjustment layer, and fiddle with the sliders to your heart's content.

This method will whip most teeth into shape, but if you encounter a set with a *serious* yellow cast, there's one extra step you can take: In the Hue/Saturation Adjustments panel, choose Yellows from the pop-up menu near the top of the panel and then drag the Saturation slider slightly to the left.

Tip: You can use the technique described in the list above to whiten eyes, too, but you don't have to reduce the saturation; just increasing the lightness should do the trick. To learn another way to accentuate eyes, skip ahead to page 451.

Super Slimmers

Photoshop has a slew of tools you can use to do some serious slimming, letting you fix flabby chins, shrink paunchy waistlines, and instantly shave off pounds. Tools of the body-sculpting trade include the Pinch and Liquify filters, the Clone Stamp tool, and more, all explained in this section. Read on!

Fixing Flabby Chins

You can suck the life out of a flabby chin with the Pinch filter. Sure it sounds gross, but it makes a *huge* difference and takes mere seconds. All you have to do is make a rough selection—the Lasso tool (page 162) works well—that includes the flab and some of the surrounding details, as shown in Figure 10-9 (bottom left). Then choose Filter→Distort→Pinch and, in the resulting dialog box, enter *100* in the Amount field, and then click OK. If you need to pinch it a little more, press ⌘-F (Ctrl+F on a PC) to run the filter again. Easy, huh?

Tip: As you'll learn in this chapter, filters are destructive (they alter your image's pixels), but you can protect your original image if you duplicate the image layer first by pressing ⌘-J (Ctrl+J on a PC). Or flip over to page 634 to get the scoop on running filters nondestructively by using Smart Filters.

Liquifying Bulges

Drastic bulges call for drastic action, and the Liquify filter is as drastic as it gets in Photoshop. This filter lets you push, pull, and pucker pixels any which way you want. You can use it to get your waistline under control, add a smile, enlarge lips, and so on (see Figure 10-10).

Figure 10-9:
Top: If you click in the Pinch filter's dialog box preview window and hold down your mouse button, Photoshop shows you the pre-pinched version of your image. You can drag to move the image around (your cursor turns into a little hand). Use the + and – buttons below the preview window to zoom into or out of your image.

Bottom: A fix like this one will earn you loyal clients for life!

Figure 10-10:
If you use the Liquify filter's Push Left tool, you can eliminate any bulge you want. If only this trick worked in real life!

Note: Give the following maneuver a try yourself. Visit this book's Missing CD page at *www.missing-manuals.com/cds* and download the practice file *Lovehandles.jpg*.

Here's how to do some serious bulge busting:

1. **Pop open your photo and duplicate the image layer.**

 To protect your original pixels, duplicate the image (Background) layer by pressing ⌘-J (Ctrl+J on a PC). That way, if you get carried away and create a lumpy mess or an alien, waiflike creature, you can trash this layer and start over. (You can't run this filter as a Smart Filter [page 634], so duplicating your original image layer is the only way to go.)

2. **Choose Filter→Liquify.**

 Photoshop opens the humongous Liquify dialog box, which may take over your whole screen.

3. **Grab the Push Left tool and increase your brush size.**

 The Liquify dialog box has a small toolbar on its left side. Grab the Push Left tool by clicking its icon in the toolbar (it looks like a checkered column of pixels poked by a left-facing arrow—it's selected in Figure 10-10). You can also press O to select the tool (that's the letter *o*, not the number zero). Though you can use the Tool Options section on the right side of the dialog box to pick a bigger brush, it's simpler to press the right bracket key (]) to increase the brush size or the left bracket key ([) to decrease it.

Note: The Ctrl-Option-drag (Alt+right-click+drag on a PC) keyboard shortcut that normally lets you resize your brush *doesn't* work in the Liquify dialog box.

4. **Mouse over to the bulge on the right side of the body and drag upward.**

 If you need to, move your image around in the preview window by pressing the space bar and dragging with your mouse. Once you've got a good view of the bulge you're getting rid of, position your cursor so the crosshair touches the background and the edge of the brush touches the bulge where it starts down at the waistband. Then push the bulge back toward the torso by dragging *upward*. If you think that's weird, you're not alone; nobody knows why this process scoots pixels to the left, but it does.

5. **Move to the left side of the body and drag downward.**

 Press the space bar and drag to move to the other side of your image. This time, position your cursor at the *top* of the bulge and then drag *down* to nudge the pixels to the right. Again, why this tool works this way is a mystery.

6. **Click OK when you're finished.**

Tip: To undo a single nudge, press⌘-Z (Ctrl+Z on a PC). To undo *everything* you've done with the Liquify filter without closing the Liquify dialog box, press Option (Alt) and the dialog box's Cancel button changes to read Reset. Click it to get the original image back. You can also use the Reconstruct tool discussed below.

You make all the tools in the Liquify dialog box work by holding down your mouse button or by dragging.. Here are the other tools you'll encounter in the Liquify dialog box (Figure 10-11 gives you an idea of what they can do):

- **Forward Warp.** Use this tool to push pixels forward (ahead of your cursor in the direction you're dragging) or Shift-drag with it to push pixels in a straight line. This is another great bulge-buster, and you can also use it to make your subjects smile whether they want to or not. Its keyboard shortcut is W.

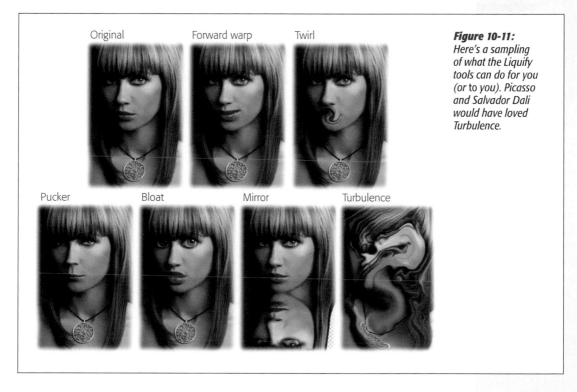

Figure 10-11:
Here's a sampling of what the Liquify tools can do for you (or to you). Picasso and Salvador Dali would have loved Turbulence.

- **Reconstruct.** Think of this one as an undo brush. To restore your pixels to their original state, paint over them with this tool. Keyboard shortcut: R.

- **Twirl Clockwise.** To spin your pixels clockwise as if they were going down a drain, grab this tool. You can click and hold or drag with this tool. Option-drag (Alt-drag on a PC) to make the pixels rotate counterclockwise. Keyboard shortcut: C.

- **Pucker.** This tool collapses pixels in on themselves like the Pinch filter (page 438). You can use it to make a tummy or thigh look smaller or shrink a flabby chin, a large nose, and so on. To make it have the opposite effect, press Option (Alt) so that it acts like the Bloat tool. Keyboard shortcut: S.

- **Bloat.** Use Bloat to enlarge pixels from the center out. If you're considering collagen injections to fluff up your lips, try this tool first. It's also useful for opening up squinty eyes. Keyboard shortcut: B.

- **Mirror.** This tool copies pixels from one spot to another and reverses them to create a reflection. Keyboard shortcut: M.

- **Turbulence.** To stir and scramble your pixels in random ways, use Turbulence. It can come in handy if you're trying to create realistic-looking fire or clouds. Keyboard shortcut: T.

- **Freeze Mask.** To protect an area from any of the Liquify filter's other tools, paint over it with this tool and you'll see the red Quick Mask overlay (page 176). It's similar to painting with black in a layer mask (page 114). Keyboard shortcut: F.

- **Thaw Mask.** To release pixels you've protected with the Freeze Mask, paint across them with this tool to make the red overlay disappear. It's the equivalent of painting with white in a layer mask (page 114). Keyboard shortcut: D.

- **Hand.** This Hand tool is the same one that you get by pressing the space bar or clicking the hand icon in the Application bar (page 14). You can use it to move around your image when you're zoomed in. Keyboard shortcut: H.

- **Zoom.** You can use this tool to zoom in and out of your document, but it's quicker to press ⌘ (Ctrl on a PC) and the + or – key. Keyboard shortcut: Z.

Slimming with the Free Transform

Years ago, Hewlett-Packard came out with a "slimming camera" that promised to make you look five pounds slimmer in every picture. Behind the scenes, the camera's software was squishing the sides of your image inward (reducing its width), making you appear slightly thinner. You can do the exact same thing with Photoshop's Free Transform tool, as shown in Figure 10-12.

Here's how to lose five pounds instantly:

1. **Pop open the soon-to-be-slimmer photo and double-click the Background layer to make it editable.**

 If your layer isn't locked (page 85), you can skip this step.

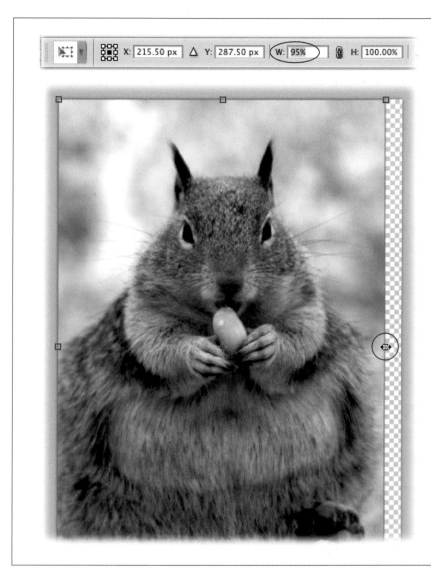

X: 215.50 px Y: 287.50 px W: 95% H: 100.00%

Figure 10-12:
Hey, squirrels need slimming, too! If you're slimming a photo while you're working in public, be sure to look over both shoulders first—you don't want to reveal this kind of retouching secret to just anyone!

2. **Summon Free Transform (page 263).**

When you press ⌘-T (Ctrl+T on a PC), Photoshop puts a bounding box around your whole image. Grab the little square handle in the middle of the right or left edge of your photo (it doesn't matter which), and then drag the handle inward while keeping an eye on the Options bar's W field. You want to make your image between 5 and 8 percent narrower (so the W value is 92–95 percent); if you narrow it any more than that, your image will look stretched out. (You can also type a new width into the W field.) When you've got the width just right, release your mouse button and press Return (Enter) to accept the transformation.

3. **Crop the image to get rid of the newly transparent area.**

 Grab the Crop tool by pressing C, draw a box around your image to nip that extra quarter inch or so off the side, and then press Return (Enter).

This simple retouch is absolutely impossible to spot—*if* you keep it between 5 and 8 percent, that is. Anything more and your subject will look decidedly smushed.

Selective slimming

Instead of using Free Transform to squish the whole image, you can use it to squish only a certain part. Just create a selection and then summon Free Transform by pressing ⌘-T (Ctrl+T on a PC). Figure 10-13 has the details.

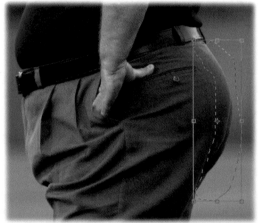

Figure 10-13:
Top: If you create a selection first, you can use Free Transform to shrink just the selected area. You may need to go back and use the Healing Brush to blend certain areas after you're finished.

Bottom: This before-and-after shot shows quite a difference, no?

Skin Softeners

Your skin is your body's largest organ though not everyone gives it the respect it deserves. We sometimes forget to use sunblock, moisturizer, and so on. This section teaches you how to make skin look like it's *really* well cared for. You'll learn how to make it look soft and glowing, and even how to reduce lines and wrinkles, all without spending tons of money on anti-aging creams.

Selective Blur

One of the fastest ways to smooth skin is to give it a good dose of the Gaussian Blur filter (it's named for the gentleman who invented this blur method, Carl Gauss). This filter is often the only skin fixer you need, and it's faster than the Healing brushes you learned about earlier in this chapter. The beauty of this filter is that you can run it on a separate layer, lower its layer's opacity, and use a layer mask to apply it only where you need it (see Figure 10-14).

Figure 10-14:
Just like Robitussin and duct tape, the Gaussian Blur filter can darn near fix anything. It made this woman's skin look nice and smooth by lessening the intensity of her freckles without removing them completely.

You can also use this technique to create a "shallow depth of field" effect in which the background is blurry and your subject is in focus.

To soften skin, follow these steps:

1. **Duplicate the Background layer.**

 Press ⌘-J (Ctrl+J on a PC) to duplicate the Background layer. If you want to use a layer mask to keep certain parts of your subject from getting blurred (like her eyes, hair, and so on), you need to run the filter on another layer. You can also adjust the intensity of the blur effect by lowering this layer's opacity, which you'll do in step 6.

2. **With the duplicate layer selected, choose Filter→Blur→Gaussian Blur.**

 In the resulting dialog box, adjust the Radius slider until your image is severely blurred (a radius of 8 was used to create Figure 10-14). Don't worry if you start to lose details; you can tweak the layer's opacity to lessen the effect in a minute.

Tip: If you click in the Gaussian Blur dialog box's preview window and hold down your mouse button, Photoshop shows you the unblurred version of your image. You can drag to move the image around.

3. **Add a layer mask filled with black.**

 As you've learned, in the realm of layer masks, black conceals and white reveals. Since you need to keep the majority of the image unblurred so folks can tell it's a face, save yourself some time by starting out with a black mask. Make sure the blurry layer is selected and then add a black-filled layer mask by Option-clicking (Alt-clicking) the circle-within-a-square button at the bottom of your Layers panel. Photoshop masks the whole layer, hiding all the blurring from your image.

4. **Press B to grab the Brush tool and set your foreground color chip to white.**

 Peek at the color chips at the bottom of your Tools panel. Press D to set the chips to black and white and then press X until white hops on top.

5. **With a fairly large, soft-edged brush, paint part of the skin you want to blur.**

 Painting with white reveals the blurry layer. Be sure to avoid your subject's eyes, lips, nostrils, and hair. If you reveal too much of the blur layer, press X to flip-flop color chips and paint that area with black.

6. **Lower the opacity of the blurry layer to around 75 percent.**

 At the top of your Layers panel, change the Opacity field's setting to about 75 percent or until the skin looks pretty natural.

Easy Glamour Glow

A quick way to add an ethereal glow to skin is to use the Diffuse Glow filter. As with Gaussian Blur, you want to create a special layer to run this filter on. Building on the skin-softening technique you learned about in the previous section, you can merge the original layer and the blur layer you created into a single layer that you'll run the filter on (this technique is called *stamping*).

Just Shift-click to select the two layers in your Layers panel and, while pressing Option (Alt on a PC), choose Merge Layers from the Layers panel menu. Photoshop merges the two layers into one and puts the merged layer at the top of your Layers panel. Next, choose Filter→Distort→Diffuse Glow and up pops the giant dialog box shown in Figure 10-15, top.

Figure 10-15:
Top: This filter adds a serious amount of grain to your image, so grab the Graininess slider and drag it all the way to the left. Set the Glow Amount to about 5 and leave the Clear Amount set to 15. Click OK when you're finished.

Bottom: Back in your Layers panel, change the glow layer's blend mode to Luminosity so Photoshop shifts only the image's lightness value, not its color, and reduce the layer's opacity to about 75 percent.

Softening Wrinkles with Faux Dodge and Burn

You've already seen a couple of tools that can reduce wrinkles: the Healing Brush (page 427) and the Clone Stamp tool (page 434). Another option is to slightly lighten or darken the wrinkled area so the wrinkling isn't so severe.

You could reach for the Dodge and Burn tools to perform this task—after all, they're designed to lighten and darken pixels (respectively). These tools hail from the days when photographers developed their own film, disappearing mysteriously into a broom closet with an amber light and emerging hours later with dilated pupils and clothes reeking of pungent chemicals. Without diving too deeply into what goes on in darkrooms, a photo is created by projecting an image onto special paper. During this process, if you block some of the light by holding an object in front of the light source, the resulting image will be lightened or *dodged* in the area that was exposed to less light. If you *increase* the amount of light that hits a certain area, that part of the image will be darkened or *burned*.

Note: The Dodge tool's icon looks like a lollipop because you could theoretically block light from hitting your developing image by holding something in front of it that looks like a circle on a stick. The Burn tool's icon looks like a hand because you could use your hand to cover the areas that you want to keep lighter while you let light through your curled fingers. The icons are a bit of a stretch, but they make more sense when you know how the techniques originated.

In Photoshop, you've got a fair amount of control over how the Dodge and Burn tools work. They each have a Range pop-up menu that lets you choose which pixels get altered—shadows, midtones, or highlights. You can also control the strength of the tools' effects by adjusting the Exposure setting, which works kind of like opacity. But it's important to remember that these tools are darn destructive (even though both tools were redesigned in CS4 so they don't completely destroy skin tones when you use 'em). You can't make them work on a layer other than your original image unless you duplicate your image, and both of them can change the color of pixels, which might make your image look worse than it did before you started messing with it. Finally, it's a pain to have to keep trotting up to the Options bar to adjust the Range and Exposure settings. That being said, these tools can certainly lighten and darken parts of your image. Just be sure to duplicate the layer first so you're not affecting the original image, and lower the Exposure setting in the Options bar before you use them.

A better solution is to use the Brush tool so it *behaves* like the Dodge and Burn tools. By filling a layer with 50 percent gray and changing its blend mode to Soft Light (page 298), you do exactly that (see Figure 10-16).

Tip: This technique isn't just good for softening wrinkles; it's a great way to lighten or darken *any* part of your image, though it's especially helpful on portraits.

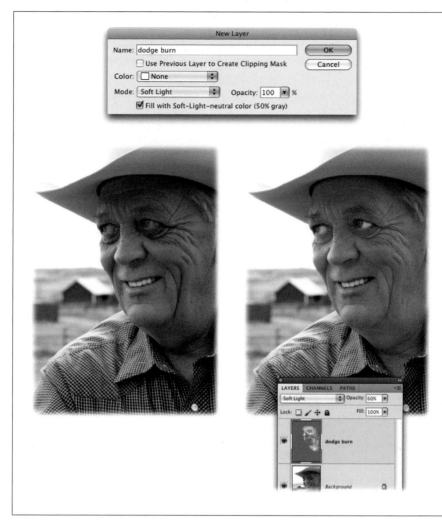

Figure 10-16:
Top: A quick way to create a layer you can use for your faux dodging and burning is to use the New Layer dialog box; press ⌘-Shift-N (Ctrl+Shift+N on a PC) to call it up. Set the Mode menu to Soft Light and then turn on the "Fill with Soft-Light-neutral color (50% gray)" checkbox and click OK.

Bottom: When you use faux dodge and burn, your subject retains his character but his wrinkles aren't so distracting. Notice how much brighter his eyes are, too. The whites were dodged and the darker rim of color around the outer edge of each iris was burned.

Here's how to do some faux dodging and burning:

1. **Open your image and, in your Layers panel, Option-click (Alt-click on a PC) the "Create a new layer" button.**

 In the resulting dialog box, name your new layer *Dodge Burn*, choose Soft Light from the Mode pop-up menu, turn on the "Fill with Soft-Light-neutral color (50% gray)" checkbox, and then click OK. Sure, you could create a new layer, use the Edit→Fill command to fill it with gray, and then change its Mode setting, but this way is faster.

2. **Press B to grab the Brush tool and set its opacity to 10–20 percent.**

 To touch up your image gradually, lower the brush's opacity to something between 10 and 20 percent. Yes, the retouching takes longer, but you can dodge and burn little by little, which is better than doing too much at once.

3. **Set your foreground color chip to white for dodging.**

 Take a peek at the color chips at the bottom of your Tools panel. Press D to set them to black and white and then press X to flip-flop them so white is on top.

4. **Mouse over to your image and paint across the dark wrinkles.**

 To lighten just the shadowy parts of the wrinkles, you need to use a small brush (or else you'll lighten areas that don't need to be lightened). It's also helpful to zoom *way* in on your image when you're doing detailed work like this. You can zoom in or out by pressing ⌘ (Ctrl on a PC) and the + or – key. Photoshop gives you a pixel-grid view when you zoom in more than 500 percent (see page 61).

5. **Swap color chips so that your foreground color is black and then paint light areas that you need to burn (darken).**

 If the wrinkles are so deep that they cause highlights, you can darken those a little. In Figure 10-16 the edge of each iris was also darkened to make the man's eyes look brighter.

6. **Lower the Dodge Burn layer's opacity slightly.**

 If you've overdone the changes a bit, you can lower the layer's opacity.

7. **Save your document as a PSD file in case you ever need to go back and alter it.**

Show-Stopping Eyes

One of the simplest yet most impressive eye-enhancing techniques is waiting for you over in Chapter 11. Just as you can selectively blur an image, you can also selectively sharpen it. Hop on over to page 472 to see how to use sharpening to make eyes really pop. Here in this section, you'll learn how to enhance and whiten eyes, fix red eye a bazillion different ways, and even get the scoop on fixing your furry friends' eyes.

Enhancing Eyes

A quick and painless way to make eyes stand out and look sultry is to lighten them by changing their blend mode to Screen. This technique enhances the iris *and* brightens the white bits at the same time, as Figure 10-17 shows. To achieve this effect without duplicating the original layer (which increases your file's size), just use an empty Adjustment layer.

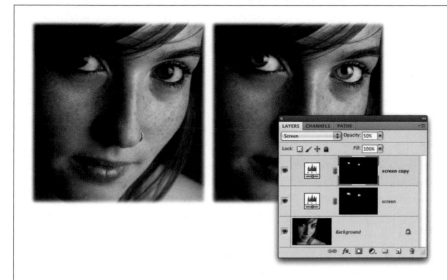

Figure 10-17:
If you use an empty Adjustment layer set to Screen mode, you can add a whole new dimension to your subject's eyes. (The original image is at left and the adjusted image is on the right.) The cool thing about this technique is that it enhances the iris and the white part simultaneously.

Here's how to quickly enhance eyes:

1. **Pop open a photo and add an empty Adjustment layer.**

 Click the half-black/half-white circle at the bottom of the Layers panel and choose Levels from the menu. When the Adjustments panel opens, click the double arrows at its top right or the dark gray bar at the top of the panel to close it (you don't need to actually make a levels adjustment).

2. **Set the Adjustment layer's blend mode to Screen.**

 At the top left of the Layers panel, use the pop-up menu to change the blend mode to Screen. When you do, Photoshop makes your whole photo *way* too light, but don't panic—you'll fix it in the next step.

3. **Fill the Adjustment layer's mask with black.**

 Peek in your Layers panel and make sure the Adjustment layer's mask is selected (it should have a tiny black outline around it). To hide the over-lightening that happened in the previous step, choose Edit→Fill, pick Black from the Use pop-up menu, and then click OK.

4. **Grab the Brush tool and set the foreground color chip to white.**

 Press B to grab the Brush tool and then glance at the color chips at the bottom of the Tools panel. If white's on top, you're good to go; if it's not, press D to set the chips to black and white and then press X until white is on top. Now you're ready to paint a hole through the mask so the lightening will show through only on your subject's eyes.

5. **Paint the eye area.**

Mouse over to your image and paint the eyeballs. If you mess up, just press X to flip-flop the color chips and paint with black.

6. **Duplicate the Adjustment layer.**

Once you've got the mask just right, you can intensify the effect by duplicating the Adjustment layer. Press ⌘-J (Ctrl+J on a PC) to duplicate the layer and lower the duplicate's opacity to about 50 percent.

7. **Save the image as a PSD file.**

Ta-da! This technique makes a galactic difference, and your subject's eyes will pop off the page.

Fixing Red Eye

One of the most annoying things about taking photos with a flash is the creepy red eyes it can give your subjects. Photoshop's Red Eye tool does a good job on most cases of red eye, though sometimes you'll encounter a really stubborn case that just refuses to go away. That's why it's good to have a few tricks up your sleeve, including stealing pupils from another channel, using the Color Replacement tool, creating a Hue/Saturation Adjustment layer, or fixing 'em in Camera Raw. This section explains all those options.

The Red Eye tool

Oh, man, if only all of Photoshop's tools were as easy to use as this one! The Red Eye tool is part of the Healing Brush toolset (it looks like an eye with a plus sign next to it). Just grab the tool, mouse over to your document, and draw a box around the eye, as shown in Figure 10-18, top. As soon as you let go of your mouse button, Photoshop hunts for the red inside the box and makes it black. That's all there is to it!

Tip: If this tool doesn't zap the red-eye completely on the first attempt, try pressing ⌘-Z (Ctrl+Z on a PC) to undo it and increase the Pupil Size and Darken Amount settings in the Options bar and then have another go at it.

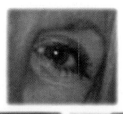

Figure 10-18:
Contrary to what you might think, it's better to draw a box around the whole eyeball rather than just around the pupil. For some odd reason, the smaller the box, the less effective the Red Eye tool is.

WORKAROUND WORKSHOP

Stealing Pupils from Channels

Why bother with all this red-eye fixing mumbo jumbo when you've got perfectly good black pupils in your Channels panel? (Since Photoshop doesn't display channels in color, the pupils aren't red.) There's certainly no law saying you can't pop into your image's channels and snatch the pupils from there. Here's how to do it:

1. Open your Channels panel by clicking its icon in the panel dock (page 188) or by choosing Window→Channels. Then stroll through the channels by clicking each one or by pressing ⌘-3, 4, 5 (Ctrl+3, 4, 5) to find the channel where the pupils are darkest (it's most likely the Green channel). If you're in CMYK mode, you've got one extra channel to look at, which you can see by pressing ⌘-6 (Ctrl+6).

2. Grab the Elliptical Marquee tool (page 139) and draw a selection that's slightly larger than the pupil in one eye. Then press and hold the Shift key to draw a selection around the other pupil.

3. Ctrl-click (right-click) in one of the selections (it doesn't matter which one) and choose Feather from the resulting shortcut menu. In the resulting dialog box, enter *1* in the Feather Radius field and then click OK.

4. Copy the pupils by pressing ⌘-C (Ctrl+C on a PC) and then turn the composite channel (page 189) back on by pressing ⌘-2 (Ctrl-2).

5. Open your Layers panel and create a new layer for the pupils: Click the "Create a new layer" button at the bottom of the panel, name the layer *New Pupils*, and then place it above the photo layer.

6. Paste the pupils onto the new layer by pressing ⌘-V (Ctrl+V). Poof—you're done! Your subject should look much less demonic now.

The Color Replacement tool

Another option for getting rid of super-stubborn red eye is the Color Replacement tool. If you choose black as your foreground color chip, you can use this tool to replace the red with black. But because this tool is destructive (and because there's no way of knowing what kind of job it'll do), it's best to select the eyes and jump them onto their own layer first. Here's what you do:

1. **Select the eyes and copy them onto another layer.**

 Using the Lasso tool (page 162), draw a rough selection around both eyes (grab the whole eye, not just the pupil) and then press ⌘-J (Ctrl+J on a PC) to jump the eyes onto their own layer. That way, if this technique goes south, you can toss this layer and start over.

2. **Select the Color Replacement tool from the Tools panel.**

 It's hiding in the Brush toolset, and it looks like a brush with a tiny curved arrow pointing to a black square (the square is supposed to represent your foreground color chip). You can press Shift-B repeatedly to cycle through this toolset.

3. **Set your foreground color chip to black.**

 Press D to set your color chips to black and white, and then press X until black hops on top. Alternatively, you can set the new color by Option-clicking (Alt-clicking on a PC) an eyelash or other black part of the eye.

4. **In the Options bar, set the Mode field to Hue, the Limits field to Contiguous, and the Tolerance field to around 30 percent.**

 Choosing the Hue blend mode means you're replacing color without altering its brightness (for more on blend modes, see page 289). The Contiguous setting tells Photoshop to replace only the red pixels that are clustered in one spot and not separated by other colors. The Tolerance setting determines how picky the tool is: lower numbers make the tool pickier; higher numbers result in a color-replacing free-for-all.

5. **Paint the red away.**

 You'll want to use a small brush for this maneuver. Press the left bracket key ([) to cycle down in brush size, and the right bracket key (]) to cycle up, or Ctrl-Option-drag (Alt+right-click+drag on a PC) to the left or right to decrease or increase your brush size. When you've got a size that looks good, mouse over to the pupils and paint over the red, being careful to touch *only* the red with your cursor's crosshair.

6. **When you're finished painting, use the Eraser tool or a layer mask to clean up the area just outside the pupil, if necessary.**

 If you end up with a little black outside the pupil, you can use the Eraser tool (see Appendix D, online at *www.missingmanuals.com/cds*) to fix it because you'll erase to the original layer below. Press E to select the Eraser and carefully paint away any extra black pixels. You can also add a layer mask to the eye layer and paint with black to hide the excess black.

7. **Save your document as a PSD file and call it a day.**

Hue/Saturation Adjustment layers

Yet another option for fixing red eye is to zap the red with a Hue/Saturation Adjustment layer, which you learned about in Chapter 8. Select the red eyes with the Lasso tool, click the half-black/half-white circle at the bottom of your Layers panel, and then choose Hue/Saturation from the pop-up menu. When the Adjustments panel opens, adjust the sliders until the red eye leaves the building.

The Sponge tool

As a *last* resort, you can use the Sponge tool to desaturate (remove) color from the pupils. The Sponge tool looks—not surprisingly—like a sponge, and it's part of the Dodge toolset. Though you can use this tool to desaturate *or* saturate an image, it's set to desaturate (which is what you want when you're zapping red eye) until you change it. After you grab the Sponge tool, head up to the Options bar and change the Flow field to 100 percent or you'll be painting for days (it's set at 50 percent originally). Finally, mouse over to your image and paint over the red area repeatedly until it turns almost black. This technique takes a while, but it's guaranteed to work…eventually.

Fixing red eye in Camera Raw

Camera Raw's Red Eye Removal tool looks and works the same as Photoshop's. It's handy to have this ability in Camera Raw because, if you're shooting in Raw format and you don't need to do any other editing in Photoshop, you don't have switch programs just to fix red eyes. After you open an image in Camera Raw (see page 234), press E to grab the Red Eye Removal tool. Then simply draw a box around the eyeball, as shown in Figure 10-19, and let go of your mouse button.

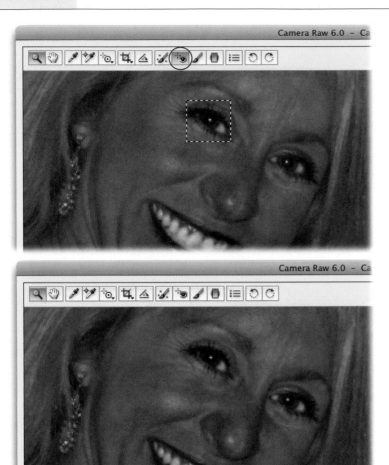

Figure 10-19:
When you're finished using the Red Eye tool in Camera Raw, you'll see a black-and-white circle around the pupil, letting you know that Raw made the red-eye fix. Just switch to another tool and the box disappears. Click Done to save your changes and close the Camera Raw window.

Fixing Animal White Eye

Okay, *technically* animals aren't people—though to some folks (your author included) they might as well be. Our furry friends have a version of red eye, too; it's called *white eye,* and it can ruin their photos, too. Actually, white eye is more challenging to fix than red eye because there aren't any pixels in the eye left to work with—the pupils turn solid white. The Red Eye tool won't work because the pupils aren't red, and the Color Replacement tool won't work because there's no color to replace. The solution is to select the pupil and fill it with black, and then add a couple of well-placed glints (tiny light reflections) to make the new pupils look real (see Figure 10-20).

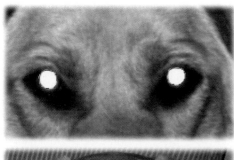

Figure 10-20:
Selecting the blown-out pupils (top), adding some black paint, and topping it off with two flicks of a white brush to add a glint transforms Miss Abbey from devil dog to angel in minutes.

Here's how to fix your furry friend's eyes:

1. **Open the image and select the white pupils.**

 Since you're selecting by color, you can use either the Magic Wand or the Quick Selection tool: Just click one pupil and then Shift-click the other. You can also select them with the Elliptical Marquee: Draw a selection around the first pupil and then press and hold Shift while you draw a circle around the second pupil. While you're holding the mouse button down, you can press and hold the space bar to move the selection around as you're drawing it.

2. **Feather the selection with Refine Edge.**

 Once you've got marching ants, click the Option bar's Refine Edge button bar and make sure the resulting dialog box's Feather field is set to one pixel and the Smooth field is set to one (otherwise the edges will be too soft). To make sure you get all the white bits, you might expand your selection by 10 to 20 percent or so by dragging the Contract/Expand slider to the right. When you're finished tweaking your selection, click OK.

Note: Remember, the settings in the Refine Edge dialog box are sticky—they reflect the last settings you used. So take a second to make sure they're all set to zero except for the ones mentioned here.

3. **Create a new layer named *New Pupils*.**

 Click the "Create a new layer" button at the bottom of the Layers panel, name the layer, and make sure it's at the top of the layers stack.

4. **Fill the selection with black.**

 To recreate the lost pupil, press D to set your color chips to black and white and then press X until black is on top. Next, press Option-Delete (Alt+Backspace on a PC) to fill your selection with black. If the color doesn't seem to reach the edges of your selection (which can happen if you feathered or smoothed your edges a little too much in step 2), fill it again by pressing Option-Delete (Alt+Backspace). Once you've filled the pupils with color, you can get rid of the marching ants by pressing ⌘-D (Ctrl+D) to deselect.

5. **Create another new layer and name it *Glint*.**

 You'll want to soften the glints you're about to create by lowering layer opacity, so you need to put the glints on their own layer.

6. **Grab the Brush tool and set your foreground color chip to white.**

 Press X to flip-flop color chips and, with a very small brush (10 pixels or so), click once in the left eye to add a glint to mimic the way light reflects off eyes (every eye has one). Next, click in the *exact* same spot in the right eye to add a sister glint. Then lower the glint layer's opacity to about 75 percent.

7. **Save your document as a PSD file.**

Pat yourself on the back for salvaging such a great shot of your pet.

The Art of Sharpening

You know the saying "Last but not least"? Well, that definitely applies to *sharpening*—a digital attempt to improve your image's focus—since it's generally the last thing you do before sending your precious images off to the printer. Sharpening is *muy importante*: It brings out details and makes your image really pop. But it's also one of the least understood processes in Photoshop. In addition to teaching you *how* to sharpen, this chapter also gives you some guidelines about *when* and *how much* sharpening to apply, so you're not just guessing.

In case you're wondering which of your photos need sharpening, the answer is pretty much all of 'em. If your image came from a digital camera or a scanner, it needs sharpening. Why? In his comprehensive book on sharpening, *Real World Image Sharpening with Adobe Photoshop CS2* (Peachpit Press, 2006), the late Bruce Fraser explains that images get softened (their pixels lose their hard edges) when cameras and scanners capture light and turn it into pixels. Then, those images get softened even more when they're printed. Even if you create an image from scratch in Photoshop, the same deterioration occurs if you shrink it. To combat all these problems, you need to spend a little quality sharpening time with your images.

While Photoshop is pretty darned good at sharpening, it's not magic—it can't take an out-of-focus image and make it *tack sharp* (photographer slang for super-duper sharp, derived from the phrase "sharp as a tack"). One of the few ways you can produce well-focused photos is to shoot using a tripod (to keep your camera stable) and a remote (so you don't move your camera when you press the shutter button), and use a lens (or camera body) that includes an image stabilizer. The program doesn't have a magical "make my blurry picture sharp" button, though maybe Photoshop

CS25 will. What Photoshop *can* do is take an in-focus image and make it nice and crisp. But before you start sharpening, it's important to understand how the whole process works.

Note: You can save a slightly blurry image by using the Emboss filter. Flip to page 652 for the scoop.

What Is Sharpening?

Sharpening an image is similar to sharpening a kitchen knife. In both instances, you're refining (emphasizing) the edges. On a knife, it's easy to identify the edge. In a digital image, it's a little more challenging: the edges are the areas where different-colored pixels meet (see Figure 11-1).

Unsharpened

Oversharpened

Figure 11-1:
Left: You can easily spot the edges in this image because its contrast is pretty high.

Right: In this before-and-after close-up of the Chihuahua's antlers—who does that to their pet?—see how the edges are emphasized after some overzealous sharpening (bottom)? The weird white glow around the antlers is the dreaded sharpening halo.

When you sharpen an image—whether in Photoshop, Camera Raw (page 480), or a darkroom—you exaggerate the edges in the image by increasing their contrast. Where two colors meet, you make the light pixels a little lighter and the dark pixels a little darker. Though it may sound similar to increasing the overall contrast of your image, it's not. When you run one of Photoshop's sharpen filters, the program analyzes your image and increases the contrast *only* in spots it thinks are edges (and, as you'll learn later on you have some control over what Photoshop considers an edge).

Sharpening is a bit of an art: If you don't sharpen enough (or at all), your image looks unnaturally soft and slightly blurred; if you sharpen too much, you get a nasty *sharpening halo*, a white gap between light and dark pixels as shown in Figure 11-1 (bottom right). But if you sharpen just the right amount, no one will notice the sharpening—they'll just know that your image looks really good.

One of the downsides to sharpening is that it also emphasizes any kind of *noise*—graininess or color specks—in your image. One way around that problem is to get rid of the noise before you sharpen, or at least have a go at reducing it (see the box on page 462 for tips).

Now that you know what sharpening does, you're ready to give it a whirl in Photoshop. The next few pages focus on basic sharpening techniques; more advanced methods are discussed later in this chapter.

Basic Sharpening

After you've retouched your image (Chapters 8, 9, and 10) and resized it (Chapter 6), it's time to sharpen. If you've ever peeked inside the Filter menu at the top of your screen, you've probably noticed a whole set of filters devoted to sharpening. They include:

- **Sharpen, Sharpen Edges, Sharpen More.** When you run any of these filters, you leave the sharpening up to Photoshop (scary!). Each filter analyzes your image, tries to find the edges, and creates a relatively narrow sharpening halo (see Figure 11-1, bottom). However, none of these filters gives you an ounce of control, which is why you should forget they're even there and stick with the next two filters instead.

- **Smart Sharpen.** When you see three little dots (…) next to a menu item, it means there's a dialog box headed your way (and when it comes to sharpening, that's good!). Luckily, this filter has those dots. Smart Sharpen lets you control how much sharpening happens in your image's shadows and highlights and lets you pick which kind of mathematical voodoo Photoshop uses to do the sharpening. Page 466 discusses this filter in detail.

- **Unsharp Mask.** This filter has been the gold standard sharpening method for years because, until the Smart Sharpen filter came along in Photoshop CS2, Unsharp Mask was the only one that gave you dialog box–level control over how it worked. Most folks still prefer this method because it's easy to use and quick (it runs faster than the Smart Sharpen filter). Page 463 has the lowdown.

No matter which filter you choose, sharpening is a destructive process, so it's a good idea to protect your image by following these guidelines:

- **Resize your image first.** Make sharpening your last step before you print an image or post it on the Web—in other words, after you've retouched and resized it. Because pixel size depends on an image's resolution (page 44) and sharpening has different effects on different-sized pixels, it's important to sharpen the image after you make it the size you want.

UP TO SPEED

Keeping the Noise Down

It's best to reduce or get rid of any noise in your image before you sharpen it, or you'll end up sharpening the noise along with the edges. Photoshop gives you a variety of noise-reducing filters: they're discussed starting on page 644. All of them work by *reducing* the amount of contrast between different-colored pixels. (This process is exactly the opposite of sharpening, which is why removing noise also reduces sharpness!) The aptly named Reduce Noise filter is the best of the bunch because it gives you far more control than the others.

Because all filters run on the currently active layer (meaning they affect your original image), be sure to convert your image to a Smart Object first so the filter itself runs on its own layer (see page 124). Choose Filter→Noise→Reduce Noise and, in the resulting dialog box, you can adjust the following settings:

- **Strength.** If you've got a lot of *grayscale noise*— luminance or brightness noise that looks like grains or splotches—or *color noise* that looks like little specks of color in your image, you can increase this setting to make Photoshop reduce it in every color channel. This setting ranges from 1 to 10; it's set to 6 unless you change it.
- **Preserve Details.** You can increase this setting to protect the detailed areas of your image, but if you do, Photoshop can't reduce as much grayscale noise. For best results, tweak this setting along with the Strength setting and find a balance between the two.
- **Reduce Color Noise.** If you've got colored specks in your image, try increasing this setting so Photoshop erases even more of the little buggers.

- **Sharpen Details.** Because every noise-reducing filter blurs your overall image, this option lets you bring back some of the sharpness. However, resist the urge to use it and go with one of the other sharpening methods described in this chapter instead.
- **Remove JPEG Artifacts.** If you're dealing with an image that's gotten blocky because it was saved as a low-quality JPEG, turn on this checkbox and Photoshop tries to reduce that Lego look.
- **Advanced.** This setting lets you tweak each color channel individually (for more on channels, see Chapter 5). So if the noise is in just one or two color channels (noise is notoriously bad in the blue channel), turn on this option and tweak each channel's settings individually. (Because Reduce Noise can make your image blurry, it's better to adjust as few channels as possible.)

Once you're finished modifying these settings, press OK to run the filter and then toggle the filter layer's visibility off and on (page 82) to see how much effect the filter really had. (You can preview the effect on your image by pressing P while the filter's dialog box is open.) You can also use the Smart Filter's included layer mask (page 634) to restrict the filter's effects to certain parts of the image if you need to.

And if you determine that the filter didn't help one darn bit, run—don't walk!—over to Chapter 19 to find a third-party, noise-reduction plug-in that can. Or, if buying a plug-in isn't in your budget, flip to page 214 to learn how to sharpen individual channels which lets you bypass the noise-riddled channel altogether.

You may now proceed with sharpening your image.

- **Get rid of any noise first.** If you see any funky color specks or grains that shouldn't be in your image, get rid of them *before* you sharpen or they'll look even worse. The box on page 462 tells you how.

- **Sharpen your image on a duplicate layer or run it as a Smart Filter.** Before you run a sharpening filter, select the image layer and duplicate it by pressing ⌘-J (Ctrl+J on a PC). That way, you can toggle the sharpened layer's visibility on and off (page 82) to see before and after versions of your image. You can also restrict the sharpening to certain areas by adding a layer mask (page 114) to the sharpened layer and reducing the opacity of the sharpened layer (page 92) if the effect is too strong (page 470 has tips for sharpening a multilayered file). Better yet, convert your image layer for Smart Filters so Photoshop does the sharpening on its own layer *and* includes a layer mask for you automatically; page 634 has the details.

- **Change the sharpening layer's blend mode to Luminosity.** Because you're about to make Photoshop lighten and darken a whole lot of pixels, you risk having the colors in your image shift. However, if you change the sharpening layer's blend mode to Luminosity, the sharpening affects only the brightness of the pixels, not their color. If you use the Smart Filter method described on page 466, change the filter layer's blend mode to Luminosity instead. This little trick does virtually the same thing as changing the color mode to Lab (page 420) and then sharpening the Lightness channel, but it's a whole lot faster!

- **Sharpen your image a little bit, multiple times**. It's better to apply too little sharpening and run the sharpening filter *again* than to apply too much sharpening all at once. Sharpening your image gradually gives you more control; just use your History panel or press ⌘-Z (Ctrl+Z on a PC) to undo the last sharpening round if you go too far.

In the following pages, you'll learn various ways to sharpen, starting with the most popular method: the Unsharp Mask filter.

Sharpening with the Unsharp Mask

This filter is the favored sharpening method of many, but its name is rather confusing—it sounds like it does just the opposite of sharpen. The odd name came from a technique used in darkrooms, which involves using a *blurred* (or "unsharp") version of an image to produce a *sharper* one. In Photoshop, the Unsharp Mask filter studies each pixel, looks at the contrast of nearby pixels, and decides whether they're different enough to be considered an edge (you control how picky the filter is using the Threshold setting, shown in Figure 11-2 and discussed below). If the answer is yes, Photoshop alters the pixel to increase the contrast of that edge. The basic process is simple: Photoshop lightens the light pixels and darkens the dark pixels.

Figure 11-2:
Before the Smart Sharpen filter came along, Unsharp Mask was the only sharpening method in Photoshop that gave you any level of control. Because it's so quick and easy to use, it's still the preferred method today. To bail out of the Unsharp Mask dialog box (shown here) without doing anything, click the Cancel button or press Esc.

The Unsharp Mask filter's effects look a little stronger onscreen than they do when you print the image. That's because the pixels on your screen are much bigger than the ones your printer prints. So to get a printed image that's nice and crisp, make your onscreen image look a little too sharp.

Here are the settings you can adjust in the Unsharp Mask dialog box:

- **Amount.** This setting, which controls the sharpening intensity, ranges from 1 percent to 500 percent. The higher the setting, the lighter Photoshop makes the light pixels and the darker it makes the dark pixels. If you set it to 500 percent, Photoshop makes all the light pixels near edges pure white and all the dark ones pure black, giving your image a sharpening halo you can see from outer space. For best results, keep this setting between 50 percent and 150 percent (you can find other magic numbers on page 466).

- **Radius.** This setting controls the width of the sharpening halo or, rather, how many pixels on either side of the edge pixels Photoshop analyzes and changes. Changing this setting alters your sharpening preview thumbnail (shown in Figure 11-2), so it's a good idea to adjust it first. Typically, when you increase this setting, you need to reduce the Amount setting to avoid creating a Grand Canyon–sized sharpening halo. For best results, never set the Radius higher than 4.

- **Threshold.** This setting lets you control how different neighboring pixels have to be before Photoshop considers them an edge. Oddly enough, Threshold works the opposite of how you might expect: Setting it to 0 sharpens *every* pixel in your image! For best results, keep this setting between 3 and 20 (it ranges from 0 to 255).

Here's how to use the Unsharp Mask filter nondestructively:

1. **Convert your image to a Smart Object.**

 This filter is destructive, but instead of duplicating your image layer (which adds to your document's file size), you can run it as a Smart Filter instead. Choose Filter→Convert for Smart Filters and Photoshop places a tiny Smart Object badge at the bottom right of your image's thumbnail (page 125).

2. **Choose Filter→Sharpen→Unsharp Mask.**

 In the resulting dialog box (see Figure 11-2), tweak the settings to your liking. In the next few pages, you'll find some recommended values that you can memorize for later use, but, for right now, just adjust the settings so the image in the preview thumbnail looks good to you. Click OK when you're finished to close the dialog box and you'll see another layer named Unsharp Mask appear in the Layers panel.

Tip: Anytime you see a preview thumbnail in a dialog box (like the one shown in Figure 11-2), you can click it and hold your mouse button down to see a before version of your image (in this case, the unsharpened version). You can also drag to move the preview around or click the little + and – buttons below the preview to zoom in or out. You can also use keyboard shortcuts: ⌘-click (Ctrl-click) to zoom in, and Option-click (Alt-click) to zoom out.

3. **Change the filter's blending options to Luminosity.**

 Click the tiny icon to the right of the Unsharp Mask layer to open the filter's blending options. Change the Mode pop-up menu to Luminosity and then click OK to close the dialog box.

Sit back and marvel at your new Photoshop sharpening prowess! If necessary, you can always use the Smart Filter's mask (the big white thumbnail beneath your image layer) to hide the sharpening from areas that don't need it. Smart Filters and their masks are covered in detail in Chapter 15.

How much to sharpen?

Some images need more sharpening than others. For example, you don't need to sharpen a portrait as much as you do a photo of Times Square because they have different amounts of detail (the Times Square photo is super busy and has lots of hard lines). If you sharpen the portrait too much, you see pores and blemishes with enough details to haunt your next power nap!

Photoshop guru Scott Kelby came up with some especially effective values to use in the Unsharp Mask dialog box and published them in *The Adobe Photoshop CS4 Book for Digital Photographers* (New Riders Press, 2009). With his blessing, here they are:

- **Sharpening soft stuff:** If you're sharpening images of flowers, puppies, babies and other soft, fluffy subjects (stuff that often blends into its background), you don't want to apply much sharpening at all. For extremely soft sharpening, try setting the Amount to 150 percent, the Radius to 1, and the Threshold to 10.

- **Sharpening portraits:** While close-up portraits need a bit more sharpening than the items mentioned above, you don't want to sharpen them as much as something hard like a building with lots of straight lines and angles. To sharpen portraits enough to make their subject's eyes stand out, try setting the Amount to 75 percent, the Radius to 2, and the Threshold to 3.

- **Sharpening objects, landscapes, and animals:** This stuff tends to be a little harder and contain more details (sharp angles, fur, and so on) than portraits, so it needs a moderate amount of sharpening. Try setting the Amount to 120 percent, the Radius to 1, and the Threshold to 3.

Note: These numbers are merely guidelines—they're not absolute rules. Experiment with your own images and printer to see which settings give *you* the best results.

- **Maximum sharpening:** For photos of cars or of buildings (which are chock-full of hard lines, angles, and details) or for photos that are a little out of focus, try entering an Amount of 65 percent, a Radius of 4, and a Threshold of 3.

- **Sharpening anything:** For everyday sharpening, regardless of what's in your image, enter an Amount of 85 percent, a Radius of 1, and a Threshold of 4, and then call it a day.

- **Sharpening for the Web:** If you've resized an image so it's small enough to post on the Web (see page 247), it needs more sharpening because downsizing often makes an image appear softer. Set the Amount to 200 percent, the Radius to 3, and the Threshold to 0.

The Smart Sharpen Filter

The Smart Sharpen filter (Figure 11-3) gives you a lot more options than Unsharp Mask, so it offers you a slightly better chance of saving an out-of-focus image. This filter also lets you save your favorite sharpening settings as presets, which is handy. The downside? It's not nearly as easy to use as Unsharp Mask and it takes longer to run. Like Unsharp Mask, this filter is destructive, so be sure to make a copy of the layer you're sharpening first (or run it as a Smart Filter, as described on page 634). Then run this filter by choosing Filter→Sharpen→Smart Sharpen.

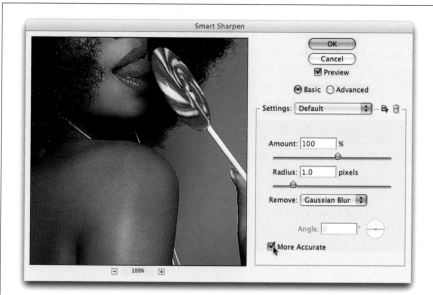

Figure 11-3:
Here you see the option-riddled Smart Sharpen dialog box in basic mode.

POWER USERS' CLINIC

Fading Filters

You may feel that this chapter is jumping the gun a little bit by covering sharpening filters because there's a *whole chapter* on filters headed your way (Chapter 15). However, some of the things you can do with filters—like fading a filter you've applied—are too dad-gummed useful to wait until then!

If you run a filter (or an image adjustment, for that matter) and the effect is a little too strong, you have one shot at lowering the filter's opacity to lessen its effect. You can also change its blend mode (page 289). However, Photoshop only lets you do this right after you run the filter, so it's super easy to miss your chance. (If you didn't duplicate the original layer before running the filter or if you didn't run it as a Smart Filter, this fix is your saving grace.)

After you run the filter and before you do or click *anything* else, head up to the Edit menu and choose "Fade [name of the last filter you ran]". (If you click another button or

select another tool, Photoshop grays out the Fade option and you're out of luck.) In the resulting Fade dialog box, enter a percentage in the Opacity field to let Photoshop know how much you want to fade the filter. For example, if you think the filter is twice as strong as you need, enter *50* to reduce its effect by half. (If you click OK and then change your mind, you can select Edit→"Fade [name of filter]" again and enter a new number. The Edit menu's Fade option remains clickable until you run another command or use another tool.

The Fade dialog box also has a Mode pop-up menu that lets you change the filter's blend mode to adjust how the sharpened pixels blend with the original ones. Changing this setting to Luminosity has the same effect as running the filter on a duplicate layer and setting that layer's blend mode to Luminosity. When you press OK, Photoshop lessens the filter's effect by the percent you entered.

In the resulting dialog box, you'll be assaulted with options that include Amount and Radius (discussed in the previous section—page 464), plus:

- **Remove.** This menu is where you pick which kind of blurs you want Photoshop to remove—or, more accurately, reduce. Your choices are:

 — **Gaussian Blur.** Think of this as the basic mode; it's the one that the Unsharp Mask filter uses.

 — **Lens Blur.** Pick this setting if your image has a lot of details or noise.

 — **Motion Blur.** If your image is blurry because the camera or subject moved, use this setting to make Photoshop *try* to fix it, as shown in Figure 11-4.

 Since choosing Gaussian Blur basically makes this filter work like Unsharp Mask (in which case you could just *use* Unsharp Mask instead) and you use Motion Blur only when your picture is blurry, go with Lens Blur for most photos.

- **Angle.** If you choose Motion Blur from the Remove menu, use this dial to set the angle of the blur currently marring your image. For example, if you have a square image and the subject is moving diagonally across the shot from the lower-left corner to the upper-right corner, set this field to 45 degrees.

- **More Accurate.** If you turn on this checkbox, Photoshop thinks long and hard before it does any sharpening. With this setting turned on, you'll get more precise results though the sharpening won't be as strong. Since turning on this option makes the filter take longer to run, you'll want to leave it off if you have a slow computer or if you're working with a huge file. If, on the other hand, you buy a new computer every time you upgrade your copy of Photoshop, you can turn it on and leave it on.

If you turn on the Advanced radio button at the top of the dialog box, Photoshop adds three tabs to the settings section. Besides the settings just listed, which appear on the Sharpen tab, you get Shadow and Highlight tabs, as shown in Figure 11-5. These two tabs, which have the same settings, let you control the following:

- **Fade Amount** lets you reduce the amount of sharpening Photoshop applies to your image's highlights or shadows, depending on which tab you're on. So, for example, if you enter *100* in the Sharpen tab's Amount field but want Photoshop to do a bit less sharpening in the shadows, click the Shadow tab and enter a Fade Amount of 25 percent or so. If you want *no* sharpening to happen in the shadows, enter 100 percent. (This setting is similar to the Fade command you learned about in the box on page 467.)

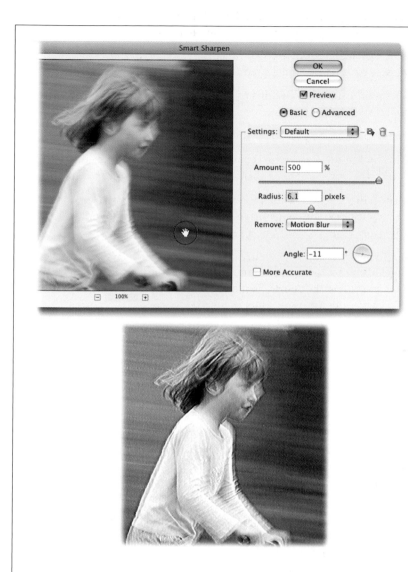

Figure 11-4:
The Smart Sharpen dialog box's "Remove: Motion Blur" setting can only do so much, as you can see in these before (top) and after (bottom) images.

If you click the preview and hold down your mouse button, your cursor turns into a little hand (circled) that lets you move your image around and see the original version.

To remove motion blur in just one area of your image (say, the cat in your subject's lap twitched its ear right when you took the picture), your best bet is to select that area and copy it to its own layer before you run the Smart Sharpen filter. Just select it using the tools discussed in Chapter 4 and then jump it onto its own layer by pressing ⌘-J (Ctrl+J on a PC). Make sure you've selected the layer that needs correcting and then run the filter. Then, if you need to, add a layer mask (page 114) to hide portions of the newly unblurred layer.

- **Tonal Width** lets you control which highlights and shadows Photoshop sharpens. It starts out at 50 percent, meaning the shadows get sharpened evenly throughout their tonal range. If you enter a lower number, Photoshop sharpens only the lightest highlights or the darkest shadows (depending on which tab you're on); if you enter a higher number, Photoshop sharpens all the highlights or all the shadows. Unless you've increased the Fade Amount, this setting doesn't do a darn thing.

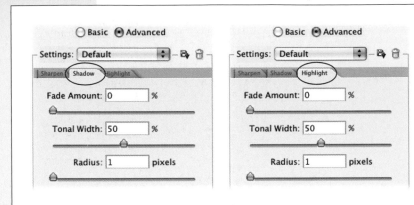

Figure 11-5:
If you turn on the Smart Sharpen filter's advanced options, you can adjust how much sharpening Photoshop does in both the shadows (left) and the highlights (right). You don't get this kind of control with the Unsharp Mask filter.

Note: If you pop into Advanced mode and tweak the Highlight and Shadow tabs' settings and then go *back* into Basic mode, the changes you made in Advanced mode *still* affect the filter, so it's a good idea to reset all the Smart Sharpen settings by Option-clicking (Alt on a PC) the Cancel button to change it to Reset (clicking the Reset button takes you back to Basic mode). Or, when you switch into Advanced mode, make a mental note to *stay there*.

- **Radius** lets you control how many pixels Photoshop analyzes to figure out whether it thinks a pixel is in a highlight or a shadow. In other words, this setting controls how wide an area Photoshop sharpens in either highlights or shadows (depending on which tab you're on). Like the Tonal Width setting, Radius doesn't do anything unless you adjust the Fade Amount first.

Tip: See the tiny disk and trash can icons in the Smart Sharpen dialog box to the right of the Settings pop-up menu? These buttons let you save or throw away custom settings. If you click the disk button to save your current settings and give 'em a name, Photoshop adds them to the Settings pop-up menu for easy access later. If you want to throw a custom setting away, choose it from the Settings pop-up menu and then click the trash can button.

Sharpening Layered Files

When you run a sharpening filter, it affects only the current layer—there's no way to make it affect *all* the layers in your document. So what happens if your image is on more than one layer? (Say you've combined several images [Chapter 7] and added several Adjustment layers [page 77].) The solution is to *merge* all those layers into a brand-new one you can sharpen, as shown in Figure 11-6.

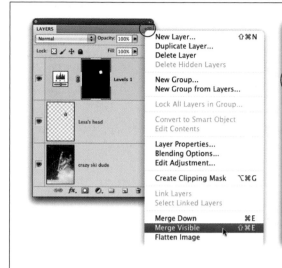

Figure 11-6:
If you need to sharpen a multilayered document, first you'll want to combine all the layers into a single, sharpenable one by Option-clicking (Alt-clicking) Merge Visible. Otherwise, you'll drive yourself crazy trying to figure out exactly which layer needs sharpening!

Here's how:

1. **Open a layered file and select the topmost layer.**

 Since the sharpening layer needs to be *on top of* your layers stack, select the topmost layer; that way, the new sharpening layer appears above it, which is exactly where you want it (see Figure 11-6, left).

2. **Make sure you've turned on the visibility eyes (page 82) of the layers you want to merge.**

3. **Open the Layers panel's menu by clicking the upper-right part of the Layers panel (circled in Figure 11-6, left) and then Option-click (Alt-click on a PC) the Merge Visible menu item.**

 If you simply *click* Merge Visible, Photoshop compacts all your layers into one. But by Option-clicking (Alt-clicking) the Merge Visible option, you tell Photoshop to compact all your layers onto a completely *new* layer at the top of your layers stack (circled in Figure 11-6, right). You can also press ⌘-Shift-Option-E (Ctrl+Shift+Alt+E) to do the same thing.

Now you can sharpen the new layer using any of the methods described in the previous pages.

Tip: When you have a multilayered file, it's a good idea to name your layers so you know what's what. Just double-click the new layer's name and type in a descriptive name like *Sharpen*. Organizing your layers into groups is another great option, as explained on page 105.

Sharpening Part of an Image

Sometimes, you need to sharpen only a portion of an image. If you've followed the advice sprinkled throughout this chapter—sharpening a Smart Object or merging several layers into a layer specifically *for* sharpening—you're more than halfway there. If you go the Smart Filter route, you automatically get a layer mask (flip ahead to page 635 to see one in action).

If you merged several layers into one, you just need to add and edit a layer mask. For example, one of the most useful portrait retouching techniques you'll ever learn is to accentuate your subject's eyes and lips, as shown in Figure 11-7.

Figure 11-7:
Left: When you sharpen a duplicate layer, you can add a layer mask that reveals the sharpening only in certain areas of the image. Here you can see what a difference the eye and lip sharpening makes (check out, for example, the details visible on the girl's sharpened lips).

Right: You can also lessen the intensity of the sharpening by lowering the sharpening layer's opacity. You're probably realizing that there are many ways to do things in Photoshop, and that applies to sharpening, too. Even though you learned the newer method of sharpening with a Smart Filter back on page 466, it's still handy to know how to sharpen part of a duplicate layer, too.

Here's how to sharpen only certain areas, leaving the rest of your image unscathed:

1. **Create a duplicate layer to use for sharpening and change its blend mode to Luminosity.**

 If you're dealing with a single-layer file, select the original layer and then press ⌘-J (Ctrl+J on a PC) to duplicate it. If you've got a multilayered file, combine your layers into a single sharpening layer as explained in the previous section (page 471). Use the pop-up menu at the top of the Layers panel to change its blend mode to Luminosity and, if you'd like, double-click the new layer's name and rename it *Sharpen*.

2. **With the new layer selected, choose Filter→Sharpen→Unsharp Mask.**

 Enter an Amount of 120 percent, a Radius of 2, and a Threshold of 3. These numbers are rather arbitrary; the goal is to severely oversharpen your image so you can scale back the effect.

3. **Run the Unsharp Mask filter two more times.**

 Have a little faith, will ya? You'll reduce this extreme oversharpening in a minute. To run the filter again, press ⌘-F (Ctrl+F on a PC) or choose Filter→Unsharp Mask (the last filter you ran always shows up at the top of the Filter menu).

4. **Add a solid black layer mask to the sharpened layer.**

 At the bottom of your Layers panel, Option-click (Alt-click on a PC) the circle-within-a-square icon to add a layer mask filled with black, which hides the sharpened layer. (Recall from page 114 that, in the realm of layer masks, black conceals.)

5. **Grab the Brush tool and set your foreground color chip to white.**

 Press B to activate the Brush tool and take a peek at the bottom of the Tools panel. If the foreground color chip (page 24) is white, you're good to go. If it's not, press D to return the color chips to the factory setting of black and white and then press X to flip-flop the chips.

6. **Mouse over to your image and paint your subject's irises.**

 When you're doing detail work like this, it's helpful to zoom in on the image by pressing ⌘-+ (Ctrl-+ on a PC) a few times. You also need to adjust your brush size: Press the left bracket key ([) to make your brush smaller and the right bracket key (]) to make it bigger. Be sure to paint only the iris of each eye. If you mess up and reveal too much of the sharpening layer, don't panic; just press X to flip-flop color chips so you're painting with black and then paint over that area to hide the sharpening.

Tip: You can also drag to change your brush size by holding Ctrl-Option as you drag left or right with your mouse (on a PC, Alt+right-click and drag).

7. **When you're finished painting the eyes and you're still zoomed in, hold the space bar and drag to move the image so you can see your subject's lips and reveal the sharpening in that area, as well.**

 Painting over your subject's lips is like adding a bit of digital lip gloss. You'll probably want to increase your brush size a bit.

8. **Lower the Sharpen layer's opacity until you get a realistic effect.**

 At the top of the Layers panel, change the Opacity field to approximately 50 percent to lessen the effect of the sharpening you applied in step 3.

9. **Save the image as a Photoshop (PSD) file.**

With this method, you're not harming the original pixels, and you can alter the layer's opacity to lessen the effect and make it look real instead of otherworldly. Saving the document as a PSD file (page 50) lets you go back and edit the layer mask or change the sharpened layer's opacity, which is a great option if you print the image and think, "If only it was just a *hair* sharper…"

FREQUENTLY ASKED QUESTION

The Sharpen Tool

What's all this talk about sharpening with filters? Why can't I use the Sharpen tool instead?

Just because Photoshop *has* a certain tool doesn't mean you should use it. While it seems like a no-brainer that the Sharpen tool would be your best bet for sharpening (it's specifically designed for that, right?), you can actually get better results using other methods. That said, since this book covers *all* of Photoshop, here's a quick primer on how it works:

The Sharpen Tool is part of the Blur toolset. When you click its icon (which looks like a triangle) and mouse over to your image, you see a familiar brush cursor. With the Sharpen tool, you can paint areas you want to sharpen and, well, that's it. (You don't get nearly as much control with this tool as you do with the sharpen filters discussed so far in this chapter.) Up in the Options bar, you can adjust the following settings:

- **Brush.** This menu lets you pick brush size and type (big or small, hard or soft).

- **Mode.** In this pop-up menu, you can change the tool's blend mode from Normal to Darken, Lighten, Hue, Saturation, Color, or Luminosity.

- **Strength.** This field is automatically set to 50 percent. But unless you want to oversharpen your image, lower this setting to 25 percent or less before you use it. That way, you apply reasonable amounts of sharpening and can continue to brush over areas to apply more.

- **Sample All Layers.** Photoshop assumes you want to sharpen only the current layer. If you want to sharpen *all* the layers in your document (or rather, the ones that you can see through the current layer, if it's partially transparent), turn on this checkbox.

- **Protect Detail.** New in CS5, this option prompts Photoshop to be extra careful about what it sharpens (technically, it triggers a new set of sharpening instructions called an *algorithm*). Sure it's an improvement and it could be rather handy if you need to sharpen a small area quickly without fussing with Smart Filters (page 634) or a duplicate layer. But the extra thinking Photoshop has to do means it runs like molasses on large images.

As you might imagine, using this tool can be a time-suck of epic proportions because you're sharpening with a brush *by hand*, so it's best to use it only on small areas.

Advanced Sharpening Techniques

Now that you understand the basics of sharpening, it's time to delve into the realm of advanced sharpening. Consider yourself warned that this is pro-level stuff and not for the faint of heart. (Basically, these methods involve many more steps than the techniques you've learned so far.) In this section, you'll learn how to create a detailed edge mask, make a new high-contrast channel, and sharpen using the High Pass filter. Read on, brave warrior!

Note: This book doesn't cover *every* Photoshop sharpening technique; if it did, it'd be too heavy to lift! Instead, it covers the most practical and frequently used methods. If you want to learn more, pick up a copy of *Real World Image Sharpening with Adobe Photoshop CS2* (Peachpit Press, 2006), by Bruce Fraser. The book is a few years old, but it teaches you everything you ever wanted to know about the art of sharpening.

Creating an Edge Mask

An *edge mask* is simply a layer mask that accentuates the edges in your image. (Pop back to page 460 for a refresher on what "edge" means in this context.) The mask itself, which you apply to the layer you want to sharpen, is black except for a white outline of your image. Because, in the land of the layer mask, black conceals and white reveals, this makes the sharpening show only in the edges. However, instead of drawing such a complicated mask yourself (that would take days!), you can have Photoshop create one for you by using the (rather lengthy) method described in this section. It takes some time, but it's worth the effort:

1. **Find the channel with the greatest contrast and duplicate it.**

 As you learned back in Chapter 5, your image's color info is stored in individual containers called channels. To create an edge mask, you need to find the channel with the greatest contrast (which channel that is depends on your image). To do that, open the Channels panel (page 188) and cycle through them—if you're in RGB mode—by pressing ⌘-3, 4, and 5 (Ctrl+3, 4, and 5 on a PC). (If you're in CMYK mode, you've got one more channel to look at so add ⌘-6 [Ctrl-6] to that list.) To leave your original image intact, you need to keep your channels intact, so that means creating your edge mask on a *duplicate* of the highest-contrast channel. To duplicate the channel, first select it in the Channels panel, Ctrl-click (right-click on a PC) it and then choose Duplicate from the shortcut menu that appears. In the resulting dialog box, name the channel *Mask*. (Or you can create a brand-new, even higher-contrast channel by using the Calculations adjustment or Channel Mixer. See the box on page 481 for the scoop.)

2. **With the Mask channel selected in the Channels panel, choose Filter→ Stylize→Find Edges.**

 You don't get a dialog box when you run this filter; it's an all-or-nothing kind of deal. Photoshop instantly makes your image look like a drawing (see page 650 to learn more about this filter), with the edges shown in dark gray and black. This is the exact *opposite* of what you want, but you'll fix that in the next step.

3. **Invert the Mask channel by choosing Image→Adjustments→Invert.**

 Photoshop flip-flops the info in the Mask channel so the image's edges are white instead of black (see Figure 11-8). That way, when you copy the Mask channel and paste it into a layer mask on the sharpened layer, the sharpening is revealed only along the edges; the black areas hide the sharpening from the rest of it.

Note: If you'd like to work with the image used in this example, you can download the file *Building.jpg* from this book's Missing CD page at *www.missingmanuals.com/cds*.

Figure 11-8:
Left: When you first run the Find Edges filter, your image looks like a pencil sketch as shown here. (To see the original photo, check out Figure 11-9, left.) The edges of the image are black, which is the opposite of what you want.

Right: After you invert the Mask channel, your edges turn white and everything else turns black. That way, when you paste this channel into a layer mask, the sharpening shows through only in the white areas.

4. **Increase the Mask channel's contrast with a Levels (page 390) or Curves (page 411) adjustment.**

 To really accentuate the edges in your image, you can add extra contrast to the Mask channel with a Levels adjustment: Choose Image→Adjustments→Levels and then move the gray slider to get the most contrast (see page 390 for more on Levels). (Normally you create an Adjustment layer when you use Levels or Curves, but in this case you need to *apply* the adjustment to the Mask channel, so a trip up to the Image→Adjustments menu is in order.) Photoshop doesn't sharpen the black areas of the Mask channel, only the light gray and white areas. Press OK when you're finished to close the dialog box.

5. **Blur the Mask channel slightly with the Gaussian Blur filter.**

 To avoid harsh sharpening halos (page 460), you can blur the Mask channel a little by choosing Filter→Blur→Gaussian Blur. Enter a radius between 0.5 and 3 to soften the edges of your mask. (Use a lower number for low-resolution images and a higher number for high-resolution ones.)

6. **Load the Mask channel as a selection and then throw the channel away.**

 Since you're already in the Channels panel, go ahead and load the Mask channel as a selection (you don't need it just yet, but you will in a minute). Click the tiny dotted circle at the bottom left of the Channels panel and you'll see marching ants appear (with an active selection, Photoshop will automatically fill in the layer mask you create in the next step). Delete the channel by dragging it down to the tiny trash can at the bottom of the Channels panel, or Ctrl-click (right-click on a PC) it and then choose Delete from the resulting shortcut menu.

7. **Back in your Layers panel, duplicate the layer you want to sharpen (or combine several layers to create a new one as described in the previous section [page 473]) and add a layer mask to the duplicate.**

 Select the layer you want to sharpen and duplicate it by dragging it to the "Create a New Layer" icon at the bottom of your Layers panel—the usual ⌘-J [Ctrl+J] trick won't work because you'll only duplicate the selected parts. Then add a layer mask to it by clicking the circle-within-a-square-icon at the bottom of the Layers panel.

8. **Click the image's layer thumbnail, then choose Filter→Sharpen→Unsharp Mask.**

 Head up to the Filter menu and choose Sharpen→Unsharp Mask. Adjust the settings as described on page 466, and then press OK to make Photoshop run the filter.

9. **Lower the sharpened layer's opacity if you need to (see Figure 11-9).**

 If the sharpening looks too strong, you can lower the sharpened layer's opacity in your Layers panel. You may not need to lower it, but it's sure nice to have the option.

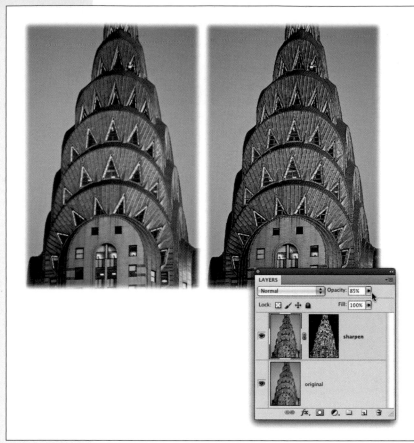

Figure 11-9:
*Left: The original, unsharp-
ened photo of the Chrysler
Building in New York City
looks rather flat.*

*Right: Sharpening the same
photo with an edge mask
(visible in the Layers panel)
confines the sharpening to
the image's details.*

Whew! That was a lot of work, but your image should look light years better, as shown in Figure 11-9. You can toggle the sharpened layer's visibility off and on to see what a difference the edge sharpening made. Thanks to the edge mask, only the building's details got sharpened, leaving areas like the sky untouched (which all but eliminates sharpening-induced noise).

Sharpening with the High Pass Filter

When you're dealing with a fairly flat image like the one shown in Figure 11-10, give this sharpening method a spin. It's quick and it lets you add a bit more depth by increasing contrast in the midtones (the colors in your image that fall between the lightest and darkest). It involves using the High Pass filter, which essentially keeps the highest-contrast edges in your image (the ones with the biggest difference between colors) and makes everything else gray.

Figure 11-10:
Top: The original image with no sharpening is pretty flat and lacks contrast in the details.

Bottom: If you sharpen this image with the High Pass filter, you can give it some depth. Notice how many more details appear around the crown, face, and torch.

First, create a duplicate layer for sharpening just like you did in the previous pages (or use Smart Filters as described on page 634). Then change its blend mode to Overlay as shown in Figure 11-11, top. (As page 298 explains, Overlay mode can brighten or darken your image, which increases contrast.) Next, choose Filter→Other→High Pass and enter a Radius between 0.5 and 3 (Figure 11-11, bottom). That's it! Check out your image to see if you like it, and turn off the sharpening layer's visibility to see what the original image looked like.

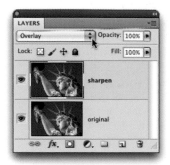

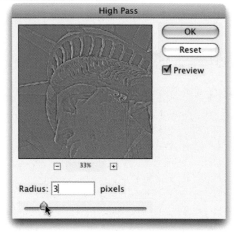

Figure 11-11:
Top: After you create a duplicate layer for sharpening, change its blend mode to Overlay.

Bottom: The Radius setting controls the width of the sharpening halo (page 460) that the High Pass filter creates, so you'll want to keep this setting pretty low.

Sharpening in Camera Raw

Camera Raw's sharpening capabilities have improved greatly in the last couple of versions of the plug-in (starting with Camera Raw 4.1, which was released after Photoshop CS3), and its controls now rival the sharpening you can produce in Photoshop. Sharpening in Camera Raw even affects your image's luminosity (lightness or brightness values) and leaves the color alone.

But *should* you use Camera Raw for sharpening? The answer is yes—*if* you're not going to edit the image much in Photoshop. If you *are* going to do a lot of editing in Photoshop, you should save the sharpening for your very last step (after retouching and resizing) and use one of the methods described earlier in this chapter instead.

You *don't* want to sharpen in both programs—at least, not the whole image. Sharpening in Camera Raw is a global process, meaning it affects your entire image (though you can wield a little control using Camera Raw's Adjustment Brush, discussed later in this section). It's also a somewhat automatic process: your image gets sharpened the minute you open it in Camera Raw (unless you turn off automatic sharpening as described in the next section). If you let Camera Raw sharpen your image, you'll need to practice selective sharpening (described on page 472) once the image is in Photoshop to avoid oversharpening it and introducing halos.

Note: With Photoshop CS5, sharpening in Camera Raw is even better than before. The new Camera Raw 6 produces smaller sharpening halos and boosts improved noise reduction (which Adobe says works better than the third-party plug-in, Noise Ninja [see page 772]).

POWER USERS' CLINIC

Creating a High-Contrast Edge Mask

If you're trying to create an edge mask (page 475) but your color channels don't have much contrast, you can always create a *new* channel with contrast aplenty. If creating a new channel sounds hard, don't panic; it's easier than you think. There are two ways to go about it:

- **The Calculations adjustment** can combine two channels for you. After strolling through your channels to see which ones have the most contrast (let's say they're the Red and Green channels), head up to the Image menu and choose Calculations. In the resulting dialog box, tell Photoshop which channels you want to combine by choosing the Red channel from the Source 1 section's Channel pop-up menu and Green from the same pop-up menu in the Source 2 section. From the Blending pop-up menu near the bottom of the dialog box, pick one of the blend modes in the Overlay category like Soft Light (Chapter 7 describes all these blend modes in detail, beginning on page 289). When you press OK, Photoshop creates a brand-new channel you can tweak into a high-contrast edge mask. *Now* you're ready to proceed with step 2 back on page 476. (Since this channel is totally new, you don't have to duplicate it like you did in step 1 on that page.) To learn more about the Calculations adjustment, flip back to page 214.

- **The Channel Mixer** doesn't really create another channel; instead, it lets you create a grayscale (black-and-white) version of your image that you can use as if it *were* a channel. Duplicate your image layer and then choose Image→Adjustments→Channel Mixer. Turn on the Monochrome checkbox at the bottom left of the dialog box and then tweak the various sliders. When you get some really good contrast, press OK. Next, start with step 2 on page 476 and run the Find Edges filter in the Layers panel instead of the Channels panel (the steps are exactly the same).

Global Sharpening

You can sharpen in Camera Raw by first opening your image (page 234) and then clicking the tiny Detail icon circled in Figure 11-12. If you don't want any global sharpening, drag the Amount slider to zero (from the factory, it's set to 25). If you *do* want to sharpen your image, mosey on down to the lower-left corner of the Camera Raw dialog box and change the view percentage to 100 percent so you can see the

effect of the changes you make to the Detail settings (otherwise it looks like your sharpening is having no effect at all). Then, tweak the following settings to your liking:

- **Amount.** This setting works just like Unsharp Mask dialog box's Amount slider (page 464); it controls the intensity of the sharpening. Setting it to 0 means no sharpening, no how; setting it to 150 means tons of sharpening (which is way too much). Try setting it to 40 and toggling the Preview checkbox at the top of the Camera Raw window off and on to see if it makes a difference (be sure you're zoomed in to 100 percent, though!).

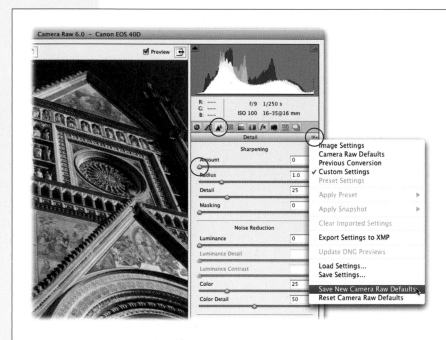

Figure 11-12:
If you don't want Camera Raw to sharpen your images automatically, you can make it stop. Click the Detail icon (circled, top) and then drag the Amount slider to zero (circled, left). Then open the Camera Raw menu (circled, right) and choose Save New Camera Raw Defaults as shown here.

- **Radius.** This slider controls the size of the details that Camera Raw sharpens. If you're sharpening a photo with lots of fine details, leave it at 1. If your photo doesn't have many details, you can pump it up to 1.5, or if you're feeling wild and crazy, *maybe* 2.

- **Detail.** This slider lets you control the level of detail Camera Raw brings out (how much it emphasizes the edges). Crank this setting way up (to 90 or so) if you've got an image with tons of details and textures (like a rocky landscape, a close-up of a tree, or a fancy-schmancy building). This slider ranges from 0 to 100; for most images, you can keep it around 40 (but be sure to experiment to see what looks good to you).

- **Masking.** If you increase this setting, Camera Raw reduces the amount of sharpening it applies to areas that aren't edges. It's sort of like using a layer mask on a sharpened layer in Photoshop, except that it's automatic, so you can't really control where the sharpening is hidden. Nevertheless, it's worth experimenting with. If you set it to 0, Camera Raw sharpens everything; at 100, it sharpens only the edges.

- **Luminance.** This setting controls the amount of grayscale noise (see the box on page 462) Camera Raw tries to decrease in your image by *smoothing* the pixels (similar to blurring). Make sure you're zoomed in to at least 100 percent and then drag the slider to the right to reduce the grains or splotches in your image. For example, a setting of 25 should provide a reasonable balance of noise reduction and maintaining image detail, though you'll need to experiment with your own images.

- **Luminance Detail.** New in Camera Raw 6, this slider controls the *noise threshold*, or how much smoothing it performs in the areas of detail in your image. Drag it to the right to preserve more details and apply less noise reduction in those areas. Drag it to the left to produce a smoother image, thereby applying more noise reduction in those spots. Straight from the factory, it's set to 50.

- **Luminance Contrast.** Also new in Camera Raw 6, this setting lets you safeguard your image's contrast. Drag it to the right to preserve contrast and texture, or drag it to the left to throw caution to the wind and produce a smoother, less-noisy image. Out of the box, this slider is set to 0.

Note: The new Luminance Detail and Luminance Contrast sliders are dependent on the Luminance slider—if it's set to 0, they'll both be grayed out. The fix is to increase the Luminance slider in order to activate the other two.

- **Color.** If your image has a lot of color noise (funky specks of color), which can happen if you shoot in really low light or at a high ISO (your camera's light-sensitivity setting), move this slider to the right to make Camera Raw try to remove the specks. A value of 25 produces a decent amount of speck zapping.

Tip: To see what's *really* going on with any of Camera Raw's sharpening options, hold the Option key (Alt on a PC) as you drag the individual sliders (this works only if you're zoomed in to 100 percent or more). Your image goes grayscale, letting you see which areas Camera Raw is adjusting (though it's tough to see *anything* when you're tweaking Radius). The most useful setting is Masking—if you hold the Option (Alt) key while you tweak it, you see what looks like an edge mask (page 475) that shows exactly which parts of your image are being sharpened and which are being hidden by the mask.

Selective Sharpening in Camera Raw

As you learned in Chapter 9 (page 388), Camera Raw sports an Adjustment Brush that lets you paint slider-based adjustments directly onto your image. Behind the scenes, Camera Raw builds a mask to hide the adjustments from the rest of your image. Great, but how does the Adjustment Brush relate to sharpening, you ask? The Sharpness slider lets you selectively increase or decrease the amount of global sharpening you set in the Detail tab by painting certain areas with the Adjustment Brush. Sure, the global sharpening still affects your whole image, but by using the Adjustment Brush, you can turn the volume of global sharpening up or down in specific areas, as shown in Figure 11-13. The Sharpness slider ranges from –100 to +100.

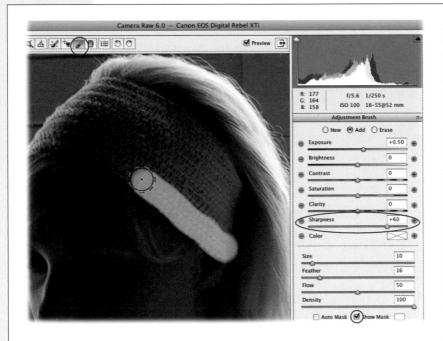

Figure 11-13:
If you've applied a round of sharpening to your whole image by adjusting the Detail tab's settings, you can apply even more sharpening to specific areas like this girl's headband. Press K to grab the Adjustment Brush, increase the Sharpness slider (circled here), and then paint the headband. If you want to decrease the sharpening in a specific area, drag the Sharpness slider to the left into negative numbers. To better see the area you're adjusting, turn on the Show Mask option near the bottom right of the Camera Raw window, shown here.

Painting in Photoshop

Many artists who learned to sketch and paint using pencils, oils, and brushes have come to love the creativity that the digital realm affords. Heck, the biggest advantage is that there aren't any brushes to clean or paints to mix! And you can't beat the infinitely forgiving Undo command. Most important, as you can see in Figure 12-1, there's no limit to the kind of artwork you can create in Photoshop.

If you're a traditional artist, the techniques covered in this chapter will set you on the path of electronic creativity. You'll learn how to use Photoshop's color tools and built-in brushes to create a painting from start to finish, in full step-by-step detail. And in Photoshop CS5, the brushes behave more realistically then ever before! You'll also discover how to load additional brushes, customize the ones Photoshop provides, and create new brushes of your very own.

If you're a graphic designer or photographer, there's a ton of info here for you, too. Just think about how much time you spend with brushes when you're working in Photoshop. Whether you're retouching an image with one of the healing brushes (page 427), painting on a layer mask to hide an adjustment (page 114), or duplicating objects in your image with the Clone Stamp tool (page 434)—all of those things (and more) involve either the Brush tool itself or a tool that uses a brush cursor. For that reason, learning how to work with and customize brushes is extremely important. Plus you'll learn all kinds of other fun and useful stuff like the basics of color theory, how to use Photoshop's various tools to choose the colors you work with (including the Kuler panel from which you can snatch whole color schemes!), and how to give your photos a painted edge.

Since painting is all about using color, that's where your journey begins.

Figure 12-1:
This beautiful painting by Melissa Findley was created entirely in Photoshop. You can see more of her artwork at www.WickedFae.com.

Color Theory: The Basics

Color can evoke emotion, capture attention, and send a message. That's why choosing the *right* color is so important. It may also explain why picking colors that go well together can be an exercise in frustration. Some colors pair up nicely, some don't, and who the heck knows why.

The great thing about using Photoshop is that you don't actually need to know *why* certain colors go together. Instead, thanks to a circular diagram called a *color wheel*, you can easily identify which colors live in sweet visual harmony. A color wheel won't turn you into the next Matisse, but for most mortals it's the tool of choice for deciding which colors to use in their projects.

Before you take the color wheel for a spin, you need to understand a few basic color concepts. Consider this section *Color Theory: The Missing Manual*:

- **A color scheme** (or color palette) refers to the group of colors you use in a project or painting. Just take a look at any book cover, magazine ad, or website and you'll see that it's made from a certain set of colors (usually between three and five colors, plus white or black). The designer usually picks a main color (like blue) and then chooses the other colors according to how they look together and the feeling they evoke when they're viewed as a group. There's a

whole science behind picking colors based on what they mean to us humans and how they make us feel. For example, have you ever pondered why hospitals are bathed in pale blue or green? It's because researchers have found that those colors have a soothing effect. If this type of thing interests you, pick up a copy of *Color: Messages and Meanings* by Leatrice Eiseman (Hand Press Books, 2006).

- **A color wheel** is a tool that helps you pick colors that look good together. Without diving too deeply into the science of color relationships let's just say that all colors are related because they're derivatives of one another. The color wheel, which dates back to the 17th century, arranges visible colors on a round diagram according to their relationships. It's based on the three basic colors: yellow, blue, and red—known as *primary colors*—from which all other colors spring. By mixing equal amounts of the primary colors, you get a second set of colors called—surprise—*secondary colors*. As you might suspect, mixing equal parts of the secondary colors gives you a third set of colors called *tertiary colors*. Together, all these colors form the color wheel shown in Figure 12-2.

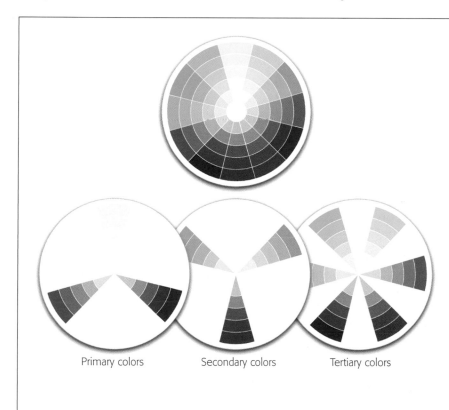

Primary colors Secondary colors Tertiary colors

Figure 12-2:
Top: You can pick up a color wheel at your local art-supply store or order one online from the Color Wheel Company at www.colorwheelco.com. *It may not look exactly like the one shown here (it might have more colors), but it'll be similar. Once you learn a few rules about which colors go best together (described in the next section), you can easily use a color wheel to pick visually pleasing color schemes.*

Bottom: Here's the same color wheel with a few of the color wedges hidden so you can see the primary, secondary, and tertiary colors by themselves.

Note: Photoshop has a built-in color wheel inside the Kuler panel, a color scheme generator discussed in detail later in this chapter.

You'll also run into three different terms used to describe color: hue, saturation, and brightness (you've seen them here and there throughout this book). Together, they form all the glorious colors the human eye can perceive:

- **Hue** can mean a few different things, but for the purposes of this discussion, you can think of it as another word for "color," as in red, blue, lime green, or cotton-candy pink. So when you see it in a Photoshop dialog box, just substitute the word *color* in your mind.

- **Saturation** describes a color's strength or intensity. For example, a highly saturated hue has a vivid, intense color. A less saturated hue looks dull and gray. Think "vibrancy" and you'll have this one down pat.

- **Brightness** (or lightness), which is usually measured in terms of percent, determines how light or dark a color appears. You can think of brightness as the amount of light shining on an object, ranging from white (100 percent) to black (0 percent). For example, if you shine an incredibly powerful flashlight on an apple, the apple looks almost white (100 percent lightness). When the flashlight is off, you've got no light, so the apple appears almost black (0 percent lightness).

Selecting a Color Scheme

As mentioned earlier, if you're picking a color scheme for your project, you usually begin by choosing a main (or *base*) color. This main color can come from a piece of art that you're starting with (like a logo or photo) or it can be a color that you want to build your design around. Once you know the main color, you can use a few simple rules to find other colors that go well with it. In this section, you'll learn how to use a color wheel to pick a color scheme based on four popular *color scheme harmonies* (color combinations proven by color experts to go well together). But don't worry: You'll also learn where to find tools to automate this process in case picking colors manually isn't your cup of tea.

Using a Color Wheel

Let's say you've gotten your hot little hands on a color wheel. Great! Now, what the heck do you do with it? For starters, you need to pick the main color you want your color scheme to revolve around and then plot its location on the color wheel. Once you've done that, you can use one of the following color scheme harmonies to help you pick other colors that go well with it (to see what these color schemes look like, skip ahead to Figure 12-4):

- **Monochromatic** schemes use colors from the same wedge of colors on the color wheel.

- **Analogous** schemes use colors from the wedges on both sides of the main color.

- **Complementary** schemes use colors from the wedge directly across from the main color.

- **Split complementary** schemes use colors from the wedges on either side of the main color's complement.

Note: This list isn't comprehensive; it includes only the four most common color scheme harmonies. If you want to learn more, grab a copy of *Color Index* (Turtleback, 2002) by Jim Krause.

To use a color wheel to pick a color scheme, follow these steps:

1. **Open an image and choose a main color.**

 Every project starts with something, whether it's a photo, a company logo, or a piece of art. Give it a good long stare and decide on a main color to use for your color scheme. Let's say you want to add color to the design shown in Figure 12-3. Since there's quite a bit of blue in the image, you could easily start there and designate one of the blues as your main color.

Figure 12-3:
Instead of racking your brain trying to pick colors for the text and background of this greeting card, it's much easier to start with a color that's already in your design. In this case, you could start with one of the blues in the photo.

2. **Once you've picked a color, identify its general location on the color wheel.**

 If you've got an actual color wheel in your hand, you can find the main color on the wheel simply by looking at it.

3. **Locate other colors that go with the main color by using one of the color scheme harmonies described earlier in this section and shown in Figure 12-4.**

 If you choose your other colors from the related color wedges, you can be sure they'll look good when you use them together.

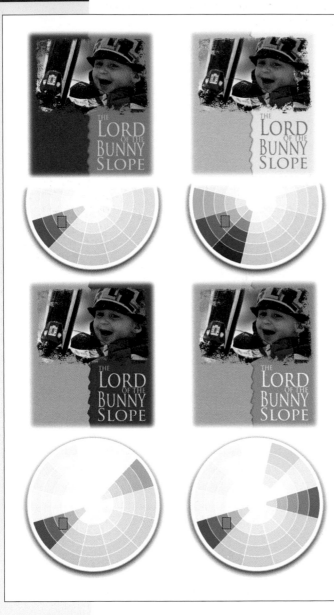

Figure 12-4:
There are tons of color scheme harmonies out there (you'll need to study up on color theory to learn about them all), but you can think of the ones shown here and described on page 488 as the Fantastic Four. The red box marks the main color's location; each color wedge used in the color schemes is highlighted (the other wedges are faded out).

Here you can see what the design looks like using monochromatic (top left), analogous (top right), complementary (bottom left), and split complementary (bottom right) color schemes.

Using the Kuler Panel

Kuler is an amazingly useful, community-driven color scheme generator that debuted in Photoshop CS4, though it began life a few years ago as a Web application. If you're not a fan of the color wheel, don't have one handy, or just need some fresh new color scheme ideas, you can choose from many *themes*—Kuler's name for color

schemes—that folks in the Kuler community have created. To pop open the panel, choose Window→Extensions→Kuler (see Figure 12-5).

Note: In order for the Kuler panel to download the latest and greatest themes from the Kuler online community, you need to be connected to the Internet.

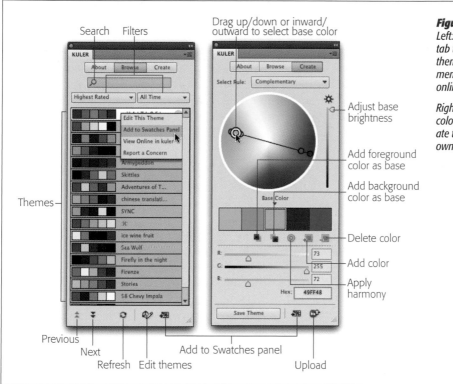

Figure 12-5:
Left: Use the Browse tab to check out themes created by members of the Kuler online community.

Right: You can use the color wheel in the Create tab to make your own themes.

At the very top of the Kuler panel are three buttons:

- **About.** If you want to get to know—or get involved with—the online Kuler community, this button will transport you to the Kuler website. If you create a free account, you can upload your own themes, rate other people's themes, post to the forums, and so on.

- **Browse.** If you want to browse themes that other people have created, you can search for themes by entering a descriptive word ("rustic," "nature," "corporate," and so on), creator, theme name, or *hex number* in the search field (see the box on page 725 to learn about hex numbers). Or just use the scroll bar to see what's there. The pop-up menus at the top of the panel let you sort themes by their ratings, when they were uploaded, and so on.

To use a particular theme—that is, to import its colors into Photoshop—select it and then click the "Add selected theme to Swatches" button shown in Figure 12-5 (the Swatches panel is discussed on page 496). You can also click the little triangle that appears at the right of the scheme when it's selected and choose "Add to Swatches Panel" from the pop-up menu (see Figure 12-5, left).

- **Create.** Click this button to see the tab shown in Figure 12-5, right, which lets you cook up your own themes. Start by picking a color scheme (page 486) from the Select Rule pop-up menu—choices include analogous, monochromatic, triad, complementary, and so on—and then click the white-rimmed circle on the color wheel and drag it to the color you want to base your theme on (your main color, in other words). You'll see little bars sprout out from your original color choice that follow the rule you picked earlier. The other colors will move around, too, as you move the base color. You can drag the base color's white circle inward or outward, left or right, up or down until you find the color you want. The middle, square color swatch beneath the wheel shows the resulting base color.

 Once you find the right color, you can change its lightness value by using the brightness slider on the right (drag it up to make the base color lighter or down to make it darker). To change another color in your theme, select it by clicking its square swatch below the color wheel. You'll see the corresponding circle on the wheel highlighted in white (or you can click the circle itself to highlight it). Once the circle is highlighted, you can drag it to another area on the wheel to change the color or use the slider on the right to adjust its brightness. When you're happy with your theme, click the Save Theme button at the panel's bottom left to save it and then click the button to its right to load it into your Swatches panel (page 496). If you want to share your theme with the world, click the Upload button and Photoshop sends you to the Kuler website.

Tip: For easier access to the Kuler panel, drag its tab into the Color and Swatches panel group so you don't have to trot up to the Window menu every time you want to use the panel. If your Color and Swatches panel group looks too crowded, drag the Styles tab out of the panel—you won't use it much (if ever) anyhow. See page 21 for more on working with panels.

Other Color Scheme Generating Tools

If this whole color-picking business feels overwhelming, never fear—helper applications a-plenty are lurking around the Web, and most work just like Kuler: You pick a base color and a color-scheme rule, and the software generates the rest of the scheme for you based on the rule you chose. Helpful websites include:

- **Color Scheme Designer 2.** Free, Web-based version only (*www.colorscheme designer.com*).

- **Color Schemer.** Free, Web-based version or $50 download; versions for both Mac and Windows (*www.colorschemer.com*).

- **GenoPal.** $50 download, Mac and Windows versions (*www.genopal.com*).

- **Painter's Picker** replaces Photoshop's Color Picker (see the next section) with a *real* color wheel. $20 download, Mac only (*www.old-jewel.com/ppicker*).

Choosing Individual Colors

Once you decide on the colors you want to use, the next step is to summon the colors in Photoshop. As you learned in Chapter 1 (page 24), you can use the color chips at the bottom of the Tools panel to choose colors quickly. But, as with most things in Photoshop, you've got plenty of other options, including the Color Picker, the Eyedropper tool, and the Color and Swatches panels. They're all discussed here.

Note: In Photoshop CS5, you can also summon a heads-up version of the Color Picker while you're painting. Flip ahead to page 506 to see it in action.

The Color Picker

To choose the color you want to paint with, click the foreground color chip at the bottom of the Tools panel to open the *Color Picker* (Figure 12-6). The Color Picker is a fine tool for selecting colors, and it's probably the one you'll use most often (especially while you're learning). If you're not trying to summon a specific color value, pick a color by selecting it in the big, square *color field* on the left side of the dialog box; use the color slider to the right of the field to pick a different range of colors. The color you pick shows up in the smaller square swatch at the upper right of the box. Close the Color Picker dialog box and your foreground color chip changes to match the color you chose.

If you need to pick a *specific* color, you can enter its color values in the HSB (hue, saturation, brightness), RGB (red, green, blue), hex number (page 725), Lab (page 198), or CMYK (cyan, magenta, yellow, black) fields. As you learned back in Chapter 2, each color mode identifies colors with specific numeric values. As you click within the color spectrum on the left side of the dialog box, you'll see those values change to reflect the currently selected color. If you want to use a color that already exists in your Photoshop document, just mouse away from the Color Picker and your cursor turns into an eyedropper. When you click the color you want to snatch, it appears in the topmost color swatch in the Color Picker. Sweet!

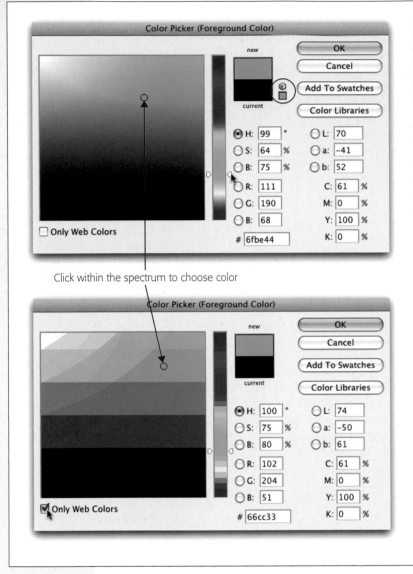

Click within the spectrum to choose color

Figure 12-6:
Use the Color Picker to tell Photoshop which color you want to use with a particular tool. If you see a tiny gray triangle with an exclamation point (shown in Figure 12-8) beside one of the color swatches, it means the color can't be reproduced with CMYK ink (see Chapter 16 for more info on printing images).

A little 3-D cube beside the swatch (circled) means the color isn't Web safe (the box on page 717 explains what that means and why it's not such a big deal anymore).

Photoshop CS5 lets you mix your own colors by using the new Mixer Brush. Skip to page 502 to learn how.

Note: Once you get used to working with colors and seeing their numeric values, you may begin to visualize the color from the values alone. But if you really want to understand how colors mix to make other colors, you need to study color theory. One great starting point, in addition to some of the books suggested earlier, is *www.avivadirectory.com/color*, which has a huge list of color-related links.

The Eyedropper Tool

When you're developing a color scheme, you may want to start by grabbing colors that are already in your image. The Eyedropper tool is perfect for that job and in CS5 you get a new Sample Ring that lets you more accurately snatch the *exact* color you're after (as shown in Figure 12-7). Grab it by pressing I, mouse over to your image, and then click once to make your foreground color chip match the color your cursor is over. If you want to use the Eyedropper tool to set your *background* color chip, Option-click (Alt-click on a PC) in your image instead.

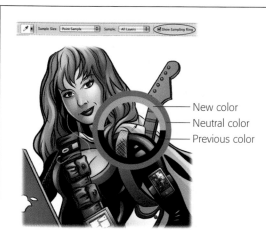

Figure 12-7:
CS5's new Sample Ring displays the original color on the bottom and the new color (the one your cursor is over) on the top. To help isolate those colors from the rest of the colors in your image (so you can actually see 'em), Photoshop places a neutral gray ring around the whole thing.

If you're unimpressed by the new ring, you can turn it off by clicking the Show Sampling Ring checkbox in the Options bar (circled). (Author caricature by Richard and Tanya Hories.)

New color
Neutral color
Previous color

Tip: When you're painting with the Brush tool and want to pick up a color from your image, you can Option-click (Alt-click) to switch temporarily to the Eyedropper tool. See the box on page 725 to learn how to snatch color from a document or web page *outside* Photoshop.

Loading Color Libraries

Sometimes, you need to be very precise about your color picking. Maybe a client has given you specific colors to match or you're creating a piece of art that needs to mesh with another designer's work. Enter Photoshop's many built-in *color libraries*, which feature specialized color collections. Figure 12-8 shows you how to get started with them.

The most popular library is the Pantone Matching System (PMS), which lets designers keep colors consistent across projects (it's used by professional printing presses). Each PMS color has a number corresponding to a very specific ink mixture that lets professional printers reproduce the color with the same results every time. That said,

to use *true* PMS colors you have to create a spot channel (see page 688). If you pick a color from a color library without using spot channels, Photoshop picks the nearest RGB or CMYK equivalent (depending on which color mode you're in).

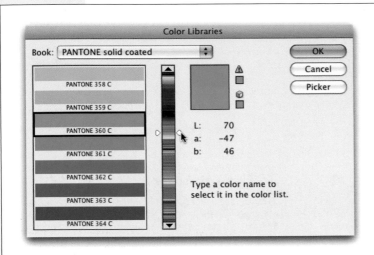

Figure 12-8:
Click the Color Libraries button at the top right of the Color Picker to open this dialog box (you can also load libraries using the Swatches panel, discussed in the next section). Choose a library from the Book pop-up menu at the top and then use the slider (or your up and down arrow keys) to move through the list. Once you've found the color you want, click it once to make it your foreground color. Then click the Picker button to go back to the Color Picker or click OK to close the dialog box.

Tip: If you're in the Color Libraries dialog box and you know the name of the color you want (for example, Pantone 375), you can enter a shorthand version of its name using the number keys on your keyboard. Typing a number feels weird because there's no text field to enter it in, but you must trust in the Force! If you type *375*, you'll see a lovely light-green swatch appear in the list on your left.

The Swatches Panel

The built-in color libraries are actually just collections of swatches. If you want to save a certain group of colors that you've created yourself—or snatched from Kuler (page 490)—you can store them in the Swatches panel (see Figure 12-9). Think of this panel as a holding pen for frequently used colors; it lets you store an ever-growing inventory of colors, each of which you can summon with a quick click. To open the panel, choose Windows→Swatches. To use a swatch as your foreground color, just click it (Figure 12-9, bottom right).

Tip: Both the Color Picker and Kuler have buttons for adding a selected color to your Swatches panel so you can easily find that same color later.

Figure 12-9:
Top: If you need quick access to one of Photoshop's built-in color libraries, you can load it into your Swatches panel by choosing it from the bottom of the panel's menu (circled).

Bottom Left: Photoshop then asks if you want replace the swatches you already have with these new ones.

Bottom Right: If you choose Append, the new swatches appear at the bottom of your Swatches panel, where they remain for as long as you need them. If you've gone hog wild and loaded a ton of colors into the Swatches panel, you can clean it out by choosing Reset Swatches from the panel's menu (top) to make Photoshop restore the factory-fresh swatch set.

Here's how to manage your Swatches panel like a pro:

- **To create a new swatch that's the same color as your current foreground color,** hover over an empty area of the panel. When your cursor turns into a little paint bucket, click to add the new swatch. Photoshop displays a dialog box where you can give your swatch a descriptive name.

- **Use the Preset Manager to arrange your swatches.** Since Photoshop lets you load additional swatches only at the end of the list, you may want to use the Preset Manager to rearrange them by project, client, and so on. Flip back to page 38 for the details.

- **To make a swatch's color your foreground color** (page 24), click the swatch.

- **To make a swatch's color your background color** (page 24), ⌘-click (Ctrl-click on a PC) the swatch.

- **To delete a swatch,** Option-click (Alt-click) it.

The downside of using the Swatches panel is that there's no way to open a certain set of swatches *in its own panel*—they're always intermingled with the other swatches in the panel. You can keep 'em all together using the Preset Manager, or make your own swatch layer in the document where you're using those colors. Just create a new layer and use the Brush tool to add little blobs of color from your project or color scheme. Lock the layer (page 104) so you can't accidentally paint on it, and then use the Eyedropper tool to sample colors from it when you need them. You can keep the swatch layer out of the way by turning off its visibility (page 82).

The Color Panel

Photoshop has yet *another* place where you can choose colors: the Color panel (Figure 12-10). It's a lot smaller than the Color Picker and, since it's a panel, it won't pop open a dialog box that covers up your image. To open the panel, choose Window→Color. You'll see the color values of your foreground or background color chip on the right side of the panel (just click the appropriate swatch to select it). You can use the sliders to adjust the colors of the current color chip. If you want to pick a new color, click within the spectrum bar at the bottom of the panel (your cursor turns into an eyedropper).

Tip: In Photoshop CS5, you can capture the hex value of any color after you've chosen it by opening the Color panel's menu and choosing Copy Color's Hex Code. For more on what you can *do* with that info, skip ahead to the box on page 725.

Figure 12-10:
Though the Color panel stays nicely tucked out of the way in your panel dock (page 21), it's much smaller than the Color Picker, making it a little tough to see. If your eyesight is good, you'll probably enjoy using it because it takes up so much less space. It's also customizable; you can use its menu to control what it displays. In this example, the sliders are set to RGB and the spectrum bar at the bottom is set to Grayscale.

(Re)Introducing the Brush Tool

You've already used the Brush tool for all kinds of things in previous chapters: editing layer masks (page 115), creating a selection (page 176), colorizing grayscale images (page 358), and so on. In this section you'll learn how to *paint* with it, and in CS5 it's a more realistic experience than ever before. But first you need to understand a bit more about how this tool works. Grab the Brush tool by pressing B or by clicking its icon in the Tools panel (see Figure 12-11).

Brush Preset picker
Brush panel
Save preset
Panel menu
Tablet controls brush opacity
Tablet controls brush size
Airbrush mode

Figure 12-11:
The Brush toolset also harbors the Pencil tool (see the caption of Figure 12-17 on page 508 for more about the Pencil tool) and the Color Replacement tool (page 454). Just press Shift-B repeatedly to cycle through the tools.

Use the Options bar to set your brush size, choose the kind of tip you want, and adjust opacity, among other things.

Tip: In Photoshop CS5, you can control brush size and hardness with a keyboard shortcut: Ctrl-Option-drag (right-click+Alt-drag on a PC) horizontally left or right to change brush size, or vertically up or down to change brush hardness.

If you peek in the Options bar, you'll see a slew of settings:

- **Tool presets.** Use this pop-up menu to access brush settings you've previously saved.

- **Brush Preset picker.** Photoshop has a ton of built-in brushes, and you can use this pop-up menu to access and manage them (page 516), as well as to control brush size and edge hardness *and* to save your settings as a preset (page 531). Think of it as a mini version of the full-fledged Brush panel.

- **Brush panel.** New in CS5, this tiny icon gives you one-click access to the Brush panel discussed on page 519 (it looks like a folder containing three paint brushes) that lets you customize your brushes in ways you've never imagined.

- **Mode.** This pop-up menu contains all the blend modes (page 289) you've seen so far, along with two others: Behind and Clear. Behind mode makes the pixels you're painting appear *behind* the pixels already on that layer (which is essentially the same, though not quite as safe, as painting on a new layer below it). Clear mode makes the pixels you paint transparent.

- **Opacity.** This setting controls how transparent your brushstrokes are; you'll use it a lot since it lets you change the appearance of the paint you're applying. For example, you can start by painting with bright green at 100 percent opacity and then keep lowering the opacity to produce lighter and lighter shades of green.

- **Tablet pressure controls opacity.** If you use a graphics tablet, you can click this icon (it looks like a pen pointing to a transparent circle) to make your stylus (pen) control opacity by varying the amount of pressure you apply to the tablet. This button is new in Photoshop CS5.

- **Flow.** To control the flow of paint to the brush or, rather, the rate at which the color is applied, use this setting. If you paint by dragging across an area multiple times, the paint builds up in that spot, so you can set the Flow to a low number for less paint and a high number for more paint.

- **Airbrush.** Click this button to make your brush work like a can of spray paint, as Figure 12-12 explains.

- **Tablet pressure controls size.** If you have a graphics tablet, you can click this icon to control brush size with your stylus (it looks like a pen pointing to a series of rings). This button is also new in CS5.

Once you've adjusted these settings, you can paint with the brush by mousing over to your image and dragging. Your cursor reflects the size and shape of your brush (most of the time it's round like in Figure 12-12, top, unless you've chosen one of the textured or more creative brushes discussed later). If you mouse over a dark part of your image, the ring representing your cursor turns white; if you mouse over a light area, it turns black.

Figure 12-12:
Top: In Airbrush mode, the Brush tool works like a can of spray paint. If you drag, you keep applying more paint (left) than you do in regular mode or with a single click (right).

Middle: Here you can see the difference between a soft-edged brush (top), which has very soft, semitransparent pixels around the edge, and a hard-edged brush (bottom).

Bottom: In CS5, you get access to new Bristle Tips that work like their real-world counterparts, letting you create more natural strokes. If you're using a graphics tablet, pressing down with your stylus makes the bristles splay, just like a real brush (the new Round Blunt Medium Stiff brush was used here). You can also use the new tips with other tools that employ a brush cursor, such as the Mixer Brush (see the next section), Eraser (page 284), and Clone Stamp (page 434) tools.

Tip: To paint a straight horizontal or vertical line (or one that's at a 45-degree angle) with the Brush tool, click once where you want the line to start and then Shift-click where you want it to end.

Controlling the Brush Cursor's Appearance

Straight from the factory, your brush cursor reflects the size and shape of whatever brush you've chosen, but you can change your cursor using Photoshop's preferences (Figure 12-13). Most of the time, you'll want to stick with either the Normal Brush Tip or the Full Size Brush Tip setting because they give you a more natural painting experience (the Normal Brush Tip is slightly smaller than your actual brushstroke). The Precise version of the cursor is a crosshair so small it's almost impossible to see, and the Standard option is even less useful because it makes your cursor look like the Brush tool's icon (neither option gives you any indication of your brush size). New in Photoshop CS5 is the "Show only Crosshair While Painting" option, but again, the crosshair gives you no indication of size and it's so darn small, you'd probably only use it for painting the tiniest of details when you're zoomed in.

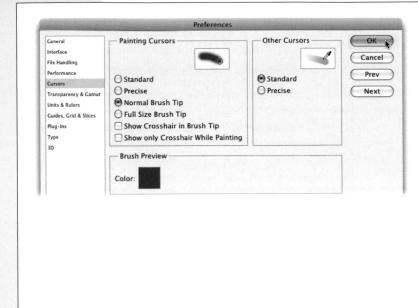

Figure 12-13:
Choose Photoshop→ Preferences→Cursors (Edit→Preferences→ Cursors on a PC) to control how Photoshop displays your brush's cursor. The settings in the Painting Cursors section let you adjust what the Brush tool's cursor looks like while the ones in the Other Cursors section let you choose between the standard, tool-shaped version or a precise (crosshair) version for tools like the Eyedropper, Patch, and Eraser. If you want to see a crosshair in the middle of your cursor so you know exactly where it's centered, turn on the "Show Crosshair in Brush Tip" checkbox. The color swatch in the Brush Preview section shows which color you see when you use the drag-to-resize keyboard shortcut (page 521).

Tip: If your brush cursor suddenly turns into a microscopic dot inside a crosshair, check your keyboard to see if Caps Lock is turned on. Pressing Caps Lock lets you switch between the precise cursor (the crosshair) and the cursor you're currently using, which could be useful when you're zoomed in and painting tiny details. Turning on Caps Lock is a *fantastic* trick to play on your coworkers; just make sure you 'fess up before they reinstall the program! Other good tricks include setting the Crop tool's width to 1 pixel and setting the Brush tool's mode to Behind.

Meet the Mixer Brush

In CS5, Photoshop's brush engine—the electronic brains behind its Brush tool—got a major overhaul (the first since CS1) and the program also got a brand new tool: the Mixer Brush. As the name implies, you can use it to mix colors just like you can mix paints in real life, as well as load multiple colors onto its tip for painting.

You can start with a blank canvas or a photograph to create realistic, "painterly" effects, as shown in Figure 12-14. The Options bar lets you control the wetness of your canvas, the amount of paint you're mixing from canvas to brush, as well as whether you want Photoshop to *clean* or *refill* your brush after each stroke. (If you're feeling extremely creative, you can paint with a *dirty* brush!)

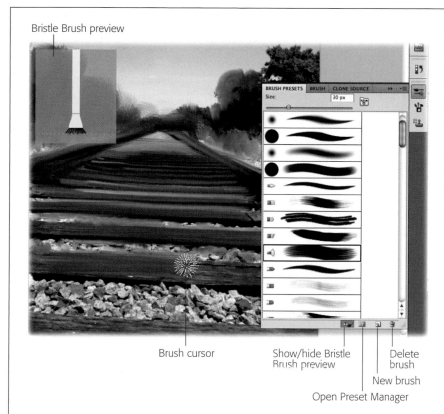

Bristle Brush preview

Figure 12-14:
As with all new features, it'll take a few versions of the program for the Mixer Brush to grow and come into its own, so to speak (meaning you're liable to get some funky results); though you've got to admit, it's off to a great—and fun—start! On the right you can see the new Brush Presets panel.

Brush cursor

Show/hide Bristle Brush preview

Delete brush

New brush

Open Preset Manager

Note: You can follow along by visiting this book's Missing CD page at *www.missingmanuals.com/cds* and downloading the practice file *Railroad.jpg*.

To turn a photo into a painting, follow these steps:

1. **Open a photo and add a new layer at the top of the layers stack.**

 Click the "Create a new layer" icon at the bottom of the Layers panel, and then position it above your image layer. (This new layer is where the new paint will go.) If you'd like, name the new layer something clever, like *Paint*.

2. **With the Paint layer selected, grab the Mixer Brush by pressing Shift-B repeatedly until you see it appear in your Tools panel.**

 The Mixer Brush lives in the Brush toolset and looks like a brush with a drop of paint above it.

3. **In the Options bar, turn on Sample All Layers.**

 Turning on this checkbox makes Photoshop sample colors from the image layer below, though the paint will appear on the new layer. This keeps you from completely destroying your original image.

4. **Click the Brush panel icon in the Options bar to open the Brush panel as well as the new Brush Presets panel.**

 Photoshop opens both the Brush panel and the Brush Presets panel within the same panel group (see Figure 12-14).

5. **Click the Brush Presets panel's tab, and from the resulting list of brushes, scroll down until you see the Round Fan and give it a click to select it.**

 If your computer can run OpenGL (see the box on page 64), you'll see a preview of the bristle near the top left of your Photoshop window, as Figure 12-14 shows. If not, well—you won't.

6. **Adjust the size of your brush.**

 You can use the Brush Preset picker in the Options bar, or—better yet—Ctrl-Option-drag (right-click+Alt-drag on a PC) to the right to increase your brush size, or to the left to decrease it. You can also change brush hardness (opacity) with the same shortcut—drag up to make your brush softer or down to make it harder.

7. **From the Brush Combinations menu in the Options bar, choose "Wet, Light Mix".**

 This menu lets you tell Photoshop how you want the brush to behave, using a combination of the Wet, Load, and Mix settings to its right, as shown in Figure 12-15. Even if you make a choice from this menu, you can fine-tune it using the individual settings for Wet, Load, and Mix.

8. **Mouse over to your image and start painting.**

 Photoshop begins applying paint to the new layer you created in step 1. As you brush across your image, the Mixer Brush samples color from your image and mixes it with the color shown in the color swatch at the top left of the Options bar (which comes from your foreground color chip, page 24). You can vary your brush strokes by tweaking the Bristle Qualities settings in the Brush panel (page 519), or switch brush tips by picking a new one in the Brush Presets panel.

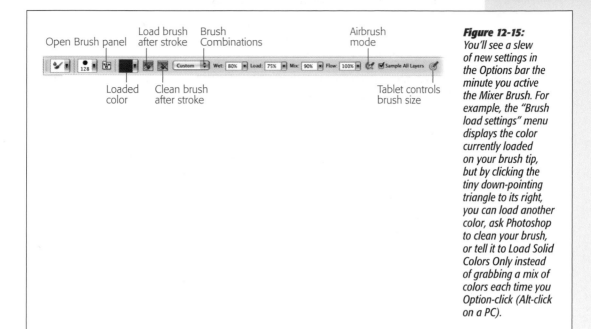

Open Brush panel

Load brush after stroke

Brush Combinations

Airbrush mode

Loaded color

Clean brush after stroke

Tablet controls brush size

Figure 12-15:
You'll see a slew of new settings in the Options bar the minute you active the Mixer Brush. For example, the "Brush load settings" menu displays the color currently loaded on your brush tip, but by clicking the tiny down-pointing triangle to its right, you can load another color, ask Photoshop to clean your brush, or tell it to Load Solid Colors Only instead of grabbing a mix of colors each time you Option-click (Alt-click on a PC).

9. **Change the Options bar's Mix setting bar to 70% and then Option-click (Alt-click) a color in your image to load it onto the brush tip.**

 You can change the Mix setting by double-click its field in the Options bar and typing a new percentage, or by clicking its down-pointing triangle and dragging the resulting slider to the right. Option-clicking (Alt–clicking) your image lets you add more colors to your brush tip to create a different painting effect. To switch to a completely different color, summon the new *heads-up display* (HUD) Color picker by Ctrl-Option-⌘-clicking (Alt+Ctrl-right-clicking on a PC). Figure 12-16 has the scoop.

10. **Continue painting until you've covered the whole image with brushstrokes.**

 If you like the results, save your file as a PSD file (page 50). If you don't, delete the paint layer by selecting it and pressing the Delete key (Backspace on a PC).

Whew! Painting a photo is a lot of work, but it's also lots of fun (if you like painting, that is). And you don't have to start with a photo—you can use a blank canvas instead. In fact, that's what the next section is all about!

Figure 12-16:
Top: The new HUD Color Picker (shown here in Hue Strip mode) lets you swap paint colors while you're painting. While it's onscreen, you can mouse over to the Hue selector bar on the right to change color categories and then press your space bar to select a category. Next, mouse over to the Lightness and Saturation selector on the left to pick the color you want to paint with (just hover over it with your mouse). Release your mouse button and the HUD Color Picker disappears. It takes some getting used to, as any additional clicks—or releasing your mouse button—will close the HUD Color Picker. Oy!

Bottom: You can also change the HUD Color Picker to a groovy Hue Wheel by opening Photoshop's Preferences (Photoshop→Preferences→General on a Mac; Edit→Preferences→General on a PC). From the HUD Color Picker menu near the top of the Preferences dialog box, choose Hue Wheel (you get to pick from a variety of sizes), and then click OK to close the Preferences dialog box. The Hue Wheel works the same way as the Hue Strip.

Painting from Scratch

Now you're ready for the really good stuff: actually painting in Photoshop. Not only is it fun, but it's a great way to get used to the Brush tool.

One thing to remember about painting is that different people use different techniques. Some folks start by drawing a sketch while others dive right into painting. People even have different ways of creating sketches: Some draw pencil sketches on paper, scan them into their computers, and then paint over them while others sketch right in Photoshop. And some folks use graphics tablets (which make painting a lot easier and more natural) while others fare quite well with a mouse. The following steps are very basic and explain how most folks paint from scratch, but, in the end, it's all about what works for you, so feel free to adapt these steps to suit your style.

Tip: You can rotate your canvas so it's at a more natural angle while you paint. See page 65 for details.

Turn on some music, think about what you want to draw, and follow these steps:

1. **Create a new document by pressing ⌘-N (Ctrl+N on a PC), give it a white background, and then save it.**

 Which canvas size resolution to use depends on what you want to do with your painting. If you've got a new computer with a lot of memory, you may as well make it big enough to print just in case it turns out really well; 3600×5400 pixels at a resolution of 300 ppi is a good choice. If you're going to post it on the Web or view it only onscreen (or if you have a slow computer), make it 1200×1800 at a resolution of 72 ppi instead. It's a good idea to make your document at least 1200 pixels wide or high (it doesn't matter which); that way, you'll have enough pixel info to show details when you zoom in to work on tiny stuff. (If it's less than 1200 pixels in one direction, it'll look really blocky when you zoom in.) And since the steps ahead are a bit long and involved, protect your hard work by saving the document as a PSD file now by choosing File→Save.

2. **Create a new layer and name it** *Sketch.*

 It's usually best to start with a rough sketch, though you certainly don't have to. You can draw the sketch on paper and scan it into Photoshop (see the box on page 514 for the scoop on isolating a sketch onto its own layer) or sketch it with the Brush tool, as explained in the following steps. To add a layer to your document, click the "Create a new layer" button at the bottom of the Layers panel (see Chapter 3 for more on layers) or press Shift-⌘-N (Shift+Ctrl+N on a PC).

3. **Press B to grab the Brush tool.**

 Hop up to the Options bar and pick a fairly small, round, hard-edged brush using the Brush Preset panel (Figure 12-14, bottom). Then set your foreground color chip to a dark gray (the color of real pencil lead).

4. **Sketch your drawing.**

 With the Sketch layer selected, mouse over to your document and draw a rough sketch of what you want to paint like the one shown in Figure 12-17. Don't worry about fine lines or getting things perfect; you can add details later.

Tip: If you want to practice painting this sketch, you can download the file named *Pumpkins.psd* from the Missing CD page at *www.missingmanuals.com/cds.*

Figure 12-17:
Here's the original sketch (top) and the more detailed, refined drawing (bottom). If you set the Refined Drawing layer's blend mode to Multiply (see step 6, page 509), it appears much darker, which helps you paint over it later.

Technically, you could use the Pencil tool to draw your sketch, but the Brush tool is far more flexible and produces nice, soft-edged lines instead of the hard, jagged edges you get with the Pencil tool. The only redeeming feature of the Pencil tool is its Auto Erase option that lets you erase previous strokes by drawing over them a second time (which is mainly just cool to watch).

5. **Lower the Sketch layer's opacity to about 40 percent.**

 At the top of the Layers panel, lower the opacity of the sketch until it looks kind of ghostly. You'll use this sketch to help you create a more detailed drawing in the next step.

6. **Create a new layer named *Refined Drawing.***

 Press Shift-⌘-N (Shift+Ctrl+N on a PC) to add another new layer, name it, and then click OK. Use the pop-up menu at the top of the Layers panel to change the layer's blend mode to Multiply (Figure 12-17, bottom) to make it appear darker so it's easier to paint over later.

 This new layer helps you fine-tune your sketch—think of this layer as a piece of tracing paper you've placed on top of the original sketch. The Sketch layer underneath acts like a guide to help you draw more precise and intricate details on the Refined Drawing layer.

7. **Refine the drawing until you're happy with it.**

 By refining your sketch on another layer, you're protecting the original. If you need to erase some of your brushstrokes, hold the E key to switch temporarily to the Eraser tool. Once you're satisfied with the refined drawing, turn off the original sketch layer's visibility by clicking its visibility eye.

8. **Create another new layer named *Blue Background* and drag it below the Re-
 fined Drawing layer.**

 If you build the background of your painting before you paint the drawing, you create a strong color foundation on which to build your painting. That way, you can bind the painting together using the background color(s).

9. **Fill the background layer with whatever you want your dominant background
 color to be.**

 Over in the Tools panel, click the foreground color chip and choose a fairly dark blue from the Color Picker and then fill the Blue Background layer with that color by pressing Option-Delete (Alt-Backspace on a PC). Alternatively, you can choose Edit→Fill and then pick Other from the Use pop-up menu to open the Color Picker; then click OK twice to fill the layer—once to close the Color Picker and again to close the Fill dialog box.

10. **In the Options bar, grab a large, round, textured brush, lower its opacity to 25
 percent, and start painting over the background.**

 You're getting ready to add even more paint to the Blue Background layer. Why? So you can keep the pumpkins and vines from looking flat by using textured brushes or brushes with rough edges (like the speckled spatter brushes). Once you pick a brush, lower its opacity to 25 percent in the Options bar. Then mouse over to your document and start painting over the dominant background color until you get the look you want, varying brushes, brush sizes, color, and opacity as you go (see Figure 12-18, top).

Figure 12-18:
*Top: A variety of grainy, tex-
tured brushes were used at
varying sizes and opacities to
create this chalky pastel look.
To give the background some
depth, use darker versions
of similar colors for shadows
and lighter versions of similar
colors for highlights. (A
major newbie mistake is to
use white for highlights and
black for shadows—doing
that just makes your painting
look flat.)*

*Middle: While you'd normally
keep the background turned
on when you're filling a
sketch with color, it's turned
off here so you can get a
good look at how the orange,
green, and yellow really
soak up the underlying blue.
Though the areas of dark
shading may look black,
they're really blue (if you
look closely, you can see
blue around the edges of the
pumpkins and in the dark
parts of the vines).*

*Bottom: Here's how the
colors look on top of the
background.*

Tip: To paint with a color that's already in your document, Option-click (Alt-click on a PC) to temporarily
turn your brush cursor into an eyedropper, letting you use the color you click as your foreground color
without switching tools. You can also use the new HUD Color Picker, described back on page 506.

11. **Create a new layer named *Blocked Colors* and drag it between the Blue Background and Refined Drawing layers (Figure 12-18, bottom).**

 You'll use this layer to add colors to your drawing (also referred to as "blocking with color" or "roughing in" because you'll add more details later).

12. **Use a big, round brush with an opacity of 25 percent to colorize your drawing.**

 For this step, pretend you're a kid with a coloring book; you don't have to worry much about staying within the lines. Start with the big stuff first—painting works best when you work from the general (larger areas) to the specific (tiny details). Using a big brush at a low opacity (25 percent) lets you build up color with multiple strokes (see Figure 12-18, middle). For a smooth look, paint with a soft-edge brush. To add more character, use one of the textured or spatter brushes. Remember to use the foreground color chip or any of the other color-picking tools you learned about earlier in this chapter when you need to change colors.

13. **Create a new layer named *Refining and Detailing* and drag it above your Refined Drawing layer.**

 You'll use this layer to add fine details to your painting like lined edges and other embellishments.

14. **Using a variety of brush sizes, add details to your painting.**

 Use a big, soft brush set to 65 percent opacity for large areas of color and blend them by painting over them again and again, changing colors as necessary. Switch to a small (about 5-pixel), textured brush at 100 percent opacity for finer details (see Figure 12-19, top).

Tip: If you're having trouble getting certain colors to blend with others, try the new Mixer Brush (page 502) or the Spot Healing Brush (page 425)—both can do wonders for blending stubborn areas. Steer clear from the Smudge tool (see Appendix D, online at *www.missingmanuals.com/cds*) because all it does is smear your paint and move it around, creating a truly awful effect.

15. **Create a new layer named *Effects* and drag it to the top of your layers stack.**

 If your painting needs a bit more punch, you can add some special lighting effects. Figure 12-19 (bottom) shows blue-tinted shadows around the edges of the pumpkins. If you change the layer mode to Multiply, the blue paint acts like a double coat of ink, although if you lower the layer opacity to about 34 percent, the effect remains subtle.

Figure 12-19:

Top: The painting really starts to take shape when you add details. Brushes from the Dry Media set work really well in this situation (see page 514 for the scoop on loading them). You'd normally leave the background turned on so you can pick up color from it, but it's turned off here so you can see what the colorized drawing looks like in isolation.

Bottom: For a bit of extra polish, add some blue highlights using a new, separate layer. Remember to experiment with different layer blend modes and opacities to get just the right effect. (Flip back to Chapter 7 for a refresher on blend modes.)

16. **Add some texture.**

 To keep your painting from look too perfect and, well, *digital*, you can mess it up with additional texture. You can use *anything* to create texture, including grainy, funky-edged brushes or a photo set to Overlay blend mode. Figure 12-20 describes one texture-inducing maneuver—the addition of, get this, a photo of a messy garage floor.

Figure 12-20:
Texture can give your painting life and keep it from looking plastic because it's too perfect (top). In this example, a photo of a messy garage floor was added at the top of the layers stack. Changing the photo layer's blend mode to Overlay (page 298) gives the painting a little depth and makes it look more believable (bottom).

This image was created by Melissa Findley (www.WickedFae.com).

Tip: To learn more about digital painting techniques, pick up a copy of *ImagineFX* magazine (*www.imaginefx.com*) or visit these websites: Computer Graphics Society (*www.cgsociety.org*), Concept Art (*www.conceptart.org*), and Epilogue (*www.epilogue.net*). You'll be glad you did!

17. **Save your painting one last time by pressing ⌘-S (Ctrl+S on a PC).**

 Congratulations for sticking through a *ton* of steps to create your first digital painting from scratch!

As you can see, Photoshop paintings are a lot of work, but they can be very rewarding. By creating every aspect of your painting on a separate layer, you build the image gradually so you don't destroy any one part if you mess up. Okay, who needs a nap?

Loading More Built-in Brushes

For all the built-in brushes you see in the Brush preset menu (Figure 12-11 [page 499]), there are hundreds more lying in wait right inside Photoshop—you just have to load them. More brushes means more creativity at your fingertips for stuff like digital paintings, applying a painted edge to a photo (discussed in the following list), adding a sparkle (page 517), or aging a photo so it looks torn and tattered (page 535).

Here's how to load more brushes *and* give your photo a painted edge (if you want skip the technique and go straight to loading brushes, see steps 6–7):

1. **Open a photo and double-click its Background layer to make it editable.**

 This technique involves adding a layer mask, which means you have to unlock the Background layer first or Photoshop won't let you add the mask. In the resulting dialog box, give the layer a new name if you like and then click OK.

2. **Create a new layer at the bottom of your layers stack.**

 At the bottom of the Layers panel, ⌘-click (Ctrl-click on a PC) the "Create a new layer" button.

FREQUENTLY ASKED QUESTION

Isolating a Scanned Sketch

Help! I scanned my sketch, but it's got a white background! How do I get rid of it?

If you go the pencil-and-paper route rather than drawing your sketch in Photoshop, you'll end up with a white background when you bring the scanned image into Photoshop. Luckily, you can get rid of it quickly using channels.

Flip back to Chapter 5 (page 166) for the scoop on using channels to create a selection. Once you've got marching ants around your sketch, open the Layers panel and create a new layer for the sketch. Fill your selection with the color of your choice by choosing Edit→Fill. Poof! That's all there is to it. Now you've got an inked outline of your sketch, ready for you to fill with paint.

3. **Fill the new layer with white or any solid color.**

 In a few steps, you're going to hide the edges of your image with a layer mask. If you kept the layer you added in the previous step as is, you'd see through to a transparent checkerboard pattern that makes your edges tough to see. A white background (or other high-contrast solid color) works much better. Choose Edit→Fill and, in the resulting dialog box, pick White from the Use pop-up menu and then click OK.

4. **Press M to grab the Rectangular Marquee tool and draw a selection box around your image about a quarter of an inch inside the edges of your image.**

 You'll paint the edges outside this selection box in step 9.

5. **Select the image layer and add a layer mask to it.**

 Over in the Layers panel, select the image layer (the one you started out with in step 1) and then click the circle-within-a-square icon to add a layer mask. When you do, Photoshop hides the edges of your photo outside the selection you made in the previous step.

6. **Press B to grab the Brush tool, and then open the Brush menu in the Options bar.**

 Head up to the Options bar at the top of your screen and click the down-pointing triangle to the right of the brush preview to see all your brushes (circled in Figure 12-21, top).

7. **Choose Faux Finish Brushes from the Brush fly-out menu.**

 Click the tiny right-facing arrow at the top right of the Brush menu (it's circled in Figure 12-21, top). In the resulting fly-out menu, you'll see options for setting the size of your brush previews, loading and saving brushes, and so on. Toward the middle of the menu you'll find lots of new brushes organized into categories like Assorted Brushes, Basic Brushes, and so on. Scroll down to Faux Finish Brushes and click it. Photoshop asks if you want to replace your current brushes with the new ones. Instead of clicking OK, click Append so Photoshop adds them to the bottom of the list (after the ones you've already got).

Tip: If you load a new brush set and want to get back to the set you had when you first started using the program, choose Reset Brushes from the fly-out menu shown in Figure 12-21, top.

8. **Pick one of the new brushes.**

 Scroll down the Brush menu until you see "Rolled Rag – Terry 120 pixels" (circled in Figure 12-17, bottom) and click it. Then mouse over to your document and you'll see the funky, squarish brush cursor circled in Figure 12-22.

Figure 12-21:
Top: Once you open the Brush menu, you can click the tiny right-facing triangle (circled, right) to open its fly-out menu. You'll see a long list of menu items that let you load, save, and reset brushes (along with several options for controlling the size of your brush previews). Toward the middle, you'll see a variety of brush categories (your list may differ slightly from the one you see here).

Bottom: Once you've selected a new category of brushes to load (like Faux Finish Brushes), they'll appear at the bottom of your Brush menu as shown here. For this particular technique, the Rolled Rag brush (circled) works quite well.

9. **With black as your foreground color chip and the layer mask selected, paint along the edges of your image to create a unique border.**

 Peek at the color chips at the bottom of the Tools panel and press X until black hops on top. With the layer mask selected, paint over the edges of your photo as shown in Figure 12-22. If you paint too much of your image, press X to swap color chips so that white is on top and then paint the areas you want to reveal.

Figure 12-22:
Top: Be careful
to make short
brushstrokes or you'll
create an edge that
looks like a repeating
pattern of your brush
shape. Just keep
brushing back and
forth until you get an
interesting look.

Bottom: If you use a
layer mask to create
this effect, your origi-
nal image remains
unharmed as shown
here in the Layers
panel.

If you like this edge
effect, you can create
something similar
by using CS5's new
Refine Edge dialog
box. Flip back to the
Note on page 172 for
more info!

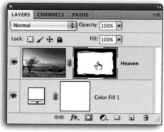

10. **Save your image as a PSD file.**

 If you decide to go back and edit the painted edges, just select the layer mask,
 grab the Brush tool and have a ball.

Making an object sparkle

Another fun use for interesting brushes is to make an object look like it's sparkling.
Just follow steps 6–7 in the previous list but instead of loading the Faux Finish Brushes,
load the Assorted Brushes. Once the new brushes are in your Brush menu, scroll
down the list of brush previews and you'll see a couple of crosshatch brushes that
make a perfect sparkle if you rotate them (see Figure 12-23). Click one of the cross-
hatch brushes to select it, click your foreground color chip at the bottom of the Tools
panel, and then pick a nice gold from the resulting Color Picker. Over in the Layers
panel, create a new layer for each sparkle, so you can rotate each layer individually.

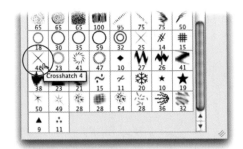

Figure 12-23:
Top: The Assorted category's crosshatch brushes, like the one circled here, are perfect for making an object in your image sparkle.

Bottom: The beauty of creating each sparkle on its own layer is that you can move them around, spin 'em, and control their intensity with the layers' opacity settings.

With the first new layer selected (it should be at the top of the Layers panel), click once on your image to add a sparkle. Add another new layer and click again to add another sparkle. Finally, rotate the sparkle using Free Transform by pressing ⌘-T or Ctrl+T on a PC. (Page 263 has the lowdown on Free Transform.) Press Return (Enter) when you're finished rotating and then Shift-click to select both sparkle layers in the Layers panel. Then press V to grab the Move tool and drag the sparkle into place.

Tip: You can also hold the V key to switch temporarily to the Move tool. When you let go of the key, you switch back to whatever tool you were using before.

Painted photo edges and sparkles are two of an infinite number of visually interesting effects you can create using the extra brushes that come with Photoshop. Look through the various brush sets and see if some of the unusual shapes inspire you!

Customizing Brushes

Once you get really comfortable with the Brush tool, you can experiment with changing the way it behaves. Maybe you'd like to change the spacing between brush marks in a single stroke, have the brush apply a texture, or whatever. The Brush panel (see Figure 12-24) gives you an amazing amount of control over your brushes.

To open the panel, go to Window→Brush.

The following sections explain in detail the various settings you can tweak in the Brush panel, but here's the basic procedure for customizing brushes: In the upper-left part of the Brush panel, click the Brush Presets button. Then, in the upper-right part of the panel, choose the brush you want to edit by clicking its icon. Finally, turn on the checkboxes on the panel's left side, click the category name to the right of the checkbox, and then tweak the various settings. The preview window at the bottom of the panel shows you how your changes affect the brush in real time.

The next few sections explain the ways you can customizer brushes—Photoshop gives you a ton of options. They're divided into the categories listed on the left side of the panel; when you click the category's name (and turn on the checkbox), Photoshop displays the options for that category on the right side of the panel. Once you've got a brush's settings in a particular category just right, click the little padlock icon to the right of that category's name to lock those settings.

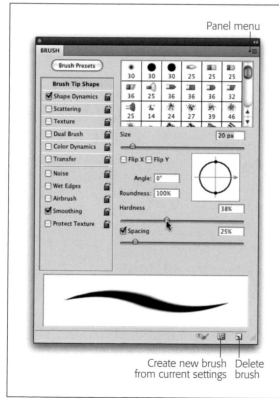

Panel menu

Create new brush Delete
from current settings brush

Figure 12-24:
The Brush panel gives you oodles of options for changing the way your brushes behave. If you master these controls, you can make some super-cool brushes that make your brushstrokes look more real and less perfect. Start by selecting one of the brushes displayed in the upper-right part of the panel.

The numbers beneath each brush represent its size in pixels.

The Joy of Painter

If you got a charge out of creating a painting from scratch (page 506), you may enjoy using a program called Painter (*www.corel.com/painter*) as a companion program to Photoshop. For years, Painter has been revered by fine artists, commercial designers, and entertainment artists who work on everything from special effects to character and set design. Painter is designed by artists for artists: it's the digital equivalent of a traditional art studio. It works on both Macs and PCs, and it costs $100 for the junior version (called *Essentials*) and $419 for the full version. If you want to get really serious about digital painting, it's a must-have. Here's a sampling of what you can do with it:

- See the bristles of each brush and how they splay onto your canvas, just like brushes in the real world.
- Control how fast the paint dries, where the wind is coming from, and how many bristles are in your brush.
- Create color swatches from an image, layer, or from its mixer pad, letting you have custom swatch sets for different projects.
- Blend paints using a mixer pad just as if you were mixing two colors of wet paint together.
- Specify the kind of (virtual) paper you're drawing on and whether your brush picks up that texture. You

can also create custom brush- and paper-texture palettes (think panels in Photoshop).

- Automatically save the settings you use for each individual brush, so you don't have to keep resetting them. For example, if you tweak one brush, switch to another brush, and then go back to the *first* one, Painter remembers the settings you used for it (unlike Photoshop, which resets the original brush completely unless you saved it as a preset).

You can save layered PSD files from Painter that you can open in Photoshop for more fine-tuning like color correcting (Chapter 9) and sharpening (Chapter 11). You can also work the other way around and open PSD files directly in Painter.

For true bliss, invest in a Wacom graphics tablet while you're at it (*www.wacom.com*) and you may never leave your studio again. A graphics tablet is an electronic pad that you can draw on with a special pen (called a *stylus*). You can control brush size and opacity by varying the amount of pressure you apply to the tablet with the stylus. Combined with the Rotate View tool (page 65), a tablet gives you a truly natural painting experience—without all the mess!

Note: In the following pages you'll learn a million ways to customize your brushes (okay, maybe not that many, but a whole lot). It'd be great to list an example of what each one is best suited for, but there's just not enough room in this book. You can use a brush to paint nearly anything in Photoshop, so how you use the following options is based more on your personal preference and experimentation than on a specific formula. You'll find that the majority of these settings are geared toward introducing random behavior into your brushstrokes so they don't look quite so perfect.

Brush Tip Shape

The settings in this category affect (surprise!) how the tip of your brush is shaped, which determines how your brushstrokes look. Once you select a brush tip from the list of presets on the upper-right part of the panel, you can control the following characteristics:

- **Size.** This setting controls how big the brush is. You can also change brush size by going to the Options bar and clicking the down-pointing triangle next to the Brush Preset picker and then adjusting the Size slider. Another option is Ctrl-Option-dragging (Alt+right-click-dragging on a PC): Drag left to decrease your brush size and right to increase it.

- **Flip X.** Turning on this checkbox flips the brush tip horizontally. For example, if your brush is shaped like a curved line that points to the right, turning on this checkbox will make it point to the left instead. If the brush is symmetrical, you won't notice any change.

- **Flip Y.** This checkbox flips the brush vertically. If your brush tip is a leaf that points up, for example, this setting will make it point down.

- **Angle.** If you're working with an irregular-shaped or elliptical brush, this setting lets you change its angle, which is great for making a chiseled stroke (imagine an ellipse tilted to one side or the other, similar to calligraphy). You can either enter a number in the Angle box or drag the right-facing arrow in the window to the right (the diagram looks like a crosshair).

- **Roundness.** Use this setting to control the shape of your brush, from perfectly round to elliptical. You can also click the black dots on the crosshair image and drag up or down to change this setting.

- **Hardness.** This slider controls the edges of your brush, from 0 percent (very soft) to 100 percent (hard). The harder the brush's edges, the cleaner your lines; softer edges give you an airbrushed look. You can't adjust this setting on custom brushes you've made from images. Bummer!

- **Spacing.** This slider lets you control the amount of space between brush marks when you make a stroke. The lower the percentage, the closer together they are, creating a more solid, cleaner line. Higher percentages make gaps between the brush marks, which is excellent for scatter brushes. If you turn off the Spacing checkbox, Photoshop bases the spacing on how quickly you move your mouse while you paint: Drag slowly for narrow spacing and quickly for wider spacing.

Shape Dynamics

The settings in this category let you make brushes that create natural, realistic-looking brushstrokes made from a series of brush marks rather than solid, perfect-looking brushstrokes.

- **Size Jitter and Control.** These settings determine how much the size of the brush marks varies (see Figure 12-25). When you're painting with a real brush, the strokes aren't perfectly uniform (you'd be hard pressed to make two identical strokes). With this setting, you can specify how much jitter you want by entering a percentage or dragging the slider, or turn it off altogether by choosing Off from the Control pop-up menu. The Fade setting makes each stroke taper off (like it ran out of paint) within the number of steps you enter in the text box that appears. Setting the Control menu to Pen Pressure makes your stroke taper off at the beginning and end of the mark *if* you're using a graphics tablet. If you have a high-end pen tablet like an Intuos or Cintiq (*www.wacom.com*), you can choose the Stylus Wheel or Pen Tilt setting for other variations (like being able to tilt your brush by tilting your pen).

Note: Some of the settings in the Shape Dynamics category may not work for you. For example, Pen Pressure doesn't work with a mouse, so if you choose it from the Control menu, you'll see a tiny triangular warning symbol next to it if you don't have a graphics tablet attached to your computer.

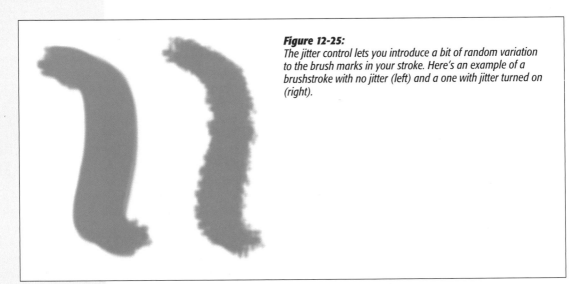

Figure 12-25:
The jitter control lets you introduce a bit of random variation to the brush marks in your stroke. Here's an example of a brushstroke with no jitter (left) and a one with jitter turned on (right).

- **Minimum Diameter.** This setting controls how small the brush can get. It's helpful on custom brushes when you don't want them to get too small and on round or elliptical brushes when you don't want them to get too thin.

- **Tilt Scale.** This setting is available only if you have a graphics tablet (otherwise it's grayed out); it lets you resize a brush by tilting your stylus.

- **Angle Jitter and Control.** These settings determine how much the angle of the brush marks vary within a single stroke. It's automatically set to 0 percent, but if you want a lot of variation in the angle of your brushstrokes, set it higher. Use the Control pop-up menu to choose from settings like Off, Fade, Pen Pressure, Pen Tilt, Stylus Wheel, and Rotation, discussed earlier under Size Jitter and Control. Also included are Rotation, which rotates the brush marks; Initial Direction, which bases the brush-mark angle on the way you *initially* drag your mouse when you start the brushstroke; and Direction, which bases the brush-mark angle on the direction of the brushstroke. Adjusting the Angle Jitter of sampled brushes (custom brushes you've made from images, see page 531) can turn a flat, repetitive brushstroke into a richly textured one.

- **Roundness Jitter and Control.** This setting lets you control how much the roundness of your brushstrokes varies. The Control menu includes Off, Fade, Pen Pressure, Pen Tilt, Stylus Wheel, and Rotation options, as well as Minimum Roundness, which lets you specify a minimum percentage of roundness for your brush (it indicates the ratio between your brush's width and height).

- **Flip X Jitter** and **Flip Y Jitter.** These checkboxes let you flip the jitter on its x- or y-axis (or both), much like you can flip the shape of the brush.

Scattering

Turn on this category's checkbox when you want to make the spacing between your brush marks a bit random as if your brushstroke were splattered onto the canvas instead of applied evenly as shown in Figure 12-26. You can adjust the following settings:

- **Scatter and Control.** Unless you change this setting, all your brush marks will follow the line of your stroke. The Scatter slider distributes the brush marks above and below the center of the stroke line, giving them a random look. Turn on the Both Axes checkbox to make Photoshop scatter to the right and left, too.

- **Count.** This setting controls the number of marks Photoshop applies at each spacing interval, which you set using the Spacing setting in the Brush Tip Shape category (page 521). Increasing this setting's percentage makes a scatter brush denser; lowering it thins out the brush.

- **Count Jitter and Control.** These settings control how random the number (quantity) of marks is. If you're using a graphics tablet, set the Control pop-up menu to Pen Pressure and the brush marks will thin out at the beginning and end of your stroke but be dense in the middle.

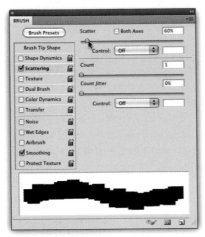

Figure 12-26:
When you use it with a layer mask, a Scatter brush lets you break a photo into pieces as shown here. To create this effect, select a brush from the Square Brushes category, turn on Scatter and set it to 60 percent, and then, in the Brush Tip Shape category, set the Spacing to 25 percent.

Texture

These options let you apply a repeating pattern to your brushstroke, which makes it look textured. Photoshop comes with a ton of ready-to-use patterns—although you have to load most of them as explained in Figure 12-27—and you can add your own.

- **Invert.** Since texture in Photoshop doesn't literally mean that some parts of your image stick up farther than others, the program bases texture on the colors in a pattern. It considers dark areas "lower" than lighter ones, which makes sense because, in the real world, the parts of a textured surface that protrude receive more light than lower areas, which are darker because they're filled with shadows. Also as in real life, when you paint over a textured part of your document, the lighter (higher) areas get more paint than darker (lower) ones since the hairs

on your brush have a hard time reaching down into those low areas. If you turn on this checkbox, Photoshop reverses the high and low points of the texture, so light areas are low points that don't get very much paint and dark areas are the high points that get lots of paint.

- **Scale.** This slider lets you adjust the size of the pattern. Drag it left to make the pattern smaller or right to make it bigger.

- **Texture Each Tip.** This checkbox applies the texture to each brush mark *within* the stroke, rather than the *whole* stroke, which results in a more textured look (and slightly less chance of creating a painfully obvious repeating pattern). You have to turn this option on to use the Depth setting discussed later in this list.

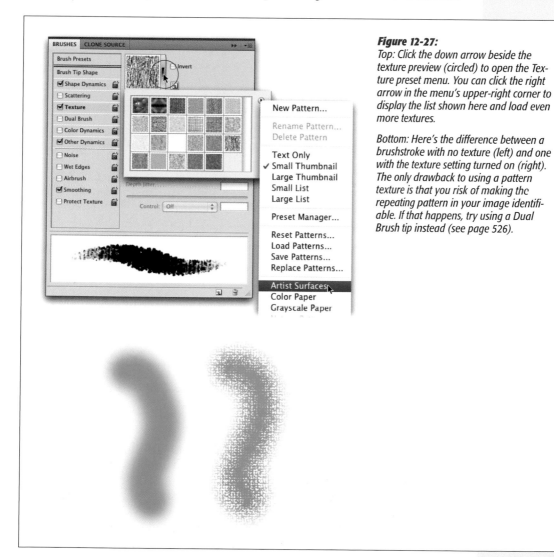

Figure 12-27:
Top: Click the down arrow beside the texture preview (circled) to open the Texture preset menu. You can click the right arrow in the menu's upper-right corner to display the list shown here and load even more textures.

Bottom: Here's the difference between a brushstroke with no texture (left) and one with the texture setting turned on (right). The only drawback to using a pattern texture is that you risk of making the repeating pattern in your image identifiable. If that happens, try using a Dual Brush tip instead (see page 526).

- **Mode.** Use this pop-up menu to pick a blend mode for Photoshop to use to apply the pattern to the brushstroke (see page 289 for more on blend modes).

- **Depth.** This slider controls how deeply the paint "seeps into" the texture by increasing the contrast of the colors in the texture. Changing this to a high percentage means the low points of the texture won't get any paint and entering a low percentage means all the areas get the same amount of paint, which reduces the contrast so much you can't see the texture.

- **Minimum Depth.** This slider lets you set the minimum depth that paint can seep into the texture.

- **Depth Jitter and Control.** These settings let you introduce randomness into how the depth varies when the Texture Each Tip checkbox is turned on. To decrease the amount of depth jitter, drag the slider to the left; to increase it, drag the slider to the right. In the Control pop-up menu, you can choose from Off, Fade, Pen Pressure, Pen Tilt, Stylus Wheel, and Rotation (discussed on page 522).

Dual Brush

These options let you combine two brush tips to introduce more texture and randomness into a brushstroke or to give texture to a brush that doesn't have any (see Figure 12-28). Photoshop applies the second brush's texture to the first brush's brushstrokes wherever the two strokes overlap (brush tips of differing shapes will overlap in different places). Pick your first brush in the Brush Tip Shape category by clicking one of the presets and then adjusting its options. Then click the Dual Brush category and follow the same process to choose your second brush. The Dual Brush category gives you these options (and they all apply to the second brush tip you selected):

- **Mode** lets you set the blend mode Photoshop uses to combine your brush marks.

- **Diameter** controls the size of the second brush tip.

Figure 12-28:
If you want to introduce texture to a brush that doesn't have any, like the leaf brush shown here (left), you can combine it with a textured brush tip (right).

- **Spacing** controls the distance between the each tip's brush marks in a stroke.

- **Scatter** lets you control how the brush marks are distributed throughout the stroke.

- **Count** lets you specify the number of brush marks at each spacing interval.

Color Dynamics

These settings let you control how the paint color varies throughout a brushstroke—another way to introduce a bit of variety into your strokes so they don't look uniform (see Figure 12-29).

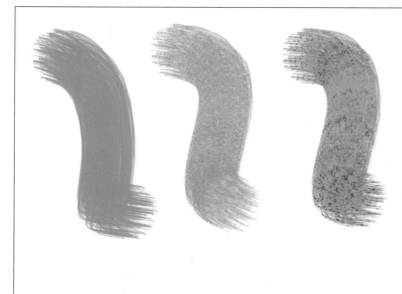

Figure 12-29:
The Color Dynamics settings let you make a single brushstroke look like it's made from more than one color. If you don't have Color Dynamics turned on and your foreground color chip set to green, your brushstroke will look like the one on the left. But if you turn on Color Dynamics and set your background color chip to yellow, you can use the Foreground/Background Jitter slider to create a brushstroke that randomly combines those two colors (middle). And if you turn on the Hue Jitter setting, you can introduce all kinds of funky colors to your brushstroke (right).

- **Foreground/Background Jitter and Control.** These settings let you control how the paint alternates between the foreground and background colors throughout a stroke. In the Control pop-up menu, you can choose from Off, Fade, Pen Pressure, Pen Tilt, Stylus Wheel, and Rotation (described on page 522).

- **Hue Jitter.** Lets you control color variation in your brushstroke; a higher setting introduces all kinds of funky color flecks. Figure 12-29, right, shows this setting in action. Drag the slider to the right to introduce more color flecks and drag it left to introduce fewer.

- **Saturation Jitter.** Increasing this setting makes Photoshop vary the saturation of the color throughout the stroke.

- **Brightness Jitter.** Use this setting to vary the brightness of the color throughout the stroke.

- **Purity.** This setting increases (if you set it to a positive percentage) or decreases (if you set it to a negative percentage) the color's saturation.

Transfer

This category, which used to be called Other Dynamics, lets you adjust how much paint Photoshop lays down with each brushstroke (see Figure 12-30). The Opacity and Flow settings here override the ones in the Options bar, so if you tweak them, you may find that the Options bar's settings don't seem to work. For example, if you set your Opacity Jitter to 60 percent, that's the most opaque your brush can be, even if you set it to 100 percent Opacity in the Options bar. You've been warned!

Here are your options:

- **Opacity Jitter and Control.** These settings control how transparent the paint is throughout the brushstroke. Setting the Opacity Jitter slider to a higher percentage makes the stroke more see-through (see Figure 12-30, bottom). In the Control pop-up menu, your choices are Off, Fade, Pen Pressure, Pen Tilt, and Stylus Wheel (page 522).

- **Flow Jitter and Control.** This lets you specify how much paint the brush lays down throughout the brushstroke. A higher percentage means the flow varies more and a lower percentage means the flow varies less. The Control menu gives you the same options as Opacity Jitter Control menu.

- **Wetness Jitter and Control.** You can use this setting to make Photoshop vary how wet (liquidy) your brush strokes are.

- **Mix Jitter and Control.** Tweak these settings to vary how much paint you're mixing from your canvas onto your brush.

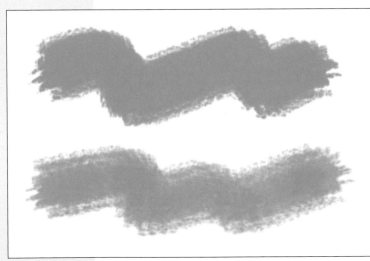

Figure 12-30:
If you want your brushstroke's opacity to vary randomly, increase the opacity jitter. Here you see the difference between a brushstroke with no opacity jitter (top) and one with the opacity jitter set to 100 percent (bottom).

Noise

Turn on this checkbox to make Photoshop apply a dose of random, grainy texture to your brush tip (if you're using a dual brush tip, the program applies it to both tips). You can use it to introduce more texture and randomness to your brushstrokes. For some reason, the noise isn't as noticeable with hard-edge brushes as it is with soft-edge brushes (maybe because the noise is just more visible in the gray edge pixels you get with soft-edged brushes).

Wet Edges

Turning on this checkbox makes the center of your brushstrokes transparent, so the paint looks like it's building up along the edges of the stroke (similar to painting with watercolors).

Airbrush

Turn on this checkbox to make your brush behave like a can of spray paint. It has the same effect as clicking the Airbrush button in the Options bar (page 500).

Smoothing

If you want your brushstrokes to look smoother than they were when you painted them, turn this checkbox on. It's especially helpful if you don't have a very steady hand, which can make your brushstrokes look jagged.

Protect Texture

This checkbox lets you apply the same texture, pattern, and size to all your brush presets (the built-ins) that have a texture. So, for example, you could use this option to make it look like you're painting on the same surface with a variety of brushes without actually having to turn on the Texture category for each brush. You can think of it as a global texture option.

Suggested Brush Customizations

With so many settings, it can be confusing to figure out which brushes really need changing. You'll find that the presets are really handy, and with just a few tweaks here and there, they can become indispensable. Figure 12-31 shows a sample of some extremely useful yet simple customizations. If you like what you see, check out Table 12-1 to learn about specific settings.

Table 12-1. *Suggested brush customization*

Brush number in Figure 12-26	Description	Opacity	Spacing	Shape Dynamics	Other Dynamics	Uses
1	Round, hard-edged brush	25%	0%	Size Jitter = Pen Pressure	None	Shading, blocking in color, sketching
2, 3	Rough-edged brush	25%	0%	None	With (2) or without (3) Flow Jitter = Pen Pressure	Shading, adding texture, making hair
4	Rough brush (custom)[3]	30%	0%	Angle Jitter = 20%; Control = Off	None	Adding texture, shading
5	Small dot brush (custom)[3]	30%	0%	Size Jitter = Pen Pressure	Opacity Jitter = Pen Pressure	Making hair, shading
6	Round, rough-edged brush	100%	20-25%	Size Jitter = Pen Pressure	Opacity Jitter and Flow Jitter = Pen Pressure	Shading, blocking in color
7	Textured round brush	30%	0%	None	Flow Jitter = Pen Pressure	Adding texture, shading
8	Textured round brush	100%	0%	Size Jitter = Pen Pressure	Flow Jitter = Pen Pressure	Sketching, creating line art, adding fine details in small areas
9	Scattered spot brush (custom)[3]	70%	25%	Scatter = 20%; Size Jitter = Pen Pressure	Opacity Jitter and Flow Jitter = Pen Pressure	Adding texture

1 Adjust this setting in the Options bar.
2 Set this in the Brush Tip Shape category—see page 521.
3 Meaning a custom made brush you make from scratch as described in the next section.

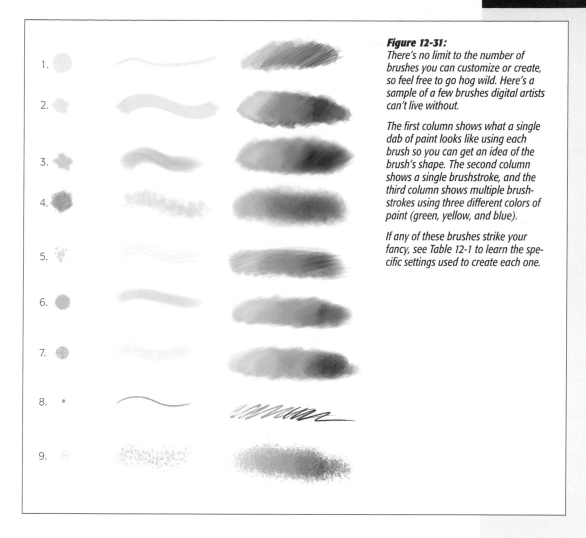

Figure 12-31:
There's no limit to the number of brushes you can customize or create, so feel free to go hog wild. Here's a sample of a few brushes digital artists can't live without.

The first column shows what a single dab of paint looks like using each brush so you can get an idea of the brush's shape. The second column shows a single brushstroke, and the third column shows multiple brushstrokes using three different colors of paint (green, yellow, and blue).

If any of these brushes strike your fancy, see Table 12-1 to learn the specific settings used to create each one.

Defining a New Brush

For some seriously creative fun, try making your own brushes. You can make them out of anything—a stroke that you've drawn with another brush, your logo, even an image that you've scanned into your computer to use as texture (like a leaf). Some folks call brushes that you create yourself *sampled brushes* because you *sample* part of a pattern, object, or image to create them; in other words, you have to select the pattern, object, or image you want to base the brush on.

The first step is to create the *paint dab*—a dab of paint in the shape of the brush tip—you want to turn into a custom brush (see Figure 12-32, left). You can create a paint dab in a variety of ways, from the quick to the super involved. The basic premise is to create a new 300×300–pixel document and then use a variety of brushes at

various opacity settings to create your dab. You can even add texture to it—the more irregular and messy the dab, the more interesting your brush will be. To turn the dab into a brush that you can use to apply color, you *have* to create it using black and gray paint at 100 percent opacity (that's the Options bar's opacity setting). When you paint with the brush later, the 100-percent black areas will create opaque color and the gray areas will be semitransparent.

Note: If you want to practice making a custom brush using the paint dab shown in Figure 12-32, download the file *DotsBrush.psd* from the Missing CD page at *www.missingmanuals.com/cds*.

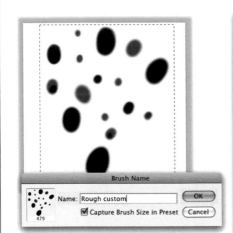
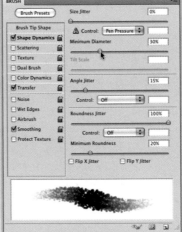

Figure 12-32:
Left: You can create this paint dab by starting with one of the small, soft-edged brush presets. Set your foreground color chip to black, paint a few dots, and then switch to some percentage of gray and paint a few more. Just make sure that the Options bar's Opacity field is set to 100 percent.

Right: If you make a few changes in the Brush panels, you can create an extremely useful texture and shading brush.

Once you've created your paint dab, follow these steps to turn it into a brush:

1. **Use the Rectangular Marquee tool to select the dab.**

 To define a brush, you have to select the object first. Press M (or Shift-M) to grab the Rectangular Marquee and draw a selection around the dab (Figure 12-32, left).

2. **Choose Edit→Define Brush Preset.**

 In the resulting dialog box (Figure 12-32, left), give your brush a name and then click OK.

3. **Create a new document (it can be any size) and press B to grab the Brush tool.**

 Press ⌘-N (Ctrl+N on a PC) to open a new document so you can test drive your new brush.

4. **In the Options bar, select your new brush from the Brush menu and then open the Brush panel.**

 Once you've selected your new brush, click the button at the far right of the Options bar to open the Brush panel (or click its panel dock icon on the right side of your screen or choose Window→Brush).

Tip: Alternatively, you can open the Brush panel first, click Brush Presets, and then select your new brush from there.

5. **In the Brush panel, click the Brush Tip Shape category.**

 To create a brush similar to number 4 in Figure 12-31, change the diameter to 100 pixels, the angle to 70 degrees, and the spacing to 1 percent. If you have a graphics tablet, click the Other Dynamics category and set Opacity Jitter and Flow Jitter to Pen Pressure.

6. **Click the Shape Dynamics category.**

 If you have a graphics tablet, set Size Jitter to Pen Pressure and Minimum Diameter to 30 percent (Figure 12-32, right). If you don't have a graphics tablet, try entering a Size Jitter of 25 percent instead (you just won't be able to change it by applying more or less pressure with your pen).

7. **Turn on the Smoothing checkbox.**

 As explained on page 529, this setting makes your brushstrokes smoother, so they look less jagged.

8. **Save your brush again.**

 Click the "Create new brush" button at the bottom right of the Brush panel (it looks like a piece of paper with a folded corner). If you don't save the brush again, you lose the settings you just changed. In the resulting dialog box, give it the same name that you did in step 2.

Not only have you created a brush that's great for textures in digital paintings, but you can also use it to make some interesting grunge effects when you're editing photos. The ability to make your own brushes gives you a ton of control when you're applying textures. Who knew?

Installing New Brushes

You're not alone when it comes to creating new brushes. Folks love sharing their creations, and once they've made a really cool brush, they're usually happy to share it with the masses. That's why all manner of free brushes are available on the Web.

One of the best resources you'll ever find is the Adobe Studio Exchange site (*www. adobe.com/cfusion/exchange*). Click the site's Photoshop link and then choose Brushes from the category list on the right side of the page (you can find all manner of actions, custom shapes, gradients, and so on here, too). You can even download a brush set that'll make your image look like it was printed on torn paper as shown in Figure 12-33. Once you've downloaded the brush set to your hard drive, choose Load Brushes from the Brush Preset picker's fly-out menu (or from the Brush panel's menu) and navigate to where the brush set lives (look for a file whose name ends in ".abr", such as *Paper_Damage.abr*) and then click Load (you can also double-click the .abr file and Photoshop will put it in the right spot). Your new brushes appear in the Brush menu, ready for you to use.

The streaks in Figure 12-33 were made by setting the foreground and background chips to white and brown (respectively) and then choosing Filter→Render→Cloud followed by Filter→Blur→Motion Blur. Next, the streak layer's blend mode was changed to Hard Light. With a few clicks of the funky Paper Damage brushes, the photo looks ancient!

Figure 12-33:
*At the Adobe Studio
Exchange site, you
can download some
amazing brushes
and share your own
creations (top left).
After you download
and install the Paper
Damage brush set
(top right), for
example, you can use
its brushes to age a
photo (bottom).*

*In this image, each
damaging brush-
stroke was painted in
white on its own layer
to control the layer's
opacity and protect
the original image.*

The Art History Brush

Adobe would have you believe that you can use the Art History Brush to turn a photo into a painting, but the darn thing doesn't work very well (as is painfully clear in the figure below). It's similar to the more useful History Brush (page 29) in that you can select a snapshot of your image (a previous version saved at a particular time) to work from, which is why it's in the same toolset. That said, take this tool for a spin and decide for yourself whether it deserves a spot in your regular tool rotation. Here's how:

1. **Grab the Art History Brush by pressing Y.** Adding the Shift key lets you cycle through all the tools in a toolset. So, if pressing Y selected the History Brush, simply press Shift-Y to select the Art History Brush instead.

2. **In the History panel, pick a snapshot or history state (page 27).** Open the History panel by choosing Window→History and then choose a state by clicking the left column beside the state or snapshot you want to work with.

3. **Pick a small, soft-edged brush from the Options bar's Brush menu.** You can set the tool's blend mode and opacity in the Options bar just like you can with the Brush tool, and use the Ctrl-Option-drag (Alt+right-click+drag on a PC) keyboard shortcut to resize your brush on the fly—drag left to make your brush smaller and right to make it bigger.

4. **In the Options bar, choose Tight Short from the Style menu.** You'll find 10 different painting styles in this pop-up menu, including Tight Short, Loose Medium, Loose Long, and so on. Anything with the word "tight" in the name works a little better than the others because it keeps the brushstrokes close together.

5. **Change the Options bar's Area field to 50 pixels.** This setting controls the area covered by the artsy (and totally destructive) brushstrokes you create as you brush across your image. Enter a large number for more strokes or a smaller number for fewer strokes. If you have any hope of recognizing the object you're painting, keep this number relatively low (less than 40 percent).

6. **Make sure the Tolerance field is set to 0 percent.** A low tolerance lets you paint strokes anywhere you want. A high tolerance limits them to areas that differ from the color in the snapshot or history state you picked in step 2.

7. **Mouse over to your image and paint it.** As you brush over your image, your clear, recognizable photo will be replaced with random, supposedly artistic swaths of paint, transforming it into madness and mayhem. Undo command, anyone?

Drawing with the Vector Tools

I f your first thought when someone mentions drawing is, "But I can't even draw a straight line!", don't worry: You *can* draw in Photoshop. To draw a straight line, just grab the Line tool (it's one of the shape tools—see page 554) and drag from one spot to another. Or, as you learned in the previous chapter, grab the Brush tool, click in one spot, and then Shift-click another spot; it's that simple. The program also includes all kinds of built-in shapes like circles, rectangles, and rounded rectangles that are incredibly easy to use.

But what about creating more sophisticated drawings and illustrations? The good news is you don't have to worry about drawing *anything* freehand, whether it's a line or a curvy shape. Instead, the vector drawing tools you'll learn about in this chapter let you set down a series of *points*; Photoshop then creates *paths* in between those points to form the outline of your shape. Unlike the things you draw by hand with the Brush tool or a real-world pencil, these vector objects are infinitely tweakable: You can move points and adjust the paths to create any shape you want, letting you create complex yet flexible works of art from scratch, as Figure 13-1 shows.

Figure 13-1:

Top: Here you can see the paths that make up the basic shapes of this digital painting by Bert Monroy called "Red Truck." You read that correctly: it's not a photograph—Bert drew every detail by hand. He created the basic shapes using the Pen tool, and then filled in the details with the Brush tool. Instead of a mouse, he used a Wacom interactive pen display (a monitor you can draw directly on; see www.wacom.com/cintiq).

Bottom: This wireframe drawing (called "Oakland" and also by Bert) is even more complex. If you look closely, you can make out the shapes he created with the Pen tool to make the neon tubes and the sockets that the tubes go into. Now that's something to aspire to! You can see more of Bert's amazing work at www.bertmonroy.com.

Now, if you're tempted to bail from this chapter because you're not an artist, hold your horses—you can use the vector drawing tools in a variety of other ways. For example:

- Once you get the hang of these tools, you can use them to add elements to your images that don't exist and can't be photographed, like the ornamental shapes and embellishments shown on page 316.

- You can use the drawing tools to create precise selections that you can't make any other way. In fact, the Pen tool is a favorite of seasoned Photoshop jockeys because of its selection prowess (see page 566).

- You can use the shape tools to mask (hide) parts of your image (see page 572). Because they're vector based, they're a lot more flexible than the regular ol' layer masks you learned about back on page 113.

Learning to draw with Photoshop's vector tools takes time and patience because they work *very* differently than any other tool you've used so far. But taking the time to master them sets you on the path (pun intended) to becoming a true Photoshop guru.

Before you dive into using the tools themselves, though, you need a quick tour of the different drawing modes you can use. Take a deep breath and read on!

Photoshop's Drawing Modes

In the real world, the word *drawing* implies that you're sketching lines and shapes by hand. But in Photoshop and in this book, drawing refers to creating objects using Photoshop's vector tools: the Pen tool and the various Shape tools. Drawing with these tools is more like drafting (think technical illustrations such as blueprints) because you're creating precise outlines of shapes instead of the varying lines of a sketch or painting.

Note: Here's a way to make sense of the difference between Photoshop's painting tools and its vector drawing tools: If Van Gogh or Michelangelo had used Photoshop, they would have liked the Brush tool because of its similarity to real-world paintbrushes. However, artists like Matisse, Mondrian, and Picasso would have favored the vector drawing tools because their painting styles are more precise and angular and depend on creating smooth, clean geometric shapes and lines.

Photoshop has three different drawing tool modes (see Figure 13-2), which determine exactly what happens when you use the tools. Here's what each mode does:

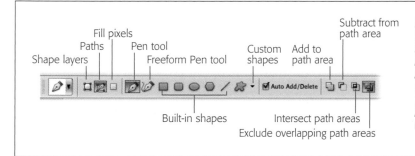

Figure 13-2:
When you press P to grab the Pen tool, you see three buttons for different drawing modes near the left end of the Options bar. The third option (Fill Pixels) is grayed out here because you can only use it with shape tools (page 551).

- **Shape Layers.** When you're in this mode and you make your first click with any vector drawing tool, Photoshop creates a new Shape layer (page 77) for you to work on. When you finish drawing the shape, Photoshop automatically fills it with your foreground color (page 24). Drawing in this mode is like using a pair of scissors to cut shapes out of a piece of construction paper—these shapes can hide content on any layers below them, where the layers overlap.

 Shape Layers mode works with the Pen tool and the shape tools. It's great for creating geometric shapes filled with color that you can use in your design or overlay onto your image (like the embellishments shown on page 316). You can also use this mode to add a symbol or logo to a product in your image (see page 553). Photoshop comes with a slew of built-in shapes to choose from, but you can also create your own (page 557) and download shapes from the Internet. As you learned back in Chapter 4, you can also use the shape tools to create selections. (See page 147, for example, to learn how to round the edges of your photo using the Rounded Rectangle tool.)

- **Paths**, as you learned earlier, are lines and curves between *points*, which you'll find out more about in the next section. Paths mode doesn't create a new Shape layer or fill the path with color; instead, when you're in this mode, Photoshop turns whatever you draw into an empty outline. Use this mode when you want to use the Pen tool to make selections (page 566) or create a clipping path (page 568), or want to create a vector mask that you may need to resize (see page 572). You can also fill paths with color (page 564) and give them a stroke (page 563), but Photoshop doesn't automatically create a new layer when you use the Pen tool or a Shape tool in Paths mode; you have to create a new layer first *and then* add the fill or stroke. The paths you create in this mode live in the Paths panel, which you'll learn about on page 550.

- **Fill Pixels.** This mode works only with the shape tools (page 551). Normally when you use one of these tools, Photoshop plops you into Shape Layers drawing mode and fills the vector shape with your foreground color. But in Fill Pixels mode, Photoshop creates a *pixel*-based layer instead (it still fills the shape with your foreground color). This is handy if you need to edit the shape using tools that don't work with vectors, like filters, painting tools, and so on. That said, you could just as easily rasterize a Shape layer (see page 110) *and then* use those tools. So unless you know *for sure* that you'll never need to change the shape of the object you're drawing, you won't use this mode very often.

The basic drawing process is the same no matter which mode you choose: You pick the Pen tool or one of the shape tools, choose a drawing mode, draw the shape, edit the shape, and then save it for future use. In the following sections you'll learn how to do all that and more.

Now that you have a bird's eye view of the process, it's time to dig into drawing with the Pen tool.

Drawing Paths with the Pen Tool

The Pen tool made its debut in Adobe Illustrator way back in the late '80s and offered people precision and control the likes of which they'd never seen. The only problem was that the tool was (and still is) *darn* hard to use. It was met with all kinds of resistance from the artistic community because it didn't conform to the way folks were used to working with digital graphics (not to mention pens and pencils). Instead of dragging to draw a line, when you use the Pen tool, you create *anchor points* and *control handles*, which are collectively referred to as *vector paths* or *Bezier curves* (named for their inventor). The handles aren't actually part of the line; they're little levers you use to control each line segment's shape (see Figure 13-3).

As you learned back in Chapter 2 (page 52), you can edit and resize vectors without losing quality. For example, you can adjust an object's points and paths (see Figure 13-3, bottom) to tweak its shape and then use Free Transform (page 263) to resize, rotate, distort, warp, or flip your object. When it's just right, you can fill the shape with color (page 564), trace its outline with one of the painting tools (page 563), or use it to create a layer mask (page 566).

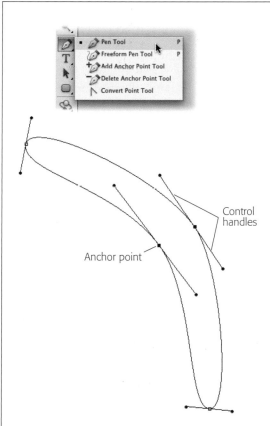

Figure 13-3:

Top: The mighty Pen tool lives near the middle of the Tools panel.

Bottom: This boomerang shape is made from a series of points and paths. The points mark the beginning and end of each line segment; in Photoshop-ese, a line segment is called a path. To change a path's shape, you can drag the points, adjust the control handles, and add or subtract points.

Control handles

Anchor point

With the Pen tool, you have to click twice to create a line: The first click creates the line's starting anchor point, the second click adds the ending anchor point, and Photoshop automatically adds the path in between. It's kind of like digital connect-the-dots: each time you add a new anchor point, a path appears connecting it to the previous point.

You use two different kinds of anchor points to tell Photoshop whether you want a curved or straight path:

- **Smooth.** Use these anchor points when you want your path to curve. If you click to set an anchor point and then drag in any direction—before releasing your mouse button—the Pen tool creates a *control handle* that you can drag to make the next path curve. (The direction you drag is extremely important, as you're about to learn.) When you click to make the second anchor point, Photoshop creates the actual path—a curved line between the two points.

- **Corner.** Use these anchor points when you want to draw a straight line. Simply click *without* dragging to set a point, and you don't get any control handles; instead, the Pen tool creates points connected by straight paths. To draw perfectly horizontal or vertical lines, press and hold the Shift key while you click to set more points. This limits the Pen tool to drawing straight lines at angles that are multiples of 45 degrees (45, 90, and so on), which is great when you want to draw geometric shapes.

Once you have, well, *a handle* on points and handles, you can make any shape you want. In the following pages you'll learn how to create both straight and curved paths.

Drawing Straight Paths

The easiest thing you'll ever do with the Pen tool is create straight paths. Here's how:

1. **Press P to grab the Pen tool.**

 The Pen tool lives above the big T in the Tools panel, and its icon looks like a fountain pen nib.

2. **Choose Paths mode (page 540) in the Options bar.**

 The Paths mode button (shown in Figure 13-2) looks like a fountain pen nib in a box with little square corners. You could use Shape Layers mode for this exercise, but in that mode, Photoshop starts filling your path with color as soon as you start drawing it, which gets visually confusing (and these techniques are hard enough as it is!). So to see only the path itself—with no fill color—work in Paths mode.

3. **Mouse over to your document and click once to create your first anchor point.**

 Photoshop puts a tiny black square where you clicked (Figure 13-4, top).

First click

Second click

Path Selection Tool A
Direct Selection Tool A

Figure 13-4:
*Each time you click, Photoshop adds another anchor point, and connects each point
with a path that forms your shape. If you want to start a new path instead of adding
to an existing one, just tap the Esc key and then click somewhere else in your image.*

4. **Move your cursor to the right of the first anchor point and click to create a
 second anchor point.**

 Photoshop adds a straight line that connects the two points.

5. **Move your cursor down an inch or so and click to create another anchor point.**

 Photoshop continues to connect the points with paths after you place each
 point. If you want to create a perfectly horizontal or vertical line, press and hold
 the Shift key as you click to add another anchor point (you can also use this trick
 to create lines at 45-degree angles).

6. **When you're finished drawing your lines, press the Esc key or ⌘-click (Ctrl-
 click on a PC) elsewhere in your document.**

 The anchor points you created disappear and you see a thin gray line represent-
 ing the path you just drew.

7. **If you want to move an anchor point to change the angle of your line, grab
 the Direct Selection tool by pressing Shift-A until the white arrow appears in
 the Tools panel.**

 The Direct Selection tool it lives in the toolset just below the big T in the Text
 tool (see Figure 13-4, bottom). You'll learn more about this tool when you start
 editing paths on page 557.

8. **Drag one of your line's anchor points.**

 As long as you hold your mouse button down, you can move the point wherever
 you want. When you get it positioned just right, release the mouse button.

Congratulations! You've just drawn your first path with the Pen tool. Enjoy your suc-
cess because it gets a lot harder from here on out.

Drawing Curved Paths

Drawing curves with the Pen tool is more complicated because you have to use the control handles mentioned on page 542 to tell Photoshop how big you want the curve to be and in what direction you want it to go. Here's what you do:

1. **With the Pen tool selected, click your document to set your first anchor point and—without letting go of your mouse button—drag to the left or right to make the point's control handles appear.**

 The control handles pop out from the point you created, and one of the handles sticks to your cursor. These handles indicate the direction your path will take; if you drag to the right, your path curves right when you add your next anchor point; if you drag left, your path curves left. For this exercise, drag upward and to the right about half an inch, and then release your mouse button (see Figure 13-5, top).

Note: It's next to *impossible* to get a sense of how the control handles work just by reading about them. So if you're near a computer, turn it on and fire up Photoshop so you can follow along. Better yet, visit this book's Missing CD page at *www.missingmanuals.com/cds* and download the file *Curve.tif* so you can practice drawing the curves shown in Figure 13-5.

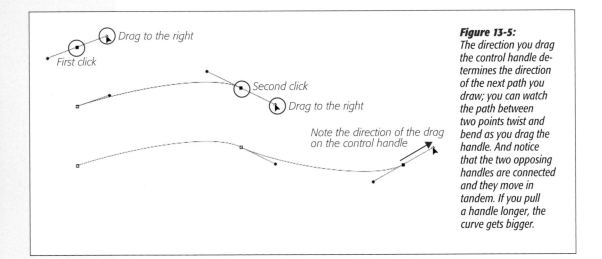

Figure 13-5:
The direction you drag the control handle determines the direction of the next path you draw; you can watch the path between two points twist and bend as you drag the handle. And notice that the two opposing handles are connected and they move in tandem. If you pull a handle longer, the curve gets bigger.

2. **About two inches to the right of the first point, click to add a second point and, while holding your mouse button down, drag the new handle downward and to the right half an inch, and then release your mouse button.**

 In step 1, you pulled the first handle upward and the curve obediently bent upward. By dragging this second control handle downward, your next curve heads downward (see Figure 13-5, middle).

3. **Create a third point by clicking and dragging upward and to the right.**

 The path that appears when you click to add this third point curves downward because you pulled the control handle downward in the previous step. Drag the third point's control handle upward and slightly to the right to make the curve shown in Figure 13-5, bottom.

4. **When you're finished, press the Esc key to let Photoshop know you're done drawing your path.**

 You can also ⌘-click (Ctrl-click on a PC) elsewhere in your document.

You've just drawn your first curved path! With practice, you'll get the hang of using the control handles to determine the direction and size of the curves. And as you may have guessed, the drawing process gets even more complicated from here.

Converting Anchor Points

As you learned on page 542, there are two kinds of anchor points in Photoshop: smooth and corner. To draw complicated paths, you need to know how to switch between these types so you can create curves within a single path that go the same direction. (Take a peek ahead at Figure 13-7, bottom, to see what this looks like.) To do that, you start by creating a series of curves, and then convert some of the smooth points to corner points. Here's how:

1. **With the Pen tool active, click and hold with your mouse button to create your first point, and then drag the control handle up and away from the anchor point to set the direction of your next curve (Figure 13-6, top left).**

 Release your mouse button when you're ready to make your next anchor point.

Note: To practice drawing these paths yourself, visit this book's Missing CD page at *www.missingmanuals. com/cds* and download the file *ComboPath.tif*.

2. **Move your cursor an inch or so to the right, and then click to set your second point to the right of the first and drag downward (Figure 13-6, top right).**

 When your path has the curve you want, release your mouse button.

3. **Move your cursor another inch to the right and then click and drag downward to create a third point (Figure 13-6, middle).**

4. **Hop right another inch and then click and drag downward once again to create a fourth point (Figure 13-6, bottom).**

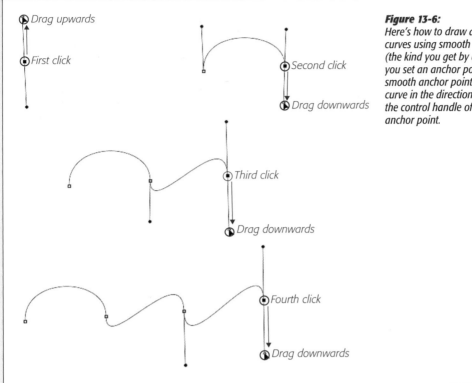

Drag upwards

First click

Second click

Drag downwards

Third click

Drag downwards

Fourth click

Drag downwards

Figure 13-6:
Here's how to draw a series of curves using smooth anchor points (the kind you get by dragging as you set an anchor point). With smooth anchor points, your paths curve in the direction you dragged the control handle of the preceding anchor point.

5. **Head over to the Tools panel and grab the Convert Anchor Point tool (Figure 13-3).**

 The Convert Anchor Point tool is tucked away inside the Pen toolset (its icon looks like an upside-down V). Just click and hold on the Pen tool to see the rest of the toolset, and then give it a click (for unknown reasons, the Shift-P trick doesn't work for the Insert, Delete, or Convert Anchor Point tools).

6. **Drag the bottom control handle that's attached to your third anchor point (see Figure 13-7, top) up so it's close to the opposite control handle on the same anchor point.**

 The Convert Anchor Point tool "breaks" the bottom half of the control handle away from the top half so it can move all by itself. This nifty little maneuver converts the anchor point from a smooth point to a corner point, and changes your path from a smooth curve to a sharp angle. Once you break control handles apart, they behave much like the hands of a clock and you can move them independently to adjust the angle and curve of your path.

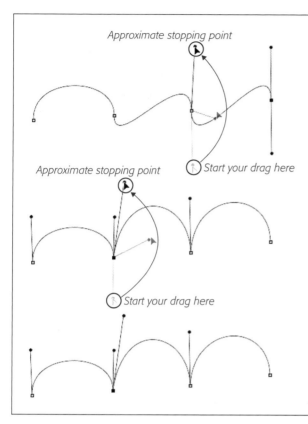

Approximate stopping point

Approximate stopping point Start your drag here

Start your drag here

Figure 13-7:
Once you convert smooth anchor points into corner points, you can adjust each control handle separately to create a series of curves that bend in the same direction, as shown here.

If you move both parts of your control handle so they're on top of each other, you only see one handle (like the third anchor point shown at the middle and bottom), just as you only see one hand of a clock at noon, when the hour and minute hands overlap. If that happens, grab the Direct Selection tool and drag one of the handles out of the way so you can see them both.

7. **Use the Direct Selection tool to grab your path's second point from the left.**

 Unfortunately, you can't select points with the Convert Anchor Point tool, so to see the second anchor point's control handles, you have to use the Direct Selection tool. You can use Photoshop's spring-loaded tools feature to temporarily grab the Direct Selection tool: Just press and hold A, click the point, and then release the A key. As soon as you select the anchor point, its control handles appear.

Tip: Holding down the ⌘ key (Ctrl on a PC) changes the Convert Anchor Point tool to the Direct Selection tool temporarily, saving you a trip to the Tools panel.

8. **Grab the Convert Anchor Point tool (or release the A key), click the bottom control handle that just appeared, and drag it upward next to its partner (see Figure 13-7, middle).**

 When you're finished, you should have a series of curves that all bend in the same direction (see Figure 13-7, bottom).

Drawing with a French Curve

This Bezier curve business is darn tough to wrap your brain around. But if you've taken any kind of art class—even if it was as far back as middle school—there's a real-world counterpart that makes the curved paths you draw with the Pen tool a little easier to understand.

Drawing with Photoshop's Pen tool is similar to using a brush, pencil, or art knife with a set of *French curves*—plastic stencils that folks use as guides to create flowing, curved lines. French curves have some of the same limitations as the Pen tool. For example, the main challenge when using French curves is picking the stencil that will give you the longest sweep (or arc) possible. You often have to switch stencils or change its position to follow a particular sweep.

With the Pen tool, you can take a similar approach: Try creating the longest possible distance between two points to keep your paths as simple—that is, with as few anchor points—as possible. The more points in your path, the longer Photoshop takes to draw the path, which is especially important when you want to turn the path into a *clipping path* (see page 568) that you can use in a page-layout program like Adobe InDesign or QuarkXPress. Those other programs have to translate and draw your path, so keeping it as simple as possible helps you avoid problems.

Path Drawing Tips

Here are some things to keep in mind when you're drawing curved paths with the Pen tool:

- **Exaggerating curves**. If you want to create an exaggerated curve or one that curves back on itself, you need to drag one side of the control handle in the opposite direction that you drew the path (see Figure 13-8, left). Also, keep in mind that it's the *length* of the handle that determines the height or depth of the curve. (You lengthen a control handle by dragging it farther in any direction.) Figure 13-8, right, shows the affect of different length handles on two similar paths.

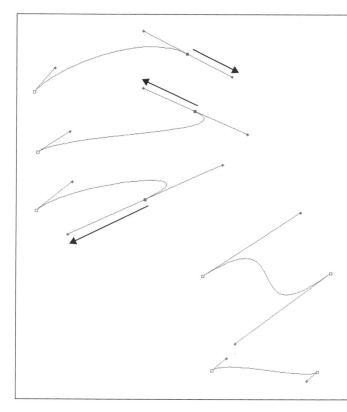

Figure 13-8:
Top: Here's what happens when you drag the control handles in different directions. In all of these images, the path was drawn from left to right. The top image shows what happens when you drag the control handle in the same direction as the path is traveling (left to right), the middle image shows what happens when you drag the handle up and to the left, and the bottom image shows what happens when you drag the control handle down and to the left.

Bottom: The farther you drag control handles, the longer they get and the more curved your path becomes. In the upper image, long control handles make for a really deep curve. In the lower image, short controls handles result in a shallow curve.

- **Closing a path**. The paths you've seen so far have all been left open, meaning the starting and ending anchor points aren't connected. If your goal is to draw an arc, you *want* to leave your path open. To make an open path, after you create the last anchor point, just press the Esc key, ⌘-click (Ctrl-click on a PC) somewhere else in your document, or select another tool from the Tools panel. But if you want to fill your path with color, you need to close it to create a *closed shape*, where the path's two ends are connected. To create a closed path, add your last anchor point and then hover your cursor over the path's starting anchor point until a tiny circle that looks like a degree symbol appears next to your cursor. Once you see the tiny circle, click the starting anchor point and Photoshop adds a straight path that joins the two points and closes the shape.

- **Adding control handles**. If you want to add a control handle to an anchor point that doesn't have one—like the starting or ending anchor point of a straight line—grab the Pen tool and Option-click (Alt-click on a PC) the anchor point. You'll see a tiny, upside-down V (called a *caret*) appear next to your cursor. Keep holding your mouse button down and drag outward to create a *new* control handle that you can adjust to any angle you want, as shown in Figure 13-9. (If you Option-click (Alt-click) an anchor point that already has handles, you'll just grab that point's handles instead of creating a new one.)

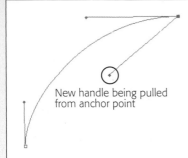

Figure 13-9:
If you need to change the direction of a curve, you have to create a control handle, as shown here. When you drag the new control handle away from the path, you get a curve that heads in the direction you're dragging. But if you Option-click (Alt-click on a PC) the control handle and drag toward the path, you'll create a corner point that changes the direction of the curve. This gives you independent control over each of the point's control handles, as you learned on page 547.

New handle being pulled from anchor point

Tip: You can adjust the length of a path's control handles by ⌘-dragging (Alt-dragging on a PC) the path. This trick changes the depth of the curve as you drag. If the anchor point at the other end of the path segment doesn't have control handles, you'll end up with an angled corner at the far end of the path segment. You can move anchor points that don't have control handles by ⌘-dragging (Ctrl-dragging on a PC). These tricks make it easy to edit your paths while you're drawing them.

Saving Paths

After all your hard work creating a path, it's a good idea to save it so you can edit it and use it later. Or you might want to use the path with other objects in your image, like when you're using a path as a vector mask, as explained on page 572. Since paths are vector-based, they don't take up much memory and won't increase your file size hardly at all, so feel free to save as many paths as you want.

As you're drawing a path, Photoshop stores it in the Paths panel as a temporary *work path* (see Figure 13-10) and displays it in your document as a thin gray line. If you want to hide the gray line—so you don't accidentally edit or move it—just press Return (Enter on a PC). To create multiple paths in a single document, you have to save each path before starting on the next one, or Photoshop adds the subsequent path to the previous one. To work with your paths, open the Paths panel by choosing Window→Paths (see Figure 13-10).

Note: Miraculously, Photoshop keeps an unsaved work path in your document even if you close the file and don't open it for a year. The catch is you can only have *one* unsaved work path in a document at a time. If you want to add to that work path, simply select it in your Paths panel and start drawing. Don't forget to select it, because if you start drawing *without* selecting the work path first, your original path goes the way of the Dodo. To be safe, you're better off saving a path if you think you'll want to reuse it.

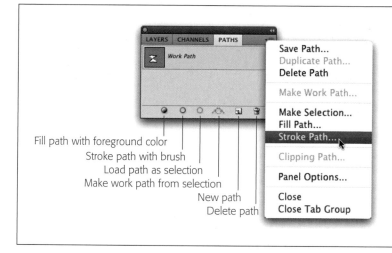

Fill path with foreground color
Stroke path with brush
Load path as selection
Make work path from selection
New path
Delete path

Figure 13-10:
The Paths panel works pretty much like any other panel. Photoshop highlights the current path in the panel. If you want to delete a path, select it and then press Delete (Backspace on a PC) or drag it onto the trash can at the bottom of the panel. As with layers, you can change your paths' stacking order, double-click to rename them, and so on. Changing the stacking order is a good way to keep related paths together; unfortunately, you can't group paths to organize them like you can with layers (see page 105).

Photoshop gives you several ways to save a path:

- **Choose Shape Layers mode** (page 540) from the Options bar before you start drawing and Photoshop stores your path on its own layer. Don't forget to name the layer so you can keep track of your different paths.

- **Save the path before you draw it** by clicking the "Create new path" button at the bottom of the Paths panel (it looks like a piece of paper with a folded corner). Photoshop names the currently empty placeholder *Path 1*, but you can double-click its name later to change it.

- **Save the path after you draw it** by choosing Save Path from the Paths panel's menu.

- **Save the path as a custom shape** (page 556) that you can access through the Options bar's Custom Shape menu. You can save as many paths as you want (they won't bloat the size of your file), so go ahead and have a path-saving party so you can reuse them again later.

- **Save the path as a clipping path** (see page 568) that you can use to *isolate* an object (hide its background) in a page-layout program like QuarkXpress or In-Design. If you plan on working with your image in older versions of these programs—which don't understand layered Photoshop documents—this method is your best bet.

Drawing with the Shape Tools

Photoshop has a pretty good selection of built-in, vector-based shapes, which are perfect for adding artistic embellishments or using as vector masks (discussed later in this chapter). They include a rectangle, a rounded rectangle (great for making round-edged selections; see page 147), an ellipse, a polygon, a line, and a gazillion

custom shapes (page 556). These preset goodies are huge timesavers because they keep you from having to draw something that already exists. And since these preset shapes are made from paths, you can also use the techniques described later in this chapter to morph them into anything you want.

The shape tools work in all three drawing modes (see page 539). This section focuses on the first mode: Shape Layers. Just like any other kind of layer, you can stroke, fill, and add layer styles (page 128) to Shape layers, as well as load them as selections.

UP TO SPEED

Drawing with the Freeform Pen Tool

Lurking in the Pen toolset is the *Freeform Pen* tool, which lets you draw simply by dragging (kind of like how you draw with a real pen) instead of clicking to add points and tugging on control handles. Once you've used it to draw a path, you can edit that path using any of the techniques discussed in this chapter. If you're comfortable working with a graphics tablet (see the box on page 520), the Freeform Pen tool may be the way to go. For precise shapes, however, you're probably better off sticking with the Pen tool.

When using the Freeform Pen tool, you can turn on the Magnetic checkbox in the Options bar to switch to *Magnetic Pen* mode, which lets you create a path by clicking and then moving your cursor around the edge of the shape you want to select, trace, or mask (like you do with the Magnetic Lasso tool, page 164). (When you turn on the Magnetic checkbox, Photoshop puts a tiny horseshoe magnet next to your cursor.) The downside is that this tool sometimes produces more points than you can shake a stick at, which means you have to go back and do some point pruning as explained in a moment.

To change the Magnetic Pen tool's settings, in the Options bar, click the down-pointing triangle to the left of the Magnetic checkbox. The resulting menu lets you change the following settings:

- **Width** determines how close to an edge your cursor has to be before Photoshop selects the edge, like the Magic Wand's tolerance setting (page 152). You can enter a value from 1 to 256 pixels.
- **Contrast** tells the tool how much contrast there has to be between pixels before it considers an area an

edge and plunks down points. You can enter a percentage between 1 and 100; use a higher value for objects that don't have much contrast.

- **Frequency** lets you control how many points the Magnetic Pen tool adds. Enter a value between 0 and 100; the higher the number, the more points it adds.
- **Pen pressure.** If you're using a graphics tablet and pressure-sensitive stylus, turn on this checkbox.

When you're ready to start drawing, click once to set the starting point and then simply trace the outline of the object with your cursor. If the tool starts to go astray and adds points in the wrong spot, just click to add a point of your own. If you want to delete a point the tool created, hover above the point and press Delete (Backspace on a PC). When you've got an outline around your shape, move your cursor over your starting point (a little circle appears next to your cursor) and then click once. That's it—the point's gone!

Let's say you want to create a starburst shape to draw a viewer's attention to some important text in your ad (Figure 13-11); there's no sense drawing the starburst from scratch because Photoshop comes with one. And since the shapes are all vector-based, they're resizable, rotatable, and colorable. If you need to make the shape bigger, for example, just select the Shape layer, press ⌘-T (Ctrl+T on a PC) to summon Free Transform, and then use the little handles to make it as big as you want with no fear of quality loss.

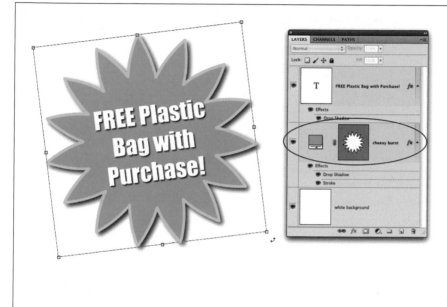

Figure 13-11:
You can save time and energy by using Photoshop's built-in shapes. Unless you tell the program otherwise (page 540), it puts each shape on its own Shape layer (circled). You can resize and rotate the shape using Free Transform (both the Shape and Type layers are selected here so they'll rotate together). You can change the shape's color by double-clicking its layer thumbnail, or gussy it up even more by adding a layer style (see page 128).

Using the Shape Tools

The shape tools couldn't be easier to use: If you can move your mouse diagonally, you can draw a shape. Each shape (rectangle, rounded rectangle, and so on) has its own Options bar settings; Figure 13-12 shows the Line tool, which Photoshop considers a shape. These settings let you create shapes that are certain sizes or have certain proportions, specify the number of sides in a polygon, indent the sides to make a star, and so on.

Click to open
shape options

New shape layer
Add
Subtract
Intersect
Exclude

Apply a Style
to shape

Shape fill color

Figure 13-12:
One of the most commonly used shapes is the Line tool. When you select it, you can use its options (shown here) to add arrowheads to either end of the line—or both ends.

Tip: To draw a symmetrical shape (like a perfect square or circle), press and hold the Shift key as you drag with a shape tool and Photoshop keeps the shape's sides the same size. To draw a shape from the center out, press and hold Option (Alt on a PC) as you drag.

All the shape tools work pretty much the same way. Here's how to use the Line tool:

1. **Grab the Line tool from the Tools panel.**

 The Line tool lives in the shape toolset near the bottom of the Tools panel. If you've never used the shape tools before, the Rectangle tool is probably on top. Click it and hold down your mouse button to choose the Line tool from the resulting fly-out menu, or cycle through the various shape tools by pressing Shift-U repeatedly.

Note: Don't forget to set your drawing mode to Shape Layers in the Options bar *before* you draw with the Line tool. If you've used any other drawing mode (page 539), the Options bar will still be set to that previous mode.

2. **In the Options bar, open the shape options menu and add an arrowhead.**

 Click the down-pointing triangle that's circled in Figure 13-12 and turn on the Start or End checkbox (or both). If you like, specify a size for the arrowhead(s) by entering percentages in the Width and Length fields (the factory setting of 500% times the line weight usually works fine). To curve the sides of your arrowhead inward, enter a percentage in the Concavity field.

3. **Enter a width for the line.**

 In the Options bar's Weight field, enter a width for your line in pixels.

4. **Pick a line color.**

 Click the Color box at the far right of the Options bar to summon the Color Picker (page 493); choose a color and then click OK. If you don't select a color, Photoshop uses your foreground color (page 24).

5. **Mouse over to your document and click where you want the line to start, and then drag and release your mouse button where you want the line to end.**

 Photoshop creates a new Shape layer in your Layers panel that has a large colored box and a mask area. If your line isn't quite at the angle you wanted or it's not long enough, summon Free Transform by pressing ⌘-T (Ctrl+T on a PC) and then use the resizing handles to rotate the line or make it longer (be careful, though: Your arrowhead might get squished or stretched in the process).

6. **Just for fun, change the line's color by double-clicking the Shape layer's thumbnail in your Layers panel and choosing a different color from the resulting Color Picker.**

 Click OK when you're finished and your line turns the new color.

Note: If you don't like how your line turned out, you don't have to start over—just grab the Direct Selection tool (page 558) and move the line's anchor points until you get the look you want.

For practice, you can try using the Rectangle or Ellipse tool the same way. And remember, once you've created a shape you can modify it in lots of ways:

- Grab the Direct Selection tool and move the shape's anchor points or alter the points' control handles.
- Use the Pen tool to add or subtract points. You'll learn more about editing paths on page 557.
- Change the shape's color by double-clicking the Shape layer's thumbnail.
- Use Free Transform to resize, distort, or rotate the shape (page 263).
- Use layer styles to add special effects to your Shape layer (page 128).

You can do all kinds of wonderful things with Shape layers, so it's worth taking the time to experiment with the shape tools.

Drawing Multiple Shapes on One Layer

Each time you draw with a shape tool in Shape Layers mode (page 540), Photoshop adds a new Shape layer to your document. If you want to keep drawing on the *same* Shape layer instead, use the Options bar's Add, Subtract, Intersect, and Exclude buttons (see Figure 13-12). Flip ahead to page 560 for details on how these options work.

Tip: You can move shapes independently even if they live on the same layer. To do that, grab the Path Selection tool from the Tools panel (the black arrow—see page 543), click to select the shape, and then drag it wherever you want. Or instead of dragging, use the arrow keys on your keyboard to nudge it one pixel at a time (add the Shift key to nudge it *10* pixels at a time).

Using Custom Shapes

As soon as the menu opens, click the little right-facing arrow circled in Figure 13-13. In the resulting menu, choose All. A dialog box pops up asking if you want to replace the current shapes; click OK. Now you can see a preview of *all* the built-in shapes right there in the Custom Shape Preset picker (why Photoshop doesn't load these shapes automatically is a mystery). You can also use this menu to change the size of the previews or display them as a text-only list.

Click to open Custom Shape Preset picker

Figure 13-13:
If you create a shape with the Pen tool, you can save it by choosing Save Shapes from the menu shown here (click the circled button to open it). Give your shape a name and it appears in your list of presets. You can also do the same thing by creating a shape, selecting its layer in the Layers panel, and then choosing Edit→Define Custom Shapes.

Tip: To find the really useful shapes that come with Photoshop, you have to do a bit of foraging. Grab the Custom Shape tool (which looks vaguely like a starfish) from the Tools panel—it's in the same toolset as all the other shape tools. Then head up to the Options bar and open the Custom Shape picker by clicking the down-pointing triangle shown in Figure 13-13. Photoshop CS5 comes packed with even more Custom Shapes than ever before. The new categories include Artistic Textures, Film, Grime Vector Pack, and LightBulb. Whee!

You draw with these shapes just as you do with the Line tool (page 554) except that instead of dragging horizontally or vertically, drag *diagonally* to create the shape. You can also press and hold the Shift key to make the shape perfectly proportional so it looks like the little icon you selected in the shape presets menu. You can modify the shape by filling it with color, applying layer styles, and customizing them by using the Direct Selection tool to tweak their anchor points and control handles.

The *real* power of using custom shapes, however, lies in defining your own, which can save you tons of time. For example, if you have a piece of vector art that you need to use over and over, you can save it as a custom shape. Choose File→Place to import the art into Photoshop (page 316), and then load it as a selection by ⌘-clicking (Ctrl-clicking on a PC) its layer thumbnail. Next, save it as a path by opening the Paths panel and choosing Make Work Path from the Paths panel's menu. Finally, choose Edit→Define Custom Shape and, in the resulting dialog box, give your new shape a name and then press OK.

From that point on, your custom shape appears in the Options bar's shapes menu any time you're using the Custom Shape tool. To draw the shape you added, just select it from the shapes menu and then drag in your document. The only drawback is that the artwork can only be one solid color because Shape layers can only contain one color.

Editing Paths

All this talk about setting points, dragging handles, and creating shapes can sound a bit intimidating. But it's important to remember that the Pen and shape tools are very forgiving—if you don't get your path right the first time, you can always edit it by adding, deleting, and repositioning points and dragging their control handles. The trick lies in knowing *which* tool to use to make the changes you want. This section explains all your options.

Adding, Deleting, and Converting Points

At first, you may have a wee bit of trouble drawing paths that look exactly like you want (surprise!). But don't stress; just add more points, move them around, and adjust the curves until you get the shape you want. You'll need fewer and fewer points as you get more comfortable using the vector drawing tools. And if you've had yourself a point party, you can delete the extra ones.

Adding and deleting points is really easy since the Pen tool figures out what you want to do depending upon what your cursor is hovering over. For example:

- **To add a point**, grab the Add Anchor Point tool (shown on page 541) from the pen toolset (it looks like the Pen tool's icon with a plus sign next to it). When you see a tiny plus sign appear next to your cursor, you can click an existing path to create a new point. You can also just grab the Pen tool, hover your cursor over

an existing path (but avoid hovering over any anchor points) and your cursor turns into the Add Anchor Point tool automatically. Click anywhere on the path to set new anchor points.

- **To delete a point**, open the pen toolset and grab the Delete Anchor Point tool (it looks like the Pen tool but with a tiny minus sign). Or grab the Pen tool and then place your cursor over an existing point, and a tiny minus sign appears next to your cursor to let you know that the Delete Anchor Point tool (shown on page 541) is active. Either way, click once to get rid of that point.

- **To convert a point from a smooth point to a corner point (or vice versa)**, use the Convert Anchor Point tool nested in the pen toolset (see the exercise on page 546). To quickly change to this tool while you're using the Pen tool, press the Option key (Alt on a PC) and place your cursor over an anchor point. (Photoshop puts a tiny, upside-down V next to your cursor to let you know that it's swapped to the Convert Anchor Point tool.) Click to make Photoshop change the anchor point from one type the other.

- **To add a segment to a path**, put your cursor over the ending anchor point of an open path (shown on page 546) and then click or simply drag to continue drawing. (A tiny forward slash appears next to your cursor.)

- **To join the ends of two open path segments**, grab the Pen tool, click one segment's endpoint and then hover your cursor over one of the other segment's endpoints. When a tiny circle with a line on either side of it appears next to your cursor (it looks almost like a chain link), click to connect the two.

Selecting and Moving Paths

Because Photoshop's paths are made from multiple line segments or individual shapes, you can select, move, reshape, copy, or delete parts of your path—or the whole thing—using the Direct Selection tool and the Path Selection tool, which share a toolset near the middle of the Tools panel (both their icons are arrows). To select them, click the arrow icon in the Tools panel or press A (or Shift-A to switch between them).

The Direct Selection tool turns your cursor into a *white* arrow and lets you select specific points in a path or individual line segments and apply changes only to them, leaving the rest of the path alone (see Figure 13-14, bottom left). The Path Selection tool turns your cursor into a *black* arrow and lets you select a whole path (Figure 13-14, bottom right) so you can do things like move, resize, or rotate the whole thing.

Figure 13-14:
Top: To move points and paths around, grab them with the Direct Selection and Path Selection tools, respectively.

Bottom Left: Use the Direct Selection tool to choose specific points. You can tell which points are selected because they turn black (here, two points selected).

Bottom Right: Use the Path Selection tool to select a whole path (notice how all the points are black).

Tip: You can make the Direct Selection tool act like the *Path* Selection tool by pressing Option (Alt on a PC). You can also select multiple points by drawing a box around them by dragging with either the Direct Selection or Path Selection tool.

Once you've selected a path or part of a path, you can:

- **Copy it** by Option-dragging (Alt-dragging on a PC) it to another location. This is handy if you're making a pattern or want to add a bunch of objects to your document. Add the Shift key to copy in a straight line (the copies are all part of the same work path or saved path).

- **Delete a segment** by pressing Delete (Backspace on a PC). If you've got a point selected, you can delete the whole path by pressing Delete (Backspace) twice.

- **Align it** using Photoshop's alignment tools (page 97). Use the Path Selection tool to select two or more paths and Photoshop displays alignment tools in the Options bar.

- **Combine it** with another path by selecting the paths and then clicking the Options bar's Combine button.

- **Resize it.** Turn on the Options bar's Show Bounding Box checkbox and Photoshop adds a bounding box around the path you selected, complete with resizing handles. Or summon Free Transform by pressing ⌘-T (Ctrl+T on a PC).

- **Change its intersect mode**. In the Options bar between the Show Bounding Box checkbox and the Combine button are four buttons that let you intersect overlapping shapes (closed paths) in a variety of ways. These modes, which are described in the next section, let you combine your paths to make new shapes.

- **Change it** (fill it with color or add a stroke to it, for example) without affecting the whole path. As shown in Figure 13-15, by selecting certain segments, you can fill them with color or give them a stroke (you'll learn how on page 564 and page 562, respectively).

Figure 13-15:
Top: Here's a close-up of the painting shown in Figure 13-1, bottom, with certain paths selected (notice the black anchor points around the selected shapes).

Bottom: By selecting specific paths, you tell Photoshop to apply any changes you make only to those paths. Here, the selected paths were filled with dark blue.

Making Paths Intersect

You can use the Options bar to change the *intersect mode* of two or more overlapping paths. These modes let you combine overlapping shapes in a variety of ways. Here are your options:

- **Add to shape area.** Use this mode to add one shape to another. The combined shapes merge into one, and Photoshop deletes the paths in the shapes' overlapping areas (see Figure 13-16). Its button looks like two overlapping squares that blend together in the middle.

Figure 13-16:
Left: The first piece in this flower was drawn in Shape Layers mode (page 540), but the rest of the parts were drawn in "Add to shape area" mode so that everything stayed on one layer. Drawing all your shapes on a single layer lets you combine the parts together into a single shape.

Right: Use the Path Selection tool to grab all the shapes in the flower, and then click the Options bar's Combine button. Photoshop joins the selected paths together into a single shape.

- **Subtract from shape area.** This mode cuts out the area where two shapes overlap (see Figure 13-17). Its button looks like a white square overlapping a gray square.

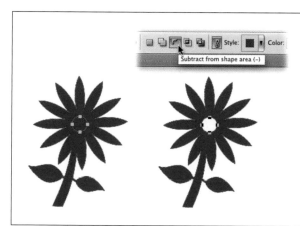

Figure 13-17:
Left: While you're in "Add shape to area" mode, draw a circle in the flower's center.

Right: With the new circle selected, head up to the Options bar and click "Subtract from shape area" button. When you do, Photoshop knocks the center out of the flower.

- **Intersect shape areas.** Use this mode to get rid of the areas of your shapes that *don't* overlap, as shown in Figure 13-18. Its button looks like two hollow squares with a dark area where they overlap.

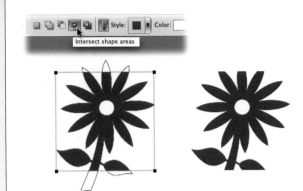

Figure 13-18:
Left: To hide the top and bottom of the flower, grab the Pen tool, and then pop up to the Options bar and click the "Intersect shape area" button. Next, grab the Rectangle tool and drag over the flower to hide everything that falls outside of the square's edges.

Right: Want to see your work without lines and handles? You can hide the shape outlines and handles by tapping the Return key (Enter on a PC); press Return (Enter) again to bring 'em back.

- **Exclude overlapping shape areas.** This mode hides the areas where your shapes overlap (see Figure 13-19). Its button looks like two overlapping grey squares that are transparent where they intersect.

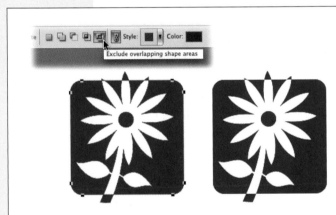

Figure 13-19:
Left: You can hide the whole flower except its tips by excluding overlapping areas. Start by trotting up to the Options bar and clicking the "Exclude overlapping shape areas" button. Then grab the Rounded Rectangle tool and drag over the flower to hide the parts that overlap your rectangle. (Since the circle in the center of the flower was already hidden, it flips back to its original color.)

Right: Press Return (Enter on a PC) to hide your shape outlines so you can see what your finished piece looks like.

Adding a Stroke to a Path

After you create a path with the Pen tool, you can add a *stroke* (outline) to it using any of the painting tools. This is handy when you're trying to draw a long, smooth, flowing line like the one in Figure 13-20 (right). Try drawing that Z freehand using the Brush tool—it's *really* hard to create such a perfect Z shape. But with the Pen tool, you can draw the path first, edit it (if necessary) using the techniques described in the previous sections, and *then* add the fancy red stroke using your favorite brush (see Chapter 12 for more on brushes).

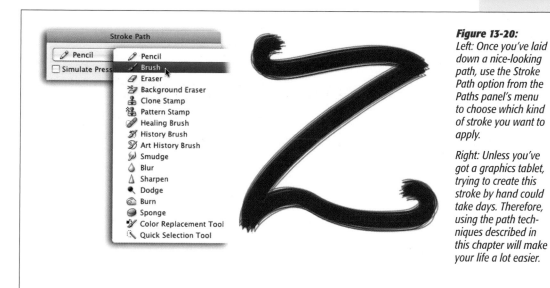

Figure 13-20:
Left: Once you've laid down a nice-looking path, use the Stroke Path option from the Paths panel's menu to choose which kind of stroke you want to apply.

Right: Unless you've got a graphics tablet, trying to create this stroke by hand could take days. Therefore, using the path techniques described in this chapter will make your life a lot easier.

Note: When you add color to a path with either a fill or stroke, the color appears on the current layer. So it's a good idea to take a peek in your Layers panel and make sure you're on the right layer first.

Once you've created a path, open your Layers panel and add a new layer by clicking the "Create a new layer" button at the bottom of the panel. With the new layer selected, you can add a stroke to a path in a couple of ways:

- **Choose Stroke Path from the Paths panel's menu.** In the resulting dialog box (Figure 13-20, left), pick the tool you want to use for the stroke. The drawback to this method is that the stroke picks up whatever settings you last applied to that tool (you don't get a chance to change them). For example, if you set the Brush tool to a certain blend mode or lowered its opacity, your stroke uses that blend mode or opacity.

Tip: You can open the Stroke Path dialog box by Option-clicking (Alt-clicking on a PC) the Stroke Path button at the bottom of your Paths panel (it looks like a hollow circle), or by Option-dragging (Alt-dragging) the path in the Paths panel onto the Stroke Path button.

- **Activate the tool you want to use to stroke the path.** Adjust its settings in the Options bar and then click the Stroke Path button at the bottom of your Paths panel. This method helps you avoid having to undo the stroke because the tool's settings are all screwy.

Filling a Path

Before you fill a path, take a moment to consider whether it's an open or closed path. As described on page 549, the starting and ending anchor points of an open path don't meet. Since you can't really fill a shape that's not closed, if you try to fill an open shape, Photoshop *imagines* a straight line that connects the starting point to the ending point, and then fills all the closed areas created by that imaginary line. This can lead to some rather strange results, as shown in Figure 13-21, top. When you fill a closed path—one where the starting and ending points *do* meet—Photoshop fills the whole shape just like you'd expect (see Figure 13-21, bottom).

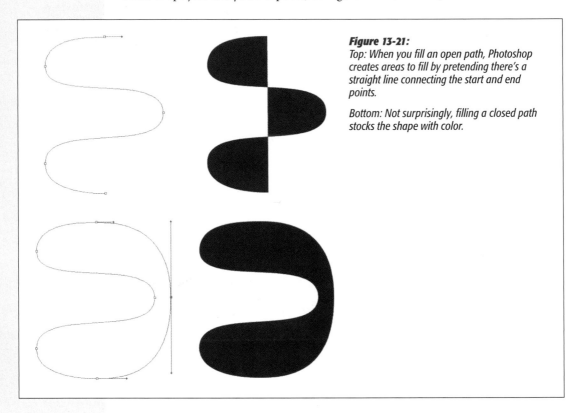

Figure 13-21:
Top: When you fill an open path, Photoshop creates areas to fill by pretending there's a straight line connecting the start and end points.

Bottom: Not surprisingly, filling a closed path stocks the shape with color.

After you draw a path, create a new layer for the fill color, and then choose from the following fill methods:

- **Choose Fill Path from the Paths panel's menu.** Photoshop opens the Fill Path dialog box, where you can choose what you want to fill the shape with (see Figure 13-22). This is handy if you want to use a pattern or a specific blend mode (page 289).

- **Click the "Fill path with foreground color" button** at the bottom left of the Paths panel (it looks like a gray circle) and Photoshop uses your foreground color (page 24) as the fill color (you don't get a dialog box with this method).

Selecting the path in the Paths panel and then dragging it onto this button does the same thing.

- **Option-click (Alt-click on a PC) the "Fill path with foreground color" button** to summon the Fill Path dialog box (Figure 13-22). You can do the same thing by selecting the path in your Paths panel and then Option-dragging (Alt-dragging) it onto this button.

Figure 13-22:
You can use this dialog box to tell Photoshop exactly what you want to fill the path with and change the fill's blend mode or feather its edges. To open the Color Picker, choose Color from the Use pop-up menu.

The Fill Path dialog box (Figure 13-22) is divided into three sections:

- **Contents.** The Use pop-up menu lets you decide whether to fill the path with your foreground or background color, Content-Aware (new in CS5—see page 181) or a pattern (you can pick a pattern from the Custom Pattern pop-up menu). Choose Color to summon the Color Picker so you can choose any color you want. If you choose History, Photoshop fills the path with the currently selected History state or a snapshot of the image in a previously saved state (see page 27).

- **Blending.** Use the Mode pop-up menu to change the fill's blend mode (see page 289), and the Opacity field to change the fill's opacity. Turn on the Preserve Transparency checkbox if you're filling a path on a layer that's partially transparent so Photoshop only fills the part that's *not* transparent.

- **Rendering.** If you want to make the fill's edges soft and slightly transparent, enter a number in the Feather Radius field (this setting works like the Refine Edge dialog box's Feather slider; see page 170). The higher the number, the softer the edge. Leave the Anti-alias checkbox turned on to make Photoshop smooth the fill's edges by adding a slight blur; if you turn it off, your fill's edges will be hard and look blocky in curved areas.

Making Selections and Masks with Paths

As you learned in Chapter 4, Photoshop is loaded with selection tools. However, when you're trying to select something *really* detailed, like the column section shown in Figure 13-23, none of the regular selection tools can help. That's because the shape is complex and there's very little contrast between the area being selected and the surrounding pixels.

Luckily, you can use the Pen tool to draw a path that follows the contours of any shape you want to select (Figure 13-23, bottom), no matter how intricate it is. The beauty of this method is that the Pen tool is so forgiving—if you don't get it right the first time, you can edit the path. When you've got the path in place, you can load it as a selection and proceed merrily on your way, doing whatever you want with the selected object.

Figure 13-23:
The lack of contrast in this image makes it nearly impossible to select just part of the façade (top). But with the Pen tool, you can draw a path around the section you want by hand (bottom).

To load a path as a selection, first create the path with the Pen tool and then choose one of these methods:

- **Choose Make Selection from the Paths panel's menu.** This summons the dialog box shown in Figure 13-24, where you can adjust settings like the selection's feather amount and whether you want Photoshop to apply anti-aliasing. In the Operation section, you can choose to create a new selection, add to or subtract from an existing one, or create a selection from the intersection of this one and an existing one.

Figure 13-24:
The Make Selection dialog box lets you feather the selection, apply anti-aliasing to its edges, or combine it with an existing selection (discussed on page 568).

- **Click the "Load path as a selection" button** at the bottom of the Paths panel (it looks like a tiny dotted circle). This method lets you bypass the Make Selection dialog box. Photoshop applies the settings you used the last time you used the Make Selection dialog box (like the feather radius). If you haven't yet used that dialog box, Photoshop sets the feather radius to zero, leaves anti-aliasing turned on, and, if a selection tool is active, creates a brand-new selection.

- **Option-click (Alt-click on a PC) the "Load path as a selection" button** at the bottom of the Paths panel. When you do, Photoshop opens the Make Selection dialog box.

- **Drag the path's thumbnail in the Paths panel onto the "Load path as a selection" button**. This method bypasses the Make Selection dialog box and applies the settings you used last time.

- **⌘-click (Ctrl-click) the path's thumbnail in the Paths panel.** You won't get a Make Selection dialog box this way, either; the program simply applies the last settings you used.

Tip: If you're a fan of keyboard shortcuts, you can load your path as a *new* selection by pressing ⌘-Return (Ctrl-Enter on a PC); add your path to an *existing* selection by pressing ⌘-Shift-Return (Ctrl+Shift+Enter); *subtract* your path from an existing selection by pressing ⌘-Option-Return (Ctrl+Alt+Enter); or *intersect* your path with an existing selection by pressing ⌘-Shift-Option-Return (Ctrl+Shift+Alt+Enter).

At the bottom of the Make Selection dialog box lies a section called Operation (Figure 13-24). If you don't have any active selections, Photoshop assumes you want to make a new selection and doesn't let you choose any of the other options. But if you already have an active selection, you can make the selected path interact with it in different ways:

- **Add to Selection** adds the path's shape and attributes (like feather radius, fill color, stroke thickness, and so on) to the selection.

- **Subtract from Selection** subtracts the path's shape and attributes from the selection.

- **Intersect with Selection** selects only the area where the path and the selection overlap.

Making a Path from a Selection

You can also do the opposite and create a path from an existing selection. This is helpful if you need to alter a selection you made with another tool. For example, you can start out with a selection you created with the Rectangular Marquee tool, turn it into a path, and then tweak it with the Pen tool. Here's how: With an active selection, click the "Make work path from selection" button at the bottom of the Paths panel (it looks like a circle with lines extending from either side). Then, using the path-editing techniques you learned earlier in this chapter, edit away. To transform the path back into a selection, just use one of the options listed in the previous section.

Warning: The paths that Photoshop creates when you turn a selection into a path aren't always terribly sharp. Pixel selections—especially ones you make with the Magic Wand—can create bumpy paths that have too many points. If you select an area that needs to be smoothed, open the Paths panel's menu and choose Make Work Path. In the resulting dialog box, you can adjust the Tolerance setting to smooth out the pixels. The higher the tolerance, the smoother the resulting path will be. But if you set the tolerance too high (anything over 5), you'll start to lose details. (This dialog box does not appear when you click the Make Work Path button at the bottom of the Paths panel.)

Making a Clipping Path

If you want to isolate an object from its background to use it in a page-layout program like QuarkXPress or Adobe InDesign, you need to create a *clipping path*. A clipping path is like a written description of your selection that those programs can understand even if they can't handle PSD files, layers, and transparency. You still send the whole document to the page layout program, but the clipping path specifies which *portion* of your image to display.

For example, Figure 13-25 shows a cup that's been isolated from its background in Photoshop using a clipping path and then placed on a blue background in a page-layout program. The page-layout program understands the clipping path that travels along with the file, and uses it to hide the cup's original background.

Figure 13-25:
Top: You can use a clipping path to isolate this cup from its background in a way that older page-layout programs understand.

Bottom: Here's the cup after it was placed on a totally different background in a page-layout program.

Both Adobe InDesign CS4 and later and QuarkXPress 8 can read layered Photoshop files with transparency, and recognize paths saved in TIFF files. So if you're using the latest versions of those programs, you don't need to worry about clipping paths. But if you're dealing with an older version, mastering clipping paths can make you the office hero.

To create a clipping path around an image like the cup in Figure 13-26, follow these steps:

1. **Draw a closed path around the cup with the Pen tool.**

 Press P to grab the Pen tool and draw a path around the outside edge of the cup using the techniques discussed earlier in this chapter. (Zoom in nice and close when drawing the path; see Figure 13-26, top.) When you're done, make sure you click the starting point to close the path.

Tip: If you're trying to isolate an object from its background, it's a good idea to draw the path about 1 or 2 pixels *inside* the object's edge just to make sure that none of the background sticks around. This way, you're more likely to avoid jagged edges where bits of the background show through your selection.

2. **Draw a second path inside the cup's handle.**

 To knock out the area inside the handle, click the Options bar's "Exclude overlapping path areas" button so the second path cuts a hole through the first (see Figure 13-26, bottom). Be sure to close this second path by clicking its starting point.

Figure 13-26:
You can see the path as it travels along the edge of the cup (top left), and continues until the entire cup is surrounded (top right).

To omit the space inside the handle, draw a second path around the inside of the handle (bottom).

3. **Save the paths.**

 Photoshop won't let you make a clipping path until you save your path. Over in the Paths panel, select the work path (page 550) and drag it onto the "Create new path" button at the bottom of the panel, or choose Save Path from the Paths panel's menu. In the dialog box that appears, give your path a descriptive name like *Cup outline*.

4. **Turn your path into a clipping path.**

 From the Paths panel's menu, choose Clipping Path. In the resulting dialog box (Figure 13-27, top), choose the path's name from the Path pop-up menu. The Flatness field controls how accurately printers will follow your path. A lower number means the printer pays attention to more points on your path (so the print is more accurate), and a higher number means it pays attention to fewer points (so the print is less accurate). Some printers can't handle paths with lots of points, so setting this field to a higher number reduces your path's complexity and helps make things easier on your printer. For now, though, just leave this field blank and click OK. In the Paths panel, your path's name now looks like a hollow outline to let you know that it's a clipping path (Figure 13-27, bottom).

Figure 13-27:
Top: Pick your path from the pop-up menu at the top of the Clipping Path dialog box.

Bottom: Once Photoshop has converted your path into a clipping path, it displays the path thumbnail's name in hollow text in your Paths panel.

Tip: If you get a call from your printing company complaining that your file caused a printing error, you may need to redo the clipping path and increase the Flatness setting to 4 or 5. This cuts the printer a little slack as far as how precisely it has to follow the clipping path.

5. **Save your document as an EPS or TIFF file.**

Choose File→Save As and pick EPS or TIFF from the Format pop-up menu. If you're paranoid about print quality, pick EPS to ensure the best results; because this format is based on the same language PostScript printers use, it tends to print a little more crisply.

You've now got yourself a perfectly selected and isolated cup, ready to be beamed up into the nearest page-layout program.

Tip: Some stock photography comes with clipping paths, which save you a *ton* of work if you need to place that object on another background. The next time you download a stock image, open it in Photoshop and then take a peek in your Paths panel to see if the file contains a clipping path. If so, you can select the path's thumbnail and then open your Masks panel by choosing Window→Masks and click the "Add vector mask" button (page 120) to add a mask yourself. Sweet!

Using Vector Masks

Photoshop gives you two ways to make *vector masks* with paths: using Shape layers and using the path outlines themselves. These masking methods are quick and easy, and you're absolutely gonna love their flexibility (vectors are infinitely resizable and editable, remember?). That said, it's worth noting a few things about using Shape layers or paths as vector masks. First, they work just like the pixel-based masks you learned about in Chapter 3: They can hide any underlying layer content that's *beyond* the shape's edges. Second, because a vector mask is made from vector-based paths, they give you much smoother edges than pixel masks. Third, you can feather them nondestructively on the fly by using the Feather slider in the Masks panel. Woo-hoo!

Masking with Shape layers

Technically speaking, a Shape layer is one that's filled with color using a vector mask. It only lets the fill color show *through* the shape. That means you can use a Shape layer to mask *other* layers, whether they're pixel- or vector-based, as shown in Figure 13-28. Here's how:

1. **Open an image and double-click its Background layer to make it editable.**

Since you need to place the Shape layer beneath the image layer, you have to unlock the Background layer or Photoshop won't let you put anything below it. (If you've worked with the photo before and you've already unlocked the Background layer, you can skip this step.)

Figure 13-28:
*Left: Here's an oval
drawn with the Ellipse
tool (the Ellipse shape
tool, not the Elliptical
Marquee tool).*

*Right: After placing
the Shape layer
below the photo,
you can clip the two
layers together so the
photo is only visible
through the shape.*

2. **Using one of the shape tools, draw a shape on your photo.**

 Any shape tool will work, but for this example, press Shift-U to cycle through
 the tools until you've got the Ellipse tool selected. Then mouse over to your im-
 age and draw an oval. Don't worry about the fill color because it'll disappear in
 the next couple of steps.

3. **In the Layers panel, drag the image layer above the Shape layer.**

 To use a Shape layer as a mask, it has to live below the image layer.

4. **With the image layer active, choose Layer→Create Clipping Mask.**

 Photoshop clips the image layer to the Shape layer that lies below it. (You can
 accomplish the same thing by hovering your cursor between the line that sepa-
 rates the two layers in the Layers panel and then pressing Option [Alt on a PC];
 when your cursor changes to two intersecting circles, click once.) In your Layers
 panel, the image layer's thumbnail scoots over to the right and you see a down-
 pointing arrow letting you know that it's attached to the layer below.

5. Since the edges of the image layer are now hidden by the Shape layer, you might want to create a new solid-colored background by adding a new Fill layer to the bottom of your layers stack (see page 91), though this step is purely optional.

The wonderful thing about this kind of mask is that you can activate the Shape layer and modify it using Free Transform (page 95). You can also edit the anchor points that make up the shape's path using the techniques described on page 557. Photoshop instantly reflects any changes you make in your document because the image layer is bound to (clipped through) the Shape layer.

You can also mask more than one layer with a Shape layer. Just arrange your layers so the soon-to-be-a-mask Shape layer is *below* the other layers. Next, ⌘-click (Ctrl-click) to select the layers you want to mask—don't select the Shape layer—and then, from the Layers menu (or Layers panel's menu), choose Create Clipping Mask or press ⌘-option-G (Ctrl+Alt+G on a PC). Either way, Photoshop clips all the selected layers to Shape layer.

Creating a vector mask from a path

You can also create a vector mask from a path outline made by any Shape tool or the Pen tool, which saves you the step of creating a clipping mask in the technique described above. It works just like the regular ol' layer masks you learned about back in Chapter 3 and adds a mask thumbnail to the currently active layer. (If your Background layer is locked, you'll need to double-click it before adding the vector mask.) The difference is that, since the mask is vector-based, you can resize it all you want and its edges stay nice and sharp.

Here's how to make a vector mask from a path:

1. **Grab the Pen tool by pressing P and, in the Options bar, select the Paths drawing mode.**

 You can also use any of the Shape tools set to Paths mode.

2. **Draw a path using the method described on page 542 or page 544.**

3. **Over in your Layers panel, select the layer you want to add the mask to and then create the mask by ⌘-clicking (Ctrl-clicking on a PC) the "Add a layer mask" button at the bottom of the panel.**

 Photoshop adds an infinitely resizable vector mask to your layer.

Tip: You can also create a vector mask by choosing Window→Masks to open the Masks panel and then clicking the "Add a vector mask" button in the panel's top-right corner. See page 120 for more on the Masks panel.

If you decide you need to edit the vector mask, just select its thumbnail in the Layers panel and use the Path Selection tool to activate its anchor points and control handles. Sweet!

Creating Artistic Text

Text has the power to make or break your design and Photoshop has a veritable smorgasbord of text creation and formatting options. But just because you *can* do something doesn't mean you *should*. The act of creating text is something of an art form (called *typography*), but it's all too easy to get carried away with decorating rather than creating legible prose.

Keep in mind that Photoshop isn't always the right place to be wordsmithing in the first place. The box on page 577 gives you some pointers to help decide whether to hunt and peck in another program altogether. Nevertheless, Photoshop has plenty of tools that, when used tastefully, can help create beautiful type. Some of these tools are easy to find, while others are hidden so deep in the program that you'd need a treasure map to find 'em. This chapter guides you in the right direction, and more importantly, teaches you when and how to use each tool. You'll also learn quite a lot about the art of type in the process.

Typography 101

People have been creating and arranging symbols for thousands of years. In the early days of print, text and symbol wrangling was handled by exacting craftsmen called typesetters, who lovingly hammered letterforms into metal plates that were then physically set onto printing presses (hence the phrase, *setting type*). With the advent of desktop publishing, however, everyone *and* their cocker spaniel started creating text. This has been both good and bad: It's great that you can whip up your own yard sale signs, invitations, and posters; but, as you might suspect, the quality of typography has suffered since most folks lack professional training. Figure 14-1 shows examples of good and bad typography.

Figure 14-1:
Left: When formatted well, type can be a beautiful and powerful form of art.

Right: Done badly, type can be garish and difficult to read. The combination of Comic Sans (a truly horrible font) and multiple layer styles (page 128) makes this innocent text hideous.

Some of the most frequent typographic offenses include:

- **Overusing decorative fonts (page 580) and using too many fonts per design.** Just because you have a ton of wacky fonts doesn't mean you should use them—especially not all in one document.

- **Setting whole sentences in capital letters.** This makes the text hard to read and tends to imply that you're YELLING.

- **Underlining text that isn't a hyperlink.** Thanks to the Internet, when folks see an underlined word, they assume it's a hyperlink. Find another way to make your text stand out, such as bolding or italicizing.

- **Centering large bodies of text.** It's best to reserve centered text for formal announcements; you'll learn why on page 615.

- **Misusing straight and smart (curly) quotation marks and apostrophes.** Use the straight ones to indicate units of measurement (feet and inches) and curly ones for everything else. Photoshop can take care of this for you by turning on the Smart Quotes feature shown on page 582.

- **Misusing (or not using) hyphens, en dashes, and em dashes:**

 — **Hyphens** are for combining two words (like "pixel-jockey") and for line breaks (when a word gets split across two lines of text).

 — **En dashes** are slightly longer than hyphens and are a good substitute for the word *to*, as in "Chapters 1–4" or "8:00 a.m.–5:00 p.m." On a Mac, you can create an en dash by typing Option-Hyphen (on a PC, press and hold Alt and type the numbers 0150).

— **Em dashes** are the longest of the bunch and imply an abrupt change—like this!—or a halt in thought or speech. Use them instead of a comma or period when the former is too weak and the latter too strong. To create an em dash on a Mac, press Shift-Option-Hyphen (on a PC, press Alt and hold and type the numbers 0151).

— **Improperly spaced ellipses (…).** An ellipsis indicates an omission, interruption, or hesitation in thought, as in, "But…but…you promised!" Instead of typing three periods (which can get broken between lines), let your computer create the dots for you. On a Mac, it's Option-; (on a PC, press Alt and type the numbers 0133).

There are more offenses, to be sure, but this isn't *Typography: The Missing Manual* (now there's an idea!). Nonetheless, the guidelines listed above will serve you well throughout the rest of this chapter, if not your entire career.

FREQUENTLY ASKED QUESTION

Photoshop and Text

When should I use Photoshop for text?

There's a time and place for everything, and that includes Photoshop text. Although each new version of the program boasts new and improved text formatting capabilities, it's just not made for handling big hunks of text. This book, for instance, was written in Microsoft Word, *not* Photoshop.

Here are a couple of rules of thumb that can help you figure out when to use Photoshop for text:

• **Avoid using Photoshop if you're sending the piece to a professional printer.** It's much better to use page-layout software like Adobe InDesign or QuarkXPress because both programs produce *vector* text (each character is described mathematically as a series of curves and lines—see Chapter 13 for details), which will print nice and crisp. Though Photoshop text starts out as editable vectors, it can get *rasterized* (converted to dots) when the file is flattened (page 112) and exported, making it look fuzzy

when printed (take a peek at the ads in the back of any magazine and you'll spot some). The fix is to save the Photoshop file in EPS format, so the letterforms remain vectors (though they don't remain editable), or Photoshop PDF format, which lets you turn on the "Preserve Photoshop Editing Capabilities" option in the Save Adobe PDF dialog box. You could also convert the text into a *shape*, as discussed on page 631.

• **Use Photoshop if the text is part of the image itself.** For example, if you want to make a photo visible through the text (as shown on page 630) or give it an artistic treatment like a texture (see page 624), then Photoshop is the way to go. Just save the file as an EPS or Photoshop PDF before sending it to a commercial printer to ensure it will print smoothly.

Of course, if Photoshop is the only program you've got, then you have no choice. May the force be with you!

The Face of Type

At the heart of typography lies the *glyph*, a unique graphical representation of a letter, number, punctuation mark, or pictographic symbol. In the digital realm, a collection of glyphs is called a *typeface* or *font*. Technically, a typeface is the overall shape or design of the glyphs and a font is the specific size, style, and weight, but people use the terms interchangeably. For example, the text you're reading right now is Times, a typeface, while Times 14-point, bold is a *font*—the latter being more descriptive. (For the purpose of this book—and your sanity—they'll be referred to as fonts from here on out.) Just to keep you on your toes, you may also encounter the term *font family,* a collection of various weights and widths of the same design. An example of a font family is Futura Book, Futura Semi-Bold, Futura Heavy, Futura Sumo (kidding!), Futura Bold, Futura Extra Bold, and so on.

Common font formats

Fonts come in various formats that determine how and what kind of information gets stored in each font file and ultimately, how they print. There are only three formats you need to worry about in Photoshop: PostScript, TrueType, and OpenType. These days font format isn't such a big deal—any printer with equipment less than 15 years old can print any format you throw at 'em. Nevertheless, here's how the formats differ:

Tip: If you've already created some Photoshop text, you can discover what font format you've used by taking a peek at the font family menu—the unlabeled pop-up menu showing the font's name—in the Options bar (shown on page 601) or the Character panel (page 603), as explained in Figure 14-2.

Figure 14-2:
In the font family menu, you'll spot a symbol to the left of each font name denoting its format. A lowercase a means it's a PostScript font, TT stands for TrueType, and an O indicates OpenType. All three formats create vector text, where the characters are made up of curves and lines, so you can resize them infinitely without losing quality.

- **PostScript.** Most graphic design pros consider this format the safest and most reliable for printing because it's been around for years (it comes in both Mac and Windows flavors). Each PostScript font consists of two files: one that contains the shapes that get displayed onscreen (called *screen* or *bitmap* because monitors

display bits or dots) along with font family and spacing info, and another that contains outline drawings of each glyph for the printer (commonly referred to as the *printer* file). This format produces high-quality text when printed on PostScript devices like laser printers and professional printing presses. The downside is that the two files can get separated or (gasp!) lost. (If you lose the screen file, you can't see the font onscreen; if you lose the printer file, you can't print it.) Folks who install and manage fonts manually (see the box on page 581) occasionally run into these kinds of problems.

- **TrueType.** Developed jointly by Apple and Microsoft, TrueType is the most common font format today and it's what you'll find in both the Mac and Windows operating systems—the fonts that came on your computer (though they're likely to be different versions so they may not look the same). Both the screen and outline information are stored in a single file, so they can't be separated or lost. Though they rival the quality of PostScript, and their usage in the design community has increased, many professional printers still prefer PostScript out of habit. TrueType fonts for Windows can be used on Macs, but not vice-versa.

- **OpenType.** This font format, created by Microsoft and Adobe, is the new standard. Like TrueType, OpenType fonts store the screen and outline information together in one file. They work well and look the same on both Macs and Windows computers (which is helpful), plus they can store more than 65,000 different glyphs in one font file. This makes them ideal for decorative and pictorial languages like Asian and Middle-Eastern ones, and for other fancy typographic goodness like ligatures and stylistic alternates (page 611). The same OpenType font can be used on either Macs or Windows. As with most things, change takes time, so a lot of printers don't yet support this format. But because it's so versatile, someday OpenType will rule the typographic world!

Note: If you're designing a piece that'll be posted online, font format doesn't matter because the text isn't headed for a printer. If you're printing to a non-postscript device like an inkjet printer, *anti-aliasing* matters more than font format—see page 602 for details.

Font categories

Font foundries, the purveyors of fonts, crank out new fonts daily. Depending who you ask, there are between 50,000–150,000 known fonts in the wild. No wonder it's tough to choose! Luckily, there are a few basic principles for choosing a font that's appropriate to your message—one that will reinforce, rather than distract from it. Figure 14-3 shows you an example of the following font categories:

- **Serif.** These fonts have little lines (*serifs*) extending from the main stroke that resemble tiny feet, like the ones at the top and bottom of this T. The main strokes vary from thick to thin, and the serifs help lead the eye from one character to the next. Serifs are great for large bodies of text like books (you're reading a serif font now), newspapers, or magazines where legibility is paramount. However,

they're not so good for large bodies of *online* text (the next bullet point explains why). Examples include Times New Roman, Garamond, and Minion.

- **Sans serif.** Fonts lacking the aforementioned feet are called *sans serif* ("sans" means "without"). They're perfect for headlines, subheads, and surprisingly enough, online body copy. Because their main strokes are uniform—they don't vary from thick to thin—they display well at small sizes, so they're ideal for Web use. Examples include Arial, Helvetica, and Futura.

- **Slab serif.** These guys have uniform main strokes, thick serifs, and often appear bolded. Use them when you want to attract attention, or when printing body copy under less than optimal conditions (cheap paper, cheap printer, or fax machine). Examples include Bookman, Courier, and Rockwell.

- **Decorative, Display.** This group includes all kinds of distinctive, eye-catching fonts, from the big and bold, to the swirly, to letters made out of bunnies. Though gloriously unusual, they're harder to read due to the extra ornamentation or stroke thickness. Use them sparingly and on small blocks of text (perhaps a single word). Examples include Impact, Party, and Stencil.

Figure 14-3:
Different situations call for different fonts. It'd be silly to print a newspaper in a decorative font—it'd be nearly impossible to read.

And no one will come to your tea party if they're put off by the big, bold letterforms of a display font, which seem to say, "Come to my party or else!"

- **Scripts.** Casual scripts are designed to look as though they were drawn (quickly) by hand. Formal scripts have carefully crafted strokes that actually join the letters together, like cursive handwriting. Use casual scripts for small blocks of text

(again, because they can be hard to read), and reserve formal scripts for fancy announcements (weddings, graduations, and so on). Examples include Brush Script, Freestyle, and Edwardian.

Font styles

Most fonts contain several *styles* (variations) like bold, semi-bold, italic, condensed, and so on. When these styles are included in the font itself (meaning they were designed by the font's creator), they're called *native* or *built-in styles*. To view all native styles for a particular font, use the font styles pop-up menu (which sits to the right of the font family menu) in the Options bar (page 600) or in the Character panel (page 603). Just click a style to select it.

POWER USERS' CLINIC

Managing Fonts

Unless you never, ever work with text in your Photoshop documents, you've had to make font choices now and then. Odds are good that you've also added fonts to your computer, which means you've got more than a handful floating about.

Installing fonts manually can be dangerous, as you'll eventually run into *font conflicts*—when you have two or more font formats with the same name—or worse, damaged fonts (fonts that get corrupted and don't work properly). Either scenario can wreak all manner of havoc on the performance of both your computer and Photoshop, and can make them crash. If you think this is scary, you're right; and, if you've got a ton of fonts, it's a matter of *when* you'll run into a conflict, not *if*.

The solution, dear Grasshopper, is to invest in font-management software. These programs serve as a repository for all your fonts so you don't have them scattered throughout your hard drive. They can turn fonts on or off (so you don't have to scroll through a mile-long font list), and let you organize them in a multitude of ways such as by favorites, project or client, and so on.

There are some free font-management programs flitting around on the Web, but when it comes to working with professional programs like Adobe Creative Suite, it's worth paying for one. Extensis (*www.extensis.com*), Insider Software (*www.insidersoftware.com*), and Linotype (*www.*

linotype.com) have great offerings that are loaded with features designed to make your font life easier and more importantly, headache free.

Extensis offers Suitcase Fusion for the Mac and Suitcase for Windows XP and Vista for $100. Insider Software has a cross-platform offering called FontAgent Pro, which is also $100. Both programs have similar features: They track and manage the fonts you add to your computer as well as system fonts (the ones that came with your computer), which is a real bonus if you have third-party fonts with the same names as your system fonts. They also let you activate fonts as you need them and perform basic checks when you add new ones to make sure they're not damaged. This alone could save your hide because damaged fonts are notorious for causing Photoshop crashes and printing problems. If you're using a Mac, Linotype's FontExplorer X Pro is only $80 and it runs rings around the other two programs: its design is friendlier, the features are easier to access, it has an excellent font sample printing feature, and so on.

FontAgent Pro and FontExplorer X Pro also have one special feature that Suitcase doesn't: Auto font activation in Photoshop. That means if Photoshop encounters a missing font when opening a document (see the box on page 588), they'll activate it on the fly, without you having to lift a finger. Whee!

If the font doesn't contain a bold or italic version, Photoshop can fake it for you. Just select a font from the font family menu and then head over to the Character panel and click the bold or italic button (the bold button has a capital T on it, and the italic button has a slanted *T*). Photoshop will do its best to tilt the characters or make them thicker, creating what's known as a *simulated* or *faux style*. These faux styles often look fine onscreen but terrible when printed, as the printer has no outline file (drawing) to go by. Whether it's font styles, shoes, or handbags, real is *always* better than fake.

Previewing fonts

Choosing a font is 100 times easier if you can actually *see* what it looks like. Photoshop is happy to show you an example of each font in the font family menu. In Photoshop CS5, the Font menu's font-preview feature is turned on right out of the box, but in previous versions you had to turn it on manually: On a Mac, choose Photoshop→Preferences→Type, or Edit→Preferences→Type in Windows; turn on the Font Preview Size checkbox, pick a preview size from the pop-up menu as shown in Figure 14-4 (Large is a good choice), and then click OK. Both the Options bar and Character panel's font family menus display the word "sample" in the actual font to the right of the font's name, making it a heck of a lot easier to choose one. To turn the previews off, just pop open the Type preferences as described above and then turn off the Font Preview Size checkbox.

Note: Font previews can make Photoshop feel sluggish. If you have thousands of active fonts, a slow computer, or very little memory (RAM), you might want to turn them off.

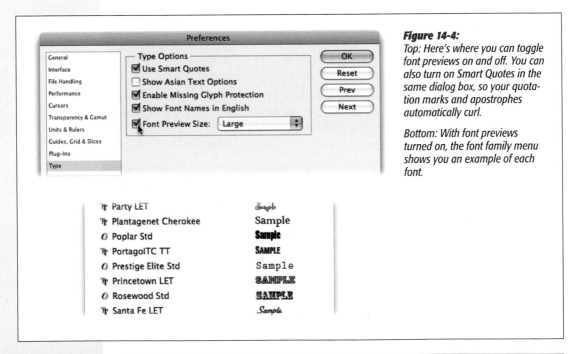

Figure 14-4:
Top: Here's where you can toggle font previews on and off. You can also turn on Smart Quotes in the same dialog box, so your quotation marks and apostrophes automatically curl.

Bottom: With font previews turned on, the font family menu shows you an example of each font.

Scrolling for Fonts

Have you ever grown weary of scrolling through all your available fonts? Even with font previews turned on, you'll still probably try out several fonts before you find one that's just right. The process usually goes like this: Select the text, mouse over to the Options bar or Character panel's font family menu and choose a font and then deselect or hide the text selection (page 586) to see how it looks in your document. If you don't like it, you reselect the text, trot back to the font family menu and select another and then deselect or hide, and so on. A font-management program lets you preview fonts quickly and easily (see the box on page

581), but if you don't have one, this kind of manual font trolling is a royal pain.

Here's a better method: The next time you need to pick a font, highlight the text in your document, and then click the font family menu in the Options bar or in the Character panel. Click the name of a font and then use your up and down arrows on your keyboard to cycle through the list. The selected text changes as you scroll through the list, saving you loads of mouse-travel time. Nice!

Creating and Editing Text

You can create all kinds of text in Photoshop: from plain ol' horizontal to up-and-down vertical. You can even lay down text that flows around or inside a shape. No matter what kind of text you create, it lives on a special layer called a *Type layer*. You can do anything to a Type layer that you can with any other layer (see Chapter 3): adjust its opacity, change its blend mode, apply layer styles, and so on. (Type layers are labeled with a big fat T in the Layers panel so they're easy to spot.) Photoshop automatically names each new Type layer with the first few words you type, though like any other layer, you can double-click its name in the Layers panel to give it a more meaningful name.

Tip: You can change the orientation of your text—whether it flows from left to right or top to bottom—anytime. Just click the Text Orientation button in the Options bar—it looks like a capital T with tiny downward and right-facing arrows—to switch from one direction to the other (see page 610). To create text that flows backwards (from right to left or bottom to top), see page 590.

To create a new Type layer, select either the Horizontal or Vertical Type tool from the Tools panel as shown in Figure 14-5. Click once in the document where you want your text to start and let the hunting and pecking begin. When you're finished typing, press Enter on your computer's numeric keypad (not Return!) or click the black checkmark at the far right of the Options bar to let Photoshop know you're done (you can also just select another tool from the Tools panel).

Horizontal

V
e
r
t
i
c
a
l

Figure 14-5:
*Left: Click the big T in the Tools panel to reveal all
your Type tool options: the Horizontal and Vertical
Type tools, and the Horizontal and Vertical Type
Mask tools (discussed on page 589).*

*Right: Use the Horizontal Type tool to create text
that flows from left to right in a straight line. Use
the Vertical Type tool to create text that flows down
the page from top to bottom, as in a column.*

Tip: To edit several Type layers at once, first select them in the Layers panel and make sure the Type tool
is active. Then make your changes using either the Options bar or the Character panel and they'll apply
to *all* the selected layers in one fell swoop, which can be a huge timesaver. (Find and Replace is another
great tool for multilayer changes—see page 599.)

Point Text vs. Paragraph Text

Chances are, most of the text you'll create in Photoshop will be *point text*, which
starts at a certain spot (or point) and continues along a single line. To create point
text, just click in a document and start typing. If you type a bunch of text and want
it to wrap to the next line, press Return (Enter on a PC) to force the line to break
(Photoshop is quite content to let text dangle off the edge of your document). If you
want Photoshop to automatically wrap text to the next line, you'll need to create
paragraph text instead.

Note: Photoshop refers to these two kinds of text as point and paragraph, but you might hear people call
them *character* and *area text*, respectively.

Paragraph text is text that lives inside a box, wherein Photoshop is happy to make
your prose flow from line to line all by itself. To create paragraph text, you can drag
with the Type tool to draw a box or Option-click (Alt-click on a PC) your document

(with the Type tool active) and enter the desired width and height into the resulting dialog box, shown in Figure 14-6, left. (Photoshop assumes these measurements will be in points, though you can type another unit of measurement such as *in* for inches or *px* for pixels.) Click OK to dismiss the dialog box and Photoshop places a dashed box in your document, with the upper-left corner in the spot where you originally clicked (as shown in Figure 14-6, right). If the box isn't the right size, press Esc and have another go at it, or simply adjust the box's size by dragging the tiny white resizing handles strategically placed around its edges.

Figure 14-6:
Left: To create a multiline text box, Option-click (Alt-click on a PC) in your document and enter the dimensions you want.

Right: You can also drag with the Vertical or Horizontal Type tools to draw the box manually, as shown here. To resize a text box, select the Type layer, click in the box, and then drag any of the resulting white square handles, like the one circled here.

When the text box is all set, just start typing. When your text hits the edge of the box, Photoshop adds line breaks—and hyphenates words. You can still resize the text box after you type in it—just make sure the Type layer is selected in the Layers panel. Then click in the text box and drag any of the resulting handles. The size of the *text* doesn't change, but the size of the text box does; and just like magic, the text reflows automatically to fit inside the newly sized box. (If you want to change the size of the text itself, flip to page 588.) Using paragraph text instead of point text gives you some extra formatting options in the Paragraph panel, like justification; see page 614 for details.

Tip: Photoshop can convert point text to paragraph text (or vice versa) on the fly. Just select the appropriate text layer in the Layers panel and then choose Layer→Type→"Convert to Point Text" or "Convert to Paragraph Text". You can also Ctrl-click (right-click on a PC) the text itself and choose the same items from the resulting shortcut menu.

Moving Text

If you start typing and then decide it's not in the right spot, no problem—moving text is easy. Just grab your mouse and move the cursor *away* from the text (about an inch or so) until the cursor turns into a tiny arrow (just as if you'd grabbed the

Move tool). Then drag the text to a new position and continue typing. Another way to move text while typing is to press and hold ⌘ (Ctrl on a PC), place your cursor inside the resulting box, and then drag it to a new location.

If you've already finished typing the text, you can still move it. Just make sure the appropriate Type layer is selected over in the Layers panel, press V to grab the Move tool, and then drag the Type layer to a new position. If dragging isn't your bag, grab the Move tool and nudge it by tapping the arrow keys on your keyboard.

Selecting Text

Chances are, the text you create won't be perfect right off the bat; it'll need to be massaged, manipulated, and played with (and honestly, that's half the fun). To tweak your text, activate the appropriate Type layer in the Layers panel (it'll be highlighted, as shown in Figure 14-7, top), and then *select the text itself* (you'll learn how in a sec). When text is selected, you see a black (or blue) background behind the characters (which are now white or orange), as shown in Figure 14-7 middle.

Tip: The background that appears behind text to show that it's selected can be distracting, and make it hard to see your image. Toggle it off and on by pressing ⌘-H (Ctrl+H on a PC). That is, unless you've reassigned that keyboard shortcut to hide Photoshop, as explained in the tip on page 14.

Selecting text is totally different from *loading* text as a selection, wherein marching ants surround the characters as shown in Figure 14-7, bottom. To load text as a selection, simply ⌘-click (Ctrl-click on a PC) the Type layer's thumbnail. What's the difference, you ask? Selecting text lets you edit the characters (to fix a typo, for example), whereas loading text as a selection lets you apply effects to the *shape* of characters, such as adding a stroke (page 621), altering other images in the shape of the characters (page 629), or creating another piece of art out of 'em altogether.

You've got several ways to select text (you need to have the Type tool active to use any of them):

- **To select a character,** click within the text and, once your cursor turns into a blinking I-beam, drag across the character(s).

- **To select a word,** click within the text and then double-click the word.

- **To select a whole line,** click within the text and then triple-click anywhere in the line you want to select.

- **To select a paragraph,** click within the paragraph and then quadruple-click (that's four quick clicks).

- **To select the whole Type layer,** in the Layers panel, double-click the layer's thumbnail or, in your document, click within the text and then click five times really fast.

Figure 14-7:
Top: To alter text in Photoshop, you've got to select the Type layer on which it lives. Once selected, the Type layer gets highlighted, as shown here.

Middle: When you select text, a black (or blue) background appears behind it. (Photoshop temporarily makes the text white or orange so you can see it.) You can hide this background by pressing ⌘-H (Ctrl+H on a PC).

Bottom: Here's what text looks like when it's been loaded as a selection. Notice how the edges of the letters look blurry? That's because each letter is surrounded by marching ants.

There is no escape;

you have been selected!

There is no escape;

you have been selected!

- **To select multiple Type layers,** mouse over to the Layers panel and Shift- or ⌘-click (Ctrl-click on a PC) the name—*not* the thumbnail—of each layer you want to select.

- **To select all the Type layers in a document,** select one Type layer then choose Select→Similar Layers. This maneuver is handy if your Layers panel has grown unwieldy and contains a bazillion Type layers.

Tip: When you've got a Type layer selected in your Layers panel and the Type tool is active, Ctrl-click (right-click on a PC) anywhere in your document to summon a shortcut menu with all kinds of useful options for working with text. These include Check Spelling (page 500), Find and Replace (page 599), Rasterize (page 589), "Create Work Path" or "Convert to Shape" (page 631), and more.

Resizing Text

Photoshop lets you create everything from nano-sized text that you'd need an electron microscope to read, to ginormous letters fit for the side of a building. You can resize text by selecting it using any of the methods described above, and then altering the point size in either the Options bar (page 600) or the Character panel (page 603). But where's the fun in that?

Unless you know the exact size your type needs to be, you may be better off resizing it visually, either while typing or afterward. To resize visually, select a Type layer from the Layers panel and click inside the line of text (or the text box) so you see an I-beam cursor blinking within the text (if you're typing, you should already see this cursor). Then press and hold ⌘ (Ctrl on a PC) to make Photoshop display resizing handles around the text. Drag any handle to resize the text, as shown in Figure 14-8, left (press and hold the Shift key while dragging to resize the text proportionately—meaning the relationship between the width and the height stays the same). The point size displayed in both the Options bar and Character panel changes as you drag.

Tip: If you're a keyboard shortcut fan, you can increase the font size of selected text in 2-point increments by pressing Shift-⌘->, and decrease it by pressing Shift-⌘-< (use Shift+Ctrl+> and Shift+Ctrl+< on a PC). To increase or decrease in *10-point* increments, add the Option key (Alt on a PC) to those key combinations.

FREQUENTLY ASKED QUESTION

Type Warnings

Sometimes when I open a document, I see a little triangle on the Type layer in the Layers panel. What the heck does that mean?

One day you're bound to open a Photoshop document only to be met with a *type warning*. They come in two flavors, and show up in the Layers panel as a tiny yellow or gray triangle on the Type layer's thumbnail:

- **A yellow warning symbol** means you're missing a font. You'll see this icon if you open a document that uses a font that's not installed on your machine (though you'll likely see an error message *before* the document actually opens that lets you either cancel opening the document or proceed). If you don't need to edit the text, you've got nothing to worry about—just do what you need to do and then save the file. If you *do* edit the text, Photoshop will sub-

stitute something else for the missing font, and this substitution is permanent, even if you send the file back to its creator who *has* the original font. If it's important to keep the original font, you'll have to close the document, quit Photoshop (unless you're running font-management software—see the box on page 581), install the font, relaunch Photoshop, and then re-open the document.

- **A gray warning symbol** means that the document you've opened was created in a different version of Photoshop and that the text *may* get reflowed if you edit it (but that doesn't mean it *will* get reflowed). Because each new version of Photoshop contains new type features, text created in an earlier version might get spaced or hyphenated differently in the new version. Now you know.

You can also use Free Transform to resize text. With a Type layer selected—not the *text* itself, just the Type layer—summon the Free Transform tool by pressing ⌘-T (Ctrl+T on a PC). Up pops a now familiar resizing box (complete with little white handles) around the text. Drag one of the handles in any direction to resize the text. (You won't see the point size change as you drag because that happens only when the Type tool is active.) Again, hold the Shift key to resize the text proportionately. For more options, Ctrl-click (right-click) in the transform box for a handy shortcut menu (see Figure 14-8, right).

Creating a Hollow Text Selection

Sometimes you don't really need the letters *themselves* to create the effect you're after, you just need a *selection* of them (in other words, their outline). Enter the Type Mask tool, a wonderful tool hidden in the Type toolset (shown on page 584). Instead of creating a Type layer, the Type Mask tool creates an empty text *selection*, which you can use on other layers, like one that contains an image.

WORD TO THE WISE

Beware of Rasterizing Text

Most of the text you create in Photoshop—whether it's horizontal, upside down, inside a shape, or what have you—begins life as *vector type* (aside from the Type Mask tool;, explained above). With vector type, each character is made up of curves and lines, rather than pixels. (See the box on page 52 for a detailed discussion of raster vs. vector files.)

This is great news because it means that the text is editable and fully *scalable*, so you can make it bigger or smaller without worrying that it'll be blurry when printed. However, some cool effects require you to rasterize the text (convert it to pixels), like running filters (though there is a workaround, see page 624), distorting, and applying perspective, to name a few. If you try to do any of these things to a Type layer, you'll be met with an error message asking your permission to rasterize.

The bad news is that some things in Photoshop *automatically* rasterize text so that it becomes completely un-vectored, un-editable, and pretty much un-resizable. (Sure, you can shrink raster text without much quality loss, but making it bigger will give you disastrously jagged results.) Photoshop automatically rasterizes text when you:

- Merge a Type layer with another layer(s) (see page 111).

- Flatten a file (see page 112).
- Save a file as any format other than PSD, Photoshop PDF, or TIF (see page 50).
- Send a file to a non-PostScript (inkjet) printer (see Chapter 16).

If you save a file in EPS or DCS format (see page 670 or page 694, respectively to learn all about your format options), Photoshop preserves the text by converting it into vector outlines, which is pretty much the same thing as converting it into a shape (see page 631). You won't be able to edit it anymore, but it'll look nice and crisp when printed. Watch out, though: If you open *either* of these file types again in Photoshop, the program will automatically rasterize the text. However, you can use File→Place to import the file into your document as a Smart Object (page 125) to preserve the text, though it still won't be editable.

All that being said, if you truly wish to rasterize text, it's a good idea to duplicate the Type layer first (as described on page 87) just in case you want to edit it later. Once you've duplicated the layer, you can rasterize either the copy or the original by choosing Layer→Type→Rasterize.

Figure 14-8:
*Left: You can resize
text visually while
typing by pressing ⌘
(Ctrl on a PC) and
then dragging one of
the resizing handles
circled here.*

*Right: You can also
resize text using Free
Transform. After
you've summoned
the tool by press-
ing ⌘-T (Ctrl+T on
a PC), Ctrl-clicking
(right-clicking) in the
transform box will
bring up this shortcut
menu, which offers a
slew of text-altering
options.*

*Bottom: If you've
ever anted text to
flow backwards, Free
Transform can make
it so. Just open the
shortcut menu as
described above, and
then choose Flip Hori-
zontal (or Flip Vertical
for upside-down text).*

When you use the Type Mask tool, it'll look like you're creating normal text, but once you're finished typing, marching ants will surround the edges of the characters, creating a hollow selection in the shape of text, and Photoshop won't create a new Type layer. Think of a type mask as one of those plastic stencils you used as a kid to draw perfectly formed letters and numbers—the letters are hollow so you can see through them to the layer below.

Note: Sure, you could just use the regular Type tools to create text and then load it as a selection by ⌘-clicking (Ctrl-clicking on a PC) the Type layer's thumbnail. But the Type Mask tool *creates the selection for you*, sparing you that extra step.

The Type Mask tools open a boatload of graphic design possibilities because they let you affect other graphical elements (other layers) through the shape of the text, as shown in Figure 14-9. The Type Mask tool comes in two flavors: One for creating

horizontal text and one for creating vertical text. They both merely create a selection of whatever you type without creating a new layer. You can treat the text selection as you would any other selection: move it around, use it to create a layer mask (page 176), wear it as a hat (kidding), save it to use later (see page 180), or turn it into an editable path (page 568).

One of the many neat effects you can create with the Type Mask tool is a text-shaped photo fade; a unique look that'd make an eye-catching magazine ad. Here's how:

1. **Open a photo and grab the Horizontal Type Mask tool.**

 To activate the tool, click the big T in the Tools panel and then click the Horizontal Type Mask tool in the flyout menu (you can also press Shift-T repeatedly to cycle through all the tools in the Type toolset). You don't need to bother duplicating the background layer because this technique is 100% nondestructive, meaning the original pixels will remain untouched.

2. **Choose a font from the font family menu.**

 Be sure to choose a thick, fat font so the selection area will be fairly big (thin or script fonts won't work). Arial Black or Impact works well for this technique.

3. **Click anywhere in the document and type your text.**

 You'll notice that the text appears hollow (you can see through to the photo, as shown in Figure 14-9, top), while the background takes on the red cast of Quick Mask Mode (page 176), though you can't use other tools or filters like you *normally* can in Quick Mask Mode.

TROUBLESHOOTING MOMENT

Adding Type Layers

There are lots of benefits to creating different pieces of text on their own Type layers. As you learned in Chapter 3, you can edit anything that lives on its own layer independently of everything else, letting you change blend modes, opacity, and so on, without messing with other layers. So, if you're creating a poster publicizing Woodstock IV, for example, it's a good idea to put the (obligatory) psychedelic heading on one layer and the details of the concert on layers of their own.

Creating your first Type layer is easy: As explained on page 583, simply click the big T in the Tools panel to activate the Type tool and then click in your document to add the new

Type layer. However, it can be challenging to create *additional* Type layers while the Type tool is selected because when you click, Photoshop insists on selecting the *existing* Type layer nearest to where you clicked. Likewise, if you hover your cursor close to an existing path (page 537), Photoshop assumes you want to create type on a path (see page 597) and promptly attaches the text to it.

The fix for both situations is to press and hold the Shift key while you click a blank area of the document, which forces Photoshop to create a brand-new, bright and shiny Type layer. Now, take back all those bad things you said about the Type tool.

Figure 14-9:

Top: When the Type Mask tool is active, clicking in a document causes a red overlay or mask to appear (see page 176 for more on this particular mask). As you type, the letters are revealed through the mask. The text remains editable (and resizable) until you accept the mask by clicking the black checkmark at the far right of the Options bar or pressing Enter on your computer's numeric keypad.

Middle: Once you accept the mask, you'll see a selection of the text appear, indicated by the little army of marching ants surrounding the characters, as shown here (in real life, they actually move).

Bottom: After you inverse the selection (see the box on page 55), the area behind the text gets selected, letting you change the background of your design in the shape of the text. Here, the text selection was used in conjunction with an adjustment layer on a photo of pizza. As you can see, all manner of graphic design goodness is possible with this technique.

4. **Format the text to your liking.**

 If you don't like the font, change it by selecting the text (page 586) and making a new choice from the font family menu. You can reposition the text by moving your cursor away from it about an inch and then dragging with the resulting arrow cursor. You can also move the text by pressing ⌘ (Ctrl on a PC) and clicking inside the resulting box and then dragging it or nudging it with your keyboard's arrow keys. Drag any of the square handles to resize the text (remember to hold the Shift key to resize it proportionately).

5. **Convert the mask to a selection.**

 When the text looks just right, click the black checkmark at the far right of the Options bar to accept the mask, or just press the Enter key on the numeric keypad (*not* Return). This creates a selection of the text (so you see marching ants) and gets rid of the red overlay, as shown in Figure 14-9, middle.

Note: If you decide to edit or reformat the text after accepting the mask, you have to start over. You need to get rid of the existing selection first by pressing ⌘-D (Ctrl+D on a PC) to deselect; then you can grab the Type Mask tool and retype the text.

6. **Inverse the selection.**

 In order to fade the area of the photo around the letters, you need to flip-flop the selection. Choose Select→Inverse to select everything *except* the letters. Now you can adjust the photo's background while leaving the letter area alone.

7. **Create a Hue/Saturation Adjustment layer (page 342) and use it to desaturate (page 324) and lighten the part of the photo in the selection area.**

 Over in the Layers panel, click the "Create New Fill or Adjustment Layer" button (the half-black/half-white circle) and choose Hue/Saturation from the pop-up menu. Using an Adjustment layer lets you do the desaturating and lightening on another layer, instead of on the original image. That way, the original photo remains unchanged.

 In the Adjustments panel that opens, drain most of the photo's color by lowering the saturation to –65. Next, drag the Lightness slider to +60 to screen back (lighten) the photo, making the text more legible.

Note: Since you had an active selection before creating the adjustment layer, Photoshop plopped the selection into the Adjustment layer's mask for you (see page 77 for more on Adjustment layers and their masks). This ensures that only the selection area will be affected by the changes you make here.

You're done! Figure 14-9 (bottom) shows the final result: clear, photo-filled text with a faded background.

Creating Type on a Path

Photoshop lets you bend text to your every whim, and one of the coolest tricks you can do is make text march around a shape. The key is to use the Type tool on a pre-existing path (either open or closed—see page 549) that was drawn with the Pen tool or created with a vector shape such as the Rectangle, Rounded Rectangle, Ellipse, Polygon, or Custom Shape tools (Figure 14-10). (See Chapter 13 for a detailed discussion of paths and vector shape tools.) When you attach text to a path, both the text and the path remain editable, so you can reformat the text or reshape the path anytime you want.

Tip: Heck, you can even turn text *into* a path or a vector outline (think shapes)—a nifty trick that lets you rotate individual letters and create cool intersecting effects. Grab a beverage and head on over to page 631 for the details.

Here's how to attach text to a custom shape:

1. **Create a path.**

 Using either the Pen tool or one of the vector shapes mentioned above, create a path for the text to follow. Figure 14-10 shows a snail drawn with the Custom Shape tool (see page 556 to learn how to load other built-in shapes).

Note: The direction you draw the shape (or path) determines the direction the text flows. For example, draw the shape from left to right and the text will flow normally; draw it from right to left and the text will appear backwards and upside down.

2. **Attach text to the path.**

 Grab the Horizontal Type tool (click the big T in the Tools panel) and then hover your cursor above the path or the shape's edge. You'll see a wavy line appear beneath the I-beam cursor (see Figure 14-10, top). This is the Type tool's way of telling you that it recognizes the path you're about to attach the text to. Click once and then start typing.

3. **Align or reposition the text on the path.**

 You can use any of the alignment buttons in the Options bar (page 600) or Character panel (page 603) to align the text on the path.

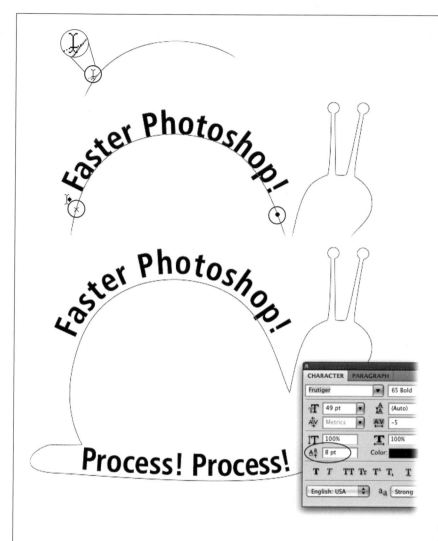

Figure 14-10:
Top: With the Type tool active, hover your cursor above any path and a little wavy line appears at the bottom of the cursor. That's Photoshop's way of saying "permission granted" for creating type on a path.

Middle: Slide the type along the path by dragging with the Path Selection tool (the black arrow that lives below the Type tool in the Tools panel, assuming it's in single-column mode, of course!). A tiny black arrow appears next to the cursor facing either left or right, depending on which end of the text you're hovering near (here it's facing right). The start point of the text is marked with a tiny x, and the end point is marked with a dot (both circled).

Bottom: To give your text a little breathing room, adjust the base-line shift (page 607) over in the Character panel (page 603). This maneuver scoots the text away from the path it's attached to. You can also increase tracking if the letters start crashing into each other.

You can also slide the text back and forth along the path, or flip it from the top of the path to the bottom, using the Path Selection tool—just click the black arrow below the Type tool in the Tools panel to select it (see page 558 for more on this tool). Hover your I-beam cursor over the starting point of the text (which is marked with an x—see Figure 14-10, middle). When a tiny, right-facing arrow appears next to

your cursor, drag to the left or right to move the text. (The little arrow points to the left if you hover your mouse over the end of the text, which is marked with a black dot.) To flip the text to the opposite side of the path—in this example, that means putting it inside the snail shell rather than on top—drag your cursor below the path (toward the bottom of the shape).

What's really happening here is that Photoshop is adjusting the start and end points of the text. You can move the start point by clicking the path with the left-arrowed cursor. Likewise, you can move the end point by hovering at the end of the text and clicking with the right-arrowed cursor. (If the text is center aligned, you'll likely see a double-arrowed cursor.)

Note: If your text disappears, that means the space between the start and end points is too small to house the text. In that case, adjust one of the points or reformat the text to make it fit.

You can format type on a path like any other text. Just switch back to the Type tool (or double-click the Type layer's thumbnail in the Layers panel) and then make a selection using one of the techniques described on page 586.

Tip: You may need to adjust tracking (page 607) over in the Character panel to keep letters from colliding in tight spaces. To make the text sit above or below the path (instead of directly on it, see Figure 14-10, bottom), adjust the baseline shift as described on page 607.

Filling a Shape with Text

Placing text inside a shape is even simpler that placing it on an object's edge, and it's a fun little exercise in type design. First, create a closed shape with the Pen tool or one of the shape tools as discussed above, and then grab the Horizontal Type tool. Hover your cursor inside the shape and, when it turns into an I-beam surrounded by tiny dots (shown in Figure 14-11, top), just click and type your text. Easy, huh?

When you're finished typing, you can format the text using any of the options discussed on page 600 and beyond (you'll likely need to change its color in order to actually *see* it). Centered alignment (page 615) is especially useful for this technique, because you can use it to push the text away from the edges of the object (see Figure 14-11, bottom). Otherwise, you can give the text a little more space using the Indent Left and Indent Right Margin controls over in the Paragraph panel (page 614).

Figure 14-11:
*Top: Once your cursor is surrounded by tiny dots,
just click inside the object and start typing to add
your text.*

*Bottom: Using a centered alignment helps push the
text away from the object's edges.*

Warping Text

Another way to create text that follows a shape is to use the Create Warped text com-
mand. Be forewarned, though, that this option distorts the *shape* of the letters (so
they might not be very legible when you're done), whereas type on a path alters only
the baseline and orientation (direction).

The Create Warped Text button appears in the Options bar when a Type tool is active (with any other active tool, choose Edit→Transform→Warp). Unlike placing type on a path or inside an object, to warp text, you have to create the text first and *then* click the Warp button. Pick one of the 15 canned settings in the Warp Text dialog box's Style pop-up menu (Figure 14-12), and then customize the style by tweaking the Bend, Horizontal, and Vertical Distortion sliders.

Tip: Make sure the Warp dialog box isn't covering up your text. Photoshop applies all your changes in real time, so you'll want to be sure and watch.

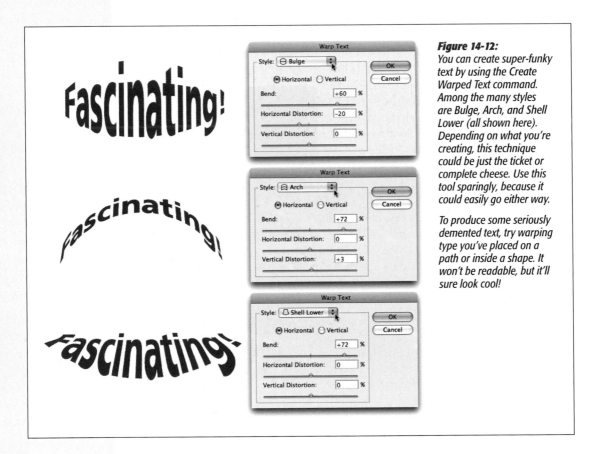

Figure 14-12:
You can create super-funky text by using the Create Warped Text command. Among the many styles are Bulge, Arch, and Shell Lower (all shown here). Depending on what you're creating, this technique could be just the ticket or complete cheese. Use this tool sparingly, because it could easily go either way.

To produce some seriously demented text, try warping type you've placed on a path or inside a shape. It won't be readable, but it'll sure look cool!

If you don't like the result, just press Option (Alt on a PC) and the Cancel button will change to read Reset. Click it to snuff out any changes you've made so far (click Cancel to exit the dialog box completely). Once you've got your text looking good and warped, click OK.

As long as you don't rasterize the Type layer (see the box on page 589), you can change the warp settings at any time. Just select the Type layer, grab the Type tool, and then click the Warp button to see the warp settings you used previously.

Note: You'll get an error dialog box if you try to warp text that's been faux bolded (see page 582). However, Photoshop will let you warp faux italic text with nary a squawk.

Using Find and Replace

No matter what kind of text you set, at some point you might need to exchange a word, phrase, or character for something else. It's usually easy enough to make such fixes manually, but if there's a fair amount of text in your document, you can reach for the "Find and Replace" command instead. For example, suppose you're working on a full-page ad for a sports-drink company and they've just changed the name of their flagship product from Dr. Bob's Thirst Remedy to Quenchtastic 4000. In that situation, you can save yourself lots of time by using the "Find and Replace" feature. Photoshop will seek out the offending word or phrase and replace it with whatever you want.

Choose Edit→"Find and Replace Text" to summon the dialog box shown in Figure 14-13 (you don't even need to have the Type tool active or a Type layer selected). Enter the offending word or phrase in the Find What field and its replacement in the Change To field. Use the checkboxes to tell Photoshop whether you want it to search through all the Type layers in your document; look only for instances that match the case (capitalization) of what you've typed; search from a specific point in a Type layer forward (this one's only available if you have the Type tool active and the cursor blinking at a point within the text); look for whole words only; or any combination of these options.

Figure 14-13:
Hopefully you'll never set enough text in Photoshop to need the "Find and Replace Text" feature, but it can come in handy in a pinch.

Thou Shalt Spell Check

Few mistakes are as embarrassing (or avoidable) for a graphic artist as a misspelled word. Most software comes with a built-in spellchecker—and Photoshop is no exception. There's little excuse for the common typo (on the other hand, *wordos*—real words in the wrong place—are another story). And let's face it: The people who create copy can rarely spot their own mistakes, either because they've been staring at it for too long or they're rushing to meet a deadline. In those situations, using a spellchecker is essential.

To check spelling in Photoshop, choose Edit→Check Spelling. Photoshop scours the document (layer by layer) and, in the resulting dialog box, alerts you to words it considers suspect. It dutifully offers a list of suggestions that you can ignore or accept, changing just one instance or all of them. If it encounters an unknown word that is oft-used and correctly spelled, just click the Add button and Photoshop assimilates the word into its dictionary.

Whether you're typing five words or five paragraphs, take time to run the spellchecker—you'll be glad you did.

Formatting Text

Now that you've learned all about the different *kinds* of Photoshop text, it's time to dig into how to format it. Photoshop CS5 lets you control text to within an inch of its life. Beyond the basics of font, size, and color, you can adjust the softness of the letters' edges, the space between each letter, the space between lines of text, and so on.

The most commonly used settings live in the Options bar, while the more advanced typographic goodies are nestled snugly inside the Character and Paragraph panels. But no matter where the settings live, if they control text, you'll learn about them in the following pages. Read on!

Formatting with the Options Bar

When you have the Type tool active, the Options bar (Figure 14-14) offers basic text-tweakers such as font family, style, size, anti-aliasing (see page 603), alignment, and color. (The Character panel, discussed on page 603, offers all these settings and more.)

Note: Remember, any changes you make in the Options bar *remain* until you change them back. If you suddenly find that your text isn't behaving like you expect, chances are there's a setting in the Options bar that needs changing.

Hover above a field
label to get this
scrubby cursor

Toggles Character and
Paragraph panels
on/off

Text orientation Font style

Anti-aliasing Text color

Font family Font size Left align Warp
 Center align
Type tool preset picker Right align

Figure 14-14:
*You'll see these
formatting choices
in the Options bar
anytime the Type tool
is active. A handy
way to change any
numeric setting (like
font size) is to hover
your cursor over the
field's label until you
see a double-arrowed
scrubby cursor
(circled). Simply drag
to the left or right to
decrease or increase
that setting without
using the field's drop-
down menu (or your
keyboard).*

You can apply formatting either before or after you create text:

- **Before you type.** If you know exactly what font, style, and size you want to use before you start hammering out text, applying formatting beforehand is the way to go. Press T to select the Type tool and then head up to the Options bar or the Character panel to pick your settings.

- **After you type.** This is the more common method, since it's easier to see how formatting choices affect *existing* text than try to imagine how it might look. With the Type tool active, select the text you want to format using one of the methods described on page 586, and then use the Options bar or Character panel to change the formatting however you wish.

From left to right, the Options bar gives you control over the following:

- **Type Tool Preset picker.** Out of the box, this tool performs the fairly useless service of letting you quickly summon horizontal type in either the Myriad or Minion font in a variety of sizes. Thankfully, with just a little bit of work, you can create your own presets—a fantastic idea if you use the same formatting over and over again.

 Start by formatting the text exactly the way you want it and make sure the Type layer is selected (you don't have to select the text itself). Then click the triangle next to the Tool Preset picker and choose New Tool Preset from the pop-up list. Enter a meaningful name in the resulting box, and then click OK. Photoshop memorizes how you formatted the text so it can apply that formatting automatically the next time around. Just grab the Type tool, select your style from the Tool Preset picker, and then click in your document and start typing.

- **Text orientation.** There's no need to decide if you want horizontal (left to right) or vertical (top to bottom) text before you type: pushing this little button will flip the whole Type layer on the fly. You don't even have to select any text first.

- **Font family.** This menu lists every font currently installed on your machine, and includes a preview of what each font looks like. (If you want to turn off this preview, flip over to page 582.)

- **Font style.** Here's where you can choose a native style (page 581) for the font you selected, such as light, bold, condensed, and so on.

- **Font size.** Enter a point size for your text in this field, or hover above the field's label and use the scrubby cursor shown in Figure 14-14 to change the size. Though text size is typically stated in points, you can change the unit of measurement to pixels or millimeters by choosing Photoshop→Preferences→Units & Rulers (Edit→Preferences→Units & Rulers on a PC).

Tip: If you need to create *super* large text, Photoshop will put up a fight. When you type a number greater than 1296 into the Font size field, you'll see an error message asking you to enter a number between 1 and 1296. This is an odd little quirk of Photoshop's, but if you're sneaky, you can work around this limitation by resizing your text with the Free Transform tool (page 95): Enter 1296 into the size field and then choose Edit→Transform→Scale. Drag the resulting resizing handles outward to make the text really honkin' big and then press Return (Enter on a PC) to accept the transform.

- **Anti-aliasing.** Anti-aliasing was mentioned way back in Chapter 4 as a method for smoothing the edges of a selection (page 141). Similarly, this option can also smooth text, helping you avoid the dreaded jagged edges so common when printing to an inkjet printer or posting on the Web.

 Your choices here are None, Sharp, Crisp, Strong, and Smooth. Each setting has a different effect on various text sizes, so you might have to do a little experimenting. Use None on extremely small text to make it clean and sharp (especially super-small text destined for the Web), and Strong or Smooth for larger text to keep it from looking jagged when it's printed (especially if it's headed for an inkjet printer).

- **Alignment.** These three buttons make text appear flush left, centered, or flush right, within a single line of text or a text box. To align a single line of text on a Type layer that contains many lines, press T to activate the Type tool, click within that line, and then press one of the alignment buttons. To center everything on a Type layer, double-click the Type layer's thumbnail in the Layers panel, and then click an alignment button. (Unless you specifically apply a different alignment, Photoshop automatically left-aligns text.)

Tip: You can also use keyboard shortcuts to align text. To left align, select some text and press ⌘-Shift-L (Ctrl+Shift+L on a PC). For center alignment, press ⌘-Shift-C (Ctrl+Shift+C), and for right alignment, press ⌘-Shift-R (Ctrl+Shift+R).

- **Text color.** You can set text color by selecting your text and then clicking the little colored swatch on the Options bar, which shows the current text color. (There's a similar button in the Character panel that does the same thing.) You can also set text color before you type by clicking the foreground or background color chip (page 24). To recolor the text with your foreground color, select the text using one of the methods described on page 586, and then press Option-Delete (Alt+Backspace on a PC). To use the background color instead, press ⌘-Delete (Ctrl+Backspace).

Note: When choosing a text color, resist the urge to go hog wild. Bear in mind that black text on a white background is the easiest to read, as is any dark-colored text on a light background. The key is contrast—it's really hard to read text that's similar in color to its background. However, if you're adding text to a dark background, you risk the danger of introducing *too* much contrast. For example, a single line of pure white text on a black background is quite legible, but a large block of white text on a black background—especially on the Web—is eye-numbing. In that situation, you'd be better off using light-gray text instead, because the contrast won't be quite so high.

- **Create Warped text.** You can use this option to curve and distort text in all manner of exciting ways, as explained on page 597. This button is easy to spot: It has a capital T perched atop a curved line.
- **Character panel.** Click this little button to pop open the Character and Paragraph panels for even more text formatting goodness, as explained in the next two sections. (Click it again to hide them.)

The Character Panel

You've probably noticed the Character and Paragraph panel icons lurking near the right side of your screen in the panel dock (see page 21 for more on the panel dock)—they look like a capital A and a paragraph symbol, respectively. If you don't see them in the panel dock, choose Window→Character (or Window→Paragraph) and Photoshop adds both panels to the dock for you. (It assumes that if you're using one, you'll soon be using the other, which is a pretty safe bet.) Read on for a detailed discussion of each.

The Character panel, shown in Figure 14-15, has enough formatting options to please the most discerning typesetter. It includes all the settings found in the Options bar, plus it lets you control the space in and around individual characters, where they sit on a line, the height of the line, and more. The Character panel also holds the key to unlocking some amazing OpenType features discussed on page 579. Mastering this panel can help you turn ordinary type into a work of art.

Note: Like the Options bar, any changes you make in the Character panel remain in effect until you change them back. So, if you play with leading (explained below) on Monday and then add text to a brand-new document on Tuesday, the leading may look a bit off. Either use the leading pop-up menu to change it back to Auto or go to the Character panel's menu (see Figure 14-15) and choose Reset Character, which reverts *all* the Character panel's settings back to normal.

Panel menu

Character panel dock

Leading

Tracking

Horizontal scale

Text color

Anti-aliasing

Kerning

Vertical scale

Baseline shift

Character set language

Figure 14-15:
Behold the mighty Character panel! Here you'll find controls for tracking, kerning, adjusting text's baseline, and more. You can control every bit of horizontal and vertical space in and around the letters in your document from this panel. Hover your cursor above any numeric field's label to summon the ever-handy scrubby cursor (shown in Figure 14-14), and drag left or right to decrease or increase the field's value. If you (understandably) forget what some of these settings do, hovering your cursor over any of the field's labels also displays a handy balloon that tells you what that setting does.

Note: To close the Character panel, click the two right-facing arrows in the upper-right corner of the panel, and Photoshop slides it shut. To get it back, just click the A button in the panel dock or choose Window→Character.

A lesson in leading

If you've ever added extra carriage returns between lines of text to create space or wondered how designers make lines of text appear all squashed together, you've encountered *leading*. Leading (rhymes with "bedding") controls the amount of blank space between lines of text. The term originated back in the days when type was set by hand onto printing presses, and lead strips of various thicknesses were used to create space between lines. Learning to control leading is a useful design skill, and happily, Photoshop gives you complete control over it as shown in Figure 14-16.

I never think
of the future,
it comes soon
enough.

I never think
of the future,
it comes soon
enough.

I never think

of the future,

it comes soon

enough.

Figure 14-16:
Attention Goldilocks: The leading on the left is too little, the leading on the right is too much, but the leading in the middle—set to Auto—is just right (for this situation, anyway; auto leading isn't perfect for every project). As you can see, leading can make a design statement; ask yourself which one your typography needs to make.

Leading is measured in points just like text, though it *includes* the point size of the text itself. Leading that's equal to the point size of text is called *solid leading*, which creates lines of text that almost touch (resulting in spacing that's somewhere between what's shown in the left and middle of Figure 14-16). Photoshop's leading is set to Auto (unless you change it), which is approximately 120 percent of the text's point size (see Figure 14-16, middle). For example, 10-point type has an auto leading of 12 points.

In the Character panel, the leading control (labeled with two As stacked on top of each other) lives directly beneath the font style pop-up menu. You can adjust the leading of several lines of text at once or one line at a time. To adjust the leading of multiple lines of text on the same layer, select the offending Type layer in the Layers panel (there's no need to highlight the text), and then choose a point size from the leading pop-up menu, or type directly into the text field. (Better yet, hover your cursor above the field's label and use the handy scrubby cursor.) If you want to adjust the leading of a single line of text on a Type layer that contains many lines, select the text first (page 586) and then change the leading.

Tip: You can also use keyboard shortcuts to change leading. Select the text and then press and hold Option (Alt on a PC) and tap the up or down arrow keys to change the leading in increments of 2 points; add ⌘ (Ctrl) to change it in increments of 10 points. To set leading back to Auto, press Shift-Option-⌘-A (Shift+Alt+Ctrl+A).

Learning to kern

To *kern* means to adjust the amount of space between pairs of letters. Poorly kerned (or unkerned) text looks funky and can be distracting to the reader, as you can see in Figure 14-17, top. A lack of kerning is perhaps the biggest clue that text has been set nonprofessionally (nothing exposes a typographical novice faster!). Admittedly,

the problem is more noticeable with less expensive—or free—fonts (like Frolicking Ferrets), scripts, and decoratives (especially fonts that mimic handwriting, like the one in the figure).

Figure 14-17:
Top: Here's some text borrowed from a BMW motorcycle ad in a naked, unkerned state. Notice how several of the letters appear too close together? The punctuation is even worse—it's practically in a different Zip code.

Bottom: After a little kerning, the text looks normal instead of helter-skelter, so readers can focus on what the copy says instead of the weird spacing. (Get it? My hairstylist is my motorcycle helmet? Oh, never mind.)

Over in the Character panel, the kerning button is marked by the letters AV and two arrows pointing in opposite directions. The numbers in the kerning pop-up menu range from positive to negative; positive values increase space, and negative values decrease space. Kerning values are measured in 1/1000 em; an *em* is a relative measurement based on the point size of the type. For example, if the type size is 12-point, 1 em equals 12 points. Since you can create type of various sizes, this measurement ensures that your kerning is always based on the type size you're currently working with.

Note: Though Photoshop tries to kern text automatically, it's best to do it manually as described here. For more on auto vs. manual kerning, see the box on page 608.

Because the amount of space each letter needs (on either side) differs according to which letter comes next—an *A* can tuck in closer to a *V* than it can to an *M*, for example—you'll want to kern each space individually. Press T to grab the Type tool and position the cursor in the first problem area you spot (in Figure 14-17, that's between the *a* and *v* of *have*—they're way too close together). To widen the space, pick a positive value from the kerning pop-up menu or drag the scrubby cursor gently to the right (you can also type a value into the kerning field). If you want to narrow the space, pick a negative value or drag the scrubby cursor to the left.

Tip: There's a keyboard shortcut for changing kerning, but you need to place your cursor between the letters you want to adjust first. Press and hold Option (Alt on a PC) while tapping the left or right arrow key to change the kerning in increments of 20. Add the ⌘ key (Ctrl) to change it in increments of 100.

Track it out

If you want to change the spacing between *all* letters in a word by the same amount, you need to adjust *tracking*. This adjustment is great for when you're trying to make text fit into a small area. Also, vast amounts of tracking, as shown in the word "conference" in Figure 14-18, can be a useful design trick. Like kerning, tracking is measured in 1/1000 em. To make an adjustment, you must first select the word(s) you want to track and then trot over to the Character panel and look for the setting marked with an AV with a double-headed arrow beneath it. Pick a value from the pop-up menu, enter it manually, or use the scrubby cursor you get by hovering your cursor above the AV.

Figure 14-18:
Tracking is a great way to make a word fit into a small space, or fill a big space. In this example, the word "conference" has been tracked out to stretch from the g in "digital" to the last a in "camera." Because the large amount of space between the letters is uniform and obviously deliberate, it becomes a useful design element (and it's also one of the few ways all-caps text looks good—the extra space makes it easier to read).

Tip: As you might suspect, there's a keyboard shortcut for this one too. To adjust tracking in increments of 20, select some text and then press and hold Option (Alt on a PC) while tapping the left or right arrow key. Add the ⌘ key (Ctrl) to change tracking in increments of 100.

Doin' the baseline shift

Text's *baseline* is the invisible line on which its letters sit. Changing it can make a character appear higher or lower than other characters on the same line (see Figure 14-19). This is called *baseline shift*, and you can think of it as an exaggerated super- or subscript control (as in dollar signs and degree symbols). Remember the section back on page 594 about type on a path? Baseline shift was used to scoot the text above the path. It's also helpful when you want to create fractions, use initial caps (shown in Figure 14-19), or manually adjust characters in a decorative font.

Figure 14-19:
Notice how the big, fancy D is lower than the rest of the word "diva"? That's because its baseline shift has been decreased to −30 points.

To adjust the baseline of a character, word, or phrase, select the text you want to tweak and then head to the Character panel (if you don't select anything, the adjustment will be applied to the next thing you type). Use the baseline shift setting (it's marked with a big A and little a) to move the text up or down by picking a positive or negative value (respectively) from the pop-up menu, by entering a value manually, or by using the scrubby cursor.

Tip: Once you've selected some text, press Shift-Option (Shift+Alt on a PC) while tapping either the up or down arrow on your keyboard to shift the baseline in increments of 2 points. Add the ⌘ key (Ctrl) to shift it in increments of 10 points.

POWER USERS' CLINIC

Auto vs. Manual Kerning

Ever helpful, Photoshop tries to kern text for you. Perched at the top of the kerning pop-up menu in the Character panel are two auto-kerning methods: Metrics and Optical.

Metrics kerning is the most common method. It tells Photoshop to adjust the space between letters according to their *kern pairs*—the amount of spacing between letter pairs (like *Tr, To, Ta*, and so on) that the designer specified when creating the font. Photoshop applies metrics kerning automatically anytime you create or import text (unless you've changed this menu's setting).

However, some fonts contain little or no info about kern pairs, but you won't know that until you start typing. So, if the kerning looks really bad, Adobe recommends that you manually switch to optical kerning, where Photoshop adjusts the space according to characters' shapes instead. Optical kerning is also helpful when you use more than one font (or font size) in a single word.

The best method of all, though, is to kern text manually as described on page 605. It takes more time, but the results are well worth it.

Other character options

The Character panel is chock-full of other formatting controls. Just remember that, to apply any of the formatting discussed in this section, you first have to select some text.

As shown in Figure 14-15 (page 604), the Character panel is where you can turn on faux styles (page 582), like bold and italic (they're not built into the font, but faked by Photoshop instead). Feel free to use faux styles if you're creating a piece for online use or at-home printing, but it's best to stay away from the faux stuff if the project is bound for a professional printer, as they can cause unexpected results. Problems include jagged text (due to rasterization); characters that refuse to print (which will cause Photoshop to substitute another font); or a PostScript error, which can halt printing altogether.

Among the other styles offered by the Character panel for your formatting pleasure are underline (which places a line under the text), and strikethrough (which places a line *through* the text).

Tip: The keyboard shortcut for bolding text (after it's selected) is Shift-⌘-B (Shift+Ctrl+B on a PC), for italicizing, it's Shift-⌘-I (Shift+Ctrl+I), for underlining it's Shift-⌘-U (Shift+Ctrl+U), and for adding a strike-through, it's ⌘-Shift-Ctrl-? (Ctrl+Shift+?). Whew!

The other options in the Character panel are:

- **Horizontal/Vertical Scale.** These two settings (which stretch or shrink text horizontally or vertically) have the power to squish, cram, and spread type to within an inch of its life, rendering it utterly unreadable and unrecognizable, so use these options at your own risk! If you're trying to save space, a better solution is to adjust kerning or tracking (or both). If you're trying to fill space, increase the type size or tracking instead.

Tip: If you've played around with the scale of your text, you can instantly get it back to normal with the flick of a keyboard shortcut. Reset the vertical scale to 100 percent by selecting your text and then pressing Shift-Option-⌘-X (Shift+Alt+Ctrl+X on a PC), or reset the horizontal scale to 100 percent by pressing Shift-⌘-X (Shift+Ctrl+X).

- **All Caps/Small Caps.** If you need to switch lowercase text to uppercase, just select the text and then press the All Caps button (marked with TT). But keep in mind that, unless you're creating a small amount of text and perhaps tracking it out as shown in Figure 14-18, using all caps is a bad idea. They're extremely hard to read because the words all take on the same blocky shape. Besides, they tend to insinuate screaming (LIKE THIS), and that's not very reader friendly. The Small Caps button (marked with a big T and a smaller T) isn't much better

as it creates smaller versions of the same, hard-to-read all caps. The keyboard shortcut for all caps is Shift-⌘-K (Shift+Ctrl+K on a PC); for small caps, it's Shift-⌘-H (Shift+Ctrl+H).

- **Super and Subscript.** The Superscript and Subscript buttons cause the baseline and point size of the selected character(s) to change. (If you don't have any text selected, the next character you type will be superscript or subscript.) Superscript increases the baseline shift so the character sits above other text in the same line (great for trademark symbols such as ™ and ®), while subscript decreases the baseline shift so the character sits below other text (perfect for footnotes and scientific or mathematical text).

Tip: The keyboard shortcut for superscript (which you can use after selecting text) is ⌘-Shift-plus (Ctrl+Shift+plus on a PC). For subscript, press ⌘-Shift-Option-plus (Ctrl+Shift+Alt+plus).

- **Language.** The language pop-up menu at the bottom of the Character panel won't translate text for you; it merely means that Photoshop will adjust spell checks and hyphenation to suit the selected language. The 40 or so choices include everything from Bulgarian to Ukrainian. (The box on page 600 has info on spell checking.)
- **Anti-Aliasing.** The Character panel's anti-aliasing control (in the lower-right corner of the panel) works just like the anti-aliasing control on the Options bar, described on page 602.

But wait—that's not all! The Character panel has *even more* settings hidden in its menu, and they're all covered in the next few pages.

Orienting text

The Character panel is jam-packed with formatting options, and even though Adobe managed to cram an astonishing amount of stuff into this one panel, they couldn't fit everything. The solution was to stuff the remaining features into a menu tucked away in the upper-right corner of the Character panel (circled in Figure 14-20). When you open it, Photoshop unveils a long list of options that you won't use all that often, but they occasionally come in handy.

The first couple of options determine how text is oriented (the direction in which it's headed):

- **Change Text Orientation.** This menu item lets you switch horizontally-aligned text to vertical, and vice versa. Just select the Type layer you want to swap, not the text itself.

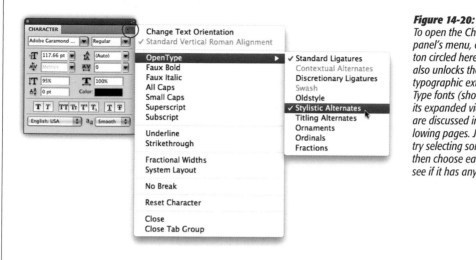

Figure 14-20:
To open the Character panel's menu, click the button circled here. This menu also unlocks the secret typographic extras of Open-Type fonts (shown here in its expanded view), which are discussed in the following pages. Just for fun, try selecting some text and then choose each option to see if it has any effect!

- **Standard Vertical Roman Alignment.** This is a fun one, though it works only on vertical type. Instead of the letters flowing from top to bottom, perched atop each other, they'll flow from left to right as if they were turned on their side. (Picture the word "Vertical" back in Figure 14-5 [page 584] lain down on its side.) Another way to create this effect is to use the Free Transform tool (page 95) to spin the type around 90 degrees.

Alternate ligatures and other fancy flourishes

These goodies are reserved for OpenType fonts only (PostScript and TrueType fonts don't have them). As discussed on page 579, this format lets font designers include alternative character designs and all manner of glyphs into a font. Some have alternate *ligatures* (two or more characters that have been designed into one for better flow—like an *fi* or *fl* combination), fancy flourishes, a whole set of ornaments, and more. These embellishments are perfect for creating fancy initial caps, formatting numbers, and for adding a bit of typographic pizzazz, as shown in Figure 14-21.

Choose OpenType from the Character panel's menu and Photoshop displays the extras in yet another menu (shown in Figure 14-20). Be aware, though, that some OpenType fonts have extras and some don't; if one of the menu items is grayed out, that means it doesn't exist in that particular font. Here's a quick rundown of what you might encounter in the OpenType menu:

- **Standard Ligatures** are alternate character designs for certain letter combinations that tend to touch—like *fi, fl, ff, ffi,* and *ffl*.

Fancy

Fancier

Fanciest

Figure 14-21:
The top line of text is in standard Adios Script Pro, a truly gorgeous OpenType font. The middle line was created using Contextual Alternates, which summons alternate letter designs depending upon where the letter falls within a word. The last line was created using the extra-flourishy Swash option.

- **Contextual Alternates** substitutes certain letterforms for others that join together more fluidly. This option is common on script fonts because it makes the letters look like cursive handwriting.

- **Discretionary Ligatures** are replacements for letter pairs like *ct, st,* and *ft.* They tend to have a bit more flourish than their standard ligature counterparts.

- **Swash** will substitute a standard character for one with an exaggerated stroke (think calligraphy).

- **Oldstyle** prompts Photoshop to use smaller numerals than normal; some even sit below the baseline (page 607) so they blend more smoothly into the flow of text. Use this option when you want your numbers to appear more elegant, but not when numbers need to line up in a stack, as in an annual report.

- **Stylistic Alternates** are characters that have extra bits of decoration here and there, as shown at the bottom of Figure 14-21. They're for your visual pleasure only (and, of course, that of the font designer).

- **Titling Alternates** calls to action a special set of all capitals designed to be used at large sizes, for things like titles (hence the name).

- **Ornaments** are symbols or pictographs (like WingDings).

- **Ordinals** decreases the size of letters appearing next to numbers and increases their baseline shift so they look like this: 2nd, 3rd, 4th, and so on.

- **Fractions** converts a number-slash-number combination (like this: 1/2) into a real fraction (like this: ½).

To apply the special OpenType features to existing text, you have to select the text using one of the methods described on page 586 *and then* choose an item from the OpenType menu. If you don't have any text selected, Photoshop will apply the feature to the *next* character you type.

Fractional widths

Also in the Character panel's menu, the *fractional widths* command rounds character widths to the nearest part of a pixel instead of the normal whole pixel. This setting is automatically turned on because it usually tightens text spacing, making it more visually pleasing (like kerning, discussed on page 605). However, Adobe recommends turning this option off if you're working with anything smaller than 20-point text because the tighter spacing can make small text hard to read. When it's turned off, Photoshop uses whole-pixel spacing, which gives each character a bit more breathing room and keeps them from running into each other.

Note: You can't apply the fractional widths command to individual characters; it's an all-or-nothing, "everything on the Type layer is affected" kind of thing. To use whole-pixel increments for the entire document, choose System Layout (explained next) from the Character panel's menu.

System Layout

The *System Layout* option will revert your text to the way your particular operating system displays it—similar to what you might see in TextEdit on a Mac or WordPad on a PC. It switches character widths to whole pixels (as discussed in the previous section) and turns off anti-aliasing (page 602). This is a good option to use when designing text for the Web, because the extra space and letter sharpness makes super small text a little easier to read.

No Break

When it comes to hyphenation, some words are meant to be broken and some aren't (as shown in Figure 14-22). To prevent such typographical gaffes from happening to you, select the word(s) you want to keep together and then select *No Break* from the Character panel's menu. This forces Photoshop to reflow the text so the word doesn't end up sliced in two. For more on hyphenation, see page 616.

Reset Character

If you've gone a bit overboard with formatting and want to return the formatted text to its original glory, select the text and then choose *Reset Character* from the Character panel's menu. If you don't have an active text selection, the newly restored character settings will affect the next thing you type.

In MotoGP, Rossi is a leg-end.

Angry wife is jailed for mans-laughter.

Figure 14-22:
This is what happens when good hyphenation goes bad. The fix is to highlight the offending word and choose No Break from the Character panel's menu.

Close and Close Tab Group

Close and *Close Tab Group* were new in Photoshop CS4. Choose Close to make the currently active panel disappear (like the Character panel), or Close Tab Group to make a whole group of related panels disappear (both the Character and Paragraph panels, for example). See Chapter 1 for more on panels and docks.

The Paragraph Panel

The Paragraph panel, shown in Figure 14-23, doesn't have anywhere *near* the number of options as the Character panel, though that doesn't make them any less important. Paragraph formatting controls alignment, hyphenation, justification, indentation, and spacing. Read on for a full discussion of each.

Not one to be left out, the Paragraph panel also has a menu containing features that just wouldn't fit anywhere else (Figure 14-24); they're discussed in the following pages.

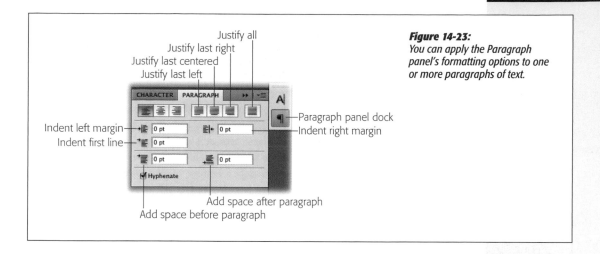

Figure 14-23:
You can apply the Paragraph panel's formatting options to one or more paragraphs of text.

Figure 14-24:
You can open the Paragraph panel's menu by clicking the button in the upper-right corner of the panel (circled).

Just like the Character panel, any changes you make in the Paragraph panel remain until you change them back. If you want to restore the settings (or your text) to their original form, choose Reset Paragraph from the panel's menu.

Aligning text

Alignment gives readers' eyes a hard edge to follow as they read through text, with the edge itself forming an invisible line that connects items on a page. The basic alignment types are left, center, and right, and picking the correct one for your document can make it look stronger, cleaner, and more dramatic. So which alignment should you choose? It depends on what you're going for. Here are a few guidelines:

- **Use left alignment for big blocks of text.** Newspapers, books, and magazines (which should not be created in Photoshop, mind you) usually stick with left alignment because it's the easiest to read. Unless you tell it otherwise, Photoshop will left-align everything.

- **Use centered alignment for formal situations.** There's a reason the copy in every graduation and wedding announcement you've ever seen is centered—it conveys a feeling of formality and elegance. So unless you live on Pennsylvania Avenue, resist the urge to center the copy on your next yard sale flyer.

- **Use right alignment for small blocks of text or numbers.** Right alignment can make text stand out because it's unusual and therefore draws attention. Bear in mind, though, that it's harder to read than left alignment, meaning you'll want to save it for relatively small chunks of text (don't right align your next novel). However, it's great for using on lists of numbers because it makes the decimals points (or commas) line up.

Tip: With vertical type, these options align the text based on a vertical line instead of a horizontal one. So instead of left, center, or right alignment, your options are top, center, or bottom.

You can align text on a single layer (or even a single line on a layer) or across multiple Type layers:

- **Aligning text on a single Type layer or on multiple Type layers.** Feel free to use different alignments on lines of text on the same Type layer. First, activate the Type tool and the Type layer you want to work on. If you want to align a single line of text, click anywhere within that line and then press the appropriate alignment button in the Options bar or the Paragraph panel. To align all the text on that layer, select it using one of the methods described on page 586, and then click an alignment button. To align the text on several Type layers, select the layers by Shift- or ⌘-clicking (Ctrl-clicking on a PC) to the right of the layers' thumbnails and then clicking an alignment button.

- **Aligning Type layers themselves.** If you need to align the left edge of text across several layers, you use a whole different set of alignment tools. Select the offending layers as described in the previous bullet point, and then press V to grab the Move tool (which makes sense because in this case, the Type layers will move) and poof!—a whole slew of alignment tools appears in the Options bar. Click the one you want to apply and the selected layers dutifully jump to the left, right, or center. These alignment tools are covered more fully on page 96.

Hyphenation and justification

Known to page-layout pros as H&J, these controls work together to spread paragraph text so that both the left and right edges are perfectly straight, or *justified*. (The text in most magazines, newspapers, and books—including this one—is justified.) They also determine how the words are sliced and diced (*hyphenated*) in order to make them fit within a text box or to make the margins perfectly straight.

Note: Hyphenation and justification work only on paragraph text, not point text (page 584 explains the difference).

Photoshop's hyphenation feature is automatically turned on, but you can turn it off using the checkbox at the bottom of the Paragraph panel, or by selecting the text and pressing ⌘-Shift-Option-H (Ctrl+Shift+Alt+H on a PC). However, you have to turn justification on manually by selecting one of the following options:

- **Justify last left.** This setting spreads text so that the left and right edges are perfectly straight (even on both sides), with the last line of the paragraph left aligned (meaning it doesn't reach across to the right margin), like the text in this book. The keyboard shortcut for this kind of justification is to select your text and then press Shift-⌘-J (Shift+Ctrl+J on a PC).

Tip: Justification is affected by which *composition method* you've chosen. See the box on page 620 for more info.

- **Justify last centered.** This is the same as the previous setting, but with the last line center aligned instead.

- **Justify last right.** Same again, but with the last line right aligned.

Note: If you're working with vertical text, your justification options are justify last top, centered, and bottom.

- **Justify all.** With this setting turned on, the left and right edges of text are perfectly straight, but the last line is spread out to span the entire width of the paragraph. The results usually don't look very good (the last line tends to be really sprawled out), but once in awhile some rebellious designer manages to pull it off, as shown in Figure 14-25.

It's unlikely you'll ever need to adjust the H&J options, and if you do, that's a sign you should be creating your text in another program (see the box on page 577). Nevertheless, you *can* customize hyphenation and justification through the Paragraph panel's menu (see Figure 14-24). For the scoop on adjusting these settings, see Figure 14-26.

Tip: If you don't want a word or phrase to get hyphenated, use the No Break option over in the Character panel's menu (see page 613).

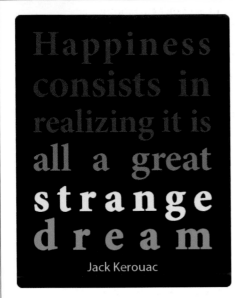

Figure 14-25:
If you want to truly tax your text, use blocked justification. This forces all the lines of text to line up vertically, even the last one. It's really hard to make blocked text look good, though the folks at QuotableCards.com managed it quite nicely in this magnet design.

Figure 14-26:
Top: To get to this dialog box, select Hyphenation from the Paragraph panel's menu (shown in Figure 14-24). Here you can specify the minimum length of words that Photoshop can break across lines, where it can break them (after how many letters), and how many consecutive lines can have hyphenated words at the end (for the best results, leave this at two). The Hyphenation Zone field controls how close to the right margin text can get before Photoshop hyphenates it. Turn off the Hyphenate Capitalized Words checkbox to make sure names and proper nouns stay intact.

Bottom: Access this dialog box by choosing Justification from the Paragraph panel's menu. This is where you control how far apart words and letters get spread when Photoshop makes the margins perfectly straight. You can also adjust how far Photoshop stretches glyphs (page 578) during the process, and specify leading (page 604).

Indenting text

It should be clear by now that Photoshop is no word processor, so don't go rooting around expecting any serious margin controls. However, you do have *some* say in how much space Photoshop puts between the text and the left or right edge of a single line (for point text) or the boundaries of a text box (for paragraph text). You can find the following options in the middle of the Paragraph panel (shown back in Figure 14-23):

- **Indent Left Margin and Indent Right Margin.** These options will scoot a line of text to the left or right by the number of points you enter here.

- **Indent First Line.** This option indents only the first line of the paragraph. If you need to create a *hanging indent*—where all lines of a paragraph are indented *except* the first—you can do that here. (However, this is yet another indicator that you should be using page-layout software instead.) To create a hanging indent, enter a positive number (like 10) for the left indent and a negative number (like –10) for the first line indent.

- **Roman Hanging Punctuation.** This totally awesome feature is tucked away in the Paragraph panel's menu (circled in Figure 14-24). You can use it to make the punctuation sit *outside* the text margin, while the letters themselves remain perfectly aligned, as shown in Figure 14-27. (You don't need to select any text before applying this setting.)

"To enjoy the
flavor of life
**take big
bites.**"
Robert Heinlein

Figure 14-27:
The Roman Hanging Punctuation setting moves punctuation (in this case, the initial quotation mark) outside the margin, leaving the text perfectly aligned. Graphic designers love this option!

Photoshop's Composition Methods

"Great artists steal," or at least that's what Picasso and Steve Jobs say, and the folks at Adobe clearly agree: Deep within the Paragraph panel's menu (Figure 14-24) you'll find a couple of options snatched unabashedly from Adobe's page-layout program, InDesign.

Displaying text is a complicated matter. To determine how paragraph text is displayed, Photoshop takes into consideration word spacing, letter spacing, glyph spacing, and any hyphenation options you've set. With that information, it uses a complex formula to determine how lines of text are spaced (and broken, if necessary) in order to fit them within the text box you've created. This is called *composition*, and you have two composition methods to choose from:

- Use **Single-Line** if you're dealing with just one line of text, or if you want to hand-craft the spacing between letters and lines with kerning or by inserting manual line breaks (carriage returns). With this method, Photoshop composes each line individually, no matter how many lines your paragraph contains.

- Go with **Every-Line** if you've got more than one line of text. Choosing this method tells Photoshop to compose the paragraph as a whole. The program tries to arrange lines in such a way that it avoids nasty line breaks. This method generally creates more visually pleasing text, in part because it makes Photoshop avoid hyphenation whenever possible. Photoshop uses this method automatically unless you tell it otherwise.

Space Before and After

Take a peek at the headers and subheads in this book. Notice how there's more space above them than below? This kind of spacing makes it easy for you to tell—even at a glance—that the paragraph following the header is related. That's because the spacing itself is a visual clue: Information that *is* related should appear closer together than information that's *not* related. (In design circles, this is known as the rule of *proximity*.) Proper spacing makes it a lot easier for people to read a document quickly (or even just scan it) and understand how it's organized.

To adjust the spacing in your document, you could take the easy way out and add a few extra carriage returns, though chances are good that you'll introduce too much—or too little—space. Instead, use the Paragraph panel's Space Before and Space After options, which let you control spacing right down to the point (oh, glorious control, let us bow before thee!). To do that, select a Type layer and grab the Type tool by pressing T. Click anywhere in the offending line (don't select it, just click it), and then head to the Paragraph panel and enter an amount (in points) into the Space Before or Space After field, or both. (You can also use the scrubby cursor as discussed previously.)

Special Text Effects

You can spice up Photoshop text in a variety of ways by adding strokes, drop shadows, textures, and more. You can even take a photo and place it *inside* of text. The great thing is that you can perform all these techniques without rasterizing the text,

so it remains fully and gloriously editable. Read on to learn all kinds of neat ways to add a little something special to your text.

Tip: Perhaps the easiest special effect of all is creating partially opaque or *ghosted* text. All you have to do is lower the Type layer's opacity in the Layers panel, as explained on page 92. That's it!

Stroked Text

One of the easiest ways to enhance text is to give it an outline, making it really stand out. Photoshop calls this outline a *stroke*, and it's simple to add using the layer styles menu you learned about back in Chapter 3 (page 128). The following steps explain how to add a plain black stroke, as shown at the top of Figure 14-28.

Tip: You might be tempted to choose Edit→Stroke instead of following the steps below. Don't. To use the Edit menu's Stroke command, you have to rasterize the text first (in fact, the Stroke menu item will be grayed out if you've selected a Type layer, since it's vector-based). Using Layers Styles is a much more flexible way to outline text because your text remains editable.

1. **Add some text.**

 Press T to grab the Type tool and type a word. Be sure to choose a fairly weighty font like Futura bold or Cooper (the words in Figure 14-28 are in Cooper). If the letterforms are too thin, the stroke can overpower them.

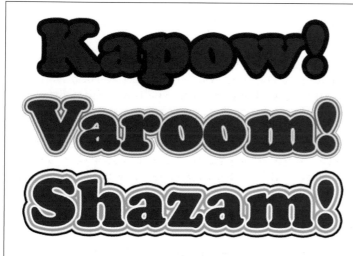

Figure 14-28:
Here are a few ways of stroking text with a layer style. The great thing is that, no matter what kind of stroke you create, you can edit it by double-clicking the newly added stroke style layer in the Layers panel.

Top: The classic thick, black, outside stroke.

Middle: By changing the Stroke Type to Gradient and the Style to Shape Burst, you can introduce more than one color to the stroke, which gives it a bit of flair. This gradient stroke was made with the Silver preset from the Metal set (see page 363 for more on loading gradients).

Bottom: By using the Gradient Editor (page 623) to create a custom solid gradient, you can make multi-stroked text, as explained in the next section.

2. **Choose Stroke from the Layer Style menu at the bottom of the Layers panel.**

 Photoshop pops open the Layer Style dialog box and displays the many options for adding a stroke to your text.

3. **Enter a stroke width.**

 In the Size field, enter a pixel width (or use the slider). Use a lower number for a thin stroke and a larger number for something more substantial (in Figure 14-28, top, the size was set to 8).

4. **Pick Outside from the Position menu.**

 Using Outside works well for text because it tells Photoshop to put the stroke on the *outside* of the character (as opposed to the inside where it takes up more space, or straddling the character's edge, as is the case with a Center position). Leave the blend mode set to Normal and the opacity at 100 percent.

5. **Choose Color from the Fill Type pop-up menu.**

 Photoshop assumes you want to fill the stroke with color (as opposed to a gradient, as explained in the next section) and it automatically chooses black. To create a standard black stroke, as shown at the top of Figure 14-28, leave this setting alone. If you want to pick something else, click the little color swatch and choose something else from the resulting Color Picker.

6. **When you're finished, click OK to close the Layer Style dialog box and admire your newly stroked text.**

You can edit the new stroke at any time by double-clicking the new stroke style layer in the Layers panel.

Tip: To produce hollow text, apply a Stroke layer style and then lower the Type layer's Fill opacity (page 92) to 0%. The stroke will still be visible, but everything *inside* the stroke will vanish.

The rare multi-stroked text effect

If you want to *really* make your text stand out—like in a comic book situation—try giving it more than one stroke, like the Shazam at the bottom of Figure 14-28. This technique is rewarding, but requires a few more steps than the plain ol' single-stroked version in the previous section. Begin with steps 1 and 2 for creating stroked text, and then proceed as follows:

1. **In the Layer Style dialog box, set the Fill Type field to Gradient and the Style menu to Shape Burst, as shown in Figure 14-29, top.**

 Using a gradient lets you add a multi-colored stroke to the text, though you'll need to do some gradient editing first. Choosing Shape Burst as the gradient

style makes the gradient stroke appear on the *outside* of the text only. You don't have to select a gradient style before editing the gradient; doing so just lets you see what you're creating.

2. **Open the Gradient Editor (page 365) and choose a new a gradient.**

 To open the Gradient Editor, shown in Figure 14-29, bottom, click the rectangular gradient preview. In the resulting dialog box, click once to use one of the handy preset swatches that appear at the top (see page 363 for more on loading and editing gradients).

 If you want to get really creative, proceed to the next step. If not, skip to step 4.

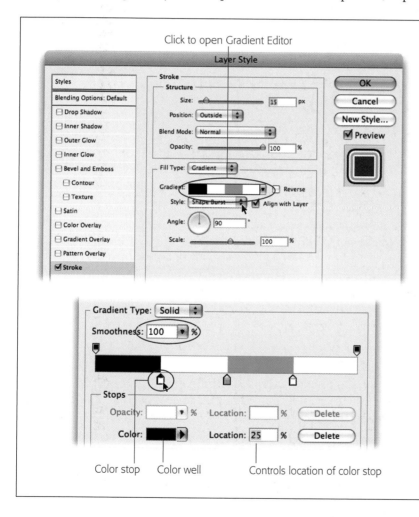

Click to open Gradient Editor

Color stop Color well Controls location of color stop

Figure 14-29:
These are the settings that were used on the Starship Enterprise…er, that were used to create the multicolored strokes around Shazam in Figure 14-28.

Top: Once you get the hang of editing gradients, you can simulate space between the color strokes by creating a solid gradient that goes from black to white (or whatever your document's background color is) to green and then back to white. Note that the color appearing closest to the text (white in this case) is the last color in the gradient preview shown here.

Bottom: To make your gradient match this one, you'll need to create six color stops. Place two at the 25% mark (black with white on top), two at 50% (white with green on top), and two more at 75% (green with white on top). As shown here, you'll see only three color stops when you're finished because the other three will be directly underneath them.

3. **Choose Solid as the Gradient Type and edit the individual color stops.**

 To edit one of the gradient's colors, click the tiny color stop (circled in Figure 14-29) and then click the color well that appears below it (or just double-click the color stop itself). Move the color stops around by dragging or by entering a number in the position field. You can create the illusion of space between the color strokes by introducing white into the gradient, as shown in Figure 14-29.

4. **When the preview looks good, click OK in the Gradient Editor, and then click OK again to close the Layer Style dialog box.**

Pretty nifty, 'eh? Once again, if you want to edit the stroke, just double-click the stroke style layer in the Layers panel.

Note: To learn how to create text that looks like it's made out of shiny metal, head to this book's Missing CD page a *www.missingmanuals.com/cds*.

Texturizing Type

Design trends come and go, but the distressed, tattered look has been popular for a long time. You can spot it everywhere: in movie posters, magazine ads, and book and album covers. Admittedly, it looks pretty darn good when applied to text. After all, text doesn't always have to look new, does it?

As with most effects, Photoshop gives you all kinds of ways to create a textured look. You can use a photo for the texture, run a filter (or several), or hide portions of the text using a layer mask and then paint it back with an artistic brush. Depending on your situation, one of these methods will work better for you than the rest (or at least be faster). They're all covered in the following pages.

Note: Adding a layer mask to a Type layer opens up all manner of creative possibilities, some of which appear in the following pages (there are just too darn many to include them all). However, one simple text-masking trick is a classic text fade: Simply add a layer mask to an existing Type layer and use the Gradient tool to fill it with a black-to-white gradient. The resulting text will appear to fade softly out of sight. See page 287 for more fun with gradient masks.

Texture from a photo

You can come up with some unique effects by grabbing texture from a photo and applying it to text through a layer mask. And the great thing about this technique is that it's completely nondestructive: the Type layer remains editable. Start with an extremely busy photo—one with lots of hard lines and angles, like a picture of wood, leaves, or an interesting piece of architecture. In the steps below, you'll use the Threshold adjustment (page 337) to morph that photo into a high-contrast texture primed for plopping into the nearest layer mask, as shown in Figure 14-30.

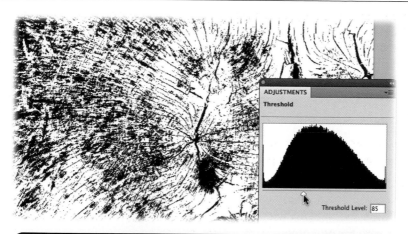

Figure 14-30:
Top: You can create a texture from any photo using a Threshold adjustment (the more lines the photo contains, the better). Areas in shadow will become black and the highlights will become white.

Bottom: Here's what the wood texture looks like after it's been copied into the layer mask of a Type layer. Imagine the possibilities!

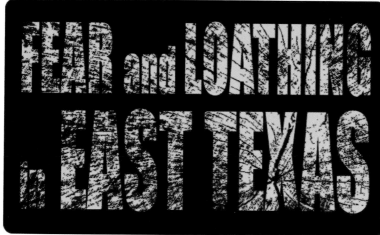

Here's how to texturize your text using a photo:

1. **Add some hefty text to your document.**

 Use a thick font (like Impact), and set the font size to something high (try 107 point). This will ensure you have plenty of surface area to texturize.

2. **Open a photo and convert it to a high-contrast, black-and-white image using a Threshold adjustment.**

 Choose Image→Adjustments→Threshold. Drag the Threshold Level slider almost all the way to the left to make the highlights in the image turn completely white, and the shadows turn black. The black areas will become the texture, so bear in mind that too much texture (black) will render the text unreadable.

3. **Create a selection of the black areas and then copy them.**

 When you want to create a selection based on color, reach for the Magic Wand (page 151). Press W to activate it and then click inside one of the black spots. Select the rest of the black areas by choosing Select→Similar. (You can also Ctrl-click [right-click on a PC] inside the selection area and choose Similar from the shortcut menu that appears.) Copy the selection by pressing ⌘-C (Ctrl+C).

4. **Add a layer mask to the Type layer, and then open the mask.**

 Give the Type layer a layer mask by clicking the circle-within-a-square icon at the bottom of the Layers panel (see page 113 for more on layer masks). Next, open the mask by Option-clicking (Alt-clicking on a PC) the mask's thumbnail in the Layers panel. Your document should go completely white because the mask is empty.

5. **Paste the texture into the mask and, if necessary, reposition the text, mask, or both with the Move tool.**

 Once you're in the layer mask, press ⌘-V (Ctrl+V on a PC) to paste the new texture into the mask. Feel free to resize the texture using Free Transform (page 263) or move it around with the Move tool.

6. **Deselect the texture and exit the layer mask.**

 Banish the marching ants by pressing ⌘-D (Ctrl+D on a PC) or choosing Select→Deselect. To see the finished product, exit the layer mask by clicking the Type layer's thumbnail to the left of the layer mask.

Note: Photoshop assumes that if you want to move a layer mask, you'll want to move whatever it's attached to as well, though this may not always be the case. If, for example, you want to move the text independent of the mask, or vice versa, you have to unlink them first. Just click the little chain icon that lives between the type and layer mask thumbnails in the Layers panel, and the chain vanishes. Next, activate the Move tool and then click the thumbnail of whatever you want to reposition—either the image or its mask—and drag it into place. To lock them back together, click between their thumbnails in the Layers panel and the chain icon reappears.

Texture from a brush

Another way to texturize text is by painting on a layer mask with the Brush tool. Photoshop has some amazingly funky-shaped brushes, so you might as well make good use of them! With this method, you can be a little more particular about exactly where the texture goes since you'll paint it by hand, as shown in Figure 14-31.

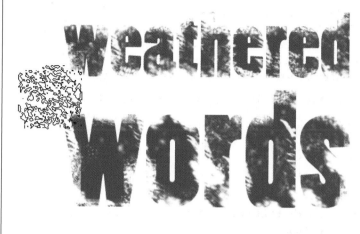

Figure 14-31:
By using some of Photoshop's more creative brushes, you can paint a unique texture onto your text using a layer mask (circled here). The cursor even takes on the shape of the brush, as you can see on the left side (it looks like a bunch of black squiggles). As with most text effects, you'll want to start out with a weighty font so you can actually see the texture you've so painstakingly applied (Poplar Std at 134 and 236 points was used here).

Add some big, thick text to your document, and then proceed with the following steps:

1. **Add a layer mask to the Type layer.**

 Select the Type layer and add a layer mask by clicking the circle-within-a-square icon at the bottom of the Layers panel. This mask will let you *hide* bits of the text instead of deleting it.

2. **Select the Brush tool and choose one of its more artistic manifestations like Spatter or Chalk.**

 Press B to select the Brush tool and then open the Brush Preset picker in the Options bar, or open CS5's new Brush Presets panel by choosing Window→Brush Presets. Scroll through the brush previews and select one of the more irregular, splotchy brushes. (Photoshop CS5 has a ton of super cool built-in brushes; you can learn more about loading 'em on page 514.)

3. **Increase the brush size till it's 100 pixels or so.**

 Making the brush fairly big will help you see the brush's edge more clearly when you paint, so you'll know exactly what kind of texture you're painting where. While the Brush tool is active, you can press the right bracket key (]) repeatedly

to increase brush size, or the left bracket key ([) to decrease it. This is an important keyboard shortcut to memorize because this particular technique looks better if you vary the brush size quite a bit.

4. **Make sure your foreground color chip is set to black and the mask thumbnail is selected, and then mouse over to your document and start clicking on the text to apply the texture (clicking works better than dragging).**

 As you learned on page 117, painting with black within a layer mask conceals (hides) whatever is on that layer, while painting with white reveals. To hide portions of the text in the shape of the brush, you need to paint with black, so take a peek at the color chips at the bottom of the Tools panel (page 24) and make sure black is on top. If it's not, press X to flip-flop the color chips.

 If you hide too much of the text, press X to swap color chips so that white is on top, and then click to paint that area back in. (You'll do a lot of swapping color chips when editing masks, as explained on page 117.)

The best part of this technique is that, by using a layer mask, you haven't harmed the text. If you don't like the effect, just delete the layer mask (page 121) and you're back where you started.

Texture from filters

Running a filter on text is among the fastest ways to give it extra character. Like the previous two techniques, this method involves using a layer mask, though this time you need to create a selection of the text *before* adding the mask.

Add some chunky text to your document and, in the Layers panel, ⌘-click (Ctrl-click on a PC) the Type layer's thumbnail to load the text as a selection. Once you see marching ants, add a layer mask to the Type layer as described in step 1 in the previous technique (page 267). Then head to the Filter menu and choose Distort→Ocean Ripple. (Other filters that work well include the Artistic and Distort sets, along with Sketch→Torn Edges.) In the resulting dialog box, tweak the filter's settings so that the text's edges look fairly tattered in the handy preview window. Figure 14-32 shows the results of changing the Ripple Size to 8 and Ripple Magnitude to 4, and then running the filter 3 times. Press OK to dismiss the Filter dialog box and admire your newly distressed text.

Tip: To rerun the last filter you used, just press ⌘-F (Ctrl+F on a PC), and Photoshop will use the exact same settings you used last time (don't expect a dialog box, though). This trick works until you quit Photoshop.

Figure 14-32:
Top: By loading the text as a selection before adding the layer mask, the mask takes on the shape of the letters, giving you a safe place to run the filter (otherwise, you'd have to rasterize the Type layer before running it).

Bottom: As you can see in the Layers panel, the Type layer remains unscathed after applying this technique, so you can still change the text's color or resize it even after you're done. To change the color, double-click the Type layer and click the color swatch in either the Options bar or Character panel, as described on page 601. Page 588 explains how to resize text.

Placing a Photo Inside Text

Ever wonder how designers place an image inside text? It takes *years* of practice. (Just kidding!) They do it by creating a *clipping mask* (see the box on page 123), which takes about 5 seconds. All you need is a photo, a Type layer, and the secret layer stacking order. To create the effect shown in Figure 14-33, follow these steps:

1. **Open a photo and make it editable.**

 Photoshop tries to protect you from yourself by locking the Background layer. Just double-click it to make it editable, and give it another name if you'd like. You have to do this in order to change the layer stacking order in the next few steps.

2. **Create some text.**

 Press T to grab the Type tool and add some text to your document. It doesn't matter what color the text is (as long as you're able to see it while you're typing); what matters is that you pick a really big, thick font. Figure 14-33 was made using Impact—a display font—at 95 points. Short words work better than longer ones (they're easier to read), and you may want to use all caps so more of the photo shows through.

Figure 14-33:
Placing a photo inside text is one of the easiest text tricks to perform, though it looks really complicated. Be sure to pick a nice, thick font like Impact (shown here). That way, you can see a good chunk of the photo through the letters. For even more fun, use layer styles to add a stroke or drop shadow to the Type layer, as shown here.

3. **Over in the Layers panel, drag the Type layer** *below* **the image layer.**

 If the Type layer is *above* the photo layer, this technique won't work.

4. **Clip the photo layer to the Type layer.**

 With the photo layer selected, choose Layer→Create Clipping Mask, or press and hold Option (Alt on a PC) while hovering your cursor over the dividing line between the two layers in the Layers panel (when the cursor turns into two intersecting circles, click once). The thumbnail of the photo layer scoots to the right and a tiny downward-pointing arrow appears to let you know that it's clipped (masked) to the Type layer directly below. You should now see the photo peeking through the text.

5. **Add a new Fill layer at the bottom of the layer stack.**

 Rather than stare into the checkerboard of a transparent document, add a colorful background instead (in Figure 14-33, the background is sage green). Create a new Solid Color Fill layer (page 91) and position it at the bottom of the layers stack. To make sure the background goes well with the photo, once the Color Picker opens, mouse over to your image and click within the photo to snatch a color.

6. **Use the Move tool to reposition either the photo or the text (see the box on page 120 to learn how to move the layer independently of its mask, or vice versa).**

 You're basically done at this point, but feel free to play around with text formatting, layer styles, different fonts, or just sit back and admire your handiwork.

Tip: Another neat Photoshop trick is to place text *behind* an object. This technique, in all its step-by-step glory, is detailed on page 115.

Converting Type to a Shape or Path

Last but certainly not least, Photoshop lets you do all kinds of cool things with text that's been converted into a vector shape or path (for more on shapes and paths, see Chapter 13). Though you can't edit the converted text, what used to be the Type layer turns into a resizable, distortable piece of art or editable path that you can do all kinds of interesting things to.

To convert text into a shape or path, just select the Type layer in the Layers panel and then choose Layer→Type→Create Work Path or "Convert to Shape". That's it! This miraculous transformation lets you:

- **Edit the letterforms themselves.** Want to add an extra flourish here or a swoosh there? Create a work path from the text and then use the Path Selection tool (page 558) to twist and pull the letters any which way you'd like.

- **Apply distort and perspective with Free Transform.** You may have noticed that the Free Transform tool's distort and perspective options are grayed out when a Type layer is active; but they're ready for action on a Shape layer. If you've ever wanted to create text that fades into the distance in proper perspective, here's your chance.

- **Rotate individual letters.** Instead of creating each letter on its own layer and rotating them individually, you can convert the word into a Shape layer first, and then use the Path Selection tool (page 558) to grab one letter at a time and rotate it with Free Transform, as shown in Figure 14-34. Graphic designers love doing this kind of thing.

- **Creating intersecting or intertwining text.** Once you've converted text to a shape, you have the full arsenal of shape commands at your disposal, including the ever-useful Exclude Overlapping Shape Areas button, whose effect is shown in Figure 14-34. (For more on shape commands, see page 560.)

- **Scale to infinity—and beyond!** Because the shape is a vector, you don't have to worry about jagged edges. So after you've created one of the techniques in this list, feel free to resize it using Free Transform without fear of losing quality.

- **Enjoy stress-free printing.** That's right: You can send the file off to a professional printer (or to an inkjet printer, for that matter) without a care in the world. By converting text to a shape, you don't have to worry about including the original fonts or how the text will print.

More Typographic Resources

This book is by no means the be-all and end-all on typography and fonts. If you want to learn more about finding, identifying, and buying fonts, crack open a nice bottle of wine and check out some of the following resources:

Figure 14-34:
This effect was created by converting text (Arial Black) into a shape and then spinning each letter individually using Free Transform. (Don't forget to press Return—Enter on a PC— when you're done rotating each letter.) For added fun, you can use the Path Selection tool to move each letter so they overlap just a touch.

Next, use the same tool to select all the letters and then click the Exclude Overlapping Shape Areas button in the Options bar. This makes the color disappear from the overlapping areas (as shown here), letting the white Solid Color Fill layer show through.

- *The Non-Designer's Type Book, Second Edition,* by Robin Williams (Peachpit Press, 2005). This book is an easy read and well worth the time; you'll learn more than you ever wanted to know about typography.

- *Fonts & Encodings* by Yannis Haralambous (O'Reilly, 2007) is a priceless resource. If you've ever wondered how our current font situation came to be, or how and why fonts work they way they do, you'll enjoy this tome.

- *www.Helveticafilm.com.* Visit this site for a feature-length film about typography and graphic design made in celebration of the Helvetica font's 50th birthday in 2007. It's fascinating!

- *www.fonts.com.* Hands down the Internet's number one resource for all things font-related.

- *www.myfonts.com.* Another great resource, this site also features a font-identification service called WhatTheFont. Just send them an image of the text and they'll tell you what the closest matching font is. How cool is that?!

- *www.fontsite.com.* If you want professional fonts at a fraction of their usual price, this is the place to go.

- *www.macworld.com/topics/create.* Jay Nelson, founder and publisher of DesignToolsMonthly.com (another fabulous resource for graphic designers), writes this monthly font column for *Macworld* magazine wherein he discusses all manner of font features and news.

The Wide World of Filters

Filters apply special effects to your images. They're both incredibly useful and outrageously fun. You can run them on image layers, masks, channels, shapes, and even Type layers. The list of special effects you can create by applying filters once, twice, or even ten times is a mile long. There are a slew of the little buggers too, each with its own special brand of pixel wrangling. As of this writing, Photoshop sports 13 filter categories, each of which includes anywhere from 2 to 15 filters!

You've already seen a few filters in action like the ones used for sharpening (page 466), blurring (page 638), adding texture to type (page 624), and mapping one image to the contours of another (page 319). But that's just a tiny sliver of what's available. In this chapter, you'll be immersed in the world of filters and discover how you can use them to:

- Transform your image with painterly effects (page 637).
- Create a shallow depth-of-field effect (page 639).
- Fix funky edge halos or color fringes (page 638).
- Add artistic edge effects to your images (page 643).
- Make a portrait pop with a dark-edge vignette (page 656).
- Add texture (page 624 and page 653).
- Create additional lighting (page 646).
- Conjure up fake snow (page 648).
- Rescue a slightly out-of-focus image (page 652).

- Turn a photo into a pencil sketch (page 650).

- Tighten or expand a layer mask (page 656).

But before you start plowing through the Filter menu, you need to know how to use filters in ways that won't harm your original images. That means learning to use Smart Filters. Onward, ho!

Note: Just because Photoshop CS5 is 64-bit enabled (page 6) doesn't mean that all of its filters are 64-bit *compatible*. If your favorite filter is missing from the Filter menu, don't panic—you probably just need to launch Photoshop in 32-bit mode to make it show up (see the box on page 6 for details). Otherwise, you may be able to install it as an optional plug-in. You'll find info on which filters work in 64-bit mode—and which ones don't—sprinkled throughout this chapter.

The Joy of Smart Filters

Filters, by their very nature, are destructive—they move, mangle, distress, and distort pixels like you can't believe, and they *always* run on the currently active layer (or active selection). Back in the pre-Photoshop CS3 days, the only way to protect your image—and give yourself *any* level of editing flexibility—was to duplicate the layer first and run the filter on the copy. At least then you could lower the filter's strength by reducing layer opacity (page 92) or hide the filter from parts of the image using a layer mask. However, as you know from Chapter 3, duplicating layers can bloat your document's file size and make Photoshop move like a sloth (especially if you've got a slow computer).

Then along came Photoshop CS3 with its nifty new *Smart Filters*. If you convert a layer into a Smart Object (page 126) before you modify it, you can make the filter run on its *own* layer, complete with blend mode (page 289) and opacity control (page 92). It even comes with a layer mask.

Smart Filters are, indeed, the best thing since sliced bread, but a few filters—the old Extract (see the Note on page 160), Liquify (page 438), Vanishing Point (page 657), and Lens Blur (page 639)—will run only on regular image layers (those that haven't been converted to Smart Objects). In that case, just duplicate your image layer and run the filter on the copy. Smart Filters are also picky about which color mode your image is in (not all of 'em work in CMYK or Lab modes, for instance); but since you'll spend most of your time in RGB mode, anyway, that isn't a huge deal.

When Smart Filters *are* an option, they're the only way to roll, and creating them couldn't be easier: All you have to do is open your image, select the layer you want to work on, and choose Filter→"Convert for Smart Filters". You'll get a friendly message letting you know that Photoshop is about to turn the selected layer into a Smart Object, to which you should reply with a resounding OK. (You'll probably want to turn on the "Don't show again" checkbox to keep Photoshop from showing you this message in the future.)

Over in the Layers panel, the image layer now carries the special badge of a Smart Object at the bottom right of its thumbnail, and the next filter you run appears on its own layer (see Figure 15-1). You can run as many filters on the image layer as you want by choosing them from the Filter menu; they'll just continue to stack up in your Layers panel, like layer styles (page 128). If you need to rearrange their stacking order—say, to keep one from covering up the effect of another—you can drag them up or down in the Layers panel.

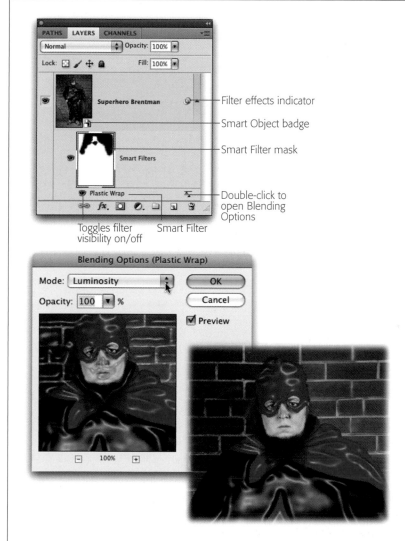

Figure 15-1:
Top: Smart Filters occupy their very own layer, complete with a layer mask, as shown here. (The layer the filter is applied to is highlighted in blue.) Once you've run a filter, the image layer displays both a Smart Object badge and a Filter Effects icon.

Bottom: Double-clicking the Blending Options icon opens a dialog box that lets you lower the filter's opacity and change its blend mode (left). When you change the blend mode to Luminosity, the Plastic Wrap filter affects only the lighter areas of the superhero's cape. You can also use the built-in mask to hide the effects of the filter from certain areas—like his face and the bricks—as shown here (right).

Tip: If you can't use a Smart Filter and you forgot to duplicate your image layer, you can lessen the filter's strength and change its blend mode by using the Edit→Fade command. But you have to run this command before you do *anything* else, or it won't be available. Flip back to the box on page 467 for the skinny on using the Fade command.

If you want to apply the same filters to another layer, you can copy them from one layer to another by Option-dragging (Alt-dragging on a PC) the Smart Filter layer. To get rid of 'em entirely, drag them to the trash can icon at the bottom right of the Layers panel.

Note: You can delete a garden-variety layer by selecting it and then pressing Delete (Backspace on a PC), but you can't do that with Smart Filters (or layer styles for that matter). You have to drag the filter layer to the trash or select the layer, click the trash can icon and then click OK in the resulting "Are you sure?" dialog box.

A Filters Tour

With so many filters to choose from, it can be tough to get a handle on what they all do. That's why several filters—those in the Artistic, Brush Strokes, Distort, Sketch, Stylize, and Texture categories—summon a large dialog box called the Filter Gallery (Figure 15-2). There's a nice big preview of your image on the left (zoom in or out by using the + and – buttons below it), a list of *all* the filters in these categories (with cute little preview thumbnails) in the middle, and the specific settings associated with each filter on the right.

Note: Not all filters are listed in the Filter Gallery dialog box, so don't let that throw you; you can choose the others straight from the Filters menu. That said, if the Filter has three dots after its name in the Filter menu, it summons a dialog box that lets you tweak various settings. If it doesn't, the sucker just runs— you've been warned!

Once the Filter Gallery dialog box opens, you can go through the whole list of filters by clicking each one and then tweaking its settings; Photoshop updates your image preview accordingly. You can even select additional filters while you're in the dialog box by clicking the "New effect layer" button at the bottom right (Photoshop shows each filter as a list above the buttons). You can also delete individual filters you've added by clicking the tiny trash can icon at the bottom right.

Throughout this chapter, you'll find some helpful ideas of how to use at least one filter in each filter category; think of it as a greatest hits tour. (A complete listing of every filter would swell this book to Yellow-Pages proportions.) Grab your favorite beverage, sit back in your chair, and read on.

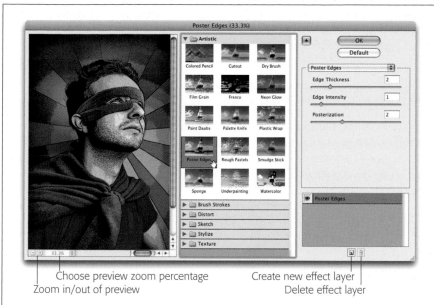

Figure 15-2:
Several filters auto-matically open Photo-shop's Filter Gallery, though you can open it yourself by choosing Filter→Filter Gallery. This big dialog box makes it easy to zip through most filters to get a quick idea of what they do. (Heck, with the right music and snacks, filter browsing can make for an entertaining evening!) Here you can see what the Poster Edges filter looks like on a superhero wannabe. Even with no adjust-ments to the factory settings, the effect gives you a neat cartoonish look.

Choose preview zoom percentage
Zoom in/out of preview

Create new effect layer
Delete effect layer

Tip: If you want to rerun the last filter you used with the same settings, press ⌘-F (Ctrl+F on PC). You can also click the Filter menu; the last filter shows up as the first item on the list. To summon the filter's dialog box, press ⌘-Option-F (Ctrl+Alt+F).

Artistic

If you want to make your image *resemble* a painting or a cartoon, turn to the filters in this category. Their special purpose is to mimic real-world artistic effects created with brushes, pencils, and palette knives, though they can also give your image a very artsy look. If you're just looking for a quick artistic touch, these filters can get the job done.

For example, if you want to soften an image and make it look like it's painted, try running the Paint Daubs filter to introduce brush strokes and then running the Un-derpainting filter to give the image a little texture (as if it were painted on a real canvas). But if you *really* want to make your image look like a painting, you need to use these filters along with the painting techniques covered in Chapter 12 (or paint the image from scratch).

You've already seen two filters from this category in action. Figure 15-1 shows the effects of Plastic Wrap, which makes your image look shiny—as if it were covered in plastic; it's also great for making an object look glossy or slimy. Figure 15-2 shows the Poster Edges filter, which makes the edges of your image black and gives the whole thing a cartoonish look (for more on posterizing, see page 353).

Blur

You've seen various blur filters in action already, including Gaussian Blur to smooth skin (page 445) and Motion Blur to simulate motion (page 286). They're worth their weight in gold when you need to soften pixels for better blending, but you can also use blur filters to zap edge halos or eliminate *color fringe*—that slight blue or purple haze loitering around the edges of near-black objects (see Figure 15-3, left).

Figure 15-3:
At a zoom level of 200 percent, you can see the weird color fringe around the 8 (left). Happily, running the Gaussian Blur filter removes it completely (right).

The color-fringe problem is especially common in photos taken using cheaper wide-angle lenses, though it also rears its ugly head when you shoot something really dark on a light background (like a white clock face). The image may look okay at a glance, but a closer inspection often reveals some serious bluish or purplish fringing (also called *artifacts*) around the dark objects. Here's how to fix that using a good dose of the Gaussian Blur filter:

1. **Open the blurred image and select the layer you want to work with.**

2. **Choose Filter→"Convert to Smart Filters".**

3. **Choose Filter→Blur→Gaussian Blur.**

 In the resulting dialog box, enter a Radius of five to seven pixels (this setting controls how much blurring is applied to your image) and then click OK. Depending on your image's pixel dimensions, you may need to experiment with this value; increase it for larger images or reduce it for smaller ones.

4. **Change the filter Blending Options to Color.**

 In the Layers panel, double-click the Blending Options icon next to the Gaussian Blur layer and change the Mode pop-up menu to Color. As you learned in Chapters 7 and 8, the Color blend mode affects only hue, and since your goal is to blur the *colored* pixels (as opposed to the black ones), this mode works perfectly.

5. **Adjust the Opacity setting to 96 percent.**

 This high setting keeps the blur from looking too obvious.

6. **Click OK when you're finished.**

 A quick zoom-in reveals that the pesky color fringe has left the building, as shown in Figure 15-3.

Lens Blur

Another handy filter in the Blur category is Lens Blur, which is perfect for creating beautifully blurred backgrounds…*after* you've taken a photo. In fact, you can use it to mimic a popular tilt lens called the Lensbaby (*www.lensbaby.com*), which is a bendable lens—if you can imagine—that lets you control which part of the picture is in focus. Once you get the angle just right, you can lock the lens into place and snap the shot. It's a great way to draw the viewer's eye to your subject, but at $150 or more, it's not quite an impulse buy.

You won't want to use the following background-blurring technique on every picture, but it can certainly enhance a few, especially those with distracting backgrounds:

1. **Open your image and locate the Channels panel.**

 Open the Channels panel by clicking its tab in the Layers panel or by choosing Window→Channels. To tell Photoshop which part of the image you want to blur and which part should stay in focus, you need to create a selection that the Lens Blur filter can use. An easy way to do that is by making an alpha channel (page 189), which you'll do in the next step.

2. **Create a new alpha channel.**

 Click the New Channel icon at the bottom of the Channels panel. Then, at the top of the panel, click the visibility eye next to the RGB channel (also called the composite channel—see page 189). Your entire image takes on the Quick Mask mode's red overlay (page 176), which lets you create your selection by using a big soft, fluffy brush. Don't panic: the red overlay is temporary—your image won't end up pink.

3. **Grab the Brush tool and set your foreground color chip to white.**

 Your goal here is to edit the mask so that the area you want to keep in focus doesn't have any red on it (any areas that you *do* leave red will become blurry once you finish this technique). Make sure your color chips are set to black and white (press D if they're not), and press X until white is on top.

4. **Choose a big, soft brush and lower its opacity to 50 percent.**

 Hop up to the Options bar and, from the Brush Preset picker, choose a nice soft brush (with fuzzy edges rather than hard) that's fairly big (around 200 pixels, or even a bit larger). To create a subtle transition from sharp to blurry pixels, lower the brush's opacity to 50 percent.

Tip: You can also resize your brush by Option-Ctrl-dragging (Alt+right-click+dragging on a PC) to the left to make it smaller or to the right to make it bigger. In CS5 you can also adjust the hardness of your brush with the same keyboard shortcut by dragging vertically up or down.

5. **Paint across the areas you want to keep in focus.**

 In Figure 15-4, top, for example, paint across the boy's face. As you paint, the photo starts to show through just a little, but since you lowered the opacity of your brush, you need to keep painting over the same area to achieve 100 percent focus. Remember: Anything that's red will be blurry when you're done, and the rest of the image will remain sharp. To create a perfectly sharp area, lower your brush size and paint over that area until all the red is gone. If you mess up and bring back too much of the photo, press X to flip-flop the color chips and paint that area with black to make it blurry again.

6. **Turn off the alpha channel's visibility eye and select the RGB channel.**

 There's no need to leave the alpha channel turned on, so go ahead and hide it by clicking its visibility eye. Next, click the RGB channel so you can see the full-color version of your image again.

7. **Open the Layers panel and duplicate the original layer.**

 Since Lens Blur isn't available as a Smart Filter, the only way to protect your original image is to copy the layer and then run the filter on the copy. To open the Layers panel, click the Layers tab in your panel dock (page 19) or choose Window→Layers. Click to select the image layer and duplicate it by pressing ⌘-J (Ctrl+J on a PC).

8. **With the duplicate layer selected, choose Filter→Blur→Lens Blur.**

9. **In the Lens Blur dialog box, change the Depth Map source to Alpha 1.**

 Use the dialog box to tell the filter about your alpha channel by selecting it from the Depth Map pop-up menu. Unless you gave it a different name, the channel goes by Alpha 1.

10. **Turn on the Invert setting.**

 Initially, the blurry and sharp areas will be flip-flopped from what you created in the alpha channel. Turning on the Invert checkbox fixes things, as shown in Figure 15-4.

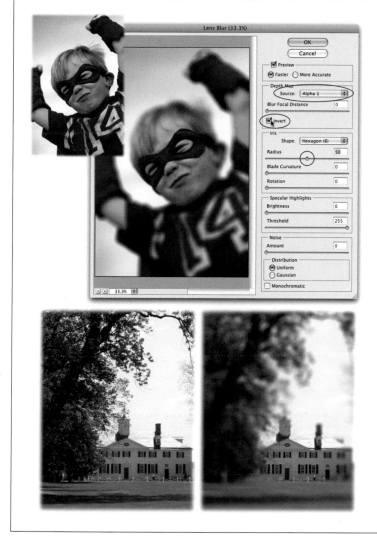

Figure 15-4:
Top: When you first run the Lens Blur filter, it does the exact opposite of what you want—it blurs what's supposed to be sharp, and vice versa. To fix it, just turn on the Invert option, circled here.

Bottom: This effect not only draws the viewer's eye, it can also make a building look like a miniature, which is a neat effect all by itself!

11. **Adjust the Radius slider until you get the right amount of blur.**

 This slider lets you determine just *how* blurry the background gets. If you're working on a really big image (for example, one from your digital camera), it may take Photoshop a second to update the preview, so be patient. Be sure to release your mouse button so Photoshop can generate a new preview.

12. **Click OK when you're finished.**

Since you used an alpha channel to create this effect, you can change the results. If you don't like how your image looks, just toss the duplicate Background layer, pop open your Channels panel, grab your Brush tool, and edit the alpha channel. Then repeat steps 6–12 to run the filter again.

Tip: To make your image look less perfect, you can add a little noise to the blurry bits. At the bottom right of the Lens Blur dialog box, adjust the Noise Amount slider and turn on both the Gaussian Distribution option and the Monochromatic checkbox, and then click OK.

Brush Strokes

There are a slew of filters in this category and, like the Artistic set, they're geared toward creating traditional fine-art effects. If you want to add interesting edge treatments to your images, these filters work especially well when you use them with a layer mask (see Figure 15-5). Among the most useful filters for these kinds of edge effects are Spatter and Sprayed Strokes (choose Filter→Brush Strokes→Spatter or Sprayed Strokes).

Note: You can give this technique a spin by trotting on over to this book's Missing CD page at *www. missingmanuals.com/cds* and downloading the image *Superchick.jpg*.

When you're ready to spice up the edges of your image, take this technique for a spin:

1. **Open a photo and double-click the Background layer to make it editable.**

 Since you'll run the filter on a layer mask, you don't need to use Smart Filters.

2. **Grab the Rectangular Marquee tool and draw a box where you want the frame to appear.**

 For best results, draw your box at least a quarter of an inch in from the edges of your photo as shown in Figure 15-5, top. The filter will run outside your selection, on the edges of the image.

3. **Add a layer mask.**

 At the bottom of the Layers panel, click the circle-within-a-square icon to add a layer mask to the part of the image where you'll apply the filter.

4. **With the layer mask selected, choose Filter→Brush Strokes→Spatter.**

 In the resulting Filter Gallery dialog box, increase the Spray Radius to 20 and the Smoothness to 8.

5. **Click OK.**

 If you want to soften the edges just a bit, you can run an additional filter: Choose Filter→Blur→Gaussian Blur, adjust the blur radius until you get the look you want, and then click OK.

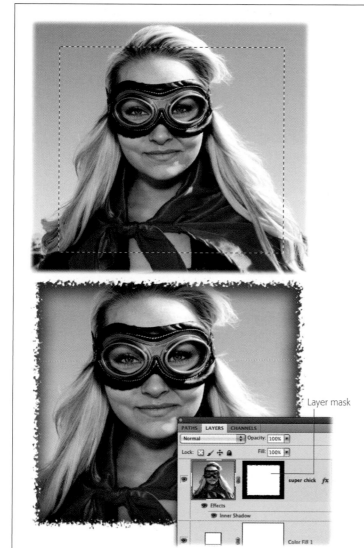

Figure 15-5:
If you draw a selection around your image (top) and then add a layer mask (bottom), you can run a filter on the mask itself, which makes for some really nice edge effects—without harming your original image. Tack on a well-placed inner shadow for an even more interesting look!

A couple of other filters that work well with this technique are Glass, Ocean Ripple, Twirl (all found under Filter→Distort), and Torn Edges (Filter→Sketch→Torn Edges).

In CS5 you can also use the Refine Edge dialog box to give your photo interesting edges, too. Flip back to the Note on page 172 to learn how.

Because the layer mask hides the edges of your image, you'll see the checkerboard transparency pattern (see the box on page 47). To add a new background, add a layer of solid color *beneath* the image layer by ⌘-clicking (Ctrl-clicking on a PC) the "Create a new layer" icon at the bottom of the Layers panel and then choosing Edit→Fill. Choose Color from the Use pop-up menu, pick a color from the resulting Color Picker, and then click OK. Photoshop fills the new layer with the color you selected. As a final touch, add an inner shadow or drop shadow to the image layer using layer styles (page 128).

Tip: If you want to reposition either the photo or the frame, you have to unlock the layer from the mask by clicking the little chain icon between the layer and mask thumbnails in the Layers panel. Then click the thumbnail of the layer or mask you want to move and reposition it with the Move tool (see Appendix D). To lock them together again, just click between the two thumbnails to make the little chain icon reappear.

Distort

The filters in this category, not surprisingly, distort and reshape your image. It includes all kinds of goodies like the Displace filter, which lets you apply one image to the contours of another (page 319); the Pinch filter, which is great for shrinking double chins (page 438); and the Glass, Ocean Ripple, and Twirl filters, which work well as edge effects, as you learned in the previous section. The real gem of this category used to be the Lens Correction filter, but in CS5, Adobe moved it to near the top of the main Filters menu. Skip ahead to page 655 to learn all about it.

Noise

These filters let you add or remove noise (graininess or color speckles). If you're working on an extremely noisy image or restoring an old photo, these filters can come in really handy. For example, if you've scanned an old photo that has scratches in it, you can run the Dust & Scratches filter to make Photoshop scour your image for irregular pixels and blur them to smooth that area. More than likely, you'll use the Reduce Noise filter most often because it can help lessen noise in the dark areas (shadows) of images shot in low light. The box on page 462 has the scoop.

Sometimes, you may need to *add* noise to an image, as odd as that sounds. For example, if you're working with a portrait that's been corrected within an inch of its life and it looks *too* perfect (as if it were airbrushed), you can use the Add Noise filter to introduce some random speckles to make it look more realistic.

Pixelate

You probably won't use the Pixelate filters often, but once in awhile they're useful for applying funky blurs and textures to your image as shown in Figure 15-6. For example, the Crystallize filter makes your image look like it's behind a textured shower door. If you're aiming for the newspaper image look (think lots of tiny, visible dots) try the Halftone filter.

Figure 15-6:
If you want to distress an image with random streaks and strokes, check out the Mezzotint filter (Filter→Pixelate→ Mezzotint). In this example, medium strokes were applied (right), and the Blend- ing Options were changed to Soft Light at 50 percent opacity.

Render

These filters generate cloud patterns, introduce lens-flair effects, and add lighting to your images. Two in particular—Clouds and Difference Clouds—are great for creating all kinds of backgrounds, like the splotchy-colored ones you see in portrait studios, for example. These filters mix your foreground and background colors into what looks like soft, fluffy clouds. The more times you apply each filter, the more clouds you get (Difference Clouds gives you clouds with higher contrast). If you use them with a Motion Blur filter (applied after the Cloud filter), you can create some terrific streaks to make an image look old.

Another useful filter in this category is Lighting Effects (Figure 15-7). If you didn't get your subject lit right in the studio, there's a good chance you can fix it here. This filter, which works only with RGB images, gives you three light types (think light sources) to choose from including Omni (shines light in all directions like a light-bulb), Directional (shines light from a distance like the sun), and Spotlight (shines light in a beam like a flashlight).

Note: In Photoshop CS5, the Lighting Effects filter works only in 32-bit mode. See the box on page 6 for info on how to switch between 32- and 64-bit modes.

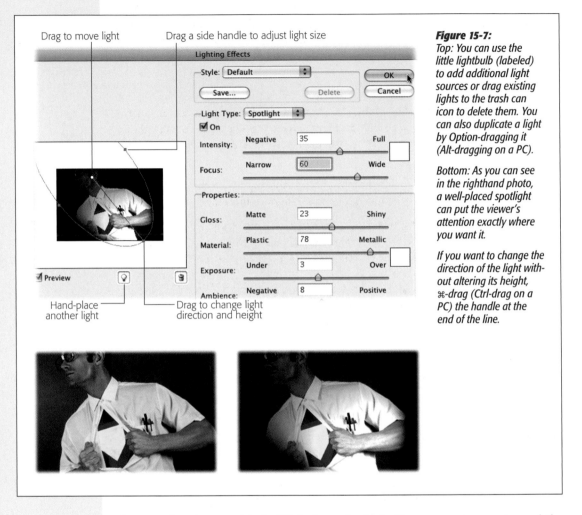

Drag to move light

Drag a side handle to adjust light size

Hand-place another light

Drag to change light direction and height

Figure 15-7:
Top: You can use the little lightbulb (labeled) to add additional light sources or drag existing lights to the trash can icon to delete them. You can also duplicate a light by Option-dragging it (Alt-dragging on a PC).

Bottom: As you can see in the righthand photo, a well-placed spotlight can put the viewer's attention exactly where you want it.

If you want to change the direction of the light without altering its height, ⌘-drag (Ctrl-drag on a PC) the handle at the end of the line.

Once you've chosen a kind of light from the Light Type pop-up menu toward the top of the dialog box, you can adjust its strength with the Intensity slider (drag it to the left to weaken the light or to the right to make it stronger). If you want to change the light's color, click the color square to the right of the Intensity slider and pick a color from the resulting Color Picker. For example, instead of adding a stark white light to a portrait, you could change it to light peach or yellow to give your subject a slightly warm glow. If you've chosen Spotlight, you can also adjust the width of the light beam with the Focus slider; drag it to the left to make the light narrower and to the right to make it wider (Figure 15-7 shows a fairly wide spotlight).

The Lighting Effects dialog box is a little complex, although you can find some excellent presets in the Style pop-up menu at the very top. Once you've chosen a style, you can tweak the Light Type settings as mentioned earlier, as well as the following:

- **Gloss.** Use this setting to control how reflective you want the surface in your image to be. For example, if you shine light onto a plain old piece of paper, it won't reflect very much. But if you shine it onto a glossy piece of paper, the reflection is much greater. Drag this slider to the left to decrease reflection and to the right to increase it.

- **Material.** This setting lets you change the surface the light is reflecting on. For example, a plastic surface reflects the light's color while a metallic surface reflects your subject's color. Drag the slider to the left to make the surface plastic or to the right to make it metallic (anything in between affects both your light's color and your subject's color).

- **Exposure.** You can control the amount of available light with this setting. Drag the slider to the left to decrease light or to the right to increase it.

- **Ambience.** This setting lets you tone down the light source you've been painstakingly creating in this dialog box by mixing in more light from another source (as if the sun were also shining in the room or you had turned on an overhead light). Drag the slider to the left to remove the additional light source or to the right to mix in more light from it. You can change the light's color by clicking the color square to the right of the slider. Just choose a color from the resulting Color Picker and then click OK.

Tip: A little known fact about the Lens Flare filter, which also lives in this category, is that Option-clicking (Alt-clicking on a PC) in the dialog box's preview lets you reposition and/or enter precise coordinates for your flare. Who knew?!

For even more creative fun, give your lighting depth by using the Texture Channel option at the bottom of the dialog box, which lets you tell Photoshop to shine the light through a grayscale image (referred to as a *bump map*). Turn on the White Is High checkbox to make the white parts of your grayscale image appear raised (so they take on a shine as if they're taller than other areas). You can control how much they're raised by using the Height slider (drag it to the left to decrease height or to the right to increase it). If you want the dark parts to appear raised instead, leave this checkbox turned off. To get the grayscale image, use one of the existing color channels in your image (red, green, or blue) or an alpha channel you've created (page 201).

Tip: Click the Save button near the top of the dialog box to save a light source that you want to use again later as a preset. Give your custom light source a memorable name and then click OK to add it to the bottom of the Style pop-up menu.

Sketch

If you want to add a bit of texture to your images, this category is the one to reach for. Here you'll find a variety of filter-driven pens, crayons, paper, and so on that give your images a hand-drawn look. The Graphic Pen filter is perfect for adding realistic snow, as shown in Figure 15-8.

Figure 15-8:
Meet the Graphic Pen filter. To create a visually pleasing snowfall that doesn't completely bury your subject, lower the filter's Stroke Length setting to around 5 and increase the Light/Dark Balance setting to about 90. A too-high Stroke Length and a too-low Light/Dark Balance leave your subject stuck in what looks like a blizzard of sleet.

Here's how to use the Graphic Pen filter to add some realistic-looking flurries:

1. **Open a snowless photo and create a new layer filled with black.**

 As you learned back in Chapter 7 (page 291), blend modes have various neutral colors that disappear when that particular blend mode is used. If you run the Graphic Pen filter on a solid black layer, you can use a blend mode to make the black disappear, leaving you with just the streaks made by the filter (which look like snow). Click the "Create a new layer" icon at the bottom of the Layers panel and drag it above the image layer if you need to. Fill it with black by choosing Edit→Fill and picking Black from the Use pop-up menu, and then clicking OK.

2. **With the black layer selected, choose Filter→"Convert for Smart Filters".**

 To make the Graphic Pen filter run on its own layer, you have to convert it for Smart Filters first (page 634).

3. **Change the blend mode of the black layer to Screen (see Figure 15-8, circled).**

 As you learned on page 296, the Screen blend mode lightens the underlying photo and completely ignores black, which means the snow-like streaks you create in the next step will lighten the photo and the black will disappear.

4. **Choose Filter→Sketch→Graphic Pen.**

 Photoshop opens the Filter Gallery dialog box set to the Graphic Pen filter. Since it generates random streaks in the direction and length you choose, it's perfect for making fake snow.

5. **On the right side of the dialog box, change the Stroke Direction pop-up menu to Vertical.**

 This setting makes the snow fall straight down.

6. **Enter a Stroke Length of 5 and Light/Dark Balance of 90.**

 Think of Stroke Length as flake size; lowering it to around 5 creates fairly small flakes. Think of Light/Dark Balance as the amount or heaviness of the snowfall. Set it to 60 for a blizzard or a higher number (like 90) for light snow. Click OK when you're finished to close the Filter Gallery dialog box.

7. **Choose Filter→Blur→Gaussian Blur and, in the resulting dialog box, enter a Radius of 1.5.**

 To soften the snowflakes (so they don't have hard edges), you need to blur them slightly.

8. **Click OK when you're finished.**

The beauty of creating artificial snow using a Smart Filter is that you can control the

opacity—if the effect is too strong, just trot over to the Layers panel and double-click the icon to the right of the Graphic Pen Smart Filter and then lower the opacity in the Blending Options dialog box. If it looks terrible, you can trash the filter and start over. It's lots of fun to add snow to *completely* inappropriate photos, too!

Stylize

This category is also artistic, but its filters let you create a look with more contrast than you can with the Artistic filters. One filter in this category, discussed a little later in this section, can save an out-of-focus image. Several of the filters found here enhance the edges in your image, and Find Edges does such a good job that you can use it to create a pencil-sketch effect. It's a great technique to have in your bag of tricks because it can single-handedly save an image with color problems that can't be fixed by anything you learned back in Chapter 9. As a bonus, you create an image with a totally different look and feel from the original as shown in Figure 15-9.

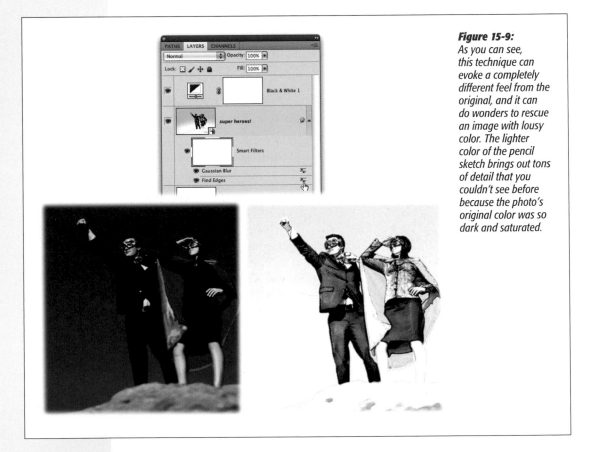

Figure 15-9:
As you can see, this technique can evoke a completely different feel from the original, and it can do wonders to rescue an image with lousy color. The lighter color of the pencil sketch brings out tons of detail that you couldn't see before because the photo's original color was so dark and saturated.

Here's how to use Find Edges to convert a photo into a pencil sketch:

1. **Pop open a photo and create a Black & White Adjustment layer.**

 The first step toward a pencil sketch is to get rid of the image's color, which you can do easily with a Black & White Adjustment layer (page 234). Click the half-black/half-white circle at the bottom of your Layers panel and choose Black & White (you can also create the Adjustment layer straight from the Adjustments panel). Adjust the various color sliders in the Adjustments panel until you're happy with the contrast in your image.

2. **Select the image layer and choose Filter→"Convert for Smart Filters".**

 Once again, to make the filter run on its own layer, you have to convert it for Smart Filters first. Besides protecting your original image, Smart Filters let you change the filter's blend mode and opacity (which you'll do in a couple of steps).

3. **Choose Filter→Stylize→Find Edges.**

 You won't get a dialog box with this filter; it just runs. Don't panic when your image turns into a freaky-looking outline; you'll reduce the filter's strength in a second.

4. **Open the Find Edges filter's Blending Options dialog box.**

 In your Layers panel, double-click the little icon to the right of the Find Edges Smart Filter to open this dialog box.

5. **In the Blending Options dialog box, change the blend mode to Hard Mix and lower the opacity to about 85 percent.**

 As you change these settings, keep an eye on how your image looks back in your document (move the dialog box out of the way if you need to). As you learned in Chapter 7 (page 298), the blend modes in the Lighting category increase your image's contrast, which is great if you're trying to make a pencil sketch (and you are). You may need to experiment with other Lighting blend modes when you're trying out this technique because, depending on the colors in your image, some work better than others. The Opacity setting also varies according to how much contrast you had in the original image, though a setting between 75 and 85 percent usually works just fine. Click OK to close the Blending Options dialog box.

6. **Choose Filter→Blur→Gaussian Blur and, in the resulting dialog box, enter a Radius of 2.**

 Your image should start resembling a pencil sketch at this point, though you'll want to soften it by blurring it slightly. A Radius of 2 usually works well, but, again, you'll have to experiment with this setting. Click OK to close the Gaussian Blur dialog box.

7. **Open the Gaussian Blur Smart Filter's Blending Options dialog box.**

 In your Layers panel, double-click the icon to the right of the Gaussian Blur layer to open this dialog box.

8. **In the Blending Options dialog box, change the blend mode to Lighten.**

 When you change this blend mode, the Gaussian Blur filter blurs only the light pixels in your image. That way, you preserve the darker pixels' details (the edges you accentuated with the Find Edges filter).

9. **Click OK to close the Blending Options dialog box.**

 You're finished, but if your sketch looks too dark, you can try placing it atop a white background and then lowering its opacity. Click the half-black/half-white circle at the bottom of the Layers panel and choose white from the resulting Color Picker. If your original image layer is a locked Background layer, double-click it to make it editable (if you don't unlock it, Photoshop won't let you place any other layers beneath it). Then drag the new Fill layer *below* your original image layer. Make sure the original image layer is selected and then lower its opacity to about 85 percent (see page 92 for more on layer opacity). That oughtta soften your sketch right up!

Tip: For a watercolor look, select the Black & White Adjustment layer and then lower its opacity slightly to let some of the original color show through.

Emboss

Although no magic fixer-upper can make an out-of-focus image look like it's in focus, the Emboss filter comes close. Technically it's not really *fixing* the image and making it sharp, it's merely bringing out the edges that are already there, making the image *look* sharper than it was (see Figure 15-10).

Here's how to use it:

1. **Open the out-of-focus image and choose Filter→"Convert for Smart Filters".**

 Smart Filters make the filter run on its own layer and let you fiddle with filter-blending options and opacity.

2. **Choose Filter→Stylize→Emboss.**

 In the resulting dialog box, leave the angle, height, and amount settings as they are. Your image will look gray, and the edges of your subject will be brightly colored (as shown in Figure 15-10), but that's exactly what you want. In the next couple of steps, you'll change the blend mode to make the gray parts disappear.

3. **Open the Emboss filter's Blending Options dialog box.**

 Over in the Layers panel, double-click the tiny icon to the right of the Emboss layer.

Figure 15-10:
The Emboss filter won't save a completely out-of-focus image, but it can sure take one that's only slightly blurry (top) and make it look sharper (bottom).

By the way, Samantha and Sylvester say hello!

4. **In the resulting dialog box, change the blend mode to Hard Light.**

 As you learned on page 298, the blend modes in the Lighting category add contrast to your image *and* ignore gray. Since the Emboss filter turned your image gray and gave it brightly colored edges, changing the blend mode to Hard Light makes the gray vanish, leaving *only* the edges visible so they stand out more and appear sharper than they really are. Who knew?

5. **Click OK to close the Blending Options dialog box.**

 That's all there is to it—well, aside from grinning triumphantly because you fixed your image.

Texture

As you'd expect, the filters in this category add texture to your image, which can help give it some depth and visual interest as shown in Figure 15-11. You can access them through the Filter Gallery (page 363) to get an idea of what they can do. For example, if you want to spice up the an image's background, you can add a texture to just that area by creating a selection first.

Figure 15-11:
If you select the dark-green rays in the background with the Quick Selection tool before you run the Craquelure filter (Filter→Texture→ Craquelure), you can make the filter's effects visible in just those areas. As you can see here, Photoshop filled in the Smart Filter mask for you. Remember from Chapter 3 that, when you're dealing with layer masks, black conceals and white reveals (see page 113 for a refresher on layer masks).

The technique is very simple: Just open an image and choose Filter→"Convert for Smart Filters". Then select the area behind your subject using any of the techniques in Chapter 4. Next, choose Filter→Texture and pick one of the six options: Craquelure, Grain, Mosaic Tiles, Patchwork, Stained Glass, or Texturizer. (The Texturizer filter actually lets you load your *own* images so you can use them as a texture; see page 625 for an example of this filter used with text). Adjust their various sliders in the Filter Gallery dialog box and then click OK.

Note: PatternMaker, a staple of the Texture category for several versions of the program, has gone the way of the Dodo bird. However, it's available as an optional plug-in via the CS5 installation disc.

Video

As the name suggests, the two filters in this category deal strictly with individual frames extracted from videos. De-Interlace smoothes moving images and NTSC Colors restricts the image's color palette to colors that TVs can display. For more on video layers, head to this book's Missing CD page at *www.missingmanuals.com/cds* and download the Video Layers sidebar from Chapter 3.

Other

Since these filters don't really fit into any *other* category, they get their own. Custom, for example, lets you design your own filters to manipulate an image's brightness. As you learned on page 478, you can use the High Pass filter to sharpen images. Maximum and Minimum have more practical uses—you can use them to shrink or enlarge a layer mask (page 113). For example, if you select an object, add a layer mask, and then place it atop *another* image, you may find some stray pixels left around the edges from the original background. To eliminate those stray pixels, you can use the Minimum filter to shrink the mask (see Figure 15-12).

Digimarc

The Digimarc filter lets you add a nearly invisible watermark to your images to protect them from being stolen and used without your permission (a problem inherent with images posted online). Page 740 has the scoop.

Browse Filters Online

Since filters are basically little programs that run inside Photoshop, they're easy to install (see the instructions on page 767). When you choose the Filter menu's Browse Filters Online option, you'll be transported to Adobe's website, where you can choose from loads of third-party plug-ins.

Lens Correction

Not only can you use this filter to fix all kinds of geometric weirdness you might get from your camera lens (like the spherical look caused by wide-angle lenses), you can also use it to add a dark-edge vignette effect that can beautifully frame a portrait (see Figure 15-13). In Photoshop CS5, the Lens Correction filter got a *major* overhaul, as the box on page 658 explains.

Figure 15-12:
Top: Here's the original image before the background was hidden by the layer mask.

Bottom Left: If you run the Maximum filter on the layer mask, you can expand it. Notice how a wee bit of the original background is visible around the hero.

Bottom Right: The Minimum filter does the exact opposite—it shrinks a layer mask—a great way to snip away leftover edge pixels.

However, one of the easiest things to do with this filter is to create a darkened-edge vignette. Here's how:

1. **Pop open a portrait and choose Filter→"Convert for Smart Filters".**

 Flip back to page 634 for a refresher on Smart Filters.

2. **Choose Filter→ Lens Correction.**

 Photoshop opens the petite (ha!) Lens Correction dialog box.

Figure 15-13:
Even a little thing like softly darkening an image's edges can make a huge difference, especially in portraits. Notice how the dark edges draw your eyes more quickly to the pint-sized superhero.

This technique is also handy to use with a sepia tone (page 327) to produce an aged photo look.

3. **Click the Custom tab (new in CS5) and adjust the Vignette amount.**

 Toward the top right of the dialog box are two tabs. Click Custom and then, toward the right middle of the dialog box, grab the Vignette section's Amount slider and drag it all the way left; Photoshop softly darkens the edges of the image. To darken the edges even more, grab the Midpoint slider and drag it slightly left to about 20 (see Figure 15-13).

4. **Click OK.**

See how fast that was? If, after admiring your handiwork, you decide the effect is a little too dark, mouse over to the Layers panel, double-click the icon to the right of the Smart Filter to open the Blending Options dialog box, and then lower the opacity slightly. In most cases, though, full strength looks just fine. If the edge vignette bleeds into your subject's face, you can always use the Smart Filter mask (page 634) to hide it from that area.

Vanishing Point

This filter is covered last because it behaves nothing like *any* of the filters you've read about so far.

Over your illustrious Photoshop career, there will be times when you need to edit an object so it appears in proper perspective (meaning it seems to get smaller as it disappears into the distance). Here are a few situations where you'll likely run into perspective problems:

- If you need to affix a graphic or text onto any kind of surface that's not flat, like an image of a book cover, a cereal box, or a DVD case that's positioned sideways.

- If you need to clone an object on the side of a wall or on top of a table.

- If you want to make a building or other structure look taller than it really is.

UP TO SPEED

Fixing Lens Distortion

No matter what kind of image editing voodoo you've got up your sleeve, you can't hide the quality of your camera's lens. Some lenses distort your image to the point that tall buildings appear to *bend* toward a vanishing point in the sky (called *pincushion distortion*, where lines bend inward), or make people and objects look bowed (called *barrel distortion*, where *lines* bend outward). However, sometimes it's not the lens but your own sense of balance—say, you accidentally tilted your camera vertically or horizontally—that makes a lake or ocean look like it's running *down*hill instead of staying level (called adjusting *perspective*). Other problems include a darkening of your image in the corners called *vignetting*, or a weird color fringe along an object's edges called *chromatic aberration*. Luckily, Photoshop CS5 can fix *all* of these problems for you with its new and improved Lens Correction filter (that is, if your image is 8- or 16-bit and in RGB or Grayscale mode only).

Choose Filter→Lens Correction and Photoshop displays a status bar, while updating its database of lens profiles (a detailed set of info about common lenses). Once it finishes, the Lens Correction dialog box opens with a new tab on the right side called Auto Correction. Here you can tell Photoshop what kind of problem you have—just turn on the checkbox for Geometric Distortion, Chromatic Aberration, or Vignette.

If fixing the image will cause it to expand or shrink beyond its original size, turn on Auto Scale Image and then let Photoshop know what to do with any resulting blank edges by choosing an option from the Edge menu. Your can have Photoshop fill the empty spots with transparency, black or white pixels, or enlarge the image to fill the edges by choosing Edge Extension.

In the Search Criteria section, tell Photoshop what equipment you used to capture the image. Pick your camera's make, model (this one doesn't have to match exactly), and lens model from pop-up menus. If Photoshop finds a matching profile, it appears in the Lens Profiles section below. To see all the profiles for a specific make, choose it from the Camera Make pop-up menu, and then set the other two menus to All.

If Photoshop doesn't find a match, click the Search Online button at the bottom of the dialog box. You can also click this section's panel menu and choose Browse Adobe Lens Profile Creator Online, which also lets you make your own custom profiles. If you'd like to snag a profile so you can use it when you don't have a live Internet connection, choose Save Online Profile Locally from the panel's menu.

To use a lens profile, simply give it a click and Photoshop does its very best to fix the problems you told it your image has.

This kind of editing is a real challenge because Photoshop sees everything as flat, with no perspective at all. The fix is to use the Vanishing Point filter to draw *perspective planes*—a mesh grid that you can use in your editing—*before* you start painting or cloning. Once you've drawn the grid, you can do your editing *inside* the Vanishing Point dialog box. While you're there, you can create a selection, copy and paste an image or text, or use the Clone Stamp or Brush tool, all in perfect perspective.

Here's how to paste one image on top of another in proper perspective:

1. **Select and copy the image you want to paste (for example, the cartoon superhero in Figure 15-14).**

 Open the image, select it using one of the techniques in Chapter 4, and then press ⌘-C (Ctrl+C on a PC).

Figure 15-14:
When you get the grid placed and sized just right, it turns one of three colors: red, yellow, or blue. A red grid means you've drawn an impossible perspective, so grab the Edit Plane tool (it looks like an arrow with a grid behind it) from the left side of the dialog box and resize the grid by dragging one or more of the corner points to another position. A yellow grid means your perspective is possible though unlikely; you can continue to edit the plane or keep it as is. A blue grid means you've drawn the plane in proper perspective. You can also use the Grid Size slider at the top of the dialog box to resize the grid mesh to fit your object.

2. **Open the image you want to add the copied image to and create a new layer.**

 You can't run the Vanishing Point as a Smart Filter, which means it runs on the currently active layer. To run the filter nondestructively, you either have to duplicate your image layer or add a *new* layer to work with, depending on what you're going to do.

For example, if you're going to use the Brush or Clone Stamp tool, you need to duplicate your image layer by pressing ⌘-J (Ctrl+J on a PC). However, if you're pasting another object *into* your document—as in this exercise—you need to create a new layer for the pasted object to land on. Click the "Create a new layer" button at the bottom of the Layers panel (its icon looks like a piece of paper with a folded corner). Since the new layer is transparent, you can see through it to the layer below—the original image layer—which you'll use as a guide when you draw your perspective plane in step 4.

3. **Choose Filter→Vanishing Point.**

 Photoshop opens the *huge* Vanishing Point filter dialog box (you can also open it by pressing ⌘-Option-V [Ctrl+Alt+V on a PC]).

4. **Use the Create Plane tool to draw your perspective plane.**

 Happily, Photoshop automatically activates the Create Plane tool as soon as you open the Vanishing Point dialog box (it looks like a + sign with a tiny grid behind it). Just click once on your image to set the first corner point of your plane. Mouse over to the next corner point and click it, mouse to the third corner point, and then click again to close the grid. If you have trouble seeing where to click to add corner points, zoom into your image by holding the X key (as soon as you let go, the image goes back to its normal viewing percentage). As you draw the plane, Photoshop places a blue mesh grid over the area as shown in Figure 15-14.

5. **Use the Edit Plane tool to position and tweak the grid.**

 Once you've drawn the grid, Photoshop automatically activates the Edit Plane tool, letting you move a point by dragging it (the tool looks like an arrow with a tiny grid behind it). If you need to move the whole grid, click within it and then drag it to another position.

Tip: If you need to draw more than one perspective plane in your image (if you have two similar buildings to work on, say), you can copy a plane to another area by Option-dragging (Alt-dragging on a PC). If you're working with an object that has more than one side and you need to make the grid wrap around it (like a book cover and its spine), you can ⌘-drag (Ctrl-drag) one of the mesh points (it doesn't matter which one) to tear off another plane that you can position at an angle.

6. **Paste the object you copied back in step 1 and drag it on top of the plane.**

 Press ⌘-V (Ctrl+V on a PC) to paste your image into the Vanishing Point dialog box. At first, your image appears flat (not in perspective) and surrounded by a black-and-white selection box, but when you drag the image on top of the plane, it twists and distorts to conform to the perspective you've drawn.

7. **If you need to resize the image you just pasted, press T to summon a resizable bounding box.**

 Photoshop puts a bounding box around your image. To resize it proportionately, hold the Shift key as you drag one of the corner handles inward to make it smaller. If your object is bigger than the perspective plane, you can't *see* the handles because they extend beyond the edges of the mesh grid. In that case, click the center of the image and move it in one direction or another until you can see one of the handles, and then drag the handle inward to make the object small enough so you can see them all. When you're finished resizing it, *don't* do anything else: If you press Return (Enter) when you finish resizing, you'll close the Vanishing Point dialog box before you're ready. If you need to move the pasted image, click inside it and then drag it to another position. When you're finished, click OK to close the dialog box.

8. **Change the blend mode of the pasted image layer to Soft Light.**

 Back in the Layers panel, you can make the colors of the superhero (the pasted image) blend better with the colors of the building by changing the blend mode to Soft Light, as shown in Figure 15-15.

Figure 15-15:
As you learned back on page 298, the Soft Light blend mode is great for creating reflections.

Tip: Interestingly, you're allowed *multiple* undos when you're in the Vanishing Point dialog box—just keep pressing ⌘-Z (Ctrl+Z on a PC) and Photoshop keeps undoing the last thing you did.

Other tools in the Vanishing Point dialog box include:

- **Marquee** lets you draw a selection (in perspective) to duplicate an area inside the plane you've drawn (if, say, you want to make a building taller, you can duplicate the top few floors). Or you can use the Marquee tool to restrict the Stamp or Brush tools (discussed later in this list) to a specific area of your image. Your selection can be smaller than the plane itself, and you can use the options at the top of the dialog box to feather the selection so its edges are soft. Or, if you're moving the selected pixels to another area in your image, you can change their opacity.

Tip: To select the entire plane, double-click the mesh grid with the Marquee tool.

If you're copying the selection to another area, you can use the Heal pop-up menu to determine how the selection blends with the area you're dragging it to. Your options include Luminance (Photoshop blends the selected pixels with the lightness values of surrounding pixels), On (it blends the selected pixels with the pixel color values that you're dragging the selection onto), or Off (it doesn't blend any pixels).

The Move Mode pop-up menu lets you specify how the selection behaves. For example, you can choose Source to *fill* the selection with the pixels you move your mouse over (you can also ⌘-drag or Ctrl-drag the selection). The selection itself won't move, but it'll get filled with the pixels you hover your cursor over. Use this option when you want to remove an object like a window or door by copying other pixels on top of it. Destination *selects* the area you move the selection to; the selection moves, but Photoshop doesn't copy any pixels. Choose this option when you want to copy a selection that can be resized using the Transform tool (discussed below) to make it *float*. For example, if you've removed a window using Destination mode, you can copy the selection and then move it into place to remove even more windows. You can also press ⌘-Shift-T (Ctrl+Shift+T on a PC) to duplicate your last duplicating move (helpful when you've got a bunch of windows to zap).

- **Stamp** works just like the Clone Stamp tool (page 434) and lets you copy pixels from one area to another by painting while you use the perspective of the plane you've drawn. This tool comes in handy when you're extending an object or a building's height.

- **Brush** lets you apply paint with perspective. If you choose Luminance in the Heal pop-up menu, the new paint takes on the lightness values of the underlying pixels. You can set the brush's color by clicking the color well toward the top right of the Vanishing Point dialog box.

- **Transform** resizes a floating selection (one that you've pasted), although it's quicker to press T to activate the Transform tool. Don't press Return (Enter) when you finish resizing or you'll close the Vanishing Point dialog box. At the top of the Point dialog box, you can turn on the Flip option to flip your selection horizontally. Flop does the same thing, but vertically.

- **Eyedropper** snatches a color from the image so you can use it with the Brush tool.

- **Measure** shows up in the Extended version of Photoshop, and lets you measure the distance and angle of items in a plane. Architects, interior designers, and scientists love this option.

- **Hand** allows you to move around your image while you're zoomed in. Just click the hand and then drag to move around in your image.

- **Zoom** lets you zoom in and out of your image. You can also press ⌘ and the + or − minus key (Ctrl and + or − on a PC) or pick a magnification percentage at the bottom left of the Vanishing Point dialog box.

Photoshop and Print

G etting your prints to match what you see onscreen is one of the biggest challenges you'll face when dealing with digital images. As you learned in the box on page 406, your image files are actually filled with grayscale information—it's the monitor and printer's job to give them color. And with the sheer volume of monitors, printers, inks, and papers out there, producing consistent color is a *nightmare*. That's why you hear so many folks screaming, "But my print doesn't match what I see on my screen!" Unless you prepare your monitor and files properly, it's *impossible* to make them match.

Thankfully, there's a solution, but it lies in understanding *why* this stuff happens to begin with. Unfortunately that means learning about things like color modes, gamuts, and color profiles. It's dense stuff, to be sure, but it's not rocket science. The main concepts are (fairly) straightforward, and if you can make it through this chapter (an energy drink might help), you'll know how to create consistent, predictable high-quality prints.

The Challenge of WYSIWYG Printing

WYSIWYG, as you may know, is an acronym for "What You See Is What You Get." For image-editing buffs, it describes that elusive goal of getting your prints to match what you see on your screen. When you think about the different ways colors are produced by monitors versus printers, the problem starts to make sense.

A monitor's surface is made from glass or some other transparent material, and, as you learned in Chapter 5, it produces colors with phosphors, LCD elements, or other light-emitting technology. In contrast, printers use a combination of opaque paper, reflected light, and CMYK ink. (Remember, that's short for cyan, magenta, yellow,

and black.) To add even more excitement, some printers use additional colors like light cyan, light magenta, several varieties of black, and so on. Given these two completely different approaches to creating colors, it's a miracle that the images on your monitor look *remotely* similar to the ones you print. And because there are a bazillion different monitors and printers on the market—each using different printing technologies—you'll see a big difference in how your images look simply because of the monitor or printer you're using at that time. Heck, even changing the paper in your printer makes a big difference in how your images print.

The only way to achieve consistent printing results is to know which printer your image is headed for, which color mode (page 46) that printer wants your image to be in, which *range* of color that printer can reproduce on paper, and which paper you're using. Whew! Once you get that info, you have to communicate it to Photoshop. This section describes how you can make all that happen.

Understanding Color Gamuts and Profiles

As a first step toward WYSIWYG printing, remember from Chapter 5 that, in most cases, your image starts life in RGB color mode when you capture and view it and eventually ends up being converted to some version of CMYK when it's printed (as you'll learn later, either the printer can convert the modes or you can do it manually). Your next step is to understand a little more about how those two color modes differ. Enter the concept of *color gamuts*.

A color gamut is the range of colors a given device can reproduce (flip back to Chapter 5 for more on how color works). An RGB monitor, for example, can reproduce one range of colors and a CMYK printer can reproduce another (and no printer on the planet can produce a color range as wide as your eyes can see). While the color ranges of monitors and printers frequently overlap, they're rarely identical. Your printer's color gamut depends on the specific combination of printing technologies you're using, which include:

- **Colorants (color-producing substances).** The printers you're likely to encounter include inkjet and laser printers, commercial offset presses, and digital presses. Some printers, like commercial offset presses, use pigment-based inks to produce color. Others, like inkjets, use dye-based inks, and still others, like laser printers and digital presses (which are like fancy laser printers), use toners.

- **Dot pattern.** All the printers mentioned above use a pattern of dots to reproduce your images. Commercial offset presses use *halftone dots* that are commonly made from circles and diamonds.

- **Paper type.** Each printer can also use a wide range of paper. For example, you can print on plain paper, matte, or super high-quality glossy paper (quick tip: You'll get a *much* higher-quality print using glossy paper). If you want your inkjet printer to reproduce its full gamut of color, you need to use a specially coated paper made to work with dye-based inks.

To account for all these variations, you have to use *color profiles* to tell Photoshop exactly which colorants and papers you want to print with. Color profiles contain detailed info about the printer's color gamut and, in some cases, the paper you're using. Photoshop comes with a variety of all-purpose, rather generic, profiles, but you can also get profiles from the printer and paper manufacturers. Throughout this chapter, you'll learn how to use profiles both to proof (check and review) and to print your images on commonly used printers like inkjets, commercial printing presses, and digital presses.

Note: Manufacturers are inventing new output devices all the time and this book can't possibly cover them all. That said, if you're going to use one, you'll want to work *very* closely with your output service to ensure an accurate print. One such device is the LightJet 5000 (*www.cymbolic.com/LJ5000.html*), which uses photographic paper and lasers to create continuous-tone images at extremely large sizes. Far out!

Finding and installing color profiles

Most of the time, you can download color profiles right from the printer or paper manufacturer's website, although you might have to poke around a bit to find 'em! However, you can also get custom profiles from professional printing companies, which are usually quite happy to share them with you if you ask. Luckily the profiles you get from larger companies, such as Epson (see Figure 16-1), come with an installer program. If yours didn't, you can ask the company who provided the profile where you should put it on your computer (you have to put it different places depending on your operating system).

Once you've installed the profiles, you can access them through Photoshop's Print and Custom Proof dialog boxes, explained later in this chapter.

Calibrating Your Monitor

Now that you understand how to tell Photoshop which kind of printer and paper you're using, you need to make sure your monitor is displaying color accurately. For best results, rather than using the built-in calibration program that came with your computer, you need to calibrate your monitor using an external measuring device like a *colorimeter* or *spectrophotometer*—hand-sized gadgets that clamp onto your monitor and measure the color it displays. The calibration process involves adjusting your monitor so that it displays a series of colors and images consistently. Having a calibrated monitor also lets you accurately preview how images and colors will print (a process called *soft-proofing*, discussed later in this chapter).

Figure 16-1:

Top: Not every printer or paper manufacturer's website will look the same, though they'll have similar options (you may have to hunt for 'em!).

Bottom: If the installation doesn't begin automatically, double-click the installer.

The good news is that you can buy a calibration system for around $100, although the more sophisticated devices will set you back a little more. There's certainly no harm in starting with an affordable model like the Pantone HueyPro (*www.pantone.com/hueypro*), but if you want to *truly* trust the colors your monitor is showing you, you'll need to spend extra. Other options include the Spyder (*http://spyder.datacolor.com*), which runs about $180, and the ColorMunki (*www.colormunki.com*), which costs roughly $400, or the Eye-One (*www.xrite.com*), which is around $250. However a simpler and perhaps more accurate solution is to buy a monitor that comes with its *own* calibration software and colorimeter, such as the NEC Spectraview (*www.nec-display-solutions.com*).

Another step toward making your monitor display your images as they'll look when they're printed is telling Photoshop exactly which document color profile (also called your *color work space*) you want to use while you're working on the image. Choose Edit→Color Settings and, in the Working Spaces section of the resulting dialog box, choose a profile from the RGB and CMYK pop-up menus. If you spend a lot of time editing images from digital cameras, choose "Adobe RGB 1998" from the RGB pop-up menu; if you're preparing images for the Web, leave this option set to sRGB. If you routinely edit CMYK images, pick a profile from the CMYK pop-up menu that most closely describes the kind of press your images will be printed on.

Tip: You can also change your *digital camera's* color work space to match what you use in Photoshop. For example, most cameras are set to sRGB mode right out of the box, but you can change it to Adobe RGB instead. Yes, you'll have to dig out your owner's manual to learn how, but the increased color accuracy is well worth it!

Printer-Friendly Resizing and File Formats

Besides making sure your images are in the right color mode, installing the right color profiles for your printer and paper, and calibrating your monitor—are you exhausted yet?—you also need to make sure your image's size matches the size you want to print. For example, if you want to print your image at 5"×7", it should really *be* 5"×7" (as opposed to, say, taking a 6"×8" image and cramming it into that smaller format). You also need to make sure your image has sufficient resolution (see the table on page 243 for resolution guidelines). Finally, you need to save your image in a file format that works well with your printer.

UP TO SPEED

Profiles Aren't All Equal

It's shocking but true: Some profiles are just plain wrong!

Photoshop offers many built-in profiles (like "Adobe RGB 1998") that include general color mode info, along with slightly more specific though still generic profiles (like "US Sheetfed Coated v2") that contain gamut information for printing on a standard sheetfed printing press, using standard inks and coated paper. If your printing conditions are indeed standard, you may get decent results by using this profile.

You can also use paper-specific profiles, commonly referred to as *paper* or *output profiles*, created by manufacturers like Epson, who make profiles to match almost every kind of paper they sell: glossy, luster, matte, and so on. The more closely a profile matches your printing conditions, the more accurate and useful it is. You'll find that high-quality profiles like the Epson paper profiles provide invaluable help with proofing and printing.

When you're out paper shopping, it's wise to confirm that the paper manufacturer does indeed have paper profiles that match your printer and ink (and be wary of buying paper from companies that don't!).

You'll also want to test the profiles by actually printing with them. If you've been printing with other paper and profiles, print some test images using the same image for both sets of papers and profiles and then compare your results. You'll probably find that some paper manufacturer's profiles are better then others

Printers can accept a wide range of file formats, including PSD (Photoshop), as well as TIFF, EPS, PDF, and even JPEG. Don't worry: Choosing the format isn't as hard as you might think. Once you've saved your master file as a PSD file (see the box on page 51), choose File→Save As and pick one of the following formats:

- **TIFF.** This format (whose name is short for "tagged image file format") has long been considered the print-safe gold standard and for that reason, almost any program can work with TIFF files. Saving a file in TIFF format doesn't involve any kind of automatic compression, so the quality remains as good as that of your original file. And if your image will be used in another program but you don't know what that program is—for instance, if your work will be used in a book or magazine—save it as a TIFF.

Tip: If you have to email or upload a TIFF, be sure to create and send a .zip archive of the file first because TIFFs are notorious for getting corrupted in transit. On a Mac, Ctrl-click the file's icon and choose Create Archive from the resulting shortcut menu. On a PC, you can zip the file using an application like WinZip (*www.winzip.com*). If you're using Windows Vista or Windows 7, the ability to zip files is built into your operating system.

- **PDF.** This format (short for "portable document format") is becoming more popular by the minute. While it *can* compress files, it doesn't do so automatically, which makes it perfect for images you plan to print (plus it preserves the smooth edges of vectors). And if you need to transfer your file via the Internet before you print it, PDF is a better choice than TIFF because PDFs were designed to be used online.

- **EPS.** If you've created a multitonal image (page 340) or one with spot colors (page 197), you can use the EPS format (which stands for Encapsulated PostScript), long the native format for vectors. However, PDF files can *also* handle multitonal images and ones with spot colors, and you'll find that saving a file is in PDF format is simpler than saving it in EPS format. For that reason, go with PDF format unless someone—like a prepress manager at your printing company—specifically requests an EPS file. (And if she does, ask her tactfully if she's heard about PDFs!). There's more on this topic on page 672.

Resizing and Saving as a TIFF

Here's how to prepare your image for a high-quality print even if you don't know exactly what resolution you need or which program will be used to print your image:

1. **With your image open, summon the Image Size dialog box.**

 Choose Image→Image Size or press ⌘-Option-I (Ctrl+Alt+I on a PC). See page 239 in Chapter 6 for a full introduction to this important dialog box.

2. **At the bottom of the dialog box, turn off the Resample Image checkbox.**

 This prevents you from changing the pixel info in your image—and therefore changing its quality.

3. **In the middle of the dialog box, set the document width and height to the size you want to make your print (for example, 10"×10").**

 Don't worry about changing the resolution for this exercise because you'll save the file at its maximum resolution (Photoshop changes it automatically as soon as you enter the width and height). If you're sending the file to a professional printer and your resolution is between 300 and 450 ppi, you can sleep well knowing it'll print nicely. (If the resolution is lower than that, see the box on page 244 for a workaround.) Click OK to close the Image Size dialog box.

4. **Save the file in TIFF format.**

 Choose File→Save As or press ⌘-Shift-S (Ctrl+Shift+S on a PC) and, in the resulting dialog box, choose TIFF from the Format pop-up menu.

5. **At the bottom of the dialog box, turn off the Layers and Alpha Channels checkboxes.**

 Turning these options off forces Photoshop to save a new, flattened version of your image that's good for printing while preserving your original, fully editable file.

6. **At the top of the dialog box, name the new file and tell Photoshop where to save it.**

 You may want to develop your own naming system for print files. A name like "AlaskaLight_10x10_Print_CMYK.tif" specifies the file's dimensions, that it's a file designed for printing, and its color mode (see Figure 16-2, left). Click Save to close the Save As dialog box. Photoshop opens the TIFF Options dialog box.

7. **Adjust the TIFF Options dialog box's settings.**

 In the box's Image Compression section, choose None; this option prevents Photoshop from compressing your image, keeping the quality as high as possible. Leave the Pixel Order section set to Interleaved, and in the Byte Order section, turn on the IBM PC radio button to make the file compatible with Windows computers (a Mac can read either one). Leave the "Discard Layers and Save a Copy" option at the very bottom of the dialog box turned on (see Figure 16-2, right).

8. **Click OK and Photoshop saves your image as a TIFF file.**

Following these steps lets you create an uncompressed, simplified, print-ready copy of your image at the right print size without harming your original file. You can print the TIFF image straight from Photoshop or hand it off to a page-layout program like Adobe InDesign.

Figure 16-2:
*Left: Adopting a
naming scheme like
this one can help you
keep your images
organized.*

*Right: As soon as you
click Save, you see
the big ol' TIFF Op-
tions dialog box.*

Note: You can print multilayer PSD files and place them in page-layout software like Adobe InDesign and QuarkXPress (InDesign actually prefers PSD files). So why bother saving a simplified TIFF? Because if you don't know which program your image will be used in (and you can't find out), you're safer with a TIFF.

Resizing and Saving as a PDF File

Another high-quality format option is PDF. You can use PDF format to save some of the most complex images you'll ever create like those with spot colors (page 197) or multitonal images (page 340) that historically required EPS format or its print-specific variation, DCS (Desktop Color Separations) format (page 694).

As mentioned earlier, creating a PDF file is usually easier than making an EPS file, and PDF files are safer to transfer over the Internet. To resize your image and save it as a PDF:

1. **Open your Photoshop document and duplicate the image.**

 Since this technique involves lowering the resolution, it's safer to work with a *copy* of your image rather than the original. Choose Image→Duplicate and name the new image something like "Alaska Light_5x5_300", which is a handy way of embedding info about the file's size and resolution in its file name.

2. **Open the Image Size dialog box, turn off the Resample Image checkbox, and resize the image.**

Choose Image→Image Size or press ⌘-Option-I (Ctrl+Alt+I on a PC) and turn off the Resample Image option at the bottom of the dialog box. Then change the width and height if you need to. For example, the image shown in Figure 16-3 started at 9"×9", but now it's 5"×5"; this change caused the resolution to balloon from 348 ppi to 691 ppi. The next step shows you how to lower that number to a more reasonable level (see page 243 for a discussion of resolution overkill).

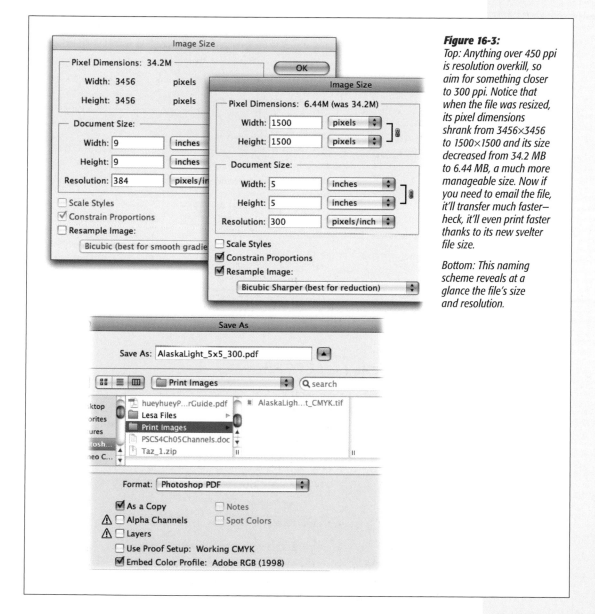

Figure 16-3:
Top: Anything over 450 ppi is resolution overkill, so aim for something closer to 300 ppi. Notice that when the file was resized, its pixel dimensions shrank from 3456×3456 to 1500×1500 and its size decreased from 34.2 MB to 6.44 MB, a much more manageable size. Now if you need to email the file, it'll transfer much faster—heck, it'll even print faster thanks to its new svelter file size.

Bottom: This naming scheme reveals at a glance the file's size and resolution.

3. **At the bottom of the Image Size dialog box, turn the Resample Image checkbox back on and lower the resolution to 300 ppi.**

 To change the image's resolution, the Resample Image checkbox has to be on. Enter *300* in the resolution field.

4. **Choose "Bicubic Sharper (best for reduction)" from the resample method pop-up menu at the bottom of the dialog box.**

 Choosing this method makes Photoshop reduce the softening (blurring) that results from making your image smaller. (See page 240 for more about resampling.) Click OK to close the Image Size dialog box.

Tip: You may also want to apply a round of sharpening after you resize and resample an image to help maintain its sharpness (an amount between 50 percent and 75 percent should do the trick). See Chapter 11 for sharpening enlightenment.

5. **Summon the Save As dialog box by choosing File→Save As or pressing ⌘-S (Ctrl+S on a PC).**

 Since you're working on a copy of the image that you haven't saved yet, you need to tell Photoshop where you want to save it and in what format.

6. **In the Format pop-up menu, choose Photoshop PDF and then turn off the Layers and Alpha Channels checkboxes.**

 Turning off these checkboxes forces Photoshop to duplicate your image, creating a new, simplified PDF version for printing and preserving the original layered Photoshop file.

7. **Give your file a name and tell Photoshop where to save it, and then click the Save button.**

 When you do, the Save Adobe PDF dialog box appears.

8. **On the left side of the dialog box, choose General and make sure the Compatibility pop-up menu on the right-hand side is set to "Acrobat 5 (PDF 1.4)" as shown in Figure 16-4, top.**

 If you want to edit your PDF in Photoshop later, you can also turn on the Preserve Photoshop Editing Capabilities checkbox.

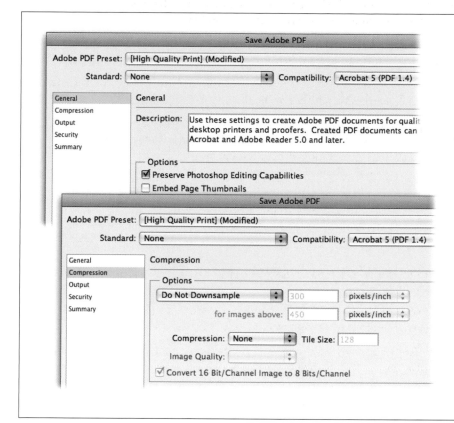

Figure 16-4:
The Save Adobe PDF dialog box has a slew of options, and you can go through them all by selecting each category on the left (General, Compression, and so on).

9. **Click the Compression category on the left and, from the Options pop-up menu in the middle of the dialog box, choose Do Not Downsample and then set the Compression pop-up menu to None (see Figure 16-4, bottom).**

 These options let you retain all your original pixel info so you can create a high-quality print. If you want to reduce the file's size without losing much of the image's quality, choose "Zip 8 bit" or JPEG Maximum Quality from the Compression and Image Quality pop-up menus (respectively). A maximum-quality JPEG is a great choice when you're sending an image to a service bureau or print company that lets you upload files to its website.

10. **Click the Output category and pick No Conversion from the Color Conversion pop-up menu.**

 This option will make Photoshop retain all your image's original color info.

11. **Optionally, save these settings as a preset so you can use them again later.**

 Before you click the Save PDF button, ask yourself if you'll ever want to use these settings again. If the answer is yes (and it probably is), click the Save Preset button in the lower-left corner of the dialog box (Figure 16-5). Give your preset a descriptive name like *Print Image PDF* and then click Save.

Figure 16-5:
If you save your settings as a preset, you can access them in the PDF Presets pop-up menu at the top of the Save Adobe PDF dialog box. You can save as many presets as you want, which can be a huge timesaver.

You can also choose one of the built-in PDF standards listed in the Standard pop-up menu, shown here. When you make a choice from this menu, it sets all the other options for you. Ask your printer which standard to use.

12. **Click the Save PDF button when you're finished.**

You can place your newly created PDF file in an Adobe InDesign document or send it to somebody via the Internet. Unlike TIFF or EPS files, which usually need to be encased in a protective .zip or .sit archive (a compressed document container), PDF files are Internet compatible and safe.

Printing on an Inkjet Printer

If you're a photographer, you probably use an inkjet printer, most likely an *expanded-gamut* inkjet printer—one that uses six to eight inks, rather than the standard four (they're technically dyes, but most folks call them inks). The most common combination of expanded-gamut ink includes the four standard *process colors*—cyan,

magenta, yellow and black (CMYK)—plus light cyan and light magenta. You may also have a choice of black inks, like glossy or photo black, matte black, light black, and even light *light* black (seriously!).

Note: Inkjet printers are more common than dye-sublimation or color laser printers, so they're the focus of this section, but you can use printer and paper profiles no matter what kind of printer you use.

Nearly all expanded-gamut inkjet printers can convert your RGB images to CMYK (plus any additional inks they may have). For the best results (and the brightest colors), you should let the printer convert the color mode for you.

If you've already converted your RGB image to CMYK, don't panic—many of these printers can print a regular, four-color CMYK file, too. However, some print your image using CMYK inks and others convert your image into *another* color mode, like Lab (see page 47) and *then* convert it to the printer's own so-called CMYK-Plus mode before printing it. The latter option can be scary because anytime you do massive color-mode shuffling like this, you can lose your brightest and most saturated colors. And some colors may change altogether—for example, blue becomes purple—which is *not* good! That's why it's better to print an RGB image instead.

FREQUENTLY ASKED QUESTION

Why Not Print JPEGs?

Hey, what do you have against JPEGs? It seems like a decent enough file format.

You may be wondering why you shouldn't save and print your images in JPEG format. That's a legitimate question because, after all, JPEG is the format used by most digital cameras. The problem occurs once you start editing, resaving, and printing your images as JPEGs.

When you save your images as JPEGs, they're automatically compressed using a process known as *lossy compression*, which reduces the amount of info in your image (some of it is thrown out or lost), lowering the image's quality. The amount of compression, and the resulting loss of info and quality, varies from one JPEG to another (you can set the level of compression yourself as discussed on page 718). However, when you *resave* a JPEG without changing its format to something else like PSD or TIFF, you apply yet *another* round of compression, and *that's* when everything goes to heck in a handbasket.

Here's what you should do instead:

- If possible, set your digital camera to capture your images in an uncompressed format like TIFF or Raw to prevent any initial compression and resulting loss of info and quality. As you learned on page 57, Raw is the most flexible format, so choose that option if possible (not all cameras can save images in Raw format; consult your owner's manual to see if yours can).

- Save any JPEGs you receive in TIFF or PSD format to prevent them from getting any worse. To speed up this file conversion, you can use Photoshop actions (Chapter 18) and/or the Image Processor script (page 255) to quickly and automatically convert several images from one format to another.

If you have no choice but to use JPEG—because the image is large or your computer doesn't have much memory—use the highest quality and lowest compression settings to preserve as much quality as possible.

To print a high-quality image with an expanded-gamut printer, follow these steps:

1. **Prepare your image for printing by cropping, editing, and resizing it.**

 Make sure you've color-corrected (Chapter 9), cropped, and resized the image and set the resolution to between 200 ppi and 450 ppi (Chapter 6). If you forget to crop your image to the exact dimensions you want, your printer may crop it for you (it's far better to do it yourself). It's also a good idea to double-check the Image Size dialog box to confirm that your document's dimensions and resolution are correct (open it by pressing ⌘-Option-I or Ctrl+Alt+I on a PC).

2. **Choose File→Print or press ⌘-P (Ctrl+P) to summon the Print dialog box, shown in Figure 16-6 (top).**

3. **Select your printer from the Printer pop-up menu at the top of the dialog box.**

 For this example, choose Epson Stylus Photo R2400.

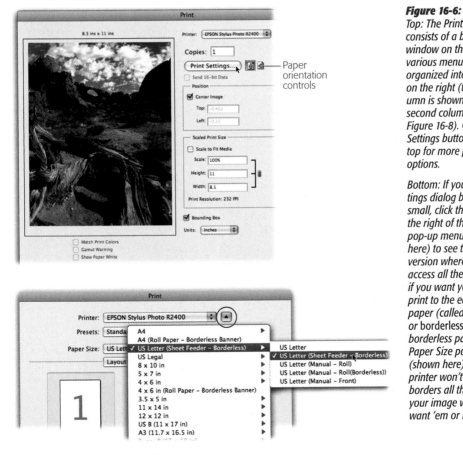

Figure 16-6:

Top: The Print dialog box consists of a big preview window on the left, with various menus and fields organized into two columns on the right (the first column is shown here and the second column is shown in Figure 16-8). Click the Print Settings button toward the top for more printer-specific options.

Bottom: If your Print Settings dialog box is really small, click the triangle to the right of the Printer pop-up menu (circled here) to see the expanded version where you can access all the goodies. Also, if you want your photo to print to the edges of your paper (called a full bleed or borderless print), choose borderless paper from the Paper Size pop-up menu (shown here) so your printer won't slap white borders all the way around your image whether you want 'em or not.

Note: Photoshop CS5 now saves your favorite print settings within your document so you perform one-button printing later on. After you've made changes in the Print dialog box, click Done (instead of Print) and then save your document before closing it. The next time you want to print it with the same settings, you can simply choose File→Print One Copy. Sweet!

4. **Click the Print Settings button.**

 Most folks miss this super critical setting (see Figure 16-6, top), which is why Adobe changed its name from Page Setup to Print Settings in CS5. This dialog box controls the printer (in this case, an Epson model).

5. **In the Print Settings dialog box, choose your printer from the Printer pop-up menu.**

6. **From the Paper Size pop-up menu, choose your paper's dimensions.**

 If you're printing borderless, be sure to choose a borderless version of the paper dimension you picked (see Figure 16-6, bottom). If you *don't* pick an option that includes the word "borderless," your image will print with a border.

7. **From the pop-up menu in the middle of the dialog box, choose Print Settings (circled in Figure 16-7).**

 The wording of your dialog box may vary slightly or you may not have this option at all. Instead you may see the settings listed below:

 - **Borderless.** Make sure that your Page Setup is set to Sheetfed Borderless.

 - **Media Type.** Choose the paper you're printing on, like Ultra Premium Photo Paper Luster (now that's a mouthful!).

 - **Color.** Make sure you've chosen to print in color or all this color-management and profile stuff won't do you any good.

 - **Color Settings.** Make sure these settings are turned off so the printer doesn't adjust the color. This setting—another one that most folks miss—is crucial because if you don't turn it off, it conflicts with the color-management settings and profiles you've assigned in Photoshop.

 - **Mode.** Click Advanced and make sure Print Quality is set to Best Photo or something similar. (You may find the Quality setting hiding in the Media Type options mentioned earlier in this step.)

 - **High Speed.** If you have this option, which lets your printer's *print head* (the bit that applies the ink to the paper) print while it's moving in *both* directions instead of just one, turn it off initially. Your image will print more slowly, but it'll look better. If you want, you can fire off a couple of test prints with High Speed turned on and off; look closely at your image's details to see the difference.

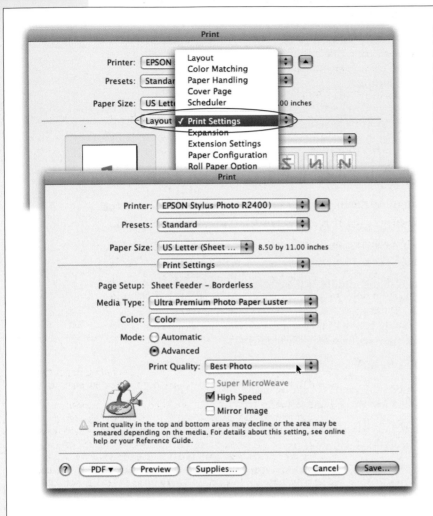

Figure 16-7:
The dialog boxes you see may look a little different depending on your operating system and printer, but you should find all these settings lurking somewhere.

8. **Click Save to close the Print Settings dialog box and return to the first Print dialog box you encountered.**

 Check your paper orientation to make sure it's what you want—portrait or landscape (see Figure 16-6, top). Also, peek at the preview window on the left side of the dialog box to make sure your image fills the whole window. If you wisely cropped your image to your exact print dimensions, it should fill the preview area perfectly.

9. In the Position section of the Print dialog box, turn on the Center Image checkbox (see Figure 16-6, top).

 If for some reason you *didn't* crop your image before starting this process, you can use this setting to print your image from the center outward—as much of it as will fit on the paper size you picked—instead of the whole thing.

10. Make sure the Scaled Print Size section's Scale option is set to 100%.

 You can use this setting, along with the Position setting mentioned earlier, to control which part of your image prints if you didn't crop it first. However, just because you *can* scale (resize) your image while it's being printed doesn't mean you *should*; besides preventing you from sharpening your image after you make it smaller, scaling it through the Print dialog box makes it take longer to print.

11. Choose Color Management from the pop-up menu at the top right of the Print dialog box and turn on the Document radio button (see Figure 16-8).

 Color management is the process of making the colors produced by the devices you work with—your digital camera, monitor, and printer—match as closely as possible by referencing specific color profiles. Choosing Document rather than Proof means you intend this print to be the final copy rather than a simulation used for proofing (you'll learn more about Photoshop's proofing function later in this chapter).

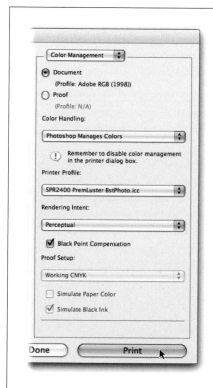

Figure 16-8:
Here you can see the second column of the big ol' Print dialog box that lets you determine exactly who controls your document's color management.

In previous versions of Photoshop, the Print dialog box included an option near the bottom called "Print to Selection", which was helpful for printing (and thus proofing) a small portion of your image, provided you remembered to make a selection first (see Chapter 4 for more on selections). Few folks ever used this option, so Adobe nixed it in CS5. However, a quick workaround is to temporarily crop your image (page 222), print it, and then undo the crop by pressing ⌘-Z (Ctrl-Z on a PC) or stepping back in your History panel (page 27).

12. **In the Color Handling pop-up menu near the top of the dialog box, choose Photoshop Manages Colors.**

 This setting controls whether Photoshop or the printer converts the color mode from RGB to CMYK-Plus. It's certainly worth experimenting with both options, though you'll likely find that controlling the conversion through Photoshop gives you higher quality and more consistent results *if* you're using paper-specific profiles.

 Heed the warning that Photoshop displays when you choose Photoshop Manages Colors: "Remember to disable color management in the print settings dialog box." Most printers are configured to apply *some* kind of color management profile to your image, which can conflict with the color management you're trying to apply through Photoshop (usually with unsavory results). In the Print Settings dialog box discussed back in step 7, you should see an option to disable printer color management (hunt for a setting labeled "color management," or "color options").

13. **From the Printer Profile pop-up menu, choose the paper-based profile that matches the paper and print settings you're using to convert your image from RGB to CMYK-Plus mode.**

 Click the Printer Profile menu and scroll down the long list of profiles (it'll get longer each time you install new ones). For example, the Epson profile begins with SPR2400, and the name of the paper and a print setup condition is included in the name. So if you're printing on Epson's Premium Luster Paper with a Best Photo condition, choose "SPR2400 Premluster BstPhoto.icc."

Note: The file extension .icc refers to the industry standard color profile format created by the International Color Consortium (ICC). If you're feeling inquisitive, you can visit their website at *www.color.org*.

14. **In the Rendering Intent pop-up menu, choose Perceptual and turn on the Black Point Compensation checkbox.**

 These options help maintain the color relationships in your image and make sure that the black shadows in your original RGB image are also black in the final CMYK-Plus version (which preserves contrast).

15. **Below the Print dialog box's preview section (on the left), turn on the Match Print Colors and Show Paper White settings to view an onscreen proof (also called a *soft proof*).**

 Photoshop displays a simulation of what your printed image will look like (see page 700 for more info).

16. **Turn on the Gamut Warning checkbox to make any out-of-gamut pixels appear gray in the preview area of your Print dialog box.**

 You can ask Photoshop to show you a proof of any colors in your image that are *out of gamut* (meaning they're unprintable) for the printer and paper you've selected. When you're printing to expanded-gamut printers, you'll encounter far fewer out-of-gamut colors than you would with a standard CMYK printing press. Adobe improved Photoshop's soft-proofing accuracy in CS4, so the preview should give you a good sense of what your print will look like. Of course, none of this means diddly unless you've calibrated your monitor so you see reliable results (see page 667).

17. **Glance over your settings in the Print dialog box one last time and, if they're okay, click the Print button.**

 After *all* that hard work, you see the fruit of your labors in the form of a gloriously accurate, high-quality print. Yippee!

Note: In CS4 and earlier, you encountered the Print Settings dialog box *after* clicking the Print button. In CS5, the settings from the Page Setup dialog box and the Print Settings dialog box have been combined into the Print dialog box, meaning you've got one less dialog box to deal with before hearing the pitter patter of your printer actually *printing*.

POWER USERS' CLINIC

Printing Vectors and 16-bit Images

If your image contains vectors or 16-bit images (page 45), the Print dialog box contains yet another set of printing options you need to worry about:

- **Include Vector Data.** Choose Output from the pop-up menu at the top right of the Print dialog box and you'll see this checkbox. If your image contains vector artwork (Chapter 13) or Type layers (Chapter 14), you need to print them with a PostScript printer (like *some* laser and inkjet printers). If you're printing to a non-PostScript printer (like *most* inkjets), you should rasterize (page 110) your vectors first so you can see how they'll look *before* you actually print them. (If you don't know whether your printer supports PostScript, check your owner's manual or print a specification or diagnostic page that lists which technologies the printer works with.) If your printer *is* a PostScript printer, you can preserve the wonderfully crisp edges of your vectors by turning on this checkbox. If it's grayed out, your image doesn't include any vector info so you don't have to worry about it.

- **Send 16-bit Data.** In CS4 this option was one of the Output settings discussed above, but in CS5 it lives beneath the Print Settings button (see Figure 16-6, top). If your image contains 16-bit pixel info, Photoshop lets you print all 16 bits of it; that is, if your printer can handle it (the checkbox is grayed out if it can't). To make sure the extra info is sent to your printer, turn on this checkbox.

Printing on a Commercial Offset Press

If you prepare artwork for stuff that's printed using a commercial offset printing press (magazines, product packaging, newspapers, and so on), you've got *loads* more to worry about than if you're sending your image to an inkjet printer. Unlike printing to an inkjet printer, where your images gets converted from RGB to CMYK during the printing process, a commercial offset press usually requires you to convert your image to CMYK *before* it's printed. In this section, you'll learn the very specific steps you need to follow to preserve your image's color when you convert it to CMYK. But before you dive too deeply into color-mode conversion, you need to understand a bit more about how offset presses work.

Note: Inkjet printers spray their ink from a print head directly onto a page. An offset press, however, transfers, or *offsets*, ink from an image on a plate onto a rubber blanket and *then* onto a page—which is why commercial printing presses are called "offset presses."

Commercial offset presses are huge, noisy, ink-filled metal beasts. As you learned back in Chapter 5 (page 195), they split your image's four CMYK channels into individual color separations, which are loaded onto big cylinders aligned so that all four colors are printed, one on top of another, to form your final image. If the cylinders aren't aligned properly, you'll see faint traces of one or more colors peeking outside the edges of your image, making it look blurry (this blurriness is called being "out of registration").

Instead of the dyes used by inkjet printers, commercial offset presses use two types of ink: *process* and *spot*. Process inks include cyan, magenta, yellow, and black (CMYK), and they're printed as overlapping patterns of halftone dots (Figure 16-9, left) that let you economically reproduce the wide range of colors found in *continuous-tone images* like photos (Figure 16-9, right).

Spot inks, on the other hand, are used to match very *specific* color requirements (like a color in a corporate logo—the official UPS brown, for example), and they're printed on a *separate* cylinder on the press. More spot colors mean more cylinders and therefore more separations, which translates into higher printing costs. Since it's easy to get hit with unexpected costs when you're sending out a print job, you need to make *darn* sure you know exactly how many colors it'll take to print your image (most print jobs involving color photos use only the four process colors). You'll learn all about spot colors later in this chapter.

Figure 16-9:
*Left: If you look
closely at an image
printed on a press,
you can see the dots
it's made from. The
next time you pick
up a magazine or
newspaper, stick it
right up to your nose
and you'll see 'em. To
keep the dots from
printing on top of
each other, they're
printed at specific
angles according to
ink color.*

*Right: Images that
contain a wide range
of smooth colors are
called continuous-
tone images, like this
beautiful photo by
Taz Tally (*www.taz
tallyphotography.
com*).*

Finally, unlike sending an image straight from Photoshop to your inkjet printer, you'll *rarely* (if ever) send a single image to an offset press. Instead, you place your image in a page-layout document (like one made with Adobe InDesign) that contains other images, along with text (referred to in geek circles as *copy*), and *that's* what you send to the printing company. You need to make sure your images have the right print dimensions and resolution (discussed on page 669) and that they're in the right color mode *before* you place your image in InDesign. The following pages explain how to do that as painlessly as possible.

Converting RGB Images to CMYK Using Built-In Profiles

First and foremost, you need to know who's handling the conversion from RGB to CMYK. Historically, printing companies have requested (required!) you to convert images yourself but this is *slowly* changing, particularly with the increased use of digital presses (see page 705).

If you have no idea whether you're supposed to convert the RGB to CMYK yourself or if you want to know whether the printing company has a custom profile you can use for the conversion, *pick up the phone*. Communication is crucial in situations like this because if your print job hits the press at 2:00 a.m., it'll be *your* phone that rings if there's a problem. This is one call you're better off making than receiving.

If you have to convert the color mode yourself, it's important to choose the proper CMYK color printer and paper profile. You can do it in a couple of ways, but the following steps will lead you down a simple and foolproof path:

1. **Open your RGB image and duplicate it.**

 Choose Image→Duplicate to create a new copy of your image to *guarantee* that you won't accidentally save over your original RGB image.

2. **Name your new image and save it as a TIFF file.**

 Choose File→Save or press ⌘-S (Ctrl+S on a PC) and then give it a name. (It's a good idea to include the file's color mode in the name so you can see at a glance which mode it's in.) Choose TIFF from the Format pop-up menu at the bottom of the Save dialog box and then click Save.

3. **Choose Edit→"Convert to Profile".**

 In the Conversion Options section of the dialog box that appears (see Figure 16-10), set the Engine menu to "Adobe (ACE)" and the Intent menu to Perceptual. Also, turn on the Use Black Point Compensation checkbox.

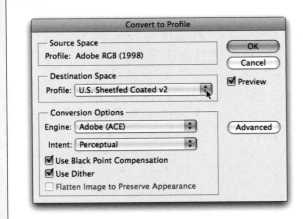

Figure 16-10:
Don't panic when you see the Profile pop-up menu. These super funky names are simply the various color profiles you can use to convert RGB to CMYK. As you learned at the beginning of this chapter, there are a bazillion printers, papers, and colorants (inks, dyes, toners) out there, so this long list merely reflects that diversity.

4. **From the Destination Space's Profile pop-up menu (Figure 16-10), choose a profile that reflects the type of ink, press, and paper your printing company will use to print the image.**

 You can think of this menu as a printer profile menu. If you can't find a custom profile (see the next section), hunt for a profile that matches the ink, press, and paper for your current print job. If your image is being printed in North America on a sheetfed printing press using coated paper stock, for example, you can pick the tried-and-true "U.S. Sheetfed Coated v2" profile. A newer commercial sheetfed profile that also might work is "Coated GRACoL 2006". But before you guess, *ask* your printing company what profile it wants you to use.

5. **Click OK to complete the color conversion process and save your image.**

 Press ⌘-S (Ctrl+S) to save your image in the new color mode.

After you save your CMYK image, you're ready to place it in your page-layout document. Because you wisely duplicated your image in step 1, you've still got the original, full-color RGB image to go back to if you ever need to edit it. Sweet!

Custom RGB to CMYK Profile Conversions

If your printing company has painstakingly created its own custom color profile, you're much better off using it than one of the built-ins. The process is similar to the one explained in the previous section, but you need to *install* the custom profile (as explained on page 667) before you can use it. Once you've downloaded it, follow these steps to put it to use:

1. **Locate the appropriate profile folder on your hard drive.**

 Figuring out where to store the profile is your biggest challenge since different operating systems *and* different versions of Photoshop store profiles in different places. On a Mac running OS X 10.5 or later, you can find the main color profiles folder in *Computer/Library/Application Support/Adobe/Color/Profiles*. If you have a Windows computer, look in *Users\Profiles and Windows\System32\Spool\Drivers\Color*. However, you can always search for a folder named *profiles*, or better yet, call your printing company and ask them where the folder for your particular operating system lives.

Note: If your computer uses Windows, you can use the Color Management Control Panel to add and remove profiles.

2. **Copy the custom profile to the Profiles folder described in the previous step.**

 Figure 16-11 shows a profile named "MwHwkCC98_28#txt_CMYK_o_PCG.icc". The name indicates that this profile was made using a 28-pound Mohawk text stock paper. Printing companies that have embraced color management have CMYK color profiles for a *variety* of paper stocks, so be sure you load the one for the paper you're printing on by dragging the file into the folder.

3. **Open your image, duplicate it, and save it as a TIFF file.**

 To duplicate your image, choose Image→Duplicate and then choose File→Save or press ⌘-S (Ctrl+S on a PC) and give the copy a name. Pick TIFF from the Format pop-up menu at the bottom of the Save dialog box and then click Save.

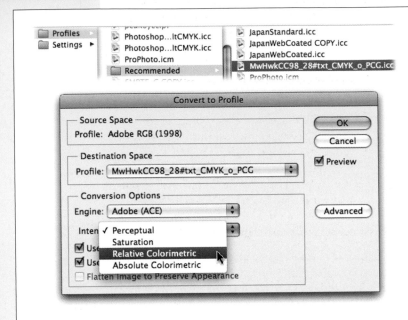

Figure 16-11:
Top: The toughest part of using a custom profile is figuring out where the heck to put it! Fortunately, on a Mac, the folder is named Profiles (shown here).

Bottom: If you're using a custom profile, the printing company may also want you to change other settings in the Print dialog box. For example, they might have you select Relative Colorimetric rather than Perceptual from the Intent menu. But you won't know unless you ask 'em.

4. **Choose Edit→"Convert to Profile" and, in the resulting dialog box, choose your new profile from the Profile pop-up menu.**

 If you don't see the right profile in the list, you may need to restart Photoshop. In that case, press ⌘-Q (Ctrl+Q) to quit the program and then double-click your image file to relaunch the program.

5. **Change the Conversion Options settings if you need to.**

 Ask the printing company if you need to adjust any settings in the Conversion Options section of the "Convert to Profile" dialog box.

6. **To save your image, click OK and then press ⌘-S (Ctrl+S).**

You've just completed your first custom CMYK conversion.

Using Spot Color

As mentioned earlier, commercial printing presses sometimes use special premixed custom inks called *spot colors*. If you're a graphic designer working in *prepress* (the department that preps files for printing), the info that lies ahead is really important. If you're a photographer or Web designer, save your brainpower and skip this part. Really.

Photoshop wizard Ben Willmore (*www.DigitalMastery.com*) has come up with a great analogy to explain spot colors. Remember the box of crayons you used as a kid? A small box had 8 basic colors like blue, orange, and yellow. And then there was the big box of 64—with a sharpener on the back!—that had special colors like cornflower, melon, and thistle. No matter how hard you tried, you couldn't reproduce the special colors with a box of 8 crayons. In Photoshop, you can think of those special colors as spot colors and the box of 8 crayons as the CMYK color mode.

Because of the impurity and variety of CMYK inks, they can't produce all the colors you see in RGB mode (just like you can't reproduce, say, cornflower from those original 8 crayons). If you happen to be tooling around in the Color Picker (page 493) and choose a color that *can't* be produced in CMYK, Photoshop places a little gray warning triangle next to it (see Figure 16-12). This triangle is known as an out-of-gamut warning (gamut, as you learned earlier, means the full range of colors). If you click the triangle (or the tiny, square color swatch below it), Photoshop will change your color to the closest possible match that *can* be printed with CMYK inks.

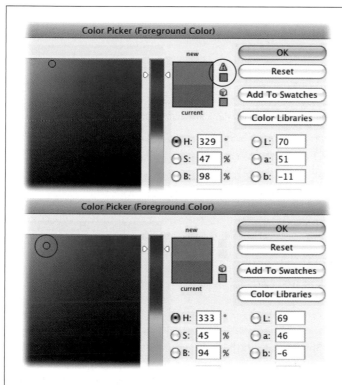

Figure 16-12:
Top: If you pick a color that can't be produced with CMYK inks, a little warning triangle appears next to the color swatch (circled). Click the triangle or the tiny square of color below it to make Photoshop pick the next best color.

Bottom: In most cases, you can't see any difference between the original color and the new one, but if you check your cursor's location in the color field (circled), you can see that Photoshop moved it slightly.

In some cases, the closest color match is close enough, but spot-color ink comes in handy in certain situations, like when you need:

- **To reduce printing costs.** As you learned earlier, the more colors you use, the more cylinders and separations you need and the more the job will cost. If you print an image in black and one or two spot colors, you can *reduce* your printing costs because you'll be using two or three separations instead of four. This technique is commonly used with line art (illustrations or outline drawings like those in a coloring book), though you can also use it for photos (see page 684).

- **To ensure color accuracy.** If your paycheck depends on color accuracy, you *have* to use spot-color ink. For example, if UPS hires you to design a flyer for their company party, you want to make sure that *your* version of brown matches their *official* brown. Unless you use a spot color (which is consistent because it's premixed), your brown will be printed using a mix of CMYK inks and may end up looking maroon.

- **To use specialty inks.** If you want to add a bit of pizzazz to your printed image, you can use specialty inks like metallics or a varnish that looks glossy when it's printed. You can also add a vibrant spot color to a particular area to make that part stand out. However, if you use specialty inks on a CMYK document, you're *adding* color separations to your job, which will increase the cost.

The most popular brand of spot-color ink is Pantone (*www.pantone.com*), and before you can use it, you have to create a special channel for it called a *spot channel*. Each spot color you use needs its very own spot channel. (See Chapter 5 for more on channels.)

Note: You'll also hear Pantone colors called *PMS* colors, which stands for "Pantone Matching System."

Let's say you're preparing the cover photo for the next issue of *Cutting Horse* magazine, and, to reduce printing costs, the magazine has decided to use a grayscale image with one spot color for visual interest. (That way, they're paying for two separations instead of four.) Your mission is to make the horse's bridle Pantone Red. No problemo! Just make a selection of the bridle and then create a spot channel for the special ink (see Figure 16-13).

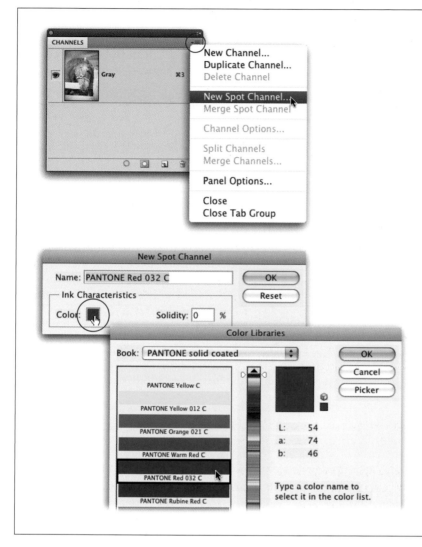

Figure 16-13:
Top: Once you've selected the area you need to colorize, you can add a new spot channel by choosing New Spot Channel from the Channels panel's menu (circled, top).

Bottom: Click the little color swatch (circled) in the New Spot Channel dialog box to open the "Select spot color" dialog box, and then click the Color Libraries button to see the oh-so-helpful list of Pantone presets shown here. Photoshop will automatically add the ink you choose here to your selection.

Here's how to add a spot channel:

1. **Use one of the methods described in Chapter 4 to select the area you want to colorize.**

 If you're lucky enough to start with the full-color version of the photo, you can easily select the horse's bridle by using Color Range (page 154). See page 323 for the scoop on converting a color image to black and white and page 329 for changing your image's color mode to Grayscale.

2. **From the Channels panel's menu (see Figure 16-13, top), choose New Spot Channel.**

 Photoshop opens a dialog box where you can name your new channel and pick a color. You can also add a new spot channel by ⌘-clicking (Ctrl-clicking on a PC) the New Channel icon at the bottom of the Channels panel.

3. **In the New Spot Channel dialog box, click the color swatch to open the "Select spot color" dialog box and choose an ink color.**

 To see a list of Pantone presets, click the Color Libraries button. In the resulting dialog box, choose a spot color (see Figure 16-13, bottom). From the pop-up menu at the top of the Color Libraries dialog box, choose a color book (if you're preparing a photo for a magazine, for example, pick "Pantone solid coated" because magazines print on glossy paper). If you know the number of the ink you want (like 032), you can type the number and Photoshop will flip to that color in the list for you, or you can drag the triangles along the vertical scroll bar to find the one you want (you can also use the arrow keys to move through the list of ink swatches). Click the color's swatch to select it and then click OK to close the Color Libraries dialog box.

Note: By picking a color from the Color Library, you don't have to worry about naming your new spot channel—Photoshop names it automatically.

4. **Back in the New Spot Channel dialog box, leave Solidity set to 0% and click OK to close the dialog box.**

 You can think of Solidity as ink opacity, though it affects only the onscreen image and not the printed version. Depending on the image you're working with, increasing the ink's opacity so it appears solid and not see-through may be helpful (it's a personal preference). When you click OK, you'll see a new spot channel appear in the Channels panel as shown in Figure 16-14.

Editing a spot channel

Once you've created a spot channel, you can change its ink color by double-clicking it in your Channels panel. You can also add or remove color by painting with the Brush tool (or by using any other selection tool and filling it with color, as described on page 181). Since Photoshop shows channel information in grayscale, you can edit a spot channel just like a layer mask (page 113)—by painting with black, white, or shades of gray:

- **To add color at 100 percent opacity,** grab the Brush tool by pressing B and set your foreground color chip to black. Then mouse over to your image and paint where you want to add color.

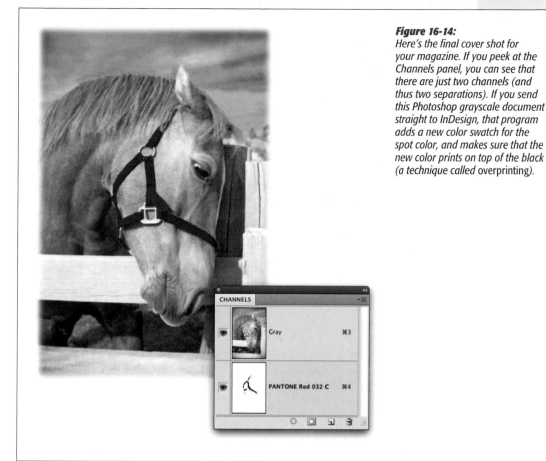

Figure 16-14:
Here's the final cover shot for your magazine. If you peek at the Channels panel, you can see that there are just two channels (and thus two separations). If you send this Photoshop grayscale document straight to InDesign, that program adds a new color swatch for the spot color, and makes sure that the new color prints on top of the black (a technique called overprinting).

- **To remove color at 100 percent opacity,** set your foreground color chip to white before you begin to paint.

- **To add or remove color at any other opacity,** set your foreground color chip to a shade of gray before you paint.

Saving a document with spot channels

To keep your spot channels intact, you need to save the document in a format that works with spot channels: as a DCS, PSD , or PDF file. So which one do you pick? It depends on what you're going to do with the file.

If you're the hired Photoshop gun and you'll be handing the file off to someone else for further fluffing, save it as a PSD file, get your motor runnin', and head out on the highway (insert guitar riff here). If you're importing the image into InDesign or QuarkXPress 6.5 or later, you'll also want to save your image as a PSD file.

If you're using the file in QuarkXPress 6 or earlier, you need to save it as a DCS 2.0 or PDF file (see page 695). DCS is a special format that lets you save color separations if your image will be printed on a printing press. To save your document as a DCS file, make sure your document is in either Grayscale or CMYK color mode (page 46) and then choose File→Save As and pick Photoshop DCS 2.0 from the Format pop-up menu. When you click Save, you'll see the DCS 2.0 Format dialog box (Figure 16-15) where you can fine-tune the following settings:

- **Preview.** This setting controls which kind of image preview you see in your page-layout software. If your image is headed for a Mac and you want a 256-color preview, for example, choose "Macintosh (8 bits/pixel)" or "Macintosh (JPEG)" (the second choice gives you a slightly nicer preview). If it's headed for a Windows computer, choose "TIFF (8 bits/pixel)". See the box on page 45 to learn what the term "8 bits" is all about.

- **DCS.** You'll want to leave this one set at "Single File DCS, No Composite" so Photoshop doesn't generate all kinds of files that only the printing press peeps know what to do with.

- **Encoding.** This menu lets you control how Photoshop encodes (represents and stores) the print information in your file. If you're on a Mac, choose Binary. If you're on a Windows computer, choose ASCII or, for a more compact file, ASCII85.

Note: In case you're wondering, *DCS* stands for "Desktop Color Separation" and *ASCII* stands for "American Standard Code for Information Interchange." ASCII was developed as a way to convert binary (computer) information into text, and ASCII85 is the newest version. This stuff is *great* bar-bet trivia.

Figure 16-15:
The DCS 2.0 Format dialog box. DCS 2.0 is one of three formats you can use to save spot channels intact. While most page-layout programs can read DCS files, you may find that using a PDF is easier, as discussed on page 693.

Leave the checkboxes at the bottom of the dialog box (Include Halftone Screen, Include Transfer Function, Include Vector Data, and Image Interpolation) turned off and then click OK. You're now ready to import the DCS file into QuarkXPress 6 or earlier. Party on!

Saving Spot Colors in PDF Format

While DCS 2.0 has long been the standard format for saving documents with spot colors, PDF format is simpler. To see for yourself, follow these steps:

1. **Open an image with a spot color and press ⌘-Shift-S (Ctrl+Shift+ S on a PC) or choose File→Save As.**

 Figure 16-16 shows a file named "Autumn Art_CMYK" that contains the Digital Gypsies logo with an assigned spot color of 810C (the C indicates the coated version of the color).

2. **Choose Photoshop PDF from the Format pop-up menu.**

 If your document has layers, turn off the Layers checkbox to flatten the image.

3. **Turn on the Spot Colors checkbox.**

 Turning on this checkbox ensures that Photoshop includes your spot colors in your image, along with process colors (CMYK).

4. **Rename your image to indicate that it harbors a spot color.**

 For example, rename the image "Autumn Art_CMYK_Spot" and then click Save to summon the Save Adobe PDF dialog box.

5. **In the General settings, choose Acrobat 5 (PDF 1.4) from the Compatibility pop-up menu.**

WORKAROUND WORKSHOP

Printing Spot-Channel Proofs

Since spot channels are used only by commercial printing presses, getting them to print on your *own* printer for proofing can be…exciting. The solution is to pop into RGB mode temporarily and merge the spot channels.

To safeguard your original document, save it and open a copy by choosing Image→Duplicate. Next, choose Image→Mode→RGB Color and then, in your Channels panel, Shift-click to select each spot channel you've created. Then open the Channels panel's menu and choose Merge Spot Channel.

When Photoshop asks if it's okay to flatten the layers, click OK. Each spot channel is instantly swallowed up by the closest matching RGB equivalent.

At this point, you can fire it off to your printer without a fuss. The colors won't be *exact*, but you'll get a decent approximation of what your image will look like when you finish editing it. After you print it, you can toss the temporary RGB document and continue editing the original.

Figure 16-16:
Left: You might consider adding the spot color's name (like Pantone 810C) to your document's name to help maintain color-naming consistency as you move your image from one program to another (for example, from Photoshop to InDesign).

Right: If you think you might use these settings again, click the Save Preset button (not shown here; it's at the bottom left of the dialog box) before you click the Save PDF button. Give your preset a name (like "Print Image PDF") so you can access it again later from the Adobe PDF Preset pop-up menu at the dialog box's top left. It'll come in handy when you learn about duotones later in this chapter.

6. **In the Compression settings (click Compression on the left side of the dialog box to see them), choose Do Not Downsample and pick Maximum Quality JPEG or None from the Compression pop-up menu.**

 Picking either compression option *should* leave you with a high-quality image because Maximum Quality JPEG essentially leaves your images uncompressed. If you aren't comfortable using a compression format that can reduce your image's quality, choose None instead.

7. **In the Output settings, check to make sure the Color Conversion pop-up menu is set to No Conversion.**

8. **Click Save PDF.**

 You're now free to send the PDF file to the page-layout program of your choice.

If you save the settings you entered as a preset, this method is much faster than saving your file in DCS 2.0 format. However, be sure to ask your printing company if they'll accept a PDF file with spot colors. Some companies using older equipment may not be familiar with PDFs or may not be able to use them just yet (change is hard, you know!).

Printing Duotone (Multitonal) Images

One of the advantages of printing with a commercial printer is that you can print duotones and other multitonal images (see the box below) by adding a second ink to your grayscale images. You can add a spot color, another gray ink, or even process colors—great news if you want to colorize a grayscale image, add some tonal depth and richness, or both. Either way, you can create some amazingly beautiful effects as discussed back in Chapter 8. However, it's really easy to add *too* much ink, which makes your image way too dark once it's printed. If that happens, you lose details in the shadows and your contrast goes down the tubes.

To produce a truly amazing duotone or multitone image, you need to start with a good quality grayscale image—one that has high contrast and isn't overly dark. Once you've settled on an image, convert it to Grayscale mode (page 46) and then follow these steps:

1. **Duplicate your image.**

 Choose Image→Duplicate and then give the copy a name. To get descriptive with your image name, consider incorporating the word "duotone," as in "Red Mtn_Duotone".

2. **Choose Image→Mode→Duotone.**

 If this option is grayed out, you're not in Grayscale mode. In that case, choose Grayscale mode first and then switch to Duotone. When the Duotone Options dialog box opens, it reports that your image is a monotone image made from nothing but black ink.

UP TO SPEED

Defining Duotones

The term *duotone* generally refers to a grayscale image that has had additional inks added to it: Technically, if you add one ink, it's a duotone; two inks make it a tritone; and three inks make it a quadtone, so the correct *general* term is multitonal images. But most folks use the term duotone to describe all these alternatives, which can get confusing.

So why add other inks to grayscale images to begin with? A couple of reasons: Some folks use duotones to add color to an image inexpensively—as you learned on page 684, reducing the number of colors in your image can mean a cheaper print job. However, duotone (or multitone) aficionados will tell you the additional inks add tonal range and depth to an image (and they're right!). In fact, you can add a second gray ink to enhance tonality without adding any color at all.

The two keys to creating high-quality duotones are:

- Start with a high-quality grayscale image with a good tonal range and high contrast.
- Substitute your second ink for part of the original black ink—rather than just adding it (see page 698). This prevents your image from becoming too dark and flat because it's drowning in ink.

With a bit of practice, you'll gain confidence in creating duotones and enjoy doing it. However, it's always a good idea to plan extra time in your production schedule to print some tests. Since you can't trust your monitor or proof your own nonprocess duotones (see page 699), a test print is worth its weight in gold.

3. **Click the Curve icon to the left of the Black Ink (see Figure 16-17).**

Clicking this icon opens the Duotone Curve dialog box, where you can peek at how the ink will be applied in your image. For this particular ink, you have a straight 45-degree curve from the highlight to shadow areas, and it's being applied at 100 percent. Click OK to close the Duotone Curve dialog box.

Figure 16-17:
Duotone Curves are just like the Curves you learned about back in Chapter 9 (page 406,) except that here they let you know how much ink will be applied to your image's shadows, midtones, and highlights. The percentages tell you how much ink is being added.

4. **Choose Duotone from the Type pop-up menu.**

This menu gives you a choice of various kinds of multitonal images. If you choose Duotone, Photoshop activates two inks in the dialog box (choosing Tritone activate three inks, and so on). However—and this is key—both inks have straight, 45-degree highlight-to-shadow curve lines, which means they print with the same amount of ink in the same color range. That's *not* good! If you click on the "Ink 2:" color swatch and load a new color, you'll add too much ink for the image to print decently. So instead of editing the Duotone Curves *yourself*, use one of the many presets as described in the next step.

5. **Click the Preset pop-up menu and choose one of the Duotone presets from the list (see Figure 16-18, top).**

Feel free to experiment with the wide variety of choices in the Preset menu. Some of the selections, like the true duotones, offer anywhere from one to four options, which represent substitutions for the second ink ranging from stronger to weaker. These are excellent starting points for your creations. There's nothing wrong with tweaking the Duotone Curves to fine-tune your results, but you'll want to print some tests first to make sure you're not adding too much ink.

Testing duotones is tough because you *can't* proof them unless you've made a duotone out of process colors (which really makes it a quadtone). If you select a preset with inks not available on your printer, you won't get an accurate proof. The best you can do is contact your printing company and see if they'll print you a test on the paper they'll use for the final image. If you don't need the proof right away, they may be able to hold onto it and slide it in with another job that uses a similar ink-and-paper combo.

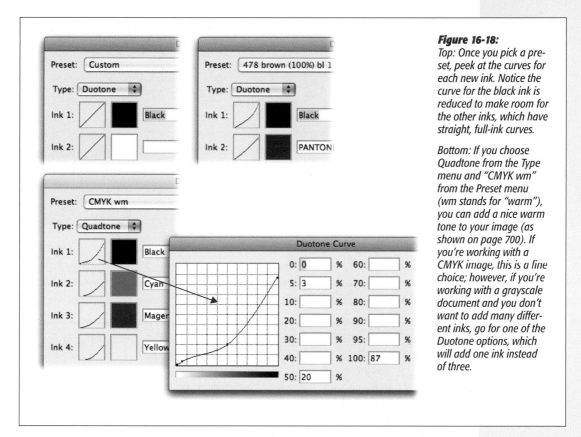

Figure 16-18:
Top: Once you pick a preset, peek at the curves for each new ink. Notice the curve for the black ink is reduced to make room for the other inks, which have straight, full-ink curves.

Bottom: If you choose Quadtone from the Type menu and "CMYK wm" from the Preset menu (wm stands for "warm"), you can add a nice warm tone to your image (as shown on page 700). If you're working with a CMYK image, this is a fine choice; however, if you're working with a grayscale document and you don't want to add many different inks, go for one of the Duotone options, which will add one ink instead of three.

6. **Save your document as an EPS or PDF file.**

 Here's yet another opportunity to chat with your printing company! Give 'em a ring and ask if they prefer EPS or PDF format for duotones or multitones. If they say EPS, ask them which settings they prefer, choose File→Save As, and then pick Photoshop EPS from the Format pop-up menu. In the EPS Options dialog box (Figure 16-19, bottom), choose an 8-bit option from the Preview pop-up menu and pick Binary from the Encoding pop-up menu. Unless your printing company tells you otherwise, leave the rest of the options turned off and click OK.

To save your duotone as a PDF file instead, you can use the same settings you used to save a spot-color image in the previous section (page 695).

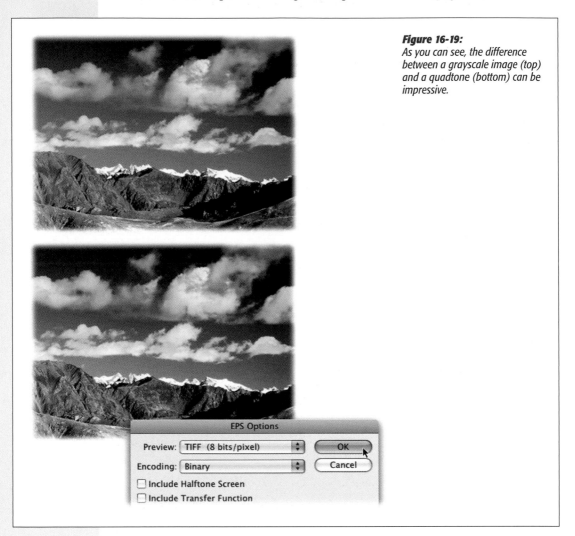

Figure 16-19:
As you can see, the difference between a grayscale image (top) and a quadtone (bottom) can be impressive.

Proofing Images Onscreen

When it comes to sending images out for printing, it'd be nice to peek into the future and *see* what they'll look like. Happily, Photoshop can create an onscreen proof simulation known as a *soft-proof*, a straightforward process using the same color profiles you learned about in the previous sections. Here's how to do it:

1. **Calibrate your monitor using the tools described earlier (page 667).**

 If you haven't calibrated your monitor, soft-proofing is a *galactic* waste of time.

2. **Open an RGB image you intend to print.**

 You can soft-proof either RGB or CMYK images, but it's especially cool to proof an RGB image and see what it will print like in CMYK without having to color-convert it first.

3. **Choose Window→Arrange→"New Window for" to create a second window showing a copy of your image.**

 Position the windows so they're side by side by choosing the 2-Up display from the Application bar's Arrange Documents menu.

4. **Click the right-hand window to activate it and then choose View→Proof Setup→Custom.**

5. **In the resulting Customize Proof Condition dialog box, turn on the Preview checkbox (Figure 16-20, top).**

6. **From the "Device to Simulate" menu, choose the profile for your final printer.**

 If your image is headed to a printing press, for example, pick your old profile friend, "U.S. Sheetfed v2".

7. **Choose Perceptual from the Rendering Intent menu and turn on the Black Point Compensation checkbox.**

 Perceptual takes into account how humans see color. The Black Point Compensation option makes sure that Photoshop maps your black values and converts them to blacks in your final print, which helps preserve the contrast of your original.

8. **In the "Display Options (On-Screen)" area, turn on the Simulate Paper Color checkbox.**

 Watch your onscreen proof change as you turn this option on and off.

9. **Sit back and examine the differences between your left and right windows.**

You can apply soft-proofing to other printers like your inkjet printer or a digital press (see page 705). All you need to achieve good results is a calibrated monitor, an accurate printer, and a paper-specific profile. That said, soft-proofing isn't 100 percent accurate, but it's better than nothing and you'll almost always find it useful. It's also a good tool to help control your client's expectations, especially when the client is printing on cheap, low-quality paper.

Figure 16-20:
Top: Turning on Preview lets you see the results of your proof settings without clicking the OK button.

Bottom: Notice that the image on the right is slightly less saturated and has lower overall contrast than the original image on the left (which looks kind of flat). You can also select other profiles and see how they affect the soft-proofing results.

Printing Color Separations

To avoid running into unexpected printing costs, it's a good idea to print your separations (called *seps* around the water cooler) to make sure another color hasn't sneaked its way into your document—especially if you've toyed with some spot colors that you're not going to use. Honestly, though, you probably won't use Photoshop to print separations at all—in most cases, you'll place an RGB or CMYK image in a page-layout program (like InDesign), along with text and other images, and let *it* print the separations. The page-layout program does the final printing using *its* print dialog box. However, just in case you ever *do* need to print separations from Photoshop, you can visit this book's Missing CD page at *www.missingmanuals.com/cds* for step-by-step instructions.

Printing Proofs

If you're working in a prepress environment—and especially if you're not printing to a digital press (covered in the next section)—you're often proofing on a different printer than the one that will print your final document. For example, you might print a proof using an inkjet, but your final image will print on a commercial offset printing press. In that situation, your proof printer can print a *simulation* of what will happen on the printing press. Simulating an image involves reining in the proof printer's much larger color gamut to include only the colors that the printing press can reproduce. You can prepare a simulation in Photoshop using profiles, along with the proofing function you learned about in the previous section. Here's how to do it:

1. **Pop open an image and then choose File→Print.**

2. **Pick your proofing printer from the Printer pop-up menu.**

 For this example, choose Epson Stylus Photo R2400.

3. **Click the Print Settings button and deactivate the printer's color management.**

 In the resulting dialog box, pick your paper dimensions and then be sure to turn Color Settings off to keep the printer driver from interfering with the color management voodoo you've got going on in Photoshop. If you pick Printer Manages Color from the Color Handling menu in the Print dialog box (discussed in a moment in step 6), you can manage the color through your printer driver or RIP (see the box on page 705).

4. **Click Save to return to the Print dialog box.**

5. **Choose Color Management from the pop-up menu at the top right of the Print dialog box and turn on the Proof option.**

 This setting lets Photoshop know you intend to print a proof on one printer (your inkjet printer) and simulate it on *another* printer, which you can choose from the Profile pop-up menu shown in Figure 16-21, left.

6. **From the Color Handling menu, choose Photoshop Manages Color.**

Note: If you choose Printer Manages Color, which you might do if your color-conversion tool is a special RIP set up for proofing (see the box on page 705 for more on RIPs), Photoshop has zero effect on your color—all the color conversion occurs at the RIP. You can't soft-proof your image using the Print dialog box, but you can still do it using the Proofing tools in the View menu (see the previous section on soft-proofing).

Figure 16-21:
Left: Choose Proof in the Color Management section to tell Photoshop that you want to print on one printer as it if were another.

Right: Turn on the Gamut Warning checkbox beneath the preview to see colors that may not print correctly on the printing press (they appear in gray).

7. **From the Printer Profile menu, choose the printer/paper/quality profile for the printer you'll use to print the proof.**

 For this example, choose "SPR2400 on Premium Luster Paper" using the Best Printer setting.

8. **From the Proof Setup menu, pick either Working CMYK or Current Custom Setup as the proof profile for the print simulation.**

 Pick the Current Custom Setup (in this case, the "Coated GRACoL 2006" profile mentioned earlier on page 686) to use the Custom soft-proofing profile you set up in the previous section.

9. **Turn on Simulate Paper Color for the best simulation.**

10. **On the left side of the Print dialog box, turn on all three checkboxes: Match Print Colors, Gamut Warning, and Show Paper White.**

 These options let you see an onscreen view of your image that indicates which, if any, colors might not print on the simulated printer because they're out-of-gamut on your GRACoL press (Figure 16-21, right). For the fun of it, test the Gamut Warning results using both coated and uncoated paper stock to see how the paper affects the printed image.

11. **Click Print and wait eagerly to see what your proof looks like.**

 Isn't it amazing what you can do with color profiles? Quick, go tell everyone you know how cool this stuff is and watch their eyes glaze over.

Printing on a Digital Press

In the past, when you prepared a document for a commercial printer, you would—and in many case still do—convert your images to the CMYK color mode (see the previous section on commercial offset printing) *before* you inserted them in a page-layout document and certainly before you fired them off to the printing company. However, that process is changing because an increasing number of printers also use *digital presses.*

Digital presses work just like laser printers or copiers; they use electrostatic charges to transfer images from cylinders to the print surface. Like commercial offset presses, digital presses are primarily CMYK printers, but they use toners instead of inks (which is why they can't print spot-color inks). Some digital presses, like the Kodak NexPress, offer additional toner spot-color printing but they're limited to very specific colors like red, green, or blue. Rather than being used for special objects like logos, these additional spot colors typically expand the gamut of the CMYK toners, much like light cyan and light magenta in inkjet printers. The following sections explain how to prepare various types of images for a run on a digital press.

Printing RGB Images on a Digital Press

Digital presses handle images much like expanded-gamut inkjet printers (see page 677). Because the RGB to CMYK-Plus conversion occurs at the printing press's processing RIP (see the box below) by using a built-in profile specific to that press and the paper you're using, you'll be dealing with RGB images the whole time instead of converting them to CMYK. That's great news because, as you learned at the beginning of this (exhausting!) chapter, RGB mode provides you with the widest range of printable colors. So if your image is already in RGB mode, you're good to go.

FREQUENTLY ASKED QUESTION

Meet the RIP

I thought RIP meant "rest in peace." What the heck does that have to do with printing?

Quite a lot actually, and it has nothing to do with a funeral blessing.

The acronym RIP refers to a device known as a Raster Image Processor. It's a term you'll often hear tossed around at commercial printing services (also called *service bureaus*).

RIPs are processors that convert your image and document info into print-ready formats that specific printers and other output devices understand. You can think of them as sophisticated and powerful printer drivers (the little programs that power your home printer). Some RIPs can convert RGB color-mode files to CMYK, but others prefer to receive CMYK images. Ask your printing company which color mode it wants before you send your file.

Printing CMYK Images on a Digital Press

If your images are already in CMYK mode, it's okay to leave them that way. Most digital presses recognize CMYK values and print them well enough. That said, you might want to confirm with your printing company that the press will use your current CMYK values rather than converting your image to another color mode and then back to CMYK on the press. (This type of color-shuffling can lead to unpredictable—and usually terrible—results.) And keep in mind that your CMYK images will be darker and more saturated if they're printed on a digital press than if they're printed on a conventional, ink-based printing press.

Printing Spot Colors on a Digital Press

Since digital presses don't print conventional spot-color inks, any spot colors you've assigned in Photoshop or a page-layout program get converted into CMYK or CMYK-Plus colors, depending on the toners the press uses. This conversion happens automatically using a built-in spot-to-process color lookup table. Basically, you've got two choices for handling spot colors on a digital press:

- Leave the spot color in Photoshop and let the RIP automatically convert it to process color.

- Convert the spot color to process color yourself.

Because RIP uses expanded-gamut color lookup tables customized for that printer, letting it convert the spot color typically yields better results, especially if the digital press is using one of its additional, digital, spot-color toners to simulate the original spot-color ink (talk about a tongue-twister).

If you plan on leaving the spot color in your image, be sure you use the name provided by Photoshop when you created the color. For example, "Pantone 810C" is a proper color name, whereas "Logo spot color" isn't. Since the digital press can't print standard spot colors, it converts them to CMYK or CMYK-Plus process colors. For the RIP on the digital press to identify the spot color properly and produce the best simulation of that color, your spot color needs a standard color name that the RIP can use to find that color in its little black conversion book (er, color lookup table).

Since these toner-based digital presses are becoming more common in commercial printing companies, it's important to know which kind of press your image or document will end up on. If it's destined for one that uses gamut-expanding digital spot toners, leave your images in RGB mode to take full advantage of the press's expanded color gamut.

Printing Several Images on a Page

Sometimes you'll want to print multiple images on a single page, like if you want to review them and proof the content or if you're printing family reunion photos.

Photoshop used to have three very handy tools to help you quickly and easily organize, format, and print multiple images on a single page: PDF Presentation, Picture Package, and Contact Sheet. They were wildly useful, and nary a one of 'em made it into Photoshop CS4 (much less CS5) though a crippled version of Contact Sheet is available in Bridge (see Appendix C, online at *www.missingmanuals.com/cds*).

The good news is that you can download and use CS3 versions of Picture Package and Contact Sheet as explained in this section. For PDF files, you can use Bridge's "Output to PDF" option, explained in Appendix C.

Using Picture Package and Contact Sheet

You can fetch the Picture Package and Contact Sheet plug-ins from Adobe's website (*www.adobe.com*) or copy one or both from Photoshop CS3 (if it's still hanging around on your hard drive) or CS4 if you've done this dance before. If you go the "snag from a previous version" route, you need to grab a couple of files to make the plug-ins work. Here's what you do:

1. Find the Contact Sheet plug-in in the *Photoshop CS3 (or CS4)/Plug-Ins/Automate* folder and copy it into the same folder in Photoshop CS5, as shown in Figure 16-22, top.

2. Copy the entire Layouts folder from Adobe Photoshop CS3→Presets into Photoshop CS5's Presets folder.

 Photoshop stores the template presets for both Contact Sheet and Picture Package in the Layout folder, so you need to grab the whole thing (there's no Layouts folder in CS4 or CS5).

3. Restart Photoshop CS5 and then choose File→Automate→Contact Sheet II or Picture Package.

4. In the resulting dialog box, configure either Contact Sheet II or Picture Package to your heart's desire.

5. Preview your handiwork, grin smugly at your cleverness, and click Print.

Who knows, maybe Adobe will buckle under the public outcry and include these two popular tools in some future version! One can always hope, although so far the old plug-ins work just fine.

Recap: Stress-Free Printing Tips

Congratulations! You've just waded through a ton of dense information. Some of it you'll remember and some of it you won't; but, no matter what, it's here whenever you need to refer to it. To recap, here's a quick list of some of the most important tips:

- **Calibrate your monitor with an external calibration tool.** These tools are the only way you can accurately view and proof your images onscreen.

Figure 16-22:
Top: Because neither Picture Package nor Contact Sheet was updated and included in CS4 or CS5, you may encounter unexpected weirdness if you use them. Try downloading new versions from Adobe's website if your CS3 versions of the Contact Sheet plug-in and Layout folder cause problems.

Bottom: Once you've copied the files and restarted Photoshop, both plug-ins should appear in the File→Automate menu as shown here.

If the plug-ins don't reappear, try quitting Photoshop and relaunching it in 32-bit mode; the box on page 6 tells you how.

- **Resize your images to the print dimensions before you print.** This lets you make sure your image prints at the size you expect. Besides, a smaller image prints faster.

- **Make sure you have enough resolution.** After you resize your image, make sure you have between 200 and 300 ppi to produce a high-quality print. (Resolution is discussed in detail in Chapter 6 on page 238.)

- **Sharpen your image if you've made it substantially smaller.** Any time you change the number of pixels in your image it'll soften (blur) just a bit. A final round of sharpening (page 460) can help you get some focus back.

- **Simplify your images before printing.** Though it's not essential, flattening layers and removing alpha channels makes your document less complex, resulting in a smaller file size so it prints faster and more reliably.

- **Proof, convert, and print with printer- and paper-specific profiles.** Now that you've seen how powerful profiles can be, take the time to download and use them (or make your own). Using proper profiles lets you proof, change color modes, and print your images with the most reliable, most predictable, and highest-quality results.

- **Know your target color mode.** Be sure to choose the correct color mode for your image, whether it's RGB for expanded-gamut printers like inkjets and digital presses or CMYK for commercial printing presses.

- **Choose a high-quality print file format.** Use compression-free, print-compatible file formats like TIFF, PDF, and EPS for saving, sending, and printing your images.

- **Save editable PSD files.** Saving your Photoshop document in its native format lets you go back and edit your layers, alpha channels, and so on whenever you want. When you're creating a version for printing, duplicate the file or use File→Save As to make a copy so you don't overwrite the original.

- **Use real names for spot colors.** When you're printing spot colors, use the name built into Photoshop's Color Libraries instead of your own custom name. This increases the chance it'll be recognized by other applications like InDesign, or by RIPs that may have to convert it to process colors during printing.

- **Use duotone or multitone presets.** When you're creating duotones or multitonal images, be sure to use the presets rather than adding additional colors yourself (at least as a starting point). The presets make sure your original black ink and any additional inks are properly controlled by Duotone Curves that reduce the total ink used during printing, which keeps you from losing details and contrast because your image is dripping with ink.

- **Communicate with your printing company.** Find out at the beginning of your project *exactly* which file format and settings the company wants. Knowing ahead of time exactly what they expect from you can help keep your client's project from going past its deadline and over its budget.

Photoshop and the Web

Preparing graphics for a website is a journey into the unknown: You've got no idea what kind of monitor folks will use to view your images, how fast (or slow) their Internet connections are, or what kind of web browsers they've got. It's a proposition riddled with variables that you have no control over; all you can do is prepare your graphics well and hope for the best.

Your challenge as a designer boils down to finding a balance between image quality and file size. Premium-quality, minimally compressed JPEGs look stunning under almost any conditions—but if your site visitor has a pokey dial-up connection, she might decide to click elsewhere rather than waiting for the darn thing to download. On the other hand, if you try to satisfy the slowest common denominator by making ultra-lightweight images, you'll deprive those with broadband (high-speed) Internet connections from seeing impressive detail you've lovingly created.

Luckily, there are several tricks for keeping file sizes down *and* retaining quality. That's what this chapter is all about. You'll learn which size and file format to use when creating images destined for the Web. You'll also discover how to make animations; craft *favicons* (those tiny graphics you see in web browsers' address bars); mock up web pages, and publish professional-looking online photo galleries.

Note: For a tutorial on creating your own custom Twitter page using Photoshop (Twitter is the 140-character blogging phenomenon), visit this book's Missing CD page at *www.missingmanuals.com/cds*.

Creating Web- and Email-Friendly Images

Whether you're designing an image destined for life on the Web or creating an email-friendly version of a digital photo, you need to follow three very specific steps to create a high-quality image that people can download quickly:

1. **Adjust the image's dimensions.**

 First, you need to decide how big your image should be. In some cases, someone else may give you the size (like when you're hired to make a web banner or ad). Other times, you choose the size (like when you email a digital photo, send a sample design to a client, or post an image in an online discussion forum). And if you're designing graphics for smart phones and other mobile devices, you have some very specific sizes (and even file formats) to consider. All of these situations are discussed in this section.

2. **Decide which file format you want to use.**

 The two most common choices are JPEG and GIF. A relative newcomer, PNG, has a lot to offer, but it isn't compatible with all browsers just yet. See page 715 for the pros and cons of each Web-friendly format.

Note: As you learned in Chapter 2, you should always save your master file as a PSD file (Photoshop document) so you can open, edit, and resave it as often as you want without losing quality (each time you save a JPEG, your computer recompresses it, degrading the image's quality). The PSD format also lets you retain any layers you created during the editing process.

3. **Save and compress the file.**

 When you're finally ready to create the version of your image that's going to live online, you can squeeze it down to the smallest size possible using the "Save for Web & Devices" dialog box, which you'll learn all about beginning on page 718.

If you follow each of these steps, you'll end up with images that match the dimensions you want, look great, and download quickly. The following pages explain how to do all of those things.

Resizing Your Image

As you learned in Chapter 6, resolution matters when you *print*, but it doesn't mean a hill of beans when you're preparing images for the Web, presentation software, or an email. In the online realm, it's the *pixel dimensions* that matter most. If you reduce your image's pixel dimensions first, you won't force unsuspecting folks to download an image that's so large it takes over their whole screen, and you'll end up with a smaller file, which means it'll download faster.

Note: If you're emailing an image to someone who needs to print it, send him a full-size version in one of the print-friendly formats discussed on page 669. Be sure to compress the image into a .zip or .sit file before you send it so it transfers as fast as possible (see the Tip on page 670).

If you're a graphic designer, someone may tell you the pixel dimensions for your project. In that case, you can create a new document at that size (page 44) to start with. If you're emailing a digital photo or sample design or posting an image to an online forum, you can choose the size. If the size is up to you, here are a few all-purpose pixel dimensions you can use as guidelines:

- **800 (width)×600 (height) or 600×800.** Use this size if you're sending a design or photo sample to a client and she doesn't need to print the image. This size image is almost big enough to fill a web browser window (unless your viewer has a 30-inch screen, that is), so she won't have to scroll very much (if at all) to see the whole thing.

- **640×480 (or 480×640).** Use these dimensions if you're emailing a photo or posting it to an online forum. These dimensions produce an image big enough to see well and a file size of less than 1 megabyte (so it transfers nice and fast).

- **320×240 (or 240×320).** These dimensions work well if you're emailing multiple photos or posting to an online forum that contains *a lot* of images. If your recipient has a slow Internet connection, she'll appreciate the smaller file size. And if you crop it wisely—see page 219—these dimensions produce a photo that's big enough for your subject to be identifiable.

- **100×133 (or 133×100).** If you're creating headshots for the company web page—a great way to humanize your firm—this size makes for a nice, small portrait. If you're building a catalog page with a ton of product thumbnails (small preview pictures), this size won't bog down the page. (Linking the thumbnails to full-sized versions lets visitors view enlargements if they want to.)

Once you pick a size, flip back to Chapter 6 for step-by-step instructions on how to resize your images without losing quality.

Resizing Web images visually

Sometimes, it's easier just to choose the size you want for your resized image by looking at it. You can use the Zoom tool to decrease the size of your image until it looks good on your screen and then enter that zoom percentage in the Image Size dialog box. Here's how:

1. **Open the image you want to resize and zoom in or out until it looks like it's the right size on your screen.**

 Grab the Zoom tool in the Application bar at the top of your screen and click within your image to zoom in or Option-click (Alt-click on a PC) to zoom out. If you want to use keyboard shortcuts instead, press ⌘ (Ctrl on a PC) and the + or – key to zoom in or out (respectively).

2. **Make a note of the zoom percentage.**

 You can find the zoom percentage in several places: in the document's tab at the top of your screen, in its title bar if you're using floating windows (page 68), and in the status bar at the bottom left of your document window (page 63). The last two are circled in Figure 17-1, top.

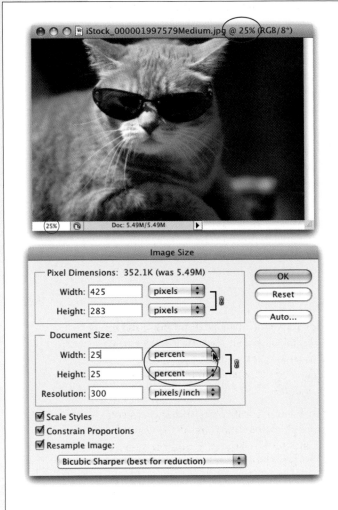

Figure 17-1:
Top: After you use the Zoom tool to visually resize your image onscreen, make a note of the zoom percentage shown in the title bar or status bar (both are circled).

Bottom: Then pop open the Image Size dialog box and enter the percentage in the Document Size section (circled).

3. **Open the Image Size dialog box by choosing Image→Image Size or pressing ⌘-Option-I (Ctrl+Alt+I on a PC).**

 At the bottom of the resulting dialog box (Figure 17-1, bottom), make sure the Resample Image checkbox is turned on.

4. **Change the Width and Height pop-up menus to "percent".**

 If the Constrain Proportions checkbox at the bottom of the dialog box is turned on, Photoshop automatically changes the second menu when you change the first one.

5. **Type the zoom percentage into the Width or Height field.**

 Again, if the Constrain Proportions checkbox is turned on, you only have to enter the percentage in one field.

6. **Choose Bicubic Sharpener from the Resample Image pop-up menu at the bottom of the dialog box.**

 When you make an image smaller, you lose some details, but with this particular method you won't lose quite so many (see page 241 for more info on these methods).

7. **Click OK when you're finished to close the Image Size dialog box.**

 Now you can upload your image to the Web (or fire it off in an email) knowing you did your part to be a respectful Web citizen. Your mom would be proud.

Tip: To make up for the bit of quality you lose when you make an image smaller, you can give it another round of Unsharp Mask (see page 463).

Choosing the Best File Format

Once you've resized an image, you need to save it in a format that's not only compatible with both the Web and email, but also reduces it to the smallest possible file size. As you learned back in Chapter 2 (page 51), those formats include JPEG, PNG, GIF, and WBMP (see Figure 17-2). The one you pick depends on how many colors are in your image and whether it has any transparent areas:

- **Use JPEG for photos.** This format supports millions of colors, although as you learned in the box on page 677, it's a "lossy" format, meaning it throws away fine detail to compress the image into a smaller file. However, you can choose the level of compression in the "Save for Web & Devices" dialog box (page 718), where you can set the amount of compression on a scale of 0–100 (0 is the most compression and lowest quality; 100 is the least compression and highest quality) or by using the Quality pop-up menu.

Tip: No matter which file format you choose, be sure to crop the image as close to the artwork's edges as possible before you save it. That way, you shave off extra pixels you don't need. The Image→Trim command (page 231) is especially handy for that particular job.

- **Use GIF for images with solid blocks of color.** If you're dealing with line art (black and white with no shades of gray) or images made from areas of solid color (logos, comic strips, and so on), GIF is the way to go (see Figure 17-2). It supports fewer colors than JPEGs, so it doesn't work very well on photos. GIFs can be lossy or not; it's up to you. If you want to make 'em lossy, use a 0–100 scale (it works just the *opposite* of JPEGs: 0 is lossless and 100 is full-on lossy). To make the files smaller without resorting to lossy compression, you can limit the number of colors you include in your image to anywhere between 2 and 256 (fewer colors equal a smaller file).

Figure 17-2:
Once you learn each format's strengths and weaknesses, it's easy to decide which one to use when.

Here are prime examples for two of the three formats: Use JPEG for photos (top left) and GIF for solid blocks of colors (bottom left) and line art (right).

- **Use GIF or PNG for images with transparent backgrounds.** Use this format when you want a graphic (a logo, say) to blend seamlessly into the background of a web page. If you've painstakingly deleted the background in your image, JPEG won't work since Photoshop automatically sticks a solid background behind any empty spaces in a JPEG. Only GIF or PNG lets you use transparent regions.

 The newer PNG-8 format is a lossless format (meaning it doesn't throw away any details) that can create a higher-quality file at smaller file sizes than GIF. The PNG-24 format supports 256 levels of transparency so it produces the highest-quality transparent image of all, though the file size is substantially larger than a

PNG-8 or GIF. The drawback to PNGs is that some older web browsers—Internet Explorer 6 in particular—don't display transparent PNGs properly and stick a white background behind them. PNG is still a relatively new kid on the file-format block, so hopefully this problem won't be around forever. If you know your Web audience will view your site on outdated browsers, stick with GIF. If you think they'll have the latest and greatest browsers, go with PNG.

- **Use PNG for super high-quality files.** If quality is more important than download speed, save your image as a PNG-24. For example, if you're a photographer trying to sell your images, use PNG-24 for the enlarged versions in your portfolio so potential clients can see every last detail in your images.

- **Use GIF for animations.** If you want to combine several images into an automatic slideshow, save it as an animated GIF. These animations are handy when you have too much ad copy to fit in a small space on a website; an animated GIF lets you cycle through the content automatically. You'll learn how to create an animated GIF starting on page 725.

- **Use WBMP (Wireless Bitmap) for black-and-white images headed for mobile devices.** If you're designing black-and-white images for handheld devices (cellphones, smart phones, and so on), choose WBMP. It supports only black and white pixels and gives you crisp text and logos that are readable on those itty-bitty screens.

FREQUENTLY ASKED QUESTION

A Farewell to Web-Safe Colors

Dude, do I still have to use Web-safe colors in my graphics? That feels so 1990.

Negative, good buddy. Computer monitors have come a long way over the years, and they can now display a much wider range of colors than they used to. Heck, today's iPods and cellphones display more colors than the monitors of the early '90s! For that reason, there's no need to stick with the boring, 256-color Web-safe palette.

However, if you're convinced that the majority of your audience is afflicted with prehistoric monitors—ones that can display only 256 colors—you can find the Web-safe color palette in the Color Picker by turning on the Only Web Colors checkbox at the bottom left of the dialog box (page 493). You can also convert other colors to their Web-safe equivalents by using the Color Table section of the "Save for Web & Devices" dialog box (see page 718).

These days, it's more important to make sure you have decent contrast in your images. Sure, you can upload them and see how they look on as many monitors or devices as you can get your hands on, but you can't possibly see how your images look on *every monitor* (although the "Save for Web & Devices" dialog box and Adobe Device Central [page 49] can help).

The cold, hard fact is that your images will look darker on some monitors and lighter on others—that's just the way it is. But as long as you have a decent amount of contrast between those colors, your images will still look good.

Saving and Compressing Your File

The "Save for Web & Devices" dialog box can save your image *and* compress the heck out of it at the same time. It also gives you four big preview windows—one for your original image and three others—so you can monitor the image's quality while you're trying to squeeze it into a smaller file size (see Figure 17-3).

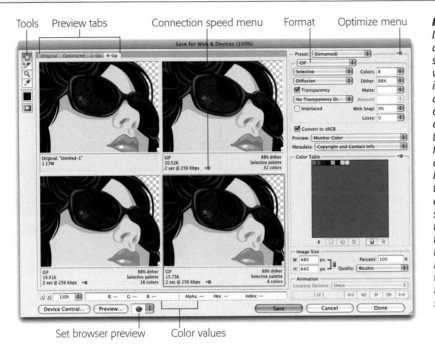

Tools Preview tabs Connection speed menu Format Optimize menu

Set browser preview Color values

Figure 17-3:
In this Texas-sized dialog box, you can see up to four previews of your image in various file formats at different levels of compression. Below each preview, Photoshop lists the file format, the file size, and an estimate of how long the image takes to download at a given connection speed. You can use the tiny pop-up menu to the right of the time estimate (it looks like a down-arrow with four tiny lines) to choose a different speed.

You saw this dialog box in action when you resized a JPEG back in Chapter 6 (page 248). To explore even *more* of its settings, follow these steps:

1. **With an image open, choose File→"Save for Web & Devices" and, in the resulting dialog box, click the 4-Up tab.**

 At the top of the dialog box, you'll notice four tabs that let you see your original image alongside three previews that show what the image looks like if you change it in particular ways. The most useful tabs are 2-Up and 4-Up. Pick 2-Up if you already know the format you want to use and 4-Up if you want to make more comparisons. Optimize gives you no comparison at all and shows only the new image.

2. **Click the preview window to the right of the original and, at the top right of the dialog box, choose a file format from the Preset pop-up menu.**

The Preset menu contains a list of frequently used file format/compression level combinations for the formats previously mentioned. Photoshop changes the various quality and color settings on the right side of the dialog box for you and displays the file size and estimated download time below the preview. (You can change the connection speed Photoshop uses to calculate the download time by clicking the tiny icon to the right of the listed speed as shown in Figure 17-3.) If you don't want to go the preset route, you can pick the format from the pop-up menu *underneath* the Preset menu and then adjust the quality/color settings manually, as discussed in the next step.

Tip: To make Photoshop automatically fill in the remaining two preview windows, choose Repopulate Views from the "Save for Web & Devices" dialog box's option menu (see Figure 17-3). Photoshop looks at the currently selected preview window's file format and then loads up the other windows with previews of the same format at lower compression or color settings.

3. **Adjust the quality and color settings for the format you picked.**

Each item in this menu has its own entourage of settings related to quality and color. Here's the lowdown on what they all mean:

— **JPEG.** This format is the one you'll probably use most often. You set the compression level using the Quality pop-up menu, which includes five settings from low (highest compression, smallest file size) to maximum (least compression, largest file size). You can fine-tune the quality by using the numeric quality field to its right (0 is the highest compression/smallest file size and 100 is the least compression/largest file size).

— **Optimized.** Normally, an image has to download completely before it appears in a web browser, but if you turn on the Progressive checkbox, your image loads a little bit at a time (row by row), sort of like a waterfall effect. Turning on this checkbox creates a slightly smaller, though somewhat less compatible file. Leave it off if your audience is likely to use older browsers.

— **Embed Color Profile.** If you want the image's color profile (page 667) to tag along with the file, turn on this checkbox. On the off chance that the viewer's monitor can actually *read* the profile correctly (some can't), the colors will look more accurate. If the monitor can't read the profile, you've added a little file size for nothing (which is why you should probably leave it off).

— **Blur.** Use this field to run a slight Gaussian Blur on the image (page 445) to reduce its file size a little more. For a decent-quality image, you can get away with a setting of 0.1–0.5 pixels, but anything higher looks terrible.

— **Matte.** This color swatch lets you pick a color to use in place of any transparent (or partially transparent) pixels in your image. Since JPEG doesn't support transparency, those pixels will turn white unless you pick another color here. (Transparency options are discussed on the next page.)

— **GIF and PNG.** You get similar options for both these formats. Near the top right is the most crucial setting, the Color pop-up menu, which controls the number of colors you use to create your image (shown in the Color Table a little lower in the dialog box). If you reduce the number of colors in the image, you can greatly reduce its file size (though Photoshop substitutes the closest match for the missing colors, which can produce some weird-looking images). Both GIF and PNG-8 let you choose anywhere between 2 and 256 colors. PNG-24, on the other hand, gives you 16.8 *million* colors.

— **Color reduction method.** This pop-up menu lives below the Format menu. If you've reduced the number of colors as described earlier, this menu lets you pick the method Photoshop uses when it tosses them out. From the factory, it's set to Selective, which makes Photoshop keep colors that your eyes can see, although it favors colors in broad areas (like a sky) and those that are safe for the Web. Perceptual favors only those colors that your eyes can see, and Adaptive creates a palette from the most dominant colors in the image (like greens and blues for landscape images and peachy colors for portraits). Restrictive uses only the Web-safe palette (see the box on page 117), and Custom lets you modify the color palette yourself (eek!) using the Color Table section of the dialog box. Choose "Black - White", Grayscale, Mac OS, or Windows to use those respective color palettes. The Selective method usually produces the most visually pleasing palette, so feel free to leave this menu alone.

— **Dither method and amount.** If your image contains colors that the viewer's monitor can't display, you can fake 'em with a process called *dithering*. Use the pop-up menu on the left to set the dither method (or to turn dithering on or off) and the numeric field to its right to set the amount. A high dither amount (percentage) produces more accurate color; the tradeoff is larger file size (try a setting between 80 and 90 percent). If you're desperate to make the file smaller, lower the dither amount. As far as how it does what it does, Diffusion simulates missing colors with a random pattern that's not too noticeable, so it's usually the best choice. Pattern simulates missing colors with a square pattern (which can sometimes create a weird color seam), and Noise uses a random pattern that doesn't spread across the whole image (so you won't get a weird seam). If you choose No Dither, Photoshop won't fake any colors. Since you never know how many colors folks' monitors are set to display (256 vs. thousands or millions), it's a good idea to leave the dither method set to Diffusion and the amount at 100%; however, if file size is more important than quality, choose No Dither.

— **Transparency** and **Matte.** If you've deleted your image's background, turn on the Transparency checkbox. If you want to change partially transparent pixels (those around the edges; see Figure 17-4) to a certain color, click the Matte swatch and pick a color from the resulting Color Picker. You can also choose a matte color from within your image by choosing Eyedropper from the Matte pop-up menu. Grab the Eyedropper tool at the far left of the dialog box—*not* the one in the Tools panel—and then click a color in the image; the color you clicked shows up in the square color swatch beneath the Eyedropper tool. Use the pop-up menu below the Transparency option to turn dithering on or off for the matte color, and use the numeric field to its right to set the dither amount. You'll typically leave transparency dithering off.

Note: The Refine Edges dialog box in Photoshop CS5 got a major overhaul. If you've masked (hidden) your background using the new Color Decontamination feature, this whole Matte color business is less of an issue. Skip back to page 166 for the scoop on how to use it.

— **Interlaced, Web Snap, Lossy.** Turn on the Interlaced checkbox to make the image appear a little at a time in your visitor's web browser. If you want to convert your colors to the Web-safe color palette (see the box on page 717), use the Web Snap slider (the higher the number, the more Web-safe colors you get). Use the Lossy slider to lower the quality of your GIF which makes the file smaller. (Lossy isn't available for the PNG-8 or PNG-24 formats.) You'll typically leave these settings turned off or set to 0, but feel free to experiment with them if you're feeling frisky.

— **WBMP.** If you've made a black-and-white image that's destined for a cell-phone or other hand-held device with an itsy-bitsy screen, choose this format. Since you're dealing only with black and white pixels, you just need to decide whether to turn on dithering (page 720) and, if you turn it on, the amount. Out of the box, it's set to Diffusion at 88 percent.

Tip: If you're saving a graphic that has to weigh in at a certain size (like a Web banner ad), you can choose "Optimize to File Size" from the "Save for Web & Devices" dialog box's Optimize menu (shown in Figure 17-3). In the resulting dialog box, enter the target size and select a Start With option. Choose Current Settings to make Photoshop use the settings in the "Save for Web & Devices" dialog box. If you want Photoshop to pick a format, choose Auto Select GIF/JPEG. If you're dealing with an image that contains slices, you can choose to optimize the current slice, each slice, or all of 'em. Click OK to make Photoshop try to get your image as close to the target size as possible. You may still have some tweaking to do afterward, but Photoshop does most of the work for you.

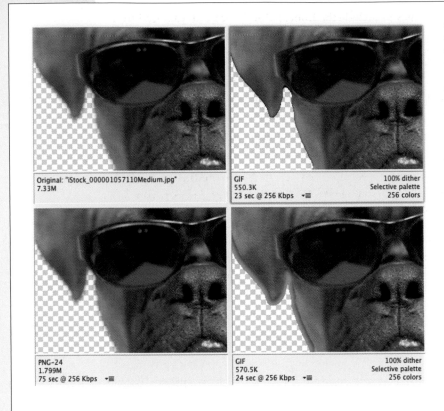

Figure 17-4:
As you can see here, the edges of a transparent image with a drop shadow look much better as a PNG-24 (bottom left) than a GIF (top right) because the PNG-24 can display so many more colors. But, as the file sizes beneath each preview show, the PNG-24 is also larger, so it takes longer to download. If file size is more important than download speed, use the Matte menu to change the shadow's partially transparent pixels to the color of your destination background (bottom right). This trick makes the shadow look nice and soft again because Photoshop mixes the matte color with the shadow. It also keeps you from seeing edge halos—leftover pixels from the image's original background.

4. **Make sure the "Convert to sRGB" checkbox is turned on.**

 If you leave this option turned on, Photoshop converts your image to sRGB, a color space designed to mimic the characteristics of a Windows monitor. Since the majority of monitors *are* attached to Windows computers, leave it on.

5. **Use the Preview pop-up menu to see what your image looks like on a Mac or Windows computer with no color management or with the document's current color profile (page 667).**

 This setting doesn't change your image; it just lets you see it through the eyes of someone with a different monitor.

6. **Set the Metadata pop-up menu to "Copyright and Contact Info".**

 This pop-up menu lets you include the information Photoshop captured from your camera (metadata) or the copyright and contact info you stored using the File Info dialog box (page 739). As you might suspect, including data with your document increases its file size a hair, but it's a good idea to include it anyhow so your image carries info with it about where it came from; otherwise it can appear *orphaned* (visit Wikipedia.com and search for "Orphan Works" for more on this topic).

7. **Use the Color Table to edit the colors in your image.**

 This chart of color swatches lets you change or delete colors in your image. If your viewers are certain to have super old monitors, use the tiny Color Table panel's menu to shift the colors in a GIF or PNG-8 image to Web-safe colors. If you need to make your file even smaller, you can delete colors by clicking the swatch of the color you want to zap and then clicking the little trash can icon at the bottom right of the Color Table (shown in Figure 17-3). If you want certain colors to be transparent, select the swatch and click the transparency button below the table (it looks like a white-and-gray checkerboard). And finally, if the look of the Color Table scares you, don't panic; you'll probably never use it.

8. **When you're finished, click Save.**

 Photoshop opens the Save dialog box letting you pick a name and storage space for your new file.

Tip: If you decide you've got some image editing left to do but you want Photoshop to remember your current settings, click Done instead.

The left side of the "Save for Web & Devices" dialog box contains these tools:

- **Hand.** This tool lets you move the image around within the preview windows just like the regular Hand tool. You can also press the space bar (or H) to activate it and then move your mouse to see another part of the image.

- **Slice Select.** If you've mocked up a web page and sliced it accordingly (see page 732), you can use this tool to select those slices for saving in specific formats. Its keyboard shortcut is C.

- **Zoom.** You can use this tool to zoom in and out of your image just like the Zoom tool in your Tools panel, though it's faster to press ⌘-+ or – (Ctrl-+ or – on a PC). Alternatively, in the field at the bottom left of the dialog box, you can enter a zoom percentage or choose a preset from the pop-up menu. You can also Ctrl-click (right-click on a PC) within the preview window and choose a zoom percentage from the shortcut menu. Keyboard shortcut: Z.

- **Eyedropper.** Use this tool to snatch colors from the image in your preview window. It's helpful when you're creating a matte color for a transparent background as discussed on page 720. Keyboard shortcut: I.

- **Eyedropper Color.** This color swatch shows the Eyedropper's current color.

- **Toggle Slices Visibility.** If you want to see the slices in your image, click this button. Slicing is discussed starting on page 732. Keyboard shortcut: Q.

The buttons at the bottom of the dialog box include:

- **Device Central.** If you're designing for a cellphone or other mobile device, this button launches a program that lets you preview the image on several devices. On the left side of the resulting window, choose your device and click the Emulator tab in the middle to see what your image looks like on that device (see Figure 17-5).

- **Preview.** To see what your image looks like in a web browser, click this button (it uses the main browser on your computer). To choose a specific browser installed on your machine, use the pop-up menu to the Preview menu's right and navigate to that browser.

- **Save, Cancel, Done.** Once you have all the settings just right, click the Save button to save your image and give it a name. If you want to bail and do nothing, click the Cancel button. Clicking Done makes Photoshop remember the current settings and close the dialog box. Holding Option (Alt on a PC) changes the last two buttons to Reset and Remember, respectively.

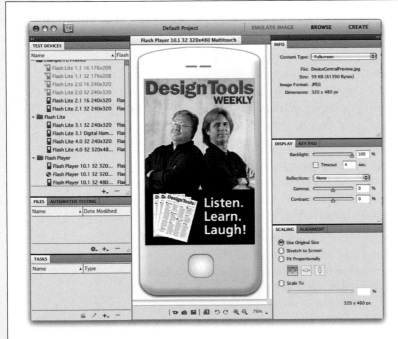

Figure 17-5:
Adobe Device Central has a ton of device-specific preview frames that show you what your graphic looks like on various gadgets. You can use the panel on the left side of the window to load more devices from the Online Library, and the options on the right to adjust things like the brightness of the display screen.

Animating a GIF

You may think that creating an animation is a complicated process, but it's really not. In Photoshop, all it means is that you're creating a slideshow that plays automatically. You can control which images the program uses, the amount of time it displays each one, whether it *loops* the slideshow (automatically starts over), and so on. This kind of control is really handy when you're making website ads. For example, if you're designing a 140-pixel × 140-pixel ad for your costume shop, you need to include a logo, a few costume samples, and a 10%-off coupon. Since you'll never fit all that into a tiny space, you can make an animated GIF that cycles through several images automatically. Here's how:

1. **Create the images you want to string together, with** *each image on its very own layer* **within the same Photoshop document.**

POWER USERS' CLINIC

Matching and Snatching Colors on the Web

If you're designing an image destined for an existing web page, you may find yourself in a color-matching conundrum. If you need to match the color scheme (page 486) or the colors in a company logo, you can do it by finding out the colors' *hexadecimal* values.

Hex numbers, as they're affectionately called, are six-digit, alphanumeric programming codes for color values. The first two digits represent red, the next two represent green, and the last two represent blue (since your image appears only onscreen, RGB values are the only ones that matter). You can find a color's hex number in several different ways:

- In CS5, you can open the Color panel by choosing Window→Color, and then from the Color panel's menu, choose Copy Color's Hex Code.

- Choose Window→Info and, from the panel's menu, choose Panel Options. From the Mode menu, choose Web Color and then click OK. When you mouse over to the color, its hex number appears in the Info panel.

- Using the Eyedropper tool (page 495), Ctrl-click (right-click on a PC) any color in an open Photoshop document. From the resulting shortcut menu, choose Copy Color's Hex Code (new in CS5) and paste the number into your HTML editor by choosing Edit→Paste.

- Using the Eyedropper tool, click a color in an open

Photoshop document to load it as your foreground color chip. Choose Window→Color and then, from the Color panel's menu, choose Copy Color's Hex Code (new in CS5). You can also click the foreground chip to open the Color Picker (page 493), where the color's hex number appears at the bottom of the dialog box in the field labeled #.

- Snatch color from anywhere on your screen, whether it's on your desktop or in a web browser. In Photoshop, just click your foreground color chip to open the Color Picker, mouse over to your document, and then click somewhere within the document. Other methods include using the Eyedropper tool, or pressing and holding Option (Alt) while using the Brush tool (page 499). *Outside* Photoshop it gets a little trickier. You can use any method mentioned, but you have to click and hold your mouse button down *while you're in the Photoshop window* and keep it held down as you mouse *outside* Photoshop, hover over the color you want to snatch, *and then* release the mouse button. As long as you click *within* your document first, your cursor remains an eyedropper no matter where you drag it.

At the bottom of the Color Picker dialog box, you can enter the hex number in the field marked # or use it in your favorite HTML editor when you're building the web page.

2. **Open the Animation panel by choosing Window→Animation.**

 At the bottom of the Application Frame (page 13) or near the bottom of your document if you've got the Application Frame turned off, find the long horizontal panel called "Animation (Frames)". Each frame serves as a placeholder for the image you want to show onscreen. As soon as you open the Animation panel, you see one frame representing what's currently visible in your Layers panel.

Warning: If you have Photoshop CS5 Extended (page 5), Photoshop opens the Animation (Timeline) panel instead of Animation (Frames). To switch between the two panel modes, click the tiny button at the bottom right of the panel (it looks like a little box with three sliders and is labeled in Figure 17-6).

3. **Add another frame.**

 At the bottom of the Animation panel, click the "Duplicate selected frames" icon (it looks like a piece of paper with a folded corner) as shown in Figure 17-6 (where it's labeled New Frame) to create a new placeholder for the next image in your animation. Initially, it contains the same image as the starter frame (don't worry; you'll fix that in the next step).

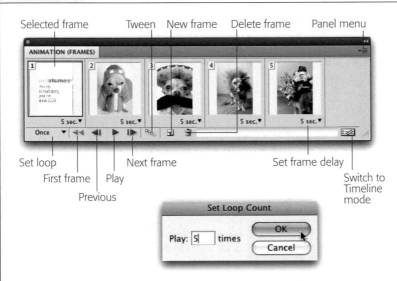

Figure 17-6:
Top: Use the playback buttons at the bottom of the Animation panel to move through your animation frame by frame. Photoshop highlights the selected frame as shown here. You can also click a frame to select it.

Bottom: Open the Set Loop Count dialog box by clicking the Set Loop Count triangle (labeled, top) and then choosing Other. The dialog box lets you determine how many times your animation plays. If you want it to keep playing without stopping, click the Set Loop Count triangle and select Forever.

4. **In the Layers panel, use the visibility eyes to show only the layer containing the next image in your animation.**

 When you turn off the visibility of every layer *except* the one you want to show next, Photoshop displays the visible layer in the frame you created in step 3. That's all there is to it! There's no dragging or dropping, just showing and hiding using the layers' visibility eyes.

5. **Repeat steps 3 and 4 until you've made all the frames of your animation.**

6. **Press the Play button to see the slideshow.**

 Photoshop displays your animation in the main document window. The images flash by quickly, but don't worry—you'll learn how to make 'em stick around longer in the next section.

You did it! You created your first animated GIF. There's still some work to do, but you're more than halfway there.

Note: In Photoshop CS5 you can open Animated GIF files and preserve the individual frames from which they're made. This is helpful when you need to edit an existing animation, and keeps you from having to start from scratch.

Editing Your Animation

Once you've made all the frames in your animation, you can edit your masterpiece using the following controls:

- **Frame delay.** To control the length of time each image is visible, use the pop-up menus at the bottom of each individual frame (shown in Figure 17-6). To open one of the menus, click the down arrow near the bottom of a frame. Photoshop gives you a list of options ranging from No Delay to "10 seconds". If you want to enter a duration that's not listed, choose Other and type a number in the Set Frame Delay dialog box. You can set a duration for each frame or change several at once by Shift- or ⌘-clicking (Ctrl-clicking on a PC) to select multiple frames and then changing the duration of one of the selected frames.

- **Set Loop Count.** If you want the animation to play over and over, you can set it to loop a certain number of times. Click the down-pointing triangle at the bottom left of the Animation panel and choose Once, "3 Times", Forever, or Other from the pop-up menu. If you choose Other, Photoshop opens the dialog box shown in Figure 17-6, bottom, where you can enter any number you want.

- **Rearrange frames.** To change the frames' order, simply drag them into place.

- **Delete frames.** Just like almost every panel in Photoshop, this one has its own little trash can icon. If you want to zap a frame, select it and then click the trash can or drag it onto the trash can. If you want to delete more than one frame, select them first by Shift- or ⌘-clicking (Ctrl-clicking on a PC) and then click the trash can. In the resulting "Are you sure?" dialog box, click Yes.

- **Tween frames.** At first, there isn't any kind of transition between your frames; the animation works just like a regular slideshow, in which one frame abruptly gives way to the next. If you want to make the frames fade in and out, you can

add *tweening* (short for "in-betweening"). Just tell Photoshop *which* frames you want to tween and how many frames of fading you want and Photoshop adds the new frames for you. When you play the animation, the frames blend softly into one another. Figure 17-7 has the details.

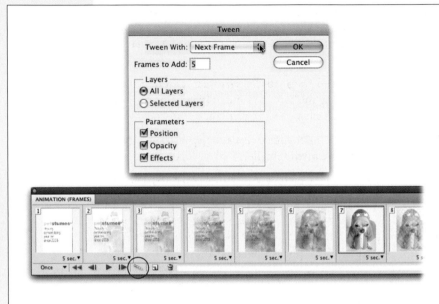

Figure 17-7:
Top: If you want to fade the first frame shown in Figure 17-6 into the second, select the first frame and then click the Tween button (circled, bottom) and choose Next Frame from the Tween With pop-up menu. Enter 5 in the "Frames to Add" box and then click OK.

Bottom: Here, Photoshop has added five additional frames (numbered 2–6) that gradually change opacity. When you play the animation, it'll look like the text and dog images fade together. For a more gradual fade between frames, enter 10 in the "Frames to Add" box.

Note: Once you start adding tweened frames, you should speed up the whole animation's frame duration so it doesn't take forever to play.

You can create all kinds of special effects using tweening, though you'll need to experiment and play around with it to learn what you can do. It's all about setting up a layer for each frame, creating the frames, and then adjusting what you want to happen *between* each frame. For example, if you move the contents of a layer in one frame, you can use tweening to make it look like the object is moving. You can also turn layer styles (page 128) on or off, add solid-colored frames to make the animation look like it fades to that color, and so on. The creative possibilities are endless!

Saving Your Animation

When you've got the animation just right, you need to do just a couple of things before you post it on the Web. Save it as a Photoshop (PSD) document so you can go back and edit it later, and then:

- **Optimize it.** If you choose Optimize Animation from the Animation panel's menu, you end up with a slightly smaller file, which makes the animation download faster and run more smoothly. The resulting Optimize Animation dialog box has two settings:

 — **Bounding Box** crops each changed frame to the part that's different from the previous frame. It's like running the Trim command (page 231) on each frame, so that each one is cropped closely to the content.

 — **Redundant Pixel Removal** makes unchanged pixels transparent in subsequent frames, which makes the file a little smaller.

 Both these settings are turned on from the factory, but Photoshop doesn't apply them until you choose Optimize and then click OK.

- **Save it as an animated GIF.** Last but not least, choose File→"Save for Web & Devices" and, in the upper right of the dialog box that appears, choose GIF from the unlabeled format pop-up menu (it's right below the Preset menu). When you do, Photoshop activates the Animation section at the bottom right of the dialog box, giving you one last chance to change the Looping Options and preview your handiwork. When you've finished, click Save and say with gusto, "I'm an animator!"

Designing a Website Favicon

You know those tiny little icons on the left edge of your web browser's address bar (see Figure 17-8). They're called *favicons* (short for "favorites icons"), and they're great for adding a bit o' branding to your web pages. They not only show up in your web browser, they also appear in news feeds (clickable headlines from your favorite websites that you can access through special newsreader software or your favorite browser). Creating them in Photoshop is a snap, and you'll be designing them like a pro after you read this section.

First, spend some quality time looking at other sites' favicons. Your goal is to brand your website with a graphic that's exactly 16 pixels × 16 pixels—no more, no less. It's tough to design anything recognizable that small, but it can be done. For example, you might use a portion of your logo rather than the whole thing or your company's initials rather than the full name.

Figure 17-8:
Here's an example of four different favicons for various websites (the top one is circled). Designing favicons is a good way to test your design skills since you're limited to 16 pixels square!

Next, you need to download a plug-in that lets Photoshop save the file in the Windows Icon (ICO) file format. You can download a free plug-in called ICO Format from *www.telegraphics.com.au/sw/*. Just quit Photoshop and follow the instructions on page 767 to install it. When you relaunch Photoshop, you should see ICO appear in the Format pop-up menu of the Save As dialog box. Now you're ready to create your tiny work of art:

1. **Create a new document that's 64 × 64 pixels with a resolution of 72.**

 Choose File→New or press ⌘-N (Ctrl+N on a PC) to make a new document. Your favicon *will* ultimately be 16 pixels × 16 pixels, but that's too small a size to work with initially. To save yourself some eyestrain, start out with a larger, 64-pixel × 64-pixel canvas; you'll reduce its size later.

2. **Create or place your artwork in the new document.**

 If you designed a logo using Adobe Illustrator, choose File→Place to open it as a Smart Object (page 54). If you're creating art in Photoshop, be sure to turn off anti-aliasing so the edges are nice and crisp (this is especially important on text as discussed on page 602).

3. **If you need to, resize the artwork to fit the canvas.**

 To resize your artwork, press ⌘-T (Ctrl+T on a PC) to summon Free Transform (page 264) and then drag one of the corner handles. When you're happy with the size, press Return (Enter) to let Photoshop know you've finished.

4. **Resize the document.**

 When your design is done, choose Image→Image Size. Make sure the Constrain Proportions checkbox at the bottom of the dialog box is turned on and set the Width or Height field to *16 pixels* (Photoshop automatically changes the other field to 16), and then click OK.

5. **Sharpen your image if you need to.**

 If your design looks a bit blurry, run the Unsharp Mask filter (see page 461).

6. **Save your file in the ICO format and name it *favicon*.**

 Choose File→Save As and pick Windows Icon (ICO) from the Format pop-up menu at the bottom of the dialog box and then click Save.

That's it! You've created your very first favicon. If a client asked you to create a favicon and send it to her, email the *favicon.ico* file and let her add it to her website. If you created it for your own site, you're ready to upload the file to the root level of your website, where your index (home) page lives. (If you have no idea what that last sentence means, check out *Creating a Web Site: The Missing Manual,* 2nd Edition.)

Be aware that not all web browsers support favicons, and some even want you to bury a link to the favicon in the code of each page. If you want to take that extra step, you can insert the following code somewhere within the <head> section of your web pages:

```
<link rel="SHORTCUT ICON" href="/favicon.ico">
```

If you've got a big website, adding that line of code can be time consuming, so you may want to use the "Find and Replace" command found in most HTML editors, which lets you search for a piece of code that appears in every page, like the closing </title> tag. For example, you could search for *</title>* and Replace it with *</title><link rel="SHORTCUT ICON" href="/favicon.ico">*.

Creating Web-Page Mockups and Image Maps

As you've learned throughout this book, Photoshop is an amazingly powerful image editor, which means it's great for designing web pages. In fact, Photoshop has a tool that'll let you slice your design into Web-friendly pieces that, when clicked, lead to whatever web address you want to link them to. Photoshop churns out the proper code that you can paste into your own web page using your favorite HTML editor.

But does all that mean you should use Photoshop to build a website? Heck, no. Remember how back in Chapter 14 you learned that, even though Photoshop has a powerful text tool, you shouldn't use it to create a book? The same principle applies here. While you *could* use it to build real web pages, you shouldn't; you're much better off using a program designed for the job, like Adobe Dreamweaver. That said, the Slice tool comes in really handy in a few situations:

- **Building a website prototype.** If you've designed a website for a client in Photoshop and want to give him an idea of how the site will look and behave, you can use the Slice tool to get it done fast. If you slice up your design and assign different hyperlinks to navigation bars, you can give your client a good idea of how the navigation in the final website will *feel*.

- **Making an image map.** If you want to add hyperlinks to certain portions of a single image, you can do it with the Slice tool.

- **Making an image-heavy page load a little faster.** Chopping images into pieces makes them load a little at a time instead of in one big piece. (However, this is becoming less of a problem as more people get fast Internet connections.)

Tip: An alternative to slicing and dicing the images yourself is to buy a plug-in called SiteGrinder, which will build an entire, fully functional website from your layered Photoshop document. See page 782 for details.

Slicing an Existing Image

Once you've created an image that you want to slice, you can use the Slice tool to draw the regions by hand or you can make Photoshop create slices from individual layers by choosing Layer→New Layer Based Slice. You can also make Photoshop slice your images according to the guides you've drawn (discussed later in this section). Here's how to slice and dice a web page mockup:

1. **Turn on Photoshop's Rulers and draw individual guides around the areas you want to slice.**

 Instead of drawing each slice yourself, make Photoshop do the hard work by dragging a few well-placed guides around each slice you want to create. Turn on Rulers by pressing ⌘-R (Ctrl+R on a PC) and then click within the horizontal ruler and drag downward to drop a horizontal guide. Do the same thing to create vertical guides until you've placed a guide around every slice you want to make as shown in Figure 17-9.

Figure 17-9:
As you can see here, Photoshop created individual slices from the guides. A bounding box and a tiny number appear at the top left corner of each slice; Photoshop numbers each one, beginning at the document's top left and working down to the bottom right. If you draw the slices yourself (to create what are called user-slices), *the number appears in a blue box. If you make Photoshop draw the slices for you (to create* auto-slices), *the number appears in a gray box instead.*

2. **Press C to grab the Slice tool.**

 The Slice tool, which looks like a tiny X-Acto knife, hides in the Crop toolset.

3. **Trot up to the Options bar and click the Slices From Guides button.**

 In less than a second, Photoshop draws slices around your images, following the guides you placed in the first step. If you opted out of drawing guides first, you can slice areas yourself by clicking where you want the slice to begin and then dragging diagonally to the right. When you let go of your mouse button, Photoshop puts a blue bounding box around the slice. This kind of slice is called a *user-slice*. To account for the rest of your image (the areas you haven't yet sliced), Photoshop draws other slices (called *auto-slices*) automatically and marks them with a gray bounding box. Auto-slices are discussed in the next section.

Tip: If you've drawn a slice that's perfectly suited for another graphic, you can duplicate it by Option-dragging (Alt-dragging on a PC) the slice onto another image. If you want to draw a perfectly square slice, hold Shift as you drag.

Modifying Slices

Once you create a slice, you may need to move or change it. If so, select it using the Slice Select tool. (Press Shift-C to activate the tool or, if the Slice tool is active, you can grab the Slice Select tool temporarily by pressing ⌘ [Ctrl on a PC]. When you let go of that key, Photoshop switches back to the regular Slice tool.) To select a slice, just click it. Its bounding box turns brown and little squares appear in the center of each line as shown in Figure 17-10.

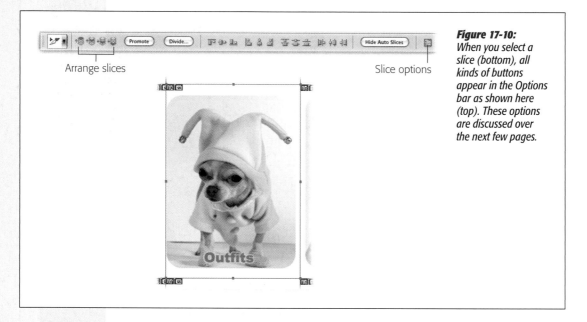

Arrange slices

Slice options

Figure 17-10:
When you select a slice (bottom), all kinds of buttons appear in the Options bar as shown here (top). These options are discussed over the next few pages.

Now you're ready to:

- **Resize the slice.** Once you select a slice, you can drag any corner or center handle (they look like tiny solid squares) to make it bigger or smaller.

- **Move the slice.** Click within the slice and then drag it to another location. To restrict your drag horizontally or vertically, hold the Shift key as you drag.

Tip: If you want your slices to snap to guides, other slices, or objects, choose View→Snap To. (Unless you've previously turned it off, this option is already turned on.)

- **Promote slices.** You can change a layer- or an auto-slice to a user-slice by clicking the Option bar's Promote button (Figure 17-10, top). You can't edit auto-slices because they were made by Photoshop, For example, if you place guides and let Photoshop make the slices for you as described in the previous section,

you can't move or resize any of those slices until you promote them to user-slices (as shown in Figure 17-11). Similarly, layer-based slices are tied to the pixel content of that layer. To change the slice itself or the layer's contents, you have to promote the slice to a user-slice first.

Figure 17-11:
By promoting auto-slices to user-slices, you can divide them in the pink navigation bar as shown here. Notice that the auto-slices around the document's edges are tagged with gray icons while the user-slices are tagged with blue ones.

- **Arrange slices.** Because the Slice tool draws only rectangles, you have to overlap slices to make other shapes. In that case, you may need to fiddle with their stacking order by first selecting the slice with the Slice Select tool and then clicking the Bring Forward or Send Backward buttons (and so on) shown in Figure 17-10, top.

- **Align slices.** You can align slices just like you can align layers (page 96). Using the Slice Select tool, just Shift-click to select more than one slice and then click the appropriate alignment button in the Options bar.

- **Divide slices.** If you need to slice a slice (oy!), select it with the Slice Select tool and click the Options bar's Divide button. In the resulting Divide Slice dialog box, turn on the Divide Horizontally Into or Divide Vertically Into checkbox, enter the number of slices you want to create, and then click OK.

- **Combine slices.** Select two or more slices by Shift-clicking with the Slice Select tool. Next, Ctrl-click (right-click on a PC) and choose Combine Slices from the resulting shortcut menu. Combining slices is helpful when Photoshop creates too many auto-slices and you want to combine 'em so they'll load as one image.

- **Copy and paste slices.** You can copy and paste a slice by selecting it and then pressing ⌘-C (Ctrl+C). Next, open the target document and press ⌘-V (Ctrl+V). The slice and graphics from the associated layers appear in your new document, but they're all on one layer (which means you can't edit them individually—you have to do that in your original document).

- **Give it a URL.** If you want to transport visitors to a particular web address when they click a slice, select the slice and click the Slice Options button shown in Figure 17-10 or just double-click the slice itself. In the resulting Slice Options dialog box, enter the full web address into the URL field (for example, *http://www.petstumes.com/*). The next section also discusses Slice Options.

- **Delete it.** To delete a slice, select it with the Slice Select tool and then press Delete (Backspace on a PC).

- **Hide.** If you find a document riddled with slice borders and numbers distracting, you can hide them temporarily by pressing ⌘-H (Ctrl+H on a PC). That is, unless you've reassigned that keyboard shortcut to hide Photoshop on your Mac, as described in the Tip on page 14.

- **Lock.** To lock your unlocked slices so they can't be changed, choose View→Lock Slices.

- **Clear.** To zap all your slices, choose View→Clear Slices.

Slice Options

Once you've drawn slices and put them in the right spot, you can start controlling how they behave in your web browser by setting Slice Options (see Figure 17-12). The Slice Options dialog box lets you control the following:

Figure 17-12:
If you click the Slice Options button at the top right of the Options bar (shown in Figure 17-10), Photoshop opens this dialog box, which lets you give each slice a custom name and URL. You can also open this box by double-clicking the slice with the Slice Select tool.

- **Slice Type.** Most of your slices consist of an image, although they can also be solid blocks of color or plain text. If you want to create an empty space that you can fill with HTML color or HTML text later, choose No Image from this pop-up menu and a "Text Displayed in Cell" field appears that lets you enter text that'll be—you guessed it—displayed in that cell.

Tip: To change the color of the slice lines, choose Photoshop→Preferences→"Guides, Grids, & Slices" (Edit→Preferences→"Guides, Grids, & Slices" on a PC). In the Slices section at the bottom of the dialog box, use the pop-up menu to change the line color. You can turn off the Show Slice Numbers checkbox here, too.

- **Name.** Straight from the factory, your slices get generic names that include the document name and a number. If you want to use a name that's more descriptive (and useful), enter it here.

- **URL.** One of the big benefits of slicing images is that it lets you make part of the image act as a hyperlink that takes visitors to another web page. Enter the full web address here to make that happen. Photoshop doesn't actually embed this info into your image; instead, it stores the info in a separate HTML file that you can copy and paste into your own web page.

Note: Assigning a hyperlink to part of your image is called *creating an image map*. Now if you hear image maps mentioned at the water cooler, you'll be in the know!

- **Target.** This field determines where the hyperlink opens. For example, to make the hyperlink open the URL in another browser window, enter *_blank* into this field (complete with underscore). If you want the page to load within the same window, leave this field blank.

- **Message Text.** Almost every web browser has a status bar at the bottom of the window to let folks know what's going on in the background. For example, when you type a URL into your browser's address bar and press Return (Enter on a PC), you'll see some kind of "loading" message. If you enter text in this field, you can send messages in the status bar (like a love note to your visitors: "Dude! Thanks for clicking!"). But since few folks ever look down that far, your efforts may be in vain.

- **Alt Tag.** Because some folks surf the web with their graphics turned off, you can use this field to give your image an alternate text description. Visually impaired people using web readers—special software that speaks the contents of web pages—hear this text read to them. The text also pops up as a balloon or tooltip when visitors hover over it with their cursors.

- **Dimensions.** This info lets you know the width and height of your slice, along with its X and Y coordinates.

- **Slice Background Type.** If you chose "No Image" in the Slice Type menu, you can use this pop-up menu to give the selected cell a color. If your slice has any transparent pixels, this color will show through the transparent areas. Your choices include None, Matte (page 720), White, Black, and Other (which summons the almighty Color Picker).

Saving Slices

Once you've set all the options for your slices, it's time to save them to use on the Web (finally!). Use the File→"Save for Web & Devices" dialog box to set all those glorious file type, compression, and other options discussed earlier in this chapter. (If you use File→Save As, all your slice options will fly right out the window.)

On the left side of the "Save for Web & Devices" dialog box, click the Slice Select tool to grab each slice so you can apply different format and compression settings to each one (though if you're building a website prototype, choosing one file format for the whole thing probably works just fine). When you've finished, click OK and tell Photoshop where you want to save the files. If you've assigned URLs to the slices, be sure to choose "HTML and Images" from the Format pop-up menu at the bottom of the Save Optimized As dialog box as shown in Figure 17-13. (Make sure to change the Format menu back to Images the next time you use the Save Optimized As dialog box.)

Figure 17-13:
Left: If you've chosen to save both HTML and images, it's a good idea to make a folder first—that way all your files are saved together in one place.

Right: Once you've saved the slices, you can open the folder and see your images, along with the HTML document containing code you can use in your very own web page.

Protecting Your Images Online

Being able to share your images with the world via the Web is a glorious thing, but, in doing so, you risk having your images stolen (gasp!). It's frighteningly easy for thieves to snatch photos from your website to sell or use as their own, so it's important to take a few extra steps to protect them. You can deter these evil-doers in several different ways, including posting smaller versions of your images (640×480 pixels, for example), using photo galleries such as *www.smugmug.com* that prevent folks from Ctrl-clicking (right-clicking on a PC) to copy your images to their hard drives, embedding copyright info, adding watermarks, or using Zoomify (see the box on page 743). Read on for the scoop on each option.

Embedding Copyright Info

One of the first steps you can take toward protecting your work is to embed copyright and contact info into the image file by choosing File→File Info. Sadly, it won't keep folks from stealing your image (heck, they won't even see it unless they choose File→File Info themselves), but it *might* make them think twice about taking it if they do find a name attached to it. Alternatively, you can declare that the image is in the public domain, granting anyone and everyone a license to use it. See Figure 17-14 for more info.

Figure 17-14:
If you choose File→File Info, you can attach all kinds of descriptive info to your image (top). Once you change the Copyright Status pop-up menu to Copyrighted, Photoshop puts a © in the document window's title bar (bottom).

You can also choose Public from this menu to give anyone permission to use your image.

Watermarking Images

One of the best ways to protect your images online is to add a *watermark* to them—a recognizable image or pattern that you either place atop your image (as shown in Figure 17-15, bottom) or embed into it invisibly. A watermark is a great deterrent because would-be thieves will have one *heck* of a time trying to erase it. You can add watermarks in Photoshop in a couple of ways:

- **Use custom shapes to add an opaque copyright symbol or logo.** The simplest way to watermark an image is to stick a big ol' copyright symbol (or your logo) on top of it (this process is called *visual watermarking*). If you make the logo partially see-through, folks can still see the image but won't, presumably, steal it because of the huge graphic stamped on it.

- **Use the Digimarc filter.** This paid service creates a nearly invisible watermark by adding noise to your image (this process is called *digital watermarking*). It's not cheap, but you also get other features like image linking and tracking, online backups, and visual watermarking. The cost depends on the number of images you use it on and the type of service you pick. A basic account runs $50 per year for 1,000 images, a pro account (which includes an online image-tracking service) is $100 for 2,000 images, and so on. You can learn all about it by visiting *www.digimarc.com*.

Since you've already plunked down good money on both Photoshop and this book, here's how to watermark your images *free* using the Custom Shape tool:

1. **Open the soon-to-be-watermarked image and grab the Custom Shape tool.**

 You can find the tool in the Shape toolset, or you can grab it by pressing Shift-U repeatedly (it looks like a rounded star).

2. **Set your foreground color chip to light gray.**

 By setting the foreground color now, you won't need to change the watermark's color later on. At the bottom of the Tools panel, click the foreground color chip, pick a light gray from the resulting Color Picker, and then click OK.

3. **Open the Custom Shape menu and choose the copyright symbol.**

 Up in the Options bar, click the down-pointing arrow to the right of the word Shape to open the menu of presets (see Figure 17-15, top). Scroll down until you see the copyright symbol (©), and then click once to select it.

4. **Draw the shape on your image.**

 Mouse over to your image, click once where you want the shape to begin, and then Shift-drag diagonally to draw the shape. (Holding Shift keeps the symbol perfectly square instead of squished.) When you let go of the mouse, Photoshop adds a Shape layer to the document. If you want to resize the shape, summon Free Transform by pressing ⌘-T (Ctrl+T on a PC).

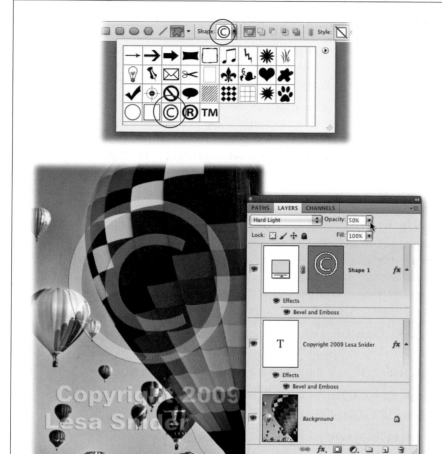

Figure 17-15:
*Top: The Custom
Shape tool makes
creating your own
watermark a snap.*

*Bottom: If you change
the blend mode to
Hard Light and lower
the opacity to about
50 percent, you
can create a nice,
professional-looking
watermark.*

5. **Add a "Bevel and Emboss" layer style.**

 To give your watermark a little depth, you can tack on a layer style. Click the tiny
 fx at the bottom of the Layers panel and choose "Bevel and Emboss" from the
 pop-up menu. If you want to fiddle with the settings, feel free (though they're
 probably fine the way they are). Click OK to close the Layers Style dialog box.

Tip: The shape's gray outline can make it darn difficult to see a preview of the layer style you're about to
apply. Luckily, you can hide the outline by pressing ⌘-H (Ctrl+H on a PC). This trick works with paths, too!

6. **Grab the Type tool and type your name below the copyright symbol.**

 Press T to fetch the Type tool, mouse over to your image, and then click where you want the text to start (Photoshop adds a Type layer to your document). You can type whatever you want, but it's a good idea to include "Copyright," followed by the current year and your name or studio name. To change the font and type size, double-click the Type layer in the Layers panel and tweak the Options bar's settings (Arial Black is a good choice). Flip back to Chapter 14 for more on formatting text.

7. **Copy the Shape layer's style to the Type layer to make the text look similar to the copyright symbol.**

 You can copy a layer style from one layer to another by Option-dragging (Alt-dragging on a PC) the style layer to the new layer (your cursor turns into a double-headed arrow when you drag). In this example, Option-click (Alt-click) the layer named "Bevel and Emboss" and then drag it to the new layer and release your mouse button. If you don't press Option (Alt) *before* you start to drag, you'll *move* the layer style instead (if that happens, just press ⌘-Z or Ctrl+Z to undo and then try it again).

8. **Change the Shape and Type layers' blend modes to Hard Light.**

 Doing this makes your watermark see-through. Over in the Layers panel, select the Shape layer and change its blend mode to Hard Light using the pop-up menu at the top of the panel (see page 289 for more on blend modes). Then select the Type layer and do the same thing. (Unfortunately you can't select both layers and change their blend modes at the same time.)

9. **Lower the Shape and Type layers' opacity to 50 percent.**

 To keep the watermark from overpowering your image, lower its opacity to 50 percent using the slider at the top of the Layers panel.

Note: Photoshop CS5 lets you change the opacity of multiple layers in one fell swoop—just Shift-click both layers to activate them first *and then* change the opacity. (Unfortunately this trick doesn't work on blend modes.)

10. **Save the file and upload it to the Web.**

 Enjoy peace of mind knowing that it'd take someone *weeks* to clone away your watermark.

Protecting your images takes a bit of effort, but it's well worth it. In fact, watermarking is exactly the type of thing you should record as an action. Just follow the instructions in Chapter 18 for creating a new action (page 754) and then repeat the steps in this list. You can even include the bit about embedding copyright info in your file (page 739). Once you create the action, you can run it on a whole folder of files to save yourself tons of time!

Note: You can also use the Image Processer script (page 255) to resize your images, run a watermarking action, and add copyright info at the same time!

Building Online Photo Galleries

Once you've massaged and tweaked your images to perfection, why not have Photoshop prepare a Web-ready photo gallery, complete with thumbnails and enlargements, like the one shown in Figure 17-16? Actually, *Bridge* does all the work using the Adobe Output Module, but that doesn't make it any less cool.

Note: In previous versions of Photoshop, you could create a gallery by choosing File→Automate→Web Photo Gallery, but in CS4 that feature was moved to Bridge, and in CS5 you get a lot more options than you did before!

POWER USERS' CLINIC

Zoomify Your Enlargements

It can be dangerous to post a full-sized image on the Web—you're practically giving thieves permission to steal it. But if you're a photographer and you want folks to see all the intricate details of your work, you can protect your images by using a Photoshop feature called Zoomify.

Instead of posting your image as one high-quality piece, Zoomify chops it into pieces and displays it in a Flash-based window with controls that visitors can use to zoom in on and move around within your image. (People who view your image need to have Flash installed on their computers, but if they don't, their browser should prompt them to get it.) Instead of seeing the whole thing at the enlarged size, they see only one piece at a time, so they can't grab it by taking a screen shot or downloading the whole image. To use Zoomify, follow these steps:

1. Adjust the image's size using the techniques discussed in Chapter 6. (This step is optional; if you want to upload a full-size image from your camera, feel free, although Zoomify won't work on Raw files).

2. Choose File→Export→Zoomify.

3. In the Zoomify Export dialog box, use the Output Location section to name the file and choose where to save it.

4. In the Image Tile Options section, choose an image quality. Use the Quality text box, pop-up menu, or slider to set the quality of the individual pieces. In the background, Zoomify chops up your image into a bunch of pieces that it reassembles when your visitor looks at that area. Leave the Optimize Tables checkbox turned on so Photoshop optimizes the compression tables for each tile.

5. Enter a width and height (in pixels) for the Zoomify window to determine how large it is in your visitor's web browser window.

6. Click OK when you're finished, and Zoomify creates a block of code that you can paste into your web page. If you leave the Open In Web Browser checkbox turned on, Photoshop opens your browser to show you what your Zoomify window looks like.

Now, just open the HTML document that Zoomify made, copy and paste the code into your web page, and then upload the page and image pieces that Zoomify created to your server. After that, folks who look at your image online can see all its exquisite details but can't swipe it and claim it as their own.

Figure 17-16:
Bridge offers a handful of beautiful photo-gallery templates like the one shown here. The templates let you plug in your own photos and, in return, you get ready-to-use HTML pages that you can upload to your website.

Bridge CS5 also includes new Appearance settings that let you control photo size and quality. You can learn more about Bridge by downloading Appendix C.

Here's how to create a web gallery using Bridge:

1. **Place the images in a single folder.**

 It's a lot easier to grab all the images you want to post online if you stick them in a folder first.

2. **Fire up Adobe Bridge.**

 You'll learn tons about Bridge in Appendix C, online at *www.missingmanuals. com/cds*. For now, launch it by clicking the Bridge icon in the Application bar (if you've got it turned on; see page 17) at the top left of the Photoshop window (it's a tiny square with "Br" in the center).

3. **On the left side of the Bridge window, use the Folders panel to navigate to your images.**

 Your images appear at the bottom of the Bridge window in the Content panel.

4. **In the Content panel, arrange your images in the order you want them to appear in the gallery.**

 A vertical blue line appears as you drag an image around. When you get it in the right place, just let go of your mouse button.

5. **Select the images for your gallery.**

 If you've changed your mind about including only one or two images, here's your chance to select the photos you want to place in the gallery. You can ⌘-click (Ctrl-click on a PC) to select just a few or press ⌘-A (Ctr+A) to select them all.

6. **At the top of the Bridge window, click the Output button (which looks like a piece of paper with a folded corner) and choose "Output to Web or PDF" as shown in Figure 17-17, top.**

 On the right side of the Bridge window, Bridge opens the Output panel. You can also open this panel by clicking the word Output at the top of the Bridge window (which switches you to the Output workspace).

7. **Click the Web Gallery button at the top of the Output panel.**

 Bridge has all kinds of settings that let you customize how your web gallery looks.

8. **In the Output panel, choose HTML Gallery from the Template pop-up menu.**

 There aren't many templates to choose from, but for a basic photo gallery, this one is tough to beat (as shown in Figure 17-16).

9. **In the Site Info section, add a title, caption, and description.**

 You can add all sorts of other info, too, if you want, including your name, email address, and copyright info. These extra tidbits appear at the top and bottom of your web page as shown in Figure 17-16.

10. **Scroll down to the Output panel's Color Palette section and edit the background, text, and link colors.**

 To change your gallery's colors, just click the little color swatch and choose something else from the Color Picker.

11. **In the Appearance section, set the photo size, quality, and number of columns and rows.**

 Unless you change these settings, your gallery has three rows and columns, and the previews are medium sized. If it needs to, Bridge automatically builds more pages to accommodate all your images.

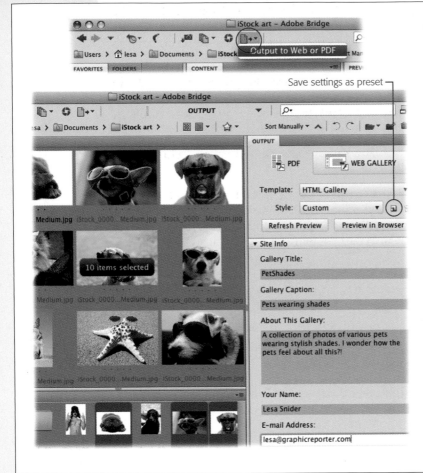

Figure 17-17:
Top: Bridge CS5 (which comes with Photoshop) has an Output menu (circled) that lets you create a web gallery or PDF page.

Bottom: When you choose Web Gallery from the Output panel, Bridge adds all kinds of options to the Output panel that you can use to customize your gallery. Thankfully, in Bridge CS5 you can click the tiny icon circled here to save your settings as a preset style you can use later. Yay!

12. Back near the top of the Output panel, click the Refresh Preview button and then, in the middle of the Bridge window, click the Content Preview tab to preview your web gallery within Bridge.

If you'd rather see your web gallery in a real web browser, click the "Preview in Browser" button instead. Bridge works away and eventually displays your gallery in your browser. (Depending on the number of images in your gallery, this process may take a while.)

13. If everything looks good, head back to Bridge (if you switched to a web browser in the previous step) and scroll down to the Create Gallery section of the Output panel to tell Bridge whether to save the gallery to your hard drive or upload it to the Web. (If you want to make changes to your gallery, scroll to the appropriate Output panel section and tweak the settings.)

 At the bottom of the Output panel, you can give your gallery a name and save it to your hard drive or upload it to your web server. If you choose to upload it, you need to enter your website's *FTP* (file transfer protocol) settings, along with your login and password.

14. Click Save (if the gallery is headed for your hard drive) or Upload (if it's bound for the Web).

The only downside to using Bridge to make photo galleries is that you have to keep clicking the Refresh Preview to update the Content Preview panel within Bridge, and if you decide to preview the gallery in a real web browser, Bridge takes a while to make it happen. Hopefully, Adobe will keep improving the Output panel in subsequent versions of Bridge.

Working Smarter with Actions

I t's fun to spend hours playing and working in Photoshop, but once you've used the program for a while, you'll start to notice that you repeat the same steps over and over on most of your images. At first, the repetition probably won't bother you—it's actually good while you're learning—but when a deadline approaches and the boss is eyeing you impatiently, you need a way to speed things up.

Luckily, Photoshop includes all manner of automated helpers (some of which you've already learned about), including:

- The Image Processor script, which resizes images and converts their formats (page 255).

- The "Layer Comps to Files" script, which exports images you can turn into PDF files (page 109).

- Automated photo stitching with Photomerge (page 305).

- Automated layer aligning and blending with the Auto-Align and Auto-Blend Layers commands (Chapter 7, beginning on page 99).

- The Adobe Output Module, which can build web galleries, rename lots of files at once, and build Contact Sheets (discussed in Appendix C, online at *www. missingmanuals.com/cds*).

One of the best timesavers of all, however, is *actions*—an all-purpose, amazingly customizable system for automating mundane tasks like adding or duplicating layers, running filters with specific settings, and so on. You can use actions to record nearly every keystroke and menu choice you make and then play them back on another

image or a whole *folder* of images. Because Photoshop doesn't make you waste time pressing keys or clicking a mouse when you're running actions, it can blast through them at warp speed. Just imagine how much time you'll save!

This chapter shows you how to use the actions that come with Photoshop and how to create, edit, and save your own. You'll also learn how to create drag-and-drop actions called *droplets*—icons you can drop files on to trigger an action—as well as where to find and how to load actions made by other folks. By the time you're finished reading, you'll be working ten times smarter (and faster) instead of harder.

The Actions Panel

Photoshop lets you record, play, and edit your keystrokes using the Actions panel (Figure 18-1). Choose Window→Actions to summon the panel and plop it into the panel dock on the right side of your screen (its icon looks like the triangular play button on a DVD player).

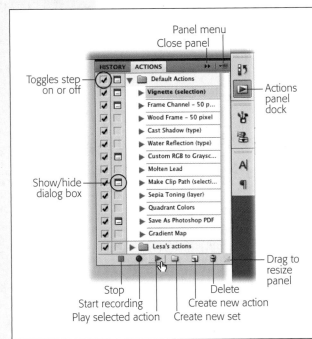

Figure 18-1:
You can rename, duplicate, and delete actions just like you can layers and channels. Shift-click or ⌘-click (Ctrl-click on a PC) to select multiple actions so you can add them to a set (page 765) or delete them.

The Action panel's menu is chock-full of useful commands for working with actions (Figure 18-2 unfurls its goodies). You can see each step in an action by clicking the little flippy triangle next to the action's name.

The panel's controls are pretty straightforward. The Stop, Record, and Play buttons do what you'd expect: They stop, record, and play actions. The "Create new set" button at the bottom of the panel (it looks like a folder) lets you store actions in a set just like you can store layers in a group (page 105). You can create a brand-new action by clicking the "Create new action" button, and duplicate an action by dragging it atop that same button or by Option-dragging (Alt-dragging on a PC) it up or down in the

panel. Duplicating an action comes in handy when you want to run the same filter more than once within an action, or when you want to edit a copy of an action to make it do something slightly different (which is faster than rerecording the action from scratch).

The Actions panel has three unlabeled columns that let you:

- **Turn steps on or off.** The first column lets you turn individual steps in an action on or off via a checkbox next to each step. This option is useful if you've made a fairly complex action and only want to run, say, half of it. For example, if you created an action that stamps all visible layers (page 112), sharpens your image (Chapter 11), and then saves it as a TIFF file (page 670), you can turn off the "save" step and stop at sharpening instead. To turn off a step, click the checkmark to the left of its name. To turn off *all* the steps in an action or all the actions in a set, click the checkmark to the left of the action's or set's name. To turn off all steps *except* the one you've selected, Option-click (Alt-click on a PC) its checkmark.

Tip: In the Actions panel, a *black* checkmark next to an action's name means Photoshop will run all the steps in that action; a *red* checkmark means that it'll skip some of the steps.

- **Show/hide dialog boxes.** The next column is for showing or hiding dialog boxes associated with the action's steps. When you create an action, you can design it so that, at a certain point, it stops and opens a dialog box that prompts you to enter settings such as feather amount, filter values, and so on. If the action needs your input, you see a little black square with three dots in this column next to the action's name (it's supposed to look like a tiny dialog box); if the action doesn't need your input, the column is empty. If you'd rather not be bothered by dialog boxes, you can hide them by clicking the square with the dots in it to make Photoshop use the settings you entered when you originally recorded the action. Hiding dialog boxes is handy when you're using Photoshop's built-in actions because entering different values changes the action's effect on your image. For example, you can increase the feather setting in the Vignette action to create a softer edge.

Tip: A tiny *black* dialog-box icon to the left of the action's name means that *all* the steps in that action need your input. A tiny *red* dialog box icon means that some do and some don't.

- **Expand or collapse an action.** The third column in the Actions panel lists each action's name and keyboard shortcut (if you've assigned one). If you want to see the individual steps within an action, you can expand the action by clicking the little flippy triangle to the left of its name—handy when you want to turn off individual steps as explained earlier, or when you'd like to explore the inner workings of a built-in action (great for learning how to make your own).

Tip: To expand or collapse all the actions in a set or all the steps in an action, Option-click (Alt-click on a PC) the action or step's flippy triangle.

Straight from the factory, Photoshop displays your actions as a list (see Figure 18-1), though you can make it display them as clickable buttons instead (see Figure 18-2). Just open the Actions panel's menu and choose Button Mode. Now, instead of selecting an action and then pressing the play button, you can trigger the action by clicking its button. Unless you're creating or editing actions, this is the way to roll.

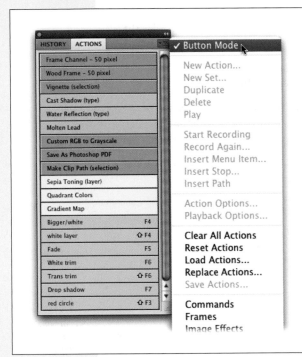

Figure 18-2:
One drawback to using Button mode is that it doesn't let you edit actions or create new ones. You also can't turn individual steps in an action on or off. Darn!

Using Actions

Photoshop comes loaded with dozens of built-in actions, though only a smidgeon of them appear in the main part of the Actions panel. Seven more sets of built-in actions are tucked away in the panel's menu (shown in Figure 18-2, bottom right): Commands, Frames, Image Effects, LAB - Black & White Technique (see page 47 for more on Lab mode), Production, Star Trails, Text Effects, Textures, and Video Actions. To load one of these additional action sets, simply select it from the menu and Photoshop adds it to the panel's main list.

Each set includes several actions that you can use as is or edit to your own personal taste. For example, if you think the Spatter Frame action (part of the Frames set) is a little lame with its 15-pixel spray radius, you can bump it up to 25 pixels instead.

(Editing actions is discussed later in this chapter.) You can also duplicate that particular step to make the Spatter filter run twice!

Tip: An easy way to duplicate an action you want to edit is to Option-drag (Alt-drag on a PC) it to a different set.

To use one of the program's built-in actions, follow these steps:

1. **Open an image.**

 With most actions you simply need to open the image and you're ready to invoke the action magic. You don't even have to unlock the Background layer because Photoshop duplicates it for you.

2. **If necessary, select the part of your image you want to work with.**

 Occasionally, you have to make a selection before you use some of the built-in actions (like the ones with "selection" in parentheses after their names, such as "Vignette (selection)" [see Figure 18-3]).

Figure 18-3:
Top: Photoshop's built-in actions include "Vignette (selection)". To use it, you first have to create a selection.

Bottom: Another useful built-in action adds a sepia tone to your image. In both cases, the action created all the layers you see here, except for the original Background layer (which shows you what the original images looked like).

3. **Select the action of your choice.**

 Over in your Actions panel, click an action to select it.

Note: If you're in Button mode (page 752), simply clicking an action's name triggers that action, so you're done.

4. **Click the Play button.**

 Click the little Play button at the bottom of the Actions panel to run the action. Before you can blink, Photoshop is finished and dusting off its hands. If Photoshop displays a dialog box that requires your input, the action pauses while you enter settings. Once you click OK, it continues on its merry way.

Tip: To play just one step of an action—without playing any of the steps that follow—double-click that step in the Actions panel. (You have to click the flippy triangle next to the action's name to see its individual steps.) You can also select the step in the Actions panel and then ⌘-click (Ctrl-click on a PC) the play button to run it.

Creating Actions

When you're trying to decide on an action to record, start by thinking of any repetitive tasks you often perform. For example, back in Chapter 4 you learned that a simple one-pixel black border adds a classy touch to an image headed for a website, newspaper, or newsletter (page 183). If you add those borders regularly, that's an excellent candidate for an action.

Tip: Before you record your first action, it's a good idea to create a new *set* (group) for it to live in (you can also drag new actions into an existing set). There's no limit to how many sets you can make or how many actions you can add to each one. If you forget to make a set before you record an action, you can drag and drop the action into a set later. You can also move actions between sets by Option- (Alt-) dragging them.

Here's how to create an action that places a black border around your image:

1. **Open an image.**

 To record the steps, you have to perform them, so you need to open an image to play with.

2. **Open your Actions panel and create a new set.**

 Open the Actions panel by choosing Window→Actions, and then click the folder icon at the bottom of the panel. In the resulting dialog box, enter a descriptive name for your new action set (see Figure 18-4) and then click OK.

Tip: For reasons known only to Microsoft, you can't assign F1 as a shortcut key on a PC. To assign F keys as shortcuts on the Mac, you first have to turn on the "Use all F1, F2, etc. keys as standard function keys" option in the System Preferences→Keyboard pane.

Figure 18-4:
Top: You can keep your Actions panel organized by storing your actions in sets. This also lets you keep the actions you've made (or downloaded; see page 764) separate from those that are built into the program.

Bottom: In the New Action dialog box, you can give your action a name and assign it a keyboard shortcut for faster access. The shortcut can be a function key (the F keys at the top of your keyboard) and, if you want, a modifier key (Shift or ⌘ [Ctrl or Alt on a PC]). By combining F keys and modifiers, you can create as many as 60 custom shortcuts for your actions (depending on the number of function keys on your keyboard).

WORKAROUND WORKSHOP

Different Files, Different Results

When you're recording actions, it's important to realize that not only is Photoshop recording every step *exactly* as you perform it, it's also memorizing info about your document. It remembers stuff like file size, color mode, layer names, and even what color your foreground color chip is set to.

For that reason, if you try to run an action on a file that's in a different color mode (page 46) or a different size than the original, you may encounter unexpected results. For example, if you create an action that applies a 20-pixel feather to a selection in a 320×240 pixel image and then run it on a 3888×2492 pixel image, you won't get the same results. (In fact, you'll barely see the feather, if at all!) Since the pixel dimensions of those two images differ so much, you have to create two separate actions: One for the smaller pixel-size file and one with a higher feather amount for the larger pixel-size file.

Also, when you use certain tools while you're recording an action, Photoshop remembers the tool's position within the image by snagging coordinates from your vertical and horizontal rulers (page 72). Among these are the Marquees, Slice, Gradient, Magic Wand, Lasso, Shape, Path, Eyedropper, and Notes tools. If you run an action involving these tools on files of varying pixel dimensions, you'll run into problems. For example, if you record an action that includes drawing an Elliptical Marquee in the center of a document and then you run that action on a document with vastly different pixel dimensions, the document's center won't be in the same place. The fix is to change the unit of measurement for your rulers to *percentages* (page 36) before you record the action. That way, Photoshop records your cursor's location as a *relative* position instead of an absolute one.

3. **Click the panel's "Create new action" button.**

 The button looks like a piece of paper with a folded corner (just like the "Create new layer" and "Create new channel" buttons). In the resulting dialog box, give your action a short but meaningful name, like *Black border*. You can also assign it a keyboard shortcut and a color (you see these colors only when you're in Button mode [page 752], but they're still handy). When everything looks good, click the Record button to close the dialog box and start recording your action.

 Note: You can edit these settings after you've recorded the action by selecting the action and then choosing Action Options from the Actions panel's menu, or by double-clicking the action's set or name.

4. **Perform the steps you want to record.**

 Once you click the Record button, the circle in its center turns red to let you know Photoshop is recording nearly every keystroke and mouse click you make (it doesn't record brushstrokes or paths drawn with the Pen tool). To record the border action mentioned earlier, consider whether you'll always start out with a locked Background layer or not. If so, begin by double-clicking the Background to make it editable. If not, click the square Stop button at the bottom of the Actions panel, double-click the Background layer to unlock it *before* you start recording your action, and then click the Record button again.

 Next, press ⌘-A (Ctrl+A on a PC) to select the whole image and then head up to the Edit menu and choose Stroke. Be sure to enter a pixel value even if the correct pixel value is already there—you never know what you might change in the Stroke dialog box between now and when you run the action. (Since Photoshop's settings are sticky [page 16] you need to make sure your action includes resetting anything that may have changed in any dialog boxes you open.) Click the Inside radio button for Location (even if it's already set to Inside) and then choose Black from the Use pop-up menu (again, even if it's already selected).

 Tip: If you record a File→Save As command, don't enter a name for the document. If you do, Photoshop will use that exact file name every time you run the action, no matter what your original document was named. Instead, use the Save As dialog box to navigate to another folder on your hard drive and let Photoshop save the edited document *there*, with its original filename. That step tells Photoshop to save the edited version of your image in the folder you selected without renaming the file.

5. **Click Stop.**

 Once you're finished recording, click the Stop button at the bottom of the Actions panel (the Record button turns black) or press the Esc key.

6. **Choose File→Revert and test your action on the open image.**

To make sure your action works, return your image to its original state, select the new action, and then click the Play button. (Might as well give her a spin while she's fresh!) If you run into problems, you can delete the action by dragging it to the trash can icon at the bottom of the panel and then have another go at it, or you can edit the action using the techniques discussed later in this chapter.

Give yourself a big pat on the back for successfully recording your first action.

Tip: If you make a mistake while recording an action, just click the Stop button. Delete the bad steps by dragging them to the trash can icon and then choose Edit→Step Backward until you get back to the last good step. Then, click the Record button and continue.

Running Actions on a Folder

To really make actions work for you, you can run them on more than one file (this technique is called *batch processing* or *batching*). It takes an extra step or two, but it's worth it. For example, remember the black-border action you created in the previous section? You can run it on all your open files or on a folder of files instead of opening each one individually. Just imagine how much time that could save!

TROUBLESHOOTING MOMENT

Action Errors

Recording actions is usually a trial-and-error operation—it can be challenging to get them just right. If Photoshop encounters *any* condition that varies from what you recorded, it slings an error dialog box at you.

One of the most common errors is Layer Unavailable, because most folks don't realize Photoshop captures *layer names* when you record an action. For instance, if you start an action by double-clicking the Background layer to make it editable, Photoshop searches for a layer named Background when you run that action. If it doesn't find it, you'll be greeted with an error dialog box that says "the object 'layer Background' is unavailable". At that point, you can

either continue running the action (by clicking Continue) or stop right there (by clicking Stop). If you've chosen to proceed and Photoshop *can* finish out the steps, it will. If it can't, you get (surprise!) another error dialog box expressing Photoshop's regret.

Admittedly, having to click Continue once in awhile is no biggie, but it brings your action to a screeching halt. To cut down on this type of error, use keyboard shortcuts to select layers. That way Photoshop records the *shortcuts* instead of specific layer names. See the box on page 81 for a honkin' big list of shortcuts for selecting and moving layers.

Here's how to run an action on more than one file:

1. **Open the files or place them in a folder.**

 Photoshop's Batch command works on all open files or a whole folder (unless you're using Bridge, as noted in step 3 below), so depending on how many files you want to work on, you'll probably want to stick 'em in a folder first.

2. **Choose File→Automate→Batch.**

 In the resulting dialog box (Figure 18-5), choose the action you want to run from the Action menu.

Tip: You can also record actions that trigger other actions, which is *extremely* helpful when you're batch processing. That way, instead of running the actions on the files one after another, you can simply run the action that triggers the rest. (This process is serious action voodoo and not recommended for beginners.)

3. **Select source files or folders to process.**

 Use the Source pop-up menu to tell Photoshop whether to run the action on all open files or on a folder. If you pick Folder, click the Choose button and navigate to the folder with your images. You can also choose Import to snatch files parked in your scanner or on an attached digital camera or memory card.

 If you've selected a few files and/or folders in Adobe Bridge, you can run the action on them by choosing Tools→Photoshop→Batch in the Bridge window. You can also trigger an action on multiple files from CS5's new Mini Bridge panel, as shown in Figure 18-5 (see Appendix C for more on using Bridge).

Note: Unfortunately, CS5's new Mini Bridge won't let you run the Batch command on folders; it only works on individual files. A workaround is to double-click a folder in Mini Bridge to open it, click the Select menu labeled in Figure 18-5, and then choose Select All (the Select All keyboard shortcut of ⌘+A [Ctrl-A] won't work either). It's also worth noting that if you make a selection in Mini Bridge and then choose File→Automate→Batch, Photoshop completely ignores your Mini Bridge selection.

4. **Adjust other settings if needed.**

 Turn on the "Override Action 'Open' Commands" checkbox if you have a step in your action that opens a file. That way, Photoshop opens the files you've selected in the Source menu instead of hunting for the filename recorded in the action. Leave this checkbox off if you recorded the action to open a *specific* file that's necessary for the action to work properly like when you're using Match Color to snatch the color from one image and apply it to others (see page 351).

 If you've chosen Folder as a source and the folder you want to work with contains *other* folders of images that you want Photoshop to process, turn on the Include All Subfolders checkbox.

Figure 18-5:

Top: To reap the full reward of using actions, use the Batch dialog box to run them on multiple files (called batches). You can choose to process files in folders within a master folder (turn on the In-clude All Subfolders checkbox), which is especially handy if you use nested folders to organize your images.

Bottom: You can also access the Batch dialog box within CS5's new Mini Bridge panel. Open the panel by clicking its icon (it looks like a folder with a tiny Mb on it) in the Application bar or in the panel dock on the right side of your screen, Shift or ⌘-click (Ctrl-click on a PC) to select the appropriate files, and then choose Photoshop→Batch from the panel's Tools menu, as shown here.

If you want to bypass any options associated with the Open dialog box, turn on the Suppress File Open Options Dialogs checkbox. Turning on this checkbox hides the options in Photoshop's Open dialog box so you can open a group of images without seeing the Open dialog box for each one (handy if you batch process Camera Raw images from your digital camera).

Finally, turn on the Suppress Color Profile Warnings checkbox if you want Photoshop to always use its own color profile (page 667) without asking if it's OK.

5. **Tell Photoshop where you want to save the processed files.**

 From the Destination pop-up menu, choose None to have Photoshop leave your files open *without* saving them (not a good idea if you're running the action on hundreds of files!). Choose "Save and Close" to overwrite the originals and close the files. If you want to preserve your originals, choose Folder and then click the Choose button to tell Photoshop where it should save the new files.

 If you've got any "Save As" steps in your action, turn on the "Override Action 'Save As' Commands" checkbox and Photoshop uses the settings you've specified in this dialog box. If you don't turn on this checkbox, Photoshop saves your images twice: once where you specified in your original action and a second time in the location you set when you began batch processing.

6. **If you want to rename the resulting files, enter a naming scheme in the File Naming section.**

 You can name the new files anything you want. Choose "DocumentName" from the first pop-up menu to have Photoshop keep the original file name, or enter something else in the field. You can also rename files with the current date (in several formats), using an alphabetical code or numeric serial number, and so on. Keep the second field in each row set to "extension" so you don't encounter any problems with incompatible file formats down the road.

7. **Turn on the appropriate Compatibility checkbox(es) based on where the files are headed.**

 If you know your images will be opened or stored on a computer that runs a different operating system, be sure to turn on the checkboxes for each system your file is likely to end up on. For example, if you're using a Mac and your images are destined for a Unix-based web server or a Windows-based file server, check Mac and Unix or Windows. (It's OK to turn on all three compatibility checkboxes.)

8. **Choose an error-handling method from the Error pop-up menu.**

 This is the place where you tell Photoshop what to do if it encounters an error while it's running the action. Your options are Stop For Errors and Log Errors To File. If you choose the latter, Photoshop writes down all the errors in a text file and continues to process your images; click the Save As button below this pop-up menu to tell the program where you want it to save that text file.

9. **Click OK to run the action.**

 Sit back and smile smugly as Photoshop does all the work for you (and cross your fingers that you don't get any errors!).

Managing Actions

If you don't get your action quite right the first time (which is perfectly normal when you're starting out), you can go back and edit it; though, honestly, it's usually easier to start over from scratch. That said, the Actions panel's menu has a few commands that can help you whip misbehaving actions into shape:

- **Record Again.** When you choose this option, Photoshop runs through all the steps in the action and opens all the dialog boxes associated with them so you can adjust their settings.

- **Insert Menu Item.** For some unknown reason, you can't record any items in the View and Window menus when you're creating an action, but you can *insert* them—or any other menu item—using this command, either while you record the action or after. Simply select the step directly above where you want the menu item to go, or, if you want to insert the menu item at the end of the action, select the action's name. Then choose Insert Menu Item from the Actions panel's menu and, in the resulting dialog box, select the item and then click OK. If the menu item pops open a dialog box, Photoshop won't record any settings, so you'll have to enter them when you run the action.

Tip: There's no way for you or anyone else running an action to turn off a dialog box that you've added using the Insert Menu Item command (though you can turn off *other* action dialog boxes—see page 751), so it's a good way to *force* whoever is running the action to enter a particular menu's settings. You can use this command to insert any menu item you want, even ones like a feather radius that you can record in an action.

- **Insert Stop.** Use this command to pause the action so you can do something that you can't record, like paint with the Brush tool or draw with the Pen tool. To add a stop after a particular step, select the step in the Actions panel and then choose Insert Stop (see Figure 18-6). You can even include a dialog box that says what to do next, like "Use the Brush tool to paint a happy face now". When you're running an action and come across a stop, after you've done what you need to do, click the Play button in the Actions panel to run the rest of the action's steps.

- **Insert Path.** Photoshop can't record the act of drawing a path, but you can use this command to insert a path you've *already* drawn. Just open the Paths panel (page 550), select the one you want, and then choose this command.

- **Action Options.** This command opens the Action Options dialog box so you can edit the action's name, keyboard shortcut, and color (this maneuver works on custom actions as well as built-in ones). You can also open this dialog box by Option-double-clicking (Alt+double-clicking on a PC) the action or rename an action by double-clicking its name in the Actions panel.

Figure 18-6:
Top: When you insert a stop, you can include instructions for the person running the action; you can type whatever you want. The message appears when that person triggers the action's stop point. If you want to let folks continue with the action after they've preformed the step described by the message, turn on the Allow Continue checkbox.

Bottom: Here's what you see when you run the action and hit the stop point. Since a continue button wasn't included, your only choice is to click Stop. After you've performed the part that couldn't be recorded, click the Action panel's Play button to finish the action.

- **Playback Options.** If you can't figure out where an action has gone haywire, you can make Photoshop play the action more slowly by selecting this command. In the resulting dialog box, you can choose Accelerated (normal speed), Step By Step (Photoshop completes each step and refreshes the screen before going to the next step), or "Pause For _ Seconds" (Photoshop pauses between each step for the number of seconds you specify).

Editing Actions

You can add, delete, or tweak an action's steps anytime you'd like, as well as scoot them around within the Actions panel (just like Layers). To rearrange the actions in your Actions panel, just drag an action to a new position in the panel. When you see a highlighted line where you want it to go, release your mouse button. Rearranging actions is helpful when you want to keep certain actions together so they're easier to spot (handy when you're in Button mode [page 752]). You can also drag and drop steps *within* an action to rearrange them. To change an action's settings (such as the feather amount), just double-click the relevant step while an image is open, enter a new amount in the resulting dialog box, and then click OK.

Note: Clicking OK actually *runs* the command associated with the dialog box (feathering a selection, for example), but you can undo it by pressing ⌘-Z (Ctrl+Z on a PC). Photoshop still remembers the new settings you entered and will use them the next time you run that action.

You can also add steps to an action—just select the step that comes *before* the one you want to add and click the Record button. Perform the new steps you want to add, and then click the Stop button. Photoshop adds the new steps below the one you first selected.

To get rid of a step, action, or set of actions, just select what you want to delete and drag it onto the trash can icon at the bottom of the Actions panel. You can also select items and then Option-click (Alt-click on a PC) the Delete button to bypass the "Are you sure?" dialog box. To do a *thorough* spring cleaning of your Actions panel, choose Clear All Actions from the Actions panel's menu and, when Photoshop asks if you *really* want to delete everything (including Photoshop's built-in Default Actions set), click OK.

Tip: To get the Default Actions set back after using the Clear All Actions option, just choose Reset Actions from the Actions panel's menu. Whew!

Creating Droplets

Droplets are actions that you trigger by dragging and dropping files onto special icons. As self-contained mini-applications, they can live outside Photoshop on your desktop, as aliases (pointer files) in your Dock (or taskbar on a PC), or on someone else's computer.

It's easy to create a droplet from an action; just follow these steps:

1. **Trot over to the Actions panel and select an existing action.**

 You can't put the cart before the horse! To make a droplet, you've got to record the action first.

2. **Choose File→Automate→Create Droplet.**

 The resulting dialog box looks like the Batch dialog box shown in Figure 18-5. Click the Choose button at the top to tell Photoshop where to save your droplet and then set the other options according to the advice on pages 758–760.

3. **Click OK when you're finished.**

 Your droplet (which looks like the one shown in Figure 18-7, top) appears wherever you specified.

Sharing Actions

When it comes to actions, folks love to share—there are tons of actions floating around on the Web. Most are free (though you'll probably have to register with the website you're downloading from), but you have to pay for the more useful and creative ones. Sharing actions is pretty easy; the only requirement is that you save your actions as a set (page 765) before uploading them to a website.

Figure 18-7:
Top: Your droplet looks like a big, fat blue arrow.

Bottom: To use a droplet, drag and drop a file or folder on top of its icon. If Photoshop isn't currently running, it launches automatically.

If you're using a Mac, you need Snow Leopard (OS X 10.6) or higher to use Droplets in 64-bit mode. If you're using an earlier version of OS X, you can always launch Photoshop in 32-bit mode instead (the box on page 6 tells you how).

Loading Actions

One of the best action resources is the Adobe Studio Exchange website (*www.adobe. com/exchange*). Others include Action Central (*www.atncentral.com*), PanosFX (*www.panosfx.com*), and ActionFx (*www.actionfx.com*). (These sites are also great resources for brushes, textures, and so on.) Most of these sites arrange their goodies by program, so you'll have to choose Photoshop and then Actions. Downloading and analyzing actions made by other folks is a fantastic way for you to learn what's possible. That said, actions that are short and sweet—ones that expand your canvas, add new layers and fill it with white, and so on—can be even more useful than more complex ones because you'll use 'em more often.

FREQUENTLY ASKED QUESTION

Sharing Droplets

I want to send my extra special Mac droplet to a Windows computer. Is that legal?

Sure! It's within your Photoshop User Bill of Rights to share droplets between computers with different operating systems; however, the droplet won't work unless you know these secrets:

- Save the droplet with a *.exe* extension, which tells a Windows computer that it's an executable file—in other words, a program you can run (this extension isn't necessary on a Mac).

- If you created the droplet on a Windows computer and want to move it to a Mac, drag it onto the Photoshop CS5 icon to make Photoshop update it so it works on the Mac.

- File name references aren't supported between operating systems, so if your action includes an Open or Save As step that references a specific file, the action pauses and demands the file from the poor soul who's using the droplet. If that happens to you, find and select the file Photoshop is asking for so the droplet can work just like it did on the computer it came from.

Here's how to load somebody else's action:

1. **Download the action or action set to your computer.**

 What you're actually downloading is an ATN file. Save it somewhere you'll remember (like on your desktop).

2. **Drag and drop the action into an empty Photoshop window (no documents open), as shown in Figure 18-8.**

 You can also load a new action by choosing Load Action from the Actions panel's menu, by double-clicking the ATN file, or by right-clicking the ATN file and choosing Open With→Adobe Photoshop CS5. No matter which method you use, it appears in your Actions panel.

Figure 18-8:
You can quickly load an action by dragging and dropping the ATN file into the Photoshop window. You won't see anything happen, but it shows up in your Actions panel instantly.

3. **Select the action and give it a whirl.**

 Test drive your new action by opening an image, selecting the action, and then pressing the Play button. That's the only way to find out whether it's lovely or lame.

Saving Your Actions

Photoshop temporarily stores the actions you create in a special spot on your hard drive. If you reinstall or upgrade the program, there's a *pretty* good chance your actions will get zapped in the process. If you've grown fond of them, you need to save them so you can back them up *outside* the Photoshop application folder. That way, you can reload them if they accidentally get deleted. As a bonus, once you save your actions, you can share them with others by uploading them to sites like Adobe Studio Exchange, discussed in the previous section.

Here's what you need to do:

1. **In the Actions panel, select an action set.**

 You can only save actions that are part of a set—you can't save individual actions.

2. **Choose Save Actions from the Actions panel's menu.**

 In the resulting dialog box, Photoshop prompts you to save the file in the Presets folder, though you can put it anywhere you want. To keep from losing your actions when you reinstall or upgrade Photoshop, you'll want to save them somewhere else. No matter where you save them, if you add or edit the set later, be sure to pick the same spot or you'll end up with multiple versions of the action set.

3. **Click Save.**

 Photoshop creates an ATN file that you can move between computers, back up to an external hard drive, or share with the world via the Web.

Tip: On the Mac, Photoshop saves your actions in *Home/Library/Application Support/Adobe/Adobe Photoshop CS5/Presets/Actions*. On a Windows computer, it saves them in *C:\Users\[your user name]\ AppData\Roaming\Adobe\Adobe Photoshop CS5 Settings\Presets\Actions*. In Windows 7, the path is *Desktop\Libraries\[your user name]\AppData\Roaming\Adobe\Adobe Photoshop CS5\Presets\Actions*. (You can also use the Windows "Save in" pop-up menu in the Save dialog box to see where Photoshop hides your actions.)

Beyond Photoshop: Plug-Ins

With enough patience, practice, and keyboard shortcuts burned into your brain, you can get smokin' fast in Photoshop. But you'll never be as fast as a computer. As you've learned, some things—like creating complex selections, correcting colors, retouching skin extensively, and so on—are darned difficult, so they're going to take you a long time no matter how fast you get.

That's where plug-ins come in handy. Think of them as helper programs that run inside Photoshop (though a few run outside Photoshop, too) and let you do the hard stuff faster. You can get plug-ins from all kinds of websites, and they range from free to pricey. The really good ones give you amazing results in seconds, rather than the hours it would take to do the same thing yourself (if you can do it at all). Plus, the newer ones do their thing on a separate layer and, in some cases, run as Smart Filters (page 634), so you don't even have to duplicate your original layer first. Nice!

In this chapter, you'll learn how to add and remove these little jewels, as well as how to store them somewhere other than your Photoshop CS5 folder (it's safer that way). You'll also be introduced to some of the most amazing plug-ins on the market today—the crème de la crème—that run on Macs *and* PCs.

Adding and Removing Plug-Ins

To install a plug-in on a Mac, download it or copy it from the installer disc it shipped with and then drag it from wherever it's saved on your computer into the Plug-ins folder (see Figure 19-1, top): *Adobe Photoshop CS5/Presets/Plug-ins*. (You can also store plug-ins elsewhere as discussed on page 37.) On a PC, download the plug-in or copy it from the installer disc. It should be an .exe (executable) file, so you can run it to install a program. Simply find the file on your computer and double-click it.

Figure 19-1:
On a Mac, you can install a plug-in manually by dragging it into Photoshop's Plug-ins folder (top) or by using the installer provided by the folks who made the plug-in (bottom). On a PC, simply run the plug-in's .exe file.

If you have trouble installing a plug-in, contact the person or company who created it for help.

After you install the plug-in, quit Photoshop if it's running (File→Quit [File→Exit on a PC]) and then relaunch it. When Photoshop reopens, you should see the plug-in listed at the bottom of the Filter menu.

Note: If a plug-in deals with *batch processing* (modifying multiple files at once), you may find it in the File→Automate menu instead of the Filter menu. If it deals with selections or masking (page 113), you may find it lurking in the Select menu.

Some plug-ins come with an installer (like the one in Figure 19-1, bottom), which may also include an uninstaller (handy if you want to get rid of the plug-in). To remove a plug-in, open your Plug-Ins folder and drag it to the Trash. (On a PC running Windows 7, Start→Control Panel→Programs→"Uninstall a program"; Windows Vista, go to Start→Control Panel→Classic View→"Programs and Features"→"Uninstall a program". Then select the plug-in from the list of programs and click Uninstall. The next time you launch Photoshop, you'll see neither hide nor hair of the banished plug-in.

Now that Photoshop CS5 runs in 64-bit mode on both the Mac and the PC (see page 6), you may find some of your plug-ins are incompatible with it and are missing from Photoshop's menus even after you install them. Rest assured that plug-in companies are hard at work making them 64-bit compatible. In the meantime, you may need to launch Photoshop in 32-bit mode in order to make them work (see the box on page 6 to learn how).

Note: When you install Photoshop on a PC, you get two full versions of the program in two separate folders: one for 32-bit mode and another for 64-bit mode (located in Program Files→Adobe→Photoshop C5 and Program Files (x86)→Adobe→Photoshop CS5, respectively). They don't share plug-ins like the Mac version does, so each version has its own set of plug-ins in its respective folder. All this means you need to know *before* you install whether the plug-in works in one mode or the other, or else you run the risk of installing it into the wrong plug-in folder. (As if there wasn't enough to worry about already!)

Managing Plug-Ins

Photoshop expects you to store plug-ins in its Plug-ins folder, so that's where it looks each time you launch the program. That's all well and good, but there's an awfully good chance your plug-ins will get zapped if you upgrade to a new version of Photoshop or reinstall the current one. The same is true of actions (Chapter 18), brushes (Chapter 12), and so on. (See online Appendix B for more on backing up those extra goodies.)

To protect your precious plug-ins, it's wise to store them somewhere else, but you have to tell Photoshop where you put them by choosing Photoshop→Preferences→Plug-Ins (Edit→Preferences→Plug-Ins on a PC). Turn on the Additional Plug-Ins Folder checkbox and then click Choose to navigate to the folder where you've decided to store your plug-ins. Click OK when you're finished, drag the plug-ins you want to move from Photoshop's Plug-Ins folder (shown in Figure 19-1) to the location you just picked, and then relaunch Photoshop to make your changes take effect. Photoshop won't stop peeking inside the original plug-ins folder; it just takes a gander inside the *new* folder, too.

Note: If Photoshop starts acting weird after you install a plug-in, you can temporarily disable the plug-in to see if it's the culprit by finding it on your hard drive and adding a tilde (~) to the beginning of its file name. Some manufacturers install their plug-ins in a new folder; for example, you'll find a folder called Mask Pro inside your Plug-Ins folder. In that case, you can put the tilde at the beginning of the folder's name to disable everything inside. Either way, adding the tilde means the plug-in won't load the next time you launch Photoshop. When you want the plug-in to load again, just delete the tilde and relaunch Photoshop.

In the following pages, you'll find brief descriptions of some of the most amazing plug-ins on the market. Each one performs its own special brand of magic like noise removal, color enhancement, or special effects—one even turns your Photoshop document into a fully functional web page!

These plug-ins range in price from $70 to $500, but don't let that scare you; you can find tons of cheaper (and even free) offerings on the Web (though you may very well get what you pay for). Don't be alarmed if you don't see your favorite plug-in in the following list—it's simply impossible to list them all here.

FREQUENTLY ASKED QUESTION

Dude, Where's My Plug-In?

Help! I don't see my plug-in in the Filter menu. Did it load or what?

Peace, dear Grasshopper. You can find out whether your plug-in loaded in a couple of ways.

When Photoshop encounters a plug-in that won't load, it presents you with a dialog box that says, "One or more plug-ins are currently not available on your system. For details, see Help→System Info." To see why the plug-in didn't load, choose Help→System Info and scroll down in the resulting dialog box until you see the plug-in in question, along with Photoshop's oh-so-brief explanation of what went wrong. For example, if you try to learn why the Variations adjustment (page 371) didn't load in 64-bit mode, you'll see the following line of text: "Variations NO VERSION - 32-bit plug-in not supported in 64-bit - next to the text: 'Variations.plugin'."

In CS5, if a plug-in doesn't load, you've more likely than not encountered one that only works in 32-bit mode. In

that case, if you're on a PC you need to make sure you've installed it into the right program folder (see the box on page 6). If you're on the Mac, check out the box on page 6 to learn how to launch Photoshop in 32-bit mode.

If you don't get the "plug-in didn't load" message and your plug-in is *still* missing, take a peek in other menus, such as Select or File→Automate to see if it ended up in there. You can also look at the list of loaded plug-ins by choosing Photoshop→About Plug-In (Help→About Plug-In on a PC). Because so many Photoshop features are actually plug-ins (most filters, import and export commands, and so on), the list is rather long, so you may need to scroll to see if Photoshop loaded the one in question.

If your plug-in is on the list but isn't loading, about the only thing you can do is install a fresh copy of it or, better yet, see if a newer version is available from the developer's website. Keep in mind that some plug-ins continue to work with newer versions of Photoshop, but some don't.

Note: For a comprehensive list of Photoshop plug-ins, visit *www.adobe.com/products/plugins/photoshop*. And why, you might wonder, are some of them called "third-party" plug-ins? Because they're made by someone other than Adobe!

Noise Reducers

If you've taken a photo in low light (in a dark restaurant, say), or if you set your camera to a high ISO (a setting that increases the camera's sensitivity to light), chances are you've got a ton of *noise*—grainy-looking speckles—in your image. While you'll find a couple of noise-reducing tricks in Chapter 11, if the image is *really* important, you should spring for a noise-reducing plug-in instead.

Noiseware

This plug-in has quickly become the noise reducer of choice for professional photographers. Instead of blurring the whole image to make the noise less visible, Noiseware analyzes the image and reduces noise only in the parts of the image that really need it. You also get a handy before-and-after view so you can see what it did. It's available from *www.imagenomic.com* and costs around $50.

Tip: You can often get plug-ins much cheaper if you buy them bundled together. Be sure to look for special deals on the developer's website.

Dfine

This plug-in also reduces the noise in your image in a very simple and nondestructive way. When you launch it and click its Measure button, Dfine scours your image for noise in areas without much detail (where noise is easiest to see). Start by trying the factory setting and then increase or decrease the noise-reduction level using the sliders (see Figure 19-2). When you find a setting you like, click OK to make Dfine make a copy of the currently selected layer and apply the noise reduction to the duplicate instead of the original.

Figure 19-2:
Dfine's handy split-screen view lets you see how much noise the plug-in removes from your image before you commit to the change. Here you see the original image on the left side of the red vertical line and the result on the right.

Thanks to Nik Software's amazing *control points* technology, Dfine lets you reduce noise in certain areas of your image without making a mask. It also figures out which kind of camera you used to take the photo and then applies the right amount of noise

reduction for your particular model (which makes sense because your camera is what introduced noise in the first place). You can buy Dfine for $100, but it's cheaper if you buy it along with other Nik products, like Sharpener Pro, Color Efex Pro, Viveza, and more (*www.niksoftware.com*).

Note: One nice thing about Nik Software's plug-ins is that they all use the same window layout; so, once you learn how to use one, you can easily use 'em all.

Noise Ninja

Long considered the gold standard of noise-reduction software (though the newer Noiseware may have changed that), photographers and newspapers have used this plug-in for years. It helps reduce noise (speckled imperfections) and grain (textured imperfections) while preserving details. It can tackle 16-bit images (see the box on page 45), do batch processing, and work as a Smart Filter (page 634). It'll set you back about $80 (*www.picturecode.com*).

Making Selections and Masking

As you've learned in previous chapters, selecting stuff like hair and fur is really hard. Sure, you can learn some tricks, but a plug-in specifically designed for that task can make your life a heck of a lot easier and save you tons of time. That said, you'll need a bit of patience when you start working with masking plug-ins because they're not for the faint of heart. With practice, though, you can use them to create selections you just can't make any other way.

Note: Adobe put a lot of work into improving the Refine Edge command in Photoshop CS5. So before you plunk down cold hard cash on a masking plug-in, make sure you're up to speed on the new enhancements discussed starting on page 166.

Fluid Mask

Fluid Mask is a powerful plug-in that helps make easier work of masking around complex areas like hair and fur. As soon as you open Fluid Mask, it analyzes your image and marks what it thinks are edges with blue lines (see Figure 19-3) so you can decide which edges you want to keep and which ones you want to zap and then create a cutout of your image to send back to Photoshop to use as a mask. You can also save your project and return to it later—a nice touch. Fluid Mask costs about $150 (*www.vertustech.com*).

Figure 19-3:
These blue lines mark the edges that Fluid Mask found in the image. If you use a combination of the plug-in's tools (on the left), you can mark areas you want to keep and ones you want to throw away.

Mask Pro

Mask Pro helps you pick the precise colors you want to keep or remove as you build image masks. It gives you two eyedroppers to work with: Use one to select colors you want to keep and the other to select colors you want to throw away (see Figure 19-4). Then, you can use its Magic Brush to paint away the background while the program helps you along by referring to the Keep and Drop color palettes you made.

Mask Pro can also extract partial color from a pixel, leaving you with a partially transparent pixel—important when you're selecting hair or fur (the edges are so soft that they have to be partially see-through to blend in with a new background). You can also view the image in mask mode, which helps you see what the selection looks like because it's displayed in shades of gray (just like a layer or channel mask). Mask Pro can work with 16-bit images and works as a Smart Filter though you have to turn the layer into a Smart Object first (see page 126); otherwise, the plug-in deletes the selected pixels as soon as you apply it. It costs around $160, though it's cheaper if you buy it as part of a bundle (*www.ononesoftware.com*).

Tip: When you install an onOne Software plug-in like Mask Pro, it shows up in the Filter menu and in a brand-*new* menu between Window and Help called "onOne".

Color Correction and Enhancement

The plug-ins in this category can spruce up or fix the color in your images and produce a startling array of special effects while they're at it. Read on for the scoop!

Viveza

As you've learned in previous chapters, before you adjust the color of a specific part of your image, you need to select it. Not so with Viveza. Since this plug-in made its debut in early 2008, it has revolutionized selective color and light adjustments. If you mark the areas you want to change with *control points* (the small gray circles shown in Figure 19-5), you can adjust the saturation, brightness, and contrast of those areas at warp speed. And Viveza performs its magic on a duplicate layer, so you don't have to worry about it destroying your original image. It's available from *www.niksoftware.com* and costs around $200.

Color Efex Pro

If you could buy just one plug-in, Color Efex Pro would be a darn good choice. Using the same control points as other Nik Software plug-ins, this one lets you selectively apply 52 enhancement filters and over 250 effects to your images—all nondestructively. You can use them to enhance images in creative ways, as well as to fix color casts, smooth skin, and so on (see Figure 19-6). Drop as many control points as you want and use them to set the effect's opacity in certain areas of your image or click the Brush button to paint the effect where you want it. The price ranges from $100 for 15 filters to $300 for all 52, and it's available from *www.niksoftware.com*.

Figure 19-5:
By dropping lots of control points on your image (the little gray dots), you can adjust each area's satura- tion, brightness, and contrast individually. Notice that the con- trast and saturation of the woman's jeans and the grass have been increased while the man's red shirt has been desaturated and the sky remains untouched.

PhotoTune

This plug-in lets you correct color and skin tones easily. It's actually made up of two separate programs: ColorTune and SkinTune. The ColorTune part works like an eye exam, asking you which of two images you like better (see Figure 19-7). Through a series of six steps based on the choices you make, ColorTune resets your black and white points (see "Setting Target Colors" on page 368), applies curves for bright- ness and contrast (page 406), and so on. Since it's incredibly simple, it's great for newbies or those who (rightly!) fear the Curves dialog box. If you're more advanced (or brave), you can skip to the fine-tune panel and adjust the settings manually. You can also take a snapshot of your image and compare it with other versions that use different settings.

Figure 19-6:

Top: This split-screen preview shows you before and after versions of an image. This particular filter, called Bleach Bypass, creates a high-contrast grunge look. (If this look interests you, head over to page 778 and read about LucisArt Pro.)

Bottom: The Glamour Glow filter gives the original image (left) a seriously dreamy look (right). But because Color Efex Pro applies the effect on another layer, you can always lower its opacity to blend it with the original.

SkinTune, the other half of PhotoTune, is designed to produce accurate skin color based on the subject's ethnicity. Just click a patch of skin and then select the person's ethnicity from a pop-up menu (shown in Figure 19-8). SkinTune presents you with a row of color swatches similar to that particular skin tone; just click the one that looks best to you. It also zaps any color cast from the skin and removes the same cast from the rest of the photo. You can take a snapshot of your image and compare it with other versions produced with different settings, as well as save your settings and apply them to similar images later. Both ColorTune and SkinTune work as Smart Filters, but you have to convert your image layer to a Smart Object first (page 126). PhotoTune costs $160, and it's available from *www.ononesoftware.com*.

Figure 19-7:
ColorTune asks you to pick the better of two images in a series of six steps. It's by far the easiest way to color correct your images.

Figure 19-8:
After you choose your subject's ethnicity, you can pick from a row of color swatches developed by the folks at onOne Software. They took countless photos of people and assembled their skin tones into a massive database of over 400,000 different skin types. That's a lot of skin!

PhotoTools

This plug-in includes more than 150 photographic effects developed by the onOne team, as well as 100 extra effects from Photoshop guru Jack Davis and wedding photographer Kevin Kubota. PhotoTools helps you create beautiful portraits and vignettes, combine multiple effects into a layer mask, and more. You can export several versions of your image with different color profiles (page 48), which is handy if the result is headed to a printer or the Web. You can also apply a *watermark* (a partially transparent graphic) to your files to help protect them from copyright violators when you post them on the Web. This plug-in does its thing on its own brand-new layer so it's nondestructive, and it can also batch-process images. The pro edition costs $260 and the standard edition, without the effects from Jack Davis and Kevin Kubota, costs $160 (unless you buy it as part of onOne's Plug-In Suite). It's available from *www.ononesoftware.com*.

Miscellaneous Plug-Ins

Most of the plug-ins covered in this section relate to specific tasks like enhancing detail, making enlargements, building websites, and so on, but some also alter color.

LucisArt

This plug-in has been around for many years and, while it's popular in scientific and medical circles, it's only recently begun to make a splash in the creative realm. Using a process originally developed to enhance details in images captured with electron microscopes, it brings out more detail from your image than you knew was there. Using only the luminance (lightness) info from your image, it enhances details without destroying highlights or shadows or shifting color (though you can control the color with a slider because you may *want* to shift the color a little).

With this plug-in, you can vary your image in thousands of ways by tweaking just a couple of sliders, and although you could possibly reproduce some of these effects with Photoshop, you'd never know these possibilities existed if you didn't use this software first. You can use this plug-in to tweak individual channels or work on the composite channel (page 189), and you can also blend the original back into the processed image using a slider. Figure 19-9 gives you a taste of what you can do with LucisArt. The pro version will set you back $595, but if you make your living working with images, it's money well spent; a light version that offers fewer settings and gives you limited control over mid-range contrast patterns and reducing scan lines is available for $280 for the Mac and $360 for PCs (*www.lucisart.com*).

Figure 19-9:
Top: You can use LucisArt to smooth the details of your image to create a beautiful watercolor effect.

Bottom: If you enhance the details in your image and then smooth the overall picture slightly, you can get a high-contrast grunge effect (right) similar to the effect used in the movie 300.

Silver Efex Pro

This plug-in isn't a black-and-white converter; it's a virtual black-and-white *dark-room* that helps you create stunning black-and-white images (see Figure 19-10) from color ones (though you can also use it to improve images that are already black and white). It has more than 20 black-and-white presets and also lets you create your own. You can make global adjustments using the sliders or drop control points to tweak the brightness, contrast, and structure (level of detail) in specific areas without affecting the whole image. The control points let you quickly sharpen certain parts of your image, like eyes, the pattern on clothing, and so on. You can also add a color filter just as if you'd put a filter on your camera lens. Silver Efex Pro lets you

choose from over 20 different film types to simulate the look and grain of real film, add tints, or burn the edges of your image. It works as a Smart Filter and costs about $200 (*www.niksoftware.com*).

Figure 19-10:
Silver Efex Pro, currently the most powerful black-and-white plug-in on the market, helps you create the look of black-and-white images captured on real film. If you want to add a little grain to your image, you can pick from several different options that look like real film grain.

Genuine Fractals

If you need to enlarge an image, this plug-in will save your bacon. It lets you create printable versions of even low-resolution images (like those made for the Web or captured with a low-quality setting on your digital camera). It can blow images up to over 1,000 percent to make honkin' big panoramas, enlarge still frames from old videos to create higher-quality versions, and so on. It can scale any Photoshop document—even if it's brimming with Smart Object layers (page 77), paths (page 26), or Type layers (page 76)—without losing resolution or harming the image's quality. Just pick the pixels dimensions (if you know them), enter a percentage for the enlargement, or enter the print size and resolution you want (page 243). If your image's proportions don't match those of the paper size you pick, Genuine Fractals offers you a cropping grid. It also batch-processes images. The pro version costs $300 and the standard version, without CMYK image support, runs $160 (*www.ononesoftware.com*).

FocalPoint

Like popular tilt lenses (page 639), this plug-in lets you create interestingly blurred backgrounds and shallow depth-of-field effects by controlling exactly which part of your image is in focus. Since it mimics a real tilt lens, you don't have to worry about swapping lenses while you're out shooting. You use a "focus bug" to control which part of your image is in focus (Figure 19-11): Use its "legs" to rotate the aperture shape and size, and its "antennae" to control the amount of blur, as well as the transition between the blurry and unblurry bits (otherwise known as the blur's feather amount). You can also add a vignette to darken or lighten the edges of your image and save your settings as a preset to use again later. This plug-in can batch-process images, too. It costs $160, and you can get it from *www.ononesoftware.com*.

Figure 19-11:
The FocalPoint plug-in's "focus bug" lets you control the size and angle of the blur.

Sharpener Pro

As you learned in Chapter 11, sharpening is a bit of an art. It's hard to judge the amount of sharpening you need for a print based on what you see onscreen. With this plug-in, you choose the type of printer and paper you're going to use and Sharpener Pro applies the appropriate amount of sharpening. You can use the Structure slider to control the amount of details in the edges and the Focus slider to apply

more sharpening to areas that are slightly out of focus. Drop as many control points as you want to apply more or less sharpening to specific areas (like eyes). You don't even have to worry about duplicating or stamping (page 112) your layers before you use this plug-in—it does all that for you. It costs $200, and it's available from *www. niksoftware.com*.

Eye Candy

This ever-popular set of special effects plug-ins now comes in one big honkin' set. It includes 30 filters that create everything from metal; glass; gel; natural phenomena like fire, ice, and smoke; to textures for your re-skinning pleasure like lizard, fur, and stone. The Eye Candy plug-in set runs $250 and is available from *www.alienskin.com*.

SiteGrinder

If you've designed a website in Photoshop and shudder at the thought of slicing it up and turning it into actual code, this plug-in will do it for you in just two steps (see Figure 19-12). SiteGrinder builds a web page based on *CSS* (Cascading Style Sheets) straight from Photoshop so you never have to *see* (much less tweak) any code. You can also make photo galleries, Flash slideshows, CSS-based menus, and other amazing stuff without losing the design you've painstakingly crafted in Photoshop. The magic lies in naming your layers and layer groups things like "button," "rollover," "pop-up," and so on, so the plug-in can figure out how each part of your web page should work. The pro version is $350 and the basic (which doesn't include several features like QuickTime, Flash, image gallery, and form support) is $130 (*www.medialab.com*).

Figure 19-12:
If you've mocked-up a web page in Photoshop using layers (shown in the background), SiteGrinder can turn it into an HTML reality in minutes. In the foreground you can see the SiteGrinder dialog box alerting you that it has examined your document.

Index

Buy this book and get access to the online edition for 45 days—for free!

"Lesa did a great job on this book, and in my mind, it's the new Photoshop bible."
—SCOTT KELBY, EDITOR & PUBLISHER, *PHOTOSHOP USER* MAGAZINE

Photoshop CS5
the missing manual®
The book that should have been in the box®

O'REILLY®

Lesa Snider
Foreword by David Pogue

Photoshop CS5:
The Missing Manual
By Lesa Snider
May 2010, $39.99
ISBN 9781449382599

With Safari Books Online, you can:

Access the contents of thousands of technology and business books

- Quickly search over 7000 books and certification guides
- Download whole books or chapters in PDF format, at no extra cost, to print or read on the go
- Copy and paste code
- Save up to 35% on O'Reilly print books
- **New!** Access mobile-friendly books directly from cell phones and mobile devices

Stay up-to-date on emerging topics before the books are published

- Get on-demand access to evolving manuscripts.
- Interact directly with authors of upcoming books

Explore thousands of hours of video on technology and design topics

- Learn from expert video tutorials
- Watch and replay recorded conference sessions

To try out Safari and the online edition of this book FREE for 45 days, go to *www.oreilly.com/go/safarienabled* and enter the coupon code OZCIPXA. To see the complete Safari Library, visit safari.oreilly.com.

O'REILLY®

Spreading the knowledge of innovators

safari.oreilly.com